A Garland Series

OUTSTANDING
THESES FROM THE

Courtauld
Institute
of Art

Women Artists
in Nineteenth-Century
France and England

**Their Art Education, Exhibition Opportunities
and Membership of Exhibiting Societies
and Academies, with an Assessment of
the Subject Matter of their Work
and Summary Biographies**

In two volumes

Volume II

Charlotte Yeldham

Garland Publishing, Inc., New York & London

1984

All volumes in this series are printed
on acid-free, 250-year-life paper.

Library of Congress Cataloging in Publication Data

Yeldham, Charlotte, 1951–
Women artists in nineteenth-century France and England.

(Outstanding theses from the Courtauld Institute of Art)
Bibliography: p.
1. Women artists—France—Biography. 2. Art, Modern—
19th century—France. 3. Women artists—England—
Biography. 4. Art, Modern—19th century—England.
I. Title. II. Series.
N6847.Y4 1984 704'.042'0942 [B] 83-48689
ISBN 0-8240-5989-1

Printed in the United States of America

VOLUME THREE

ALPHABETICAL NOTES

INTRODUCTION

1. All exhibitions have been covered for which abbreviated
 references have been given at the beginning of volume 1.
 See bibliography for details of these exhibitions.
 Winter exhibitions of sketches and studies held by the
 Old Water-colour Society have not been included as these
 frequently contained preparatory studies for works
 exhibited at the summer exhibitions.

2. The works listed exemplify themes given in the main text.

3. Full titles have been given.

4. Copies have not been included.

5. The medium is not given except in the case of sculpture
 or when it is included in the title.

6. When the whereabouts of a work are known, details are
 given. Otherwise, references are to illustrations
 whether in exhibition catalogues, sale catalogues, perio-
 dicals or books.
 (ill.) indicates that the work is illustrated in the
 catalogue for the exhibition.
 (ill. in Witt Library) indicates that an illustration,
 in the form of an engraving or a cutting from a
 journal, catalogue or book, exists in the Witt
 Library.

7. Artists'names are mostly lifted straight from the catalogues
 and therefore appear in different forms. Miss Anne
 Beaumont, for instance, is referred to as Miss Beaumont,
 Miss A. Beaumont, Anne Beaumont and Miss Anne Beaumont and
 her Christian name is given as Ann as well as Anne. Only
 when it has been thought necessary to stress that a number
 of works within individual alphabetical notes are by the
 same artist, have the names been standardized to that most
 frequently used.

8. (+ see ...) indicates that the full title of the work is
 given on the page (meaning volume 1) or in the note
 indicated.

9. In the alphabetical notes on France, works were exhibited
 at the Paris Salon unless otherwise indicated.

ALPAHBETICAL NOTES - ENGLAND

A. 1801 RA Miss E. Smith: "A votary of Minerva" 332
 1801 RA Miss A. Dickenson: "Flora and Zephyr" 588
 1801 RA Miss A. Dickenson: "Venus and Cupid" 589
 1801 RA Miss Paye: "Cupid 716
 1801 RA Miss J. Spicer: "ACherubim's Head, on enamel" 796
 1801 RA Miss M.A. Spicer: "A Cherubim's Head, on enamel" 799
 1802 RA Miss Sophia Smith: "The Parting of Hector and Andromache"
 ".. the illustrious chief of Troy,
 Stretch'd his fond arms to clasp the lovely boy:
 The babe clung, crying, to his nurse's breast,
 Scar'd at the dazzling helm and nodding crest.

 With secret pleasure, each fond parent smil'd,

 And Hector hasted to relieve his child -
 The glitt'ring terrors from his brow unbound,
 And plac'd the beaming helmet on the ground;

 Then kiss'd the child, and lifting high in air,

 Thus to the gods prefer'd a father's pray'r" 396
 1803 RA Miss H.A.E. Jackson: "Venus and Cupid" 585
 1806 RA Miss H.A.E. Jackson: "A nymph bathing" 248
 1807 RA Mrs James Green: "Hebe" 454
 1807 RA Mrs James Green: "Aurora" 457
 1807 RA Mrs S. Jones: "Venus, Adonis and Cupids" 486
 1807 BI Miss Hamilton: "Ariadne and Cupid" 144
 1807 BI Miss Jones: "Cupid with a dog" 141
 1808 BI Miss Jones: "Pomona" 181
 1808 BI Mrs Singleton: "An Infant Neptune" 180
 1808 AAW Mrs Green: "Ariadne" 226
 1809 BI Mrs Bell: "Vertumnus and Pomona" 58
 1809 BI Mrs Green: "Ariadne" 188
 1809 BI Mrs Singleton: "A Zephyr" 40

B. 1800 RA Miss E.A. Rigaud: "Ruth and Boaz: 'Then said Boaz unto Ruth,
 hearest thou not, my daughter? go to glean in another
 field, neither go from hence, but abide here fast by the
 maidens'" (Ruth, ch.2, v.8) 95
 1800 RA Maria Spilsbury: "The Ascension of the Innocents" (Matthew
 ch.2, v.16) 729
 1801 RA Mrs Cosway: "The Call of Samuel" 114
 1801 RA Mrs Cosway: "The exultation of the Virgin Mary, or the salva-
 tion of mankind, purchased by the death of Jesus Christ"
 232
 1802 RA Mrs Williamson: "A Head of Christ" 371
 1804 RA Maria Spilsbury: "Christ feeding the multitude, the second
 miracle of the loaves and fishes" (St. Matthew ch.15)482
 1805 RA Maria Spilsbury: "Return of the spies from the promised land
 with the fruit and large grapes from Eschol Caleb, before
 Moses and Aaron, contradicts the evil report of the fear-
 ful and unbelieving spies, etc." (Numbers ch.13, v.30)242
 1807 RA Maria Spilsbury: "Eli and Samuel in the Temple: Samuel
 declaring the judgments of God against Eli's family"
 (Samuel I, ch.3, v.18) 241
 1808 RA Miss E. Smith: "Samson and Delila" 93
 1808 RA Miss H.A.E. Jackson: "The Restoration of Moses. 'And Pharaoh's
 daughter said unto her, take this child, etc.'" (Exodus
 ch.2) 144
 1808 BI Miss Maskall: "Ruth in the Fields of Boaz" 136
 1809 BI Mrs Singleton: "The Infant Jesus" 22

C. 1801 RA Miss Gulston: "Vivaldi and Paulo, in the ruins of Paluzzi 457
 1802 RA Mary Lloyd: "Queen Eleanor's Confession to King Henry II" 873
 1804 RA Miss E. Farhill: "The Death of Cleopatra" 311
 1807 RA Miss H.A.E. Jackson: "Cleopatra dissolving the Pearl" 248
 1807 RA Mrs S. Jones: "St. Cecilia and angels" 596
 1807 BI Miss Jones: "St. Cecilia" 126
 1808 BI Miss Jones: "St. Theresa" 179
 1808 BI Miss Smith: "Mary Queen of Scots; her lament on the approach
 of Spring"
 The meanest hind in fair Scotland
 May rove their sweets among;
 But I, the queen of a' Scotland,
 Maun lie in prison strong" (Burns Poems) 184
 1809 RA Miss H.A.E. Jackson: "Agrippina habited mournfully"
 "Agrippina came forth .. with the urn of Germanicus in
 her hand, and her eyes stedfastly fixed upon that
 precious object" Murphy's Tacitus book iii 49

D. 1810 RA Miss H.A.E. Jackson: "The Assumption of Hersilia"
 "With fear the modest matron lifts her eyes,
 And to the bright ambassadress replies:
 O Goddess , yet to mortal eyes unknown,
 But sure thy various charms confess thee one;
 O quick to Romulus thy votress bear,
 With looks of love he'll smile away my care;
 In whate'er orb he shines, my heav'n is there!
 The haste with Iris to the holy grove,
 And up the Mount Quirinal as they move,
 A lambent flame glides downward thro' the air,
 And brightens with a blaze Hersilia's hair.
 Together on the bounding ray they rise,
 And shoot a gleam of light along the skies:
 With op'ning arms Quirinus met his bride,
 Now Ora nam'd, and press'd her to his side"
 Ovid's Metamorphoses, Garth's edition, book xiv 225
 1810 RA Miss L. North: "Venus and Cupid" model in wax 881
 1810 BI Mrs Green: "A Cherub" 91
 1810 BI Miss Hay: "Urania" 33
 1810 BI Miss H.A.E. Jackson: "Clymene and her Daughters mourning
 over the tomb of Phaeton"
 "The name inscrib'd on the new tomb appears,
 The dear, dear name she bathes in flowing tears,
 Hangs o'er the tomb unable to depart,
 And hugs the marble to her throbbing heart.
 Her daughters too lament, and sigh, and mourn,
 (A fruitless tribute to their brother's urn),
 And all the day stand round the tomb and weep"
 (Ovid's Metamorphoses, vol.i, book 2, Garth's Edition 14
 1810 BI Mrs Singleton: "Iphigenia" 95
 1812 RA Miss H.A.E. Jackson: "Venus lamenting the death of her dove"
 "At that sweet bird, whose office 'twas to bear
 The car of Venus through the ambient air,
 The wanton Cupid shot a playful dart,
 But pierc'd, with luckless aim,the flutt'rer's heart.
 The Paphian goddess sigh'd, with grief oppress'd,
 And dropt a tear upon her favourite's breast:
 Object divine of innocence and love:
 The Queen of Beauty mourning for her dove" Fitzgerald 238
 (a work with the same title was exhibited at the British
 Institution in 1816 no.98)

1812 BI Mrs Ansley: "Venus borne on the waves, in her shell, to
 the island of Cyprus" ("Orta Salo" - Catullus) 70
1812 BI Miss H.A.E. Jackson: "Clytemnestra and her children suppli-
 cating her husband, Agamemnon, to spare the life of
 Iphigenia" 55
1813 BI Mrs Ansley: "Perseus and Andromeda"
 " - Veniensque immenso bellua ponto,
 Imminet, et latum subpectore possidet aequor.
 Conclamat Virgo" - Ovidii Metam. Lib.IV. Fab.18 68
1815 RA Mrs Ansley: "Cupid and Psyche"
 "Psiché: 'Ouvrons. Quelles vapeurs m'offusquent le
 cerveau,
 Et que vois je sortir de cette boëte ouverte?
 Amour, si ta pitié ne s'oppose à ma perte,
 Pour ne revivre plus, je descens au tombeau.
 Amour: 'Votre péril Psiché, dissipe ma colère.
 * * *
 Tournez vos yeux vers moi'" Psiché de Molière 321
1815 BI Miss H.A.E. Jackson: "Mars subdued by Peace" (the quotation
 is given in the text) 140
1815 OWS Miss E.E. Kendrick: "Cupid and Psyche" 31
1817 RA Mrs Ansley: "Thetis and Peleus" 144
 (Also exhibited, with a quotation from Ovid's Meta-
 morphoses, at the British Institution in 1818 no.11)
1818 RA Miss E.Jones: "Olympia"
 "E di lontano le gonfiate vele
 Vide fuggir del suo signor crudele" (Orlando furioso
 c.10) 666
1818 BI Mrs Ansley: "Thetis and Peleus"
 "Bright Sol had almost now his journey done,
 And down the steepy western convex run;
 When the fair Nereid left the briny wave,
 And as she us'd, retreated to her cave.
 He scarce had bound her fast, when she arose,
 And into various shapes her body throws;
 She went to move her arms, and found them ty'd;
 Then with a sigh, 'some god assists ye' cried"
 Vide Ovid's Metamorphoses, Book the 2nd. 11

E. 1810 BI Mrs John Taylor: "The Holy Family" 31
 1810 BI Miss Jones: "A Head of Christ" 90
 1812 BI Mrs Briane: "A madona" 3
 1813 BI Miss H.A.E. Jackson: "Naomi and her daughters-in-law before
 the city of Bethlehem-Judah.
 "And they lift up their voice, and wept again: and
 Orpah kissed her mother-in-law: but Ruth clave unto
 her. And she said, behold, thy sister-in-law is gone
 back unto her people, and unto her gods: return there
 after thy sister-in-law. And Ruth said, Intreat me not
 to leave thee, or to return from following after thee:
 for whither thou goest, I will go; and where thou
 lodgest I will lodge; thy people shall be my people,
 and thy God my God. Where thou diest, will I die,
 and there will I be buried: the Lord do so to me, and
 more also, if ought but death part thee and me" Book of
 Ruth, ch. I, v.14,15,16 and 17 60

1814 BI Miss H.A.E. Jackson: "Judith, attended by her maid, leaves the city of Bethulia, to go forth into the camp of Holofernes"
"Judith went out, she and her maid with her; and the men of the city looked after her, until she was gone down the mountain, and 'till she had passed the valley, and could see her no more" Book of Judith, ch.X, v.9 and 10 54

1814 RA Miss H.A.E. Jackson: "And they lift up their voices and wept again, and Orpah kiss'd her mother-in-law, : but Ruth clave unto her" (Ruth ch.1, v.14) 38

1814 RA Mrs Ansley: "Tobit restored to sight by Tobias" 233

1814 RA Mrs Ansley: "Charity: a study for a large picture"
"She stretcheth out her hand to the poor; yea she reacheth forth her hands to the needy" (Proverbs ch.30, v.21) 113

1814 RA Mrs Ross: "The Adoration of the Shepherds" 184

1814 RA Miss H.A.E. Jackson: "He was despised and rejected of men; a man of sorrows, and acquained with grief" (Isiah, ch.1, v.3) 320

1814 RA Harriet Hill: "A figure intended for a picture of the Judgment of King Solomon"
"Then spake the woman, whose the living child was, unto the king, and she said, Oh! my lord, giver her the living child and in no wise slay it" 321

1815 RA Miss H.A.E. Jackson: "Rebekah going down to the well"
"And it came to pass that Rebekah came out with her pitcher upon her shoulder;
And she went down to the well and filled her pitcher" Genesis, ch.xxiv, v.15 and 16 14
(a work with the same title was exhibited at the British Institution in 1816 no.244)

1816 RA Mrs Ansley: "The Death of Abel"
"Oh Abel! Oh my son! my son! my dear son! cried Eve, lifting up his arm stiffened by death. When Cain, mad with despair, came without design to the place where lay the dead body of his brother, and seeing near the corpse his father speechless, and his mother pale and lifeless, he cried out trembling. He is dead! I killed him!" Vide Gessner's Death of Abel 339

F. 1810 RA Miss M.A. Flaxman: "Sappho" 648

1811 BI Miss E.H. Trotter: "A Captive at Howard's Tomb"
"Howard the philanthropist died at Cherson: he desired that he might be laid in a spot of earth which he chose, and only a sun-dial erected over his grave, without any inscription" 6

1811 BI Miss E.H. Trotter: "Oiselette and his son in prison"
"These interesting persons were both condemned to die by Robespierre: they were in prison, and lying on the same pallet; the guard came at midnight and called 'Oiselette!' The son was first on the list of the condemned; but the father, taking advantage of the deep sleep the boy had fallen into, followed the executioner and suffered in his stead" 63

1811 BI Miss Mary Anne Flaxman: "Sappho and Cupid" 96

1812 AAW Mrs S. Jones: "St. Cecilia" 219

G. 1821 RA Mrs Ansley: "Satan borne back to his chariot, after having
been wounded by the Archangel Michael"
"Forthwith on all sides to his aid was run
By Angels many and strong, who interposed
Defence, while others bore him on their shields
Back to his chariot, where it stood retired
From off the files of war; there they had him laid,
Gnashing for anguish and despite and shame,
To find himself not matchless, and his pride
Humbled by such rebuke, so far beneath
His confidence to equal God in power"
Vide Milton's "Paradise Lost" bk.vi, line 335 229
(a work with the same title was exhibited by the artist
at the British Institution in 1822 no.200)
 1824 SBA Lady Bell: "The Holy Family" 69
 1826 RA Mlle. Predl: "The Adoration of the Shepherds - The Holy
Family" 826
 1826 SBA Miss G. James: "The Madonna etc." 433
 1827 SBA Mrs Henderson: "Hagar and Ishmael" 465
 1829 SBA Miss E.E. Kendrick: "Madonna and child" 691

H. 1824 RA Mrs Ansley: "Queen Elizabeth giving the ring to the Earl of
Essex"
"Depend, my Lord, on this; 'twixt you and me
This ring shall be a private mark of faith inviolate"
(Tragedy of the Earl of Essex) 35
 1825 SBA Miss E.E. Kendrick: "Titian's daughter, Vandyke, Persian
Ambassador and Gulnare" 478
 1825 SBA Miss E.E. Kendrick: "The Lady Hamilton and Mme deMontespan"439
 1825 SBA Miss E.E. Kendrick: "Mary Queen of Scots, Anne Boleyn and
Henrietta Maris" 458
 1826 BI Miss Eliza Jones: "The Christian Captive of Drachenfels" 29
 1827 SBA Miss J. Ross: "Queen Henrietta, the wife of Charles I" 644
 1827 SBA Miss Sharples: "Suspension of Payment, County Bank" 441
 1828 SBA Miss H. Salmon: "Demosthenes" 613

I. 1820 BI Mrs W. Carpenter: "Ariadne" 278
 1820 BI Mrs E.M. Henderson: "Philoctetes in the Island of Lemnos" 77
 1820 OWS Miss E.E. Kendrick: "Andromache mourning over the helmet of
Hector" 192
 1821 RA Mrs Ansley: "Vertumnus and Pomona" (Ovid's "Metamorphoses"
bk. XIV) 23
(a work with the same title was exhibited by the artist
at the British Institution in 1822 no.297)
 1821 RA Miss E.E. Kendrick: "Venus arranging her star" 783
 1822 RA Mrs Ansley: "Iris having cut off the lock of Dido's hair"
- "Nune ego Diti
Sacrum jussa fero; teque isto corpore solvo"
Virgil's Aenid. lib.iv 330
 1823 RA Mrs Ansley: "A Bachante" 211
 1824 BI Mrs W. Carpenter: "Head of a Bacchante" 45
 1824 BI Mrs W. Carpenter: "Cupid"
"Love, banished heaven, in earth was held in scorn,
Wand'ring aborad in need and beggary,
And wanting friends; though of a goddess born,
Yet crav'd the alms of such as passed by" (Drayton
sonnet xxiii) 211
 1824 SBA Miss E.E. Kendrick: "Agrippina bearing the Ashes of Germanicus"
443

J.

K.

| 1824 | SBA | Miss E.E. Kendrick: "Andromache discovering Achilles dragging the body of Hector round the walls of Troy" 468 |

```
      1824  SBA   Miss E.E. Kendrick:  "Andromache discovering Achilles
                       dragging the body of Hector round the walls of Troy" 468
      1824  SBA   Miss E.E. Kendrick:  "A Bacchante" 489
      1825  BI    Miss Eliza Jones:  "A Bacchante" 219
      1825  SBA   Miss E.E. Kendrick:  "Venus arranging her Star" 469
      1826  BI    Miss A. Fayerman:  "The infant Psyche" 189
      1826  SBA   Miss E.E. Kendrick:  "Psyche" 670
      1827  SBA   Miss E.E. Kendrick:  "Flora clasping her Flowers" 650
      1828  BI    Mrs H.A.E. Browning (formerly Miss Jackson): "Clymene mourn-
                       ing over the tomb of Phaeton" 432
      1828  SBA   Miss E.E. Kendrick:  "A Nereid" 563
      1829  SBA   Miss M. Alabaster:  "Head of Apollo" sculpture 840
      1829  BI    Mrs H.A.E. Browning:  "Agrippina with the Urn of Germanicus" 88
      1829  BI    Mrs Pearson: "Thalia, the laughter-loving Muse" 79

J.    1830  SBA   Miss E.E. Kendrick: "Clytie" 592
      1830  SBA   Miss E.E. Kendrick: "The Birth of Venus" 643
      1831  SBA   Miss L.J. Green: "Cupid" 689
      1831  SBA   Miss E.E. Kendrick: "Psyche - the wandering butterfly" 681
      1832  NSPW  Miss E.E. Kendrick: "Hero suspending the Lamp for Leander" 281
      1833  SBA   Miss E.E. Kendrick: "Ceres" 611
      1833  NSPW  Miss E.E. Kendrick: "Venus, as the Evening Star, cherishing
                       her Dove" 278
      1833  NSPW  Miss E.E. Kendrick: "Hebe" 291
      1833  SBA   Miss E.E. Kendrick: "The God of Day" 761
      1836  SBA   Miss E.E. Kendrick: "Juno attiring herself with the Cestus of
                       Venus" 672
      1836  SBA   Mrs E.C. Wood: "Medusa" 712

K.    1830  SBA   Miss Beaumont: "Ruth" 148
      1830  SBA   Miss Fanny Corbaux:  "The Holy Family" 728
      1830  SBA   Miss C. Watson: "Esther and Ahasuerus" 681
      1831  RA    Mrs Henderson: "The Mother of the Infant Moses placing him
                       in ark" 419
      1831  SBA   Miss Beaumont: "Esther, chaper seven"
                       "Ahasueras the Persian Monarch, and Hamon his minister,
                       at Esther's banquet.  The Queen sueth for herself and
                       people:  her attendant, a Jew girl, in the background"
                       200
      1832  BI    Miss Anne Beaumont: "Esther and Ahasuerus" 547 (possibly the
                       same as the preceding)
      1833  BI    Miss Kearsley: "The Holy Family" 537
      1833  NSPW  Miss L. Burbank: "The Holy Family" 317
      1834  NSPW  Caroline Watson:        "Esther and Ahasuerus" 275
      1835  SBA   Mrs Bachhoffner (late Miss Derby): "The Infant Jesus" 623
      1836  OWS   Miss E. Sharpe:  "Ruth and Naomi"
                       "And she said, Behold, thy sister-in-law is gone back
                       unto her people, and unto her gods;  return thou after
                       thy sister-in-law.
                       And Ruth said. Intreat me not to leave thee, or to
                       return from following thee:  for whither thou goest, I
                       will go;  and where thou lodgest, I will lodge:  Thy
                       people shall be my people, and thy God my God"  Book
                       of Ruth, ch.1, v.15, 16  178
      1838  RA    Mrs Henderson:  "The sister of the infant Moses watching
                       over him.  'Think not I will leave thee'" 1229
      1838  OWS   Miss Sharpe:  "The Flight of Lot and his daughters" 68
      1838  OWS   Miss E.E. Kendrick: "An Angel" 145
      1838  OWS   Miss E. Sharpe:  "Christ and the Mother of Zebedee's children"
                       "She saith unto him:  Grant that these my two sons may
                       sit, the one on thy right hand and the other on the left,
                       in thy kingdom.'
```

But Jesus answered and said, Ye know not what ye ask.
Are ye able to drink of the cup that I shall drink of,
and to be baptized with the baptism that I am baptized
with? They said unto him, We are able.
And he saith unto them. Ye shall drink indeed of my
cup, and be baptized with the baptism that I am bap-
tized with; but to sit on my right-hand and on my left,
is not mine to give, but it shall be given to them for
whom it is prepared of my Father" - St. Matthew, ch.xx 94

1838 SBA Miss M. Gillies: "The Daughter of Zion, a series of sketches"
"I have likened the daughter of Zion to a comely and
delicate woman" (Jeremiah ch.6, v.2) 150

1839 OWS Eliza Sharpe: "Christ raising the widow's son"
"Now when he came high to the gate of the city, behold,
there was a dead man carried out, the only son of his
mother, and she was a widow; and much people of the city
was with her" 241

1839 NSPW Miss Laporte: "Ruth and Naomi"
"And Ruth said: Intreat me not to leave thee" (Ruth
ch. 1, vo.10) 4

1830 NSPW Miss F. Corbaux: "Elijah restoring the widow's son"
"And Elijah took the child and brought him down out of
the chamber into the house, and delivered him unto his
mother, and said, See thy son liveth; and the woman
said to Elijah, Now by this I know that thou art a man
of God, and that the word of the Lord in thy mouth is
truth" 293

1839 SBA Miss M. Gillies: "The captive daughter of Zion"
"Yet his hand is not shortened that it cannot save, nor
his ear heavy, that it cannot hear" (Isiah) 524

L. 1831 SBA Miss Derby: "Lady Jane Grey" 668
 1832 SBA Miss L. Adams: "Richard Coeur de Lion" (vide Neele's Romance
of History) 538
 1833 OWS Miss Sharpe: "Cleopatra" 390
 1835 SBA Miss Sarah Setchel: "Mary of Burgundy"
"Thus, perhaps, the hour which she spent each night in
her own chamber, ere she lay down to rest, was one of
the sweetest portions of time to Mary of Burgundy; it
was the hour in which her heart , relieved from all the
pressure of the day, could commune with itself at ease;
and could one have looked into her thoughts on that or
any other night, the whole course of her life gives
reason to believe that they would have displayed as fine
and pure a tissue of sweet and noble ideas as ever the
mind of woman wove" -
(Vide "Mary of Burgundy" by the Author of "Darnley",
"Richelieu" etc.) 611

 1837 SBA Miss Lucy Adams: "The Rose Queen of Salency"
"St. Medard, Bishop of Noyon in France, instituted in
the sixth century a festival at Salency, for adjudging
one of the most interesting prizes that piety has ever
offered to virtue.
This prize consists of a simple crown of roses, bestowed
on the girl who is acknowledged by all her competitors
to be the most amiable, modest and dutiful. The founder
of this festival enjoyed the high gratification of
crowning his own sister as the first Rose Queen of
Salency" 773

 1837 SBA Mrs Mannin: "Mary Queen of Scots"

"There is a witchery in the sidelong glance
Which might wake tenderness, altho' the mind
Were unprejudiced: gaze stedfastly, thou'lt find
Each look will but her sylph-like charms enhance,
And if you blame her - pity" Leigh Cliffe 769

1837 BI Mrs Criddle: "The Early Days of Mary Queen of Scots" 424
 (possibly the same as the following work exhibited
 at the Society of British Artists)

1839 SBA Mrs Criddle: "The early days of Mary Queen of Scots"
 "The Poet's fiction that o'erclouds her brow
 Would seem some joyous tale;
 Could she but read her destiny
 And learn how many woes wait but their time
 To overwhelm her" 280

1839 SBA Mrs McIan: "Edwy, at the time of his accession, was not
 above seventeen, and he ventured to espouse a princess
 called Elgiva, though she was within the degrees of
 affinity prohibited by the canon law. On the day of
 his coronation, St. Dunstan and Archbishop Odo burst
 into the Queen's Apartment, and tearing Edwy from her
 arms, pushed him back in a disgraceful manner into the
 banquet of the Nobles" Vide Hume 419

1839 SBA Miss S.E. Thorn: "Harold discovering himself to Henry the
 First" 507

M. Other works on mythological themes were:-
 1840 SBA Mrs Wood: "Diana and Endymion" 625
 1841 SBA Mrs V. Bartholomew: "Young Bacchus round her brow had wreathed
 A garland of the vine,
 And in her ear sweet words hath breathed,
 'Beloved one, thou art mine'.
 But from his glance she sadly turned,
 To mourn the Athenian youth;
 For woman's heart, though coldly spurned,
 Still loves with faith and truth"
 (From Ariadne, an unpublished Poem - by Mrs V.
 Bartholomew) 803
 1843 BI Mrs Salter: "A young Bacchante" 175
 1843 BI Mrs Dupuy: "An Infant Bacchus" 281
 1845 BI Miss Lane: "A Sibyl" 481
 1847 SBA Jessie Macleod: "Cupid tempering his Arrows in the waters of
 Bliss - a sketch" 532
 1848 SBA Jessie Macleod: "Origin of the Red Rose"
 "Venus, hearing the cries of Adonis, hastened to his
 assistance, but carelessly stepping upon a white rose,
 which lay across her path, the thorn pierced her foot -
 hence to her blood the Red Rose owes its bloom" -
 Mythological History) 442
 1849 BI Miss M. Johnson: "Ondine" 362
 1849 SBA Miss G. Parnell: "Venus" 558

N. The Two Mary's:-
 1842 RA Miss Emily Schmack: "Madonna and Child" 319
 1842 SBA Miss M.R. Sheppard: "Madonna" 750
 1842 SBA Miss M.R. Sheppard: "Madonna" 754
 1843 SBA Miss M.R. Sheppard: "The Two Mary's at the Sepulchre" 683
 1844 NSPW Miss Louisa Corbaux: "The Magdalen" 202
 1846 RA Miss E. Cole: "The Nativity" 702
 1846 BI Mrs W. Carpenter: "Head of the Madonna" 156
 1847 SBA Miss M.A. Nichols: "The Holy Family" 652
 1848 BI Lady Brinckman: "Mary Magdalen" 291
 1848 HPG Mrs Robertson: "The Virgin Mary" 326
 1849 SBA Miss A. Metcalfe: "The Virgin" 266

Hagar and Ishmael:-
1841 BI Miss S. Hubert: "Hagar" 122
1845 SDA Miss M. Johnson: "Hagar and Ishmael" 795
1847 BI Ellen M. Nicholson: "Hagar and Ishmael"
 "And the water was spent in the bottle and she cast
 the child under one of the shrubs" (Genesis ch.21,
 v. 15) 552 sculpture
1849 NSPW Fanny Corbaux: "Hagar"
 "And the water was spent in the bottle, and she cast
 the child under one of the shrubs; and she went and
 sat her down over against him a good way off, as it
 were a bow-shot: for she said, Let me not see the
 death of the child. And the Angel of God called to
 Hagar out of heaven, and said to her: What aileth thee,
 Hagar? fear not"
 (Genesis ch.21, verses 15-17) 234

Ruth and Naomi:-
1846 RA Miss E. Cole: "Ruth and Naomi" 664
1846 NSPW Fanny Corbaux: "Naomi and Ruth"
 "She shewed her mother-in-law with whom she had wrought
 and said, 'The man's name with whom I wrought today
 is Boaz'. And Naomi said unto her daughter-in-law,
 'Blessed be he of the Lord, who hath not left off his
 kindness to the living and to the dead'" (Ruth ch.2,
 v. 19-20) 333
1846 BI Miss M. Gillies: "Ruth and Naomi"
 "And Ruth said, Intreat me not to leave thee" 393
1847 BI Miss Ranger: "Head of Ruth" 222

Rachel and Leah:-
1848 NSPW Fanny Corbaux: "Leah"
 "Surely the Lord hath looked upon my affliction: now
 therefore, my husband will love me" (Genesis, ch.24,
 v.22) 187
 (according to the "Art Union" she was shown seated,
 caressing her child (p.141))
1848 NSPW Fanny Corbaux: "Rachael"
 "God hath taken away my reproach" (Genesis, ch.30, v.23)
 206

Moses:-
1848 HPG Mrs Robertson: "Moses" 149

Jephtha's daughter:-
1846 SBA Miss S. Stanton: "Jephtha's daughter" 473

The following is a list of other religious subjects exhibited by women
in the 1840's:-
1842 SBA Miss Norris: "The Maid of Judah" 738
1844 BI Ambrosini Jerome: "Christ in the Garden of Gethsemane" 297
1845 SBA Miss Crockford: "Landscape - subject from St. Luke ch.9. v.13:
 'Give ye them to eat'" 393
1847 OWS Eliza Sharpe: "The Ten Virgins" (Matthew ch.25) 157
1847 SBA Jane Sutherland: "Elisha revealing to Hazael the Misdeeds
 of his future Life"
 "And Hazael said, 'But what, is thy servant a dog, that
 he should do this great thing?' And Elisha answered,
 'The Lord hath showed me that thou shalt be king over
 Syria'" (2 Kings ch.8, v.13) 27
1847 BI Miss Ranger: "Head of Christ" 235
1848 SBA Mrs R. Green: "The Infant Saviour" 52

O. 1841 RA Mrs Criddle: "St. Katherine" for St. Katherine's Hall,
 Cambridge 1186

1841 NSPW Miss Fanny Corbaux: "Properzia Rossi - vide Mrs. Hemans's
"Records of Woman" 65
1841 BI Miss J.M. Joy: "Lady Jane Grey" 27
1841 BI Lady Burghersh: "St. Cecilia"
"On a sudden, she appeared as if struck with a vision,
and all inspired with Celestial Harmony. Angels were
seen hovering over her with looks of admiration and
comfort ... Maximus used to declare that he had seen
an Angel descend from Heaven and alight upon the Earth
near her, to encourage her and accompany her Songs" -
Translation from La Vita de Sta Cecilia Vergine e
Martine, 1598" 377
1842 RA Sarah Elizabeth Thorne: "Elizabeth, Queen of Edward IV,
parting with her youngest son in the Sanctuary of
Westminster"
"Struck with a presage of his fate she tenderly embraced
him and bedewed him with her tears" (Hume ch.23) 534
(the artist exhibited a work with the same title at the
Society of British Artists in 1843 (no. 318)
1842 BI Miss E.Grover: "Lady Jane Grey imploring mercy of Queen Mary
for Lord Dudley"
"'Your Majesty will do well to accede to Lady Jane's
request', Bishop Gardiner remarked aloud to the Queen,
'provided she will comply with your former propositions,
and embrace the faith of Rome'" - Ainsworth's Romance
of the Tower 100
1843 SBA Miss L. Green: "Elizabeth Woodville, Queen of Edward IV, in
Sanctuary at Westminster, with her son the Duke of York"
663
1844 RA Mary Thornycroft: "Bust, in marble, of Sappho" 1307
1845 BI Miss Clara Cawse: "Catherine de Mandeville" ("Queen Eliza-
beth's visit to Sandwich" by H. Curling in Bentley's
Miscellany) 214
1845 BI Mrs Thornycroft: "Sappho" 520 sculpture
1845 BI Miss E.R. Venables: "The Premature Death of Francis II, over-
took Mary Stewart in the flower of her youth - She wept
his death as a woman; and sang it as a poetess"
"Si parfois vers les cieux
Viens à dresser ma vue,
Les doux traits de ses yeux
Je vois en une nue;
Si les baisse vers l'eau,
Vois comme en un tombeau" (Brantôme v.8) 457
1845 SBA Miss E. Cole: "Marie-Antoinette taking leave of her daughter
and sister-in-law, on being separated from them a short
time previous to her execution" (October 16th, 1793) 318
1846 BI Miss Jessey Joy: "Imelda"
"She reached the door through which she had so lately
fled from her brothers - it was closed:- she applied her
ear to it; she heard not angry voices within - no, not
a sound; ... she was about to breathe a thanksgiving to
Heaven for the Hope that Bonifazia had escaped, - then
a glittering spot, a stain on the ground, attracted her
eye ... she saw that it was blood" - From the Feuds
between the Gieremei and the Lambertazzi - Vide "Romance
of History" 473
1846 RA Ambrosini Jerome: "Lady Jane Grey pleading to Edward IV for
the restoration of the inheritance of her children"
"The King being out hunting in the neighbourhood of her
mother's castle, she waited for him under a tree still

known by the name of the 'Queen's Oak'. When Edward
paused to listen to her, she threw herself at his feet
and pleaded earnestly for the restoration of Bradgate,
the inheritance of her children. Her mournful beauty
not only gained her suit, but the heart of the King" 520

1846 NSPW Jane S. Egerton: "The Lady Arabella Stuart"
"Ye are from dingle and fresh glade, ye flowers!
By some kind hand to cheer my dungeon sent;
* * * My soul grows faint
With passionate yearning, as its quick dreams paint
Your haunts by dell and stream - the green, the free,
The full of all sweet sound - the shut from me!"
(Vide Hemans's"Records of Woman") 143

1847 RA Miss E. Cole: "Portia"
"Valerius Maximus tells us, that being prevented from
that death she wished for by the constant vigilance of
her friends, she snatched some burning coals from the
fire, and shut them close in her mouth till she was
suffocated" - Plutarch's Lives 574

1848 NSPW Jane Sophia Egerton: "Vivia Perpetua"
"At Carthage itself, four young Catechumens were seized,
and also Vivia Perpetua, a lady of quality. She was
about twenty-two years of age, was married, and had a
child at her breast. While they were in the hands of
the persecutors, the father of Perpetua, himself a Pagan
but full of affection to his favorite offspring, impor-
tuned her to fall from the faith. His entreaties were
vain * * *
'Have pity, my daughter', said he, 'on my grey hairs;
have pity on your father, if I was ever worthy of that
name. If I have brought you up to this age, if I have
preferred you to all your brethren, make me not a re-
proach to mankind * * *
Have compassion on your son, who cannot survive you; lay
aside your obstinacy, lest you destroy us all; for if
you perish, we must shut our mouths in disgrace'.
Perpetua, though inwardly torn with filial affection,
could offer him no other comfort than to desire him to
acquiesce in the Divine disposal" - (Milner's Church
History, vol.1, ch. 5) 329

1848 RA Miss M. Gillies: "King Alfred, when a child, listening to
his mother's recital of the heroic deeds of the Saxons"
313

1848 SBA Ambrosini Jerome: "Meeting of Mary Queen of Scots, and her
Mother, Mary of Guise, at Rouen" 166

P. Female figures:-
1850 BI Miss Jessie Macleod: "The Return of a Prodigal son"
"All seems unaltered, he alone is changed.
* * *
Forward she sprang - as turned he to depart,
His name upon her lips - forgiveness in her heart!" 197
(a modern interpretation)
1850 SBA Miss G. Parnell: "Eve" 612
1852 SBA Miss E. Sargent: "Esther"
"And the maid was fair and beautiful" ("Esther" ch.2,v.7)
587
1852 NSPW Miss Fanny Corbaux: "Hannah"
"As she continued praying before the Lord, .. she spake
in her heart; only her lips moved, but her voice was
not heard" (1 Samuel, ch.1, v.13) 298

1852 NSPW Miss Fanny Corbaux: "Miriam"
 "His sister stood afar off, to wit what would be done to him" (Exodus 2, v.4) 312
1853 SBA Miss E. Sargent: "Jesus saith unto her, Mary" 490
1853 BI Mrs C. Smith: "Ruth" 378
1854 NSPW Emily Farmer: "Head of the Virgin"
 "Mary kept all these things, and pondered them in her heart" (Luke ch.2, v.19) 359
1854 SBA Miss Raincock: "The Annunciation" 486
1855 NSPW Emily Farmer: "Mary, the sister of Lazarus"
 "Now when Jesus was in Bethany, in the house of Simon the leper, there came unto him a woman having an alabaster box of every precious ointment" (Matthew ch.26, v. 6-7) 135
1855 SBA Miss C.E.T. Kettle: "The Daughter of Babylon" (The ruins are as they existed at the date of the Christian era, when one star was seen in the east" 720
1856 OWS Miss E. Sharpe: "Ruth and Naomi"
 "And she said, Behold, thy sister-in-law is gone back unto her people, and unto her gods: return thou after thy sister-in-law. And Ruth said, Intreat me not to leave thee, or to return from following after thee: for whither thou goest, I will go, and where thou lodgest, I will lodge: thy people shall be my people and thy God my God: where thou diest I will die, and there will I be buried" 200
1857 SFA Mrs Holford: "St. Elizabeth sending St. John into the wilderness" 199
1857 SFA Sophia Sinnett: "Jesus saith unto her, Mary! She turned herself and saith unto him, Rabboni, which is to say, Master!" 18
1857 RA Miss Jessie Macleod: "Herodias and Salome"
 "And she went forth, and said unto her mother. What shall I ask? And she said, the head of John the Baptist" (Mark 6, verse 24) 1043
1858 SFA Miss Leila Hawkins: "The Infancy of Moses"
 "When she could no longer hide him she took for him an ark of bulrushes - and put the child therein, and she laid it in the flags by the river's brink. And the daughter of Pharoah came down to wash herself at the river. Then said his sister to Pharoah's daughter, shall I go and call to thee a nurse of the Hebrew women" (Exodus ch.2, v.3-7) 315
1858 SBA Mrs F. Dixon: "Madonna and Child" 798
1858 SBA Mrs F. Dixon: "A Madonna" 799
1858 SFA Miss M.A. Cole: "Hagar and Ishmael" 35
1858 SBA Miss Jessie Macleod: "Herodias desires her daughter Salome, to ask for the head of John the Baptist" 416 (perhaps the same work as that exhibited, under a differently worded title, in 1857 (RA no.1043)
1858 BI Mrs Thornycroft: "Jephtha's Daughter" 588 sculpture
1859 SFA Miss Rachel Levison: "Eli blessing Hannah and Samuel" 311 sculpture

Other works on Biblical themes:-
1850 SBA Miss L. Corbaux: "An Infant Saviour, a study" 651
1850 SBA Ambrosini Jerome: "St. John in the Wilderness" 233
1850 SBA Mrs Rogers: "The Angel at the Sepulchre" 494

1850 PG Miss M.A. Nichols: "Our Saviour - an imitation cameo" 308
1852 SBA Ambrosini Jerome: "The Ascension - a sketch for a large
 Picture"
 "And it came to pass while he blessed them, he was
 parted from them, and carried up into Heaven" Luke
 ch.XXIV, v.5 189
1852 RA Miss E. Acraman: "The sick waiting for the passing of our
 Saviour" 1249
1852 PG Miss E. Macirone: "The Angel of Death" 341
1855 SBA Miss Seyffarth: "The Noble Army of Martyrs praise thee -Te
 Deum Laudamus" 801
1857 OWS Mrs H. Criddle: "The Night Watch"
 "Let not your heart be troubled. I will not leave you
 comfortless; I will come to you" (St. John 14) 195

Q. 1850 RA Agness E. Seyffarth: "John Knox exhorting the Queen of
 Scots" 1045
1850 SBA Miss C.E.F. Kettle: "Cleopatra" 620
1850 PG Mrs McIan: "Here's his Health in Water! -("Righ Shamus gu
 brāth mo Mhac")
 "A Highland gentleman of 1715, in Carlisle prison, the
 day previous to his execution, receiving the last visit
 of his mother, wife, and children; and instilling into
 his son - (the future Highland Gentleman of 1745) - the
 principles of loyalty" 55
 (According to the "Ladies Companion at home and abroad"
 (May 25, 1850, no.23, p.352) the work depicted a High-
 land gentleman of the Pretender's time, the evening
 before his execution, receiving a farewell visit from
 his mother, wife and son)
1851 PG Miss M. Gillies: "The Martyr of Antioch"
 "And can it be,
 Oh Christ; that I whose tainted hands so late
 Served at the Idol's altar:-
 Am chosen to bear thy cross" (Milman) 216
 (The Martyr of Antioch was St. Margaret)
1853 OWS Eliza Sharpe: "Cleopatra" 59
1854 SBA Miss Seyffarth: "Lady Jane Grey on the Morning of her Execu-
 tion consoling her attendant" 719
1855 OWS Margaret Gillies: "Portia planning the Defence of Antonia" 299
1856 SBA Miss Seyffarth: "The Princess Elizabeth Tudor, when confined
 in the Tower by her sister Queen Mary, was daily pre-
 sented with flowers by a little girl whilst walking in
 the Tower gardens" - vide Miss Strickland's "Queens of
 England" 684
1857 RA Miss H. Hosmer: "And when the priest went in to announce to
 her that she was to die in the morning, he found her
 calmly and peacefully asleep in her miserable cell"
 (Life of Beatrice. Cenci) 1211 sculpture
1857 RA Miss R. Levison: "Hypatia, daughter of Theon, the mathemati-
 cian, - celebrated for her talent, beauty and tragical
 end, in the reign of Theodosius II, about 415 (Gibbon's
 "Decline and Fall") 1241.
1858 SFA Miss Annie Howard: "Mary, Queen of Scots" 412
1858 SFA Miss Baxter: "Mary, Queen of Scots" 429
1858 SFA Mrs Thornycroft: "Sappho" 521 marble
1859 SFA Margaret Gillies: "Vivia Perpetua" 65
 "Thou, the good Shepherd, who didst gently fold
 Those little ones with blessing in thine arms,
 Wilt care for him, my tender one, my yearling,
 Else all bereft! One prayer - but one, the last -

That in the final hour of this frail life
With love and praise triumphant oyer all
We may show forth thy glory, blessed Lord" Vivia Perpetua
(By Sarah Flower Adams)
(Described in the "Art Journal" (1859 pp.83-4): She
is presented "in prison on the eve of her martyrdom.
The figure is presented in profile, in the act of
prayer, looking through the window of her prison;
but besides the light which from without illumes the
features there is also one from within, by which the
other is superceded: that of faith and hope, and this
even in the feeling of the beholder, is more impress-
ive than the material beauty that characterizes the
mould of the features")

1859 SFA The Hon. Mrs. M. Milnes: Marie Antoinette in the Conciergerie"4:

R. 1850 PG Mrs McIan: "Here's his Health in Water" 55
(see Q for description)
1852 PG Mrs McIan: "The Highlands 1852"
"That morning the fires upon sixteen native hearths
were put out; one only can be seen there now: it is
that of a stranger, a south-country shepherd. The
cradled infant, the young parents, the veteran who had
shed his blood on the sands of Egypt and the field of
Waterloo, were rendered houseless; old and young, men,
women, and children, slept many, many nights in the old
burying-ground of their tribe. When the first boat was
laden the piper palyed 'cha till, cha till, mi tuille',
(I shall return, never;) all stretched out their hands
to the glen they will never see more, and cried - and
cried - May God put the fearful sounds out of my ears!"245
(Described in the "Art Journal" (1852 p.140): "The
canvas is large and the composition embodies not less
than 70 figures - impersonating Highland emigrants and
their friends; the former embarking, and the latter
taking their last leave. It may well be conceived that
such a variety of disposition and character has involved
difficulties of composition which the casual spectator
may not apprehend; every figure is purely national, and
each is sensibly affected by the circumstances of the
occasion etc.")
1854 RA Mrs E.M. Ward: "Scene from the Camp at Chobham, in the
encampment of the 79th Highlanders" 582
1857 SFA Mrs McIan: "Highland Emigrants"
"That morning the fires upon sixteen native hearths were
put out; one only can be seen now - it is that of a
stranger, a south-country shepherd. The cradled infant,
the young parents, the veteran who had shed his blood on
the sands of Egypt and the field of Waterloo, were ren-
dered houseless; old and young, men and women, and
children, slept many, many nights in the old burying
ground of their tribe. When the first boat was laden,
the piper played, ' cha till, cha till, ma tuille' (I
shall return, never) all stretched out their hands to
the Glen they will never see more, and cried - 'May God
put the fearful sounds out of my ears'" 35
1857 SFA Mrs Musgrave: "The Crimean Legacy"
"Highland Soldier bringing to the Widow of his Officer,
the pets of her slain Husband" 221

1858 SFA Miss Martha Jones: "The Escape of a Huguenot" 31

1859 OWS Margaret Gillies: "The Highland Emigrant's last look at
Loch Lomond" 20
(A review of this work in the "Art Journal" (1859, p.173)
reads: "The emigrant is an aged man, who sits on the
mountainside absorbed in mournful thoughts: a title
is not necessary to declare it a sorrowful leavetaking")

S. She exhibited one other historical work in the 1850·s:

1859 RA "An incident in the childhood of Frederick the Great of
Prussia"
"...It had been a disappointment to papa that his little
Fritz showed almost no appetite for soldiering. Sympa-
thize, then, with the earnest papa, as he returns home
one afternoon, and found the little Fritz, with
Wilhelmina looking over him, strutting about, and
assiduously beating a little drum" - Carlyle 30

T. 1849 OWS Mrs. Criddle: "Nature and Art" 187

1850 PG Mrs McIan: "Captivity and Liberty" 244
(Described in "The Ladies' Companion at Home and Abroad"
(May 25, 1850, no.23, p.352): "Two female gypsies and
their children have been thrown into prison, and the
women, seeing a bird fly in at the barred window, look
at it wistfully. The expression of the faces is beau-
tiful;" etc.)

1851 OWS Eliza Sharpe: "Charity"
"She stretcheth out her hands to the poor; yea, she
reacheth forth her hands to the needy. She looketh well
to the ways of her household, and eateth not the bread of
idleness. Her children arise up, and call her blessed;
her husband also, and he praiseth her. Many daughters
have done virtuously, but thou excellest them all"
(Proverbs ch.31, v.20, 27, 28, 29) 318

1851 BI Mrs Thornycroft: "Winter" a statuette in bronze 534
(photograph in Conway Library)

1851 BI Mrs Thornycroft: "Summer" a statuette in bronze 536
(photograph in Conway Library)

1852 SBA Maria Murray: "Age of Poetry" 622

1855 OWS Margaret Gillies: "The Past and the Future"
"Sighing on through the shadowy past,
Like a tomb-searcher memory ran
Lifting each shroud that time had cast
O'er buried hopes" - Moore

"Hope, the brightest of the passionate choir
That through the wide world would range ,
And touch with passing fingers that most strange
And curious instrument, the human heart" - Shelley 193
(Said to contain "simply two female figures, one youth-
ful, and the other somewhat older; these are full of
sentiment and expression, brilliant in colour, and
poetic in feeling" ("Art Journal" 1855, p.185)

1858 SFA Miss Rachel Levison: "Bas relief: 'Mercy and Truth have met
together: Righteousness and Peace have kissed each
other'" (Psalm 85) 535

1858 RA Miss Anna Blunden: "Past and Present" 428
("The Past is exemplified by a picturesque ruin, the
Present by two children forming bouquets of flowers
etc." "Art Journal" 1858, p.168.)

1858 SFA Miss Ada Warman: "Music, Painting and Poetry" 397
1859 RA Mrs J.B. Hay: "England and Italy"
"Painted in the Val d'Arno 1859. Two boys, one of
English type, the other an Italian boy of the people.
In one I have endeavoured to express the pure happi-
ness of our children; in the other the obstination
of the oppressed and suffering poor of Italy" 173

U. 1850 BI Ambrosini Jerome: "Cupid and Psyche" 55
1851 BI Mrs. Thornycroft: "A Head of Psyche" marble 538
1852 SBA Ambrosini Jerome: "Nymphs Bathing - a sketch for a large
picture" 251
1852 SBA Miss E. Andrade: "The Nymph of the Brook" 329
1853 BI Mrs Rogers: "Nymph of Flora" 431
1853 RA Isabel C. Curtis: "Medea" "Fuggir non e piu tempo" 99
1853 RA Ellen Shenton: "The Greek mother, after having rescued her
child, from the eagle's nest, bearing it down the
rocks" 1368 sculpture
1855 SBA Miss J.C. Bell: "Undine" 709
1857 SFA Mrs Blackburn: "Phaeton" 54
1857 SFA Mrs E.M. Ward: "Flora" 57
1858 SFA Miss E. Pistrucci: "Head of Flora" wax model 16
1858 SFA Miss E. Pistrucci: "Head of Flora" wax model 38
1858 SFA Miss M.E. Pistrucci: "Head of Ceres" cameo (agate) 11
1858 SFA Miss M.E. Pistrucci: "Head of Niobe" cameo (German agate) 12
1858 SFA Miss E. Pistrucci: "Head of Helen" cameo (agate) 13
1859 OWS Eliza Sharpe: "Hebe" 111
1860 SFA Miss Naomi Burrell: "Bacchante" 319 sculpture
1860 PG Miss Florence Claxton: "The Choice of Paris - an Idyll" 178
("caricaturing the leaders of the Pre-Raffaellite sect,
especially Mr Millais, who is made to play Paris, etc"
"Art Journal" 1860, p.110) (Collection Mr Ralph Dutton)
1860 SBA Ambrosini Jerome: "Cupid Defeated" 19
1860 BI Miss Elloart: "Narcissus, an old Fable in a new Form" 495
1860 BI Miss Durant: "The Negligent Watchboy of the Vineyards
catching locusts" (Theocritus 1st Idyll 47) marble 648
1863 BI Mrs H. Moseley: "A Bacchante" 410
1863 SFA Miss Durant: "Thetis dipping Achilles in the Styx"
"Thetis receiving from Vulcan the Arms of Achilles"
"Thetis mourning over the dead body of Achilles"
three marble bas-reliefs
1865 SFA Mrs L. Goodman: "Flora" 195
1865 DG Miss Rebecca Solomon: "Prima Vera" 255
1867 SFA Emma Davenport: "Psyche" 271
1867 SBA Miss Lane: "Psyche Immortal" 716
1867 SBA Miss Lane: "Psyche Forlorn" 740
1869 SFA Mrs Robert Lloyd: "A Bacchante" 461

V. 1860 SFA Mrs Robertson Blaine: "Study for the head of the mother of
Moses" 65
1860 SFA Margaret Gillies: "Rebeka at the Well" (Genesis ch.24,v.9)196
1860 SBA Mme Greata: "The Infant Samuel" plaster 712
1860 PG Miss J. Deffell: "Rebekah and Eleazar" 389
1861 RA Mrs J.E.B. Hay: "Tobias restoring the eye-sight of Tobit" 308
1861 SFA Mrs Robertson Blaine: "Ruth - the Hills of Moab in the dis-
tance, as seen from a Corn-field near Bethlehem"
"So she gleaned in the fields until even" - "Ruth" ch.2
v.17, 85
1861 SFA Madame J.V.C.: "John the Baptist" on vellum, illuminated 290

```
    1861  SFA   Ellen Cole: "The Nativity" 102
    1861  SFA   Miss Eliza Sharpe: "Christ Raising the Widow's Son" 214
    1862  RA    Mrs B. Hay: "The reception of the Prodigal Son" 251
    1863  SFA   Clara E.F. Kettle: "The Daughter of Babylon" 119
    1863  SFA   E.L.: "Esther accusing Haman" 183
    1864  SDA   Madame de Feyl : "Jephtha and his daughter"
                    "And the voice of my mourning is o'er
                    And the mountains shall see me no more;
                    But if the hand that I love lay me low,
                    There cannot be pain in the blow"  (Lord Byron's
                    Hebrew Melodies) 462
    1864  SBA   Miss Babb:  "Hagar" 565
    1865  SFA   The Countess of Westmoreland:  "Angels appearing to the
                    Shepherds" 180
    1866  BI    Madame de Feyl: "Rizpah Mourning for her Sons"
                    "And Rizpah, the daughter of Aiah, took sackcloth, and
                    spread it for her upon the rock, from the beginning of
                    harvest until the water dropped upon them out of heaven,
                    and suffered neither the birds of the air to rest on
                    them by day, nor the beasts of the field by night"
                    (2 Samuel ch.21, v.10) 173
    1867  SBA   Mrs Dixon: "The Infant Samuel, on ivory" 1068
    1867  SBA   Mrs Dixon: "Madonna, on ivory" 1066
    1868  DG    Helen J.A. Miles:  "Nehemiah"
                    "And I looked and rose up, and said unto the nobles and
                    to the rulers, and to the rest of the peoples, Be not
                    ye afraid of them;  remember the Lord which is great and
                    terrible and fight for your brethren, your sons, and your
                    daughters, your wives and your houses" (Nehemiah, ch.4
                    v.14) sepia sketch 663
    1869  RA    Miss S. Durant: "Ruth" marble 1289

W.  1860  RA    Mme Elizabeth Jerichau: "Italy" 256
    1861  SFA   Mme Gozzoli: "La Peinture" 94
    1861  SFA   Mme Anais Toudouze:  "La Peinture" 188
    1862  DI    Miss A. Margetts:  "Nature and Art" 397
    1863  SFA   Mrs Robertson Blaine: "Faith, Hope and Charity" 240
    1863  BI    Miss Kate Swift:  "The Past" 47
    1864  SBA   Mrs Williams:  "England, Ireland and Scotland" 682
    1866  SBA   Mrs C.N. Oliver:  "Spring and Autumn" 1042
  1867/8 NSPW  Mrs W.M. Duffield:  "Nature - Art" Designs for larger works 415
    1869  SBA   Miss E.T. Westbrook: "Young Ireland" 624
    1869  SBA   Miss F. Claxton:  "Symbolism" 941

X.  1861  PG    Ambrosini Jerome:  "Madame Palissy entreating her husband
                    to relinquish his long continued efforts to discover
                    the blue enamel, whereby he had already brought him-
                    self and his children to great distress, and urging him
                    to return to his former occupation" (Life of Bernard
                    Palissy) 541
    1861  SBA   Miss Macirone:  "The Escape of the Countess Florien dis-
                    guised as a peasant, with her two children, on the out-
                    break of the French revolution" 835
    1861  SFA   Mlle Louise Eudes de Guimard:  "Le Tasse et la Princesse
                    Eléonore" 34
```

1861 SFA Mrs Lee Bridell: "St. Perpetua and St. Felicitas"
"Vivia Perpetua, a noble Carthaginian lady, was conver-
ted to christianity with her slave Felicitas. They
suffered martyrdom together, by the edict of the Emperor
Severus AD 203" (Vide Mrs Jameson's "Legends of the
Saints") 83 (The following was written of this work in
the "English Woman's Journal" (March 1861, vol.7, no.37,
pp.59-60): "St. Felicitas, the slave of St. Perpetua,
rendered by Mrs Bridell as an African, is beautiful in
the extreme; ... There is in this coloured martyr feel-
ing and soul, etc.")

1861 SFA Mlle Léonie L'Escuyer: "L'Enlèvement de Madame de Beauharnais
- Miramion en Août 1648"
Le Comte Bussy-Rabutin, passionément épris de Madame le
Miramion, qui était demeurée veuve dès l'âge de seize
ans, la fit enlever par un vingtaine de cavaliers armés
tous gentilhommes de ses amis, un jour qu'elle allait
faire ses dévotions au Mont Valérien. Elle avait alors
dix-neuf ans. Le moment choisi et celui où Madame
s'élance hors du carrosse, dans le forêt de Vitry pour
tâcher de se dérober à ses ravisseurs à travers les
ronces et les épines qui la déchirent" (Vie de Madame de
Miramion par L'Abbé de Choisy) 53

1861 RA Emily Osborn: "The Escape of Lord Nithisdale from the Tower
1711" 258 (Christie's May 25, 1979)
(After the Earl of Marr was proclaimed the Pretender in
Scotland, Lord Nithisdale and others rallied round the
fallen dynasty. Then, after the defeat at Preston, Lord
Nithisdale was imprisoned. His wife helped him escape
by disguising him as her stout companion - "Art Journal"
1861, p.169).

1862 SFA Miss K. Swift: "Escape of Grotius from Lowenstein"
"After two years had been passed by Grotius in prison, he
escaped in the chest in which his linen was sent to
Gorcum to be washed. During the first two years of his
imprisonment the guards invariably examined the chest,
but as they found nothing but books and linen the search
was at last wholly omitted. During the absence of the
Governor Grotius was placed in the box and it was carried
by two soldiers from the Castle. One of them, suspecting
something from the weight, insisted on taking it to the
Governor's to be opened; but his wife, probably in the
secret, told them to carry it to the boat as she was
assured it contained nothing but books. In this manner
Grotius escaped safely to his friends at Gorcum" 57

1862 SBA Miss Jones: "AD 1666. A Merchant of London in refuge with his
family during the great fire" 300

1862 RA Mrs E.M. Ward: "Scene at the Louvre in 1649 - the despair of
Henrietta Maria at the Death of her husband Charles I"
"The grief that cannot speak whispers the o'erfraught
heart, and bids it break"
"To all our exhortations and arguments, the Pere con-
tinues, our Queen was deaf and insensible. At last, awed
by her appalling grief, we ceased talking, and stood round
her in perturbed silence, some sighing, some weeping -
all with mournful and sympathizing looks bent on her
immovable countenance" - Miss Strickland ("Lives of the
Queens") 583

1863	RA	Mrs. E.M. Ward : "Queen Mary quitted Stirling Castle on the morning of Wednesday, April 23, unconscious that she was taking her last farewell of those royal bowers where she had spent her happiest days, and that she was neither to behold them or her only child again. When she had bestowed her parting embrace and blessing on that beloved object of her maternal solicitude, she delivered him into the hands of the Earl of Mar herself, and exacted at the same time from that noble-man a solemn pledge that he would guard his precious charge from every peril, and never give him up, under any pretext, with-out her consent" - Miss Strickland's "Lives of the Queens" 386 (Engraving in the Witt Library)
1863	SBA	Miss Dunn : "St. Katherine" 220
1863	RA	Miss J.M. Rogers : "Flora Macdonald" 735
1864	RA	Miss H.B. Carter : "Miss Florence Nightingale" statuette 1027
1865	DG	Miss Rebecca Solomon : "Hypatia" 221 (Hypatia was a Greek female philosopher and mathematician born in Alexandria v. 370-415. Charles Kingsley's "Hypatia or New Foes with an Old Face", first published in 1853, should be mentioned as a possible source)
1866	RA	Mrs. E.M. Ward : "Palissy the Potter" "The potter had looked forward to a day when the result of many months' labour would enable him to meet impatient creditors, and relieve the pressing wants of his hungry and scantily-clad children ; his hopes were high, and with reason ; fame would recompense him for all his trials, and fortune would be within his grasp. The furnace had been fired, and the potter bided the time to bring forth the works that were to be his glories. The moment had arrived, the wife had gone out to summon the creditors to witness his triumph ; they stand at the entrance appalled, whilst she exhausts her wrath in impreca-tions ; the children gathered round, or stare in wonderment at the broken-down and miserable father - for strewn on the ground at his feet are all the produce of his toil and his genius - deformed pieces, utterly valueless. The flints that formed the walls of the furnace had been detached by the heat, and had ruined the whole of the great works that were baking in it" Morley 385 (Leicester Art Gallery)
1867	DG	Marie Spartali : "Korinna, the Theban Poetess" 151
1867	RA	Miss R. Solomon : "Heloise" 150
1867	RA	Mrs. E.M. Ward : "Scene from the Childhood of Joan of Arc" "Her young heart beat high with enthusiasm

for her native France, now beset and beleag-
uered by the island strangers. Her young
fancy loved to dwell on these distant battles,
the din of which might scarcely reach her
quiet village, but each apparently hasten-
ing the ruin of her fatherland. We can
picture to ourselves how earnestly the des-
tined heroine - the future leader of armies -
might question those chance travellers,
whom, as we are told, she delighted to
relieve, and for whose use she would often
resign her own chamber, as to each fresh
report from the changeful scene of war"
- Lord Mahon 523
(engraving in the Witt Library)

1867 OWS Margaret Gillies : "Judge Cooke (one of the
judges of Hampden)
"When her husband was sore troubled at the
possible consequence of his then declaiming
against the crown, she told him she would
be contented to suffer want or any misery
with him rather than be an occasion for him
to do or say anything against his judgment
and conscience"
(Forster's "Life of Eliot" - vol. 2 p 344)
210

1868 SFA A.L: "Cleopatra" 171

1868 SFA Miss L. Swift : "Lesbia"
"Lesbia hath a beaming eye,
But no one knows for whom it beameth ,
Right and left its arrows fly,
But what they aim at no one dreameth"
365

1868 RA Mrs.E.M.Ward : "Sion House, 1553"
"Lady Jane Grey, of retired habits and
delicate health, on being addressed as
Queen, trembled, uttered a shriek, and
fell to the ground. On her recovery,
says Lingard, she observed to those around
her that she seemed to herself a very unfit
person to be a queen she refused
to accept the title, but overcome at last
by the entreaties of her mother, and
above all by her husband, she submitted to
their wish, and was prevailed on to
relinquish her own judgment"
467
("Lady Jane Grey at last yields, but if
we read the face aright as here rendered
by an artist who interprets character
with a woman's instinct, not without
violence to the voice of conscience, and
to that better nature which would fain
have lived apart from worldly rank and
vanity" - "Art Journal" 1868 p 102)

1869 SBA Miss E. Percy: "Anne Boleyn and Jane Seymour"
"Henry's growing passion for Jane soon awakened sus-
picion in the mind of Queen Anne. It is said that her
attention was one day attracted by a jewel which Jane
Seymour wore, and she expressed a wish to look at it.
Jane faltered and drew back" Miss Strickland's "Lives
of the Queens of England" 1013

1869 SFA Miss E. Percy: "Francis I in prison at Madrid, visited by
his sister" 175

1869 SFA Mrs Swift: "Laura" 188

Y. 1860 SBA Miss E. Macirone: "Watching in Brittany during the Vendean
War" 669

1861 RA Mrs F. Bridell: "Departing to join Garibaldi"
"Addio, Terese, Terese Addio,
Si pace a Dio
Ritornero" - Canto Populare 558

1861 RA Miss M. Jones: "The question: Cavalier or Roundhead?" 13

1861 RA Miss R. Solomon: "The Arrest of a Deserter" 581

1861 SFA Charlotte James: "'Looking forward' - a Roman Patriot ready
to join Garibaldi" 101

1862 RA Miss R. Solomon: "Fugitive Royalists"
"One touch of nature makes the whole world kin" 432

1864 SBA Miss Edwards: "War Tidings" 345
(Described in the "Art Journal" 1864, p.152: "A father,
mother and children, grouped together in a room, which
is adorned with portraits and cabinets after the olden
times, and in the manner of polite society, listen with
anxiety, if not in dismay, to the reading of a gazette.
'War Tidings' forbode anger, and bespeak a tragedy. The
artist has escaped the conventionalities which have long
reduced this class of subjects to commonplace; and
trusting to her own individual ideas, she has produced
a picture of more than usual independence")

1867 DG Helen J.A. Miles: "Suspense"
"A Scene from the French Revolution" (From Alison's
"History of Europe") 666

1867 SFA The Dowager Countess of Westmoreland: "The Duke of Wellington
writing his Despatch at Waterloo, the night after the
Battle" 14

1868 RA Miss Turck: "Bavarian Peasants alarmed at the approach of
Prussian Troups 1866" 550

Z. She exhibited the first of these in 1859 (see S)

1862 SBA Miss Macirone: "Saint Elizabeth of Hungary in her Childhood"
"It was her wont, whenever she could, to enter the
chapel of the castle, and there, at the foot of the
altar, she would lay open a large psalter; then, fold-
ing her little hands, and with uplifted eyes, would be
lost in an ecstacy of meditation and of prayer" (History
of St. Elizabeth of Hungary by Montalembert) 769

1864 RA Mrs E.M. Ward: "The Tower, ay, the Tower" - Shakespeare.
"He (Gloucester) then brought him to the Bishop's palace
at St. Paul's, and from thence honourably through the
city to the young King at the Tower, out of which they
were never seen abroad" - Miss Strickland's "Lives of the
Queens" 565 (Rochdale Art Gallery)

1867 RA Mrs E.M. Ward: "Scene from the Childhood of Joan of Arc" 523
(see X for the quotation)

1869 RA Mrs E.M. Ward: "Scene from the Childhood of the Old
 Pretender"
 "Four of the number, who were too much impaired in
 constitution to return home, continued at St. Germans.
 One day, when listlessly strolling near the iron pali-
 sades of the palace, they saw a boy of six years old
 about to get into a coach emblazoned with the Royal
 arms of Great Britain; this child was the son of the
 exiled King and Queen, the disinherited Prince of
 Wales, who was going to join the promenade of the
 French court at Marle. He recognized the unfortunate
 emigrants, and instead of entering the coach, made a
 sign for them to approach. They advanced respectfully,
 and spontaneously offered the mark of homage which,
 according to the custom of the times, was accorded to
 persons of Royal rank by kneeling and kissing his hands,
 which they bathed with their tears. The princely boy
 graciously raised them, and with that touching sensi-
 bility which is often prematurely developed by early
 misfortunes, expressed his grateful appreciation of
 their loyalty. He told them he had often heard of
 their valour, and that it made him proud, and that he
 had wept for their misfortunes as much as he had done
 for those of his own parents; but he hoped a day
 would come that would convince them that they had not
 made such great sacrifices for ungrateful princes" -
 Miss Strickland's "Lives of the Queens" 211
 (This work was also exhibited at the Society of Lady
 Artists in 1877 (no.595) and won a gold medal at the
 Crystal Palace)

A1. 1870 DG (oil) Kate Carr: "Undine" 60
 1870 RA Louisa Starr: "Undine" 964
 "She was about to add something more, when Huldebrand
 with the most heartfelt tenderness and love, clasped
 her in his arms, and again bore her back to the shore.
 There, amid tears and kisses, he first swore never to
 forsake his affectionate wife, and esteemed himself
 even more happy than Pygmalion, for whom Venus gave
 life to his beautiful statue, and thus changed it into
 a beloved wife" 964.
 1871 DG (oil) Kate Carr: Oenone" 312
 1871 DG Marie Spartali: "Antigone, in defiance of King Creon, gives
 burial rites to the body of her brother, Polynices" 75
 1872 SLA Julia Pocock: "Then pale and full of trouble, Psyche went
 Bearing the basket, and her footsteps bent
 To Lacedaemon, and thence found her way
 To Taenarus, and there the golden day
 For that dark cavern did she leave behind" (Morris's
 "Earthly Paradise") 112
 1872 SLA Miss E.C. Collingridge: "Atalanta laying the Arrows and her
 Bow on the Altar of Venus" 228
 1872 RA Mrs Thornycroft: "Mepomene" 1415 sculpture
 1872 DG Mrs H. Champion: "Chloe" 267
 1872 SLA Miss Foley of Rome: "Undine" 426 sculpture
 1873 RA Miss E. Sandys : "Undine" 646
 1873 RA Miss C. Nottidge: "Cassandra" 1444 sculpture
 1873 RA Miss C. Nottidge: "Io" 1472 sculpture
 1874 RA Miss Jessie Macgregor: "Orpheus and Eurydice" (Virgil's
 Aenid 6; Georgics 4) 64

1874 DG Edith Martineau: "Danae'

"And on the morn, when scarce the dusk was done,
Upon the sands the shallop ran aground.

. . .

Then uprose Danae, and nothing knew
What land it was: about her sea-fowl flew;
Behind her back the yet retreating sea
Beat on the yellow sands unceasingly.

. . .

Her unbound yellow hair
Heavy with dew, and washing of the sea;
And her wet raiment clinging amorously
About her body, in the wind's despite;
And in her arms her woe and her delight,
Spreading abroad the small arms helplessly
That on some day should still the battle's cry" (Morris's
"Earthly Paradise") 326

1874 DG Emily Mitchell: "Medea" 514
1874 SBA Mrs Grierson: "Ariadne" 203
1875 DG(oil)Mary Stuart Wortley: "Mournful Oenone, wandering forlorn,
 Of Paris, once her playmate on the hills" 207
1875 RA Miss A.M. Lea: "A Bacchante" 1197
1875 SBA Miss V. Parker: "Clio" 430
1875 DG(oil) BlancheMacarthur: "Danae" 63
1876 SLA Mrs G. Grierson: "Ariadne" 317
1877 GG Miss Evelyn Pickering: "Ariadne in Naxos" 30
1877 DG(oil) Evelyn Pickering: "Cadmus and Harmonia"

"With lambent tongue he kissed her patient face,
Crept in her bosom as his dwelling place,
Entwined her neck, and shared the loved embrace"
(Ovid's Metamorphoses) 20

1877 DG(oil) Margaret Hooper: "The Sleep of Brynhild"

"A high hall is there
Reared upon Hindfell,
Without all around it
Sweeps the red flame aloft

. .

Soft on the fell
A shield-may sleepeth.
The sleep-thorn set Odin
Into that maiden
For her choosing in war
The one he willed not" ('Volsunga Saga' translated by
Magnusson and Morris) 138

1877 DG(oil) Mrs Bowden: "Psyche" 350
1877 DG(oil) Mrs R.J. Fennessy: "Polypheme" bronze statuette 462
1877 SLA Mrs Champion: "Bacchante" 650
1877 DG Alice M. Mott: "Io" 461
1877 SLA Charlotte E. Babb: "The Maids of Circe, who spun neither
 flax nor wool; they plucked herbs and sorted flowers"
 166
1878 RA Miss E.M. Busk: "Psyche"

".... she came unto a chamber cool,
Paved cunningly in manner of a pool,
Where red fish seemed to swim through floating weed

* * * *

.....as she turned to go the way she came,
She heard a low, soft voice call out her name,
Then she stood still, and trembling gazed around"
William Morris, "Earthly Paradise" 25

1878 SLA Marion Nixon: "Circe" 660
1878 SLA Mary Backhouse: "Oenone" 341
1878 SLA Florence Farrington: "Pomona" 610
1878 GG Miss E. Pickering: "Venus and Cupid" 95
1879 SBA Miss O.P. Gilbert: "Circe" 649
1879 GG Miss Defries: "Ovid" translated by Henry King
 "Pygmalion now plies her with all wooing gifts
 Grateful to maids, brings glistening shells and gems
 Transparent, polished; captured buds and flowers.
 * * *
 Now robes her limbs with garments gay, and her neck
 With pendant necklave, clasps etc." 199
1879 SLA G.H. Shakerley: "Hero and Leander" 81
1879 SLA E.C. Collingridge: "The Waking of Brynhilda - Design for a
 window" 621
1879 SLA Mrs Bridell Fox: "Ave Amor"
 "Oh Venus, Queen of Cnidos, Paphos fair,
 Leave thy beloved Cyprus for awhile,
 And shine thee in that bower of beauty where,
 with incense large, Glycere woos thy smile" 257
1879 SLA Charlotte C. Babb: "Iduna, with the Apples for the Gods"
 (Northern Mythology) 386

B1. 1871 RA Miss J.K. Humphreys: "Rachel weeping for her children" 107
 (The artist exhibited a work with the same title at the
 Society of Lady Artists in 1875 (no.531))
1872 RA Miss E. Courtauld: "Daybreak on Mount Calvary, after the
 Entombment"
 "Thou art mournful and full of sorrow, O Virgin Mary;
 but the crown of tribulation hath bloomed into a crown
 of glory and a garland of joy" 1108
1872 SLA Mrs Benham Hay: "The Prodigal Son" 350
1874 SLA Mrs Benham Hay: "Tobit's return to his Father" 522
1874 SLA Miss Justina Deffell: "Judith going down to the Camp of
 Holophernes" 458
1875 RA Theresa G. Thornycroft: "Design from the Parable of the Ten
 Virgins" 475
1875 SLA Mary S. Tovey: "Ruth and Boaz" 552
1876 SLA J.C. Smith: "Elijah Meeting Ahab and Jezebel in the Garden
 of Naboth" 203
1877 RA Theresa G. Thornycroft: "The Parable of the Great Supper"
 "Go out quickly into the streets and lanes of the city,
 and bring in hither the poor, and maimed and the halt,
 and the blind" (Luke ch.14, v.21) 1039
1877 RA Jennie Moore: "Delilah" 797
1878 SLA Jennie Moore: "Delilah" 79
 (probably the same as the preceding work)
1878 RA Charlotte Dubray:"Jephtha's Daughter" 1511 sculpture
1878 GG Louisa, Marchioness of Waterford: "Christmas. The Lord of
 the Season always sends his representative to receive
 homage and an offering" 168
1878 GG Louisa, Marchioness of Waterford: "The Parable of the
 Marriage Supper" 206
1878 GG Louisa Marchioness of Waterford: "The Prodigal Son" 220
1878 RA Theresa G. Thornycroft: "Dives and Lazarus" 984 (ill. in
 "Academy Notes" op.cit. 1878, p.65)
1879 DG(b&w)Beatrice Meyer: "The Widow's Son" 194
1879 DG(b&w)Beatrice Meyer: "Christ healing the sick" 409

C1. This list consists of portraits only. Narrative portrayals are given
 in D1.

1870 RA	Miss Marie Spartali: "Saint Barbara" 530	
1871 OWS	Mrs H. Criddle: "St. Monica, the Mother of Saint Augustine" 202	
1871 RA	Emily Mary Osborn : "Isolde" 37	
1872 SLA	Helen Thornycroft: "Joan of Arc" 109	
1872 SLA	Julia Pocock: "Heloise" 149	
1872 RA	Miss C.M.B. Morrell: "Joan of Arc" 496	
1872 SLA	Mrs Charretie: "Beatrice" 408	
1873 SBA	Miss A. Carter: "Lesbia"	

"Lesbia hath a beaming eye,
But no one knows for whom it beameth;
Right and left its arrows fly,
But what they aim at, no one dreameth"
Vide Moore's Melodies 599

1873 DG	Florence Claxton: "Lesbia" 438	
1873 RA	Miss M. Grant: "Katherine of Alexandria" 1523 sculpture	
1873 DG	Julia C. Smith: "St. Agnes" 375	
1874 SLA	Miss Emma Sandys: "Fair Rosamond" 23	
1874 DG(oil)	Helen M. Johnson: "Sappho - study for a picture" 372*	
1874 DG(oil)	Florence Tiddeman: "Sappho" 143	
1875 SLA	Mary Macarthur: "Rosamond" 588	
1875 RA	Miss A.M. Lea: "St. Cecilia" 284	
1875 SBA	Miss Beatrice Meyer: "Charlotte Corday, a sketch" 508	
1876 DG(oil)	Evelyn Pickering: "St. Catherine of Alexandria" 374	
1876 NSPW	Mary L. Gow: "Lesbia" 223	
1876 SLA	Charlotte E. Babb: "Queen Iseult" 538	
1876 SLA	Helen Johnson: "Sappho" 62	
1877 RA	Miss H. Thornycroft: "Saint Margaret" 778	
1877 DG	Mrs Arthur Luxmoore: "Mary Carmichael, one of the Queen Marys" 321	
1877 DG	Helen Thornycroft: "Joan of Arc" 125	
1878 SLA	Helen Thornycroft: "Saint Margaret" 480	
1879 SLA	Edith M.S. Scannell: "Lesbia" 769	
1879 NSPW	Miss Mary L. Gow: "Vittoria Colonna" 152	

Helen Thornycroft exhibited four portraits of male saints:-

1875 DG	"Saint Sebastian" 559	
1876 DG	"Saint Stephen" 243	
1878 RA	"The Martyrdom of St. Luke" 810	
1879 DG	"Saint Sebastian" 376	

D1. 1870 RA Mrs E.M. Ward: "The First Interview of the divorced
 Empress Josephine with the King of Rome"
 "At the sight of this child Josephine experienced pro-
 found emotion. She fixed upon him her eyes dimmed with
 tears .. The little Prince returned her affection, and
 gave himself up, and all the gentleness and amiability
 of his character .. The emperor heartily thanked
 Josephine for this testimony of her affection. It was
 a day of happiness to him" Histoire de Napoléon II,
 Duc de Reichstadt 916

 1870 SBA Miss J. Macleod: "The Escape of Prince Charles Stuart,
 after Culloden"
 "Where he met with Miss Florence Macdonald, who pre-
 tended to cross the sea to visit her mother in Skye,
 having disguised the Prince in women's clothes, and
 changing his name to Betsy Barke" Bishop Forbes'
 Jacobite Memories 427

1871 SLA Kate Aldham: "The young wife of a Royalist in troublous
times" 382

1871 SBA Miss C.M. Noble: "Lady Jane Grey"
"Ascham informs us, that coming once to wait on Lady
Jane at her father's house in Leicestershire, he
found her reading Plato's works in Greek, while the
rest of the family were hunting in the park" 16

1872 SBA Miss V. Levin: "The Royalist mother depositing her infant
at the Foundling Hospital, Paris, 1792" 577

1872 RA Mrs L. Romer: "Queen Vashti refusing to show herself to
the people"
"O Vashti, noble Vashti! summon'd out
She kept her state, and left the drunken king
To brawl as Shushan underneath the palms" - Tennyson's
'Princess" 918
(In her autobiography, LouiseJopling described Vashti
as "a Queen who always had a great attraction for me,
as the originator and victim of 'Women's Rights'"
Louise Jopling: "Twenty Years of my Life" London 1925
p.32)

1874 RA Mrs E.M. Ward: "The Defence of Latham House"
"The Countess of Derby and her two daughters, Mary and
Catherine, watched over everything... On one occasion
a shell burst into the dining-room during dinner, broke
the glass and furniture, but injured no one. The
children were beside their mother at the time, but did
not move and scarcely changed colour" - "The Lady of
Latham", Guizot de Witt 445

1874 RA Miss Grant: "Incident in the Life of St. Margaret"
"Then she was dragged to a dungeon, where Satan, in the
form of a terrible dragon, came upon her with his
inflamed and hideous mouth open, and sought to terrify
and confound her; but she held up the Cross of the
Redeemer, and he fled before it" 1525 sculpture

1875 SBA Miss F.E. Maplestone: "Cromwell's favourite daughter plead-
ing for the life of Charles I" 914

1876 RA Mrs E.M. Ward: "Newgate 1818"
"Mrs Fry conducts her young friend, Mary Sanderson, for
the first time to visit the female prisoners. The
latter thus described the scene - 'The railing was
crowded with half-naked women struggling together for
front situations with the utmost vociferation;' and she
adds that she felt as if she were going into a den of
wild beasts" 120 (ill. in "Academy Notes" op.cit. 1876
p.16).

1877 SBA Miss F. Maplestone: "Zarina, Queen of Assyria, entreating
Sardanapulus, after his defeat by the Persians" 620

1877 RA Mrs E.M. Ward: "Princess Charlotte of Wales"
"When taking her usual walk with a single attendant,
she saw a boy very ragged in his attire, sitting under
a hedge, crying, and faint from a wound on his right
hand .. She proceeded to bind it with her pocket-
handkerchief when she was arrested by her attendant.
'No harm can happen to me', said the lovely child:
'for have I not read in my Bible, that He who was
greater than any earthly King, healed the wounds of
the leper, and shall I not follow His example and bind
the wounds of this poor boy'" - Huish 45 (ill. in
"Academy Notes" op.cit. 1877 p.10).

1879 RA Miss Grant: "St. Margaret of Antioch" marble statue
"Then she was dragged to a dungeon, where Satan, in
the form of a terrible dragon, came upon her with his
inflamed and hideous mouth open, and sought to terrify
and confound her; but she held up the cross of the
Redeemer, and he fled before it" 1522 (The artist exhi-
bited a work with the same title at the Royal Academy
in 1874 (no.1525))

1879 SBA Miss F. Maplestone: "Cromwell interrogating the family of
the escaped Royalist". 706

E1. 1871 SBA Miss F.E. Maplestone: "St. Dunstan reproving the King"
"In the midst of the Coronation feast the young king
withdrew to the society of his wife and mother-in-law.
Dunstan, Abbot of Glastonbury, and the Bishop of
Litchfield were deputed by the other banqueters to per-
suade him to return, and rushing into the chamber where
he and the ladies were sitting, Dunstan heaped the most
opprobrious terms upon the Queen and her mother, and
dragged Edwin back to the hall" - Vide Curtis'
"England" 885

1871 RA Mrs E.M. Ward: "The fortune of little Fritz"
"When Frederick was four years old, a remarkable pro-
phecy was made concerning him. At that time many
Swedish officers were in Berlin, who had been made
prisoners at the taking of Stralsund on Christmas Day,
1715. One of the officers, named Croom, had the repu-
tation of being able to read the stars, and to read the
future in the lines of the hand; the whole city was
full of his prophecies. When the Crown Prince was
brought to him, Croom foretold various unpleasant cir-
cumstanes that would befall him in his youth, but that
in riper years he would become Emperor, and be one of
the first princes in Europe. With the exception of the
empire, all the rest of the prophecy was perfectly
fulfilled" - Kugler 27

1872 SFA Mrs E.M. Ward: "The Tower, aye, the Tower" 321
(Probably the same work as that exhibited, with a longer
title, at the Royal Academy in 1864 (no.565) See Z).

1872 RA Mrs E.M. Ward: "The Queen's Lodge, Windsor, in 1786".
"Mrs Delaney at Court"
"'The Queen', said Mrs Delaney, 'was graceful and gen-
teel. The dignity and sweetness of manner ... soon made
me perfectly at ease .. The King's fondness for children
is well known'. The Queen's affability did not prevent
the aged lady from noticing that Her Majesty condescended
to take snuff, in the admixture and scent of which she
was curious and learned" - see Dr. Doran's "Lives of the
Queens of Hanover". "'The Queen had the goodness to
make me sit down next to her ... while the younger part
of the family are drawing and working, .. the beautiful
babe, Princess Amelia, bearing her part in the entertain-
ment .. sometimes playing with the King on the carpet ..
In the next room is the band of music playing'" - See
"Letters and Correspondence of Mrs Delaney", edited by
Lady Llanover 510 (Walker Art Gallery, Liverpool).

1872 DG Miss Fraser: "Queen Osburga, mother of Afred the Great,
promises to give an illuminated book of poems, which
has excited the admiration of her sons, to the one who
shall first learn to read it" 96

1872 DG Lucy Madox Brown: "How Cornelius Agrippa showed the Fair
Geraldine in a mirror to the Earl of Surrey" 295

1873 RA Emily Osborn: "Hero worship in the Eighteenth Century"
"It was near the close of his life that two young
ladies who were admirers of his works, but had never
seen himself, went to Bott Court and asking if he was
at home, were shown upstairs where he was writing; he
laid down his pen on their entrance, and as they stood
before him, one of the females repeated a speech of
some length previously prepared for the occasion; it
was an enthusiastic effusion, which when the speaker
had finished, she panted for her idol's reply. What
was her mortification when all he said was 'Fiddlede-
dee, my dear'" Croker's Johnson 1096

1873 RA Mrs E.M. Ward: "Chatterton, 1765"
"Each Saturday he, 'Chatterton', returned from
'Colston's' (the Bristol Bluecoat) School .. and has-
tened home to the happy solitude of the attic he had
appropriated as his study under his mother's roof...
 "His delight was to lock himself up in this little
garret, with his books, papers, and drawing materials
and there... he is found with his parchments, great
piece of ochre in a brown pan, pounce-bags full of
charcoal dust, and also a bottle of black-lead powder..
 "Mrs Edkins (his foster-mother) relates:- When she
could get into his room she would: Once he put his
foot on a parchment on the floor to prevent her taking
it up, saying, 'You are too curious and clear-sighted;
I wish you would bide out of the room. It is my room'"
- Vide Daniel Wilson's "Life of Chatterton" 361
(Bristol Museum and Art Gallery).

1875 RA Mrs E.M. Ward: "The Poet's First Love"
"Like Byron, Scott, and other illustrious men, Hogg
(the Ettrick shepherd) fell in love in his very early
childhood. He says ... when only eight years old I
was sent out to a height .. with a rosy-cheeked maiden
to herd a flock of new-weaned lambs. As she had no
dog and I had an excellent one, I was ordered to keep
close by her; and Betty had nothing to do but to sit
and sew... We dined together at the well, and after
dinner I laid my head down on her lap, covered her
bare feet with my plaid, and pretended to fall asleep.
One day I heard her say to herself, 'Poor little laddie,
he's joost tired to death', and then I wept." - W.
Howitt 380

1878 RA Mrs E.M. Ward: "One of the last lays of Robert Burns (Oh,
wert thou in the cauld blast)"
"The lady (young Jessy) relates that one morning she
had a call from the poet, when he offered, if she would
play him any tune of which she was fond, and for which
she desired new verses, to gratify her in her wish ...
She played over several times the air of an old song ..
Burns sat down, and in a very few minutes, he produced
the beautiful song of 'Oh, wert thou in the cauld
blast'. The anecdote is a trivial one in itself, but
we feel that the circumstances, the deadly illness of
the poet, the beneficient worth of Miss Lewars, and
the reasons for his grateful desire of obliging her,
gave it value" - Dr. Robert Chambers 380 (Christie's
London, July 29, 1977).

1878 DG Catherine Sparkes: "Louis de Male, Count of Flanders,
 hiding from the soldiers of Philip van Artevelde" 383
 (In the "Art Journal" (1878, p.121) a critic called
 this "the most ambitious picture in the exhibition"
 and wrote that there was nothing to compare with it
 "in largeness of execution")

1879 GG Margaret Gillies: "The Childhood of Les-Briez, the Sir
 Lancelot of Brittany"
 "It is written how the child Les-Briez, having seen
 the knight of Quimper, ran back to his home and
 sprang to his mother's knees and babbled of whom he
 had seen, and whose deeds he must follow; so that his
 mother was sad because of his tale, knowing that he
 would depart and leave her lonely, and that she must
 surely die ere ever he who had seen the knight of
 Quimper should come back a famous knight and glorious"
 255

Margaret Gillies later exhibited a pendant to this work:-
1880-1 OWS Margaret Gillies: "The Young Knight's Return"
 "Les Briez, the Lancelot of Brittany, having in boy-
 hood joined the ranks of the knight Errants, returns
 after the lapse of many years to the old mansion of
 his ancestors, which he finds in ruins. He finds his
 Sister and the old Nurse the sole survivors of the
 family" Vide "Chants Populaires de la Bretagne" 63

F1. 1867 DG Bavarian Artillery going into action" 181
 1868 SFA "Resting" 320 (probably a military subject)
 1868 SFA "On the Look Out" 380 (probably a military subject)
 1871 DG "Wounded and taken prisoner" 113
 1872 DG(oil) "Chasseur Vedette" 282
 1872 DG(b&w) "French Cavalry drawn up under fire, waiting to charge" 2
 1872 DG "Standing at Ease. Bersaglieri Recruits, Genoa" 539
 1873 RA "Missing" 590
 1873 DG(oil) "French Artillery on the March" 298
 1873 DG "Drivers watering their Horses - Infantry Camp, Autumn
 Manoeuvres 1872" 84 (Collection Mr G. Ball Duffield)
 1873 DG "Drilling the Drummers - Genoa" 305
 1873 SFA "Prussian Uhlans returning from a Raid" 311
 1874 RA "Calling the roll after an engagement, Crimea" 142 (H.M.
 the Queen. On loan to Camberley Staff College)
 1874 SFA "Tenth Bengal Lancers at 'Tent-Pegging', Sealcote, 1871" 247
 1874 DG "The Ferry - French Prisoners of War 1870" 151
 1874 DG(b&w) "'Gallop!' A Reminiscence of Woolwich"
 1874 DG(b&w) "'Halt!' A Reminiscence of Aldershot"
 1874 NSPW "'Charge!' A Reminiscence of the Life Guards at
 Wimbledon" 314
 1874 NSPW "A Tenth Bengal Lancer Tent-Pegging"351
 1875 RA "The 28th Regiment at Quatre-Bras"
 "This regiment played a conspicuous part in the battle
 of Quatre Bras, June 16, 1815. Formed together with
 the Royals into a square in a field of 'particularly
 tall rye' (Siborne's Waterloo Campaign), it was
 repeatedly assaulted by the enemy's cavalry. Cuiras-
 siers, and Polish Lancers, who closed a long series
 of unsuccessful attacks by a furious charge, simultan-
 eously delivered against three faces of the square,
 where it was 'mainly composed of the men of the 28th'
 (Siborne). The picture represents the last effort of
 the enemy at about 5pm.

The failure of these attempts to break their for-
mation was productive of much levity on the part of
some of the younger soldiers, instances of which are
traditional in the regiment.
 The mounted officer, Major, afterwards Sir Richard,
Lluellyn, K.C.B., was severely wounded on the 18th at
Waterloo" 853 (Victoria Art Gallery, Melbourne)

1875	NSPW	"'On Duty' - A Trooper of the Scots Greys" 243
1876	FAS	"Balaclava" (Queens Park Gallery, Manchester)
1876	NSPW	"The 'Scots Greys' Advancing. A sketch at Aldershot" 144
1877	FAS	"The Return from Inkermann" (Ferens Art Gallery Hull)
1879	RA	"Listed for the Connaught Rangers: recruiting in Ireland" 20 (Bury Art Gallery)
1879	RA	"The Remnants of an army: Jellalabad, January 13th, 1842" "One man alone reached Jellalabad. Literally, one man - Dr. Brydon - came to Jellalabad out of a moving host which had numbered in all some sixteen thousand when it set out on its march. The curious eye will search through history or fiction in vain for any picture more thrilling with the suggestion of an awful catastrophe than that of this solitary survivor, faint and reeling on his jaded horse, as he appeared under the walls of Jellalabad to bear the tidings of our Thermopylae of pain and shame" - "History of Our Own Times" Justin McCarthy, vol.i. 582 (Tate Gallery; on loan to Somerset Light Infantry Museum, Taunton).

(Details of many of these works will be found in the section devoted to
Lady Butler on pages 319-324 of vol.1)

G1.	1880	DG(b&w)	Alice M. Chambers: "The Fruit of the Hesperides gathered by Discord" 513
	1880	GG	Mrs John Collier: "A Bacchante" 185
	1880	GG	Mrs Arthur Murch: "Persephone" 190
	1880	GG	Miss E. Pickering: "Medea" 511
	1880	RA	Mrs C. Cubitt:"Bacchante" marble statue 1670
	1880	RA	Miss E. Seeley: "Persée" (on porcelain) 1380
	1880	RA	Mrs Sparkes: "Orpheus and Eurydice" 393
	1881	DG	Sophia Beale: "Unitita" 69
	1881	DG	Jennie Moore: "Persephone" 534
	1881	DG	Elizabeth Naughten: "Phyllis" 353
	1881	DG	Elizabeth Naughten: "Chloe" 412
	1882	RA	Jessie Macgregor: "The Wail of the Valkyrs on the death of Baldur, the Scandinavian Sun God." "When Baldur died, Hela, ruler of the dead, promised that he should return to life if everything animate and inanimate wept for him etc." 833
	1882	GG	Florence Graham: "Aenone" 92
	1882	GG	Miss D. Tennant: "The Siren" 23
	1882	DG(oil)	Isabel de Steiger: "The Priestess of Isis" 428
	1882	SBA	Emma Black: "Pyrrha" 423
	1883	RA	Jessie Macgregor: "The Wanderings of Freyja (Norse Goddess of Love and Beauty) in search of her husband, Odur the Immortal" "Then she began a weary, weary quest, Wand'ring the wide world o'er with patient constancy, And ever still she wept - tears of pure gold, For Odur lost to her! Where'er her bright tears fell, the parched earth, Unused to dews so precious, melting smiled; And herbage green and roses white and red Sprang in her chariot tracks" 328

```
1883 NSPW      Helena J. Maguire: "Orpheus" 876
1883 DG(oil)   Dorothy Tennant: "The Naiad" 201
1883 SLA       Juliana Russell: "Ariadne" 437
1883 SLA       Mrs William Barnard: "Undine" 485
1883 SLA       Charlotte E. Babb: "A Dryad" 695
1884 RA        Henrietta Rae: "Launcelot and Elaine" 854
1885 RA        Henrietta Rae: "Ariadne deserted by Theseus" 6 (ill. in
                   "Academy Notes" op.cit. 1885, p.17)
1885 RA        Henrietta Rae: "A Bacchante" 623
1885 RA        Miss E.M. Rope: "Cupid shooting" 2102
1885 OWS       Miss Constance Phillott: "Lady Flora"
                   "All-graceful head, so richly curl'd" (Tennyson's
                   "Day Dream") 71
1885 OWS       Miss Constance Phillott: "A Captive"
                   "So shalt thou abide in Argos and ply the loom at
                   another woman's bidding, and bear water from fount
                   Messeis ... being grievously entreated and sore
                   constraint shall be laid upon thee" (Iliad 6) 120
1885 GG        Mrs E. Williams: "Daphnis and Chloe" 319
1885 GG        Miss Dorothy Tennant: "Cupid Disarmed" 23
1885 GG        Miss E. Pickering: "A Dryad" 43
1885 GG        Miss Anette Callwell: "A Maid of Dian's" 226
1885/6 IPO     Miss Margaret Hooper: "Iduna, the Goddess and Giver of
                   the Apples of Everlasting Youth" 79
1885/6 IPO     Miss Ethel King: "Orpheus playing" 95
1885 DG(oil)   Isabel de Steiger: "The Lost Pleiad" (study for a large
                   picture) 140
1885 SLA       Mrs H.C. Bishop Culpeper: "Pomona" 329
1885 SLA       Mrs Belinda Alldridge: "Psyche" 715
1886 OWS       Miss Constance Phillott: "Psyche's Rest"
                   "Within a wood, far off from any town" 236 (ill.)
1886 NSPW      Agnes Gardner King: "A Rustic Orpheus" 79
1886 SBA       Frances Grace: "Pandora just possessed of the key" 87
1886 GG        Miss Dorothy Tennant: "Sweet Echo! sweetest nymph that
                   liv'st unseen" 119
1886 GG        Miss Guild: "Psyche" 341
1886 GG        Miss G. Crockford: "Satyrs and Sylvan boys were seen
                   Peeping from forth their alleys green" 372
1886 SLA       Mrs Barnard: "The Fates" 141
1886 SLA       Mrs Emily Barnard: "Aurora Borealis" 501
1886/7 IPO     Mrs Murray Cookesley: "Ariadne" 456 (ill.)
1887 RA        Henrietta Rae: "Eurydice sinking back to Hades" 534 (ill.
                   in "Academy Notes" op.cit. 1887, p.83)
1887 RA        Henrietta Rae: "A Naiad" 1016
1887 RA        Anna Lea Merritt: "Iphigenia" 568
1887 RA        Anna Lea Merritt: "A Naiad" 1016
1887 RA        Beatrice Angle: "Psyche" (bust) 1820
1887 RA        Beatrice Angle:"Bacchante" (bronze bust) 1930
1887 RA        Emmeline Halse: "The Pleiades" (high relief) 1887
1887 SLA       Annie L. Robinson: "Danae" 336
1887 GG        Mrs Evelyn de Morgan: "Clytie" 348 (Sotheby's June 20,1972)
1887 GG        Miss Grant: "Diana after her Bath" 374
1887 GG        Miss Henrietta S. Montalba: "Daphne" 373
1887 NSPW      Evelyn de Morgan: "Hero watching for Leander" 432
1887 NSPW      Marie Stillman: "A Bacchante" 442
1887/8 IPO     Miss Ida Verner: "Perseus with the Head of Medusa" 265
1887/8 IPO     Mrs Florence S. Kennedy: "Bacchante Resting" 291
1888 RA        Edith G. Jeffreys: "Psyche" statuette 1981
1888 RA        Henrietta Rae: "Zephyrus wooing Flora" 668 (ill. in
                   "Academy Notes op.cit. 1888, p.87).
```

	1888 GG	Beatrice A. Willoughby Brown: "Cupid laid by his hand and fell asleep" (Shakespeare Sonnet) bust 364
	1888 GG	Mrs Jopling: "Phyllis" 348
	1888 NG	Mrs A.L. Swynnerton: "Parcae" 84
	1888 NG	Mrs A.L. Swynnerton: "Bacchante" 103
	1888 NSPW	Miss Jennie Moore: "Aphrodite" 191
	1889 RA	Helen Thornycroft: "The Training of Theseus" (Kingsley's Heroes) 1342
	1889 RA	Henrietta Rae: "The Death of Procris" 629 (ill. in "Academy Notes" op.cit. 1889, p.55)
	1889 GG	Mrs F. Gell: "Psyche" 376
	1889 GG	Miss Spencer Stanhope: "Young Orpheus" 391
	1889 NG	Mrs K.G. Hastings: "Cassandra" 246

H1.

	1880 DG(b&w)	Helen Thornycroft: "Past" 20
	1880 DG(b&w)	Helen Thornycroft: "Present" 556
	1880 GG	The Hon. Mrs Boyle: "In a Golden Age" 221
	1880 GG	Mrs Jopling: "Charity" 75
	1881 SLA	F. Elton Davis: "Nature and Art" 644
	1881 GG	Miss E. Pickering: "The Angel of Death" 99
	1883 SBA	Miss Gertrude Crockford: "Night" terra cotta 763
	1883 SBA	Miss Gertrude Crockford: "Morning" terra cotta 765
	1883 GG	Mrs Williams: "The Senses" 83, 84, 85, 244, 245
	1883 SLA	Jennie Moore: "The Golden Age" 477
	1883 SBA	Blanche Spencer: "Poetry" 676
	1883 DG	Mary Eley: "Charity" 409
	1883/4 IPO	Miss Evelyn Pickering: "Sleep and Death, the Children of Night" 27
	1884 SLA	Edith Marrable: "Love and his Lovers" 502
	1885 RA	Ella M. Bedford: "Poetry" design for a mural decoration 1848
	1885 GG	Miss Dorothy Tennant: "Truth at the Well" 39
	1885 NSPW	Miss Marian Chase: "Music, Literature and Art" 1061 (ill.)
	1887 RA	Beatrice Angle: "Poetry" 1932
	1887 SLA	Emily Barnard: "The North Wind" 389
	1887 SLA	Emily Barnard: "The South Wind" 396
	1887/8 IPO	Miss Evelyn Pickering: "Hope in the Prison of Despair"74(ill)
	1888 SBA	Mrs Freeman Gell: "Bird of Peace" (marble) 486
	1889 RA	Christabel A. Cockerell: "A metaphor of Spring, and Youth and Morning" 1157
	1889 RA	Ida R. Tayler: "Music" 1207
	1889 RA	Kate Bannin: "Youth" 2158
	1889 NSPW	Miss Mary Eley: "Charity" 708
	1889 NG	Miss Evelyn Pickering: "Love, the Misleader" 168

I1.

	1880 SLA	Jennie Moore: "Hagar" 197
	1880 DG	Ellen G. Hill: "Ruth; the Moabitish damsel that came back with Naomi out of the country of Moab" 338
	1880 RA	Miss S.R. Canton: "Eve" 1554
	1880 RA	Miss T.G. Thornycroft: "The Feeding of the Multitude" "And Jesus took the loaves; and when he had given thanks, he distributed to the disciples, and the disciples to them that were set down; and likewise of the fishes as much as they would" - St. John vi.11 670 (ill. in "Academy Notes" op.cit. 1880, p.63).
	1880 GG	Louisa the Marchioness of Waterford: "The Home at Nazareth" 278
	1881 RA	Theresa Thornycroft: "Dawn at Bethlehem" 3
	1881 RA	Charlotee Besnard: "Judith showing the head of Holophernes to the people of Bethulia" (bronze statue) 1490
	1881 RA	Emmeline Halse: "Cain" 1510

1881 SLA		Miss Austin Carter: "Mary of Bethany entering the House of Simon the Leper" 4
1881 GG		Margaret Gillies: "Rebecca at the Well" 308
1881 GG		Miss Kate Gardiner Hastings: "The Finding of Moses" 200
1881 GG		Lady Lindsay: "Rebekah" 241
1881 GG		Lady Lindsay: "Deborah" 242
1881 DG(b&w)		Elinor Halle: "Tobias and the Angel" 531
1881 DG(b&w)		Mary Gow: "The Holy Family" (original drawing for "The Child's Life of Christ") 208
1882 SLA		E.S. Robinson: "Rebekah" 294
1882 GG		Louisa the Marchioness of Waterford: "Two blind men by the wayside begging, when they heard that Jesus passed by, asked what it meant" (St. Luke ch.28, v.36) 187
1883 GG		Mrs Kate Gardiner Hastings: "By the waters of Babylon we sat down and wept" 156
1883 GG		Miss E. Pickering: "By the rivers of Babylon, there we sat down; yea,we wept, when we remembered Zion" "We hanged our harps upon the willows in the midst thereof" 43
1883 GG		Mrs C. Wylie: "Orpah" 217
1884 GG		Mrs Kate Gardiner Hastings: "Esther" 88
1885 RA		Ella M. Bedford: "The angels appearing to the Shepherds" 1901
1885 RA		Mrs L. Jopling: "Salome carrying the head of John the Baptist to her mother, Herodias" 543
1885 RA		Miss E.M. Rope: "David playing before Saul" (low relief) 2029
1885 RA		Anna Lea Merritt: "Eve" 126 (ill. in "Academy Notes" op.cit. 1885, p.28)
1885 GG		Mrs Kate Gardiner Hastings: "Ruth" 203
1885 NSPW		Rose Barton: "The Massacre of the Innocents" 190
1886 GG		Miss B. Jenkins: "Ruth" 115
1886/7 IPO		Mrs S.E. Walker: "Eve" 670
1887 GG		Mrs Hastings: "Judith" (from a Mantegna design) 153
1888 RA		Alice Havers: "But Mary kept all these things and pondered them in her heart" 720 (Castle Museum Norwich)
1888 RA		Ethel S. King: "The Creation of Eve" 1656
1888 NG		Mrs Kennedy: "Ishmael" 187
1889 RA		Jessie Macgregor: "Jephthah" (Judges xi, 34) 315 (ill. in "Academy Notes" op.cit. 1889, p.35)
1889 NSPW		Miss Gertrude Demain Hammond: "Five of them were wise and five were foolish" decorative panel 196 (ill.)
1889 DG		Louisa, Marchioness of Waterford: "A great while before day, Jesus departed into a solitary place and prayed" (Mark 1, v.1) 122

J1. Military pictures exhibited by Lady Butler in the 1880's:-

1881 RA		"The defence of Rorke's Drift, January 22nd, 1879" 899 (Staff College, Camberley)
1881 DG		"Scotland for Ever!" (exhibited separately) (Leeds Art Gallery)
1882 RA		"Floreat Etona!" "An eye-witness of the attack on Laing's Neck thus describes the incident depicted: 'Poor Elwes fell among the 58th. He shouted to another Eton boy (adjutant of the 58th, whose horse had been shot) "Come along, Monck! Floreat Etona! We must be in the front rank!" and he was shot immediately'" 499 (engraving in the Witt Library)

1885 RA "'After the Battle': arrival of Lord Wolseley and staff
at the Bridge of Tel-el-Kebir at the close of the
action"
"The enemy's retreat, begun at the entrenchments,
pressed with an ever-increasing rapidity westward,
and it was only when the canal bridge at Tel-el-Kebir
was reached that our victorious infantry halted in
their rapid pursuit. The Commander-in-chief reached
the bridge, almost as the foremost files of the
Gordon and Cameron Highlanders gained that point. On
the short causeway leading to the drawbridge he dis-
mounted, and there dictated the orders for pursuit
by the cavalry and Indian division" 1081

1887 RA "A Desert Grave: Nile Expedition, 1885" 466

1889 RA "To the Front: French cavalry leaving a Breton city on
the declaration of war" 578

Engravings from two pictures by the Dowager Countess of Westmoreland on
themes connected with the Waterloo Campaign were exhibited in 1880:-

1880 SLA "The Duke of Wellington writing the Despatch after the
Battle of Waterloo" (From a picture painted by his
Niece (then Lady Burghersh), to whom was sent the
sword and other objects represented in the Picture,
in use at Waterloo" 683

1880 SLA "Lady Mornington (Mother of the Duke of Wellington) read-
ing the account of the Battle of Waterloo, from a
painting by the (lately deceased) Countess of
Westmoreland" 690.

Other works on historical themes:-

1880 RA Miss G.E. Bulley: "St. Elizabeth of Hungary" terra cotta
bust 1623

1880 DG Ellen G. Parker: "St. Agnes" 434

1880 DG Helen Thornycroft: "The Death of Saint Rosalia" 129

1881 SLA Helen Thornycroft: "The Martyrdom of St. Sebastian" 718

1882 GG Miss E. Pickering: "A Christian Martyr" 101

1882 SLA Juliana Lloyd: "Penelope"
"Constant she would still remain
Hoping to see him once again" 468

1883 GG Mrs Marie Stillman: "The Childhood of St. Cecily" 349

1883/4 IPO Isabel de Steiger: "The Greek Captive and her Nubian
Slave" 690

1883 SLA L. Gordon-Goguel: "Isabella, the Baby wife of Richard II"
"No man durst mention him to her" - Froissart, ch.118
228

1883 DG(oil) Annie L. Beal: "One of Queen Elizabeth's Councillors" 132

1883 DG Mary P. Mead: "Hypatia" 379

1884 SLA F. Clow: "Iseult of Brittany" 291

1884 SLA Florence Bonneau: "Dido"
But furious Dido, with dark thoughts involved,
Shock at the mighty mischief she resolved" 685

1884 GG Mrs Edmund Gosse: "The Retreat of Anthony Rowley" 350

1885 SBA Miss S.R. Canton: "Irene finding the body of St. Sebastian"
767

1885 SLA Mrs Louise Jopling: "List of the Killed and Wounded, 1885"
376

1885 NSPW Miss Ellen G. Hill: "'Companions of her Solitude' - Little
Aurore in the Spanish Palace, vide George Sand's
'Histoire de Ma Vie'" 149

1886 RA Anna Lea Merritt: "St. Cecilia" (Tennyson's Palace of Art)
134

```
      1887 RA        Julia B. Folkard: "Dante's Beatrice" 774
      1887 RA        Ellen Clacy: "The return of the Prodigal in the year
                        of the Great Plague 1665" 914
      1887 OWS       Miss Constance Phillott: "Saint Lucy" 55 (ill)
    1887/8 IPO       Miss Etheline E. Dell: "Sappho" 405
      1888 RA        Emily Little: "Vittoria Colonna" 271
      1888 SBA       Miss H.E. Grace: "Isolde"
                        "Is there a shadow of sadness cast by the Future's sun,
                        Echoings faint of the turmoil that shall be e'er life
                           is done?" 36
      1889 RA        Ellen Clacy: "A hunted Jewess, France 1610" 367
      1889 RA        Dora Noyes: "Santa Lucia" 686
      1889 NSPW      Miss E. Cameron Mawson: "St. Cecilia" 581
      1889 SLA       Mrs Louise Jopling: "Charlotte Corday" 319
      1889 GG        Miss H. Browne: "St. Catherine of Alexandria" 404
      1889 GG        Miss C. Weeks: "Saint Agnes" 223
      1889 NG        Countess Feodora Gleichen: "Hypatia" 393 sculpture

K1  Mythological works:-
      1890 SLA       Helen Thornycroft: "The Training of Theseus" (Kingsley's
                        Heroes) 40
      1890 SLA       Mrs S.E. Waller: "A Bacchante" 539
      1890 NG        Mrs Kate Gardiner Hastings: "Eurydice" 87
      1890 NG        Mrs Evelyn de Morgan: "Medea"
                        "Day by day
                        She saw the happy time fade fast away,
                        And as she fell from out that happiness
                        Again she grew to be the sorceress,
                        Worker of fearful things, as once she was"
                        (Life and Death of Jason) 84 (Williamson Art Gallery
                        Birkenhead)
      1890 GG        Mrs Louise Jopling: "Flora" 156
      1890 GG        Miss Beatrice Brown: "Bust of a Young Bacchante" terra
                        cotta 3
      1890 GG        Miss Beatrice Brown: "Bust of Psyche" terra cotta 4
      1890 RA        Miss M. Bowley: "The Danaides" 1839
      1890 RA        Miss M. Phelps: "Sibyl" 1679
      1890 RA        Miss L. Gay: "Pan" bas relief 2022
      1891 SLA       Mrs Alice Bach: "Flora" 352
      1891 SLA       Mrs Mary Waller: "A Bacchante" 517
      1891 OWS       Miss Constance Phillott: "Medea"
                        "Within her caught up gown,
                        Much herbs she had" 94 (ill.)
      1891 NG        Mrs A.L. Swynnerton: "Cupid and Psyche" 161 (Oldham Art
                        Gallery)
      1891 NG        Mrs Evelyn de Morgan: "The Bells of San Vito"
                        "A Bacchante came from the past into the present, and
                        revisited Bellosguardo, near Florence, in 1890, but
                        was scared away by the clang of the church bells" 246
      1892 RA        Beatrice Angle: "A Bacchante" (terra cotta bust) 1955
      1892 RA        Ada F. Gell: "Psyche" (marble bust) 1963
      1892 RA        Charlotte Hunton: "A young Baccante" (bronze statuette)2001
    1892/3 IPO       Miss Margaret L. Hooper: "The End of Sigmund the Volsung"
                        448
      1893 RA        Alice M. Chambers: "Psyche" 1180
      1893 RA        Charlotte Hunton: "Bacchante" (head) 1800
      1894 RA        Henrietta Rae: "Psyche before the throne of Venus" (William
                        Morris's "Earthly Paradise") 564 (George McCulloch
                        Sale, Christie's May 23, 1913)
    1894/5 IPO       Miss Annie E. Bowler: "A Bacchante" 182.
    1894/5 IPO       Miss Henrietta Rae: "Pandora" 569 (ill.)
```

1895 RA	Miss E. Casella: "Minerva" bas relief, coloured wax 1707	
1895 RA	Miss Helen Cridland: "The Judgment of Paris" 5	
1895 RA	Miss M. Giles: "Ulysses and Euryclea" relief, lead 1669	
1895 RA	Henrietta Rae: "Apollo and Daphne" 621 (ill. in Witt Library)	
1895 NG	Mrs Marie Stillman: "Persefone Umbra" 327	
1895 NSPW	Miss Annie Wardlow: "Flora" 685	
1896 RA	Edith Corbet: "Bacchante" 944	
1896 RA	Mary F. Raphael: "A wood nymph" 547 (Cheltenham Art Gallery)	
1896 RA	A. Jane Harrison: "Psyche" 1089	
1896 RA	Margaret M. Giles: "Hero" statuette 1913	
1896 NG	Mrs A.L. Swynnerton: "Hebe" 101	
1896 NG	Miss Melicent Stone: "Paris" wax 462	
1897 RA	Agnes Slott-Moller: "Agnete, the Merman's wife, comes to her mother in the church" 110	
1897 SLA	Emily Barnard: "Proserpine" 756	
1897 SLA	Mrs Swynnerton: "Hebe" 410	
1897 SLA	Mrs Mariquita J. Moberley: "Mournful Aenone" 468	
1897 RA	Evelyn W. Solly: "The Judgment of Paris" 632	
1897 OWS	Miss Constance Phillott: "A Handmaid of Circe" 17 (ill.)	
1897 NG	Mrs Marianne Stokes: "Primavera" 4	
1898 RA	Isobel C. Pyke-Nott: "Circe" miniature 1262	
1898 RA	Clarissa Barker: "Baccante" head 1885	
1898 SLA	Mrs Murray Cookesley: "A Priestess of Isis" 449	
1898 NG	Mrs Spencer Stanhope: "Pan" bronze statuette 476	
1899 RA	Henrietta Rae: "Diana and Callisto" (Ovid's Metamorphoses bk.2, fab.v) 927 (ill. in "Academy Notes" op.cit. 1899 p.145)	
1899 SWA	Louise Jopling: "Ariadne" 62	
1899 NSPW	Miss C.M. Hull: "Daughters of Pierus" "The daughters of Pierus, having offended the Muses, were transformed into magpies" 51	
1900 RA	Miss E. Casella: "Mars" coloured wax 2035	
1900 NG	Mrs Evelyn de Morgan: "The Spear of Ithuriel" 41	
1900 NG	Miss Ella Casella: "Pomona" wax 428	

Allegorical works:-

1890 NG	Miss Lisa Stillman: "Spring" 357	
1890 SLA	Mrs Emily Barnard: "Water" 224	
1890 SLA	Mrs Emily Barnard: "Fire" 235	
1890 SBA	Mary F. Field: "The Golden Age" 372	
1890 NSPW	Miss Marian Chase: "Winter" 87 (ill.)	
1890 GG	Mrs Freeman Gell: "The Bird of Peace" marble statuette 15	
1890 RA	Anna Lea Merritt: "Love Locked Out" 32 (Tate Gallery)	
1890 NEAC	Juliet Hensman: "Physics" 92	
1891 RA	Mary Bowley: "Truth" decorative panel 997	
1891 RA	Ellen M. Rope: "The Four Elements: earth, air, fire and water" bas relief 2025	
1892 RA	Florence Fitzgerald: "Innocence" bust 1936	
1892 NSPW	Miss Gertrude Demain Hammond: "Comedy and Tragedy" a decorative design 453	
1892 NSPW	Miss Alice M. Chambers: "Study for Head of Memory" 109	
1893 RA	Charlotte Hunton: "Vanity" statuette 1818	
1893 RA	Edith E. Downing: "Dignity" sculpture, head 1793	

```
     1893 RA      Beatrice Gibbs: "Righteousness and Peace have kissed
                    each other " 182
     1893 NG      Miss Annie Withers: "Faith" 58
     1893 OWS     Miss Constance Phillott: "Charity" 152 (ill.)
     1894 RA      Kate Perugini: "Past and Present" 697
     1896 RA      Ada F. Gell: "Victory" statuette 1820
     1896 RA      Henrietta Rae: "Summer" 678 (ill. in "Academy Notes" op.
                    cit. 1896, p.113)
     1896 NG      Miss Anna Alma-Tadema: "Hope - the Phoenix" 343
     1897 RA      Dora Noyes: "Peace" 683
     1897 RA      Ada Freeman Gell: "Victory" bronze statuette 2012
     1897 NG      Mme Henriette Ronner: "The Golden Age" 348
     1898 NG      Miss Florence Graham: "Past and Present" 374
     1899 RA      Harriet Sutcliffe: "Honesty" 464
     1899 RA      Mary E. Durham: "The decrees of Fate" 543
     1899 RA      Countess F. Gleichen: "Peace" bronze statuette 1960
     1899 NG      Mrs P.F. Walker: "Past and Present" 269
     1899 NG      Mrs Mary F. Raphael: "Somnia" 308
     1899 NG      Miss Nelia Casella: "Spring" coloured wax 444
     1900 RA      Miss Eleanor Fortescue Brickdale: "Time the Physician" 795
     1900 RA      Miss E. Maryon: "Religion" sketch model of a figure for a
                    public building. "Put on the whole armour of God"2032
     1900 RA      Miss H.M. Rigby: "Simplicity" 1982
     1900 SM      Miss Margaret D. Fisher: "The Age of Innocence" 137

L1. 1890 SLA     Mary Drew: "Pharoah's Daughter" 321
     1890 GG      Miss E.S. Guinness: "Eve" 236
     1891 NG      Mrs Kate Gardiner Hastings: "Moses and Aaron before
                    Pharaoh and his Magicians" 117
     1891 NSPW    Miss Helen Squire: "The Adoration of the Magi" 339
     1891 NSPW    Miss Gertrude Demain Hammond: "Behold the Handmaid of the
                    Lord" 533
     1891 NSPW    Miss M.E. Durham: "The Adoration of the Magi" 662
     1892 SLA     Agnes Lee: "The Adoration of the Magi" 370
     1893 RA      Marianne Stokes:  "Angels entertaining the Holy Child" 447
                    (ill. in "Academy Notes" op.cit. 1893, p.91)
     1893 SLA     Mrs Emily Barnard: "The Angel of Mercy" 433
     1893 SLA     Caroline Paterson: "The Queen of Sheba" 288
     1894 RA      Anna Lea Merritt: "Watchers of the Straight Gate" 404
     1894 RA      Countess Feodora Gleichen: "Satan" bronze group 1752
     1895 RA      Miss M. Giles: "Virgin and Child" relief 1692
     1896 NG      Miss Catherine Weeks: "Madonna" 400
     1897 SLA     Emily Barnard: "Esther" 210
     1897 RA      Winifred H. Thomson: "Salome" 373
     1897 RA      Mary F.A. Raphael: "Eve" 475 (ill. in "Academy Notes" op.
                    cit. 1897, p.100)
     1897 RA      Grace Baldry: "Judith" 594
     1897 SLA     Mrs Annie Martin: "Esther" 69
     1898 RA      Mary Pownall: "La Madeleine" statue 1813
     1898 SLA     Mrs Ellen Frank: "Eve" 232
     1898 SLA     Mrs Louise Jopling: "Naomi" 274
     1898 SLA     Mrs Emily Barnard: "Ruth" 289
     1899 NG      Mrs Marianne Stokes: "Eve" 160
     1900 RA      Miss C. Sparling: "The Adoration of the Magi" design for
                    a stained glass window 1849
     1900 RA      Miss C. Sparling: "The Sojourn in Egypt" 1851
     1900 OWS     Miss E. Stanhope Forbes: "Madonna" 119
     1900 SWA     Frances Burlison: "The Nativity" 486
```

M1. 1890 NEAC Henriette Corkran: "Clothilde" 88
 1890 RA Miss Beatrice Offor: "Sappho" 1650
 1890 NG Mrs Marie Stillman: "Petrarch's first sight of Laura; at
 the Church of Santa Chiara, Avignon" 203
 1890 NG Mrs Marie Stillman: "At a Florentine Wedding Feast"
 "Whereupon I remember that I covertly leaned my back
 onto a painting that ran round the walls of that
 house; and being fearful lest my trembling should
 be discerned by them, I lifted mine eyes to look on
 those ladies, and then first perceived among them
 the excellent Beatrice. And when I perceived her,
 all my senses were overpowered by the great lordship
 that love obtained, finding himself so near unto that
 most gracious being, until nothing but the spirits of
 sight remained to me.. By this many of her friends
 having discerned my confusion, began to wonder, and
 together with herself kept whispering of me and mock-
 ing me. Whereupon my friend, who knew not what to
 conceive, took me by the hands, and drawing me forth
 from among them, required to know what ailed me"
 Dante "Vita Nuova" 316
 1891 SLA Mrs Louise Jopling: "Fair Rosamonde" 335
 1891 DG Agnes Fraser: "St. Agnes" 219
 1891 DG Agnes Fraser: "St. Cecilia" 234
 1891 NG Mrs Marie Stillman: "Petrarch and Laura" 281
 1892 RA Margaret Isabel Dicksee: "'Miss Angel' (Angelica Kauffman,
 introduced by Lady Wentworth, visits Mr Reynolds'
 studio)" 71 (ill. in "Academy Notes" op.cit. 1892,
 p.38)
 1892 RA Jessie Macgregor: "In the Childhood of Dante"
 "From that time forward love ruled my heart" 905
 (Sotheby's Dec.11, 1973)
 1892 RA Beatrice Offor: "St. Agnes" miniature 1516
 1892 NG Mrs Marie Stillman: "A Study for St. Geroge" 269
 1892 NSPW Miss Ellen G. Hill: "Little Aurore and her Grandmother"
 "My grandmother sang with taste and enthusiasm the
 operas of her youth. I used to listen, sitting under
 the old harpsichord with 'Brilliant', her favourite
 dog. I could have passed whole days thus, so much was
 I fascinated by the quavering voice and the jingling
 notes" - vide George Sand's "Histoire de ma vie" 432
 1892/3 IPO Miss Edith Cannon: "Santa Cecilia" 286
 1893 RA Margaret Isabel Dicksee: "The Child Handel"
 "Handel's father, objecting to his son's absorbing
 devotion to music, forbade his following his bent,
 and banished all musical instruments to an attic,
 where, however, the little musician discovered them,
 and under cover of night resumed his beloved pursuit.
 The sounds this produced, and the flitting of the
 little white-clad figure , started the notion that
 the house was haunted, until the truth was revealed"
 279 (ill. in "Academy Notes" op.cit. 1893, p.77)
 1893 NG Mrs Marie Stillman: "Vision of the Good Monk of Soffiano"
 "How when near unto death he was roused by the blessed
 Mother of God appearing to him with. a company of
 Cherubim the Seraphim and three holy Virgins bearing
 phials of lactuary which she administered to him,
 comforting him with promise of a speedy deliverance
 from suffering into the 'glory of a future life'"
 Flowrets of St. Francis 204

1894 RA Margaret Isabel Dicksee: "The First Audience" (Oliver
 Goldsmith reading 'She Stoops to Conquer' to 'Little
 Comedy' and 'The Jessamy Bride') 392 (ill. in
 "Academy Notes" op.cit. 1894, p.99).

1894 RA Ellen Clacy: "The Saracen Maid seeking Gilbert a Becket
 in London" 923 .

1894 RA Gertrude K. Warren: "St. Agnes"
 "We know the Holy Innocents
 Laid down for Him their infant life,
 And Martyrs brave and patient Saints
 Have stood for Him in fire and strife" 1463

1894 SLA Florence Sherrard: "Study for the Head of St. Sebastian" 183

1894 NG Miss Edith Bateson: "Théocrite" a marble head 428

1895 RA Margaret Isabel Dicksee: "The Children of Charles I"
 "After the execution of the King, his younger children,
 Elizabeth and Henry, were confined in Carisbrooke
 Castle. There the little Elizabeth languished for a
 short time, dying within a year of her father's tragic
 fate" 378 (Oldham Art Gallery)

1895 NSPW Miss Helen Stratton: "Geneviève de Brabant" 386

1895 SBA Miss Agnes M. Veness: "St. Bartholomew the Great" 14

1895 NG Mrs Kate Gardiner Hastings: "Merlin and Vivian" 56

1895 NG Mrs Adrian Stokes: "St. Elizabeth of Hungary spinning wool
 for the Poor" 81

1896 RA Margaret Isabel Dicksee: "The early days of Swift and Stella"
 "When secretary to Sir William Temple, Swift first
 became acquainted with little Hester Johnson (Stella),
 the daughter of Sir William's housekeeper. His inter-
 est and affection were from the first won by the
 child, and amidst his manifold duties he found time
 to direct her education. Thus in these early days
 began that tender friendship which ended only with her
 life" 334

1896 NG Mrs Marie Stillman: "Socrate" 361

1897 NG Miss Christabel A. Cockerell: "And the angels were her
 playmates" (From "The Childhood of Elizabeth of Hungary")
 97

1897 NSPW Miss Mary Harding: "St. Bartholomew the Great" 425

1898 RA Edith Downing: "St. Margaret" relief 1944

1898 RA Edyth Starkie: "St. Cecilia" 294 (ill. in "Academy Notes"
 op.cit. 1898, p.67)

1898 SBA Mrs K.E. Hill: "Guinevere" 397

1898 SLA Ethel Wright: "St. Agnes" 377

1898 NG Miss Kathleen Shaw: "A Saint of Ancient Ireland" 473
 sculpture

1898 NG Miss Kate Tizard: "Giotto" 466 sculpture

1899 RA Margaret Isabel Dicksee: "Sheridan at the Linleys"
 In Bath, Sheridan became acquainted with the family
 of Thomas Linley, the composer, whose daughters were
 already known to the public as singers. The admira-
 tion which Sheridan from the first conceived for
 Eliza, the elder, speedily resulted in their romantic
 marriage" 310 (Sotheby's Feb. 22, 1972)

1899 RA Ida Hardy: "Jeanne d'Arc" wax statuette 1996

1899 RA Margaret A. Heath: "St. Agnes" 1377

1899 RA Isobel Lilian Gloag: "Rosamond" 219 (ill. in Witt Library)

1899 NSPW Miss Gertrude Demain Hammond: "St. Cecilia" 290

1899 SWA Frieda Rickenbach: "St. Bartholomew the Great" 122

1900 NG Miss Flora M. Reid: "The Boyhood of Landseer" 351

1900 NG Countess Feodora Gleichen: "Helena Gleichen as Joan of
 Arc" 456

1901 RA Margaret Isabel Dicksee: "The first commission"
"Thomas Lawrence, third president of the Royal
Academy, was the son of an innkeeper at Devizes.
He early evinced his remarkable artistic talent,
gaining as a very young child considerable reputation
by taking portraits of the many travellers who stopped
at the inn, on their way to Bath" 314

N1. 1890 RA "Evicted" 993 (Dublin Municipal Gallery)
 1892 RA "Halt on a forced march: Peninsular War" 27 (KSLI Depot,
Shrewsbury)
 1893 RA "The Camel Corps" 848
 1895 RA "Dawn of Waterloo. The 'Reveille' in the bivouac of the
Scots Greys on the morning of the battle" 853
(Falkland House)
 1896 NG "The Mid-day Meal. Egyptian Cavalry Horses at Berseem" 3
 1897 RA "'Steady the drums and fifes!' The 57th (Die-hards)
drawn up under fire on the ridge of Albuera. 'The
highest courage in a soldier is said to be the stand-
ing still under fire .. It is the self-command of
duty in obedience to authority. In a forlorn hope
there is the excitement of action and the forgetful-
ness of self which comes from it. But to stand still
under fire, still and motionless, is a supreme act of
the will' - Cardinal Manning" 663 (School of Infantry
Warminster)
 1898 RA "On the morrow of Talavera: soldiers of the 43rd bringing
in the dead" 303 (ill. in "Academy Notes" op.cit.
1898, p.68)
 1899 RA "The Colours: advance of the Scots Guards at the Alma"
"It was the last battle of the old order. We went
into action in all our finery, with colours flying
and bands playing" - General Earle 912 (Scots Guards
Mess. Chelsea Barracks).
(One other work on a military theme should be mentioned. In 1898 Lucy
Kemp-Welch exhibited "'To arms!' early morning in the camp of the Duke
of York's army before the first battle of the Roses at St. Albans'"
(RA 1898 no.570) (ill. in "Academy Notes" op.cit. 1898, p.108)

O1.a) The following are the most striking examples of illustrative literary
works with female subjects. Sadness was the usual mood.
 1807 RA Miss Maria Spilsbury: "Lavinia listening to her mother's
mournful tale of what her faithless fortune promised
once"(Thomson's "Autumn")246
 1807 BI Mrs Mee: "The Maniac"
"Across her breast the tangled tresses flew,
And phrensied glances all around she threw,
Th'unsettled soul those phrensied glances speak,
And tears of terror hurry down her cheek" (Vide
Pratt's Poem of Sympathy) 142
 1808 AAW Miss Emma Smith: "The Princess and the Slave"
"Drink, mother! drink! the wave is cool and clear,
But drink in silence, lest the Princess hear"
(Lewis' "Tales of Wonder") 55
 1808 BI Miss Smith: "Mary Queen of Scots, her lament on the
approach of Spring"
"The meanest hind in fair Scotland
May rove their sweets among;
But I, the queen of a'Scotland,
Maun lie in prison strong" (Burns Poems) 184

1808 BI Miss Maria Spilsbury: "The spirit of a child writing a
 letter of consolation to his disconsolate mother"
 (Mrs Rowe's Letters from the Dead to the Living) 109
 (as Mrs John Taylor - she married in 1809 - this
 artist exhibited a work with the same title at the
 British Institution in 1813, no.11)

1809 RA Mrs S. Jones: "The Descent of Charity"
 "'Tis heaven-born charity! benignant guest!
 She comes the mourner's drooping soul to cheer,
 To sprinkle comfort o'er the widow's breast,
 And gently wipe away the orphan's tear" (Poetical
 Sketches by the artist) 282

1809 RA Mrs S. Jones: "The Death of Egbert"
 "Near her dear father's honor'd clay,
 Now pale and cold in death,
 Sunk on the floor, Edwina lay;
 Warm tears suppress'd her breath.

 With eager step to her he flew,
 And caught her in his arms;
 But found, alas! an ashy hue
 Was settled o'er her charms" (Poetical Sketches by
 the Artist) 285

1809 RA Miss Croft: "Ophelia" 515

1811 BI Miss Betham: "With eyes uprais'd as one inspir'd,
 - Melancholy sate retir'd" 99

1811 BI Miss Carmichael: "The abbess and nuns of St. Hilda"
 "Clare sat upon the galley's prow,
 And seem'd to mark the waves below -
 - See, what a woeful look was given
 As she rais'd up her eyes to heaven" (Marmion Canto II)
 84

1812 AAW Miss Betham: "Alone, upon the solitary strand
 The lonely one, is list" (Southey's "Curse of
 Kahama") 266

1815 BI Miss Patrickson: "The Little Pedlar"
 "Come buy, come buy, poor Sally's ware,
 Who all for money barters;
 My boxes, toys, and ballads rare,
 My toothpicks, lace and garters" 10

1816 BI Miss Geddes: "Chloe"
 "Oh Jessy, stay thy eager hand,
 In pity let the flutterer rest;
 Nay, don't disturb the sweet repose
 It hopes to find on Chloe's breast" 82

1816 BI Miss Stock: "Blanche" vide "The Lady of the Lake" Scott 45

1817 BI Mrs Ansley: "Francesca"
 "Ready she sat with one hand to turn o'er
 The leaf, to which her thought ran on before,
 The other propping her white brow, and throw'ing
 Its ringlets out, under the sky-light glowing
 So sat she fixed; and so observed was she,
 Of one, who at the door stood tenderly -
 Gaulo" - vide "The Story of Rimini" by Leigh Hunt 81

1817 RA Miss M.A. Flaxman: "Design from the old ballad of "The
 Beggar's Daughter of Bednall Green" Part 1st.
 "Then Bessee, that was of beauty so bright,
 All clad in gray russet, and late in the night,
 From father and mother alone parted shee,
 Who sighed and sobbed for prettye Bessee" 535

1817 RA Miss M.A. Flaxman: "Design from the old ballad of "The Beggar's Daughter of Bednall Green" Part 2nd.
"All our comfort and care was our prettye Bessee" 521

1818 RA Miss E. Jones: "Olympia"
"E di lontano le gonfiate vele
Vide fuggir del suo signor crudele" ("Orlando furioso" c.10) 666

1819 RA Miss M.A. Flaxman: "Maternal Piety, from Mr Rogers' "Poem of Human Life"
"She joins his little hands in prayer" 878

b) Other literary works exhibited over the first two decades of the century:-

1800 RA Mrs Cosway: "Angelica: "How oft inscrib'd with Friendship's votive rhyme,
The bark now silver'd by the touch of Time!" Rogers 122

1800 RA Mrs Cosway: "There, while the shaded lamp's mild lustre streams,/Read ancient books, or woo inspiring dreams" Rogers 131

1800 RA Miss M.A. Flaxman: "Two designs from Mr Hayley's 'Triumphs of Temper' and two from the 'Pleasures of Memory'" 665

1800 RA Miss Paye: "L'Allegro" 862

1800 RA Miss M. Stewart: "Portraits of Miss Walton and Miss Sindal at the Monument of Harley"
"'There is a blank at the bottom of the tablet' (said Lucy): Her companion smil'd gloomily at the observation and reply'd that it should one day be fill'd up" 482

1801 RA Miss M. Stewart: "Edwin and Angelina"
"Then pilgrim, turn, thy cares forego:
For earth-born cares are wrong" (Oliver Goldsmith) 56

1801 RA Miss M.A. Flaxman: "Design from Mr Sotheby's poems" 437

1801 RA Miss M.A. Flaxman: "Design from Mr Sotheby's poems of 'Oberon'" 440

1802 RA Mrs Siddons: "A bust of Adam, from Milton's 'Paradise Los' book 4, line 300"
"His fair large front, and eye sublime etc." 1058

1802 RA Miss Maria Spilsbury: "A Working Party" vide "The Task" Cowper's poems volume 2, p.145 24

1802 RA Miss Maria Spilsbury: "Richard and Kate; or fair-day"
"Didn't I tell you they'd be here?" (Rural Tales by R. Bloomfield) 160

1803 The 13th edition of John Hayley's "Triumphs of Temper" was illustrated with six designs by Maria Flaxman (engraved by William Blake)

1807 BI Mrs Green: "Melancholy"
"And here will I skim o'er the billows so high,
And laugh at the moon and the dark frowning sky,
And the sea-birds that hover across the wide main,
Shall sweep with their pinions the white bounding plain" (Mrs Robinson's Lyrical Tales) 26

1807 RA Miss M.A. Flaxman: "A drawing from Sir Walter Scott's 'Lay of the Last Minstrel' canto 2" 874

1808 AAW Miss Emma Smith: "Lady Teazle"
"Lady Teazle: 'No, my note of hand will do'" ("School for Scandal") 247

1808 BI Miss Maria Spilsbury: "The Working Party"
"The poet's or historian's page by one
Made vocal for th'amusement of the rest
. the threaded steel
Flies quickly and unfelt the task proceeds" (Cowper's "Winter's Evening") 71

1808 BI Miss Maria Spilsbury: "Lodoic instructing Swiss peasants'
 children" (vide "Lodoic ou Leçons de Morale pour la
 Jeunesse") 230

1811 BI Mrs Singleton: "Young Norval"
 "Who shall resist me in a Mother's cause?" (Home's
 "Douglas") 95

1814 BI Miss E. Trotter: "The dying Giaour relating his story to
 the Anchoret"
 "There's blood upon that dinted sword -
 A stain its steel can never lose.
 Twas shed for her, who died for me,
 It warmed the heart of one abhorred:
 Nay, start not - no - nor bend thy knee etc." (The
 "Giaour" by Lord Byron) 56

1815 Lady Lucan finished her sixteen year task of illustrating the his-
torical plays of Shakespeare with "copies of portraits, tombs,
heraldic devices, flowers, birds and various graceful fancies"
(E.C. Clayton op.cit. vol.1, p.344). In 1876, when Clayton was
writing, the work was in the library at Althorp (in five folio
volumes).

Pl.a) Sir Walter Scott:-

1818 RA Miss M.A. Flaxman: "Meg Merrilies and Domini Sampson in
 the Kaim of Derncleugh"
 "Gape, sinner and swallow" 586

1823 BI Eliza Jones: "Brenda Troil" - (vide "Pirate") 163

1823 RA Miss E.E. Kendrick: "Amy Robsart"
 "The Countess playfully stretched her upon the pile
 of Moorish cushions, half sitting, half reclining,
 half wrapt in her own thoughts. While she was in
 this attitude, and with a corresponding expression
 betwixt listlessness and expectation etc." (vol.1,
 p.127) 842

1824 RA Miss E.E. Kendrick: "Isabel de Croye" - (Vide "Quentin
 Durward") 621

1824 RA Miss Jane Adams: "Clara, from 'St. Ronan's Well'" 500

1824 SBA Miss E.E. Kendrick: "Amy Robsart" (vide "Kenilworth") 445
 (possibly the same work as that exhibited by the
 artist in 1823 (RA no. 842))

1824 BI Eliza Jones: "Minna Troil"
 "From her mother, Minna inherited the stately form
 and dark eyes, the raven locks and finely pencilled
 brows etc." (vide "Pirate" ch.3, p.43) 198

1824 BI Eliza Jones: "Jacqueline"
 "A quantity of long black tresses were unadorned by
 any ornament, excepting a single chaplet of ivy
 leaves formed a veil around a countenance which, in
 its regular features, dark eyes, and pensive expres-
 sion, resembled that of Melpomene" ("Quentin Durward"
 ch.4, p.72) 204

1825 RA Miss E.E. Kendrick: "The Lady in the Green Mantle" (vide
 "Red Gauntlet") 582

1825 BI Eliza Jones: "Clara Mowbray: 'I must go, I am called'"
 ("St. Ronan's Well") 199

1825 BI Eliza Jones: "Diana Vernon" ("Rob Roy") 351

1826 RA Miss E.E. Kendrick: "Edith Plantaganet dropping the Rose-
 bud in the chapel at Engaddi" (vide "The Talisman")
 635 (A work with the same title was exhibited by the
 artist in 1827 (SBA no.617)

1826 BI Miss E. Jones: "The lady Edith"
 "A thin black veil extended its ample folds over the
 tall and graceful person of the high-born maiden,
 and she bore not any female ornament of what kind
 soever" (vide "Tales of the Crusaders" p.135) 224
1826 BI Miss Wroughton: "Rebecca; from the Novel of 'Ivanhoe'" 331
1827 RA Miss Anne Beaumont: "Effie Deans, from 'Tales of my Landlord'
 by Sir Walter Scott" 78
1827 SBA Miss E.E. Kendrick: "Isabel de Croix" (vide "Quentin
 Durward") 651
1827 BI Miss Anne Beaumont: "Magnus Troil, Udaller of Zetland, with
 his daughters Minna and Brenda's visit to their kins-
 woman Norna, the Pythoness of Fitful Head" (from the
 "Pirate" by Walter Scott) 432
1828 RA Miss E.E. Kendrick: "Lady Cordelia Trevanion" (vide "Dame
 Rebecca") 742
1828 SBA Miss Anne Beaumont: "Fergus MacIver's Meeting with his
 Sister Flora, Captain Waverley etc." 17
1828 SBA Miss E.E. Kendrick: "Alice Lee" 572
1828 RA Miss Anne Beaumont: "Interview between Roland Graeme and
 Catherine Seyton" 225
1828 SBA Miss Anne Beaumont: "Meg Merrilies, holding a lamp, shows
 a dead man to Henry Bertram whom she warns not to
 enter" 134
1828 SBA Miss Anne Beaumont: "Jacqueline, Countess de Croye, present-
 ing the Cup to Maitre Pierre, or King Louis disguised"
 (vide "Quentin Durward") 447
1828 BI Miss Anne Beaumont: "Effie Deans" 25
1828 BI Miss Anne Beaumont: "The White lady guiding the Lady Avenel,
 little Mary, and their old Servants, on their way to
 Dame Glendinning's" (vide "The Monastery") 30
1828 BI Miss Anne Beaumont: "Rebecca of York's visit to the Lady
 Rowena, Bride of Ivanhoe" (vide "Ivanhoe" by Sir Walter
 Scott) 431
1829 RA Mrs Mee: "Sketch of the interview between Rebecca and Rowena"
 "'Farewell - yet, ere I go, indulge me one request.
 The bridal veil hangs over thy face, raise it and let
 me see thy features, of which fame speaks so highly'.
 'They are scarce worthy of being looked upon', said
 Rowena; 'but, expecting the same of my visitant, I
 remove the veil'. 'One, the most trifling, part of
 my duty yet remains undischarged; accept this casket -
 I will never wear jewels more'" (vide "Ivanhoe") 7111
1829 SBA Miss Anne Beaumont: "Effie Deans" 117
1829 SBA Miss Anne Beaumont: "From 'Kenilworth'. Weyland disguised as
 a Pedlar,exhibiting his essences and perfumes, arrests
 the attention of Amy, Countess of Leicester, by naming
 Queen Elizabeth's intended visit to the Earl, her
 Husband, at Kenilworth Castle. The Countess - 'Ah,
 Janet, 'tis time them'" 146
1829 SBA Miss Anne Beaumont: "David Deans at his cottage door: 'Gang
 in Deans, and we'll seek grace to preserve us frae all
 manner of profane folly'" 199
1829 SBA Miss Anne Beaumont: "Scene in the Rooms, from 'The Antiquary';
 Sir A. Wardour, Miss Wardour, Lovel, and Edie O'
 Chiltree, who perceives succour in the distance, and
 waves his signal of distress" 455
1829 SBA Miss Anne Beaumont: "Two subjects from St. Valentine's Eve,
 or the Fair Maid of Perth. no.1, Katie Glover intreat-
 ing Hector to conduct Father Clement Blair safe to
 the Highlands, takes her leave - no.2 The Duke of
 Rothsay protecting Louisa, the glee maiden etc." 474

1829 SBA Miss E.E. Kendrick: "The Lady Cordelia: vide 'Trevanion'"
645

1829 BI Miss Anne Beaumont: "The Interior of Muckebackete the fisherman's hut; Elspeth dying; Jonathan Oldbuck, Captain MacIntyre and Edie Ochiltree" 323

b) Other prose sources:-

1820 BI Mrs Ansley: "Mary Mortimer"
"The fishermen found her body, floating near the cavern, which in happier hours, had been endeared to her in consequence of her deliverance in the hour of peril, by him whom she had so long loved, but whose fatal jealousy had bereft her of her senses" (Cornish Tales) 217

1824 RA Mrs Ansley: "Queen Elizabeth giving the ring to the Earl of Essex"
"Depend, my lord, on this; 'twixt you and me This ring shall be a private mark of faith inviolate" ("Tragedy of the Earl of Essex") 35

1826 SBA Miss H. Gouldsmith: "The Vicar of Wakefield, a composition in the manner of Hobbema" 287

1826 BI Miss Anne Beaumont: "Elizabeth, from the 'Exile of Siberia' by Mme. de Cottin"
"At the tomb of the Missionary she returns thanks to Heaven for the blessings which had attended the beginning of her journey; and, though not left without a guide, looks forward with cheerful hope to the full success of her undertaking" 231
(The artist exhibited a work with the same title at the Society of British Artists in 1827 (no.421))

1828 BI Mrs Henderson: "Miranda" 480

c) Poetic sources:-

1821 RA Miss E.E. Kendrick: "Gulnare on her way to the chamber of the Pacha to stab him" (From "The Corsair" of Lord Byron) 778

1825 BI Miss H. Gouldsmith: "Landscape (composition)"
"She with her widow'd mother, feeble, old, And poor, liv'd in a cottage, far retir'd, Among the windings of a woody vale" 257

1825 RA Eliza Jones: "O'Connor's child"
"Why wanders she a huntress wild, O'Connor's pale and lovely child?

. . . .

Placed in foxglove and the moss, Behold a parted various cross! That is the spot where evermore, The lady at her shieling door, Enjoys that in communion sweet, The living and the dead can meet, For lo! to lovelorn fantasy, The hero of her heart is nigh" Vide Campbell's Poem of O'Connor's child, or "The Flower of Love Lies Bleeding" 464

1826 BI Mrs J. Browning (late Miss H.A.E. Jackson): "The Sleeping Magdalen"
"Soft! She sleeps! And even now, she dreams of Penitence, And sweet forgiveness of her erring youth. 'Then wake her not!' Thus spoke the watchful cherub, as he chid The arch design of the insid'ous boy" 294

1827 RA Miss E.E. Kendrick: "Olympia" (vide "The Tale of the Rose
in the Golden Violet" by L.E.L.) 775 (Letitia
Elizabeth Landon)

1827 RA Miss Sharpe: "Belinda"
"The busy sylphs surround her darling care;
These set the head, and those divide the hair:
Some fold the sleeve, while others plait the gown;
And Betty's praised for labour not her own" 678

Q1. 1830 RA Miss Anne Beaumont: "Interior of a chapel, Sir Kenneth
kneeling; a procession of ladies, nuns and Roger"
("The Talisman": from "Tales of the Crusaders") 236

1830 RA Miss Anne Beaumont: "Ellen Douglas and James Fitzjames"
(Lady of the Lake") 544

1830 RA Mrs Mee: "Rebecca in the Turret" (See Sir Walter Scott's
"Ivanhoe") 500

1830 SBA Miss Anne Beaumont: "Interior of the Baron de Lacy's Tent"
("Tales of the Crusaders") 396

1830 BI Miss Anne Beaumont: "Sir H. Lee blessing Charles II"
"Before the King quitted Woodstock, to seek refuge
in Joceline's Hall, from Cromwell and his party,
attended by Alice Lee - Col. Lee, disguised as a
page" ("Woodstock") 142

1830 BI Miss Anne Beaumont: "Scene in Switzerland. The Landamman,
the Earl of Oxford, and Anne, with the Bow of
Buttischolz" (from "Anne of Geierstein" by Sir Walter
Scott) 355

1831 SBA Miss Fanny Corbaux: "Rebecca in the Turret" (vide "Ivanhoe")
742

1831 OWS Miss Louisa Sharpe: "Jenny Deans imploring Queen Caroline to
save her sister's life" (Vide "Heart of Midlothian")
181

1831 OWS Miss Louisa Sharpe: "Rebecca at her Evening Devotions in the
Preceptory of Templestowe" ("Ivanhoe") 279

1832 NSPW Miss Fanny Corbaux: "Lady Rowena" (vide "Ivanhoe") 299*

1832 BI Miss Cook: "Sir Edward Waverley"
"Lawyer Clippurse found his Patron involved in a deep
study.. The pen was mended in vain" (vide "Waverley"
vol. 1, ch. 2) 151

1832 BI Miss M.A. Alabaster: "The Interior of the Turret Chamber"
(vide "Quentin Durward") 456

1833 SBA Miss L. Adams: "Alice Lee" (vide "Woodstock") 651

1833 BI Lady Burghersh: "Isaac of York conducting his Daughter to
the Gallery from which to view the Tournament"
"Rebecca, terrified by the tumult, clung close to
her aged father" 150

1834 BI Mrs J. Browning: "The Lady of the Lake" 425

1834 NSPW Miss Sarah Setchel: "Jeanie Deans and her sister"
"Jeanie took that moment of affectionate sympathy,
to press upon her sister the necessity of the utmost
caution in her conduct at Edinburgh" (vide "The
Heart of Midlothian") 28

1834 NSPW Miss Dutton: "Rose Bradwardine" 252

1834 NSPW Miss Jacques: "The Page's first interview with Katherine"
(vide "The Abbot") 358

1835 SBA Miss Mary Ann Sharpe: "Jenny Denison" (vide "Old Mortality")
747

1837 SBA Mrs Fanny McIan: "The Escape of Alaster Macdonald, with his
wife and child from the soldiers of Lieutenant-
Colonel Hamilton, the morning after the Massacre of
Glencoe" (for the quotation see vol.1 p123, note 22) 417

1839 SBA Miss S.E. Thorn: "The Fair Maid of Perth and her Father
 accosted by the Prince on their way to Mass at the
 Blackfriars Monastery" (see "The Fair Maid of Perth"
 ch.2) 428

1839 SBA Miss S.E. Thorn: "Harold discovering himself to Henry the
 First" 507

R1.a) Byron:-
 1830 RA Miss Heaphy: "Bianca" 908
 "In Venice Tasso's echoes are no more,
 And silent now the songless gondolier,
 Her palaces are crumbling to the shore,
 And music meets not always now the year:
 Those days are gone - but beauty still is here"
 Vide "Child Harold", Canto iv 908

 1830 SBA Miss E.E. Kendrick: "Medora watching for the Corsair's Sail"
 600

 1831 OWS Miss Louisa Sharpe: "No: gayer insects fluttering by
 Ne'er droop the wing o'er those that die;
 And lovelier things have mercy shown
 To every failing but their own;
 And every wo a tear can claim
 Except an erring sister's shame" (Lord Byron's
 "Giaour") 327
 (for a description of this work see vol.1 p. 261)

 1833 SBA Miss Fanny Corbaux: "Gulnare"
 - "The wildness of her eye
 Starts from the day abrupt and fearfully -
 She stopp'd - threw back her dark far-floating hair
 Upon her brown, unknown, forgot.
 Her hurrying hand had left - 'twas but a spot -
 Its hue was all he saw!" 328

 1833 RA Mrs Battersby: "The Maid of Athens - a study" 843
 1835 RA Miss E.E. Kendrick: "Medora" 743
 1836 Fanny Corbaux illustrated Finden's "Byron's Beauties" (Charles
 Tilth) with nine illustrations: Olympia, Marion, Mora, Leila,
 Gulnare, Caroline, Lesbia, Genevra, Haidee)

 1837 SBA Miss Margaret Gillies: "Portrait of Miss Ellen Tree, as
 Myrrha, in Sardanapulus"
 Myrrha: "I've lit the lamp which lights us to the
 stars" 789

 1839 BI Miss Fanny Corbaux: "Genevra - vide Lord Byron" 365

 b) Oliver Goldsmith:-
 1830 OWS Miss Louisa Sharpe: "Scene in the 'Vicar of Wakefield'"
 "My wife, therefore, was resolved that we should not
 be deprived of such advantages for want of assurance,
 and undertook to harangue for the family. 'I hope',
 cried she, 'your ladyships will pardon my present
 presumption. It is true, we have no right to pre-
 tend to such favours; but yet it is natural for me
 to wish putting my children forward in the world.
 And I will be bold to say my two girls have had a
 pretty good education and capacity; at least the
 country can't shew better. They can read, write, and
 cast accounts; they understand their needle, broad-
 stitch, cross and change, and all manner of plain
 work; they can pink, point, and frill, and know
 something of music; they can do up small clothes;
 work upon catgut, my eldest can cut paper, and my
 youngest has a pretty manner of telling fortunes
 upon the cards' - Fudge!

When she had delivered this pretty piece of elo-
quence the two ladies looked at each other in silence,
with an air of doubt and importance. At last, Miss
Carolina Wilhelmina Amelia Skeggs condescended to
observe, that the young ladies, from the opinion she
could form of them from so slight an acquaintance,
seemed very fit for such employments: 'But a thing
of this kind, madam', cried she, addressing my spouse,
'requires a thorough examination into characters, and
a more perfect knowledge of each other. 'Not,
madam,' continued she, 'that I in the least suspect
the young ladies' virtue, prudence, and discretion;
but there is a form in these things, madam, there is
a form' - Fudge!" 211

1833 OWS Miss Eliza Sharpe: "An episode in the 'Vicar of Wakefield'"
"Just as he spoke they came in, and approaching the
bed where I lay, after previously informing me of
their employment and business, made me their prisoner,
bidding me to prepare to go with them to the county
jail which was eleven miles off.
 I entreated them to be expeditious, and desired
my son to assist his eldest sister, who, from a con-
sciousness that she was the cause of our calamities,
was fallen, and had lost anguish in insensibility. I
encouraged my wife, who, pale and trembling, clasped
our affrighted little ones in her arms, that clung
to her bosom in silence, dreading to look at the
strangers" - "Vicar of Wakefield" 115

1833 SBA Mrs Pierce (late Miss Anne Beaumont): "Squire Thornhill's
first interview with the Vicar of Wakefield's
family" 430

1834 BI Mrs Pierce: "Subject from 'The Vicar of Wakefield'" 45

c) Thomas Moore:-
1831 RA Miss Heaphy: "Hinda" (vide "Lalla Rookh") 725
1831 BI Miss Anne Beaumont: "Nourmahal; the light of the Harem"
("Lalla Rookh") 53
1832 SBA Miss E.E. Kendrick: "Nourmahal"
"'Till rapt she dwells on every string,
And pours again each sound along,
Like Echo, lost and languishing,
In love with her own wondrous song" (see "Light of
the Harem ", "Lalla Rookh") 706
1834 NSPW Miss E.E. Kendrick: "Hinda: 'Farewell, and blessings on thy
way'" 273
1834 SBA Mrs Battersby: "Light of the Harem " 579
1834 SBA Mrs Battersby: "Maid of Selma" 612
1835 OWS Mrs Seyffarth (late Miss Louisa Sharpe): "Here, while as
usual the Princess sat listening anxiously, with
Fadladeen in one of his loftiest moods of criticism
by her side, the young poet, leaning against a branch
of the tree, thus continued his story" ("Lalla
Rookh") 24
1836 BI Miss Fanny Corbaux: "Namouna, the Enchantress, twining the
'magic wreath of dreams' for Nourmahal" - Moore's
"Lalla Rookh" 124
1837 Fanny Corbaux designed the illustrations for Thomas Moore's
"Pearls of the East or Beauties from 'Lalla Rookh'" (they were
drawn on stone by Louisa Corbaux)
1838 SBA Miss Fanny Corbaux: "The Hindoo Girl watching her lamp" (vide
"Lalla Rookh") 564

S1. This work was first published by Saunders and Otley and ran through
several editions in the nineteenth century.
The following is a list of works depicting characters and scenes from
Shakespeare:-

1830 BI Miss Fanny Corbaux: "Titania and the Indian Boy" 496
1831 BI Miss M.A. Alabaster: "Lucentio, Hortensia and Bianca" ("The
 Taming of the Shrew") 367
1831 SBA Miss L. Adams: "Ophelia" (vide "Hamlet") 552
1831 SBA Miss L. Adams: "Twelfth Night" Act 2, scene 5 604
1831 SBA Miss Fanny Corbaux: "The Shrew"
 "B. 'Nay, then you jest, and now I well perceive you
 have but jested with me all this while. I pry-
 thee, sister Kate, untie my hands'
 Kath.'If that were jest, then all the rest were so -
 (striking her)'" ("Taming of the Shrew" Act 2,
 scene 1) 572
1831 SBA Miss Fanny Corbaux: "Juliet" 709
1832 SBA Miss L. Adams: "Olivia, from Shakespeare's 'Twelfth Night'"
 "Viola: 'Good Madam, let me see your face'
 Olivia: Is't not well done?' (Unveiling)" Act.1,
 scene 9 676
1833 SBA Miss Bartram: "Juliet"
 "Juliet, - 'Ah me!'" 566
1833 OWS Miss Eliza Sharpe: "Cleopatra" 390
1833 OWS Miss Eliza Sharpe: "Portia and Nerissa" 419
1836 SBA Miss Fanny Corbaux: "Miranda - Shakespeare Gallery no.1
 'The Tempest'" 771
1836 SBA Miss J. Jacques: "Scene from 'Twelfth Night'" 844
1837 NSPW Miss Fanny Corbaux: "Cordelia"
 "Patience and sorrow strove
 Which should express her goodliest - you have seen
 Sunshine and rain at once" ("King Lear") 34
1837 NSPW Miss Fanny Corbaux: "Beatrice: 'I wonder you will still go
 on talking, Signor Benedick, nobody marks you!'" 249
1838 BI Miss Fanny Corbaux: "We still have slept together,
 Rose at an instant, learn'd, play'd, sat together;
 And wheresoe'er we went, like Juno's swans,
 Still we went coupled and inseparable" ("As you Like
 It") 155
1839 BI Mrs Criddle (late Mary Ann Alabaster): "Lady Macbeth"
 "Hark! I laid their daggers ready- he could not miss
 them" 398
1839 SBA Miss Fanny Corbaux:
 "(Enter Beatrice, running towards the Arbour)
 'For look where Beatrice, like a lapwing, runs
 Close by the ground, to hear our conference'.
 Ursula: 'The pleasantest angling is to see the fish
 Cut with her golden oars the silver stream,
 And greedily devour the treacherous bait:
 So angle we for Beatrice, who even now
 Lies couched in the woodbine coverture.
 Fear you not my part of the dialogue'.
 Hen: 'Then go we near her, that her ear lose nothing
 Of the false sweet bait that we lay for it'"
 ("Much Ado About Nothing") 505
1839 SBA Miss Margaret Gillies: "Lady Macbeth reading the letter" 149
1839 SBA Sarah Setchel: "Scene from 'Taming the Shrew'"
 "Bianca: 'Now let me see if I can construe it:
 hacibat simois, I know not; his est sigeia tellus, I
 trust you not; his steterat priami, take heed he hear
 us not; regia, presume not; celsa senis, despair not'"
 1605

T1. 1830 RA Mrs. Henderson : "The Lady in Milton's 'Comus'"
 "This way the noise was, if mine ear be true"358

 1830 RA Miss E.E Kendrick : "Erminia" (vide Tasso's "Jerusalem
 Delivered") 831 (she exhibited a work with the same
 title in 1831 (SBA no.699))

 1830 SBA Miss Fanny Corbaux : "The Panther ; a scene from Cooper's
 'Pioneers'" 756

 1830 OWS Miss Eliza Sharpe : "Child on the Cliff"
 "While on the cliff with calm delight she kneels,
 And the blue vales a thousand joys recall,
 See, to the last, last verge her infant steals !
 O fly, yet stir not, speak not, lest it fall.
 Far better taught, she lays her bosom bare,
 And the fond boy springs back to nestle there"
 Rogers' Poems 6

 1831 BI Miss E. Drummond : "Claudia in Rienzi" 56

 1831 BI Mrs. Henderson : "Lady Ann Bothwell from an old Scotch
 Ballad" 253

 1831 OWS Miss Eliza Sharpe : "Belinda" (from Pope's "Rape of
 the Lock" Cantos I and II) 3

 1832 NSPW Miss Fanny Corbaux : "Belinda at her Toilet" 302

 1832 SBA Miss Anne Beaumont : "The noble Polish Girl, Elizabeth,
 Daughter of Stanislaus Sobieski, giving her last
 piece of money, a Rouble, to relieve the Exile she
 meets at the Hut, on her Journey to St. Peters-
 burgh to petition Alexander to pardon her Father" -
 ("Exiles of Siberia") 244 Mme de Cottin

 1832 OWS Miss Louisa Sharpe : "Brunetta was now prepared for the
 insult, and came to the public ball in a plain
 silk mantua, attended by a beautiful negro girl
 in a petticoat of the same brocade with which
 Phyllis was attired. This drew the attention of the
 whole company, upon which the unhappy Phyllis
 swooned away" ("Spectator" vol.1,no.80) 224

 1832 OWS Miss Eliza Sharpe : "The Widow"
 Lord William woos with jewels rare
 Thy lovely Ann his bride to be ;
 But round my neck I'll link and wear
 Chains of the tears I shed for thee ;
 And aye thy widowed love will be" (Old Ballad) 369

 1833 OWS Miss Louisa Sharpe : "I mean to appeal to you, whether it
 is reasonable that such a creature as this shall come
 from a jaunty part of the town, and give herself
 such violent airs, to the disturbance of an innocent
 and inoffensive congregation with her sublimities:
 I with several others of the inhabitants followed
 her out, and saw her hold up her fan to a hackney
 coach at a distance, which immediately came up to her,
 and she whipping into it with a great nimbleness,
 pulled the door with a bowing mien, as if she had been
 used to a better class. By this time the best of the
 congregation was at the church door; and I could hear
 some say, 'A very fine lady !' others,'I'll warrant
 you she's no better than she should be'; and one very
 wise old lady said, 'She ought to have been taken
 up'" (vide "Spectator" no. 503) 79

 1834 RA Mrs. Mee : "The recording angel" (vide Sterne) 596

 1834 RA Miss H. Gouldsmith : "Dorothea surprised by the curate,
 Cardenio and the Barber: 'at the stir they made in
 advancing, the beauteous phantom raised her head, and
 parting her locks with both hands to see what occas-
 sioned the noise'" - Don Quixote 890
 (The artist exhibited a work with the same title at

the British Institution in 1835 no. 439)

1834 RA Mrs Turnbull: "Portrait of Miss Ellen Tree, as Mariana, in
Sheridan Knowles Play of 'The Wife'"
"It's strange! at thought of my dear Lord
My soaring heart hath dropped at once to earth"
(Act 4, sc. 2) 724

1834 SBA Miss C. Watson: "Palemon and Lavinia" (Thomson's "Seasons"
(Autumn))
"And art thou, then, Acasto's dear remains? -
She, whom my restless gratitude has sought
So long in vain? - O heavens! the very same;
The softened image of my noble friend,
Alive his very look, his very frame
More elegantly touch'd" 587

1835 BI Miss Salaman: "Louisa"
"Oft would she pensive stroll 'neath perfumed bowers
Herself the loveliest 'mid a world of flowers,
To list the linnet's soft mellifluous song,
Ere yet she joined the gay and glitt'ring throng" 270

1837 OWS Mrs Seyffarth (late Miss Louisa Sharpe): "An Evening in
Miss Stewart's Apartments"
"'Do not -', replied the Chevalier de Grammont: 'but
tell me what put it into your head to form a design
upon that inanimate statue, Miss Stewart?' - 'How -',
said Hamilton: 'you are acquainted with all her child-
ish amusements. The old Lord Carlingford was at her
apartment one evening, shewing her how to hold a
lighted wax candle in her mouth, and the grand secret
consisted in keeping the burning end there a long
time without its being extinguished. I have, thank
God, a pretty large mouth, and, in order to outdo her
teacher, I took two candles into my mouth at the same
time, and walked three times round the room, without
their going out. Every person present adjudged me the
prize of this illustrious experiment, and Killegrew
maintained, that nothing but a lanthorn could stand
in competition with me'" ("Memoirs of Count Grammont",
London 1811, vol.2, ch.11, p.277) 191

1837 OWS Miss Eliza Sharpe: "'Myself! O madam, I was not wishing for
bracelets, I was only thinking that' - 'That what?'
'That it is a pity you are so very rich; you have
everything in this world that you want, and I can
never be of the least use to you; - and what signifies
the gratitude of such a poor little creature as I am?'
- 'Did you never hear the fable of the lion and the
mouse, Victoire?' - 'No madam, - never!' -'Then I will
tell it to you'"("Madame de Fleury" by Maria Edgeworth)
212

1837 SBA Mrs Mannin: "Mary Queen of Scots" (with a quotation from
Leigh Cliffe for which see L) 769

1837 BI Miss Fanny Corbaux: "I gang like a ghaist, and I care na much
to spin"
I dare na think o' Jamie, for that wad be a sin;
But I will do my best a gude wife to be,
For Auld Robin Gray. Oh! he is sae kind to me" 419

1837 NSPW Miss Fanny Corbaux:
 "Will Honeycomb diverted us last night with an account
 of a young fellow's first discovering his passion to
 his mistress. The young lady was one, it seems, who
 had long before conceived a favourable opinion of him,
 and was still in hopes that he would some time or other
 make his advances. As he was one day talking to her
 in company with her two sisters, the conversation
 happening to turn upon love, each of the young ladies
 was, by way of raillery, recommending a wife to him;
 when to the no small surprise of her who secretly pre-
 ferred him, he told them that his heart had long been
 engaged to one whose name he thought himself obliged
 in honour to conceal, but that he could shew her pic-
 ture on the lid of his snuff-box.
 The lady who found herself the most sensibly
 touched by this confession took the first opportunity
 of snatching the snuff-box out of his hand * * *
 upon carrying it to the window, she was very agreeably
 surprised to find there was nothing on the lid but a
 looking-glass, in which, after she had viewed her own
 face with more pleasure than she had ever done before,
 she returned the box with a smile, telling him, she
 could not but approve his choice" - Vide "Spectator"
 No. 325 131

1838 OWS Mrs Seyffarth: "Gemile"
 "So nur hall zum Orientalen umgekleidet trat
 'Andronikos' seinem Bruder 'Hassan' entgegen, der...
 ihn nun zu 'Gemile's' Gemoohern führte. Am Ende der
 Galerie durch eine hohe, geöffnete Flugelthur begegnete
 sein Auge der Reizenden Gemile, der Gemahlin seines
 Bruders" ("Andronikos" von Seyffarth T.1 Seite 47) 52

1838 OWS Mrs Seyffarth: "The Tourney"
 "It was evident to the spectators that a few more
 blows would now decide the conflict, and their interest
 rose in proportion. Not a breath was drawn. Esclair-
 monde leaned over the balcony, with a look as if her
 own life hung upon that of her lover (Crichton); nor
 would Catherine de Medicis, whose cause was leagued
 with that of the opposite party, control her anxiety.
 At this moment - 'I would give my soul to perdition',
 said the Queen of Navarre (Marguerite de Valois) 'to
 see the poignard of Gonzago pierce the heart of his
 enemy'" ("Crichton" by Ainsworth, vol.2, p.100) 99

1838 OWS Mrs Seyffarth: "The New Page"
 "He has always been kind to his little brother and
 sister, and I trust he will be as true to your Lord-
 ship as his father was, my poor husband" ("Blackwood's
 Magazine") 152

1838 BI Mrs Carpenter: "The Children gathering shells upon the
 shore" - (vide Rogers' "Italy") 47

1838 SBA Miss Fanny Corbaux: "The Captive"
 "Sadly the Captive o'er the flowers is bending,
 While her soft eye with sudden sorrow fills,
 They are not those that grew beneath her tending
 In the green valley of her native hills.

 There is the violet - not from the meadow
 Where wandered carelessly her childish feet;
 There is the rose - it grew not in the shadow
 Of her old home - it cannot be so sweet.

What are the glittering trifles that surround her?
What the rich shawl - and what the golden chain?
Would she could break the fetters that have bound her,
And see her household and her hills again!"
(L.E.L.) 351

1839 SBA Mrs Criddle: "The early days of Mary Queen of Scots" (with
a poetical quotation for which see L) 280

1839 OWS Mrs Seyffarth: "The Sisters"
"Wrapt in such thoughts, she feels her mind astray,
But knows, 'tis true, that she has lost her way;
For Lucy's smile will check the sudden flight,
And one kind look let in the wonted light"
(Crabbe's "Tales of the Hall") 5

1839 BI Miss Fanny Corbaux: "The Ionian Captive"
"What are the glittering trifles that surround her -
What the rich shawl, and what the golden chain?
Would she could break the fetters that have bound her,
And see her household and her hills again!"
Poem by L.E.L. 97

U1. 1830 SBA Miss E.F. Dagley: "Infant Visions"
"Some admiring what motives to mirth Infants meet
with in their silent and solitary smiles, have
resolved, how true I know not, that they converse with
angels, as indeed such cannot find fitter companions"
(Fuller) 246

1831 BI Mrs James Hakewill: "In peace love tunes the Shepherd's reed"
(Scott) 28
(The artist exhibited a work with the same title at
the Society of British Artists in 1832 no.162)

1832 SBA Miss Kearsley: "Hark, they whisper, Angels say,
Sister spirit come away..
The world recedes, it disappears;
Heaven opens on my eyes; my ears
With sounds seraphic ring" (Pope's"Dying Christian
to the Soul") 417

1832 BI Miss Anne Beaumont:"Sleep" "Balmy Sleep
Swift on his downy pinion flies from Woe
And lights on lids, unsullied with a tear" 63

1832 BI Miss Fanny Corbaux: "The Victim Bride"
"They speak her name - she starts - the dream is past!
Shuddering she hears again the stern command,
And the lov'd portrait leaves her trembling hand;
Each line his fondness trac'd - each treasur'd token-
She gives up all!" (The Hon. Mrs Norton) 163

1832 NSPW Mrs E.C. Wood: "The Sketch"
"The line she traced with fond precision true,
And drawing doted on the form she drew" - Hayley 80

1832 NSPW Mrs E.C. Wood: "With rapt ear drinks the enchanting serenade,
And, as it melts along the moonlight glade,
To each soft note returns as soft a sigh" - Rogers 139

1833 BI Miss H. Gouldsmith: "Not solitude"
"This is not solitude - 'tis but to hold
Converse with nature's charms, and view her stones
unroll'd" 309

1834 BI Mrs C. Pearson: "In Meditation wrapt
And thoughts of Love" 139

1834 RA Miss M. Pickersgill: "The Votaress"
 "'Tis not the missal's page or holy shrine,
 Alone can charm the youthful votaress' eye;
 Oh! there are thoughts than e'en from things divine
 Will steal the stricken heart, awake its sigh" 457

1834 SBA Miss L. Adams: "The Young Poetess" 734
 (the quotation is given in vol.1 p 137)

1835 OWS Mrs Seyffarth: "The Good Offer"
 "O what a plague is an obstinate daughter!" (Old
 Song) 241
 ("Where an angry mama is upbraiding an obstinate
 daughter for not receiving favourably an unwelcome
 proposal of marriage" ("Spectator 1835, May 2nd.
 no.357, p.425))

1835 SBA Miss Fanny Corbaux: "Nessum maggior delore che recordarsi
 del tempo felice" 86

1836 SBA Miss L. Adams: "Dolce far Niente"
 "No, no! it is not idleness! the eyes,
 Soft, dewy, beautiful - give meaning out -
 Some speculation, or some arch surmise,
 Some playful project, or some girlish doubt.
 The smile speaks quiet mirth, and no disguise.
 And n'er such language be those lips without;
 Still may they wear this frank and joyous light;
 When time has written woman on that forehead white"
 (Lucy Adams) 600

1836 SBA Miss Kearsley: "The Young Mother"
 "Heureux enfant, que je t'envie
 Ton innocence et ton bonheur!
 Ah! garde bien toute ta vie,
 La paix qui règne dans ton coeur" (Bergin) 450

1836 SBA Mrs W. Pierce (late Miss Anne Beaumont): "Retirement"
 "Sweet are the charms in thee we find" 465

1837 SBA Miss Kearsley:
 "She faded gently from the sight, as flowers
 Wither ere summer closes; - day by day,
 As melts the rainbow after sultry showers,
 Within the arch of Heaven - she sank away.
 Pale, pure, and lovely - like the snow that lies
 Upon the mountain's breast, and in the sunbeam dies"
 143

1837 SBA Miss Harriet Tucker: "La Jeune Veuve, or the Young Widow"
 (the quotation is given in vol.1 p137) 450

1837 NSPW Mrs Harrison: "Weeds" "Above,
 Circling with blushing wreaths the blighted oak,
 The woodbine drops its odours on the breeze,
 So doth affection gather strength from time
 And smiles from age and sorrow" 134

1838 NSPW Mrs Harrison: "Cottage Garden" "So fair each morn, so full
 of grace,
 Within their little garden reared,
 The flower of Phoebus turned her face
 To meet the power she loved and feared" (Langhorne)35

1838 NSPW Mrs Harrison: "Love in Idleness" "Yet mark'd
 Where the bolt of Cupid fell:
 It fell upon a little western flower,
 Before milk-white; now purple with love's word,
 And maidens call it love in idleness"
 ("Midsummer Night's Dream") 86

1838 NSPW Fanny Corbaux: "The Student"
"In nobil sangue vita umile e queta
Ea in alto intelletto un puro core;
Frutto senile in sul piovenil fiore,
E'n aspetto pensoso, anima ieta (Petrarcn) 168

1839 SBA Miss Oram: "O lady fair! where art thou roaming?" 294

1839 NSPW Mrs Harrison: "Tulip and Myrtle"
"'Twas on the border of a stream
A gaily painted tulip stood,
And gilded in the morning beam
Surveyed her beauties in the flood.

And sure more lovely to behold,
Might nothing meet the wistful eye,
Than crimson fading into gold
In streaks of fairest symmetry"
(vide Langhorne's "Fables of Flora") 110

V1. Shakespeare:-

1840 SBA Mrs Criddle: "Lady Macbeth listening during the murder of
Duncan" 424

1840 SBA Miss E. Wallace: "Hamlet and Ophelia"
"He took me by the wrist and held me hard"
("Hamlet" Act. 2, scene 1) 366

1840 BI Mrs Criddle: "The Banquet Scene in Macbeth" Act 3, scene 4.436

1841 RA Miss S. Hubert: "Desdemona" 55

1841 BI Miss Fanny Corbaux: "Beatrice in the Arbour"
"Ursula: 'She's lim'd, I warrant you; we have caught
her Madam'
Hero: 'If it prove so then loving goes by haps;
Some Cupid kills with arrows, some with traps'"
("Much Ado About Nothing") 30

1842 NSPW Miss Fanny Corbaux: "Scene from 'Romeo and Juliet'"
"Friar Laurence: * * *'Take thou this phial
And this distilled liquor drink thou off,
When presently through all thy veins shall run
A cold and drowsy humour, which shall seize
Each vital spirit; for no pulse shall keep
His natural progress, but surcease to beat.
And in this borrow'd likeness of shrunk death
Thou shalt continue two-and-forty hours,
And then awake, as from a pleasant sleep.
In thy best robes, uncovered on the bier
Thou shalt be borne to that same ancient vault
Where all the kindred of the Capulets lie.
In the mean time, against thou shalt awake
Shall Romeo by my letters know our drift;
And hither shall he come; and he and I
Will watch thy waking - and that very night
Shall Romeo bear thee hence to Mantua;
And this shall free thee. '

Act V. Scene 4 - Interior of the Monument.
Friar Laurence: 'Alack! Alack! what blood is this,
which stains
The stony entrance of this sepulchre?
What mean these masterless and gory swords
To lie discoloured by this place of peace?
Romeo! oh! pale! - Who else? what, Paris too?
And steep'd in blood? Ah! what an unkind hour
Is guilty of this lamentable chance?..'.
The lady stirs..." (Juliet awakes)

Juliet: 'Oh, comfortable Friar, where is my Lord?
I do remember well where I should be,
And there I am - Where is my Romeo?'
Fri.Laur: 'I hear some noise - Lady, come from that
 nest
Of death, contagion, and unnatural sleep;
A greater power than we can contradict
Hath thwarted our intents. Come - come away -
Thy husband in thy bosom there lies dead ...
And Paris too! -'" 110

1843 RA Ambrosini Jerome: "Sir John Falstaff and Mrs Ford"
"Falstaff: 'Have I caught thee my heavenly jewel!
Why now let me die, for I have lived long enough,
this is the period of my ambition. Oh! this blessed
hour'
Mrs Ford: 'Oh! sweet Sir John!'"
(vide "Merry Wives of Windsor") 1324
(the artist exhibited a work with the same title in
1844 at the British Institution - no.191)

1844 BI Mrs Carpenter: "Cleopatra" 13
1846 RA Miss M.A. Cole: "Romeo and Juliet" 378
1848 SBA Miss J. Sutherland: "Imogen"
"From Faires and the Tempters of the night,
Guard me, beseech ye.
To your protection, I commend me, Gods"
(Shakespeare's "Cymbeline") 364

1848 BI Miss M. Jones: "The Clemency of Leonatus - vide 'Cymbeline'
last act" 106

1848 BI Miss J. Sutherland: "Rosalind and Celia deliberating on the
means of quitting the Court of the Usurping Duke"
"Celia: 'O my poor Rosalind! whither wilt thou go?
Wilt thou change fathers? I will give thee mine.
I charge thee, be not more griev'd than I am'
Rosalind: 'I have more cause'"
("As You Like It") 249

1848 RA Mrs Carpenter: "Portia: 'I could teach you/How to choose
right'" ("Merchant of Venice" Act 3, sc.2) 1054

1849 NSPW Fanny Corbaux: "Perdita"
"This is the prettiest low-born lass that ever
Ran on the green-sord; nothing she does, or seems,
But smacks of something greater than herself,
Too noble for this place" - ("Winter's Tale") 383

Sir Walter Scott:-
1840 RA Mrs Henderson: "Pekuah waiting for her ransom"
"She was weary of expectation" 391
1840 OWS Mrs Seyffarth: "From the Abbot" ("The Abbot" vol.3, ch.5) 227
1843 SBA Mrs Criddle: "Interior of the Turret Chamber" 294
1843 SBA Miss M.H. Johnson: "Jeanie Deans going to Muscat's Cairn" 600
1843 SBA Miss Clater: "And when I place it in my hair,
Allan, a bard, is bound to swear,
He ne'er saw coronet so fair.
Then playfully the chaplet wild
She wreathed in her dark locks, and smil'd" (vide
Scott's "Lady of the Lake" canto second) 692
1843 SBA Miss C. Farrier: "Lucy Ashton - vide 'The Bride of Lammer-
moor'" 720
1844 SBA Miss C. Smith: "Rebecca, and Isaac of York" 656

1845 SBA Miss M. Johnson: "The interview between Effie and Jeanie
Deans after the Condemnation"
"'What signifies coming to greet ower me', said poor
Effie, 'when you have killed me? - Killed me when a
word of your mouth would have saved me'" 708

1847 RA Miss E. Macirone: "Effie" 708

1847 BI Mrs J. Robertson: "The Meeting of Amy Robsart and the Earl
of Leicester at Cumnor Place - vide 'Kenilworth',
chapter 7" 378

1849 SBA Miss M. Johnson: "Effie and Jeanie Deans"
"She looked at her with a sly air, in which there was
something like irony, as she chaunted in a low but
marked tone, a scrap of an old Scotch song" (vide
Scott's "Heart of Midlothian") 566

1849 SBA Miss Johnson: "So saying, he took hold of the supposed
page's cloak, and, not without some gentle degree of
violence, led into the middle of the apartment the
disguised fair one, who in vain attempted to so cover
her face, first with her mantle, afterwards with her
hands; both which impediments Master Heriot removed
something unceremoniously, and gave to view the
detected daughter of the old chronologist, his own
fair god-daughter, Margaret Ramsay" 632

1849 BI Miss Jessie Macleod: "The Interior of the Fisher's Cottage"
"The body was laid in its coffin, within the wooden
bedstead which the young fisher had occupied while
alive. At a little distance was the Father, whose
rugged weather-beaten countenance had faced many a
stormy night and night-like day. In another corner
of the cottage, her face covered by her apron, which
was flung over it, sat the mother. Two of her gossips
officiously whispering into her ear the commonplace
topic of resignation, seemed as if they were endeavour-
ing to stem the grief which they could not console.
But the figure of the old Grandmother was the most
remarkable of the sorrowing gossips" (vide "The
Antiquary") 206

Charles Dickens:-

1840 RA Miss L. Adams: "Oliver Twist left a prisoner at large in
the Jew's house"645

1841 RA Mrs Fanny McIan: "The little sick scholar"
"He was a very young boy, quite a little child. His
hair still hung in curls about his face, and his eyes
were very bright, but their light was of heaven, not
earth. The schoolmaster took a seat beside him, and
stooping over the pillow, whispered his name. The boy
sprung up, stroked his face with his hands, and threw
his wasted arms around his neck, crying out that he
was his dear kind friend. 'I hope I always was, I
meant to be, God knows', said the poor schoolmaster -
'Who is that?' said the boy, seeing Nell. 'I am afraid
to kiss her, lest I should make her ill. Ask her to
shake hands with me'. The sobbing child came closer
up, and took the little languid hand in hers"
Vide "Master Humphrey's Clock" 79

1842 SBA Miss C. Cawse: "Barnaby Rudge" (vide "Master Humphrey's
Clock") 459

1842 RA Mrs Fanny McIan: "Nell and the Widow" ("Master Humphrey's
Clock") 1260

1843 SBA Miss S.E. Thorn: "Dolly Varden" 349
1843 SBA Miss J. Joy: "Little Nell and her Grandfather" 559
1843 SBA Miss J. Blackmore: "Dolly, dressing for the Ball" 639
1844 OWS Eliza Sharpe: "Little Nell showing the Old Church to
 Visitors"
 "And those who came, speaking to others of the child,
 sent more; so that they had visitors almost daily.
 The old man would follow them at a little distance
 through the building, listening to the voice he loved
 so well; and when the strangers left, and parted
 from Nell, he would mingle with them to catch up
 fragments of their conversation; or he would stand
 for the same purpose, with his grey head uncovered,
 at the gate, as they passed through. They always
 praised the child, her sense and beauty, and he was
 proud to hear them! But what was that, so often
 added, which wrung his heart, and made him sob and
 weep alone in some dull corner? Alas! even care-
 less strangers, they who would go away and forget
 next week that such a being lived, even they pitied
 her, even they bade him good day compassionately, and
 whispered as they passed"
 - Vide "The Old Curiosity Shop", by Boz 86
1844 BI Miss J. Joy: "Dolly Varden dressing for the Ball"
 Vide "Barnaby Rudge" 386
1844 BI Miss Clater: "The Interview between Mr Haredale and Dolly
 Varden, at the library-door" - vide Mr. Dickens'
 "Barnaby Rudge" 691
1844 BI Miss M.A. Nichols: "Dolly Varden" 706
1845 BI Miss J. Joy: "Dolly Varden and Emily Haredale"
 "Dolly unmindful of all her provoking caprices, for-
 getful of all her conquests and inconstancy, with all
 her winning little vanities quite gone, she nestled all
 the live long day in Emma Haredale's bosom, and some-
 times calling on her dear old gray-headed father,
 sometimes on her mother, and sometimes even on her
 old home, pined slowly away like a poor bird in its
 cage" Vide Dickens' "Barnaby Rudge" 223
1846 RA Miss E. Macirone: "Nelly in the churchyard"
 "Whether it be as I believe it is or no, thought the
 child, I'll make this place my garden" ("Old
 Curiosity Shop") 747
1846 SBA Miss E. Macirone: "Little Nelly watching for her Grandfather"
 "In one of their rooms was a window looking into the
 street, where the child sat many and many a long even-
 ing, and often far into the night, alone and thought-
 ful. None are so anxious as those who watch and wish,
 and at these times mournful fancies came flocking on
 her mind, in crowds" Vide "Old Curiosity Shop" 660
1848 RA Miss E. Macirone: "Miss Sangstone" 728
1848 BI Ambrosini Jerome: "'The Garden Toilet' - vide the Sisters
 in Dickens' 'Battle of Life'" 444
1848 HPG Mrs Fanny McIan: "Little Nelly taking the little sick scholar
 by the hand" (according to a review in the "Athenaeum"
 Sept. 9 1848, no.1089, p.910; probably the same work
 as that exhibited by the artist at the Royal Academy
 in 1841. See above)
1849 BI Miss Jessie Macleod: "The employment of Oliver Twist in the
 Jew's House"
 "For many days Oliver remained in the Jew's room, pick-
 ing the marks out of the pocket-handkerchiefs" 501

George Crabbe:-
1842 NSPW Sarah Setchel: "life fought with love, both powerful and
 both sweet,
 * * *
 I ask'd thy brother, James, would'st thou command,
 Without the loving heart, the obedient hand?
 I ask thee, Robert, lover, canst thou part
 With this poor hand, when master of the heart? -
 He answer'd, yes! - I tarry thy reply,
 Resign'd with him to live, content with thee to die.

 Assured of this, with spirits low and tame,
 Here life so purchased - there a death of shame;
 Death once his merriment, but how his dread
 * * * "
 See "Smugglers and Poachers" - Crabbe's "Tales of the
 Hall" 58 (Victoria and Albert Museum)
 (known as "The Momentous Question")
1844 BI Mrs Criddle: "The Boat Race - Crabbe's 'Posthumous Tales'"
 "The widows dwell together - so we call
 The younger women; widow'd are they all:
 But she, the poor Elizabeth, it seems
 Not life in her - she lives not, but she dreams:-
 Yet Resignation in the house is seen,
 Subdued affliction, Piety serene" 232
1845 SBA Miss J.S. Egerton: "Fair maiden art thou well?
 'Art thou physician?' she replied, 'my hand -
 My pulse, at least, shall be at thy command'.
 She said - and saw surprised, Josiah kneel,
 And gave his lips the offered pulse to feel"
 ("The Frank Courtship" by Crabbe) 809
1849 OWS Mrs H. Criddle: "Phoebe Dawson"
 "In haste to see, and happy to be seen"
 (Crabbe's poems - "The Parish Register") 358

Edmund Spenser:-
1843 OWS Elize Sharpe: "Una"
 "It fortuned out of the thickest wood
 A ramping lyon rushed suddenly,
 Hunting full greedy after salvage blood:
 Soone as the royall virgin he did spy,
 With gaping mouth at her he ran greedily,
 To have att once devour'd her tender corse;
 But to the prey when as he drew more ny
 His bloody rage aswaged with remorse,
 And with the sight forgot his furious forse.
 * * *
 'The lyon, lord of everie beast in field',
 Quoth she, 'his princely puissance doth abate,
 And mightie proud, to humble weake does yield,
 Forgetful of the hungry rage which late
 Him prickt, in pittie of my sad estate'.
 * * *
 And sad to see her sorrowfull constraint,
 The kingly beast upon her gazing stood,
 With pittie calmed, downe fell his angry mood."
 Spenser's "Fairie Queene" 241
1847 SBA Mrs J. Robertson: "Caelia's three daughters" (vide
 Spenser's "Fairy Queen", book 1, canto X) 489

Thomas Moore:-
1845 SBA Miss M. Johnson: "All in the garden bloom, and all are
 gathered by young Nourmahal, who heaps her basket
 with the flowers and leaves, till they can hold no
 more; then to Namouna flies, and showers into her
 lap the shining store" - Vide Moore's Lalla Rookh 617
1847 SBA Emily Sarjent: "The Enchanted Wreath" (vide "Lalla
 Rookh") 461

Samuel Rogers:-
1843 SBA Miss S. Stanton: "Ginevra"
 "There, then, did she find a grave;
 Within that chest did she conceal herself,
 Fluttering with joy, the happiest of the happy;
 When a spring lock, that lay in ambush there,
 Fastened her down for ever" 204

Schiller:-
1847 SBA Caroline Jackson: "Ginevra - vide Schiller's Poem" 16

Goethe:-
1847 BI Miss Jessie Macleod: "The Erl King"
 "'My son what meaneth, that cry of despair?'
 'See Father, see! the Erl King is there!
 'O Father, dear Father, dost thou nothing see?
 The Erl King's pale daughter, she beck'neth to me!'"
 (Goethe) 331
1849 NSPW Jane S. Egerton: "Margaret"
 "Sie kam von ihrem Pfaffen,
 Die sprache sie aller Sünden frei;
 Ich schlich mich hart am Stuhl vorbei,
 Es ist ein gar unschuldig Ding,
 Das eben für nichts zur Beichte ging;
 Ueber die hab'ich keine Gewalt!" (Goethe's Faust) 391

Petrarch:-
1848 NSPW Jane S. Egerton: "Madonna Laura"
 "Gentil mis Donna, i'veggio
 Nel mover de' vostr'occhi un dolce lume,
 Che mi mostra la vie ch'al ciel conduce"
 (Canzone IX del Petrarca) 276

Mrs Hemans:-
1841 NSPW Miss Fanny Corbaux: "Properzia Rossi - vide Mrs Hemans'
 'Records of Woman'" 65
1846 NSPW Jane S. Egerton: "The Lady Arabella Stuart"
 "Ye are from dingle and fresh glade, ye flowers!
 By some kind hand to cheer my dungeon sent;
 * * * My soul grows faint
 With passionate yearning, as its quick dreams paint
 Your haunts by dell and stream - the green, the free,
 The full of all sweet sound - the shut from me!"
 (vide Hemans' "Records of Woman") 143

Robert Bloomfield:-
1845 SBA Miss C. Smith: "The Widow Jones - vide Bloomfield" 648
1846 SBA Miss S.E. Thorn: "Scene from Bloomfield's 'Walter and Jane'"
 "Jane felt for Walter; felt his cruel pain;
 While Pity's voice brought forth her tears again:-
 Don't scold him, neighbour - he has much to say, -
 Indeed, he came and met me by the way" 346

Sir Edward Bulwer Lytton:-
1840 SBA Miss M. Drummond: "Portrait of Miss Helen Faucit as 'The
 Lady of Lyons'" 238
1843 BI Miss M. Drummond: "The Lady of Lyons, from Sir E. Bulwer
 Lytton's Play" 185
1848 SBA Mrs T.R. King: "A scene from Eugene Aram" 772

Maria Edgeworth:-
1842 BI Miss E. Schmack: "Helen"
 "She leaned back on the sofa and sank into a kind of
 dreamy state" - Miss Edgeworth's Novel 84

William Harrison Ainsworth:-
1844 BI Ambrosini Jerome: "Sybil"
 "Upon a platform of rock, which rose to the height of
 the trees nearly perpendicularly from the river's bed
 appeared the figure of the Gipsy maid, her foot rested
 on the extreme edge of the abrupt cliff, one small
 hand rested upon her guitar, the other pressedher
 brow" (Ainsworth's "Rookward") 296

James Thomson:-
1847 BI Ambrosini Jerome: "Musidora"
 "In folds loose floating fell the fainter lawn;
 And fair exposed she stood, shrunk from herself,
 With fancy blushing, at the doubtful breeze
 Alarm'd" - Thomson's Seasons 398
1849 OWS Mrs Criddle: "Lavinia and her Mother"
 "Together thus they shunned the cruel scorn
 Which virtue, sunk to poverty, would meet
 From giddy passion and low-minded pride"
 (Thomson's Seasons) 226

Lady Anne Barnard:-
1849 NSPW Jane S. Egerton: "I gang like a ghaist, and I care na to
 spin, I dare na think of Jamie, for that wad be a sin"
 Auld Robin Gray 368

Mrs S.C. Hall:-
1840 RA Fanny McIan: "Katty Macane's darlint"
 "The joyousness of her look had sunk into a serious,
 if not sullen, expression of countenance. Occasion-
 ally might be heard the tune of an Irish melody, but
 it sounded like the lament of a pining bird" Vide
 Mrs S.C. Hall's Marion 94

Ossian:-
1846 SBA Miss Jessie Macleod: "Comala"
 "There Comala sits forlorn. Two grey hounds near shake
 their rough ears, and catch the flying breeze. Her
 red cheek rests upon her arm: the mountain wind is in
 her hair. She turns her blue eyes towards the fields
 of his promise. Where art thou, O Fingal? - The night
 is gathering around" - (Vide "Comala", Ossian's Poems)
 376

James Fenimore Cooper:-
1842 BI Miss J. Joy: "Christine about to sign her Marriage contract"
 "She was standing an exquisite but painful picture of
 wounded feminine feeling and of maiden shame" (Cooper's
 "Headsman") 238

Molière:-
1847 SBA Miss Clifford Smith:-
 "Béline: 'Viens, Toinette, prenons auparavant <u>toutes</u>
 ses clefs'
 Argan (se levant brusquement): 'Doucement'.
 Béline (surprise et épouvantée): 'Ahy!'
 Argan: 'Oui, Madame ma femme, c'est ainsi que vous
 m'aimez?'
 Toinette: 'Ah, ah! le défunt n'est pas mort'"
 ("le Malade Imaginaire") 575

Milton:-
1842 SBA Miss Margaret Gillies: "Comus and the lady"
 "Comus appears with his rabble, and the lady set in
 an enchanted chair, to whom he offers his glass,
 which she puts by, and goes about to rise" (vide
 Milton) 545

Longfellow:-
(In 1849 Jane Benham illustrated Henry Wadsworth Longfellow's "Evangeline"
(London, David Bogne)

Cervantes:-
1846 SBA Miss S.E. Thorn: "Sancho's Daughter, with the Present of the
 Duchess" (see Don Quixote) 459

Chaucer:-
1840 BI Miss Kearsley: "And every lady toke full womanly
 By the hand a knight, and so forth they yede
 Unto a faite laurir that stode fast by
 etc."("The Floure and the Leafe") 445
1840 NSPW Fanny Corbaux: "Griselda" 260
1841 SBA Miss Kearsley: "From Chaucer's 'Floure and Leafe'" 442

Burns and Old Scotch Songs:-
1845 SBA Miss J. Clater: "Oh! Bessy Bell and Mary Gray etc."
 (Old Scotch Song) 650
1845 SBA Miss Jessie Macleod: "Fair Margaret of Dunbar"
 "The ladye passed the secret stair,
 To seek the woodland wild and fair -
 She rose at early dawn.
 Three corbies sit in that wild wood,
 A knight is gazing, o'er the flood,
 Where gleams the early morn.
 The ladye strokes the startled hound, -
 The warder sleeps, and sleeps full sound" -
 Old Scots Ballad 546

Bernardin de Saint-Pierre:-
1841 OWS Mrs Seyffarth: "Paul et Virginie" 227

Lord Byron:-
1841 SBA Miss S.E. Thorn: "Scene from "Childe Harold'"
 "Where his rude hut by the Danube lay
 There were his young barbarians all at play
 There was their Darian mother" 431
 (the artist exhibited a work with the same title at
 the British Institution in 1843, no.367)
1848 SBA Miss C.F. Jackson: "Still the church is tenable,
 Whence issued late the fated ball
 * * *
 There they yet may rest awhile,
 Sheltered by the massive pile"
 ("Siege of Corinth") 372

Other sources:-

1840 RA Mrs Henderson: "Pekuah waiting for her ransom" 391

1841 SBA Mrs V. Bartholomew: "Young Bacchus round her brow hath
 wreathed,
 A garland of the vine,
 And in her ear sweet words hath breathed,
 'Beloved one, thou art mine'.
 But from his glance she sadly turned,
 To mourn the Athenian youth;
 For woman's heart, though coldly spurned,
 Still loves with faith and truth" (From "Ariadne",
 an unpublished poem by Mrs. V.Bartholomew) 803

1844 SBA Miss Joy: "The Interview between Lucia and the Cardinal
 de Medici - vide 'The Fop and the Actor'" 570

1844 RA Ambrosini Jerome: "Fleur de Marie at the farm of Bouqueval"
 "Holding in her hands the ends of her apron, she took
 handfuls of grain and distributed to the feathered
 crowd that surrounded her. One beautiful pigeon, of
 a silvery whiteness, more familiar than his companions,
 flew to her shoulder, and perched there. The young
 girl went on distributing her grain with a liberal
 hand, but half-turning her beautiful face, smiling, as
 she offered her ruby lips to the beak of the audacious
 favourite" - "Mysteries of Paris", chap.IV, p.214 501

1847 SBA Miss E. Macirone: "The Legend of an Ancestor"
 "But whilst his father tarried in the wars,
 And won proud honours from the hands of Death,
 The anxious mother still would lead her son
 To the dim aisle, where shade and silence dwelt,
 And their ancestral sepulchres were laid.
 She told him of those glorious deeds, his sire's
 His own inheritance ...
 ... And the child
 Grew prouder as she spoke, and said, 'Would God,
 That he might live to be but such a man!" 570

1848 SBA Miss Jessie Macleod: "Sybilla"
 "It was a pleasant spot, the summer sun
 Darted its chequer'd beams across the way;
 And thither, she would oft at eve repair,
 Amid its shady avenues to stray,
 There to await and watch for his approach,
 And dream o'er those bright hopes by love supplied;
 And listening for his step in every sound,
 Chide the long hours that kept him from her side" 256

1849 SBA Miss Scott: "The Wife of Alphonso"
 "The moon is declining, but still she forsakes not
 The lattice-worked window, where she might discern
 Her husband returning unharmed from the battle,
 Alphonso the loved one, Alphonso's return" 583

Fairy Tales:-

1840 OWS Mrs Seyffarth: "Babes in the Wood"
 "Their pretty lips with blackberries
 Were all besmeared and dyed;
 And when they saw the darksome night,
 The sat them down and cried
 * * *
 Thus wandered these two little babes
 Till death did end their grief;
 In one another's arms they died,
 As babes wanting relief" 255

1842 OWS Eliza Sharpe: "Noureddin and the Beautiful Persian"
 (from Arabian Nights' Entertainments) 206
1843 NSPW Miss Fanny Corbaux: "Cinderella" 252
1843 RA Miss Clara Cawse: "Cinderella" 624
1844 BI Miss Clara Cawse: "Cinderella" 152
1844 SBA Miss Clara Cawse: "Cinderella" 152
 (the last three may possibly be the same work)
1845 SBA Miss S.E. Thorn: "Little Red Riding-Hood listening to the
 voice of the wolf"
 "How hoarse you are grandmother etc." 166
1849 BI Mrs Whitmarsh: "Cinderella's return from the Ball" 85

Journals:-
1840 OWS Mrs Seyffarth: "Will Honeycomb's Dream"
 "... The general refused any other terms than those
 granted to the town of Weinsberg ... Immediately the
 city gates flew open and a female procession appeared,
 staggering under their respective burdens ... I saw
 the third at some distance with a little withered face
 peeping over her shoulder, whom I could not suspect
 for any but her spouse, until, upon her setting him
 down, I heard her call him 'Dear Pug'. ... The fifth
 brought a Bologna lap-dog; for her husband, it seems
 being a burley man, she thought it would be less
 trouble for her to bring away little 'Cupid'. The
 next was the wife of a rich usurer, laden with a bag
 of gold; she told us that her spouse was very old,
 and by the course of nature could not expect to live
 long; and that to show her tender regard for him,
 she had saved that which the poor man loved better
 than his life. The next came towards us with her son
 on her back, who, we were told, was the greatest rake
 in the place In short, I found but one husband
 among this great mountain of baggage, who was a
 lively cobbler that kicked and spurred all the while
 his wife was carrying him on; and, it is said, had
 scarcely passed a day in his life without giving her
 the discipline of the strap" (Vide "Spectator",
 Vol. VII, No.499) 209
1840 OWS Mrs Seyffarth: "William and Betty: "We saw a young woman
 sitting in a personated sullenness just over a trans-
 parent fountain - opposite to her stood Mr William,
 Sir Roger's master of the game. The knight whispered
 me: 'Hist! these are lovers.' The huntsman, looking
 earnestly at the shadow of the young maiden in the
 stream, exlaimed, 'Oh, thou dear picture! if thou
 couldst remain there, in the absence of that fair
 creature whom you represent in the water, how willingly
 could I stand here for ever ... Still do you hear me
 without one smile'" (Vide "Spectator", Vol.ii, no.118)
 270
1843 SBA Miss M.A. Nichols: "The Concealed Letter"
 "I have been forced to sit this morning a whole quarter
 of an hour with your papers before my face; but, just
 as my aunt came in Phyllida had brought me a letter
 from Mr Trip, which I put within the leaves, and read,
 about absence, and inconsoleableness, and ardour, and
 irresistible passion, and eternal constancy, while my

aunt imagined that I was puzzling myself with your
Philosophy, and often cried out, when she saw me
look confused; 'If there is any word that you do
not understand, child, I will explain it'.
Dear soul! how old people that think themselves wise
may be imposed upon!" (vide "Rambler", 191) 623

W1. 1840 BI Mrs Fanny McIan: "Maternal Love"
 "When sleep forsook my open air
 Who was it sung sweet lullaby
 And sooth'd me that I should not cry?
 My Mother
 Who loved to see me pleased and gay,
 And taught me sweetly how to play,
 And minded all I had to say?
 My Mother"
 ("The English Spelling Book") 245

 1843 RA Mrs Fanny McIan: "The empty cradle"
 "Affection weeps, but heaven rejoices" 634

 1847 RA Eliza Goodall: "Say why the pensive widow loves to weep,
 When on her knee she rocks her babe to sleep:
 Tremblingly still she lifts his veil to trace
 The father's features in his infant face" (Rogers) 341

 1847 NSPW Jane S. Egerton: "Hush thee, hush thee, baby dear,
 Placid slumber's chain hath bound thee;
 Lie thou still, no danger fear,
 Thoughts of love are all around thee" - Fougue 271

 1848 SBA Miss C. Smith: "I saw the young mother in tenderness bend
 O'er the couch of her slumbering boy,
 And she kissed the soft lips as they murmured her name,
 While the dreamer lay smiling in joy
 * * *
 I again saw her gaze on the same lovely form,
 Pale as marble, and silent, and cold;
 But paler and colder her beautiful boy! -
 And the tale of her sorrow was told!
 But the Healer was there, who had smitten her heart,
 And had taken her treasure away!
 To allure her to Heaven He has placed it on high,
 And the mourner will sweetly obey!" 627

 1849 SBA Miss M. Johnson: "The bloom upon thy bonnie face,
 The sunlight o' thy smiles,
 How glad they maketh everie place,
 How short the longsome miles.
 For sin I left my Minnie's cot
 Beside the orig o'Earn
 O, ours has been a chequer'd lot,
 My bonnie-bonnie bairn" 538

 1849 SBA Miss C. Sherley: "And must I turn away?
 Hark, hark! - it is my mother's voice I hear; -
 Sadder than once it seem'd - yet soft and clear;
 Doth she not seem to pray?

 My name! - I caught the sound!
 Oh! blessed tone of love - the deep, the mild, -
 Mother, my mother! Now receive thy child,
 Take back the lost and found!" (Mrs Hemans) 569

 1849 SBA Miss Scott : "The Young Nurse"
 "When acting oft the fondling mother's part,
 The infant child her nursing care employs,
 A deeper feeling wakens in her heart ,
 The dawning earnest of maternal joys" 628

X1. 1840 SBA Mrs. Fanny McIan :
 "Through woods and o'er waters the maid lonely wanders
 Then rests by the cross, where sadly she ponders ;
 While memories come, in a troubled train,
 To take back her heart to her home again" 95

 1840 SBA Mrs. Fanny McIan : "What was her grief? Why flowed that tear?
 What sorrow caus'd her breast to swell ?
 The thought of friends that still were dear,
 Of one her heart had lov'd too well !
 She mourn'd for them, for stranger hands
 were round her, heedless of her pain ;
 A wanderer 'mid foreign lands -
 Her own she ne'er might see again" 543*

 1840 NSPW Fanny Corbaux : "The Stranger's heart is with her own"
 - Mrs. Hemans 150

 1841 BI Mrs. Fanny McIan : "Marie"
 "In solitude the Maiden wept,
 With none to smile and none to cheer,
 Those sorrows that had never slept
 Drew from her eye the buried tear" 134

 1847 RA Mrs. Fanny McIan : "The Slave's Dream"
 "Again, in the mist and shadow of sleep,
 She saw her native land" 468

 1848 RA Miss M.C. Blakesley : "The Pilgrim"
 "Though in a bare and rugged way ,
 Through devious, lonely wilds I stray,
 Thy presence shall the path beguile,
 The barren wilderness shall smile" 327

 1848 SBA Miss Jessie Macleod : "The Prison Door"
 "No roof has she, but the blue waste above ;
 No home - no friends ; - the Prison's sunless wall
 Shuts out the light of hope, the voice of love,
 And frowns its sickening shadows on them all.
 She comes, with hurried step, his cell to seek:-
 She comes with faded brow and tearless eye ;
 The cold wind waves her hair, and chills her cheek,
 Yet speaks of happier scenes, and mocks her misery" 7

Y1. Four of these have already been given in W1. The others are :-
 1843 BI Mrs. Criddle : "The Parent rose fast hastening to decay
 Renews its beauty in the opening bud,
 Thus, 'tis with fleeting life" 128

 1845 OWS Miss Eliza Sharpe : "Childhood"
 "Gaze on 'tis childhood's blooming lips and cheek,
 Mantling beneath its earnest brow of thought ;
 Gaze, yet what seest thou, in those fair and meek
 And fragile things, as but for sunshine brought ?
 Thou seest what grief must nurture for the sky :
 And death must fashion for eternity !"-Mrs. Hemans
 328

 1846 RA Miss M.A. Cole : "The dead are in their silent graves,
 And the dew is cold above ;
 And the living weep and sigh
 Over dust that once was love" (Thomas Hood) 587
 (According to the "Art Union" the work showed two
 girls seated on a grave (1846 p 183))

 1847 SBA Miss Jessie Macleod : " The Widow" "At the same time she
 placed herself, to be first seen by me, in such an
 attitude as, I think, you call the posture of a
 picture" (vide "Spectator") 56

 1848 OWS Mrs. Criddle : "With him she pray'd, to him his Bible read,
 Sooth'd the faint heart or held the aching head;


She came with smiles, the hour of pain to cheer;

Apart she sigh'd, alone she shed the tear;

Then, as if breaking from a cloud, she gave

Fresh light, and gilt the prospect of the grave"

(Crabbe's "Borough" - "The Church") 73


Z1 1841 BI Mrs Criddle: "Ah me! for aught that ever I could read,
Could ever hear by tale, or history,
The course of true love never did run smooth" 259

 1841 SBA Mrs Criddle: "Sleep aiding love, unerring flies the dart,
While Hymen waits to calm the fluttering heart" 669

 1842 OWS Mrs Seyffarth: "The Wedding" 216 (see vol.1 p 138)

 1842 NSPW Sarah Setchel: "Life fought with love, both powerful and both
sweet, etc." ("The Momentous Question")
See VI under George Crabbe for full quotation and note 78

 1848 BI Miss Jessie Macleod: "The Inconstant"
"The hour is past, and yet she waits in vain;
No footstep wakes the silence of the grove,
That heart for him will never throb again,
Indignant scorn usurps the place of love!" 92

 1848 NSPW Sarah Setchel: "And ye shall walk in silk attire,
And siller ha'to spare,
Gin ye'll consent to be his bride
Nor think on Donald mair.

Oh! who would buy a silken gown
With a puir broken heart?
And what's to me a siller crown
If I from Donald part -" 54 (Victoria and Albert Museum)

 1848 SBA Miss Jessie Macleod: "The Prison Door" 7
(the quotation is given in X1)

 1849 SBA Miss Johnson: "Oh! dinna ask me gin I lo' ye,
Deed I dinna tell;
Dinna ask me gin i lo'e ye,
Ask it o'yoursel" 605

A2 1840 BI Mrs M. Drummond: "'Twas the twilight of the mind
When the thoughts are intertwined
Of grief and joy
When regret, for pleasures fled,
Feels a soothing promise shed
From hope's tinted sky" 117

 1840 RA Miss A. Cole: "A well-known tune,
Which in some dear scene we have loved to hear,
Remembered now in sadness" (Shelley) 857

 1843 SBA Miss J. Blackmore: "'Tis sweet in life's bright morning to see
so fair a thing deep in the study of that holy book which
points the way to heaven" 721

 1843 NSPW Miss Louisa Corbaux: "Meditation" "Come then, expressive
silence, muse His Praise" (Thomson's Hymn) 162

 1845 NSPW Miss Louisa Corbaux: "Pleasant Thoughts" "Whence are those
thoughts, and whither tend their way?" (Mrs Hemans) 70

 1845 NSPW Miss Louisa Corbaux: "Prayer" "Blest is that fair girl, and blest
The home where God is felt" (Mrs Hemans) 179

 1846 SBA Miss Jessie Macleod: "An Auld Wife's thoughts of Langsyne"
"Oh! age has weary days,
And nights o'sleepless pain; -
There golden time o'youthful prime,
Why com'st thou not again?" - Burns 465

 1848 RA Miss M.C. Blakesley: "The Pilgrim"
"Though in a bare and rugged way,
Through devious, lonely wilds I stray,
Thy presence shall the path beguile,
The barren wilderness shall smile" 327

1849 OWS Eliza Sharpe: "Prayer"
 "Prayer is the breathing of a sigh,
 The falling of a tear;
 The upward glancing of an eye,
 When none but God is near" 363

B2. Childhood:-
1849 NSPW Louisa Corbaux: "The Golden Age"
 "Sweet age! too young for knowledge, and for guile;
 When lips with none but truthful feelings move
 In each endearing name and artless smile,
 In ev'ry kiss of a fair cherub's love" 88

 Looks:-
1846 RA Mrs Criddle:
 "Was it the work of nature, or of art,
 Which tempered so the feature of her face
 That pride and meekness, mixt by equal parts,
 Do both appear t'adorn her beauty's grace?"
 (Spenser, sonnet xxi) 510
1846 SBA Miss J. Joy: "She is a winsome wee thing,
 She is a handsome wee thing,
 She is a bonny wee thing,
 That sweet wee wife o'mine" (Burns) 339
1847 BI Mrs Criddle: "Disdain and scorn ride sparkling in her eyes,
 Misprising what they look on" 261

C2. Flowers:-
1840 NSPW Mrs Harrison: "Primroses"
 "Now what is the flower, the ae first flower,
 Springs either in moor or dale;
 And what is the bird, the bonnie, bonnie bird
 Sings on the evening gale?
 * * *
 The primrose is the ae first flower,
 Springs either in moor or dale?
 And the thristle-cock is the bonniest bird,
 Sings on the evening gale?" Old Ballad 75
1840 NSPW Mrs Harrison: "Water Lilies"
 "Here the white lilies have spread their bells,
 Over the pools in the forest dells" (Mrs Hemans) 282

 Animals:-
1846 NSPW Louisa Corbaux: "The Young Donkey's Friend"
 "Poor patient Ass! at last he hears
 A gentle word, a voice, he need not fear; -
 Why call him dull? Why scoff at his long ears?
 When these, if they but friendly speeches hear,
 Will start up, all attention, and rejoice
 At a kind voice" 117
1846 SBA Mrs Hurlstone: "A Portrait"
 "Cold rain hath fallen through the kindless Spring!
 Sweet bird of song,
 Though hast been mute; with wet and furled wing,
 Dejected long" 730
1847 SBA Mrs Hurlstone: "Poor Dog Tray"
 "Though my wallet was scant, I remember'd his case,
 Nor refus'd my last crust to his pitiful face;
 But he died at my feet, one cold winter day.

 Where now shall I go, poor forsaken, and blind, -
 Shall I find one to guide me so faithful and kind?"
 (Thomas Campbell) 579

1847 NSPW Fanny Corbaux: "The wolf also shall dwell with the lamb..
And a little child shall lead them" ("Isiah" ch.11,
v.6) (The animals by Miss Louisa Corbaux) 144
1849 SBA Mrs Hurlstone: "John Bullism"
"Poor jaded horse, the blood runs cold
Thy guiltless wrongs to see
To heaven, O starv'd one lame and old,
Thy dim eye pleads for thee" (Monckton Milnes) 621

D2. The following works are given in full in V1 on the pages indicated:-
1841 SBA Mrs V. Bartholomew: "Young Bacchus round her brow hath
wreathed etc. " 803 See page 64
1842 BI Miss J. Joy: "Christine about to sign her Marriage contract"
238 See page 62
1844 SBA Mrs Criddle: "The Boat Race" (Crabbe's "Posthumous Tales")
232 See page 60
1846 SBA Miss S.E. Thorn: "Scene from Bloomfield's 'Walter and Jane'"
346 See page 61
1846 SBA Miss Jessie Macleod: "Comala" 376 See page 62
1846 SBA Miss E. Macirone: "Little Nelly watching for her Grandfather"
660 See page 59
1846 NSPW Jane S. Egerton: "The Lady Arabella Stuart" 143 See page 61
1847 SBA Miss E. Macirone: "The Legend of an Ancestor" 570 See page 64
1848 NSPW Jane Sophia Egerton: "Madonna Laura" 276 See page 61
1848 SBA Miss Jessie Macleod: "Sybilla" 256 See page 64
1849 SBA Miss Scott: "The Wife of Alphonso" 583 See page 64
1849 BI Miss Jessie Macleod: "The Interior of the Fisher's Cottage"
See page 58

E2.a) Love with the corollary theme of waiting for a lover:-
1850 NSPW Miss Sarah Setchel: "Jesse and Colin"
"The Youth embolden'd, yet abashed, now told
His fondest wish, nor found the maiden cold;
His mother smiling whisper'd - 'Let him go
And seek the licence!' Jesse answer'd 'No!'
But Colin went - I know not if they live
With all the comforts wealth and plenty give;
But with pure joy to envious souls denied,
To suppliant meanness and suspicious pride;
And village maids of happy couples say,
'They live like Jesse Bourne and Colin Grey'"
(vide Crabbe's Tales) 258
1850 NSPW Miss Jane S. Egerton: "Hinda"
"And see - where, high above those rocks
That o'er the deep their shadows fling,
Yon turret stands; whose ebon locks,
As glossy as a heron's wing
Upon the turban of a king
Hang from the lattice, long and wild
'Tis she, that blooming child;
All truth, and tenderness, and grace
Though born of such ungentle race.
 * * *
Such is the maid who at this hour
Hath risen from her restless sleep,
And sits alone in that high bower
Watching the still and shining deep
 * * *
Why looks she now, so anxious down
Among those rocks -". (vide "The Fire Worshippers",
"Lalla Rookh") 113

1851 BI Miss Jessie Macleod: "Scene from the Vicar of Wakefield"
"'That she is', said Jenkinson; 'and make much of her,
for she is your own honourable child, and as honest a
woman as any in the whole room, let the other be who
she will. And as for you Squire, as sure as you stand
there, this young lady is your lawful wedded wife. And
to convince you that I speak nothing but the truth,
here is the license by which you were married together'.
- so saying he put the license into the Baronet's hands,
who read it and found it perfect in every resepct.
- Happiness was expanded on every face, and even
Olivia's cheek seemed flushed with pleasure" 423

1851 NSPW Miss Jane S. Egerton: "My mother bids me bind my hair,
Tie up my sleeves with ribbons rare,
And lace my boddice blue -
 * * *
Alas! I scarce can go or creep,
Now Lubin is away" 113

1852 PG Miss E. Macirone: "Hamlet and Ophelia"
"She returns the remembrances" 347

1852 NSPW Miss Jane S. Egerton: "Mariana in the South"
"And rising, from her bosom drew
Old letters, breathing of her worth,
For 'Love', they said, 'must needs be true
To what is lovliest upon earth'.
 * * *
'O cruel heart', she changed her tone,
'And cruel love, whose end is scorn,
Is this the end to be left alone,
To live forgotten, and die forlorn!'" Tennyson 290

1852 BI Miss A.S.W. Daniel: "Donna Julia"
"Unconsciously she leaned upon her hand
Which played within the tangles of her hair,
With thoughts contending which she could not smother,
She seemed by the distraction of her air" ("Don Juan")
195

1852 SBA The late Miss Johnson: "Ye shall walk in silk attire,
Hae siller for to spare,
Gin ye'll consent to be my bride
Nor think o' Donald mair" 522*

1853 SBA Miss H. Parsons: "Nourmahal, Castletown, Isle of Man"
"Oh Nourmahal! Oh Nourmahal!
Hadst thou but sung this witching strain
I could forget, forgive thee all,
And never leave those eyes again!" ("Lalla Rookh") 622

1853 BI Miss Margaret Gillies: "From the ballad of 'Auld Robin Grey'"
"Young Jamie lo'ed me well,
And sought me for his bride" 74

1854 PG Miss Anna Mary Howitt: "Margaret returning from the Fountain"
"Margaret, having heard the harsh judgment of her com-
panions at the city fountain, returns home tortured by
self-accusation" (Goethe's "Faust") 28

1854 SBA Mrs V. Bartholomew: "Mariana"
" * * * * But most she loathed the hour
When the thick sunbeam lay
Athwart the chamber, and the day
Down sloped was westering in his bower,
Then said she, 'I am very dreary,
He will not come'" 633

1854 BI Miss Emily Osborn : "And thinking this will please him best
 She takes a ribband or a rose -
 For he will see them on to-night
 And with the thought her colour burns
 And having left the glass, she turns
 Once more to set a ringlet right"
 ("In Memoriam" - Tennyson) 444

1855 SBA Mrs Besset: "Medora watching" (Byron) 129

1855 SBA Mrs Hurlstone: "Gulnare and Conrad"
 "She watch'd his feature till she could not bear
 Their freezing aspect and averted air,
 And that strange fierceness foreign to her eye
 Fell quenched in tears, too late to shed or dry.
 She knelt beside him, and his hand she press'd,
 Thou may'st forgive, thou Alla's self detest" 4

1856 PG Mrs H. Taylor: "Margaret"
 "I watch from my window to see him appear" (Faust) 384

1856 SBA Ambrosini Jerome: "A Lover's Complaint"
 "Her hair nor loose nor tied in formal plait,
 Proclaim'd in her a careless hand of pride,
 For some untuck'd descended her sheaved hat,
 Hanging her pale and pined cheek beside,
 Some in their threaded fillet still did bide
 * * *

 A thousand favours from a mound she drew,
 Of amber, crystal, and of beaded jet,
 Which, one by one, she in a river threw,
 Upon whose weeping margin she was set
 * * *
 * * *
 * * * " 390

1857 OWS Margaret Gillies: "Jenny Coxon at the Post Office"
 "Poor Jenny could only draw her cloak about her, to hide
 the sigh of disappointment, and return meekly home to
 endure for another night the sickness of heart occasioned
 by hope delayed" ("The Antiquary" ch.15) 213

1858 SFA Mrs Hurlstone: "Gulnare and Conrad"
 "She watch'd his features, till she could not bear
 Their freezing aspect and averted air" Byron 95
 (probably the same work as that exhibited, with a longer
 quotation at the Society of British Artists in 1855 no.4)

1858 SFA Mrs Robbinson: "Othello and Desdemona" 129

1858 SFA Miss E. Macirone: "The First Meeting of Florizel and Perdita"
 "Florizel: 'I bless the time when my good falcon made
 her flightAcross thy father's grounds'" -"Winter's Tale"
 260

1859 SFA Miss Ellen Partridge: "My gentle bashful Nora Creina,
 Beauty lies in many eyes
 But love in yours, my Nora Creina" 241

b) Death, a theme which is frequently associated with love: -

1852 RA Ellen Shenton: "Parisina"
 "And still and pale,
 And silently did Parisina
 Wait her doom" 1371

1853 RA Mrs V. Bartholomew: "Portrait of Miss Glynn, in Cleopatra"
 "Cleo. 'Peace, peace!
 Dost thou not see my baby at my breast
 That sucks the nurse asleep?'
 Char. 'O break, O break!'
 Cleo. 'As sweet as balm, as soft as air, as gentle -
 O Anthony!'" 935

1853 OWS Mrs Criddle: "Ye little loves that round her wait
 To bring me tidings of my fate,
 As Celia on her pillow lies,
 Ah! Gently whisper - Strephon dies" 195
1854 NSPW Miss Fanny Corbaux: "The Close of Day"
 "She wept herself to sleep; yet not a trace
 Of anguish rested on that pallid face, -
 So still, so calm, so passionless, serene,
 Like moonlight resting where the sun hath been.
 Angel of Death! it is not always so,
 That thou dost lay the broken hearted low!"
 (From "Poems" by R.E.S.) 361
1855 PG Miss Howitt: "The Lady, vide Shelley's 'Sensitive Plant'"
 "A lady, the wonder of her kind,
 Whose form was upborne by a lovely mind,
 Tended the garden from morn till even,
 All the sweet seasons of summer-time
 * * *
 And ere the first leaf looked brown she died;
 The dark grass and the flowers among the grass
 Were bright with tears as the crowd did pass;
 From their sighs the wind caught a mournful tone
 And sate in the pines, and gave groan for groan" 257
1855 BI Miss Jessie Macleod: "The Death of Meg Merrilies"
 "'Yes', she said, in a stronger and harsher tone; 'I
 said, Henry Bertram of Ellangowan; stand from the light
 and let me see him ... Look at him', she said, 'all that
 ever saw his father, or his grandfather, and bear wit-
 ness if he is not their living image!' A murmur went
 through the crowd: the resemblance was too striking to
 be denied" "Guy Mannering" 490
1857 SBA Miss Jessie Macleod: "Scene from "Guy Mannering'. The death
 of Meg Merrilies"
 "'Yes', she said, in a stronger and harsher tone, 'I
 said Henry Bertram, of Ellangowan, Stand from the light
 and let me see him'. All eyes were turned towards
 Bertram, who approached the wretched couch. 'Look at
 him', she said, 'all that ever saw his father or his
 grandfather, and bear witness if he is not their living
 image'. A murmur went through the crowd, the resem-
 blance was too striking" 468
 (probably the same as the previous exhibit)
1858 SFA Angélique Raze: "Evangeline"
 "Sometimes in churchyards strayed and gazed on the
 crosses and tombstones,
 Sat by some nameless grave, and thought that, perhaps,
 in its bosom
 He was already at rest, and she longed to slumber beside
 him" Longfellow 350
1859 SFA Adelaide Burgess: "'Why, they say', replied the boy, looking
 up into her face, 'that you will be an angel before the
 birds sing again'. The little creature folded his hands
 and knelt down at her feet" (vide "The Old Curiosity
 Shop") 113
1959 SFA Amy Butts: "Isabella"
 "She wrapp'd it up and for its tomb did choose
 A garden pot, wherein she laid it by,
 And cover'd it with mould, and o'er it set
 Sweet basil, which her tears kept ever wet" 195

c) Suffering is the theme of several other works:-
 1850 RA Isabel Curtis:"Ego"
 "Upon her face there was a tint of grief
 And an unquiet drooping of the eye,
 As if its lid were charged with unshed tears" 254
 1851 RA Isabel Curtis: "Beatrice Cenci"
 "How comes the hair undone?
 Its wandering strings must be what blind me so,
 And yet I tied it fast" (Shelley) 788
 1852 OWS Margaret Gillies: "Jenny Deans' visit to Effie in prison" 66
 1852 BI Miss C. Cawse: "Poor Nell"
 "There were none to see the frail perishable figure as it
 glided from the fire and leaned pensively at the open
 casement; none but the stars, to look into the upturned
 face and read its history" - vide Dickens' "Old Curiosity
 Shop" 307
 1853 OWS Margaret Gillies: "Jeanie Deans pleading for her sister's life
 before Queen Caroline"
 "Tear followed tear down Jeannie's cheeks, as, her fea-
 tures glowing and quivering with emotion, she pleaded her
 sister's cause with a pathos which was at once simple and
 solemn" (Scott "The Heart of Midlothian") 47
 1853 OWS Margaret Gillies: "My father argued sair,
 My mother did not speak,
 But she looked in my face,
 Till my heart was like to break" ("Auld Robin Grey") 170
 1853 BI Miss Jessie Macleod: "The Arrest of Effie Deans at St. Leonards
 Crags"
 "It was therefore like a clap of thunder to the poor old
 man, when just as the hour of noon had brought the visit
 of the Laird of Dumbiedikes as usual, other and sterner,
 as well as most unexpected guests arrived at the cottage
 of St. Leonard's. These were the officers of justice,
 with a warrant of justiciary, for the apprehension of
 Euphemia, or Effie Deans" ("The Heart of Midlothian") 140
 1855 SBA Miss Eliza Turck: "Little Nell"
 "But now the chambers were cold and gloomy, and when she
 left her own little room to wile away the tedious hours
 and sat in one of them, she was still and motionless as
 their inanimate occupants" (Dickens) 584
 1859 RA Miss E. Shenton: "Cordelia"
 "Ay, sir, she took them, read them in my presence;
 And now and then an ample tear trill'd down
 Her delicate cheek; it seemed she was a queen
 Over her passions; who, most rebel-like,
 Sought to be King o'er her" ("King Lear" act 4, sc.3) 1284

d) Other literary works (of the illustrative category) which were exhibited
 in the 1850s:-
 1852 OWS Eliza Sharpe: no.61
 This work bears no title in the catalogue, but it was
 described in a review in the "Art Journal" (1852, p.177):
 "This composition without a title has for its subject a
 passage in the concluding scene of 'The Winter's Tale':-
 "Paulina : ''Tis time; descend; be stone no more.
 Approach, strike all who look upon with marval. Come'"
 The principal figure is, of course, Hermione on the ped-
 estal, and grouped around her are Paulina, Leontes,
 Polixenes etc"

1852 RA Miss E. Macirone: "Elizabeth, a young girl, who journeyed
 alone from Siberia to Tobalsk, to obtain the pardon
 of her exiled father" - (Mme de Cottin) 1077

1852 PG Miss Clifford Smith: "Evangeline"
 "Fairer was she when on Sunday morn * * *
 * * * *
 Down the long street she pass'd with her chaplet of
 beads and her missal,
 Wearing the Norman cap, and her kirtle of blue, and
 the ear-rings,
 Brought in the olden time from France, and since as
 an heirloom
 Handing down from mother to child through long genera-
 tions" (Longfellow) 324

1853 PG Mrs Besset: "Zuleika"
 "Soft as the memory of buried love,
 True as the prayer which childhood wafts above" 178

1853 OWS Eliza Sharpe: "Lucy Ashton" 57*

1853 RA Miss E. Macirone: "Henry Esmond's first interview with Lady
 Castlewood" 1017

1853 BI Rebecca Solomon: "Evangeline"
 "Thus did Evangeline wait at her father's door"
 (Longfellow's "Evangeline") 383

1854 OWS Mrs H. Criddle: "The Sisters"
 "She then, for Lucy mild forbearance tries,
 And from her pupils turns her brilliant eyes,
 Making new efforts, and with some success,
 To pay attention while the students guess;
 Who to the gentler mistress fain would glide
 And dread their station at the ladies' side"
 (Crabbe's "Tales of the Hall" book 8) 15

1854 OWS Margaret Gillies: "Jeannie, from the Ballad of Auld Robin Grey"
 "My father could na work, my mither could na spin;
 I toiled day and night, but their bread I could na win"154

1854 SBA Miss E. Macirone: "Elizabeth"
 "At length Springer and Smolaff, after much exertion,
 reached the wooden chapel where they expected Elizabeth
 might have sought refuge. But perceiving from a dis-
 tance the frailty of this wretched shelter, whose dis-
 jointed planks clattered in the winds, and threatened
 every moment to fall in, they trembled at the idea of her
 being there. Smolaff rushed past her father, impelled
 with irrepressible ardour, and, the first to enter, he
 saw - was it a dream? - he saw Elizabeth, not frightened,
 pale, and trembling, but sleeping peacefully at the foot
 of the altar. He passed, and with silent awe pointed
 out to Springer the angel who slept beneath the protec-
 tion of Heaven" 597

1854 BI Miss J.M. Hayward: "The shadows of the Convent towers
 Slant down the snowy sward,
 Still creeping with the creeping hours
 That lead me to the Lord:-
 Make thou my spirit pure and clean
 As are the frosty skies,
 Or this first snowdrop of the year
 That in my bosom lies" (Tennyson's St. Agnes) 83

1854 BI Miss Jessie Macleod: "Scene from the Bride of Lammermuir"
 "He planted himself full in the middle of the apartment,
 opposite to the table at which Lucy was seated, on whom,
 as if she had been alone in the chamber, he bent his
 eyes with a mingled expression of grief and deliberate
 indignation. His dark coloured riding cloak, displaced
 from one shoulder, hung around one side of his person in
 the ample folds of the Spanish mantle, etc. 'Is that your
 handwriting Madam?' he added in a softer tone, extending
 towards Miss Ashton her last letter" 439
1855 SBA Mrs Backhouse: "Tennyson's Dora" 683
1855 SBA Mrs Besset: "The Bride of Abydos"
 "Sweet as the memory of buried love,
 Pure as the prayer which childhood wafts above" 405
1855 OWS Margaret Gillies: "Portia planning the Defence of Antonia" 299
1856 RA Miss Eliza Turck: "Cinderella, after her sisters have left for
 the ball" 58
1856 SBA Miss J.C. Bell: "Leila -vide 'Giaour'" 685
1857 SFA Mrs E.M. Ward: "Mariana" 55
1857 SFA Mary Armstrong: "The Abbess Irmingard relating her life to Elise"
 "I felt the agony decrease
 By slow degrees, then wholly cease,
 Ending in perfect rest, peace!
 It was not apathy or dullness
 That weigh'd and press'd upon my brain,
 But the same passion I had given
 To earth below, - now turn'd to heaven,
 With all its overflowing fullness"
 (Longfellow's "Golden Legend") 1
1858 OWS Margaret Gillies: "Una and the Red Cross Knight in the Cavern
 of Despair"
 "Out of his hand she snatcht the cursed knife,
 And threw it to the ground enraged rife;
 And to him said, 'Fie, fie, faint-hearted knight,
 What meanest thou by this reproachful strife -
 Is this the battle that thou wentst to fight?'"
 (Spenser's "Faerie Queene" canto 9) 169
1858 SFA Miss Martha Jones: "Rosalind presenting her chain" ("As you
 Like It" Act 1, sc.2) 119
1858 SFA Miss Mary Constance Clarke: "The Child of the Marshalsea"
 (see "Little Dorrit") 151
1859 SBA Lizzie Chilman: "Adeline"
 "Wherefore those dim looks of thine,
 Shadowy, dreaming, Adeline?" (Tennyson) 751
1859 OWS Margaret Gillies: "Effie Deans waiting for Robertson in the
 Laigh Calton" 250
1859 SFA Lucy Meadows: "Isabella, Countess de Croye" (vide "Quentin
 Durward" chapter 4) 4

F2.a) Separation:-
1850 NSPW Miss Fanny Corbaux: "The last Evening at Home"
 "Tu proverai si come sa di sale
 Lo pane altrui, e com'e duro calle
 Lo scendere e'l salir per altrui scale" Dante 215
1850 OWS Nancy Rayner: "His soul is far away,
 In his childhood's land perchance,
 Where his young sisters play,
 Where shines his mother's glance

Some old, sweet native sound,
His spirit haply weaves;
A harmony profound
Of woods with all her leaves

A murmer of the sea
A laughing tone of streams; -
Long may his sojourn be
In the music land of dreams!" 17

1851 NSPW Fanny Corbaux: "The Stranger"
"The stranger's heart! oh! wound it not
A yearning anguish is its lot;
In the green shadow of thy tree,
The stranger finds no rest with thee.
Thou think'st thy children's laughing play
A lovely sight at fall of day;
Then are the stranger's thoughts oppress'd -
Her mother's voice comes o'er her breast"
(Mrs Hemans) 55
(Described in the "Athenaeum" (May 10, 1851, no.1228,
p. 507): "A female of great beauty is seated on a stone
bench on a garden terrace, fondled by two lovely children
at vigorous play. Another female - the stranger - sits
in the distance, in mournful watchfulness of the joyous
scene. This drawing is the best that we have seen by
this gifted lady..")
The sex of the subject has been changed by the artist.
In Mrs Hemans' poem,"The Stranger's Heart", the subject
is a man. (See vol.1 p 138 for two other instances of such
alteration)

1853 PG Mrs E.A. Hawkes: "I remember thy voice when sadly
I sit in the evenings alone" 330

1854 OWS Margaret Gillies: "The Mourner"
"I watch thee from the quiet shore -
Thy spirit up to mine can reach,
But in dear words of human speech
We two communicate no more" (Tennyson) 182

1854 BI Miss Emma Brownlow: "She sings the wild songs of her dear
native plains,
Every note that he loved awaking:
Ah! little they think who delight in her strains
How the heart of the minstrel is breaking" - (Moore) 425

1855 OWS Margaret Gillies: "Looking back at the Old Home"
"Unforgotten, unforgetting,
Footsteps faltering and slow,
Unchecked tears our eyelids wetting,
To another home we go" (B.R. Parkes) 46

1856 RA Miss Emily Osborn: "Home Thoughts"
"One heart heavy, one heart light; half in day, half
in night,
This globe for ever goes.
One wave dark, another bright,
So life's river flows.
And who among us knows,
Why in this stream, that cannot stop,
The sun is on one water drop,
The shadow on another?" (E.H.O.) 519 (E.Haydon Osborne)
(Sotheby's Belgravia July 9, 1974)

1856 RA Mrs A. Farmer: "The First Letter from home"
"How warmly here the tender home-light shines!
What household music lives in these dear lines!" 355

1856 PG Miss E. Hunter: "Love the mother, little one!
Kiss and clasp her neck again.
Hereafter she may have a son,
Will kiss and clasp her neck in vain" (Hood) 527

1856 OWS Margaret Gillies: "The Ministering Spirit"
"There is no fireside, howsoe'er defended
But has one vacant chair

. . . .

She is not dead, the child of our affection

. .

Not as a child shall we again behold her;
But a fair maiden in her father's mansion,
Clothed with celestial grace" (Longfellow) 236

1856 SBA Miss Rowley: "The Sailor's Wife"
"O cruel fear
That sees the breakers foam,
Oh blessed hope, that whispers near,
He yet is coming home.
I see him where the winding road
Looks golden in the sun,
But thus whole months I've thought, O God,
And still at night been lone" 240

1856 BI Miss Jessie Macleod: "The Empty Cradle"
"There is no fold however watched and tended
But one dead lamb is there.
There is no fireside howso'er defended
But has one vacant chair.
The air is full of farewells to the dying,
And mourning for the dead;
The voice of Rachel for her children crying
Will not be comforted" (vide Longfellow) 220

1857 SFA Anna E. Blunden: "Hope in death"
"At Evening time it shall be light"
(Zach. ch.14, v.7) 52

1859 OWS Margaret Gillies: "A Father and Daughter"
"But, oh! for the touch of a vanished hand
And the sound of a voice that is still" (Tennyson) 51
(Described in the "Art Journal" 1859 p.173): "The
story is simple and perspicuous. They are contemplat-
ing the portrait of one departed - the wife and the
mother - and the features of both coincide in expression
of emotion; but their language is different - for there
is light and an exaltation in the features of the girl,
that speak of her as less dwelling on the picture than
communing with her mother in the spirit"

1859 SFA Kate Swift: "'Tis sweet to know
There is an eye will mark our coming" 189

b) Thought or memory:-

1851 SBA Miss L. Grover: "What are our joys but dreams? and what our
hopes
But goodly shadows in the summer cloud?
There's not a wind that blows, but bears with it
Some rainbow promise: - not a moment flies
But puts its sickle in the fields of life"
"Time" by Kirke White 482

1852 BI Miss Emily Osborn: "Evening"
"Gazing on the clouds of Evening, slowly floating thro'
the sky,
While Life's path is strewn with roses - tears oft
glisten in the eye.

<div style="margin-left:3em">

Sunny visions pass before us - cherished dreams of
Love and Truth -
Friends on earth and friends departed - all the hopes
and fears of Youth -
Yet the forms our thoughts created, borne upon the
eddying wind,
Ever o'er the dim horizon fade, nor leave a trace
behind - " (E. Haydon Osborn) 358

</div>

1854 OWS	Margaret Gillies : "Listening to the Nightingale" - "Thy plaintive anthem fades Past the near meadows, over the still stream , Up the hill-side, and now 'tis buried deep In the next valley-glades" - Keats 276	
1854 NSPW	Fanny Corbaux : "After the Ball" "Even in laughter the heart may be sorrowful, and the end of that mirth is heaviness" - Proverbs, xiv, 13 159	
1855 OWS	Margaret Gillies : "The Past and the Future" "Sighing on through the shadowy past, Like a tomb-searcher memory ran, Lifting each shroud that time had cast O'er buried hopes" (Moore)	

<div style="margin-left:3em">

"Hope, the brightest of the passionate choir
That through the wide world would range,
And touch with passing fingers that most strange
And curious instrument, the human heart" (Shelley)193
(According to the "Art Journal" (1855 p.185) this
contained "two female figures, one youthful, and the
other somewhat older")

</div>

1856 BI	Miss M. Bleaden : "O break not her silence ! she listens to voices Whose tones are a feeling, whose echoes a turill ; And more than in ought that is real she rejoices In dreams which presage what they ne'er can fulfil"137
1856 OWS	Margaret Gillies : "From Marcello's Anthem" "I cieli immense narrano Del grande Iddio la gloria" 163 (of a woman looking up to Heaven according to the "Art Journal" 1856 p 176)
1857 RA	Miss Eliza Turck : "I'll set me down an' muse Beneath yon spreading tree , An' gin a leaf fa' in my lap , I'll la' it word fra' thee" - Vide Scotch Song 186
1857 PG	Miss L. Chilman : "A Reverie" "Who shall say whence are those thoughts, and whither tend their way?" 174
1857 OWS	Margaret Gillies : "Solitude" "She sat alone, and drew the blessing in of all that nature" (E.B. Browning)63
1858 SFA	Miss Ellen Cole : "Meditation" "One comfort yet shall cheer thine aged heart" 16
1858 SFA	Mrs. Backhouse : "The Morning Star of Memory" "Oh, if no other boon were given , To keep our hearts from wrong and stain ; Who would not try to win a heaven , Where all we love shall live again !" 173
1858 RA	Miss R. Levison : "The Sisters, a group" "In maiden meditation - fancy free" 1216
1858 PG	Miss L. Chilman : "Serenity" "Where thoughts serenely sweet express, How pure, how dear their dwelling place" (Byron) 171
1859 NSPW	Louisa Corbaux : "Lead me in thy truth, and teach me" (Psalm XXV v.5) 113

c) Maternity :-
<div style="margin-left:3em">

1856 BI Miss Jessie Macleod : "The Empty Cradle" 220 (for the
quotation, see under "separation" above)

</div>

1857 SFA Mrs Griesbach: "How can thy Mother be more blest,
 Than thus to feed thee from her breast!
 What loss of time can sweeter be,
 Than thus to nurse thee on her knee!" 94
1857 PG Miss E. Rowley: "Maternal Instructions"
 "Mothers can tell how oft
 In the hearts eloquence the prayer goes up
 From a seal'd lip; and tenderly hath blent
 With the warm teaching of the sacred tale,
 A voiceless wish" 402
1858 SFA Miss E. Hunter: "Mother and Child"
 "Love thy Mother, little one,
 Kiss and clasp her neck again,
 Hereafter she may have a son
 Will kiss and clasp her neck in vain.
 Love thy Mother, little one" - Hood 89
1858 SFA Mrs V. Bartholomew: "Domestic Life"
 "O happy mother, - happy wife!
 Within thy humble cot,
 Thou little dream'st that care and strife
 Surround a happier lot.
 All nature showers o'er thee her gifts, -
 The flower, its perfume brings;
 The minstrelsy of birds uplifts
 Thy heart to holier things" - (M.S.S.) 295

d) Social Commentary:-
1852 BI Miss J. Sutherland: "The Lady's Dream"
 "Death, death and nothing but death,
 In every sight and sound!
 And oh! those maidens young,
 That wrought in that dreary room,
 With figures drooping and spectres thin
 And cheeks without a bloom;
 And that crowd of human kind,
 Who wanted pity and dole,
 In everlasting retrospect
 Will wring my sinful soul" 42
 (The poem is by Thomas Hood)
1854 RA Miss Rebecca Solomon: "The Governess"
 "Ye too the friendless, yet dependent, that find nor
 home nor lover,
 Sad imprisoned hearts, captive to the net of circumstance"
 (Martin Tupper's "Proverbial Philosophy") 425
 (Described in the "Art Journal" (1854, p.167): "It tells
 two stories which are pointedly contrasted. A young lady
 and a youth are engaged in a flirtation at a piano, while
 a governess is plodding in weary sadness through a
 lesson with a very inattentive pupil. The tales are told
 with expressive perspicuity")
1854 SBA Anna Blunden: "The Song of the Shirt"
 "For only one short hour,
 To feel as I used to feel,
 Before I knew the woes of want
 And the walk that costs a meal" (Thomas Hood) 133
 (The artist exhibited a work with the same title at the
 Society of Female Artists in 1857, no.89)

1857 RA Miss Rebecca Solomon: "'Tis better to be lowly born,
And range with humble lovers in content,
Than to be perked up in glistening grief,
And wear a golden sorrow" (Shakespeare) 27
(Described in the "Art Journal" (1857, p.165): "Such is
the quotation from Shakespeare, standing in the place of
a title. The story is of a gentleman in the time of
Charles II, who, having been playing cards and dice,
appears to have lost very considerably. He is sitting
in deep despondency, his wife standing in sorrow near
him. The narrative is clear enough and the picture is
generally well-executed")

1857 RA Miss Emily Osborn: "Nameless and Friendless"
"The rich man's wealth is his strong city: the destruc-
tion of the poor is their poverty" (Proverbs ch.X, v.15)
299 (Collection Sir David Scott) (for a description of
this work see vol.1 p 167)

1858 SFA Mrs Backhouse: "The Orphan"
"How sad to hear a song of mirth,
Sung in the homeless street
By one, in melancholy dearth
Of clothes, and food to eat, -
A place beside the poorest hearth,
For bare and blistered feet.
Some notes of sweetness still retain
This worn and feeble voice,
That once perchance in hawthorn lane
Help'd Spring-time to rejoice" (Tennyson) 221

1859 RA Miss Emily Osborn: "Presentiments"
"For men must work, and women must weep,
And there's little to earn and many to keep,
Tho' the harbour bar be moaning" (Charles Kingsley) 943

e) 1854 OWS Miss Eliza Sharpe: "The path of sorrow, and that path alone,
Leads to the land where sorrow is unknown" 271

1857 BI Miss Jessie Macleod: "Infancy sleeping at the entrance of
the Valley of Tears"
"Sleep on - thy guardian angel watches o'er thee,
Sleep on - unconscious of the coming strife,
Little thou knowest all that lies before thee
In that mysterious valley we call life!

Pilgrims on their way are winding slowly,
Peasant and prince and mitred priest are there,
But, be their lot amid the higher lowly,
Tears mingle in the cup that all must share.

Many grow weary - weary of the way,
And proud hearts break, disdaining to repine,
But Hope points on to realms of brighter day,
And gilds the future with a ray divine" 312

1859 RA Miss Emily Osborn:"Presentiments" 943
(quotation has already been given in F2d)

1859 SBA Miss E. Edwards: "Oh woman, in our hours of ease,
Uncertain, coy and hard to please,
 * * *
When pain and anguish wring the brow,
A ministering angel thou" 238

f) Other literary works with glosses:-
 1851 SBA Ambrosini Jerome: "Sleep"
 "Enjoy the honey dew of slumber,
 Thou hast no figures now, no fantasies,
 Which busy care draws in the trains of men;
 Therefore thou sleepest so sound" (Shakespeare) 323
 1856 OWS Margaret Gillies: "The students"
 "Those that eye to eye shall look
 On knowledge . . .
 . . . In their hand
 Is nature like an open book" (Tennyson) 177
 1856 NSPW Emily Farmer: "Castle Building"
 "Smile, if you wilt at him,
 Whose calm, unsaddened eyes
 Are beaming as they watch
 His mimic mansion rise.
 Yet ask thy heart, hast thou
 Ne'er toiled, with anxious thought,
 On structures still more frail
 Than childhood ever wrought?" 137
 1857 SFA Anna E. Blunden: "The Sister of Mercy"
 "Sick, and ye visited me" (Matt. ch.25, v.36) 97
 (probably the same work as that exhibited by the artist
 - without a quotation - at the Royal Academy in 1856,
 no. 125)
 1857 SFA C.S. Lane: "Maidenhood"
 "Standing with reluctant feet,
 Where the brook and river meet" (Longfellow) 292
 1857 RA Miss M.E. Dear: "The sisters"
 "No wing of wind the region swept,
 But over all things brooding slept
 The quiet sense of something lost" (Tennyson) 821
 1858 SFA Eliza Mills: "Love and friendship"
 "In all places, then, and in all seasons,
 Flowers expand their light and soul-like wings;
 Teaching us, by most persuasive reasons,
 How akin they are to human things" 40
 1858 SFA A. Jervis: "England's Eldest Daughter"
 "Here we trace, - Ah, no! that eye -
 Where azure floats in liquid fire;
 Must all the painter's art defy,
 And bid him from the task retire.

 Here we behold its beauteous hue;
 But where's the beam, so sweetly straying,
 Which gave a lustre to its hue,
 Like Luna, o'er the ocean playing" - Byron 176
 1858 SFA Miss Emma Brownlow: "The 'Novel'"
 "Ready she sat, with one hand to turn o'er
 The page to which her thoughts ran on before" 25
 1859 SBA Miss Kate Swift: "Ready she sits with one hand to turn o'er
 The page to which her thoughts ran on before" 163
 1859 SFA Amy Butts: "Maidenhood"
 "Standing with reluctant feet
 Where the brook and river meet,
 Womanhood and childhood fleet" 143
 1859 SFA Leila Hawkins: "Sacred Music"
 "Angels, ever bright and fair,
 Take, O take me to your care" 202

g) Two landscapes were accompanied by quotations:-

1858 SFA Marianne Stone: "The Tweed, Eildon Hills, Melrose in the
 distance"
 "Oh Tweed, gentle Tweed, - as I pass your green vales,
 More than life, more than love, my tired spirit inhales;
 There Scotland, my darling, lies full in my view,
 With her barefooted lassies, and mountains so blue"
 (Robert Bloomfield's "Highland Drover's return from
 England") 306

1859 SFA Eliza Mills: "Gwindy-Llanfair Fechan, N. Wales"
 "And one bare dwelling; one abode, no more!
 It seem'd the home of poverty and toil
 Though not of want" 6

G2. 1860 RA Miss Rebecca Solomon: "Peg Woffington's visit to Triplet"
 "If it was art, glory be to such art so worthily applied
 and honour to such creatures as this, that come like
 sunshine into poor men's houses, and tune drooping hearts
 to daylight and hope" (Charles Reade's "Peg Woffington")
 269

1860 OWS Margaret Gillies: "Imogene after the Departure of Posthumous"
 " * * * I here abide the hourly shot
 Of angry eyes, not comforted to live,
 But that there is this jewel in the world
 That I may see again" ("Cymbeline" Act 1, Sc.2) 180
 ("Imogen is here presented seated and in profile, the
 face slightly turned up, sweetly eloquent in utterance of
 patient sentiment embodied in the verse. It is altogether
 a chaste and elegant composition - etc." ("Art Journal"
 1860, p.175))

1860 OWS Mrs Criddle: "My father urged me sair, but my mither didna
 speak,
 But she looked in my face till my heart was like to break;
 They gie'd him my hand, tho' my heart was at sea,
 And Auld Robin Grey is gude man to me" 184

1860 SFA Miss Adelaide Burgess: "Evangeline"
 "Sat by some nameless grave and thought
 That perhaps in its bosom
 He was already at rest" 176

1860 SFA Miss Margaret Beal: "Far from the joyous festival
 Sits in her sequester'd bower,
 With no-one near" 230 (Nourmahal in "Lalla Rookh")

1860 SFA Miss E.F. Strong: "Elaine bearing the slave-token to Sir
 Lancelot" 163

1860 SBA Miss Miles: "The Lily Maid of Astolat"
 "In her right hand the lily, in her left
 The letter; all her bright hair streaming down;

 And all the coverlid was cloth of gold,
 Down to her waist, and she herself in white
 All but her face, and that clear featured face
 Was lovely, for she did not seem as dead,
 But fast asleep, and lay as though she smiled" Idylls
 of the King 675

1861 RA Miss A. Burgess: "The Duet" (Thackeray's "Esmond") 780

1861 PG Justina Deffell: "Broomfield Hill"
 "Take ye the rings off your fingers,
 Put them on his right hand,
 To let him know when he does awake,
 His love was at his command" (Scott's "Border Minstrelsy") 512

1861 OWS Mrs Criddle: "Guinevere and the little Novice"
 "Then to her own sad heart
 Muttered the Queen,
 Will the child kill me
 With her innocent prate?" ("Idylls of the King") 16
1861 SFA Margaret Gillies: "Edith and Major Bellenden watching from
 the Battlements of the Castle the Approach of the Life
 Guards" ("Old Mortality") 153
1861 SFA G. Swift: "Last of the Barons"
 "Sibyll, meanwhile, seated herself abstractedly on a heap
 of faggots piled in the corner, and seemed busy in fram-
 ing characters on the dusty floor with the point of her
 slipper .. The man pursued his work - the girl renewed
 her dreams - The silence was unbroken, for the forge and
 model were now at rest, save by the grating of Adam's
 file upon the metal" (vide "The Last of the Barons") 84
 (Bulwer Lytton)
1862 SBA Ambrosini Jerome: "Falstaff and Mrs Ford"
 "'Have I caught thee, my heavenly jewel! Why now let me
 die, for I have lived long enough: this is the period of
 my ambition; oh, this blessed hour!'
 Mrs Ford: 'O sweet Sir John!'" 456
1862 SFA Naomi Burrell: "Blanch of Devon"
 "In tatter'd weeds and wild array
 * * * *
 She sate beneath the birchen tree,
 Her elbow resting on her knee;
 She had withdrawn the fatal shaft,
 And gazed at it, and feebly laugh'd" (Scott's "Lady of the
 Lake") 280
1862 SFA Miss Scott: "Lalla Rookh"
 "During the latter part of the journey, she had sunk into
 a sadness, from which nothing but the presence of the
 young minstrel could wake her" 256
1863 RA Mrs C. Newton: "Elaine"
 "Then to her tower she climb'd, and took the shield,
 There kept it, and so lived in fantasy" - From
 Tennyson's "Idylls" 333
1863 SBA Miss Edwards: "Catherine Glover and the Glee Maiden attempt-
 ing to succour the imprisoned Duke of Rothsay" (Scott's
 "Fair Maid of Perth") 407
1863 SFA A.H.: "Elaine bearing the shield of Sir Launcelot" 242
1864 BI Miss C. Walker: "The Nautch Girls"
 "The dancing girl oft hath sung
 Of love, which other hearts has wrung,
 But of that love - love all her own -
 No other heart that love hath known" (Hafiz) 203
1864 SBA Madame de Feyl: "Jephtha and his Daughter" 462
 (the quotation from Byron is given in V)
1864 SBA Mrs Wright: "The Peri"
 "One morn a Peri
 At the gate of Eden
 Stood disconsolate" - (Thomas Moore) 877
1865 RA Alyce Thornycroft: "Edith seeking the body of Harold" sculp-
 ture 929 (Bulwer Lytton)
1865 RA Mrs M. Robinson: "Rosalind and Celia"
 "Celia: 'O my poor Rosalind! whither wilt though go?
 Wilt thou change fathers? I will give thee mine.
 I charge thee, be not thou more griev'd than I am'.
 Rosalind: 'I have more cause'" ("As You Like It" Act 1,
 sc. 3) 430

1865 BI Alyce Thornycroft: "Ophelia at the Brook" 643
1865 DG Miss Juliana Russell: "Desdemona and Emilia"
 "Emil: 'How do you, Madam?
 How do you, my good lady?'
 Des: 'Faith, half asleep'" ("Othello " Act 4,sc.2) 58
1865 DG Lizzie Wormald: "From Keats' 'Isabel, or the Pot of Basil'"
 139
1865 SFA Clara E.F. Kettle: "Cleopatra taking the Asp from Charmian"
 ("Anthony and Cleopatra" Act 5, sc.2) 249
1866 BI Alyce Thornycroft: "Edith in search of Harold on the field of
 Hastings" plaster 645
 (probably the same work as that exhibited at the Royal
 Academy in 1865, no.929)
1866 SBA Mrs Curwen Gray: "Oft hae I roamed by bonnie doon
 To see the rose and woodbine twine;
 When ilka bird sang of its love,
 And fondly sae did I of mine" - Burns 503
1866 SBA Miss A. Howard: "Romeo and Juliet" 826
1866 SBA Adele Matthews: "Long was the good man's sermon,
 Yet it seemed not so to me,
 For he spake of Ruth the beautiful,
 And still I thought of thee" - (Longfellow) 880
1866 SBA Miss Austin Carter: "Desdemona and Emilia"
 "Des.: 'My mother had a maid called Barbara; she had a
 song of "Willow": an old thing 'twas, but it expressed
 her fortune, and she died singing it. That song tonight
 will not go from my mind'" 781
1866 DG Miss O.P. Gilbert: "Rosaline"
 "O, he hath drawn my picture in his letter!" ("Love's
 Labour Lost") 305
1866 DG Juliana Russell: "Isabella"
 "Hung over her sweet Basil evermore" (Keats) 38
1866 DG Florence Claxton: "Dante Aleghieri" from "La Vita Nuova" 484
1866 DG Juliana Russell: "Annie"
 "Often
 Her hand dwelt lingeringly on the latch
 Fearing to enter" ("Enoch Arden") 178
1866 OWS Mrs Criddle: "Ophelia"
 "There's a daisy; I would give you some violets,
 But they withered all when my father died" ("Hamlet"
 Act 4, sc.5) 212
1866 SFA A.L.: "Nourmahal"
 "Hence it is, too, that Nourmahal,
 Amid the luxuries of this hour,
 Far from the joyous festival,
 Sits in her own sequestered bower
 * * * * " 74
1866 SFA J. Joy: "Queen Guinevere's Dream"
 "Or if she slept, she dreamed
 An awful dream, for then she seemed to stand
 On some vast plain before a setting sun,
 And from the sun there swiftly made at her
 A ghastly something, and its shadow flew
 Before it, till it touch'd her, and she turn'd -
 When lo! her own, that broadening from her feet
 And blackening, swallowed all the land and in it
 Far Cities burnt" - (vide Tennyson's "Idylls of the
 King") 117

1866 SFA Alyce Thornycroft: "Ophelia at the Brook" sculpture 400
 (probably the same work as that exhibited at the
 British Institution in 1865 (no.643))

1867 DG Marie Spartali: "The Lady Pray's Desire"
 "Pensive I own I am, and sad of mien;
 The great desire of glory and of fame"
 (Spenser's "Faerie Queene") 606

1867 OWS Mrs Criddle: "Helena"
 "O, were that all! - I think not on my father:
 What was he like?
 I have forgot him: my imagination
 Carries no favour in it, but Bertram's.
 It were all one,
 That I should love a bright particular star
 And seek to wed it, he is so above me"
 (Shakespeare "All's Well that End's Well") 93

1867 SFA Miss Adelaide Claxton: "The Courtship of Sir Charles
 Grandison" 259

1867 SFA Alyce Thornycroft: "Edith in search of the Body of Harold"
 sculpture 399
 (probably the same work as that exhibited at the Royal
 Academy in 1865 (no.929) and at the British Institution
 in 1866 (no.645)

1867 SFA Ellen Partridge: "Jessica"
 "Young Jessica sat all the day,
 Her heart on idle love-thoughts pining
 Her needle bright beside her lay,
 So active once, now idly shining" (Moore) 73

1867 SFA L. Swift: "Your ringlets, your ringlets, which look so golden
 gay,
 If you will give me one, but one, to kiss it night and
 day,
 Then never chilling touch of time shall turn it silver
 grey,
 And then shall I know it is all true gold,
 To flame and sparkle and stream as of old,
 Till all the comets in Heaven are cold
 And all her stars decay" (Tennyson) 187

1867/8 NSPW Sarah Setchell: "His mother smiling, whispered - 'Let him go
 and seek the licence'
 Jesse answered, 'No', but Colin went" (vide Crabbe's
 "Tale of Jesse and Colin") 43

1868 SBA Miss E. Percy: "Elaine"
 "Then when she heard his horse upon the stones
 Unclasping flung the casement back and looked
 Down on his helm" ("Idylls of the King") 794

1868 SBA Miss E. Montalba: "Portia"
 "By my troth, Nerissa, my little body is a-weary
 Of this great world" ("Merchant of Venice") 505

1868 OWS Mrs Criddle: "Lady Macbeth: 'Out, out, damned spot'"
 ("Macbeth" Act V, sc.1) 178

1868 OWS Mrs Criddle: "Cordelia with the letter" ("King Lear") 184

1868 DG Kate Greenaway: "Kilmeny"
 "Then deep in the stream her body they laid
 That her youth and beauty never might fade" 203

1868 DG Catherine A. Edwards: "Go, go! - I deem
 Thou canst not surely be the same that thou didst seem
 I will not harm her, by all saints I swear,
 Quoth Porphyro: 'O may I ne'er find grace
 When my weak voice shall whisper its last prayer,

If one of her soft ringlets I displace,
Or look with ruffian passion in her face"
(Keats' "Eve of Saint Agnes") 336

1868 SFA Miss A. Carter: "Elaine"
" Day by day
Leaving her household and good father, climb'd
That eastern tower, and entering barr'd her door,
Stript off the case, and read the naked shield,
Now guess'd a hidden meaning in his arms,
Now made a pretty history to herself
Of every dint a sword had beaten in it,
And every scratch a lance had made upon it,
Conjecturing when and where" 79

1868 SFA Miss A. Carter: "Elaine"
"And in those days she made a little song,
And call'd her song 'The song of Love and Death'" 80

1868 SFA E.J. Rowlands: "Hinda"
"Such is the maid, who at this hour,
Hath risen from her restless sleep,
And sits alone in that high bower,
Watching the still and moonlight deep
 * * * *
Whom waits she all this lonely night?
Too rough the rocks, and too bold the steep,
For man to scale that turret's height" (Moore) 138

1868 SFA Mrs Alexander Melville: "'Amy' from Tennyson"
"Then her cheek was pale and thinner than should be for
 one so young
And her eyes on all my motions with a mute observation
 hung,
And I said, 'My cousin Amy, speak, and speak the truth
 to me:
Trust me, cousin, all the current of my being sets to
 thee'" 318

1869 RA Miss Rebecca Solomon: "Helena and Hermia"
"O and is all forgot?
All school-days' friendship, and childhood innocence.
We Hermia, like two artificial gods,
Have, with our needles, created both one flower;
Both on one sampler, sitting on one cushion,
As if our hands, our sides, and minds
Had been incorporate" (Shakespeare) 785

1869 SBA Miss F. Maplestone: "The death of Edward, Prince of Wales, son
of Henry VI, after the battle of Tewkesbury"
"Queen Margaret: 'O Ned, sweet Ned! Speak to thy mother
 boy!
Canst thou not speak? - O traitors, murderers!"
(Vide "Henry VI" Act V, sc.5) 945

1869 SBA Miss A. Carter: "Celia and Rosalind"
"Ce: 'O my poor Rosalind, whither wilt thou go?
Wilt thou change fathers? I will give thee mine.
I charge thee be not thou more griev'd than I am'
Ros: 'I have more cause'" ("As You Like It" Act 1, sc.3)
1068

1869 OWS Mrs Criddle: "Juliet and Nurse"
"Nurse: 'Faith, here 'tis: Romeo
Is banished; and all the world to nothing,
That he does ne'er come back to challenge you;
Or, if he do, it needs must be by stealth.
Then, since the case so stands as now it doth,
I think it best you married with the county.

```
                    O, he's a lovely gentleman!
                    Romeo's a dishclout to him ...'
                    Juliet: 'Speaketh you from thy heart?'"
                    (Act 3, sc.5) 217
     1869 SFA  Miss Eliza Turck: "I sit on my creepie,
                    I spin at my wheel,
                    And I think o' the laddie
                    That lo'ed me sa weel;
                    He had but a saxpence,
                    He brak it in twa,
                    And he gi'ed me the hauf o't
                    When he ga'ed awa" (Vide "Logie o'Buchan") 439
     1869 SFA  Miss Austin Carter: "She sat her down
                    Upon a musnud's edge, and, bolder grown,
                    In the pathetic mode of Isfahan,
                    Touch'd a preluding strain, and thus began:
                    'There's a bower of roses by Bendemeer's stream'"
                    ("Lalla Rookh") 77
```

H2. 1860 BI Justina Deffell: "Effie Deans" 368
 1860 RA Adelaide Burgess: "Hans Christian Andersen's Little Match
 Girl" 765
 1860 SFA Mrs Margaret Robinson: "Olivia and Sophia in their Sunday
 finery"
 "They both loved laces, ribands, bugles, and catgut"
 ("Vicar of Wakefield" chapter 4) 63
 1860 SFA Adelaide Burgess: "Tennyson's Mariana" 96
 1860 SFA Mrs Valentine Bartholomew: "Portrait of Miss Glynn as
 Cleopatra" 147
 1860 SFA Adelaide Burgess: "Hetty - vide 'Adam Bede'" 153
 1860 SFA Mrs Hawkins: "Betsy - see Punch's Calendar of Fireside
 Saints" 154
 1861 PG Mrs F. Yeames: "Rosalind" 94
 1861 SFA Madame O'Connell: "Faust et Marguerite" 28
 1861 SFA Mrs R.H. Major: "Little Red Riding-Hood" 90
 1862 OWS Mrs Criddle: "Study for Ophelia" ("Hamlet" Act 3, sc.1) 183
 1862 OWS Mrs Criddle: "Cinderella" 212
 1862 BI Miss S. Simpson: "Maud"
 "Queen rose, of the rosebud garden of girls,
 Come hither, the dances are done,
 In gloss of satin and glimmer of pearls,
 Queen lily and rose in one" (Tennyson) 292
 1862 SBA Miss Edwards: "Rosalind and Celia" ("As You Like It") 208
 1862 SBA Mrs Friswell: "Adeline" (vide Tennyson's Poems) 338
 1862 SFA Miss Justina Deffell: "Effie Deans in the Tolbooth" 4
 1862 SFA Mrs H. Moseley: "Miranda" (vide "The Tempest") 94
 1862 SFA Miss Agnes Millais: "The Blind Beggar of Bethnal Green" 107
 1863 SBA Mrs Rossiter: "Little Nell" 425
 1863 BI Miss F. Young: "Nourmahal" 32
 1864 OWS Eliza Sharpe: "Cinderella" 191
 1864 BI Mrs D. Wright: "Red Riding Hood" 152
 1864 SBA Miss Austin Carter: "Alma" (vide Spenser's "Faerie Queene"
 book 2, canto ix) 860
 1864 NSPW Mrs Clarendon Smith: "Little Red Riding Hood" 150
 1864 SFA Miss Eliza Martin: "Evangeline" 107
 1865 BI Mme de Feyl: "Britomart" (vide Spenser's "Faerie Queene") 302
 1865 BI Miss Inglis: "A Puritan Girl"
 "Dreams and shadowy mem'ries of the past
 Breathing 'round their hallowed calm" 101 (Tennyson ?)

1865 RA Mrs F.L. Bridell: "Little Ellie" (see "Romance of the Swan's
 Nest" by Mrs Browning) 608

1865 RA Mrs D.O. Hill: "Miranda" marble
 "Prospero: 'The fringed curtains of thine eyes advance,
 And say what seest thou yond'.
 Miranda: 'What is't, a spirit? Believe me, sir,
 It carries a brave form'"- (vide "Tempest") 1013

1865 SBA Miss A. Carter: "The Lady of Shalott" 862

1866 SBA Adelaide Claxton: "The Lady of the Lake" 883

1866 SBA Miss A. Howard: "Romeo and Juliet" 826

1866 SBA Mrs Margaret Robbinson: "Ophelia" 476

1866 DG Miss Beresford: "Erminia" 437

1866 SFA Alicia Laird: "Little Nelly" 17

1866 SFA Eliza Martin: "'Lilly Dale' - 'The Small House at Arlington'"
 50 (Trollope)

1866/7 NSPW Mrs Clarendon Smith: "Little Red Riding Hood" 105

1867 SBA Mrs Charretie: "Rumplestilchken"
 "The young lady who tried to spin gold out of straw"
 (vide Grimm's Goblins) 62

1867 SBA Miss A. Carter: "Cordelia" 709

1867 DG Marie Spartali: "The Pasha's Widow" 79

1867/8 NSPW Mrs Clarendon Smith: "Nanny Elmes" (vide "Stones Edge") 379

1868 RA Miss F.B. Baskett: "Ophelia" marble 1011

1868 SBA Miss E. Brock: "Mariana in the Moated Grange" 806

1868 DG Louisa Starr: "Mariana" 481

1868 DG(oil)Rebecca Solomon: "Helena" (from Shakespeare's "All's Well that
 Ends Well") 203

1868 SFA Myra Drummond Pointer: "Elaine" 398

1868 SFA Elizabeth Royal: "Shadowy, dreaming Adeline" (Tennyson) 24

1868 SFA Miss Lane: "La Belle Dame Sans Merci" 31

1868 SFA Adelaide Burgess: "Hans Christian Andersen's 'Little Match
 Girl'" 115

1868 SFA A.L.: "Cleopatra" 171

1868 SFA Miss Amy Butts: "Elaine" 322

1868 SFA Henrietta Faed: "Clelia" (from Crabbe's "Borough") 335

1868/9 NSPW Mrs Clarendon Smith: "Cinderella" 180

1869 SFA Miss Lane: "Cinderella" 8

1869 SFA Mrs Swift: "Adeline" 19

1869 SFA Miss Adelaide Burgess: "Little Nell" 38

1869 SFA Louise B. Swift: "Ophelia" 380

1869 SFA Mrs Alexander Melville: "The May Queen"
 "I thought to pass away before,
 And yet alive I am,
 And in the fields all round I hear
 The bleating of the lamb.
 How sadly I remember rose the
 Morning of the year!
 To die before the snow-drop came,
 And now the violet's here" Tennyson 389

1869 SBA Mrs H. Champion: "Little Dorrit" 826

1869 SBA Mrs H. Champion: "Daphne" (Gessner's "Idylls") 829

1869 DG Marie Spartali: "Nerea Foscari" 461

I2. 1860 BI Miss M. Bleaden: "As You Like It" (Act 3, sc.3) 166

1861 SBA Miss Selous: "Hetty's Toilet" (vide "Adam Bede") 355

1861 BI Miss Jessie Macleod: "The Low-backed Car"
 "When first I saw sweet Peggy
 Twas on a market day,
 A low-backed car she drove, and sat
 Upon a truss of hay" 423

1861 PG Justina Deffell: "Rose Bradwardine asking Edward Waverley
to construe a stanza in Tasso" (Vol.1, ch.14 of
"Waverley") 567
(The artist exhibited a work with the same title at
the Society of Female Artists in 1862 no.8)

1861 SFA Mrs Elizabeth Bailey: "They said you was a-ringing, Sir"
(Boots at the Swan) 299

1862 SBA Miss J.C. Bell: "Eve of battle; in the camp near Sardis"
"Brutus: 'Ha! who comes here?
I think it is the weakness of mine eyes
That shapes this apparition.
Speak to me what thou art'.
Ghost of Caesar: 'Thy evil spirit, Brutus'" (see
Shakespeare's Tragedy of "Julius Caesar" Act IV, sc.3) 864

1863 SBA Ambrosini Jerome: "Anne Page and Slender"
"Anne: 'I pray you, Sir, walk in'
Slender: 'I had rather walk here, I thank you; I bruised
my shin the other day with playing at sword and dagger
with a master of fence. Three veneys for a dish of
stew'd prunes; and by my troth, I cannot abide the smell
of hot meat since. Why do your dogs bark so? Be there
bears in the town?'
Anne: 'I think there are, Sir; I heard them talked of'"
"Merry Wives of Windsor" 351

1863 OWS Mrs Criddle: "Rosalind and Celia"
"Celia: 'Why cousin - why Rosalind! Cupid have mercy!
Not a word'" (Shakespeare, Act 4, sc.3) 180

1863 OWS Mrs Criddle: "Taming of the Shrew" (Shakespeare Act 4, sc.3)207

1864 SFA S.E.K: "Enid"
"And stood behind and waited on the three" - ("Idylls of
the King") 122

1864 SFA Augusta de Feyl: "Saladin disguised as a physician, visiting
Richard Coeur de Lion, when ill with a fever in the Holy
Land" (vide, Sir Walter Scott's "Talisman") 192

1864 SFA Miss Swift: "Hetty"
"With a sudden impulse of gaiety, Hetty stuck the roses
in her hair a little above the left ear; the admiration
of Adam's face was slightly overshadowed by reluctant
disappointment" 159

1864 SFA Miss Fraser: "Illustrations for Six of Hans Andersen's Fairy
Tales" 229

1864 SBA Miss Deffell: "Isabel Vere going to seek the assistance of the
Black Dwarf, with the token rose in her hand" 266
(the artist exhibited a work with the same title at the
Society of Female Artists in 1865 no.163)

1864 SBA Ambrosini Jerome: "Mrs Page and Mrs Ford"
"Mrs Page: 'Letter for letter; but that the name of Page
and Ford differs!'
Mrs Ford: 'Why this is the very same, the very hand, the
very words'
'What does he think of us?'" 556

1864 SBA Miss Miles: (vide "Hamlet" Act 3) 900

1865 SBA Charlotte E. Babb: "Emily in Italy"
"And of a sudden, this child held out her hand, and said
what would be in English, 'Fisherman's daughter, here's
a shell'" ("David Copperfield") 418

1865 SBA Miss Austin Carter: "Scene from 'Twelfth Night'"
"Viola: 'I am messenger'" 876

1865 RA Mrs A. Farmer: "Old Mother Hubbard
 Went to the cupboard
 To get her poor dog a bone" 507
1866 SBA Miss Hunter: "Red Riding Hood's Toilet" 190
1866 SBA Jessie Macleod: "The gardener's daughter"
 "For up the porch there grew an Eastern rose,
 That flowering high the last night's gale had caught
 And blown across the walk. One arm aloft -
 Gown'd in pure white, that fitted to the shape -
 Holding the bush to fix it back she stood" -
 (Tennyson) 691
1866 SFA Mrs J.F. Pasmore: "Miss Fanny crept slily and griping me fast,
 Declared she had caught the sweet creature at last,
 And she held me so tight in her pinafore tied,
 That before she got home I had like to have died -" 182
1866 SFA Miss Charlotte Babb:
 "Lucentio: 'Then give me leave to read philosophy
 And, while I pause, serve in your harmony'
 Hortensio: 'Sirrah, I will not bear these braves of thine'"
 ("Taming of the Shrew" Act 3, sc.1) 249
1867 SFA Helen Coode: "On Guard"
 "The crossbowman had not taken up his position long,
 before a head was thrust through the tapestry behind him,
 and Marion in a coaxing voice besought him to follow her.
 'Now beshrew me', said poor Roff to himself, 'but I am
 sore beset'" - (vide "The Bridge of Knightsbridge") 233
1867 DG(oil) Gertrude Martineau:
 "Little Bell sat down amid the fern:
 'Squirrel, Squirrel! to your task return;
 Bring me nuts!' quoth she
 * * *
 Little Bell looked up and down the glade;
 'Squirrel, Squirrel, from the nut-tree shade,
 Bonny Blackbird, if you're not afraid,
 Come and share with me!'
 Down came Squirrel, eager for his fare,
 Down came bonny Blackbird, I declare;
 Little Bell gave each his honest share -
 Ah, the merry three" T. Westwood 248
1867 RA Miss Louisa Starr: "Composition from 'The Taming of the Shrew'"
 613
1867 SBA Miss Austin Carter: "Sir Roger de Coverley's visit to the
 Widow"
 "Her confidant sat by her, and upon my being in the last
 confusion and silence, this malicious aid of her's turn-
 ing to her says, 'I am very glad to observe Sir Roger
 pauses upon this subject, and seems resolved to deliver
 all his sentiments upon the matter when he pleases to
 speak'. They both kept their countenances, and after I
 had sat half-an-hour meditating how to behave before such
 profound casuists, I rose up and took my leave"
 (vide "Spectator" no.113) 757
1868 SFA E.V.B.: "Illustrations to 'The Story Without an End'" 237
1868 SFA Ellen Partridge: "Compact of Jars" - (vide "As You Like It")260
1868 SBA Mrs Sophie Anderson: "Red Riding Hood"
 "My grandmother lives in the house beyond the mill" 196
1868 OWS Margaret Gillies: "Nelly and her Grandfather in the Church"
 (See Dickens' "Old Curiosity Shop") 5

1869 DG(oil) Jessie Macgregor: "Sophia sitting for her portrait"
"Sophia was to be a shepherdess, with as many sheep as the painter could put in for nothing" ("Vicar of Wakefield") 3

1869 DG Charlotte Babb: "Meantime, on shady levels, mossy fine,
Young companies nimbly began dancing
To the swift treble pipe, and humming string"
("Endymion") 147

1869 DG Kate Greenaway: "The Fairies of the Caldon Low"
"And where have you been, my Mary
And where have you been from me?
I've been to the top of the Caldon-Low
The Midsummer night to see!
 * * *
A Hundred Fairies danced last night" (Mary Howitt) 134

1869 DG Juliana Russell: "When we were to assemble in the morning, at breakfast, down came my wife and daughters, dressed out in all their former splendour" ("Vicar of Wakefield" chapter 4) 175

1869 SBA Miss Austin Carter: "Much Ado About Nothing"
"Hero: 'These gloves the count sent me; they are an excellent perfume'
Beatrice: 'I am stuffed, cousin, I cannot smell'
Margaret: 'There's goodly catching of a cold'" 668

1869 SFA A.L.: "Scene from Whyte Melvill's Gladiatures"
"Myrrhina took the pouncet box from one of the girls, and proceeded to sprinkle gold dust in Valeria's hair" (Chapter 4) 91

1869 SFA Alyce Thornycroft: "Laura and Lizzie"
"Laura started from her chair,
Flung her arms up in the air" (Christina Rossetti's "Goblin Market") 170

1869 SFA Mrs Alexander Melville: "'Look here', said Rose, with laughing eyes,
'Within this box, by magic hid,
A tuneful sprite imprison'd lies,
Who sings to me whene'er he's bid
Though roving once his voice a wing,
He'll now lie still the whole day long,
Till thus I touch the magic spring:
Then hark! how sweet and blithe his song'" (Moore's "Irish Melodies") 382

J2. 1860 NSPW Miss Farmer: "Stringing Egg-Shells"
"So he whom keen ambition prompts to climb
When he hath won the trophies which he sought,
Is blind to all the ruin he hath wrought" 318

1860 SFA Mrs Elizabeth Murray (Teneriffe): "Resignation"
"Time tempers love, but not removes -
More hallowed when its hope is fled" 105

1861 RA Miss J.C. Bell: "Mad from life's history,
Glad to death's mystery,
Swift to be hurl'd,
Anywhere, anywhere,
Out of the world" (Hood, "The Bridge of Sighs") 821

1861 OWS Mrs Criddle: "The Vacant Chair"
"Thou that she loved so long and sees no more,
Loved and still loves, - not dead, but gone before" 37

1862 SFA Mrs Robertson Blaine: "Study of a Head"
 "Ah, me! The deeply sorrowing heart reveals,
 Th'abiding ever present source of grief,
 Upon her young but care-worn face
 Which stains the mem'ry of her race" 50

1864 SFA Miss Emma Brownlow: "The Orphans"
 "When Parents, yielding to distress,
 Their helpless charge forsook,
 Then Nature's God look'd down to bless
 And pity on us took" - ("The Foundling's hymn") 204

1864 OWS Mrs Criddle: "Retrospection"
 "When, in the sessions of sweet silent thought,
 I summon up remembrance of things past,
 I sigh the lack of many a thing I sought,
 And with old woes now wail my dear time's waste" 123

1865 BI Mrs D. Wright: "Regrets"
 "Nessum maggior dolore che ricordarse del tempo felice
 nella miseria" - (Dante) 464

1865 RA Miss E. Martin: "At the Carnaval"
 "She dreams on him that has forgot her love"
 (Shakespeare) 634

1865 SBA Miss O.P Gilbert: "'Tis better to have loved and lost,
 than never to have loved at all" 977

1866 SBA Miss Hunter: "The Portrait"
 "Oh for the touch of a vanished hand
 And the sound of a voice that is still" 712

1866 RA Miss Hunt: "Hard Times" 67
1866 SFA Emma Brownlow: "Between the Acts"
 "Oft pining care in rich brocade is drest
 And diamonds glitter on an anxious breast" 225

1866 SFA Charlotte Babb: "One guiding memory I shall take,
 Of what she prayed that I might be
 And what I will be for her sake" (Miss Procter) 261

1867 DG Eliza Martin: "Life is not good - one day it will be good
 To die, then live again,
 Meanwhile to sleep" 53

1867 DG Miss Frazer: "Sweet and low, sweet and low,
 Wind of the western sea,
 Low, low, breathe and blow,
 Wind of the western sea!
 Over the rolling waters go,
 Come from the dying moon, and blow,
 Blow him again to me;
 While my little one, while my pretty one,
 Sleeps" (Tennyson's "The Princess") 676

1867 DG(oil) Miss A. Butts: "The likeness of a nun: I seemed to trace
 A world of sorrows in the patient face" 116

1867 SBA Miss J. Saville: "Long I looked out for the lad she bore
 On the open desolate sea,
 And I think he sailed to the heavenly shore,
 For he came not back to me
 Ah me!" (from Jean Ingelow) 148

1867 SFA Miss Hunter: "Bad News"
 "The days of affliction have taken hold of me" ("Job")
 577

1867 SFA Miss Hunter: "The Father's Portrait"
 "Oh, for the touch of a vanish'd hand
 And the sound of a voice that is gone" 165
 (The work and "The Portrait" (1866 SBA no.712) earlier
 in the list, may be the same work)

1867 SFA Miss Florence Claxton : "Moved on"
 "He is not here, but far away ,

```
                    The noise of life begins again,
                    And ghastly thro' the drizzling rain
                    On the cold streets breaks the blank day"(Tennyson)364
```

1868 DG Juliana Russell : "Oh, wherefore suld I busk my head ?
 And wherefore suld I comb my hair ?
 Since my troth-live has me forsook,
 And says he'll never lo'e me mair" 19

1868 DG Rebecca Solomon : "Memories"
 "I cannot but remember that such things were ;
 And were most precious to me"(Shakespeare) 147

1868 DG Jane Swallow : "Remembrance wakes with all her busy train,
 Swells at my breast, and turns the past to pain"
 (Goldsmith) 199

1868 OWS Margaret Gillies: "The Wanderer" "Her eyes are wild, her
 head is bare,
 The sun has burnt her coal-black hair ;
 Her eye-brows have a rusty stain ,
 And she came far from over the main.
 She has a baby on her arm,
 Or else she were alone" (Wordsworth) 61

1868 OWS Margaret Gillies : "Expectation"
 "The lady's fair hand a swift falcon bore,
 And she had sent him the blue lake o'er.
 Mayst thou come soon,
 Mayst thou come soon !"(German Song) 146

1869 RA Miss Banks : "Reminiscence"
 "The smile that from the picture beams
 Is mirrored in her face ,
 As a bright thought that moves the heart ,
 Lends to the lip a grace" 339

1869 SBA Mrs. Emma Brownlow King : "News from the war"
 "To whom a victory speaks of his return ,
 And a defeat means only he is lost" 327

1869 SBA Miss E. Manton : "By-gone hours come o'er my heart with
 each familiar strain" 1001

1869 SFA Mrs. Alexander Melville : "Weep no more, darling, the dawn
 is breaking -
 There's light on the deep dark sea ;
 For the storm is hushed and the morn awaking,
 And thy peace cometh back to thee" 417

K2. 1864 SBA Mrs. Melville : "Child of joy 'mid sun and flowers,
 Life's one scene of happy hours" 762

1865 OWS Margaret Gillies : "Youth and Age" 197 (+ see vol.1pp146-7)

1865 BI Miss Emma Brownlow : "Lullaby"
 "Let music mingle with the mother's smiles,
 Lulling her babe to sleep with songs at even :
 Songs that will be remembered on the day
 When the child's flaxen locks have turned to grey"598
 (The quote is from Eliza Cook. The work was also exh-
 ibited in 1866 (SBA no. 670))

1866 SBA Ellen G. Hill : "The happy morning of life and of May" 533

1866 SBA Gertrude Gauntlett : "Young Womanhood,
 Ere misplaced love or broken vow
 Had cast its shadow o'er her brow" 935

1866 NSPW Emily Farmer : "A Passing Cloud"
 "Remember thy childhood, yes ! when the brow
 Of a little child is shaded
 By worse than mere sorrow, remember thou
 the days and years that are faded.
 Though evil darken an infant breast,
 No coldness, no anger, in thine should rest ;
 Look back on thy childhood ! and gazing there
 The voice of thy chiding shall turn to pray'r" 315

1867 DG Eliza Martin : "Heaven lies about us in our infancy"

(Wordsworth) 231

1868 SBA Mrs A. Melville: "But there is one more beautiful,
Gay, tender, sweet, and mild,
A baby boy with heart of joy,
A loved and loving child" 562

1868 RA Mrs Robbinson: "The first born"
"Thou art a radiant thing of mirth,
A loving laughing child of earth,
With glossy ringlets rich and bright,
And rosy cheek and eye of light,
And limbs that vigorous life express,
And heart o'er brimmed with happiness,
And spirit unsubdued and wild,
A happy mother's happy child" - (Lines by Mary
Howitt) 345

1869 RA Mrs Charretie: "Childhood! happiest stage of life
Free from care and free from strife" (John Scott) 1045

L2. 1860 PG Charlotte Holder: "Home"
"'Tis sweet to know there is an eye will mark our coming
And look brighter when we come" 422

1861 OWS Margaret Gillies: "Watching"
"Father shall come to his babe in its nest -
Silver sails all out of the west -
Under the silver moon" (Tennyson) 280

1861 SBA Mrs A. Farmer: "The deserter"
" - sweet home, alas that e'er
The dream of thee so loved and fair,
Should tempt to aught that bringeth shame,
Or fear, or sorrow" 548

1867 SBA Miss Jessie Macleod: "The Future Home"
"Towards the vale his hand directs her gaze
And the young bride her future home surveys" 565

1868 SBA Mrs Emma Brownlow King: "Home"
"Home is home, however lowly,
Fenced around by many a spell,
If within its precincts holy
Room be found for love to dwell" 4

M2.a) The following are examples of the use of poetical quotations to empha-
size character, expression and looks. The list is not complete as
instances are extremely numerous:-

1861 SFA Kate Swift: "I know a Maiden fair to see, - beware"
(Longfellow) 309

1861 RA Margaret Gillies: "Study of a Head"
"Looks commercing with the skies,
Thy rapt soul sitting in thine eyes" (Milton) 872

1863 RA Mrs Croudace: "In maiden meditation, fancy free" 349

1866 RA Catherine Adelaide Edwards: "Her brow is like the snowdrift"
736

1867 BI Miss Emma Brownlow: "And meek humility with downcast eyes" 79

1867 BI Miss Emma Brownlow: "Her thoughts on Holy things are bent"381

1867 BI Miss J. Deffell: "Felicia"
"In maiden meditation fancy free" 571

1867 DG(oil) Louisa Starr: "A face that's best
By its own beauty drest
And can alone command the rest" 142

1867 DG(oil) Rebecca Solomon: "A study from Nature"
"Is she kind as she is fair?
For beauty lives with kindness;
Love doth to her eyes repair,
To help him of his blindness,
And, being helped, inhabits there" 24

1868 SBA Mrs Emma Brownlow King: "And meek humility with downcast
 eyes" 303

1868 SBA Miss F.M. Alldridge: "In her was youth, beauty, with
 humble assort,
 Bounty, riches, and womanly feature" 793

1869 SBA Miss E.T. Westbrook: "Hallowed memories floating by" 112

1869 SBA Mrs Sophie Anderson: "Take the fair face of woman, and
 gently suspending,
 With butterflies, flowers and jewels attending,
 Thus your fairy is made of most beautiful things"
 (Charles Ede) 239

1869 DG Miss E. Manton: "For never saw I mien or face
 In which more plainly I could trace
 Benignity and home-bred sense,
 Ripening in perfect innocence" (Wordsworth) 394

b) Some examples of the poeticisation of landscapes, scenes and still-lives:-

1861 SBA Miss Anna Blunden: "Road to Keswick"
 "'Twas summer, and the sun had mounted high:
 Southward the landscape indistinctly glared
 Through a pale stream; but all the northern downs,
 In cleanest air ascending, showed far off
 A surface dappled o'er with shadows flung
 From passing clouds, that lay with steady beams
 Of light and pleasant sunshine interposed" 691

1862 SFA M.S.F.F.: "Bramble Bush"
 "There lives and works
 A soul in all things, and that soul is God
 The beauties of all the wilderness are his,
 That makes so gay the solitary place
 Where no eye sees them" - (Cowper) 102

1862 SBA Sarah Sophia Beale: "The raptur'd eye
 Hurries from joy to joy, and hid beneath
 The fair profusion, yellow Autumn spies" - (Thomson) 653

1863 SBA Miss G. Swift: "So fair, so sweet, withal so sensitive,
 Would that the little flowers were born to live,
 Conscious of half the pleasure which they give" 371

1864 NSPW Mrs Harrison: "I wander'd lonely as a cloud
 That floats on high o'er vales and hills,
 When all at once I saw a crowd,
 A host of golden daffodils;
 Beside the lake, beneath the trees,
 Fluttering and dancing in the breeze" - (Wordsworth)167

1867 SBA Mrs A. Melville: "But now fair flowers - in your dead bloom
 I read a silent tale,
 How dearest memories must fade,
 And deepest love must fail.
 A bitter thought might whisper now,
 It is the common lot
 To live, to love, and then to die,
 And be at last forgot" (From "The Talk of the House-
 hold" by Marian Richardson) 317

1867 NSPW Mrs Harrison: "Oh! then my heart with pleasure fills,
 And dances with the daffodils" - (Wordsworth) 109

1867 RA Miss C.A. Edwards: "I saw the branches of the trees
 Bend down thy touch to meet
 The clover blossoms in the grass
 Rose up to kiss thy feet" - (Longfellow) 770

1867 DG Miss Alyce Thornycroft: "An Apple Gathering"
 "I picked pink blossoms from mine apple tree,
 And wore them all that evening in my hair:
 Then in due season when I went to see
 I found no apples there
 * * *
 I let my neighbours pass me, ones and twos
 And groups; the latest said the night grew chill,
 And hastened: but I loitered, while the dews
 Fell fast I loitered still" (Christina Rossetti) 675

1867/8 NSPW Mrs Harrison: "Tomb of Lycidas"
 "Throw hither all your quaint enamelled eyes

 And every flower that sad embroidery wears.

 To deck the laureat hearse where Lycid lies" -
 (Milton) 184

1868 NSPW Mrs Harrison: "Burns' Diary"
 "Wee modest crimson tipped flower,
 Thou'st met me in an evil hour,
 For I ha' cropped amid the stour
 Thy tender stem.
 To spare thee now were past my power
 Thou bonnie gem" 159

1869 SBA Miss F.M. Keys: "Moonlight on the Lakes, Capel Curig, North
 Wales"
 ". . . The gleam,
 The shadow, and then peace supreme" 846

1869 SBA Miss E. Percy: "A twilight reverie"
 "Sublimely tender, solemnly serene,
 Still as the hour, enchanting as the scene;
 I love thee twilight! for thy gleams impart
 Their dear, their dying influence to my heart"
 (Montgomery) 934

1869 DG Anna Blunden: "Sea and Shore"
 "You can hear that overmore,
 Distance - softened voice, more old
 Than neried's singing, the tide, spent,
 Joining soft issued with the shore,
 In harmony of discontent" 368

1869 DG Alyce Thornycroft: "Lost in Mist"
 "In dark fields dim with dew
 And river mists that rise,
 Hiding the silver river, the rushes and the reeds
 she wanders on" 30

1869 SBA Miss Williams: "Lessons sweet of spring returning" 994

1869 SFA Miss Fanny Vallance: "For low the Winter is past, the Rain
 is over and gone:
 The Flowers appear on the Earth" (Solomon's song) 201

1869 SFA Miss Fanny Vallance: "The Blue Bells"
 "The blue bells, too, that quickly bloom
 Where man was never known to come" 230

N2. Tennyson:-
 1870 RA Miss Sophie Anderson: "Elaine"
 "And the dead, steered by the dumb, went up with the
 flood" 482 (Walker Art Gallery, Liverpool)
 1870 DG(oil) Ellen Partridge: "The mild-eye'd melancholy lotus-eater"169
 1870 SBA Miss Florence Claxton: "Lady Godiva" 892

1870 SBA Miss F. Maplestone: "The Ladie of Shalott"
 "Who is this? and what is here?
 And in the lighted palace near,
 Died the sound of royal cheer,
 And they crossed themselves for fear
 All the knights of Camelot
 But Launcelot mused a little space,
 He said, 'She hath a lovely face,
 God in His mercy give her grace,
 The Ladie of Shalott'" (A. Tennyson) 616

1871 DG(oil) Mrs Charretie: "Sylvia"
 "Picture me dearest, as I sit at rest,
 Thy parting love-gift ever on my breast;
 Each link of that most precious chain of gold
 Is bright with some sweet memory of old" (From "The
 Love Letter") 1

1871 OWS Margaret Gillies: "The Reconciliation"
 "And All the man was broken with remorse;
 And all his love came back a hundredfold;
 And all his love he sobb'd o'er William's child
 Thinking of William" (Tennyson's Dora) 38

1872 RA Mrs Louise Romer:"Queen Vashti refusing to show herself to
 the people"
 "O Vashti, noble Vashti!summon'd out
 She kept her state, and left the drunken King
 To brawl at Shushan underneath the palms" (Tennyson's
 "Princess") 918

1872 SLA Miss Austin Carter: "The Miller's Daughter" - (vide
 Tennyson) 110

1873 DG(oil) Rebecca Solomon: "Enoch Arden" 359

1873 RA Mrs Marie S. Stillman: "The Finding of Sir Lancelot dis-
 guised as a Fool" 729

1873 SLA Eliza Hadwen: "Tennyson's May Queen" sculpture 451

1873 RA Mrs Marie S. Stillman: "La belle Fronde" 836

1873 SBA Mrs Charretie: "Queen Guinevere had fled the court, and sat
 There in the holy house at Almesbury
 Weeping, none with her save a little maid,
 A novice
 Who pleased her with a babbling heedlessness
 * * * * *
 And pray you, which had noblest, when you moved
 Among them, Lancelot or our Lord the King?
 Then the pale Queen looked up and answered her"
 ("Idylls of the King") 468

1873 SLA Louise B. Swift: "Dora" 288

1874 SBA Mrs Charretie: "Enid"
 "And she bethought her of a faded silk
 Which in a cedarn cabinet she kept" - (Tennyson) 348

1874 SLA Jane K. Humphreys: "Alymer's Field" (vide Tennyson) 488

1874 SLA Linnie Watt: "The May Queen" 402

1875 SBA Miss E. Westbrooke: "Maud"
 "In gloss of satin and glimmer of pearls,
 Queen, lily, and rose in one" 459

1875 NSPW Miss Mary L. Gow: "Enid's Wedding Morning"
 "And lo! it was her mother -
 * * ; and in her hand
 A suit of bright apparel which she laid
 Flat on the couch, and spoke exultingly" (Tennyson) 117

1875 SLA Mary Godsell: "Adeline" 331

1875 SLA Janet Archer: "King Arthur leaving the Nunnery, after
 seeing Guinevere" 55

```
1875 RA       Mrs Louise Jopling: "Elaine, the lily maid of Astolat"
              1236
1876 NSPW     Mary L. Gow: "Elaine"
              "Elaine the fair, Elaine the loveable,
              Elaine, the lily maid of Astolat,
              High in her chamber up a tower to the east,
              Guarded      the sacred shield of Lancelot:-
              Then fearing rust or soilure, fashion'd for it
              A case of silk, and braided thereupon
              All the devices blazoned on the shield
              In their own tinct etc." (Tennyson) 39
1876 DG(b&w)  Mrs Edward Hopkins: "The Lotus Eaters"
              "Branches they bore of that enchanted stem
              Laden with flower and fruit, whereof they gave
              to each, but whoso did receive of them
              And taste, to him the gushing of the wave
              Far, far away did seem to mourn and rave
              On alien shores; and if his fellow spake
              His voice was thin, as voices from the grave,
              And deep asleep he seemed yet all awake,
              And music in his ears his beating heart did make"
              (Tennyson) 386
1878 GG       H.R.H. the Princess Louise: "Geraint and Enid"
              "Their three gay suits of armour, each on each,
              And bound them on their horses, each on each,
              And tied the bridle-rein of all the three together,
                          And said to her, 'Drive them on
                          Before you through the wood'
                          He follow'd"  233
1878 RA       Louise Jopling: "The village maid"
              "Who sets her pitcher underneath the spring
              Musing on him who used to fill it for her,
              Hears and not hears, and lets it overflow"
              (Tennyson) 213
1879 SLA      Amelia Goddard: "Elaine"
              "And she by tact of love was well aware
              That Lancelot knew that she was looking at him" 357
1879 SLA      Julianna Lloyd: "Annie Lee"
              "Even to the last dip of the vanishing sail
              She watch'd it" 598 ("Enoch Arden")

Shakespeare:-
1870 SFA      Mrs J.H. Carter: "Portia, wife of Brutus" 67
1870 SFA      Miss A. Carter: "Miranda and Ferdinand"
              "Alas! now pray you
              Work not so hard,
              If you'll sit down
              I'll bear your logs awhile" vide "Tempest" 113
1870 DG       Miss E. Percy: "Rosalind"
              "I would cure you, if you would but call me Rosalind"
              ("As You Like It" Act 3, sc.2) 341
1871 SBA      Miss O.P. Gilbert: "Lady Macbeth"
              "Doctor - 'You see her eyes are open'
              Gent. - 'Ay, but their sense is shut'"
              ("Macbeth" Act 5, sc.1) 710
1871 SFA      S.M. Louisa Taylor: "Mariana in the Moated Grange" 414
1871 SFA      Miss Florence Claxton: "Juliet" 254
1871 RA       Eliza Turck: "Silvia"
              "A heart as full of sorrows as the sea of sands"
              ("Two Gentlemen of Verona") 291
```

1871 DG(oil) Lucy Madox Brown: "Ferdinand and Miranda" 98
1871 DG Lucy Madox Brown: "Romeo and Juliet"
 "O, my love! my wife!
 Death, that hath suck'd the honey of thy breath,
 Hath had no power yet upon thy beauty:
 Thou art not conquer'd" 336 (Wightwick Manor,
 Wolverhampton)
1872 SLA Julia Pocock: "Lady Macbeth" 267
1872 DG Miss O.P. Gilbert:
 "Pet. 'Goodmorrow, Kate; for that's your name, I
 hear'
 Kath. 'Well have you heard, but some thing hard of
 hearing; They call me Katherine, that do talk of
 me'" ("Taming of the Shrew" Act 2, sc.1) 9
1872 DG Juliana Russell: "Sweet, sweet, sweet nurse, tell me,
 what says my love?" ("Romeo and Juliet" Act 2,
 sc.5) 407
1872 DG(oil) Rebecca Solomon: "Rosalind"
 "Enter Rosalind with a paper, reading -
 'From the east to western Ind
 No jewel is like Rosalind;
 All the pictures fairest lined
 Are but black to Rosalind;
 Let no face be kept in mind
 But the fair of Rosalind'" ("As You Like It") 380
1872 OWS Mrs Criddle: "The Young Miranda" 43
1872 OWS Mrs Criddle: "Helena"
 "It were all one
 That I should love a bright particular star,
 And think to wed it; he is so far above me"
 ("All's well that Ends Well") 51
1872 SBA Mrs Charretie: "Mrs Page's first love letter"
 "What, have I 'scaped love letters in the holiday time
 of my beauty, and am now a mark for them?" ("Merry
 Wives of Windsor") 113
1873 SLA Miss A. Carter: "Hermia and Helena" 150
1873 SBA Jane M. Bowkett:
 "Baptista - 'For shame, thou hilding of a devilish
 spirit,
 Why dost thou wrong her that ne'er did wrong thee?
 When did she cross thee with a bitter word?'
 Katherine - 'Her silence flouts me, and I'll be
 revenged'
 Baptista - 'What! in my sight? - Bianca, get thee in'"
 ("The Taming of the Shrew" Act 2, sc.1) 390
1873 RA Miss E. Clacy: "Juliet"
 "What if it be a poison which the friar
 Haply has ministered to have me dead" 784
1874 DG(oil) Miss E. Clacy: "Behind the Arras, hearing something stir"317
1874 OWS Margaret Gillies: "Prospero and Miranda"
 "If by your art, my dearest father, you have
 Put the wild waters in this roar, allay them:
 * * * * Oh! I have suffered
 With those that I saw suffer: A brave vessel
 (Who had no doubt some noble creature in her)
 Dashed all to pieces: Oh! the cry did knock
 Against my very heart" ("The Tempest" Act 1,sc.2) 83
1874 SBA Mrs Bowden: "Juliet" 304

```
1874 SBA     Miss O.P. Gilbert: "Ophelia"
                 "There is a willow grows aslant a brook,
                 That shows his hoar leaves in the glassy stream,
                 There, with fantastic garlands did she come" 701
1874 SLA     M.M. Pow: "Hero and Beatrice" 9
1874 SLA     Miss A. Carter: "Olivia and Viola" (vide "Twelfth Night")111
1874 SLA     Miss Lloyd: "Ariel" 403
1875 DG(b&w) Julia Pockock: "Scenes from Richard III" 421
1875 RA      Miss M. Grant: "Lady Macbeth" sculpture 1307
1875 SLA     Miss A. Carter: "The Statue Scene" - ("Winter's Tale") 146
1875 SLA     Charlotte E. Babb: "Charmian" - ("Anthony and Cleopatra"
                 Act 5, scene 2) 241
1876 DG      Helen Thornycroft: "Portia Pleading"
                 "Be merciful:
                 Take thrice thy money, bid my tear the bond" 577
1876 SBA     Miss O.P. Gilbert: "Cordelia"
                 "What shall Cordelia do?
                 Love, and be silent?" ("King Lear" Act 1, sc.1) 611
1876 SLA     Julia B. Folkard: "Imogen" (decorative head) 89
1876 SLA     Julia B. Folkard: "Miranda" (decorative head) 90
1877 SBA     Miss O.P. Gilbert: "Portia"
                 "Tarry a little: - there is something else -
                 This bond doth give thee here no jot of blood;
                 The words expressly are, - a pound of flesh"
                         .   .   .   .   .   .   .   .
                 ("Merchant of Venice" Act 4, sc.1) 628
1877 OWS     Mrs Criddle: "Countess: 'Not I your mother!'
                 Helena: ('Would you were, so that my lord, your son,
                 were not my brother') ("All's Well that Ends Well"
                 Act 1, sc.3) 147
1877 OWS     Mrs Criddle:
                 "Nurse: 'Faith, here 'tis: Romeo
                 Is banished; and all the world to nothing,
                 That he does ne'er come back to challenge you;
                 Or if he do, it needs must be by stealth.
                 Then, since the case so stands as now it doth,
                 I think it best you married with the county.
                 O, he's a lovely gentleman!
                 Romeo's a dishclout to him...'
                 Juliet: 'Speaketh you from thy heart?'" (Act III, sc.5)
                 182
1877 SLA     Louisa Starr: "Miranda" 614
1878 SLA     Julia B. Folkard: "Hermione" 764
1878 SLA     Mrs Emily Barnard: "Rosalind and Celia" 489
1878 SLA     Mrs Bowden: "Miranda" 737
1878 SLA     Helen Thornycroft: "Portia Pleading"
                 "Be merciful.
                 Take thrice thy money: bid me tear the bond" 145
1878 DG      Helen Thornycroft: 'Rosalind in the Forest of Arden"
                 "Tongues I'll hang on every tree" 330
1878 SBA     Miss G. Crockford :Celia" terra cotta 520
1879 GG      Miss Anna L. Merritt: "Juliet: 'O God! I have an ill-
                 divining soul:
                 Me thinks I see them now thou art so low,
                 As one dead in the bottom of a tomb'" 194
1879 DG      Kate Carr Hastings: "Perdita" 371
1879 SLA     Mrs Hunter: "Rosalind" (china) 725
```

Sir Walter Scott:-

1870 SFA Miss E. Percy: "Elizabeth Woodville in the Sanctuary,
 parting from her Son, the little Duke of York" 34

1870 SFA Mrs Charretie: "The Ladye Evelina from 'The Betrothed'"
 447

1870 RA Miss Eliza Turck: "Alice Lee"
 "She quietly took a small pitcher, and flinging a
 cloak around her, walked out in person to procure
 Sir Henry the water which he desired" ("Woodstock")
 1004

1871 SFA Mrs Charretie: "The Glee Maiden"
 "She recommenced her song, and sang her best" -
 (vide "Fair Maid of Perth" - Sir Walter Scott) 444

1872 SBA Miss C. Potchett: "The Greta"
 "As 'scaped from Brignal's dark wood glen,
 She seeks wild Mortham's deeper den" 214

1872 DG Harriet Kempe: "Edith Bellenden" 272

1873 SBA Miss F.E. Maplestone: "His chain of gold the king unstrung,
 The links o'er Malcolm's neck he flung
 Then gently drew the glittering band,
 And laid the clasp on Ellen's hand" ("Lady of the
 Lake") 633

1874 DG Mrs Charretie: "Catherine Seyton" 466
1874 SLA Fanny Sothern: "Green Mantle" ("Red Gauntlet") 498
1875 DG Mrs H. Champion: "Amy Robsart" 589
1875 SLA Adelaide Claxton: "Lady of the Lake" 293
1876 SLA Mrs Frederick Vulliamy: "Meg Merrilies" 303
1877 DG Mrs H. Champion: "Catherine Seyton" 454
1877 SBA Miss Eliza Turck: "Lucy Ashton" 762
1877 SLA Mrs H. Champion: "Jeanie" 473
1877 SLA Jessie Ramage: "Scene from 'Ivanhoe'"
 "Rebecca, suddenly quitting her dejected position, and
 making her way through the attendants to the palfrey
 of the Saxon lady, knelt down and kissed the hem of
 Rowena's garment" - (ch.xix) 387

1878 DG Harriet Kempe: "What are you about here, you sluts?"
 (vide "The Antiquary") 3

1879 SLA F.G.: "Jeannie Deans" 405

Oliver Goldsmith:-

1871 SBA Mrs Charretie: "Little Goody Two Shoes"
 "She ran down the village, crying, 'Two shoes, ma'am;
 two shoes!'" (vide Goldsmith's story) 220

1876 OWS Margaret Gillies: "Miss Hardcastle"
 "Miss Hardcastle (alone) ... 'Sensible, good-natured,
 I like all that; but then reserved and sheepish,
 that's much against him. Yet can't he be cured of his
 timidity by being taught to be proud of his wife?'"
 (Goldsmith "She Stoops to Conquer" Act 1, sc.1) 129

1877 SBA Miss L. Renton: "Vide 'She Stoops to Conquer'" 839
1877 DG Mrs H. Champion: "Sophia Primrose"
 "The morning the ladies devoted to dress and study;
 they usually read a page, and then gazed at themselves
 in the glass" ("Vicar of Wakefield") 322

1878 SBA Miss L. Renton: "Miss Hardcastle" 181
1878 SLA Mrs H. Champion: "Sophia Primrose" 211

George Eliot:-
1871 DG(oil) Gertrude Martineau: "Romola finds Lillo in the Street"
 ("Romola" ch. lxi) 293
1874 RA Miss F. Tiddeman: "Dorothea" (see "Middlemarch") 712
1876 DG(b&w) Julia Pocock: 'Illustrations to 'Adam Bede' by George
 Eliot" 90
1876 SLA Jane Hawkins: "Hetty" 34
1877 RA Catherine A. Sparkes: "Romola pleading with Savonarola
 for the life of Bernardo del Nero" (See "Romola")747

Goethe:-
1870 SBA Julia Behr: "Marguerite"
 "My rest is gone, -
 My heart is heavy" (Goethe's "Faust") 402
1871 DG Julia Pocock: "Margarethe"
 "Er liebt mich" 186
1872 NSPW Mrs Clarendon Smith: "Margaret returning from Church" -
 Faust 202

William Morris:-
1871 DG Edith Martineau: "Amidst these thoughts she cross'd the
 flowery lea,
 And came unto the glittering river's side;
 And seeing it was neither deep nor wide,
 She drew her sandals off, and to the knee
 Girt up her gown, and by a willow tree
 Went down into the water, and but sank
 Up to mid leg therein; but from the bank
 She scarce had gone three steps, before a voice
 Called out to her" (Morris' "Earthly Paradise") 169
1872 SLA Julia Pocock: "Then pale and full of trouble, Psyche went
 Bearing the casket, and her footsteps bent
 To Lacedaemon, and thence found her way
 To Taenarus, and there the golden day
 For that dark cavern did she leave behind"
 (Morsis' "Earthly Paradise") 112
1874 DG Edith Martineau: "Danae"
 "And on the morn, when scarce the dusk was done,
 Upon the sands the shallop run aground.
 * * * *
 Then uprose Danae, and nothing knew
 What land it was: about her sea-fowl flew;
 Behind her back the yet retreating sea
 Beat on the yellow sands unceasingly;
 * * * *
 Her unbound yellow hair
 Heavy with dew, and washing of the sea;
 And her wet raiment clinging amorously
 About her body, in the wind's despite;
 And in her arms her woe and her delight,
 Spreading abroad the small arms helplessly
 That on some day should still the battle's cry"
 (Morris' "Earthly Paradise") 326
1877 DG(oil) Margaret L. Hooper: "The Sleep of Brynhild"
 "A high hall is there
 Reared upon Hindfell,
 Without all around it
 Sweeps the red flame aloft
 * * *

 Soft on the fell
 A shield-may sleepeth.
 The sleep-thorn set Odin
 Into that maiden
 For her choosing in war
 The one he willed not" (Volsunga Saga, translated
 by Magnusson and Morris) 138

1878 RA Miss E.M. Busk: "Psyche" (William Morris' "Earthly
 Paradise") 25

Charles Dickens:-
1871 DG(oil) Miss Hunter: "The - the what? the Marchioness? Yes; playing
 cribbage with herself at the table. There she sat,
 intent upon her game, coughing now and then in a sub-
 dued manner, as if she feared to disturb him, shuffl-
 ing the cards, cutting, dealing, playing, counting,
 pegging; going through all the mysteries of cribbage
 as though she had been in full practice from her
 cradle!" ("The Old Curiosity Shop") 117

1873 SBA Mrs A. Melville: "A Child's Dream of a Star" - 1st part
 (Illustration of a story by Charles Dickens) 883

1873 SBA Mrs A. Melville: "A Child's Dream of a Star - 2nd part
 (Illustration of a story by Charles Dickens) 901

1873 SLA Miss Adelaide Claxton: "Little Nell - 'Old Curiosity Shop'"
 170

1876 SBA Miss Gertrude Martineau: "Little Nell in the Old Curiosity
 Shop" 260

1877 SLA E. Hine: "Nellie" 206

1877 DG(b&w) Emma Squire: "Little Emily"
 "Springing forward to her destruction, as it appeared
 to me, with a look that I have never forgotten,
 directed far out to sea" ("David Copperfield") 399

1879 SLA Mrs Louise Jopling: "The Five Sisters of York, vide
 'Nicolas Nickelby'" 278

Robert Browning:-
1870 RA Mrs Eliza L. Bridell: "Cleon the Poet"
 "One lyric woman, in her crocus nest
 Woven of sea-wools, with her two white hands
 Commends to me the strainer and the cup
 Thy lip hath bettered ere it blesses mine" (Robert
 Browning "Men and Women") 427

1872 DG(b&w) Mrs Marie S. Stillman: "Constance" ("in a balcony" -
 Robert Browning) 184

1878 DG(b&w) Emily Arkwright: "The Duchess" (from "Colombe's Birthday")
 434

1878 DG(b&w) Emily Arkwright: "Mildred, from the 'Blot on the Scut-
 cheon'" 516

Lord Byron:-
1871 SFA Miss A. Carter: "Scene from 'The Two Foscari' Act 2nd"
 "Marina: '.. I fear ye not, I know ye;
 Have known and proved your worst in the infernal
 Process of my poor husband! Treat me as
 Ye treated him: - you did so in so dealing
 With him. Then what have I to fear from you,
 Even if I were of fearful nature, which.
 I trust I am not?'" 48

1872 SLA Mrs Charretie: "Medora - 'Sadly she sate'" 345
1873 SBA Mary A. Tovey: "The Maid of Athens" 121

| 1874 SLA | F. Maplestone: "Sardanapulus's Farewell to his Soldiers" |

"You have done your duty faithfully,
And as, my worthy Pania, further ties
Between us draw near a close,
I pray you take this key, search well
My chambers, feel no remorse at bearing
Off the gold; remember what you leave
You leave the slaves that slew me" Byron 210

1876 SLA	Mrs Paul J. Naftel: "Gulnare" 401
1876 SLA	Agnes Fairfield: "The Corsair" 687
1876 SLA	Agnes Fairfield: "The Corsair's Bride" 688

Sheridan:-
1871 RA	Mrs Charretie: "Lady Teazle behind the screen" 636
1871 SFA	Mrs Charretie: "Lydia Languish, sitting on a sofa with a Book in her hand" - ("The Rivals" Act1, sc.2) 116
1876 SLA	E. Westbrook: "Lady Teazle" 282

Wordsworth:-
| 1875 DG | Constance Phillott: "Oft had I heard of Lucy Grey; |

And when I crossed the wild,
I chanced to see at break of day
The solitary Child.

No mate, no comrade, Lucy knew;
She dwelt on a wide moor
The sweetest thing that ever grew
Beside a human door!" 212

| 1875 SLA | Linnie Watt: "Lucy Gray" (Wordsworth) 345 |
| 1876 SLA | Kate Belford: "Wordsworth's 'Lucy'" 21 |

Other literary sources:-
| 1870 SFA | Miss E. Percy: "The Jacobite's Bride" |

"Then blow ye east, or blow ye west,
Or blow ye o'er the faem;
Oh! bring the lad that I lo'e best,
And ane I dare not name" 318

1870 SFA	Mrs Eliza L. Bridell: "Morgiana Dancing before the Merchants, Ali Baba and Cogia Hassan" 442
1870 SFA	Miss Alberta Brown: "Cinderella" 464
1871 SFA	Mrs Hunter: "There were a power in this sweet place, An Eve in this Eden - a ruling grace"

"I doubt not the flowers of that garden sweet,
Rejoiced in the sound of her gentle feet,
I doubt not they felt the spirit that came,
From her glowing fingers, through all their frame"
(Shelley's "Sensitive Plant") 155

| 1871 SFA | Julia Pocock: "Fatima" 216 |
| 1871 SFA | Helen Hoppner Coode: "Hameline in the Watch Tower" |

"Full long she watched, her distaff thrown aside,
The faithful hound, regardful at her feet.
Ah me!' she cried, ''tis fruitless here to bide,
Since woman's love, man's faith did never meet'" 401

| 1871 SFA | Helen Hoppner Coode: "Absorbed in his sorrowful reflections, the young priest was unaware of the approach of Georgette with a basket of fish caught that morning, and in whom he recognized the young girl always so attentive at Mass" - ("Les Epreuves de Père François") 439 |

1871 RA Mrs Charretie: "Clarinda had just returned from the
 sale. Her pleasure in the bargains she had made was
 saddened by her sympathy for those who had been com-
 pelled to part with their treasures" - ("Spectator"
 1712) 439

1871 DG(oil) Mrs Charretie: "Lorna Doone"
 "I placed the chaplet on my head, and carrying my
 grey hat in my hand" 237

1871 DG(oil) Henrietta Cockran: "Vive ma Lisette" (vide Béranger) 148

1871/2 NSPW Mrs Clarendon Smith: "Una" 134

1871 SBA Miss Mary Backhouse: "Little Red Riding Hood" 320

1871 DG Mrs Charretie: "Ruby"
 "Once more I am watching her deep fringed eyes
 Bent over the Tasso upon her knee;
 And her fair face flushing with sweet surprise.
 O Ruby, my darling, that soft white hand
 That gathered the harebell" 429

1872 SLA E.C. Collingridge: "The Spell of Simulacrum"
 "She made a waxen image of the false love, had it
 baptized with his name, and pierced it with a dagger,
 uttering baneful words against him. It was after-
 wards remembered that at that time he fell into
 mortal pain, and died without sickness or disease" 123

1872 DG Eleanor Vere Boyle: "Frame of six illustrations of Fairy
 Tales by Hans Christian Anderson" (2) 669-70

1872 RA Mrs Charretie:"Lady Betty Germaine: a reminiscence of
 Knowle" 978

1873 RA Miss Louisa Starr: "Sintram"
 "Silently weeping, the son knelt down before his
 mother, kissed her garment that floated forward through
 the bars, and felt as it were in Paradise, where every
 wish and every tumult is hushed.
 'Dear mother,' said he after a time, 'let me
 become a holy man, as thou art a holy woman! Then will
 I go into that cloister of monks on the other side
 yonder'.
 'That would be a beautiful, stilly, joyful exis-
 tence, my good child', replied the Lady Verena. 'Such
 however, is not thy destiny. A brave high and mighty
 knight must thou remain, and employ thy long life in
 protecting the weak and repressing the wanton'" -
 Vide "De La Motte Fouqué" 311 (Walker Art Gallery
 Liverpool)

1873 SLA A.L.: "The Dream of Kriemhilde" (From the "Nibelungen")
 "She dreams that she has trained a wild hawk, strong
 and beautiful, and petted it as a favourite for many
 a day. Suddenly two eagles swoop down, and with their
 cruel talons, crush the delicate creature before her
 eyes. In the morning she tells her dream to her mother
 who then interprets it: 'The hawk is a noble hero,
 whose wife you are destined to become. May God
 protect him, that then thou lose him not too soon'" 75

1873 RA Mrs Charretie: "Lady Bett's waiting woman"
 "In the last century, the waiting woman was generally
 a poor relation, who combed the lapdogs, washed the
 china, and sometimes wore her mistress's cast-off
 clothes" - (note to "Life and Correspondence of Mrs
 Delany") 609

1873 SBA Miss A. Carter: "Lesbia"
"Lesbia hath a beaming eye,
But no one knows for whom it beameth;
Right and left its arrows fly,
But what they aim at, no one dreameth"
(vide Moore's Melodies) 599

1873 SBA Miss F.E. Maplestone: "Out o' the cup he drank the wine,
And into the cup he dropped the ring.
'Gat ye't by sea or gat ye't by land:
Or gat ye't frae a drowned man's hand?
 * * *
I gat it at my wooing day,
And I'll gie't to you on your wedding day" (Old
Ballad) 737

1873 OWS Margaret Gillies: "Marie"
"Marie was standing with her baby in her arms at an
upper window ... The war within her had been sharp and
fierce, but the struggle was over, and she accepted
her fate as God had willed it" 134

1873 OWS Margaret Gillies: "The end of the pilgrimage"
"And when they asked him what he was seeking, he re-
polied 'Cercando Pace' (seeking peace) .. And they
laid him in an upper chamber whose windows were towards
the rising sun .. And he found 'Peace " 157

1873 SLA Eliza A Melville: "Granny's gone to the moon" (see "The
Two Thousand Pound Reward" by Eliza R. Melville)
"O Granny, Granny, do come down to
Jemmy: you are up in the moon,
I do see you peeping at me
Like you said you would" 267

1874 SLA A.E. Jay: "Agnes, from 'Duval' by Thackeray" 316
1874 SLA Miss Lloyd: "Dorothea" ("Don Quixote") 401
1874 SLA Madame Biron: "Cinderella's Dream" 511
1874 DG Mrs Charretie: "Stephen's Complaint"
"She loveth well both flower and tree,
And yet the maiden loves not me;
Her dog doth come and rest and linger
Where I, alas, darn't lay a fiager.
She calleth all the birds about her,
Nothing that liveth seems to flout her;
All these do nestle in her smile
While I stand in the cold the while" 510

1874 DG Constance Phillott: "Peona went
Home through the gloomy wood in wonderment"
("Endymion") 144

1874 SBA Miss E.Y. Westbrook: "Clarissa" 544
1874 SBA Miss O.P. Gilbert: "Cinderella"
"Her godmother, who was a fairy, only touched her with
her wand, and at the same instant her clothes were
turned into cloth of gold and silver, beset with
jewels" 814

1874 DG(oil) Mrs Charretie: "Lady Sarah Lennox: "He left Lady Sarah
Lennox at Holland House where she appeared every morn-
ing in a field close to the road (where the king
passed on horseback) in a fancied habit, making hay"
(Walpole's "Memoirs") 358

1874 RA Mrs Charretie: "Lady Betty goes shopping"
"Pausing, uncertain which way to choose" 600

1875 SLA Miss M.C. Clarke: "Auld Robin Gray" 324

1875 SLA Eliza Devine:
 "Here once through an alley Titanic,
 Of cypress, I roamed with my soul -
 Of cypress - with Psyche my soul
 * * * *
 But Psyche, uplifting her finger,
 Said - 'Sadly this star I mistrust -
 Her pallor I strangely mistrust'" (From "Ulalume"
 - E.A. Poe) 456

1875 SLA Rose Francis Melville: "Sibyll"
 "Upon a mound formed by the gnarled roots of the
 dwarfed and gnome-like oak, she sat down and wept"
 - ("Last of the Barons" Lord Lytton) 470

1875 SBA Miss E. Gilbert: "Pamela about to deposit her letters in
 the concerted hiding place by the sun-flower"
 (Richardson's "Pamela; or Virtue Rewarded" vol.1,
 p.170) 728

1875 OWS Mrs Criddle: "This way the noise was, if mine ear be true"
 (Milton's "Comus") 212

1875 DG(oil) The late Mrs Charretie: "The White Lockade"
 "There's ne'er a lass in a' the land
 But vows, baith late and early,
 To man she'll ne'er gie heart or hand
 Wha wadna fight for Charlie" 115

1875 DG(b&w) Miss Fraser: "Illustrations of Miss Procter's Poem" 293
 and 294

1875 RA Mrs Louise Jopling: "A Modern Cinderella"
 "The hour struck, and Lisa, my patient model, like a
 second Cinderella, divested of her brilliant plumage,
 prepared to attire herself in her own homely garments"
 - (Extract from "Word Sketches by an Artist) 64

1876 SLA Miss A. Carter: "When Lubin is away" 454

1876 DG(b&w) Kate Greenaway: "They were having tea, the Queens and the
 Princess. One of the Princes came to her with a cup"
 554
 "He led her along with great ceremony. They were all
 evidently much amused" 573
 "'Now',said Prince Butterfly, 'I can croquet our side
 in'. The Princess was deeply offended" 590

1876 NSPW Mrs Elizabeth Murray: "An Eastern Jewess"
 "In broidered robes attired, with mystic look,
 The woman listens to the antique book
 That breathes some prophet vow, some patriot wish!
 A moment more, and from the symbol fish,
 She strips the glittering mail; what secret might
 Waits on the Rabbi's words, on this strange rite
 Of the world's dawn or vision of its night?"
 ("The Feast of Rahab, or Scaling the Fish") 94

1876 RA Mrs Marie S. Stillman: "The last sight of Fiametta"
 "Above her garland and her golden hair
 I saw a flame about Fiametta's head" 757

1877 SBA Miss Hepworth Dixon: "Fatima" 259

1877 DG Jennie Moore: "Glyndon was about to reply, when his eyes
 rested on the face of a young girl of a beauty so
 attractive that his colour rose and his heart beat as
 he encountered her gaze. It was Fillide" (Zanoni)177

1877 DG Constance Phillott: "Kilmeny"
 "... the air was soft and the silence deep,
 And bonny Kilmeny fell sound asleep" 374

1877 DG Juliana Russell: "... in the garden bower
 The bridesmaids singing are" ("The Ancient Mariner")
 305
1877 DG(b&w) Beatrice Meyer: "Illustration of Hans Christian
 Andersen's 'Legend of the Red Shoes'" 410
1877 DG(b&w) Ada E. Taylor: "Lorna Doone" 193
1877 DG(oil) Rosa Koberwein: "Nora Creina"
 "O, my Nora Creina, dear!
 My gentle, bashful Nora Creina!
 Beauty is in many eyes
 But love in yours, my Nora Creina" 173
1877 SLA Miss E. Macirone: "Cinderella" 14
1877 SLA F. Alldridge-Roberts: "This was not the beauty - oh!
 nothing like this -
 That to young Normahal gave such magic of bless;
 But the loveliness, even in motion which plays
 Like the light upon Autumn's soft shadowy days"
 ("Lalla Rookh") 58
1877 SLA Charlotte E. Babb: "Gabrielle" ("Sintram") 116
1877 SLA Marian Nixon: "My father urged me sair, my mither didna
 speak,
 But she looked in my face, till my heart was like to
 break,
 So they gie'd him my hand, though my heart was at the
 sea,
 And Auld Robin Gray is gude man to me" ("Auld Robin
 Gray") 612
1878 DG(b&w) Beatrice Meyer: "Three original drawings for 'The Princess
 and the Swineherd' by Hans Christian Andersen" 555
1878 DG(b&w) E. Gertrude Thomson: "Little Bridget" 512
1878 GG Miss Sarah Defries: "In the story of her life, Aurore
 (George Sand) tells how her imagination being stirred
 by the picturesque surroundings of the palace in
 Madrid, where she lived for nearly a year, she was to
 deck herself in any finery she could find, place
 herself before a mirror with her white rabbit in her
 arms, and enact whole scenes with the fancied help of
 her own reflection" 146
1878 SBA Miss E. Gilbert: "Peg of Limavaddy"
 "Thus it was I drew her,
 Scouring of a kettle
 (Faith! her blushing cheeks
 Redden'd on the metal!)
 Ah! but 'tis in vain
 That I try to sketch it;
 The pot perhaps is like,
 But Peggy's face is wretched" (Ballads by W.M.
 Thackery) 498
1878 DG(oil) Ellen G. Parker: "Karen's Repentance - from the story of
 'The Red Shoes' by Hans Andersen" 5
1878 SLA Miss A. Carter: "The Foolish Virgins" (vide Poem by Owen
 Meredith) 243
1878 SLA Elizabeth Naughten: "Lois, vide 'Boy, Love and Law'" 360
1878 SLA G.M. Merrick: "The village seems asleep or dead,
 Now Lubin is away" 396
1878 SLA Miss Helen J.A. Miles: "Bertha in the lane, vide E.B.
 Browning" 710
1879 SLA Mrs Emily Barnard: "Kathleen Mavourneen" 596
1879 RA Mary Godsall: "Cinderella" 668

1879 NSPW Miss Mary L. Gow: "Vittoria Colonna" 152 (probably based
on Longfellow's poem)

1879 GG Mrs Marie S. Stillman: "Fiametta Singing' from Boccaccio
translated by D.G. Rossetti"

"Love steered my course while yet the sun rode high,
On Scylla's waters to a myrtle grove;
The heaven was still and the sea did not move,
Yet now and then a little breeze went by
Stirring the tops of the trees against the sky.
And then I heard a song as glad as love,
So sweet that never yet the like thereof
Was heard in any mortal company.

A nymph, a goddess, or an angel sings
Unto herself within this chosen place
Of ancient loves; so said I at that sound,
And theme my lady, 'mid flowers and grassy space,
Singing, I say, with others who sat round" 158

1879 DG Catherine Adeline Sparkes: "That furtive mien, that scowl-
ing eye,
Of hair that red and tufted fell -
It is - oh! where shall Brandan fly?
The traitor Judas, out of hell!"
(Matthew Arnold "St. Brandan") 389

1879 SLA E. Colvile: "Evangeline" 322

02. 1870 DG(oil) Gertrude Martineau: "When I was in that happy place,
Upon my mother's knee" 130

1870 DG Lucy Madox Brown: "Après le Bal"
"Maintenant c'est le jour; la veille après le rêve;
la prose après les vers; c'est le vide et l'ennui;
c'est une bulle encore, qui dans les mains nous
crève; c'est le plus triste jour de tous; c'est
aujourd'hui" (Théophile Gautier) 12 (Collection Mrs
Dennis, Woodstock nr. Oxford).

1870 OWS Margaret Gillies: "Alone"
"'Tis sad to think the days are gone,
When those we loved were near;
I sit upon this mossy stone
And sigh when none can hear" 259

1870 SFA Miss Eliza Turck: "O waly, waly, gin love be bonny
A little time while it is new;
But when it's auld it waxeth cauld
And fades awa like morning dew.
O wherefore should I bresk my head,
And wherefore should I kame my hair,
For my true love has me forsook,
And says he'll never loe me mair" 25

1870 SFA Miss M.Florence Bonneau: "A cloud was o'er my childhood's
dream; I sat in solitude" ("Thoughts in Past Years")
444

1871 DG(oil) Mrs Louise Romer: "Lullaby"
"The world may be sad for us that wake,
Sleep little bird and dream not why,
Lullaby, Laby" 149

1871 SFA A.L. "Du hast Diamanten und Perlen,
Has Alles, was Menschen begehr,
Und hast die Schönsten Augen,
Mein Liebschen , was gillst Du mehr?" Heine 119

1871 SFA Mrs Lee Bridell: "Only a Curl"
 "All that is left us
 Is her memory now" 360
1872 DG Edith Martineau: "Garden Musings"
 "And eyes conveying unaware
 The distant hint of some regret
 That harboured there" 361
1872 DG Adelaide Maguire: "Where oft in childhood's playful sport
 I'd gathered shells in days before" 633
1872 DG(oil) Ellen Stone: "An Old Tune"
 "Our sweetest songs are those that
 Tell of saddest thoughts" 89
1872 OWS Margaret Gillies: "Remembered Tones"
 "Her fingers, straying idly, grew instinct
 With tender memories, and the strings
 Responsive thrill'd in long-lost harmony" 218
1873 RA Miss Jessie Macgregor: "And the veil of thine head shall
 be grief, and the crown shall be pain" 1068
 "It represents a single figure in an agony of sorrow
 with her hands clasped above her head" ("Art Journal"
 1873, p.239))
1873 DG Alice E. Manly: "In that sweet mood when pleasant thoughts
 Bring sad thoughts to the mind" 321
1873 DG Harriet Kempe:"Prayer is the burden of a sigh,
 The falling of a tear
 The upward glancing of an eye,
 When none but God is near" (Montgomery) 281
1875 RA Emily M. Osborn : "A Little mist, a little rain,
 And life is never the same again" (G. Macdonald) 545
1875 DG(b&w) Eleanor E. Manly: "And there is even a happiness
 That makes the heart afraid" (Wood) 158
1876 DG(oil) Rosa Koberwein: "And eyes conveying unaware
 The distant hint of some regret
 That harboured there" 49
1876 SLA Mrs Bannatyne: "The Grosse Mutteo"
 "Thinking o'er the days that are gone" 34
1876 SLA Alberta Frank: "A little mist, and a weeping rain,
 And life is never the same again" 237
1876 SLA S.M. Louisa Taylor: "Oh, the happy days when we were young!"
 305
1877 RA Rosa Koberwien: "In that sweet mood when pleasant thoughts
 Bring sad thoughts to the mind" 290
1877 RA Annie G. Fenton: "The mouth with steady sweetness set,
 And eyes conveying unaware,
 The distant hint of some regret
 That harboured there" (Jean Ingelow) 382
1877 RA Rosa Koberwein: "Bear through sorrow, wrong and ruth
 In thy heart the dew of youth,
 On thy lips the smile of truth
 And that smile like sunshine dart
 Into many a sunless heart,
 For a smile of God thou art" 580
1877 DG(b&w) Alice M. Motte: "Upon her face there was the tint of grief,
 The settled shadow of an inward strife,
 And an unquiet drooping of the eye,
 As if its lid were charged with washed tears" (Byron)
 286 (The artist exhibited a work with the same title
 at the Society of Lady Artists in 1878, no.655)
1877 DG(b&w) S.M. Louisa Taylor:
 "When the morn comes dim and sad,
 And chill with early showers,

Her quiet eyelids closed - she had
Another morn than ours" (T. Hood) 274

1877 DG(b&w) Rosalie M. Watson: "Sorrows remembered sweeten present
joy" 181

1877 DG(b&w) Sarah Terry: "I had learnt the secret of the years
Too sad for smiles, too deep for tears" 280

1877 SLA K.L. Langhorne: "Not lost, but gone before" 202

1879 SBA Emily M. Merrick: "In that sweet mood when pleasant
thoughts
Bring sad thoughts to the mind" 515

1879 DG Jennie Moore: "She knew not love, yet lived in maiden
fancies;
And talked strange tongues with angels in her trances;
If she had - well! she longed and knew not wherefore;
Had the world nothing she might live to care for?
No second self to say her evening prayer for" 384

1879 DG(oil) Frances L. Grace: "The Prospect, such as might enchant
despair,
She views it not, or sees no beauty there" 323

1879 SLA Emily M. Merrick: "Oh, never shall we see again
A heart so stout and true;
For gone are all the olden days
And weary are the new" 298

1879 SLA Julia B. Folkard: "Not lost, but gone before" 331

1879 SLA Florence Bonneau: "The mouth with steady sweetness set;
And eyes conveying unaware,
The distant hint of some regret" (Jean Ingelow) 745

P2. 1871 SBA Mrs Profaze: "Maiden Meditation" 296

1872 DG Harriet Kempe: "'Twixt the glitter of an axe, and the
shadow of a crown,
Unconscious she sits dreaming" 447

1872 SBA Mrs Louise Romer: "Homeward Thoughts"
"When gloaming fell, and the wheel was dumb" - (J.J.
Lonsdale) 134

1872 SLA Mrs Dangars: "Meditation"
"Truly unspeakable is the sweetness of contemplating
thee, which thou bestowest on them that love thee"
("Imitation of Christ" Book iii, chapter x) 101

1872 SBA Mrs Charretie: "Contemplation"
"Absorbed in contemplation, and the theme,
The glorious mercy of the love Divine.
When gentle accents wake her from her dream,
Flowers, sister Mary, for our lady's shrine" 96

1872 SBA Mrs Bowden: "Make thou my spirit pure and clear,
As are the frosty skies,
Or this first snow drop of the year
That in my bosom lies" 131

1872 SBA Miss E. Mitchell: "What is the subject of thy thoughts,
Oh, maiden fair and young?" 387

1873 RA Mrs Charretie: "Beneath a summer tree
As she sits, her reverie
Has a charm" 1340

1874 SLA Alberta Frank: "Unto thee O Lord, do
I lift up my soul" (Psalm XXV, v.1) 447

1874 SBA Mrs Charretie: "Prayer"
"The eye uplifted, or the downcast gaze
Alike may be the voice of prayer or praise,
and each be welcomed by that tender heart,
Who knows the ill, yet claims the better part" 317

1878 RA Rosa Koberwein: "In maiden meditation, fancy free" 362

1878 RA Julia B. Folkard: "In sweet music is such art,
 Killing care and grief of heart,
 Fall asleep, or, hearing, die" 1006

1878 DG(b&w) Kate A. Belford: "In maiden meditation, fancy free" 457

1879 RA Elizabeth Folkard: "In maiden meditation, fancy free" 682

Q2. 1871 SBA Miss E.T. Westbrooke: "Thy rose lips and full blue eyes
 Take the heart from out my breast" (Tennyson) 490
 (The artist exhibited a work with the same title at
 the Society of Lady Artists in 1877, no.442)

1871 SBA Mrs E.B. King: "The first from him"
 "Sweet, sweet and precious" 287

1871 SFA Sarah Mason: "While glory sighs for other spheres,
 I feel that one's too wide,
 And think the home which love endears,
 Worth all the world beside" 359

1872 DG Mme Bisschop: "Sweet my child, I live for thee" (Tennyson)
 227

1872 DG Constance Phillott: "I sowed the seeds of love
 All in the days of Spring
 * * *
 My gardener was standing by
 And he did offer to me
 The primrose, the lily, and the pink,
 But I did reject all three"(Old Song) 209

1874 SLA Sarah Mason: "Pray you love, remember,
 There's pansies: that's for thoughts" (Shakespeare)
 431

1874 DG Helen J. Miles: "Do not blame me if I doubt thee,
 I can call love by its name
 Where thine arm is wrapt about me:
 And even love seems not the same
 When I sit alone without thee
 * * *
 Dost thou love me, my beloved?" 57

1874 DG Fanny Sothern: "I send the flowers given to me
 Though long before thy hand they touch
 I know that they must wither'd be" 376

1875 NSPW Mrs Elizabeth Murray: "The White Rose"
 "Love, is there sorrow hidden?
 Is there delight?
 Is Joy thy dower or Grief
 White Rose of weary leaf?" (Swinburne) 5

1877 SLA Elisabeth Manton: "I tell them they need na come wooing to
 me,
 For my heart, my heart, is over the sea" 396

1877 DG(oil) Julia B. Folkard: "The Ballad"
 "How could I tell I should love thee today,
 Whom that day I held not dear?
 How could I know I should love thee alway,
 When I did not love thee anear?" (Jean Ingelow) 277

1877 GG Margaret Gillies: "The Friends"
 "Wheresoe'er we went, like Juno's swans;
 Still we went coupled and inseperable" (Shakespeare) 39

1878 SBA Miss O.P. Gilbert: "The Miniature"
 "All days are nights to me till I see thee,
 And nights bright days when dreams do show me thee"
 (Shakespeare's Sonnets) 482

1878 SLA Annie G. Fenton: "And as I walk by that vast calm river,
 That awful river so dread to see;
 I say thy depth and thy breadth for ever
 Are bridged by his thoughts that cross to me" 350

R2. 1870 SBA Miss E. Royal: "Thrice hath she been to the gate,
 Somebody waiting for somebody" (Charles Swain) 591

 1871 SBA Ellen Clacy: "In time of war: Autumn 1870"
 "Alas! so many times we have met here,
 And who can tell when that shall be again.
 My love! my love! but what have I to fear,
 Can prayers like mine be vain?" 676

 1872 DG F. Maude Alldridge: "Why is his chariot so long in coming?
 Tarry the wheels of his chariot?" 60

 1873 OWS Margaret Gillies: "Suspense"
 "But surely in the far, far distance
 I can hear the sound at last" 76

 1873 SLA Georgiana Swift: "'Tis sweet to know
 There is an eye that meets our coming" 460

 1875 SLA Theresa Chadband: "Strange Trysting Place"
 "She stood, amidst the classic ruin
 Destiny had overthrown,
 With loving, hoping, trembling heart,
 Awaiting there - her own!" 245

 1875 SLA Julia C. Smith: "Gazing far distant o'er the heaven, dear,
 Gazing in vain, my beautiful, for thee" 519

 1875 SBA Mrs J.F. Pasmore: "It may be for years, or it may be for
 ever" 316

 1876 DG Blanche Macarthur: "Weary, so weary of waiting,
 Longing for sympathy sweet" 378

 1876 DG(b&w) Mrs Edward Hopkins: "O where, and O where is my Highland
 laddie gone?" 399

 1876 SLA Florence E. Glasier: "With wishes, thinking, here to-day,
 Or here to-morrow, will he come" - ("In Memoriam")
 286

S2.a) Looks:-

 1870 RA Mrs Charretie: "Of what age is she? as a rose at fairest,
 Neither bud nor blown" 291

 1871 DG Charlotte D. Macheath: "The modest lashes of her eyes
 Upon her cheeks were drooping" 232

 1871 SBA Miss B. Sutcliffe: "Spring"
 "Forth in the pleasing Spring thy beauty walks" Tennyson
 821

 1871 SFA A.L.: "She has two eyes so soft and brown,
 Take care!
 She gives a side-long glance, and looks down,
 Beware, Beware!
 Trust her not,
 She is fooling thee!" 157

 1872 DG(b&w) Charlotte Babb: "The Children of the Week"
 "Monday's child is fair of face" 134

 1872 SBA Mrs E.K. Beeby: "She seemed a part of joyous Spring"
 (Tennyson) 98

 1873 SBA Mary Backhouse: "Maiden with the meek brown eyes,
 In whose orbs a shadow lies;
 Like to dusk of eveni g skies" 781

 1874 DG(oil) Kate Clarke: "A countenance in which did meet
 Sweet records, promises as sweet" 308

```
1874 SBA      Miss E.Y. Westbrooke: "She has two eyes so soft and
                  brown" 136
1875 DG       Edith Martineau: "There is a garden in her face where
                  roses and white lilies blow" 542
1875 SLA      Jennie Moore: "I know a maiden fair to see:
                  Take care, take care!" 19
1875 OWS      Mrs H. Criddle: "If ladies are but young and fair
                  They have the gift to know it" 190
1876 SBA      Miss M.B. Brook: "His brow was sad, his eye beneath
                  Flashed like a falchion from its sheath" 225
1876 DG(oil) Georgina Koberwein: "As the sweet moon on the horizon's
                  verge
                  The maid was on the eve of womanhood" 46
1877 DG(b&w) Rose M. Fenton: "As a gloriole sign o'grace
                  Goldilocks, ah!  fall and flow;
                  On the blooming child-like face,
                  Dimple, dimple, come and go!" (Jean Ingelow) 54
1878 DG(oil) Rosa Koberwein: "She has two eyes so soft and brown -
                  Take care!
                  She gives a side-long glance and looks down -
                  Beware!  Beware!" 239
1878 DG       Louisa Starr: "A face that's best
                  By its own beauty drest,
                  And can alone command the rest!"  86
1879 SLA      Mrs P.J. Naftel: "A face that's best
                  By its own beauty drest" 676
```

b) Flowers:-
```
1870 RA       Miss M. Harrison: "O Flower de Luce, bloom on and let the
                  river linger to kiss thy feet etc." 643
1870 DG       Emily M. Jackson: "Where a freaked, rose-coloured, flakey
                  crew,
                  Of toadstools peep indulged" (Robert Browning) 355
1870 DG       Mrs B. Riviere: "The rusted nails fell from the knots
                  That held the peach to the garden wall" (Tennyson) 215
1870 NSPW     Mrs Harrison: "The Poor Man's Garden"
                  "The poor man has his roses,
                  His lilies white and red,
                  His marigold and hollyhocks,
                  And sweet carnation bed" 149
1870 OWS      Maria Harrison: "And rows of stately hollyhocks,
                  Down by the garden wall,
                  All yellow, pink and crimson,
                  So many-hue'd and tall" 132
1871 DG       Miss Lucette Barker:  "No, there's gold coats' spots, you
                  see" 511
1871 SFA      Mrs Harrison: "Fair daffodils, we weep to see thee pass
                  away so soon" (Herrick) 272
1872 DG       Miss C. Meyer: "Cowslips tall her pensioners be"
                  ('Midsummer Night's Dream") 433
1872 SLA      Fanny Vallance: "Fair flowers that neither toil nor spin,
                  And know not any strife" 97
1873 SBA      Mrs J.F. Pasmore: "Ye field flowers, the gardens eclipse
                  you 'tis true,
                  Yet wildings of nature, I dote upon you" 320
1874 NSPW     Mrs Harrison: "Oh!  then my heart with pleasure fills,
                  And dances with the Daffodils" 84
1874 SLA      C.C. Pierrepont: "Pansies, that's for thoughts" - ("Hamlet")
                  163
```

```
1874  SLA       Agnes S. Boyd: "Lilies, each a white-robed bride,
                     With treasures of pure gold inside,
                     Like marble towers a king has made" 243
1874  DG        Mrs Edwin Arnold: "Study of Pansies"
                     "There is pansies, that's for thoughts"(Ophelia in
                     "Hamlet" Act 4, sc.3) 355
1874  SLA       Miss M.P. Taylor: "Long as there is a sun that sets
                     Primroses will have their glory" (Wordsworth) 189
1875  SLA       Kate Hill: "Since first it bloom'd in Eden's bowers,
                     The Rose is termed the queen of flowers" 461
1877  SBA       Mrs J.F. Pasmore:  "You wild flowers, I love you right well
                     Yea, better than words of mine can tell" 116
1877  NSPW      Marian Chase: "Sweet Flowers"
                     "Sweet flowers, gently raise their dulcet  voice
                     Of fragrance, varied as the notes of birds,
                     To whisper blessings on whoe'er will stoop
                     To take their benedictions" 97
1878  DG(oil)   Gertrude Martineau: "Water-lilies"
                     "Continuous as the stars that shine
                     And twinkle on the milky way
                     They stretched in never ending line
                     Along the margin of a bay" 36
1878  GG        Lady Lindsay : "Blossom"
                     "But you are lovely leaves, where we
                     May read how soon things have their end though ne'er
                         so brave" (Herrick) 210
1879  DG        Edith Martineau: "Happy flowers of the field, that toil not,
                     spin not" 10
1879  DG        Edith Martineau: "Scotch Roses"
                     "I saw the sweetest flower wild Nature yields, -
                     A fresh-blown rose" 391
1879  DG(b&w)   Mary Stuart Wortley:
                     "Here's flowers for you;
                     Hot lavender, mints, savory, marjoram;
                     The marigold that goes to bed with the sun
                     And with him rises weeping" ("Winter's Tale" Act 4,
                     sc. 4) 241
```

c) Landscape:-

```
     1871  DG        Anna Blunden: "Vesuvius, from Ischia - Evening"
                          "When the long long sunny end of evening smiles across
                              the land" 210
     1871  DG        Anna Blunden: "Vesuvius, from Ischia - Morning"
                          "Islands whose verdure climbs the Mountain Tops,
                          And tumbles down to kiss the embracing sea" 241
     1871  DG        Mrs Marrable: "Spring hangs her infant blossoms on the trees,
                          Rock'd in the cradle of the western breeze" (Cowper)227
     1872  DG        Kate Carr: "My Father's Close"
                          "Inside my father's close
                          (Fly away O my heart away!)
                          Sweet apple-blossom blows
                              so sweet" (Rossetti's Poems) 268
     1872  DG        Mrs John Sparkes: "Spring-time"
                          "Now fades the last long streak of snow,
                          Now burgeons every maze of quick" 387
     1872  SBA       Miss J.C. Widgery: "On the Island of rocks, Black-Tor,
                              Dartmoor"
                          "Let the misty mountain winds be free,
                          To blow against thee" 175
     1872  SBA       Miss J.C. Widgery: "Brenton - Dartmoor"
                          "The welcome sun, victorious rose,
                          And through the scattered haze,
                          Brent Tor uplifted his magnific brow" 178
```

```
1873 DG          Fanny C. Jolly: "From winter's rest
                     And each flower and herb on earth's dark breast
                     Rose from the dreams of its wintry rest" (Shelley) 352
1873 DG(oil) Jessie Macgregor: "An Untidy Garden, in Lancs"
                     "Not undelightful are the simplest charms"
                     (Wordsworth) 325
1874 SBA         Miss G.Swift: "Winter"
                     "Winter's solemn gloom is spent
                     Earth is wrapt in wreathed snow" 349
1875 DG          Mrs Marrable: "Glengarriffe, Co. Cork"
                     "The day is cold, and dark, and dreary!
                     It rains and the wind is weary" 113
1875 SBA         Miss H.J.A. Miles: "Spring"
                     "Spring season sweet,
                     Lovely with earliest flowers.
                     The young heart greets thee, and midst budding trees,
                     Will hear the prophecies of happier hours,
                     Breathed softly round in music of the breeze" 915
1875 OWS         Maria Harrison: "Limpsfield Common"
                     "Mountain gorses ever golden,
                     Cankered not the whole year long,
                     Do you teach us to be strong,
                     Howsoever pricked and holden,
                     Like your thorny blooms and so
                     Trodden on by rain and snow,
                     Up the hill-side of this life as bleak as
                     Where you grow" (E.B. Browning) 48
1876 OWS         Mrs Helen Allingham: "The Old Farm - South Downs"
                     "A haunt of ancient peace" (Tennyson) 90
1876 SBA         Miss C.E. Foster: "November's sky is chill and drear
                     November's leaf is red and seer" 661
1879 DG          Alice Havers: "The kine, the kine, are onward going.
                     As o'er the hills the winds are blowing,
                     They wander onward, ever lowing" 129
1879 DG          Miss M.P. Mead: "A Yew-tree ... as it stood of yore;
                     Not loth to furnish weapons for the bands
                     Of those who drew their sounding blows at Agincourt" 367
1879 DG(oil) Maud Horman-Fisher: "The tall dark trees in verdure drest,
                     And the still deep pool where herons rest,
                     And the fresh green grass in shadow lies
                     As the sun's last rays fade from the skies" (Anon) 391
1879 OWS         Mrs Helen Allingham: "The harvest moon"
                     "Globed in mellow splendour" (W. Allingham) 169

T2.a)  Shakespeare:-
1880 RA          Mrs Louise Jopling: "Ophelia"
                     "There is pansies;  that's for thoughts" ("Hamlet"
                     Act 4, sc. 5) 664
1880 RA          Mrs Anna Lea Merritt: "Ophelia" 1414 (ill. in "Academy Notes"
                     op.cit. 1880, p.74)
1880 RA          Miss Emily M. Osborn: "Nay, good goose, bite not" ("Romeo
                     and Juliet") 9
1881 RA          Ada E. Taylor: "Ophelia" 1154
1881 DG          Violet Lindsay: "My Brother, he is in Elysium" ("Twelfth
                     Night") 251
1881 RA          Jane M. Bowkett: "Ophelia" 288
1881 SLA         Mrs Emily Barnard: "Ariel's Song" ("The Tempest") 690
1882 GG          Mary Stuart Wortley: "Perdita"
                     "Here's flowers for you;
                     Hot lavender, mints, savory, etc." 210
```

1882 SLA Miss A. Carter: "Scene from 'Much Ado about Nothing'" 710

1882 SLA Mrs Agnes Nicholl: "They call me Katherine" 38

1883 SLA Jennie Moore: "Celia" 154

1883 GG Mrs Louise Jopling: "Portrait of Miss Ellen Tree as 'Portia'"
 "Bid me tear the bond" ("Merchant of Venice") 39

1883 RA Theresa Thornycroft: "Ophelia"
 "There's rosemary. That's for remembrance; pray, love,
 remember! and there is pansies, that's for thoughts" -
 ("Hamlet" Act 4, sc.5) 35

1884/5 IPO Annie L. Beal: "Ophelia" 1

1884 GG Miss Julia B. Folkard: "Sylvia"
 "Holy, fair, and wise is she,
 The heavens such grace did lend her
 That she might admired be" 100

1884 SLA Amy Giampietri: "Romeo and Juliet"
 "Give me, give me! oh, tell me not of fear" 191

1884 SLA Amy Giampietri: "As You Like It"
 "O my poor Rosalind, whither wilt thou go? Wilt thou
 change fathers?
 I will give thee mine" 532

1884 SLA Mrs Emily Barnard: "Viola" ("Twelfth Night") 756

1885 SLA Catherine J. Atkins: "Celia" 193

1885 SLA Mrs Faunthroy: "Rosalind" 395

1885 SLA C.M. Hill: "Cordelia" 409

1885 SLA Mrs Emily Barnard: "Ophelia" 702

1885 RA Miss E.M. Busk; "Portia and Lucius" ("Julius Caesar"
 Act 2, sc. 4) 591

1886 NSPW Clara Mole: "Romeo and Juliet" 416

1886 SBA Miss E. Dell: "There sleeps Titania" 366

1886 GG Louise Jopling: "Dorcas" 174

1886 SLA Anna Lea Merritt: "Miss Ellen Terry and Mrs Stirling as
 'Juliet' and her Nurse" 241

1886 SLA Helene Franck: "The Moated Grange" 315

1887 RA Annabel Downes: "Juliet: the trance" 537

1887/8 IPO Miss M.C. Stacpoole: "Cordelia" 481

1887/8 IPO Mrs Louise Jopling: "Imogen"
 "Good masters, harm me not" - ("Cymbeline") 217 (ill.)

1888 NG Mrs Kate G. Hastings: "Cleopatra"
 "Methinks I hear Anthony call" 108

1888 DG(oil) Mrs Agnes Schenk: "Hamlet" 158

1889 RA Mary L. Waller: "Perdita: a portrait" 183

1889 NG Mrs Kate G. Hastings: "Miss Ellen Terry as Lady Macbeth"
 294

1889 SBA Emma Magnus: "Portia"
 "This bond does give thee here no jot of blood"
 ("Merchant of Venice") 368

1889 SBA Gertrude Homan: "Touchstone: 'And how, Audry,
 Doth my simple feature content you?'" ("As You Like
 It" Act 3, sc.3) 452

1889 SBA Maria L. Angus: "Hermia" 468

1889 SLA Mrs Emily Barnard: "Ariel" 512

1890 SLA Helena Richards: "Ophelia" 71

1890 SLA Mrs Emily Barnard: "Reconciliation of Oberon and Titania" 490

1890 SLA Mrs Emily Barnard: "The Quarrel of Oberon and Titania" 503

1890 DG Helena Richards: "Ophelia" 307

1890 RA Henrietta Rae: "There's rue for you" - ("Ophelia") 1041
 (Walker Art Gallery, Liverpool)

1891 NSPW Miss Mary Mason: "Desdemona" 133

1892 RA Louise Jopling: "Mrs Tree as 'Ophelia'" 43 (Photograph in
 Witt Library)

1894 NG Mrs Kate G. Hastings: "Mariana" 52 (or perhaps Tennyson?)

```
1894 NG        Miss Kate G. Hastings: "Juliet" 64
1897 OWS       Miss Edith Martineau: "Silvia"
                    "Love doth to her eyes repair,
                    To help him of his blindness,
                    And, being helped, inhabits there" 195
1899 SWA       Mrs Emily Barnard: "Miranda" 240
1899 SWA       Mrs Emily Barnard: "Hermia and Helena" 329
1900 SWA       Mrs Emily Barnard: "Hermione" 119
1900 SBA       Amelia Bauerle: "Ophelia" 365
1900 RA        Mrs M. Cormack: "Titania" 726
1900 RA        Miss H.M. Rigby: "Cordelia" marble bust 2043
```

b) Tennyson:-

```
1880 DG        Edith Martineau: "What aileth thee?  whom waitest thou
                    With thy soften'd shadow'd brow
                    And those dew-lit eyes of thine,
                    Adeline?"  459
1881 SLA       Eleanor Manly: "Maud"
                    "Queen, lily, and rose in one" 268
1881 SLA       Mary Eley: "Queen Guinevere at Almesbury" 396
1881 DG(b&w) Kate A. Belford: "Divided in a graceful quiet, paused,
                    And dropt the branch she held" (Tennyson's "Gardener's
                    Daughter") 331
1881 SLA       Mary Milward: "Maud, in the light of her youth and her grace,
                    Singing of Death, and of honour that cannot die"
                    Tennyson 746
1882 GG        Mrs Marie Stillman: "The Legend of Fair Women" 201
1882 SLA       Florence Bonneau: "Nancy Lee" 720 (Perhaps Annie Lee from
                    "Enoch Arden")
1883 SLA       Helen Howard Hatton: "Isabel"
                    "The stately flower of female fortitude" (Tennyson) 254
1884 RA        Henrietta Rae: "Launcelot and Elaine" 854 (ill. in "Academy
                    Notes" op.cit. 1884, p.65)
1884 SLA       Elisabeth S. Guinness: "The Grandmother" (vide Tennyson's
                    Poem) 434
1885 SLA       Ellen Mallam: "Adeline" 759
1885 GG        Mrs Ernest Norman: "Elaine Guarding the Shield of Launcelot"
                    "Stript off the case, and read the naked shield,
                    Now guessed a hidden meaning in his arms,
                    Now made a pretty history to herself
                    Of every dent a sword had beaten in it,
                    And every scratch a lance had made upon it"
                    (Tennyson) 101
1885 OWS       Miss Constance Phillott: "Lady Flora"
                    "All-graceful head, so richly curl'd" (Tennyson's
                    "Day Dream") 71
1886 RA        Anna Lea Merritt: "St. Cecilia" - (Tennyson's "Palace of
                    Art") 134 (ill. in "Academy Notes" op.cit. 1886,p.27)
1887 SLA       Mrs Ernest Hobson: "Elaine" 109
1887/8 IPO     Miss H. Ethel Rose:
                    "Dost thou look back on what hath been?
                         *      *      *      *
                    Since we deserved the name of friends,
                    And thine effect so lives in me,
                    A part of mine may live in thee
                    And move thee on to noble ends" (Tennyson, "In
                    Memoriam") 240
1888 SLA       Katherine D.M. Bywater: "The Gardener's Daughter"
                    "There is a garden in her face
                    Where roses and white lilies grow" 221
```

1888 SBA	Mary Eley: "Guinevere at Almesbury" 383	
1889 SLA	Mary Eley: "Guinevere at Almesbury" 17	
	(probably the same as the preceding work)	

1888 SBA Mary Eley: "Guinevere at Almesbury" 383
1889 SLA Mary Eley: "Guinevere at Almesbury" 17
 (probably the same as the preceding work)
1890 SLA Mrs Emily Barnard: "Arthur in Avillon" 485
1890 SBA Miss E.A. Lilley: "The Lady of Shalott"
 "From the bank and from the river,
 He flashed into the crystal mirror" 207
1891 SLA Florence E. Sherrard: "The Gardener's Daughter" 229
1891 NSPW Miss Louisa Wren: "She, the Puritan Maiden" 168
1892 SLA Mrs Emily Barnard: "Elaine" 377
1892 RA Henrietta Rae: "Mariana in the Moated grange" 557 (ill.
 in "Academy Notes" op.cit. 1892, p.103)
1892 SBA Miss Ada Dennis: "The Gardener's Daughter" 523
1893 NG Mrs Kate L. Hastings: "Guenevere" 142
1893/4 SBA Kate Earl: "The Gardener's Daughter" 235
1894 NG Kate G. Hastings: "Mariana" 52 (or perhaps Shakespeare?)
1895 SBA Miss I.R. Tayler: "The Lily Maid" 72
1895 NG Mrs Kate G. Hastings: "Merlin and Vivian" 56
1895 NSPW Miss Ethel Woolmer: "The Puritan Maid"
 "The thoughts and light regrets that come
 Make April of her tender eyes" 490
1896 SM Kathleen E. Coad: "Miss Ellen Terry as Guinevere" 160
1897 SLA Emily Barnard: "The Beguiling of Merlin" 62
1898 SLA Mrs Mariquita J. Moberley: "She rose her height and said:
 We give you welcome" - (Tennyson's Princess) 40
1898 SBA Mrs K.E. Hill: "Guinevere" 397
1899 SWA Mildred A. Butler: "Come into the Garden, Maud" 110
1899 NG Miss Maud Seddon (Mrs Birch): "Launcelot" 266
1899 NG Mrs Florence Harvey Moore: "The Return of Enoch Arden" 334
1900 SWA Mrs Emily Barnard: "Guinevere" 734
1900 SWA Mrs Mariquita J. Moberley: "Elaine" 748
1900 NSPW Miss Mable Ashby: "Sir Launcelot and Queen Guinevere" 175
1900 RA Miss Amelia Bauerle: "The maid of Elfinmere" 1543

c) Among many other poetical sources the works of Keats, Byron, Wordsworth, Scott, Hogg, Moore, Dante, Boccaccio and Percy's "Reliques of English Poetry" were the most popular:-

1880 RA Miss M. Backhouse: "Eleanore: 'My dark eyes opened not, nor
 first revealed themselves to English air" 420
1880 RA Miss Marcella Walker: "The Village maids, with fearful
 glance,
 Avoid the ancient moss-grown wall,
 Nor ever lead the merry dance
 Among the groves of Cumner Hall" 697
1880 DG(b&w) Emily Arkwright: "To sit thus, stand thus, see and be seen,
 At the proper place in the proper minute,
 And die away the life between" (Robert Browning: "The
 Flight of the Duchess") 425
1880 DG Constance Phillott:"She sat at the door one cold afternoon
 To hear the wind blow, and to look at the moon;
 So pensive was Kathleen, my own sweet Kathleen,
 My Kathleen O'Moore" 124
1880 OWS Margaret Gillies: "The Knight and the Lady"
 "Wherefore, adue, my owne heart true!
 None other rede I can;
 For I must to the greenewode go
 Alone a banyshed man!" ("The Nut-Browne Mayd" from
 Percy's Reliques of English Poetry) 160

1880 OWS Mrs Criddle: "Lo! where she comes along with portly pace,
 Like Phoebe, from the Chambers of the East,
 Arising forth, to run her mighty race,
 Clad all in white, as seems a Virgin best;
 So well it her beseems, that ye might ween
 Some angel she had been" ("Epithalamion - Spenser)195

1880 SLA Florence Bonneau: "Cydippe"
 "Against a flowering thorn-bush fair,
 Hidden by tulips to the knee,
 His heart's desire his eyes did see" - "The Earthly
 Paradise" 591

1880 SLA Em. S. Scannell: "When Lubin is Away" 294

1881 GG Miss Violet Lindsay: "Camma"
 "Moon on the field and the foam,
 Moon on the waste and the wold,
 Moon bring him home, bring him home" 268

1881 SLA Mary Backhouse Miller: "Eleanore"
 "My dark eyes opened not,
 Nor first revealed themselves to English air" 280

1881 GG Miss E. Pickering: "The Grey Sisters"
 1st Sister: "I call myself Hunger"
 2nd Sister: "I call myself Debt"
 3rd Sister: "I call myself Care"
 4th Sister: "I call myself Necessity"
 Three together: "The gate is closed, we cannot pass;
 here dwells a rich man, we dare not enter"
 Faust (from inside): "Four saw I come but those that
 went were three"
 Care: "So fell it now; my curse thoult find
 When forth from thee I swiftly passed
 Throughout their whole existence men are blind;
 So, Faust, be thou like them at last" (Bernard
 Taylor translation of "Faust", Goethe, Part 2) 17

1881 SLA Edith Gourlie: "The Blind Beggar's Daughter of Bednall
 Green" 454 (from Percy's "Reliques of English Poetry")

1881 DG(b&w) Emily Arkwright:
 "Said Blaise, the listening monk. 'Well done
 I doubt not thou art heard, my son:
 As well as if thy voice to-day
 Were praising God, the Pope's great way'" (Robert
 Browning: "The Boy and the Angel") 103

1881 SLA Emma Whitney: "Reuben and Rose"
 "Dim, dim through the phantom,
 The moon shot a gleam" - Moore 659

1881 DG(b&w) Alice M. Chambers: "La Contemplative"
 "But my sister Rachel, she
 Before her glass abides the livelong day,
 Her radiant eyes beholding..
 Her joy -
 In contemplation" (Cary's "Dante" - "Purgatory"
 canto 27, 105) 15

1881 DG(b&w) Agnes Fraser: "O lang, lang may their ladies sit
 Wi' their fans into their hands,
 Or e'er they see Sir Patrick Spens
 Come sailing to the land" 455

1881 RA Jessie Macgregor: "The Mistletoe Bough"
 "'I'm weary of dancing now', she cried,
 'Here tarry a moment, I'll hide, I'll hide'" 551
 * * * * *

"Oh sad was her fate, in sporting jest
She hid from her lord in the old oak chest;
It closed with a spring, and her bridal bloom
Lay mouldering there in a living tomb" 552
 * * * *

"And years flew by, till their grief at last
Was told as a sorrowful tale long past;
And when Lovel appear'd, the children cried
'See the old man weeps for his fairy bride'" 553
 * * * *

(Ill. in "Academy Notes" op.cit 1881,p.59)

1881 SLA Emma Whitney: "Margaret of Branksome stealing down the
 secret stair" ("Lay of the Last Minstrel") 669

1882 DG Mariquita Phillips: "The Lady of the Lake"
 "In listening mood she seemed to stand" 581

1882 DG Constance Phillott: "Proud Maisie is in the wood
 Walking so early;
 Sweet Robin sits on the bush
 Singing so rarely

 'Tell me thou bonny bird,
 When shall I marry me?'
 'When six braw gentlemen,
 Kirkward shall carry ye'" 399

1882 GG Mrs Louise Jopling: "Fair Rosamond" 12 (her story is told
 in Percy's "Reliques of English Poetry")

1882 SLA Josephine Savile: "Gulnare" 274

1882 SLA Madame Giampietri: "My Lady's Page" 602

1882 SLA Mrs H. Champion: "Evangeline" 85

1883 SBA Miss O.P. Gilbert: "Una"
 "The Lion would not leave her desolate,
 * * * *
 Still when she slept, he kept both watch and ward;
 And when she wak't, he wayted diligent" Spenser's
 "Faery Queene" Book 1, canto iii 653

1883 OWS Constance Phillott: "Lucy"
 "A maid whom there were none to praise,
 And very few to love" 202

1883 SLA Catherine J. Atkins: "O sweet, pale Margaret" 171

1883 SLA Josephine Savile: "Kilmene" 233

1883 DG Edith Martineau: "'Ah - there's my choice - that ivy on
 the wall,
 The headlong ivy!' ..
 Thus speaking to myself, I drew a wreath
 ... across my brow,
 And fastening it behind so, turning faced
 My public!" 294

1883 RA Alice M. Mott: "In 1783"
 "You were unfashionably fair
 In '83
 And sad you were when girls are gay,
 You read a book . . .
 Alone in May.
 O head unfashionably fair,
 What end was thine, for all thy care?
 We only see thee dreaming there:
 We cannot see
 The breaking of thy vision" 961

1884 SLA Héné Wheelwright: "Kilmeny" (See Poem by James Hogg) 741

1884 SLA Florence Bonneau: "Dido"
 "But furious Dido, with dark thoughts involved,
 Shook at the mighty mischief she resolved" 685

1884 DG Ellen G. Hill: "The village seems asleep or dead
 Now Lubin is away" 434

1884 GG Lady Louisa Charteris: "Phillis"
 "Sometimes forward, sometimes coy,
 Yet she never fails to please" 354

1884 GG Mrs Marie Stillman: "Madonna Pietra Degli Schrovigni"
 "How dark soe'er the hills throw out their shade
 Under her summer green, the beautiful lady
 Covers it like a stone covered in grass" (Dante,
 translated by D.G. Rossetti) 362

1884 RA Anna Lea Merritt: "La Belle Dame Sans Merci" (Keats) 809
 (ill. in "Academy Notes" op.cit. 1884, p.62)

1885 SLA Marion Reid: "Kilmeny wakening in Fairyland" 689

1885 RA Mrs L. Rose: "Zelica"
 " . . . desolate
 In the wide world, without that only tie
 For which she loved to live or feared to die" 2081

1885 GG Mrs C. Wylie: "Rich and rare were the gems she wore,
 And a bright gold ring on her wand she bore;
 But, oh! her beauty was far beyond
 Her bright gold ring and glittering wand" 239

1885 OWS Miss Constance Phillott: "A Captive"
 "So shalt thou abide in Argos and ply the loom at
 another woman's bidding, and bear water from mount
 Messeis ... being grievously entreated and some con-
 straint shall be laid upon thee" (Iliad 6) 120 (ill.)

1886 GG Miss Helen H. Hatton: "Miss Ellen Terry as 'Margaret'"
 "Mother of many sorrows have pity" (Faust) 240

1886 RA Ada M. Palmer: "Paolo and Francesco" - ("Inferno" canto v)
 1916

1886 SLA Florence Graham: "Nourmahal" 246

1887 RA Julia B. Folkard: "Dante's Beatrice" 774

1887 SLA Emily Barnard: "Blanche" 28 (perhaps Blanche of Devon in
 Scott's "Lady of the Lake")

1887 RA Helen Jackson: "Aurora Leigh" 1065

1887 SLA Mrs Paul J. Naftel: "The Lady of the Lake" 509

1887/8 IPO Miss Kate Hitchcock: "Aurora Leigh" 647

1888 NSPW Miss Edith Mendham: "Thalaba and the Simorg" - (Southey's
 "Thalaba") 388

1888 SLA Mrs Agnes Nicholl: "Brynhild in the High Tower" 19
 (probably from "The Story of Sigmund the Volsung and
 the Fall of the Niblungs" by William Morris, an epic
 in four books, based on the "Volsunga Saga" and pub-
 lished in 1876)

1888 SBA Miss H.E. Grace: "Isolda"
 "Is there a shadow of sadness cast by the Future's sun
 Echoings faint of the turmoil that shall be e'er life
 is done?" 36

1888 SLA A.M. Youngman: "Bertram"
 "False to his patron or his rath;
 Treach'rous or perjured, one or both" - "Rokeby"
 Canto I 363

1888 NG Mrs Marie S. Stillman: "Mia suora Rachel mai non si smaga
 di duo miraglio e siede tutto il giorno" Dante 96

1888 NG Mrs Marie S. Stillman: "Gelsomina" 225

```
1888 NG        Mrs Marie S. Stillman: "Dante at Verona"
               " ....   he comes among
               The women at their palmplaying.
               The conduits round the garden sing
               And meet in scoops of milk white stone,
               Where weary damsels rest, to hold
               Their hands in the wet spurt of gold.
               One of them knowing well that he,
               By some found stern, was mild with them,
               Would run and pluck his garment's hem,
               Saying, 'Messer Dante pardon me',
               Praying that they might hear the song,
               The first of all he made when young" (D.G. Rossetti)
               233
1888 OWS       Miss Constance Phillott: "With hazel Phyllis crowns her
                        flowing hair:
               And while she loves that common wreath to wear,
               Nor bays, nor myrtle boughs, with hazel shall compare"
               (Pastoral 7) 157
1888 RA        Emily Little: "Vittoria Colonna" 271 (Although an histori-
                        cal figure, perhaps drawn from Longfellow's poem)
1889 NG        Mrs Louisa Starr Canziani: "Monichella" "Sweet love!
                        I was as vague as solitary dove,
                        Nor knew that nests were built" 128
1889 NSPW      Mrs J.W. Grey: "She hid from her Lord in the old oak chest"
                        245 (Thomas Haynes Bayly)
1889 OWS       Miss Constance Phillott: "Kathleen Mavoureen' 266 (ill.)
1889 SLA       A.E. Bowler: "Gulnare" 233
1890 RA        Miss G. Homan: "Sandalphon, the Angel of Prayer"
                        "Erect, at the outermost gates
                        Of the city Celestial he waits ...
                        And he gathers the prayers as he stands,
                        And they change into flowers in his hands"
                        - Longfellow 535
1891 RA        Florence Reason: "Rose a nurse of ninety years,
                        Sat his child upon her knee
                        Like summer tempest came her tears -
                        Sweet my child, I live for thee" 1310
1891 DG        Mariquita E. Hawker: "Nourmahal" 185
1891 SLA       Mrs Emily Barnard: "Kilmeney" 444
1891 SLA       J. Adye Ram: "Kathleen Mavourneen" 331
1891/2 IPO     Miss Gertrude Homan: "Abou Ben Adhem and the Angel" 497
1892 RA        Maud Hardman: "Norah Creena" 1090
1894 NG        Mrs Marie S. Stillman: "A Rose in Armida's Garden" 5
1894 NG        Miss Henrietta S. Montalba: "The Raven" terra cotta,
                        "When with many a flirt and flutter
                        In there stepped a stately Raven of the saintly days
                                of yore

                        .        .        .        .
                        Perched upon a bust of Pallas just above my chamber
                                door -
                        Perched, and sat, and nothing more" - Edgar Poe 412
1895 RA        Miss B. Gibbs: "Paradise and the Peri"
                        "One morn a Peri at the gate
                        Of Eden stood, disconsolate" ("Lalla Rookh") 387
                        (ill. in "Academy Notes" op.cit. 1895, p.83)
1895 RA        Miss Isobel L. Gloag: "Isabella and the pot of Basil"
                        "Love never dies, but lives, immortal Lord" (Keats) 53
                        (ill. in "Academy Notes" op.cit. 1895, p.36)
```

1895 RA Mrs J.S. Lucas: "Little Ellie sits alone, 'mid the
beeches of a meadow" 759

1895 NG Miss Elinor Halle: "Sarpedon, borne in the arms of Sleep
and Death"
"Then Sleep and Death, two twins of winged race
Of matchless swiftness and of silent pace,
Received Sarpedon at the god's command,
And in a moment reached the Lycian's land"
(Pope's Iliad) 422

1895 NSPW Mrs E.A. Frank: "And thus spake on that Ancient Man, the
bright-eyed Mariner" 234

1895 NSPW Miss Susan K. Tooth: "Fair Rosamond" 695 (her story is told
in Percy's "Reliques of English Poetry")

1896 SLA Mrs Emily Barnard: "Mavourneen" 366

1896 NG Mrs Marianne Stokes: "The Page"
"It was a grey old king,
Heavy his heart in his winter of life.
In his winter of life the poor old king
Took a young wife.

It was a page without renown,
Blond was his hair, light was his mien,
And he bore up the silken gown
Of the young Queen.

Know you the ancient lay,
So sweet, so sad its melody?
Because they loved, an well-away!
They had to die" Heine 9 (Charles Keyser, London)

1896 RA Anna Lea Merritt: "The weary King"
"He rose, and quietly he cast
His mantle from him and his crown,
And laid them by the sleeper down.
And from the shepherd's side he took
The cloak, the wallet and the crook"
(Langdon Elwyn Mitchell) 155

1897 RA Mildred H. Collyer: "La Belle Dame Sans Merci" 1083

1897 RA Henrietta Rae: "Isabella"
"She had no knowledge when the day was done,
And the new morn she saw not; but in peace
Hung over her sweet Basil evermore
And moistened it with tears unto the core" - Keats'
"Isabella" 634

1898 RA Mary F. Raphael: "Britomart and Amoret" (Spenser's
"Faery Queene") 242 (ill. in "Academy Notes" op.cit.
1898, p.61)

1898 NG Miss Ida Nettleship: "The Pot of Basil" 429

1898 RA Ella M. Bedford: "Isabella and the pot of basil" 486
(ill. in "Academy Notes" op.cit. 1898, p.94)

1899 NG Miss M. Winefride Freeman: "Lang, lang, may the ladies stand,
Wi' thair gold kems in thair hair,
Waiting for thair own dear lords,
For they'll see them na mair" ("The Ballad of Sir
Patrick Spens") 293

1899 NG Miss Maud Beddington: "And I saw her body lying without
its soul,
Among many ladies, who held a pitiful weeping"
(Dante's "Vita Nuova") 324

1900 RA Miss E.F. Brickdale: "King Cophetua and the Beggar-maid"
1595

1900 RA Miss N.E. Cook: "Alack, and well-a-day, Phillida flouts me"
1388 ("The disdainful Shepherdess" - Oxford Book of
16th century Verse")

1900 RA Mrs Margaret Murray Cookesley: "The Maid of Athens" 914

1900 RA Mary Y. Hunter: "The Duke's High Dame" 841

1900 RA Mrs F. Parkinson: "St. Agnes' Eve" statuette 1951

1900 RA Miss M.S. Phillpotts: "Dark-eye'd Carlotta, fancy rapt afar
Where all fair forms and all clear colours are" 1518

d) Prose sources include the works of Dickens, Scott, George Eliot, Jane
Austen, Sheridan, Sterne, Bunyan, Boccaccio, Goldsmith, Kingsley and
Richardson:-

1880 RA Miss Charlotte J. Weekes: "Amy Robsart"
"She has of late been casting many a backward look to
her father's halls" (Scott's "Kenilworth" ch.10) 404

1880 GG Miss H.S. Montalba: "Romola" 307

1880 GG Miss H.S. Montalba: "Tito Melema" 317

1880 GG Mrs Marie S. Stillman:
"Certain ladies of her companionship gathered them-
selves with Beatrice when she kept alone in her weep-
ing, and as they passed in and out, I could hear them
speak concerning her" (Dante "Vita Nuova") 267

1880 OWS Margaret Gillies: "Miss Byron: "Am I the delight of Sir
Charles Grandison's heart?" ("History of Sir Charles
Grandison" vol.2, letter 38) 22

1880 SLA Margaret H.A. Simpson: "Mr Darcy and Elizabeth Bennett"
(vide Miss Austen's "Pride and Prejudice") 317

1880 SBA Mrs H. Champion: "Catherine Seyton" 759

1881 RA Kate Perugini: "Little Nell" ("Old Curiosity Shop") 245
(ill. in "Academy Notes" op.cit. 1881, p.30)

1881 SBA Eliza Turck: "Little Haru at Home - Tea and Dolls" 261

1882 SLA Elizabeth M. Lovell: "Dorothea" 270

1882 SBA Miss J.M. Bowkett: "Lucy Ashton" 297

1883 SLA Florence Small: "Little Nell" - "It was early and the old
man being still asleep, she walked out into the church-
yard" 298

1883/4 SBA Miss O.P. Gilbert: "Maria made a cadence so melancholy, so
tender and querulous, that I sprung out of the chaise
to help her .." ("Tristram Shandy" ch. xxiv) 677

1884 DG Ellen G. Hill: "Catherine Morland at the Ball"
"Catherine was left to the mercy of Mrs Thorpe and Mrs
Allen; Mrs Thorpe talked of her children, and Mrs
Allen of her gowns, Catherine longed to be dancing,
but she was sharing with scores of other young ladies,
still sitting down, all the discredit of wanting a
partner" ("Northanger Abbey" Jane Austen) 378

1884 GG Mrs Alma Tadema: "Tiny Elizabeth, you must not leave us"
(George Eber's "The Burgomaster's Wife") 19

1884 SLA Mrs H. Champion: "Lucy Ashton" 705

1885 SLA Ellen Partridge: "Kate Nickleby" 724

1885 SLA Emily A. Cook: "Little Dombey" 343

1885 SLA Edith M. Scannell: "Lydia Languish" 736

1885 NSPW Mrs Mariquita Moberley: "The Flight of Little Nell and her
Grandfather" ("Old Curiosity Shop") 665

1886 NSPW Kate Sadler: "Meg Merrilies" 241

1886 NSPW Ellen G. Hill: "Lady Catherine approached, and said to
Darcy, 'Miss Bennett would not play at all amiss if she
practised more, and could have the advantage of a
London master. She has a very good notion of finger-
ing, though her taste is not equal to my daughter's.

Anne would have been a delightful performer had her
health allowed her to learn'" - (Scene from Jane
Austen's "Pride and Prejudice" p.154) 511

1887 SLA Mrs Herbert Moberley: "The Flight of Little Nell and her
 Grandfather" - ("The Old Curiosity Shop") 78

1887 OWS Miss Margaret Gillies: "Christiana by the River of Life"
 "This river has been a terror to many; yea, the
 thoughts of it have also frightened me. Now, me-
 thinks, I stand easy .. I see myself now at the end
 of my journey; my toilsome days are ended . . I have
 formerly lived by hearsay and faith, but now I go
 where I shall live by sight" (John Bunyan) 76

1887 NSPW Ellen G. Hill: "Going to supper at the 'Crown'"
 "Supper was announced. The move began, and Miss Bates
 might be heard from that moment without interruption:
 'Mr Churchill, oh, you are too obliging - so gratified.
 Upon my word, Jane on one arm and me on the other. Well,
 this is brilliant! I am all amazement - could not have
 supposed anything - such elegance and profusion -
 quantities of matting - candles everywhere!" (Scene
 from Jane Austen's "Emma") 108

1888 RA Amy H. Hunt: "Felix Holt Esq. - bust 2013

1889 NG Mrs Marie S. Stillman: "When January came and the cold was
 greatest, everything being covered with snow and ice,
 the magician turned a meadow near the city into a most
 beautiful garden full of flowers and fruit of every
 kind. Messer Ansaldo seeing this, had some gathered to
 present to his lady, inviting her to see the garden he
 had asked for, and reminding her of the promise she had
 made. Madonna Dianova wondering at the flowers and
 fruit, went with other ladies to visit Messer Ansaldo
 in his garden" - "The Decameron" 10th day, 5th story
 177 (Parke-Bernet Gallery, New York, April 19,1952)

1889 SLA Mrs Emily Barnard: "The Three Shining Ones" ("Pilgrim's
 Progress") 404

1889 NSPW Miss Frances Emeris: "Dinah Morris" - "Adam Bede" 87

1889/90 IPO Miss Beatrice Meyer: "A Picnic Scene - from the 'Antiquary'
 by Sir Walter Scott" 81

1890 RA Miss F. Homan: "Peg Woffington criticized in the place of
 her portrait" 526

1890 RA Eleanor Manly: "The arrival of Master and Mistress Harry
 Walmers Junr., at the 'Holly Tree' Inn. 'Chops and
 cherry-pudding for two'" - (Dickens) 1440

1892 RA Eleanor Manly: "Norah (Mistress Harry Walmers Junr)"
 "It's better than millions of the brightest diamonds to
 be liked by Norah" 1246

1892 SLA Mrs M.F. Field: "Sophia Primrose" 267

1892 NSPW Miss Eleanor E. Manly: "Boots at the 'Holly Tree' Inn"
 "In the evening, Boots went into the room to see how
 the runaway couple was getting on. The gentleman was
 on the window-seat, supporting the lady in his arms.
 She had tears upon her face and was lying, very tired
 and half asleep, with her hand upon his shoulder.
 'Mrs Harry Walmers, Junior, fatigued, sir?' says Cobbs"
 Charles Dickens 52

1892 RA Florence Hannam: "The doll's dressmaker" ("Our Mutual
 Friend") 516

1892/3 IPO Miss Beatrice Meyer: "The Beautiful Miss Gunnings are Pre-
 sented by their Mother to Peg Woffington" 445

1893 NSPW Miss Eleanor E. Manly: "Boots at the 'Holly Tree' Inn"
"'It's Cobbs! It's Cobbs!' cries Master Harry. 'We
are going to be married, Cobbs, at Gretna Green. We
have run away on purpose!'" 134

1893 NSPW Miss Ellen G. Hill: "A New Joy in a Quiet Life"
"Dost thou remember our first reading 'Lalla Rookh'?
It was on a washing day. We read and clapped our
clear starching, read and clapped, read and clapped,
and read again, all the time our souls were not on
this earth" (See letter from Mary Howitt to her
sister Anna) 467

1893 SLA Mrs Emily Barnard: "'Oh, you beautiful creature,' said Tom;
and he put out his hand to catch it" - "The Water
Babie-" 131

1896 NG Mrs Marie S. Stillman: "Il Falco de Messer Federigo, from
Boccaccio" 1

1897 SM(Spring) Miss E.M. Reeves: "Lady Teazle" 5

1897 SM(Spring) Miss Sara West: "Miss Ellen Terry as Lucy Ashton" 188

1897 SM(Autumn) Miss Sara West: "Miss Ellen Terry as Iolanthe" 240

1897 SLA Florence Small (Mrs Deric Hardy): "Effie Deans before the
Court of Judiciary" 354

1898 NG Mrs Marianne Stokes: "Aucassin and Nicolette" 88

1898 RA Margaret I. Dicksee: "A sacrifice of vanities"
"The next day I had the satisfaction of finding my
daughters, at their own request, employed in cutting
up their trains into Sunday waistcoats for Dick and
Bill" ("The Vicar of Wakefield") 577

1899 SM Miss Barbara Hamley: "Clarissa Harlowe" 231

1899 SWA Mabel J. Young: "Rob Roy" 219

e) Fairy Tales:-

1880 GG The Hon. Mrs Boyle: "Beauty and the Beast" Part of a Series
268

1880 SLA Mrs Michie: "Cinderella" 443

1881 SLA Constance L. Absalon: "Cinderella" 613

1881 SLA Florence Bonneau: "Princess Parizade and the talking Bird"
("Arabian Nights") 633

1881 SLA Mariquita J. Phillips: "Cinderella" 646

1882 SLA Charlotte E. Babb: "The coming of Undine to the Fisherman's
Cottage" (vide "Undine" by De La Motte Fouquet) 64

1883 DG Harriet Kempe: "Cinderella" 470

1885 GG Miss Alice Havers: "The babes in the wood" 313

1885/6 IPO Miss Nelly Hadden: "Cinderella" 582

1886 SBA Miss L. Edwardes: "Cinderella" 80

1886 GG Mrs Hastings: "The Wild Swans"
"Elsie weaving shirts of nettles in order to destroy
the spell by which her step-mother changed her eleven
brothers into swans" Hans Christian Andersen 147

1888 GG Miss K.G. Speed: "The Little Mermaid" (Hans Andersen) 257

1888 NG Miss Evelyn Pickering: "The Little Sea Maid"
"At home in the Prince's castle, when the others slept
at night, she went out to the rocks by the sea-shore,
and cooled her burning feet in the cold sea-water;
then she thought lovingly of the dear ones in the deep"
- (Hans Andersen) 199

1891 OWS Miss Edith Martineau: "The Servant Maid"
"When she reached home she wanted to begin her work,
took the broom, which still stood in its corner,
and began to sweep. When the strangers came out of
the house, and asked who she was, and what she did

there. For it was not three days as she had
believed, but seven years that she had been with the
little men in the mountain, and her old master and
mistress had died in the meantime" ("Die Wichtel-
männer" by Grimm) 144

1892 SBA Mrs M.J. Moberley: "The Frog Prince" (Grimm's Fairy Tales"
525

1892 NEAC Miss A.C. Barber: "The Swineherd, from Hans Andersen"
"So she sent one of the ladies of the Court down to
ask the price of the pot, and the swineherd said ten
kisses from the princess"

1894 SBA Miss C.M. Alston: "Red Riding Hood" 516

1895 RA M.S. (Mrs J.S.) Lucas: "Cinderella's Dream" 709

1895 RA Miss M.E. Luxmoore: "The Princess and the nettles" (from
Hans Andersen) 543

1895 RA Mrs D. Hardy (Florence Small): "Fortune and the enchanted
prince" from the book by La Comtesse d'Aulnoy - 213

1896 NG Mrs Kate G. Hastings: "Rapunzel" 25

1896 SLA F. Mabelle Pearse: "The Maiden who had to spin Straw of
Gold" - Grimm's "Fairy Tales" - 148

1897 SLA F. Mabelle Pearse: "The Princess and the Frog" - Grimm's
Fairy Tale - 239

1899 NSPW Miss Nellie Sansom: "The Little Match-Girl" from Hans
Andersen's "Fairy Tales" 541

1900 DG Miss Mariquita Moberly: "The Frog Prince" (Grimm's "Fairy
Tales") 10

1900 RA Miss W.L. Stamp: "The babes in the wood" 1308

1900 RA Miss A.B. Woodward: "Illustration to the Hundredth Princess"
1679

U2. In the Oxford Dictionary of Quotations, the phrase "Dear Lady Disdain"
appears in the following quotation:-
 Beatrice: "I wonder that you will still be talking, Signior
 Benedick: nobody marks you".
 Benedick: "What! my dear Lady Disdain, are you yet living?"
 ("Much Ado About Nothing" Act 1, sc.1)
That pictures entitled "Dear Lady Disdain" should be portraits of Beatrice
seems unlikely. It is more probable that they simply portrayed disdain-
ful ladies. The following is a list of such works:-
1880 SBA Eleonore Ritchie: "Dear Lady Disdain" 672
1882 SLA Mrs William Barnard: "Dear Lady Disdain" 655
1883 SLA Edith Heckstall Smith: "My Lady Disdain" 339
1884 SLA Florence White: "Dear Lady Disdain" 366
1885 SLA Miss A. Carter: "Dear Lady Disdain" 198
1885 SLA Florence Mann: "Dear Lady Disdain" 312
1889 NSPW Miss Maud Porter: "My Lady Disdain" 160
1892/3 IPO Miss Lily Delissa Joseph: "My Lady Disdain" 211
1895 SLA Emily A. Fawcett: "Dear Lady Disdain" 382
1895 NSPW Miss Mable Jones: "Lady Disdain" 679
1896 SLA Louise Jopling: "Dear Lady Disdain" 179
1897 SM(Spring) Miss E.M. Reeves: "Dear Lady Disdain" 2
1897 SM(Spring) Miss E.S. Cheeswright: "Dear Lady Disdain" 131
1899 SWA Hillary Coddington: "Dear Lady Disdain" 359

V2. 1880 RA Miss E. Folkard: "A Sorrow's crown of sorrow is remember-
ing happier things" 815

1880 RA Miss Emily M. Osborn: "Reflections"
"Yet the vague memory scarce forgot,
Lingers deep down within the heart" ("Songs of Two
Worlds") 1029

```
1880 DG(b&w)  Mrs Baird Martin: "And still the sweet half-solemn look,
                  Where some past thought is clinging
                  As when one shuts a serious book
                  To hear the thrushes singing" (Austin Dobson) 568
1880 GG       Miss Maude Goodman: "O for the touch of a vanish'd hand"
                  177
1880 SBA      Phoebe Cobbett: "Maiden meditation, fancy free" 453
1880 SBA      Frances L. Grace: "Dream after dream ensues,
                  And still they dream that they shall still succeed,
                  And still are disappointed" 373
1880 SBA      Frances L. Grace: "Heard melodies are sweet, but those
                  unheard are sweeter" 516
1880 SLA      Emily M. Merrick: "In that sweet mood when pleasant thoughts
                  Bring sad thoughts to the mind" 334
1881 SBA      Annie L. Beal: "In that sweet mood when pleasant
                  Thoughts bring sad thoughts to the mind" 135
1881 SLA      Kate Prentice: "Cometh sunshine after rain;
                  After sorrow joy again" 28
1881 SLA      Mary Eley: "A fond remembrance hidden deep
                  Of days that are no more" 463
1881 SLA      Florence Bonneau: "In that sweet mood when pleasant
                  thoughts
                  Bring sad thoughts to the mind" 327
1882 RA       Mary Eley: "Sweet dreams of other days arise,
                  And memory breathes her vesper sigh to thee"
                  (T. Moore) 1349
1882 RA       Louise Jopling: "A sorrow's crown of sorrow
                  Is remembering happier things" 1503
1882 GG       Miss R. Koberwien: "In that sweet mood when pleasant
                  thoughts
                  Bring  sad thoughs to the mind" 10
1882 SBA      Edith Scott: "Her thoughts were of the battlefield,
                  With the followers of the king" 393
1882 SBA      Ellen Gilbert: "Serious and thoughtful was her mind"
                  (Wordsworth) 535
1884 RA       Mary K. Benson: "Why thus longing, why for ever sighing
                  For the far off, unattained and dim?"  1
1884 RA       Harriet Kempe: "In that sweet mood when pleasant thoughts
                  Bring sad thoughts to mind" (Wordsworth) 942
1884 SLA      Miss Stanley: "Her life's clear stream
                  Flows on so calm, she cannot choose but dream" 536
1885 RA       Mrs A. Sherriffe: "And while she turns the giddy wheel
                  around,
                  Revolves the sad vicissitudes of things" 512
1885 SLA      Alice Havers: "Trouble"
                  When sorrows come, they come not single spies, but in
                  battalions" 439
1886 GG       Mrs C. Wylie: "A wanderer in the Elysian Fields"
                  "A wanderer in the Elysian fields, who yet
                  Wears on her brow a lingering regret:
                  Is it the shadow of the past that lies
                  Within the depths of the dark wistful eyes?
                  So newly entered in Elysian bliss.
                  Yet on her lips lingers a mother's kiss:
                  What if perchance, that mother's cry she hears
                  From out the music of the rolling spheres" 209
1886 SBA      Annette M. Nathan: "In Maiden Meditation" 466
1886 SLA      Emily Barnard: "The starlike Sorrow of Immortal Eyes" 508
```

1886/7 IPO Maude Goodman: ".. and pausing midst her play
 The child stood wondering there" 366

1887 SLA Kate G. Hastings: "In Maiden Meditation" 9

1888 SBA Kate Bannin: "And age is a time of peace, so be it free
 from pain,
 Happy has been my life, but I would not live it again"
 482

1888 NSPW Miss Mary Joyce: "There was a soft and pensive grace,
 A cast of thought upon her face" 438

1888 NSPW Miss Mary Joyce: "Her eyes were with her thoughts,
 And they were far away" 481

1888 OWS Miss Edith Martineau: "In sweet music is such art, -
 Killing care and grief of heart,
 Fall asleep, or hearing, die" 216

1888 SLA Florence P. Goody: "'Tis better to have loved and lost
 Than never to have loved at all'"

1888 SLA Madeleine Irwin: "The thoughts of youth are long, long
 thoughs" 357

1888 SLA Mary Angus: "There was a soft and pensive grace,
 A cast of thought upon her face" 547

1889 NSPW Miss A.M. Shrimpton: "The thoughts of youth are long, long
 thoughts" 110

1889 RA Catherine J. Atkins: "Age is a time of peace, so be it free
 from pain,
 Happy has been my life, but I would not live it again"
 1299

1889 SLA Gertrude Peel: "The world forgetting, by the world forgot" 8

1889 SLA J. Archer: "There's pansies, that's for thoughts" 318

1890 RA Miss A.M. Chambers: "Relentless memory"
 "Look in my face; my name is Might-have-been. I am
 also called No More and Too-Late. Farewell" Rossetti
 1180

1890 RA Miss Dora Hitz: "Hope deferred maketh the heart sick" 1314

1890 NSPW Miss Ada Bell: "To me the meanest flower that grows
 Gives thoughts that often lie too deep for tears" 740

1890 SBA Miss Ada M. Shrimpton: "Dreams of the days that were" 241

1890/1 IPO Miss Blanche Vicat Cole: "Without a wish or care
 Beyond the cloister calm and still" 106

1892 RA Kate E. Bunce: "She dreams, till now on her forgotten book
 Drops the forgotten blossom from her hand" 515

1891 SLA Mary E. Postlethwaite: "Maiden Meditation" 200

1892 OWS Miss Edith Martineau: "Heard melodies are sweet,
 But those unheard are sweeter" 53 (ill.)

1892 NSPW Miss M.E. Harris: "More things are wrought by Prayer than
 this world dreams of" 94

1892 RA Helen Cridland: "Oh! there's nothing left for us now
 But to mourn a happier past" 292

1892 SLA F. Abel: "In maiden meditation, fancy free" 227

1892/3 IPO Miss Edith Sprague: "So doll days die, and fantasies
 Of boundless possibilities
 Are shadowed in the troubled eyes" 594

1893 NG Mrs H.M. Stanley: "Heard melodies are sweet, but those
 unheard are sweeter" 1

1893 NSPW Miss Mary Joyce: "There was a soft and pensive grace,
 A look of thought upon her face" 384

1893 SBA Ida R. Tayler: "I cannot leave my spinning
 So fair my dream has grown" 89

1893 SLA Kate Sturgeon: "I sit on my creepie, and spin at my wheel,
 And think on the laddie that lo'es me sae weel"
 - Old Song 114

1893 SLA Edith Mendham: "A Midsummer Night's Dream" 335

1894 RA Sophie T. Stern: "There was a soft and pensive grace
 A cast of thought upon her face" 1020

1894 RA Mary Marks: "Often have I sighed to measure
 By myself a lonely pleasure;
 Sighed to think I read a book,
 Only read perhaps by me" 1105

1894 RA Margaret Butterworth: "L'Ingénue"
 "In maiden meditation, fancy free" 1234

1894 OWS Miss Edith Martineau: "Sessions of sweet silent thought"
 180 (ill.)

1894 NSPW Miss Mary Mason: "Tears, idle tears" (Tennyson) 594

1894 NG Miss Edith Fuller: "So some strange thoughts
 Transcend our wonted themes" (Henry Vaughan) 152 (ill.)

1895 SBA Miss Ada M. Shrimpton: "Eyes ever trembling with the dew
 Of dainty woeful sympathies" 407

1895 RA Miss M.L. Angus: "Romance who loves to nod and sing
 With drowsy head and folded wing" 420

1895 RA Miss M.L. Angus: "There's sure no passion in the human soul
 But finds its food in music" 1026

1895 RA Miss M.A. Heath: "Her own sweet thoughts for company" 946

1895 RA Miss Jessie Macgregor: "Music sweet as love"
 "A high-born maiden in a palace tower
 Soothing her love-laden Soul in secret hour,
 With music sweet as love" (Shelley: "To a Skylark") 880

1895 RA Miss H. Myers: "The thoughts of youth are long, long
 thoughts" 294

1896 NG Miss Lisa Stillman: "But is there somewhere on earth, I
 wonder,
 A fading figure - with eyes that wait;
 Who says, as she stands in the distance yonder
 He cometh never or comes too late?"
 (from Sir Alfred Lyall's sequel to "My Queen") 378

1897 SM(Autumn) Miss M.H. Carlisle: "In maiden meditation, fancy free" 82

1897 SBA Edith M. Mason: "With garments full of sea-winds blown
 From isles beyond of spice and balm,
 Beside the sea, beneath the palm,
 She waits as true as chisell'd stone" 335

1898 NG Miss Effie Stillman: "There all alone
 She sitteth in thought trouble,
 maidenwise" - (R.W. Gilder) 499

1899 NG Miss M. Winefride Freeman: "Lang, lang may the ladies stand,
 Wi thair gold kems in thair hair,
 Waiting for thair own dear lords,
 For they'll see them na mair" (Ballad of Sir Patrick
 Spens) 293

1899 NG Miss Nina Hardy: "Absence makes the Heart grow fonder" 322

1900 RA Miss I. Pyke-Nott: "Fancyland"
 "Where the soul doth forwards bend,
 And dream the sweet world hath no end" 1156

1900 RA Miss J.A. Ram: "Of old unhappy far off days,
 And battles long ago" 660

1900 RA Miss M.B. Worsfold: "Why so Pensive gentle Maiden?" 1480

1900 NG Henrietta Rae: "Her Eyes are Homes of Silent Prayer"
 (Tennyson's "In Memoriam") 10

W2. 1880 RA Miss K. Bisschop: "Time leaves its traces on us all,
 Young and old, great and small" 802

 1880 GG Miss Maude Goodman: "O! for the touch of a vanish'd hand" 177

1881 SLA Fanny Cook: "No more his hand will turn the well-thumbed
 leaves,
 His eyes will read the well-loved words no more" 261

1882 SBA Mary Eley: "Where hath the spirit fled?
 From earth for ever past.
 * * *
 Mysterious shadows hide
 The mystery of Heaven.
 But where all knowledge is denied,
 Hope is given" 122

1883 SLA Mrs E.M. Ward: "Winter"
 "All that lives must die,
 Passing through nature to eternity" ("Hamlet" Act II,
 sc.2) 613

1884 RA Ellen Conolly: "A gap in the ranks"
 "He shall return no more to his home, neither
 Shall his place know him anymore" ("Job" ch.7, v.10) 1641

1884 GG Miss Evelyn Pickering: "List we to love meanwhile in lover's
 fashion,
 Death nears apace with darkness round his brows;
 Dull eld is stealing up to shame our passion;
 How shall grey hairs beseem these whispered vows?"
 (Tibellus 1.1.69) 176

1885 RA Miss E. Conolly: "Oh little lids now folded fast,
 Must ye learn to drop at last
 Our large and burning tears" (Elizabeth Barret
 Browning) 738

1886 DG Helen O'Hara : "One little life the less
 One broken heart the more" 54

1887 GG Mrs Marie Stillman: "Upon a day came sorrow unto me" 303

1887 RA Margaret Isabel Dicksee: "A dawning life"
 "One generation passeth away and another cometh" 109

1888 SLA Ida Lovering: "Never a head is dimmed with grey,
 But another is sunned with curls" 311

1888/9 IPO Miss Ada Bell: "All that's bright must fade,
 The brightest still the fleetest:
 All that's sweet was made
 But to be lost when sweetest" (Moore) 19

1889 SLA Mrs Philippe Mackenzie: "Oh for the touch of a vanished hand
 And the sound of a voice that is still" 55

1889 DG Miss J. Maud Peel: "There is no time like Spring,
 The spring that passes by,
 There is no life like spring,
 Life born to die" 80

1890 RA Miss F. Reason: "The requital"
 "Up the first sunbeam the angel fled,
 Having kissed the woman and left her - dead"
 (A.A. Procter) 1285

1890 GG Miss Flood Jones: "Sleepe after toyle, port after stormy seas,
 Ease after warme, death after life, does greatly please"
 350

1890 GG Miss Flora M. Reid: "The Widow"
 "The tremulous notes dispelling
 The gloom which encircleth death,
 Grief grew to a passionate yearning,
 Lift up by an infinite faith" 202

1890 NSPW Miss Florence Goody: "We watched her breathing through the
 night,
 Her breathing soft and low,
 As in her breast the wave of life
 Kept heaving to and fro" (Thomas Hood) 324

1892 NSPW Miss Florence P. Goody: "Most like the next step passing by
Will be the Angel's whose calm eye
Marks rich, marks poor" 227

1893 RA Amy Sawyer: "All flesh is grass, and all the goodliness
Thereof is as the flower of the field" 63, 64, 65, 66

1894/5 IPO Miss Mary Baylis Barnard: "Oh little lids ...
Must ye learn to drop at last
Our large and burning tears?" 575

1895 SBA Miss E. Folliott Powell: "The night cometh, when no man can
work" ("St. John" ch.4, v.4) 86

1896 NG Miss Flora M. Reid: "The Evening of Life"
"As now the sun's declining ray,
At eventide descends;
So Life's brief space is sinking fast,
To its appointed end" 159

1898 RA Myra E. Luxmoore: "Peace let it be: for I loved him, shall
love him for ever; the dead are not dead, but alive"
139

1898 SLA E.E. Greatorex: "Today and Yesterday"
"'Each Morn a thousand Roses brings, you say'.
'Yes, but where leaves the Rose of yesterday?'"
(Omar Khayyam) 68

1899 NSPW Miss Gertrude Demain Hammond R.I.:
"All things that pass
Are woman's looking-glass;
They show her how her bloom must fade,
And she herself be laid,
With withered roses in the shade" 222

1900 RA Mrs B.M. Jenkin (M.M. Gils): "In Memoriam" marble group
"He shall give his angels charge over thee" 1914

X2. 1883 GG Mrs Catherine A. Sparkes: "Mother and child"
"Encircles all the heart and feedeth the senses
With a still delight" 213

1885 RA Miss E. Conolly: "Oh, little lids now folded fast,
Must ye learn to drop at last
Our large and burning tears" (Elizabeth B. Browning) 738

1886 SLA S.M. Louisa Taylor: "A Simple Child"
" - "That lightly draws its breath,
And feels its life in every limb -
What should it know of death!" (Wordsworth) 356

1889 DG Mrs W.E. Hine: "We'll talk of sunshine and of song,
And summer days when we were young;
Sweet childish days that were as long
As twenty days are now" 151

1891 DG Beatrice C. Smallfield: "Gather ye roses while ye may" 187

1891/2 IPO Miss Elizabeth Nourse: "So dear a life your arms enfold"
(Tennyson) 57

1894 NG Mrs Alma-Tadema: "Now folded are the wings of night, and day
Peeps through with golden eye. The birds have risen;
The white boughs, bending to the snows of spring,
Quiver with song. And who has waked besides?
What bird 'gins twitter in the nest? My babe,
O! blossom all mine own, thou bird of joy,
Mine eye sinks deep into thy sweet eye's Heaven;
My heart against thee flutters in its love,
For very feat of having. Day has come;
God bless thy day! Thou art thyself the dawn,
Bright by thy noon, my life's own light, my son"
(Lawrence Alma-Tadema) 160

1894/5 IPO Miss Mary Baylis Barnard: "Oh little lids ...
 Must ye learn to drop at last
 Our large and burning tears?" 575

1898 OWS Miss Rose Barton: "Enjoy the honey-heavy dews of slumber,
 Thou hast no figures, nor no fantasies
 Which busy care draws in the brains of men,
 Therefore thou sleep'st so sound" 144 (ill.)

1898 NSPW Miss Gertrude Demain-Hammond:
 "Golden days - where are they?
 Ask of childhood's Years" 252

Y2. 1881 DG(b&w) Fanny Sutherland: "The beggar girl"
 "Over the mountain and over the moor,
 Hungry and barefoot I wander forlorn

 . . .
 Cold blows the wind and the night's coming on"
 (Old Song) 128

1883/4 IPO Flora Reid:"A Seamstress"
 "With fingers weary and worn,
 With eyelids heavy and red" 686

1885/6 IPO Miss Dora Noyes: "There's little to earn and many to keep"
 396

1886 RA Lily Rose: "The Song of the Shirt" statuette, terra cotta
 1866

1889 DG Miss Mary Mason: "The Seamstress"
 "Tho' bright the sun, and fine the day,
 I must sew while others play" 54

1891 RA Margaret Bird: "The Song of the Shirt" (Th. Hood) 170

1894 NG Miss Flora M. Reid: "A Flemish Lacemaker"
 "Weary and worn and sad" 218

1898 RA Mary E. Postlethwaite: "It is not linen you are wearing out;
 But human creatures lives" (Hood) 745

1900 SBA Miss Nellie Sansom: "Won't you buy my pretty flowers?"
 "Underneath the gaslight's glitter
 Stands a little fragile girl,
 Heedless of the night-winds bitter
 As they round about her whirl.
 While the hundreds pass unheeding,
 In the evening's waning hours,
 Still shecries with tearful pleading
 Won't you buy my pretty flowers?" 487

Z2. The following is a list of portraits of professional people by women
 artists from 1826 to 1851

1826 RA Eliza Jones: "Francis Chantrey, Esq. RA" 598

1827 RA Eliza A. Drummond: "Richard Henry Horne, Esq." 594

1828 RA Mrs William Carpenter: "William Collins, Esq. RA" 419

1830 RA Eliza A. Drummond: " "Miss Phillips of the Theatre Royal,
 Drury Lane" 569

1830 RA Mrs Pearson: "Portrait of Miss Heaphy" 205 (Artist)

1831 RA Miss C.S. Smith: "Portrait of Miss E.E. Kendrick" 924
 (artist)

1833 RA Margaret Gillies: "The Rev. W.J. Fox" 787

1833 SBA Mrs William Carpenter: "Portrait of the late R.P. Bonington"
 68 (National Portrait Gallery)

1834 RA Mrs Turnbull: "Portrait of Miss Ellen Tree as Mariana in
 Sheridan Knowles play of 'The Wife' etc." 724

1835 RA Miss H. Kearsley: "Miss Pardoe, author of 'Traits and
 Traditions of Portugal'" 470

1835 RA	Eliza Jones: "Miss Mitford, author of 'Foscari', 'Rienzi', Charles the First' etc" 705	
1836 RA	Mrs Turnbull: "Mrs Selby of St. James's Theatre" 721	
1836 SBA	Mrs L. Goodman: "Portrait of Miss Fanny Corbaux" 117 (artist)	
1836 RA	Mrs Turnbull: "Miss Shirrett of the Theatre Royal, Drury Lane" 757	
1837 SBA	Miss Margaret Gillies: "Portrait of Miss Ellen Tree as Myrrha in 'Sardanapulus' etc." 789	
1837 RA	Miss Margaret Gillies: "Miss Pincott, of the Theatre Royal, Drury Lane, as a bacchante" 669	
1837 RA	Miss Margaret Gillies: "R.H. Horne Esq. author of 'Cosmo de Medici' etc." 794 (National Portrait Gallery)	
1837 RA	Miss Margaret Gillies: "John Finlaison, Esq. The Government Calculator" 802	
1838 RA	Mrs G.R. Ward: "Portrait of Miss Sharpe" 822 (artist)	
1838 RA	Rose Myra Drummond: "Mr Charles Kean in the character of Hamlet, etc" 299	
1839 RA	Eliza Jones: "The Lord Advocate" 866	
1839 RA	Miss H. Kearsley: "George Augustus Wallis, Esq. Member of the Royal Academy of Painting at Florence" 1200	
1839 RA	Miss Margaret Gillies: "Miss Helen Faucit as Julie de Mortemar in Sir E.B. Lytton's 'Richelieu'" 884	
1839 RA	Miss Margaret Gillies: "Mr Macready as Cardinal Richelieu" 918	
1839 RA	Miss Margaret Gillies: "Leigh Hunt Esq." 947 (National Portrait Gallery)	
1839 RA	F. Ellen Drummond: "Mr Charles Kean as Sir Edward Mortimer" 1025	
1839 SBA	Miss Margaret Gillies: "Portrait of Miss Myra Drummond" 724 (artist)	
1840 BI	Miss J.M. Drummond: "Portrait of Miss Helen Faucit as the Lady of Lyons" 238	
1840 RA	Mrs Turnbull: "George Cruikshank" 838	
1840 RA	Rose Myra Drummond: "Mr William Harrison as Captain Macheath" 895	
1840 RA	F.Ellen Drummond: "Mr Moore, as Francesco Agolante, in 'The Legend of Florence' etc" 884	
1840 RA	Miss Margaret Gillies: "William Wordsworth Esq." 716 (probably the portrait now at Dove Cottage, Grasmere. See vol. 1 pp 268-9)	
1841 RA	Mrs Turnbull: "V. Bartholomew Esq." 921	
1841 RA	F. Ellen Drummond: "Mr Anderson, as Fernando, in the 'Bride of Messina'" 850	
1841 RA	Mrs Carpenter: "Portrait of the veteran Whig, George Byng" 171	
1842 RA	Eliza Jones: "The late lamented Sir F. Chantry R.A." 929	
1842 RA	F. Ellen Drummond: "Mlle Celeste, in the character of Narranattah, or the Wept of the Wish-ton-Wish, etc" 694	
1843 RA	Mrs Turnbull: "George Catlin Esq. etc." 830	
1844 RA	Miss Margaret Gillies: "Charles Dickens Esq." 660	
1844 RA	Mrs L. Goodman: "Portrait of Miss Fanny Corbaux" 498 (artist)	
1845 RA	Mrs Carpenter: "Patrick Fraser Tytler Esq." 79 (National Portrait Gallery)	
1846 RA	Miss Margaret Gillies: "William and Mary Howitt" 931 (Castle Museum, Nottingham)	
1846 RA	Miss Kipling: "Portrait of Miss Ward" 774 (artist)	
1847 RA	Mrs Carpenter: "John Turner Esq." 296	
1847 RA	Miss Margaret Gillies: "Mary Howitt" 919*	

1848 RA	Mrs H. Moseley (Miss M.A. Chalon): "Miss Henrietta Ward" 961 (artist)
1848 SBA	Miss M. Tekusch: "Portrait of Miss Fox" 713 (artist)
1849 RA	Miss Mary Ann Nichols: "The portrait of Mlle Jenny Lind, from the bust by J. Durham Esq. - an imitation cameo" 709
1849 RA	Miss Margaret Gillies: "Miss Howitt" 762
1849 RA	Miss Gubbins: "Sketch from recollections of Jenny Lind, at Leamington" 928
1849 RA	Miss Margaret Gillies: "Miss Howitt" 762 (artist)
1851 RA	Miss Margaret Gillies: "Mrs Marsh (authoress of 'Emilia Wyndham') " 1000
1851 RA	Mrs H. Moseley: "John Tenniel" 967

A3. 1867 SBA Mrs A. Melville: "But now fair flowers - in your dead bloom
I read a silent tale,
How deepest memories must fade,
And deepest love must fail.
A bitter thought might whisper now,
It is the common lot
To live, to love, and then to die,
And be at last forgot" (From "The Talk of the Household" by Marian Richardson) 317

1876 SLA Georgina Swift: "Look at the fate of summer flowers,
Which blow at day-break, droop e're even'song" 207

1878 GG Lady Lindsay: "Blossom"
"But you are lovely leaves, where we
May read how soon things have their end though ne'er
so brave" (Herrick) 210

1888 NSPW Miss A.M. Youngman: "And All Must Die" 240 (ill.)

1890 GG Miss Ada Bell: "Loveliest of lovely things are they
That soonest pass away" 280

1890 NSPW Miss Ada Bell: "To me the meanest flower that grows
Gives thoughts that often lie too deep for tears" 740

1895 NSPW Miss A.M. Youngman: "Mors et Vita"
"Age from out the tomb
Shall immortal youth assume,
And Spring eternal bloom" 604 (ill.)

B3. Religious themes:-

1809 BI	Mrs Green: "Devotion" "Devotion is the love we pay to heaven" 193
1820 OWS	Miss E.E. Kendrick: "Devotion" 179
1822 RA	Miss C. Thicke: "Portrait of a nun" 679
1822 BI	Mrs Carpenter: "Devotion" 199
1822 BI	Mrs Ansley: "Devout Reflexion" 319
1828 BI	Miss Eliza Jones: "Devotional Reading" 213

Reading:-

1809 RA	Mrs Read: "The Novel Reader" 4
1809 RA	Miss Trotter: "The Story-book" 484
1818 BI	Miss Laporte: "A Girl Reading" 87
1823 RA	Miss J. Ross: "A Girl Reading" 878
1825 SBA	Miss J. Ross: "Girl Reading" 453
1828 BI	Miss Eliza Jones: "Devotional Reading" 213

Motherhood:-

1802 RA	Miss Spilsbury: "The Nursery" 79
1804 RA	Miss E. Farhill: "Maternal Anxiety" 293
1812 AAW	Miss M. Bourlier: "Maternal Affection" 255

1818 RA Miss Louisa Sharpe: "A mother and dead child" 830
 (see vol1 p135 for the accompanying quotation)
1818 RA Mme Varillat: "The Recovery, or filial affection" 419
1819 BI Mrs Carpenter: "Mother and Child" 81
1822 RA Miss Sharpe: "Portraits of a mother and sleeping child"
 546
1829 BI Miss Maskall: "Mother and child" 332

Other works in this category include portrayals of women dressing, working, walking, playing musical instruments, resting, dreaming and courting:-

1803 RA Miss Maskall: "Portrait of a lady at work" 246
1810 RA Miss M. Appleton: "An Evening Walk" 796
1816 RA Mrs Mee: "Portrait of a lady undressing" 719
1820 RA Rolinda Sharples: "Eliza at work" 144
1821 RA Miss M. Heape: "Fortune-telling" 853
1826 BI Miss Adams: "A Girl at Work" 406
1826 BI Miss Eliza Jones: "Reverie" 8
1826 BI Mrs James Hakewill: "A Repose" 285
1828 RA Miss M. Maskall: "A young girl at her studies" 913
1828 BI Miss Adams: "The Burgomaster's Daughter at her toilette"
 332
1828 BI Miss Wroughton: "Guittarrista" 434
1828 SBA Miss Adams: "The rejected suitor" 60
1829 RA Mrs Pearson: "Portrait of a young lady with a guitar" 32

C3. 1806 RA Miss Spilsbury: "The house of protection for destitute
 females of character: two girls applying for admission
 - This charity has been lately instituted at Bath, on
 the same plan as that of the house of refuge estab-
 lished in Dublin in 1801" 42
 18C7 BI Mrs Mee: "The Female Penitent" 127
 1807 BI Miss Spilsbury: "Two girls applying for admission into
 the House of Protection for destitute females of
 character" 163 (probably the same work as that exhi-
 bited at the Royal Academy in 1806 (no.42))
 1812 BI Miss E.E. Kendrick: "A Magdalen" 170
 1826 BI Mrs J. Browning: "The sleeping Magdalen" 294
 (With a quotation which is given in P1c)
 1827 BI Mrs J.S. Hakewill: "A Magdalen" 248

D3. Music:-
 1830 OWS Miss Louisa Sharpe: "Girl with a guitar" 127
 1840 BI Miss E. Schmack: "Young lady at the Piano forte" 259
 1843 BI Miss Grover: "The Music Lesson" 243
 1843 RA Miss M.A. Cole: "A woman playing a sistrum" 301
 1844 SBA Miss E. Cole: "A woman playing a sistrum" 480

 Reading:-
 1833 NSPW Miss Rose Drummond: "The Pleasing Volume" 348
 1846 SBA Miss M.A. Nicholls: "The Novel-Reader" 628
 1849 SBA Miss M. Townsend: "The Novel" 305

 Friendship: companions and sisters:-
 1833 BI Miss Anne Beaumont: "Affection" 51
 1834 BI Miss Eliza Jones: "Affection" 289
 1835 OWS Miss Eliza Sharpe: "The Dying Sister" 322
 1837 BI Mrs Carpenter: "The Twin Sisters" 26
 1839 BI Mrs J. Robertson: "The sisters" 142
 1841 SBA Miss E. Stephens: "The Sisters" 54
 1843 RA Elise Plowman: "Mon amie" 899

1844 SBA & BI	Miss S.E. Thorn: "The Sisters, or the Lecture Unheeded" 57
1847 RA	Mary Hamilton: "Portrait of a beloved friend" 805
1849 RA	Mary Read: "The Sisters" 444

Going out:-
1838 RA	Emily Schmack: "A Young Lady preparing for a fancy ball" 78
1838 BI	Mrs Criddle: "Preparing for the Concert" 148
1845 RA	Mrs E. Dalton: "The Opera Box" 910
1849 DG	Lucy Madox Brown: "Après le Bal" 12

Religion:-
1834 NSPW	Mrs E.C. Wood: "Matins" 311
1839 NSPW	Miss Fanny Corbaux: "Evening Prayer" 237
1839 RA	Mlle. Perdrau: "La Prière" 908
1840 BI	Miss Eliza Jones: "Reading the Scriptures" 346
1848 RA	Miss E. Cole: "Faith" 486
1849 RA	Miss M.A. Cole: "Lord, what love have I unto thy law! all the day long is my study in it" 457
1849 OWS	Miss Eliza Sharpe: "Prayer" 363 (see A2 for the accompanying quotation)

Study:-
1838 NSPW	Miss Louisa Corbaux: "The lesson" 88
1838 NSPW	Miss Laporte: "The lesson" 250
1838 BI	Mrs Criddle: "An interior, with a lady at her Studies" 59
1839 SBA	Mrs Criddle: "The Fair Student" 737
1844 RA	Mrs Fanny McIan: "The lesson" 355 ("The lesson is given in archery to a young lady by a holy hermit" ("Art Union" 1844, p.161))
1847 SBA	Mrs Besset: "The Reading Lesson" 597

Correspondence:-
1830 RA	Miss Derby: "The billet-doux" 798
1830 SBA	Miss Dujardin: "The love-letter" 353
1830 OWS	Miss Sharpe: "Girl with a letter" 225
1832 SBA	Miss Lucy Adams: "The first love-letter" 783
1835 NSPW	Mrs E.C. Wood: "The Intercepted Letter" 292
1839 SBA	Miss Oram: "The Expected Letter" 342
1842 BI	Miss E. Drummond: "The last letter" 198
1845 NSPW	Miss Fanny Corbaux: "A very Particular Confidence" 48 ("a girl submitting her love-letters to the perusal of an elder sister or mamma"- ("Spectator" 1845, April 26, no. 878, p. 403))
1846 RA	Miss Martha Jones: "A letter from home" 606

E3. For love letters see D3 under correspondence.
1833 SBA	Miss Derby: "The Proposal" 610
1833 BI	Miss Fanny Corbaux: "The Rendez-vous" 375
1836 SBA	Mrs Fanny McIan: "The Trysting Place" 72
1839 BI	Mrs Fanny McIan: "Love and Idleness" 55
1841 BI	Ambrosini Jerome: "The treasured miniature" 356
1841 OWS	Mrs Seyffarth (late Louisa Sharpe): "Constancy" 103
1841 OWS	Mrs Seyffarth: "Inconstancy" 104
1842 SBA	Miss M.A. Cole: "The Course of true love never did run smooth" 81
1844 BI	Mrs Criddle: "The Forsaken" 141
1844 SBA	Miss Stephens: "The Bridal Toilet" 543
1846 SBA	Miss Jessie Macleod: "It is better to have two strings to your bow" 395 (The work depicted two lovers emulous of a lady's favour; she prefers the richer - "Art Union" 1846, p.130)

1846 SBA Miss Eliza Sharpe: "St. Valentine's Morning" 212
1847 SBA Miss M. Johnson: "Love's Reverie" 182
1848 SBA Miss M.A. Cole: "The Stolen Interview" 120
1848 SBA Miss M.A. Nichols: "The Lover's Quarrel" 621
1849 SBA Mrs Caroline Smith: "Irish Courtship" 104
See Z1 in the literary section for pictures with poetic
titles on the theme of love.

F3. 1835 OWS Mrs Seyffarth (Louisa Sharpe): "The Good Offer"
 "O what a plague is an obstinate daughter!" (old Song)
 241 (for a description of the work see U1)
 1842 OWS Mrs Seyffarth: "The Wedding" 216
 (for quotation and description see vol.1 p 138)
 1848 NSPW Sarah Setchel: "And ye shall walk in silk attire, etc." 54
 (for full quotation see Z1 and see also vol.1 p 139)

G3. It is impossible to establish for certain if works entitled "Magdalen"
represented Mary Magdalen or the modern equivalent - a reformed
prostitute.
 1839 NSPW Miss Laporte: "The Magdalen" 303
 1843 SBA Miss Lane: "A Magdalen" 217
 1843 SBA Miss M.R. Sheppard: "Magdalen" 594
 1844 NSPW Miss Louisa Corbaux: "The Magdalen" 202
 1848 RA Emma Harriet Raimbach: "A nun of the order of the Good
 Shepherd with three penitents from the asylum governed
 by the nuns of this order; two penitents in the dress
 of the 'consecrated', and one in their ordinary costume"
 784

H3. 1832 BI Miss Eliza Jones: "A Mother and Children" 90
 1833 OWS Miss Eliza Sharpe: "The Mother" 410
 1835 NSPW Miss Laporte: "Maternal Advice" 52
 1836 BI Mrs W. Pearce: "Mother and Child" 208
 1837 OWS Miss Eliza Sharpe: "Mother and children" 223
 1839 NSPW Miss Louisa Corbaux: "The Happy Mother" 258
 1840 NSPW Miss Louisa Corbaux: "A Mother's Advice" 224
 1841 NSPW Miss Fanny Corbaux: "The Anxious Mother" 27
 1842 SBA Miss C. Sherley: "The Sick Mother" 725
 1842 BI Mrs Carpenter: "A Fairy Tale" 131
 (depicting a mother reading to a child, according to
 the "Art Union" 1842, p.59)
 1847 SBA Miss J.E. Grover: "A lady visiting her child at nurse in a
 farm-house" 291
 1847 RA Mrs Carpenter: "Mother and Child" 52
 1848 RA Mrs J. Harris: "The Careful Mother" 429

I3. 1832 OWS Miss Louisa Sharpe: "Two sisters contemplating the portrait
 of their dead mother" 272
 1835 BI Miss Eliza Jones: "Orphan Sisters" 259
 1835 OWS Miss Eliza Sharpe: "The Dying Sister" 322
 1837 OWS Mrs Seyffarth (late Louisa Sharpe): "The soldier's widow" 209
 1839 RA Charlotte B. Sharpe: "The Widow" 1005
 1845 RA Miss M.A. Cole: "The Bereaved" 450
 1846 OWS Miss Eliza Sharpe: "The mourner" 234
 1848 SBA Miss Eliza Fox: "The soldier's bequest" 109

J3. 1831 RA Miss Derby: "Contemplation" 869
 1831 RA Miss Millington: "La pensierosa" 638
 1832 BI Miss Emma Jones: "Contemplation" 535
 1832 RA Mrs Pearson; "What the painter's art had missed
 Her memory supplied" 599

```
1834 NSPW    Miss Fanny Corbaux: "Absent, but not forgotten" 140
1835 RA      Mrs Briane: "Contemplation" 864
1835 SBA     Mrs W. Pierce: "Retirement"
                 "Sweet are the charms in thee we find" 465
1836 NSPW    Miss Laporte: "Contemplating" 251
1836 RA      Mrs J.P. Knight: "Reflection" 292
1837 BI      Mrs Knight: "Reflection" 310
1839 RA      Mrs C. Aders: "Luxuriating in the pleasures of memory" 12
1839 BI      Miss M. Drummond: "Contemplation" 211
1842 BI      Mrs Criddle: "A lady's dream" 338
1842 BI      Miss E. Schmack: "A Pleasing Reverie" 86
1842 SBA     Miss M. Faulkner: "The Reverie" 118
1842 SBA     Miss J. Joy: "Some thought that makes the Heart a
                 Sanctuary" 596
1843 NSPW    Miss Laporte: "Musing on the absent" 168
1843 SBA     Mrs J.B. Pratt: "Old Memories" 379
1843 NSPW    Miss Louisa Corbaux: "The Dream" 380
1844 RA      Emilia Rose Venables: "Thoughtfulness" 620
1844 BI      Miss Lane: "Meditation" 55
1846 RA      Sarah Stanton: "Contemplation" 649
1846 NSPW    Miss Louisa Corbaux: "Lost in Thought" 157
1847 RA      Anne Winston: "Contemplation - a study" 739
1847 RA      Emily Ann Scott: "Sweet Reminiscences" 788
1847 SBA     Miss M. Johnson: "Love's Reverie" 182
1848 SBA     Miss Jessie Macleod: "Meditation" 203
1848 SBA     Miss M. Johnson: "Reflection" 618
1848 RA      Miss M.A. Cole: "Meditation" 435
1848 RA      Mrs F. Harris: "Idle Thoughts" 566
1848 RA      Miss Jessie Macleod: "The day dreamer" 576
1848 RA      Miss Clara Cawse: "Meditation" 578
1848 OWS     Miss Eliza Sharpe: "Recollections" 60
1849 SBA     Miss Zeigler: "Meditation" 550
```

This list may be completed by an examination of similar works with
poetical titles on

```
K3. 1838 SBA    Miss Steers: "L'Attente" 254
    1839 NSPW   Miss Louisa Corbaux: "The Anxious Wife" 230
    1840 NSPW   Miss Louisa Corbaux: "Expectation" 116
    1840 RA     Miss Mary Anne Sharpe: "Expectation" 529
    1841 RA     Miss E. Cole: "Expectation" 1183
    1849 BI     Mrs Thomson: "A Sail!  A Sail!" sc. 512
    1849 HPG    Mrs Fanny McIan: "Soldiers wives waiting the Result of a
                    Battle" 92
                    (Described in the "Athenaeum" (March 31, 1849, no.1118
                    p.335):  "The feeling it excites reminds us not a
                    little of our sympathy with the woman who in Wilkie's
                    'Chelsea Pensioners' looks over the individual read-
                    ing the Gazette, - seeking for news of her partner's
                    fate.  Suspense is strongly expressed in both.  The
                    group of soldiers' wives here depicted placed in the
                    rear of a contending army, are listening with eager
                    and anxious looks to the booming artillery, every peal
                    of which may carry destruction to their hopes and
                    affections etc.")

L3. Reading:-
    1852 RA     Mary A. Hodges: "Reading made easy" 620
    1853 SBA    Sophia Sinnett: "The Picture Book" 48
    1854 NSPW   Emily Farmer: "The Picture Book" 360
```

1854 BI Mrs J. Friswell: "The last New Magazine" 445
1855 SBA Emily R. Phillips: "The Novel Reader - a sketch" 773
1855 RA Mrs V. Bartholomew: "A Girl Reading" 822
1857 BI Miss E. Rowley: "The Story Book" 8
1858 OWS Margaret Gillies: "Reading an old Romance" 215
1858 RA Miss S. Forster: "Reading the Household Words" 135
1858 SFA Emma Brownlow: "The 'Novel'" 25
 (with a quotation for which see page

Sewing:-
1853 SBA Mrs Smith: "Crochet Maker" 238
1855 RA Mrs T. Gooderson: "Crochetting" 164
1856 NSPW Emily Farmer: "Sewing" 47
1857 PG Miss L. Chilman: "Knitting" 225
1859 SFA Kate Swift: "Taking up a stitch" 164

Lessons:-
1852 BI Miss E. Goodall: "La leçon religieuse" 114
1855 BI Miss Barlow: "The Evening Lesson" 534
1855 RA Mrs E.M. Ward: "The Morning Lesson" 348
1856 RA Miss Emma Brownlow: "Granny's lesson" 27
1857 RA Miss E. Partridge: "The earnest student" 44
1857 RA Mrs Carpenter: "The lessons" 828
1858 SFA M.C.: "The Morning Lesson" 268
1859 RA Miss E. Hunter: "Tomorrow's lessons" 205
1859 SFA Miss C.F. Kettle: "The students" 236
1859 SFA Mrs Backhouse: "The music lesson" 251

Sisterhood and friendship:-
1850 SBA Miss S.E. Townsend: "The Sympathizing Friend" 700
1850 NSPW Miss Fanny Corbaux: "The Convalescent" 47
 ("it represents an invalid girl reposing in the arms
 of her friend or sister, both gazing out on the
 setting sun" - "Athenaeum" May 18, 1850, no.1177,
 p.536)
1852 RA Mrs W. Hawkins: "The sisters" 766
1853 RA Miss M.A. Cole: "Playing at School" 267
1856 OWS Miss Margaret Gillies: "The Sisters" 272
1857 RA Miss M.E. Dear: "The sisters" 821
 (for the accompanying quotation see page
1858 SBA Emily Smith: "The sisters" 250
1858 RA Miss R. Levison: "The sisters - a group"
 "In maiden meditation, fancy free" 1216
1859 SFA Miss R. Levison: "The sisters" 308

Love and marriage:-
1850 BI Miss M.A. Cole: "The love letter" 411
1852 SBA Mrs C. Smith: "The Wedding Ring" 273
1853 RA Miss Ziegler: "Love's Reverie" 845
1854 RA Anna E. Blunden: "Love" 229
1856 SBA Mrs C. Smith: "The Valentine" 251
1856 SBA Miss Jessie Macleod: "Highland Courtship" 549
1857 SFA Elizabeth Lawson: "The Love Letter" 37
1858 SBA Rebecca Solomon: "Love-making in the Pyrenees" 502
1858 SFA Miss M.A. Cole: "The Love Letter" 116
1858 SFA Miss M. Tekusch: "The Wife" 311
 (This work is described on page
1859 RA Miss Rebecca Solomon: "Love's Labour Lost" 548
1859 SFA Miss G. Swift: "Rustic Courtship" 157
1859 SFA Josephine Jayes: "The girl's first valentine" 79
1859 RA Miss B.A. Farwell: "St. Valentine's Day" 644
1859 SBA Anna Blunden:"The Bride" 284

Religion:
1851 NSPW Louisa Corbaux: "The young saint" 10
1854 RA Mrs E.G. Richards: "Faith" 1264
1855 RA Mrs W. Hawkins: "Early Prayer" 1045
1856 RA Sophie Anderson: "The day of rest" 369
1856 RA Miss Seyffarth: "The communion of the sick" 833
1856 SBA Miss Anna Blunden: "Prayer" 59
1857 SBA Miss E. Andrage: "Devotion" 96

Motherhood:
1851 OWS Miss Eliza Sharpe: "A Gipsy Mother" 273
1852 BI Miss E. Goodall: "The Irish Mother" 240
1858 RA Miss Emma Brownlow: "The child restored to its mother –
 an incident in the Foundling Hospital" 1013
1859 RA Ambrosini Jerome: "The mother's darling" 2
1859 OWS Miss Margaret Gillies: "The Young Mother" 230
1859 SBA Miss S. Raincock: "The young mother with her distaff" 453
See page for four more works on this theme with poetical quotations)

Going Out:
1852 BI Rebecca Solomon: "The Morning Call" 370
1853 SBA Miss E. Andrade: "Waiting for the Carriage" 243
1853 SBA Mrs Besset: "Waiting for the Carriage" 302
1854 SBA Augusta M. Dresch: "Going to the Opera" 620
1854 NSPW Miss Fanny Corbaux: "After the Ball" 159
 ("representing a lady in modern evening dress. She
 reclines apparently fatigued; she has removed the
 wreath from her hair, and is meditating upon the inci-
 dents of the ball" – "Art Journal" 1854, p.175)
1856 RA Miss E. Rowley: "Sortie de Bal" 28
1859 SFA Miss M. Gauthorpe: "Preparation for the ball" 148

M3. Parting and Reunion:-
1850 NSPW Miss Fanny Corbaux: "The last evening at home" 215
 (for the accompanying quotation see F2a)
1854 NSPW Miss Louisa Corbaux: "Leaving Home" 367
1855 OWS Miss Margaret Gillies: "Looking back at the Old Home" 46
 (for the accompanying quotation see F2a)
1856 OWS Miss Margaret Gillies: "The Parting" 191
1856 SBA Miss E. Macirone: "Homeward Bound" 771
1857 SFA Miss Louisa Corbaux: "Leaving Home" 101
1858 SFA Miss Anna Blunden: "The Emigrant" 33
 ("a study of a girl, absorbed in grief, resting on the
 bulwark of a ship" – "Art Journal" 1858, p.254)
1858 SFA Mrs W. Smith: "Leaving the old House" 7
1859 SBA Miss Emma Brownlow: "Home again from sea" 351
1859 SBA Miss E. Macirone: "Last look at the old home" 645
1859 SFA Miss E. Macirone: "The Return home" 61
1859 SFA Kate Swift: "'Tis sweet to know
 There is an eye will mark our coming" 189

Correspondence and news:-
1850 BI Miss M.A. Cole: "The Love Letter" 411
1851 RA Miss M.A. Cole: "The first letter" 97
1851 RA Emily Osborn : "The letter" 409
1851 BI Miss J.E. Grover: "The Intercepted Letter" 140
1854 RA Miss Smallbone: "Morning Post" 324
1855 RA Miss M.A. Cole: "News from the Crimea" 400
1855 OWS Miss Margaret Gillies: "Waiting for News" 322
1856 SBA Mrs C. Smith: "The Valentine" 251

1856 RA Mrs A. Farmer: "The first letter from home" 355
 (for the accompanying quotation see F2a)
1857 SFA Elizabeth Lawson: "The Love Letter" 37
1858 OWS Miss Margaret Gillies: "News at last" 205
1858 SFA Miss M.A. Cole: "News from the Seat of War" 150
1858 SFA Miss M.A. Cole: "The Love Letter" 116
1859 OWS Mrs Criddle: "The Intercepted Letter" 96

Death:-
1850 RA Suran Durant: "The chief mourner: study of a girl"
 sculpture 1346
1853 OWS Miss Eliza Sharpe: "The soldier's widow, opening for the
 first time the wardrobe of her late husband" 54
1853 OWS Mrs Criddle: "The first sorrow - 'Thy will be done'" 244
1854 OWS Miss Margaret Gillies: "The Mourner" 182
 (for the accompanying quotation see F2a)
1854 RA Mrs C. M'Carthy: "The death struggle" sculpture 1419
1855 SBA Miss E. Macirone: "The Wife's Dream of the Crimea"
 "The Englishwoman hears that her husband or her son
 has perished from want while the wealth of England
 was pouring out for their rescue" ("Times" Feb. 1855)
 633
1856 SBA Miss Anna Blunden: "Hope in Death" 621
1856 OWS Miss Margaret Gillies: "The Ministering Spirit" 236
 (for the accompanying quotation see F2a)
1856 RA Miss Anna Blunden: "A Sister of Mercy" 125
 ("She is visiting the bedside of a poor woman, whose
 days seem numbered" - "Art Journal" 1856, p.164)
1857 SFA Miss Anna Blunden: "Hope in death"
 "At Evening time it shall be light" (Zach. ch. 14,
 v.7) 52
1857 SBA Miss Chilman: "The wreath" 729
1857 BI Miss Emma Brownlow: "The Mother's Grave - a scene in
 France" 393
1859 OWS Miss Margaret Gillies: "A Father and Daughter" 51
 (for the accompanying quotation see F2a)
1859 RA Mlle. E. Lagier: "Left alone, by an epidemic" 1040
1859 SBA Miss Anna Blunden: "Passing away" 735
1859 RA Madame Landesman: "The first grief" 66

N3. Those concerned with separation:-
1850 OWS Nancy Rayner: "His soul is far away, etc." 17
 (for full quotation see F2a)
1853 PG Mrs E.A. Hawkes: "I remember thy voice when sadly
 I sit in the evenings alone" 330
1855 RA Mrs Carpenter: "Absence" 448
 ("It consists of a single female figure, of which the
 features wear an air of grief. She is richly attired
 and that in some degree enhances the effect" - "Art
 Journal" 1855, p.185)
1855 OWS Mrs Criddle:"The Thoughts elsewhere" 246
1856 RA Emily Osborn :"Home thoughts" 519
 (for the accompanying quotation see F2a)
1857 SBA Mrs M.F. Salter: "The miniature" 87
1857 RA Miss Anna Blunden:"The Daguerrotype" 490
 (The work portrays a mother and child gazing at a like-
 ness of the absent father.
 Probably the same work as that exhibited, with the same
 title at the Society of Female Artists in 1858, no.117)
1859 BI Miss Emma Brownlow: "Thoughts of the Absent" 384

Others:-

1852 SBA	The late Miss Johnson:	"Meditation" 566
1852 OWS	Miss Eliza Sharpe:	"Solitude" 169
1852 OWS	Miss Margaret Gillies:	"The absent thought" 73
1852 RA	Miss Jessie Macleod:	"Idelness" 232
1852 RA	Ambrosini Jerome:	"Contemplation" 452
1853 SBA	Elizabeth E. Bundy:	"A Quiet Hour" 141
1853 RA	Miss Ziegler:	"Love's reverie" 845
1853 SBA	Miss Andrade:	"The Miniature" 241
1854 SBA	Miss Ziegler:	"Meditation" 640
1854 BI	Miss E. Potter:	"A Reverie" 352
1854 BI	Miss A. Henderson:	"Reflection" 519
1855 OWS	Mrs Criddle:	"The Thoughts elsewhere" 246
1856 SBA	Miss E. Andrade:	"The Peaceful Hour" 825
1856 OWS	Miss Margaret Gillies:	"Happy Thoughts" 297
1857 SFA	Miss Eliza Fox:	"Meditation" 17
1857 SFA	Miss P. Bethell:	"Meditation" 48
1857 SFA	Miss E. Hyde:	"A Day Dream" 99*
1857 OWS	Miss Margaret Gillies:	"Solitude" 63
1857 SBA	Mrs M.F. Salter:	"The Miniature" 87
1857 SBA	Miss F. Jolly:	"Reflection" 677
1857 SBA	Miss Chilman:	"Idleness" 755
1857 RA	Miss Emma Brownlow:	"Retrospection" 528
1857 RA	Miss M. Grieve:	"A reverie" 667
1857 PG	Miss L. Chilman:	"A Reverie" 174
1857 NSPW	Emily Farmer:	"A Quiet Hour" 311
1858 SFA	Miss Ellen Cole:	"Meditation" 16
1858 SFA	Adèle Kundt:	"La Rêverie" 67
1858 SFA	Miss E. Tunbridge:	"Pleasant Thoughts" 152
1858 SFA	Miss Adelaide Burgess:	"The Last Dream" 301
1859 SFA	Mrs Dix:	"Recollections of childhood" 5
1859 SFA	Adelaide Claxton:	"Despair" 199
1859 SFA	Mrs Robertson Blaine:	"In Memoriam" 259
See F2a&b	for similar works with poetical quotations	

03. 1860 SBA	Miss Emma Brownlow:	"Thoughts of the absent" 491
1860 SFA	Mrs Elizabeth Murray:	"Resignation" 105
1860 SFA	Miss Margaret Gillies:	"Waiting for the Return of the Herring Boats" 120
1860 SFA	Mrs Swift:	"Expectation" 48
1861 RA	Miss A. Burgess:	"In dem Land, der Träume" 814
1861 SBA	Miss Emma Brownlow:	"A prayer for the absent one" 286 ("The prayer is offered up by a French peasant girl, who kneels on her prie-dieu" - "Art Journal" 1861, p.140)
1861 NSPW	Miss Louisa Corbaux:	"Wandering Thoughts" 154
1861 SFA	Mrs Alexander Melville:	"Solitude" 16
1861 SFA	Mrs Backhouse:	"Patient Waiting" 280
1861 SFA	Rose Rayner:	"Meditation" 185
1861 SFA	Mrs Sergeant:	"Contemplation - Evening" 269
1862 RA	Miss Morrell:	"Idle hours" 167
1862 RA	Mrs Arundale:	"The leisure hour" 816
1862 RA	Emily Osborn:	"Die Erwartung" 399
1862 SFA	Miss Adelaide Burgess:	"Dreams more pleasant than realities" 207
1862 SFA	Miss Weigall:	"Meditation" 249
1863 RA	Mrs Croudace:	"In maiden meditation, fancy free" 349
1863 SFA	Charlotte E. Babb:	"Distant Thoughts" 176
1863 SFA	Mrs John Charretie:	"Expectation" 203
1864 OWS	Miss Margaret Gillies:	"Waiting for Father" 243
1864 OWS	Miss Margaret Gillies:	"Daydreams" 291

```
1864 SFA       Miss Lefroy: "Solitude" 216
1864 SFA       Miss J. Deffell: "Thoughts far away" 217
1865 SFA       Mrs Grierson: "Expectation" 208
1865 RA        Miss A.L. Herford: "Thoughtful" 89
1865 RA        Miss R. Place: "Reflection" 625
1865 DG        Miss Juliana Russell: "Waiting" 93
1866 SFA       Gena Franco: "Desolation" 263
1866 SBA       Miss O.P. Gilbert: "The day dream" 765
1866 SBA       Mrs J.F. Pasmore: "The leisure hour" 692
1866 SBA       Jane Bowkett: "Wandering Thoughts" 680
1866 RA        Mrs M. Robbinson: "Happy idleness" 238
1866 RA        Miss Louisa Starr: "Will he come?" 25
1867 SFA       E. Manton: "Reverie" 50
1867 SFA       Mrs Goodman: "Expectation" 201
1867 SFA       Miss E. Thomson: "Dreamland" 203
1867 SFA       Miss Freeman Kempson: "Waiting" 285
1867 BI        Mrs Charretie: "A Pleasing Reflection" 610
1867 SBA       Mrs Charretie: "Prayer for the loved one" 601
1867 SBA       Mary E. Dear: "Thinking. A Portrait" 258
1867 RA        Miss Louisa Starr: "La Penserosa" 151
1867 DG        Ellen Gilbert: "Wandering Thoughts" 227
1867 SBA       Ellen Gilbert: "The miniature" 851
1867 SBA       Mrs E.P. Mackenzie: "Sad Thoughts" 872
1867 SBA       Miss Sophia Beale: "Dreaming" 918
1867 SBA       Mrs Backhouse: "A happy thought" 982
1867 SBA       Miss Emma Brownlow: "Waiting for the Boats" 95
1868 SFA       Elizabeth Royal: "Waiting" 197
1868 SFA       Mrs J.W. Brown: "Reverie" 347
1868 SFA       Mrs E.M. Ward: "In Memoriam" 371
1868 SFA       Miss G. Swift: "Old Letters" 381
1868 SFA       S.M. Louisa Taylor: "Alone" 403
1868 SBA       Pattie Melville: "Expectation" 167
1868 SBA       Miss A. Carter: "Expectation" 677
1868 RA        Mrs D. Kemp: "Thoughts of Home" 88
1868 RA        Miss Louisa Starr: "A reverie" 603
1868 DG        Miss E. Manton: "Je m'ennuie" 379
1868 SBA       Mrs Emma Brownlow King: "Her thoughts on holy things are
                   bent" 178
1868 NSPW      Mrs Elizabeth Murray: "Idleness" 4
1869 SFA       E.K. Cummins: "Waking Dreams" 365
1869 SFA       Rosa Jackson: "Will he come?" 416
1869 RA        Miss Louisa Starr: "Pensativa" 112
1869 RA        Miss Banks: "Reminiscence" 339
1869 RA        Mrs P.J. Naftel: "Musing" 613
1869 DG        Miss R. Coleman: "Stray thoughts" 543
1869 DG(oil)   Miss Louisa Starr: "Wandering thoughts" 34
1869 SBA       Miss M.A. Parris: "Happy thoughts" 1039
1869 SBA       Mrs Backhouse: "Une paresseuse" 1075
1869 DG        Mrs Charretie:"Expectation" 616
```

See J3. for similar works with poetical quotations and see also vol.1
pp 145-7 for four works by Margaret Gillies on this theme: "The
Merry Days when we were young" of 1860, "Awakened sorrows - old letters"
of 1863, "Desolation" of 1864 and "Youth and Age" of 1865.

```
P3. 1860 SFA   Miss Backhouse: "Children on the Sea-shore discovering
                   vestiges of their lost father" 156
    1861 OWS   Mrs Criddle: "The Vacant Chair" 37
                   (for the accompanying quotation see J2)
    1862 RA    Miss Morrell: "The mother's grave" 6
    1863 SBA   Miss Emma Brownlow: "The crisis past - A ray of hope" 555
```

1863 RA	Mrs D. Wright: "Her first sorrow" 173
1863 RA	Miss Hunter: "The widow's only son" 290
1864 RA	Emily Osborn : "For the last time" 555
	(The work represents two sisters in mourning about to enter the room in which their father, or mother, lies dead - "Art Journal" 1864, p.164)
1864 SFA	Miss Kate Swift: "Das Trauenkleid (A Schewening widow buying her mourning)" 194
	(described in vol.1 p 161)
1864 SBA	Miss M.E. Edwards: "War Tidings" 345
	(described in vol.1 p 162)
1864 BI	Miss Agnes Dundas: "The loved and lost one" 12
1865 RA	Miss M.E. Edwards: "The last kiss" 574
	(a lady, young and gentle, drooping under sorrow, has dug for her pet bird a grave beneath a bower of roses and honey-suckles. Ere she commits her treasure to the earth, she gives it a parting kiss. The sentiment is exquisite in tenderness, etc." ("Art Journal" 1865, p.169)
1865 RA	Mrs A. Farmer: "An Anxious Hour" 357
	(The work, which is in the Victoria and Albert Museum, shows a mother seated at the bedside of her sick child)
1865 OWS	Miss Margaret Gillies: "A Sailor's widow of Dieppe" "Tronc pour la sépulture des Noyés" 217
1866 SBA	Miss Hunter: "The Portrait" 712
	(see J2 for the accompanying quotation and see also her exhibit at the Society of Female Artists in 1867 (no. 165 given on the same page))
1866 SFA	Lottie Westcott: "The widow's Tale" 219
1866 OWS	Miss Margaret Gillies: "Sorrow and Consolation" 39
1867 SFA	Miss Alberta Brown: "The Convalescent" 210
1867 OWS	Miss Eliza Sharpe: "A Bride taking leave of her widowed sister" 196
1867/8 NSPW	Sarah Setchel: "The Widowed Countess" 150
1868 DG	Miss E. Armstrong: "The widower" 581
1868 SBA	Miss E. Hunter: "The Father's portrait - finished sketch in water colour, for original picture" 926
1869 SBA	Mrs A.F. Allen: "Words of comfort" 310
1869 SFA	Mrs Chambre: "Convalescent" 17
1869 SFA	Adelaide Claxton: "These were his toys" 253
	(Described in the "Art Journal" of 1869 (p.82) as "a mother's lament over her lost boy")

Q3. Love and marriage:-

1860 SBA	Miss Eliza Turck: "What ails this heart?" 227
1860 SFA	Mrs Lee Bridell, late Miss E. Fox: "The Serenade" 34
1860 SFA	Mrs V. Bartholomew: "The Bride" 174
1862 BI	Alice Walker: "Wounded Feelings" 204 (Sotheby's Belgravia, June 27, 1978)
1864 SFA	Miss Margaret Gillies: "A Romance" 72
1864 BI	Miss Kate Swift: "Das Festkleid; a Schevening Girl, buying her wedding dress" 478
1865 SBA	Emily Osborn : "Of course she said 'Yes'" 45 (engraving in Witt Library)
1865 SBA	Miss J.M. Bowkett: "The Bride" 233
1866 BI	Miss H. Coode: " A Fair gentleman's coming to the house, Miss" 620
1866 RA	Miss Florence and Miss Adelaide Claxton: "Broken off" 745
1867 RA	Miss Banks: "The Trysting place" 527

1867 OWS Miss Margaret Gillies: "The Proposal" 76
1867 OWS Miss Eliza Sharpe: "A Bride taking leave of her widowed
 sister" 196
1869 DG Jane A. Horncastle: "The Bride" 644
Reference should be made to J2. for works with poetical titles on the
theme of love.

For love letters see the forthcoming section on correspondence.
Motherhood:-
1860 SFA Miss M. Tekusch: "Mother and child" 229
1860 RA Mme E. Jerichau: "The darling baby" 614
1860 RA Mme E. Jerichau: "Mother's delight" 366
1861 SFA Mme J.V.C.: "First Maternal Happiness - will illuminated
 border" 274
1862 SFA Miss Scott: "The First-born" 278
1863 OWS Miss Eliza Sharpe: "The New Mamma" 208
1863 RA Miss Hunter: "The widow's only son" 290
1863 SBA Mrs Stuart: "The mother's hope" 463
1864 SFA Agnes Dundas: "The Watchful Mother" 214
1865 SFA Miss Emma Brownlow: "The First born" 164
1865 RA Mrs A. Farmer: "An Anxious Hour" 357 (showing a mother
 watching over a sick child; Victoria and Albert
 Museum)
1867 SBA Miss E. Dunn: "Baby's charms" 544
1867 SFA Miss J. Deffell:"Mother and child" 172
1868 SBA Mrs Charretie: "A Young mother" 575
1869 SFA Kate Swift: "The Happy Mother" 422
See K2 for similar works with poetical titles

Religion:-
1861 SFA Mlle Louise Eudes de Giumard: "La Prière de l'Enfant" 38
1861 SFA Miss Emma Brownlow: "La Bénédicité" 107
1861 SBA Miss Emma Brownlow: "A prayer for the absent one" 286
1862 SFA Miss Scott: "Evening Prayer" 230
1863 SBA Miss Hunter: "Prayer" 636
1864 RA Miss Emma Brownlow: "Repentance and Faith" 488
1864 SFA Miss Eliza Partridge: "Prayer" 116
1866 SFA Miss Florence Claxton: Five or six sketches in one frame.
 Not given in the catalogue, but described in the "Art
 Journal" 1866, p.56 as "so many sly satires, thrust at
 divers phases of our modern female pharisees, under the
 several titles of 'The Chapel', 'The Oratory', 'The
 Synagogue', 'The Friends' Meeting' and 'St. George's
 Hanover Square'"
1866 OWS Miss Margaret Gillies: "In a Church at Normandy" 205
1867 SBA Mrs Charretie:"Prayer for the loved one" 601
1867 SBA Miss Louisa Starr: "Une Prière" 125
1868 RA Miss K. Aldham: "Waiting at the confessional" 240
1868 SBA Mrs Emma Brownlow King: "Her thoughts on holy things are
 bent" 178

Reading:-
1860 SBA Miss Elzia Turck: "Woman Reading" 398
1862 SBA Mrs J.F. Pasmore: "The Story Book" 177
1863 SBA Miss Anna Blunden: "Girl Reading" 345
1863 BI Ambrosini Jerome: "Reading al Fresco" 353
1866 BI Miss H.M. Johnson: "A Young Lady Reading" 152
1866 RA Miss E. Partridge: "The picture book" 159
1866 SFA Miss F. Young: "Reading the News" 248
1867 SBA Miss J.M. Bowkett: "The unravelling of the plot" 428
1868 RA Mrs O. Newcomen: "Tired of reading" 281
1868 SFA Miss J.M. Bowkett: "The unravelling of the plot" 317

1868 SBA Miss Florence E. Thomas: "The new book" 7
1868 SBA Miss A. Percy: "Il Romanzo" 875
1868/9 NSPW Emily Farmer: "A Girl Reading" 70

Correspondence and news:-
1862 BI Mrs Lee Bridell: "The Billet-doux, Carnaval Time,
 Rome" 302
1863 SFA Miss Margaret Gillies: "Awakened Sorrows - old letters" 70
 (See vol.1 p146 for accompanying quotation and descrip-
 tion)
1864 RA Mrs Lee Bridell: "The love-letters" 456
1864 OWS Miss Margaret Gillies: "The Welcome Letter" 185
1864 SBA Miss M.E. Edwards: "War Tidings" 345
 (see vol.1 p162 for description)
1865 SFA Miss Lane: "The Letter" 65
1866 SBA Mrs J.F. Pasmore: "Who is it from?" 17
1866 SBA Miss G. Swift: "Old letters" 204
1867 BI Miss Hunter: "Bad News"
 "The days of affliction have taken hold of me" (Job)
 577 (Also exhibited at the Society of Female Artists
 1868 no.383)
1867 SBA Miss M. Tekusch: "A letter. 'Here it is'" 473
1868 SFA L.P.: "Foreign Correspondence" 355
1869 SBA Mrs Charretie:"For the next mail" 320
1869 SBA Mrs Emma Brownlow King: "News from the war" 327
 (for accompanying quotation see J2)
1869 SFA Miss Lane: "Pleasant News" 87
1869 SFA Miss G. Swift: "A letter to post" 394

Others:-
1861 RA Miss M. Jones: "The lesson" 408
1862 SFA Mme Marie Chosson: "The knitter" 41
1862 SFA Mrs Faulkner Salter: "The Opera Box" 244
1863 SBA Mrs L. Goodman: "The belle of the ball" 366
1863 SFA Adelaide Burgess: "The Embroideress" 74
1864 OWS Mrs Criddle: "A Fair Student" 245
1864 SFA Miss Agnes Bouvier: "Learning to Sew" 108
1864 SFA Miss J. Deffell: "The Reading Lesson" 206
1866 SBA Mrs E.H. Croudace: Off to the party" 763
1867 SBA Mrs J.F. Pasmore: "Granny mending her counterpaine" 749
1867 SFA Adelaide Burgess: "The knitting lesson" 81
1867 BI Miss H.M. Johnson: "The Fair Student" 495
1868 SBA Miss O.P. Gilbert: "The harpsichord" 1008
1869 RA Miss A. Wells: "At needlework in the garden" 501
1869 RA Mrs C.M. Brown: "At the Opera" 619

R3. 1871 SFA Miss G. Swift: "Many a sweet Babe father less and many a
 Widow mourning" 406
1871 RA Mrs Louise Romer: "In Memoriam" 390
1873 SBA Miss O.P. Gilbert: "The wreath" 659
1873 RA Mrs L. Cubitt: "In Memoriam" sculpture 1596
1873 RA Mrs L. Cubitt: "In Memoriam" sculpture 1598
1876 RA Mrs E. Cranford: "A soldier's legacy" 58
1877 SLA K.L. Langhorne: "Not lost, but gone before" 202
1877 RA Alice Havers: "The end of her journey" 1378 (see vol. 1,
 p 170)
1877 RA Miss Sophia Beale: "The funeral of an only child - Normandy"
 1003
1878 RA Blanche Jenkins: "The widow" 108
1879 SLA Julia B. Folkard: "Not lost, but gone before" 331

1881 RA	Edith Savile: "A young widow" 172	
1882 SBA	Susan Ruth Canton: "The Death of the First Born" sculpture 772	
1883/4 SBA	Anna Pulvermacher: "Maiden widowed" 158	
1884 SLA	Fanny W. Currey: "Convalescent" 708	
1884 SLA	Sarah James: "A Convalescent" 735	
1884 RA	Ida Lovering: "Motherless" 1602	
1885 NSPW	Miss Emily E. Collier: "A motherless home" 527	
1885 SLA	Constance Dunn: "In Memoriam" 272	
1885 SLA	Beatrice Agnes Rust: "The Sick Child" 639	
1885 RA	Miss I. Wheelwright: "In half-mourning" 1578	
1886 SLA	Florence Sherrard: "Mother's Grave" 299	
1887 SLA	Madame Schwartz: "The Young Widow" 314	
1887/8 IPO	Mrs W. Miller: "Convalescence" 447	
1890 RA	Miss B. Matthews: "After confirmation - her mother's grave" 304	
1891 SLA	Maria L. Angus: "Convalescent" 269	
1892 SLA	F. Fryer Hensman: "The Widow" 456	
1894 SLA	Mabel J. Young: "Requiescat" 248	
1897 RA	A. Constance Thorp: "Grief" 102	
1900 SWA	E. Thomas Hale: "In Memoriam" 320	
1900 RA	Mrs M.M. Cookesley: "Widowed" 975 (Sotheby's, October 18, 1978)	

This list may be completed by an examination of similar works with poetical titles in W2

S3. Thought, memory, etc:-

1870 RA	Miss C. Brown: "Thinking" 601	
1870 SFA	Julia Pocock: "Wandering Thoughts" 39	
1870 DG	Miss E. Manton: "Meditation" 152	
1870 DG(oil)	Frederika Beechey: "Alone" 145	
1871 SFA	Miss Freeman Kempson: "Solitude" 117	
1871 SBA	Miss B. Macarthur: "A pleasant memory" 770	
1871 SFA	Miss E. Manton: "Happy Thought" 65	
1871 RA	Mrs H. Champion: "Meditation" 745	
1871 RA	Harriet Kempe: "Absent but not forgotten"661	
1871 SFA	E.V.B.: "Dream" 1-5 nos. 220, 222, 225, 234, 238	
1871 RA	Mrs Louise Romer: "In Memoriam" 390	
1871 DG	Mrs H. Champion: "Wandering Thoughts" 255	
1871 SFA	Miss Alberta Brown: "Sad Memories" 419	
1871 DG	Mrs H. Champion: "Musing" 365	
1871 DG	Harriet Kempe: "Listlessness" 41	
1871 DG	Harriet Kempe: "Tristesse" 393	
1871 DG	Ellen G. Hill: "Listless" 639	
1872 SLA	Julia Pocock: "Day Dreams" 12	
1872 SLA	Mrs Henry Champion: "Day Dreams" 67	
1872 SLA	Mrs Dangars: "Meditation" 101	
1872 SLA	Miss E. Manton: "Stray thoughts" 105	
1872 SLA	Miss E. Manton: "Contemplation" 128	
1872 SLA	M. Gemmell: "A Reverie" 311	
1872 SLA	Madame Jerichau: "Penserosa" 387	
1872 RA	Miss Jessie Macgregor: "Oft time, old songs awaken memories" 612	
1872 DG	Janetta C. Russell: "A Peaceful Hour" 74	
1872 SBA	Miss J. Edwards: "Idle moments" 647	
1872 SBA	Miss F.M. Bonneau: "Meditation" 34	
1872 SBA	Miss M. Woolmer: "The morning dream" 273	
1872 SBA	Miss E. Clacy: "Dreaming by the Sea" 623	
1873 DG	Mrs Champion: "Meditation" 44	
1873 SLA	Miss A. Carter: "A Reverie" 51	
1873 SLA	Miss Helen Power: "Misery" 324	
1873 RA	Miss A.E. Donkin: "Musical Memories" 130	

1873 RA	Miss F. Tiddeman: "Reminiscences" 622	
1873 RA	Mrs L. Cubitt: "In Memoriam" sculpture 1596	
1873 RA	Mrs L. Cubitt: "In Memoriam" sculpture 1598	
1873 SBA	Miss M.V. Brook: "Day dreams" 259	
1873 SBA	Mrs Backhouse: "Dolce far niente" 678	
1873 SBA	Jane Hawkins: "The miniature"	
	"Faithful remembrance of one so dear" 777	
1873 SBA	Hariet Kempe: "Pensiveness" 804	
1874 RA	Miss Goodman: "Day-dreams" 202	
1874 RA	Harriet Kempe: "Nothing to do" 873	
1874 SLA	K. Macaulay: "Solitude" 102	
1874 DG	Blanche Jenkins: "Sweetly Dreaming" 592	
1874 DG(oil)	Blanche Macarthur: "Alone" 320	
1874 SBA	Miss L. Mearns: "A quiet hour" 35	
1874 SBA	Miss Blanche Macarthur: "Weary of life" 224	
1874 SLA	Alberta Frank: "Thoughts of Home" 438	
1874 SLA	Helen Power: "Sad Memories" 457	
1874 SLA	Clara Biller: "Solitude" 533	
1874 SLA	A.B.: "Regrets; or, the Nun and the Miniature" 546	
1875 RA	Miss Eva M. Ward: "Absent" 358	
1875 SLA	Sophie Barker: "In Dreamland" 201	
1875 RA	Miss Alice Havers: "A day-dream" 400	
1875 RA	Miss V. Carte: "Betwixt this mood and that" 1165	
1875 SLA	Florence Bonneau: "An Old Love Letter" 514	
1875 SBA	Mrs C. Grierson: "Dreaming" 210	
1875 SLA	Eleanor E. Manly: "Meditation" 578	
1876 SLA	Sophie Barker: "Reflection" 22	
1876 RA	Miss E.S. Guinness: "Idle moments" 803	
1876 SBA	Mrs H. Champion: "Idle moments" 623	
1876 SLA	Harriet Kempe: "Pensiveness" 60	
1876 SLA	Miss Kempson: "Solitude" 140	
1876 SLA	Linnie Watt: "A Reverie" 372	
1876 SLA	C. Constance Pierrepont: "Penserosa" 157	
1876 SLA	Helen M. Johnson: "Retirement" 242	
1876 SLA	Elizabeth L. Vaughan: "Tender Thoughts" 250	
1877 SLA	Constance Pierrepont: "Thoughts of the Past" 576	
1877 SLA	Mrs Backhouse: "A Happy Thought" 171	
1877 SBA	Mrs H. Champion: "Daydreams" 726	
1877 SLA	Miss V. Adey: "Thinking of the days that are no more" 200	
1877 RA	Jennie Moore: "Dreams" 885	
1877 RA	Emily Osborn: "Dreaming awake" 461	
1877 SLA	Miss A. Carter: "Maiden meditation" 349	
1877 DG	Elizabeth Manton: "Anxious Times" 86	
1877 SLA	Julia B. Folkard: "A reverie" 590	
1877 SLA	Agnes Fairfield:"Thinking of the Absent" 621	
1877 SLA	Blanche Macarthur: "Alone" 444	
1878 SBA	Miss H. Farr: "Consideration" 291	
1878 SLA	K.L. Langhorne: "Vesper Dreams" 181	
1878 SLA	Elise Paget: "In Wonderland" 89	
1878 SBA	Miss E.F. Letts: "A Day-dream" 299	
1878 SLA	Miss A.M. Motte: "A Day Dream" 493	
1879 RA	Frances Redgrave: "A noonday meditation" 505	
1879 SLA	Mary Ann Paris: "Thoughts of the Future" 142	
1879 RA	Elizabeth Folkard: "In maiden meditation" 682	
1879 RA	Jennie Moore: "Sad thoughts" 758	
1879 RA	Alice Squire: "The pleasure of hope" 843	
1879 SLA	Helena Blackburne: "A Reverie" 420	
1879 RA	Catherine J. Atkins: "Thoughtful" 871	
1879 SLA	Julianna Lloyd: "Thoughts, thoughts, tender and true" 445	
1879 RA	Georgina F. Terrell (née Koberwein): "A day-dream" 923	

```
1879 SLA        A.L. Beauchamp: "Solitude" 539
1879 DG         Ellen Clacy: "A Quiet Day" 592
1879 SLA        Helena Francis: "Solitude" 553
1879 NSPW       Lady Lindsay: "The Dream-Maiden" 182
1879 SLA        Emma Squire: "Not lost to memory" 578
1879 SLA        Mrs Talbot Coke: "Twilight thoughts" 697
1879 SLA        N. Döring: "The Reverie" 750
1880 SLA        Elizabeth Naughten: "Daydreams" 29
1880 SLA        Kate Belford: "A Dream of the Past" 446
1880 RA         Miss S. Parker: "And she was left lamenting" 953
1880 RA         E.M. Osborn: "Reflections" 1029 (ill. in "Academy Notes"
                     op.cit. 1880, p.69)
1880 SLA        Fanny W. Currey: "Splendid Misery" 450
1880 SBA        Miss C.M. Noble: "Idleness" 521
1880 DG         Ellen Welby: "A Quiet Hour" 457
1880 SLA        Agatha M. Swiney: "Faithful remembrance of one so dear" 694
1880 DG(b&w)    Jennie Moore: "The perfect sweetness of sad womanhood" 614
1881 SLA        Miss Austin Carter: "Daydreams" 56
1881 SBA        Mary Bleaden: "Sad Memories" 696
1881 SLA        Norah Royds: "Golden Dreams" 215
1881 SBA        Marie Cornelissen: "L'Ennui" 93
1881 SBA        Phoebe M. Cobbett:"Idle Moments" 537
1881 SLA        Fanny House: "Day Dreams" 367
1882 SLA        Alice Price: "A Reverie" 326
1882 SLA        Alice M. Cockerill: "Lost in thought" 45
1882 RA         Jane M. Dealy: "Happy thoughts" 875
1882 SLA        N. Clutterbuck: "Solitude" 173
1882 SBA        Lillie Trotman: "Idle Dreams" 603
1882 SLA        Catherine J. Atkins: "Idle Moments" 209
1883 SLA        Mrs Hutchinson: "Dolce far niente" 27
1883 SLA        Laura Jones: "Pensierosa" 181
1883 SLA        Linnie Watt: "Day Dreams" 633
1883 NSPW       Rosa Koberwein: "Thoughtful" 122
1883 SLA        Florence N. Street: "The Dreamer" 644
1883 SLA        Miss Eva Radcliffe: "Memories" 691
1883 NSPW       Miss E.A. Armstrong: "Day Dreams" 398
1883 RA         Cathinca Amyot: "The world forgetting, by the world forgot"
                     436
1883 DG(oil)    Alice Grant: "Wandering thoughts" 107
1883 SBA        Adelaide A. Burnett-Nathan: "A Nondescript Girl doing
                     nothing" 128
1883/4 SBA      Margaret Meyer: "A leisure hour" 146
1883/4 IPO      Mrs G.B. Rosher: "Meditation" 383
1883/4 IPO      Henrietta Rae: "Shadows of memory" 392
1883/4 IPO      Mrs Latham Greenfield: "Solitude" 436
1883/4 SBA      Alice Miller: "A Prayer" 289
1883/4 SBA      Ellen Brock: "In Holy Meditation" 152
1883/4 SBA      Blanche MacArthur: "Solitude" 578
1883/4 SBA      Emily R. Stones: "Day-dreams" 680
1883/4 SBA      Ethel Murray: "Reverie" 455
1884 SLA        Katherine D.M. Bywater: "A Day Dream" 256
1884 RA         Janetta R.A. Pitman: "A brown study" 1085
1884 SLA        Mrs Schenk: "Sad Memories" 304
1884 RA         Kate Perugini: "Idle Moments" 15 (ill. in "Academy Notes"
                     op.cit. 1884, p.4)
1884 RA         Catherine J. Atkins: "Happy thoughts" 1106
1884 RA         Fanny W. Currey: "Lonely" 1172
1884 SLA        S. Janson: "Solitude" 505
1884 SLA        Miss A. Carter: "Old Letters" 511
1884 SLA        Mrs Emily Barnard: "Memories" 528
```

1884 SLA	Agnes L. Gover: "A Reverie" 575	
1884 SLA	Miss Helen Friedrich: "Dolce far niente" 686	
1885 RA	Sarah Birch: "In a world of her own" 687	
1885 RA	Miss E.G. Jeffreys: "Day-dreams" - statuette, terra cotta 2048	
1885 RA	Miss P. Linder: "Meditation" 1467	
1885 RA	Miss J. Moore: "Solitude" 1207	
1885/6 IPO	Miss M. Christine Connell: "Day-Dreams" 756	
1885/6 IPO	Miss Kathleen Hamilton: "Reminiscences" 43	
1885 RA	Miss E. Curtois: "Prayer" statue, terra cotta 1979	
1885 SLA	C.A. Channer: "Sad thoughts" 170	
1885 SLA	K. Macaulay: "Calm Reflections" 184	
1885 SLA	Constance Dunn: "In Memoriam" 272	
1885 SLA	M. Caroline Vyvyan: "In Wonderland" 495	
1885 SLA	Mrs Agnes R. Nicholl: "Pleasant thoughts" 613	
1885 SLA	Mrs Paul J. Naftel: "Dreamy Days" 694	
1885 SLA	Bessie Haynes: "Memories" 757	
1886 RA	Mary L. Breakell: "Illusions" 683	
1886 RA	Henrietta Rae: "Doubts" 702	
1886 RA	Jessie Lipscomb: "Day-dreams" bust, terra cotta 1759	
1886 RA	Edith G. Jeffreys: "Regrets" bust, terra-cotta 1847	
1886 RA	Louisa Jacobs: "A Reverie", bust 1917	
1886 NSPW	Catherine A. Sparkes: "A Reverie" 84	
1886 SBA	H. Edith Grace: " A Vision of a Waking Dream" 85	
1886 SLA	Emily Crawford: "Old Memories" 83	
1886 SLA	Emily R. Stones: "Daydreams" 146	
1886 SLA	Helen O'Hara: "Desolation" 153	
1886 SLA	Blanche Macarthur: "Thoughts of Italy" 156	
1886 SLA	M.C. Vyvyan: "A Reverie" 194	
1886 SLA	E. Isaacs: "A Reverie" 231	
1886 SLA	Helen M. Trevor: "A Morning Dream" 258	
1886 SLA	Florence M. Cooper: "Desolate" 278	
1886 SLA	Mary Macarthur: "A Reverie" 311	
1886 SLA	Alice Parting: "A Reverie" 411	
1886 SLA	S.L. Kilpack: "Left to Desolation" 451	
1886 SLA	Jessie Macgregor: "Christmas Reflections" 488	
1886/7 IPO	Florence White: "La Rêverie" 764	
1886/7 IPO	Miss E. Jex-Black:"A Reverie" 273	
1887 SLA	C.A. Channer: "Prayer" 44	
1887 RA	Georgiana Koberwein Terrell: "Sweet memories" 999	
1887 SLA	A.M. Youngman: "Filled with thoughts of Long Ago" 61	
1887 SLA	H. Donald Smith: "Memories" 335	
1887 SLA	Agnes G. King: "Dreaming" 429	
1887 SLA	Miss A. Carter:"Memories" 439	
1887 SLA	Edith Sharpe: "Solitude" 552	
1887/8 IPO	Miss Maud Naftel: "Solitude" 696	
1887/8 IPO	Miss Florence A. Saltmer: "Tranquillity" 592	
1887/8 IPO	Miss Clara Knight: "Idling" 569	
1888 SLA	Beatrice A. Rust: "In wonderland" 8	
1888 SLA	Mary Groves: "Memories" 260	
1888 SLA	Mrs Finney: "Wandering thoughts" 272	
1888 SLA	Fanny Bertie: "Memories sweet and tender" 292	
1888 SLA	Helene Franck: "Pleasant Recollections" 333	
1888 SLA	Mabel Moultrie: "Il Penseroso" 350	
1888 SLA	Leigh Badcock: "Doubts and Fears" 512	
1888 SLA	Helen Wight: "Day Dreams" 533	
1888 SLA	Caroline Armstrong: "La Pensierosa" bust 566	
1888 SLA	Amy Hunt: "Pensive" bust 568	
1888 RA	Mary H. Fores: "A Reverie" 1110	
1888 RA	Evangeline Stirling: "Meditation" bust 2076	

1888 NSPW	Miss Harriet M. Bennett: "Idle Moments" 285	
1888 NSPW	Mrs Gertrude Demain Hammond: "A Reverie" 394	
1889 SLA	Lilian Abraham: "Meditation" 5	
1889 SLA	Linnie Watt: "Dreams" 252	
1889 NEAC	Annie Ayrton: "Dreamland" 85	
1889 SBA	Beatrice A. Rust: "In wonderland" 9	
1889 RA	Florence Fitzgerald: "Meditation" bust 2098	
1889 DG	Miss M. Mason: "Despondency" 9	
1889 NSPW	Miss Jessie Scott-Smith: "A summer love-dream" 30	
1889 NSPW	Miss Gertrude Demain-Hammond: "Pleasing Reflections" 786	
1889/90 IPO	Miss Ethel Wright: "Memory" 76	
1890 SLA	Mary Godsal: "In the Vale of Misery" 315	
1890 SLA	Florence White: "La Rêverie" 330	
1890 RA	Miss C.J. Weekes: "A studious moment" 739	
1890 RA	Miss Margaret Isabel Dicksee: "In Memoriam" 1075 (Ill. in Walter Shaw Sparrow op.cit. p.112)	
1890 SBA	Miss Rosa Drummond: "Disillusioned" 401	
1890/1 IPO	Miss Kate Jackman: "Sad thoughts" 121	
1890/1 IPO	Miss Florence Small: "A Reverie" 365	
1890/1 IPO	Miss N.A.S. Pasley: "The Memory of the Past" 389	
1890/1 IPO	Miss Kate Hitchcock: "The Reminiscences of an old Sampler" 621	
1890/1 IPO	Miss Mildred Hancock: "Miserere Mei Deus" 537	
1891 SLA	Fanny W. Currey: "Solitude" 43	
1891 SLA	Mary E. Postlethwaite: "Maiden Meditation" 200	
1891 SLA	A.M. Edgelow: "Meditation" 361	
1891 NSPW	Miss Alice Grant: "Thoughts" 730	
1891 NSPW	Miss M.C. Abercrombie: "Dolce far Niente" 610	
1891 NSPW	Miss E. Cameron Mawson: "Day Dreams" 367	
1891 RA	Grace E. Sainsbury: "Thinking" 375	
1891 SBA	Ada M. Sweet: "Wandering thoughts" 342	
1891 SBA	Beatrix Fisher: "Dreaming" 356	
1891/2 IPO	Miss Henrietta Rae: "Day Dreams" 34	
1891/2 IPO	Miss Henrietta Rae: "Memories" 47	
1891/2 IPO	Miss Ida R. Tayler: "In Pensive Mood" 89	
1891/2 IPO	Miss Florence Castle: "Wandering thoughts" 222	
1891/2 IPO	Miss Joan Adams: "Solitude" 373	
1892 SLA	E.R. Stones: "After-thoughts" 155	
1892 SLA	Madame Giampietri: "Pensierosa" 194	
1892 NSPW	Miss Helen Whitfield: "Meditation" 598	
1892 SLA	Mary Woodward: "Idle Moments" 384	
1892 SLA	F. Bramley Warren: "Reverie" 388	
1892 SLA	E.S.A. McMillan: "A brown study" 427	
1892 NSPW	Miss M. Constance Stacpoole: "An Idle Moment" 238	
1892 NSPW	Miss Helen O'Hara: "Joy" 590	
1892 NSPW	Miss Mildred A. Butler: "Dolce far Niente" 26	
1892 NSPW	Miss Eva E. Pyne: "Sweet Memories" 676	
1892 SBA	Louise Parker: "Thoughts" 310	
1892 RA	Kate E. Bunce: "The day-dream" 515 (ill. in "Academy Notes" op.cit. 1892, p.100)	
1892 RA	Christabel Cockerell: "Weighty Cares" 132	
1892 RA	Alice G. Brown: "Day-dreams" 830	
1892 RA	Harriet Halhed: "Dreamland" 903	
1892 RA	Ada Holland: "A dream of happiness" 978	
1892 RA	Ada Beard: "Day-dreams" 1264	
1892 SBA	Constance E. Plimpton: "Day Dreams" 336	
1892 SBA	Mrs W.P. Watson: "Thoughts" 356	
1892 NSPW	Miss Helen O'Hara: "Sorrow" 614	
1892/3 IPO	Miss M.E. Edwards: "A Quiet Afternoon" 484	
1892/3 IPO	Miss E.C. Hayes: "Lonely" 196	

1892/3 IPO	Miss Edith Sprague: "Regrets" 237	
1892/3 IPO	Miss M.L. Gwendoline Lee: "A Reverie" 260	
1892/3 IPO	Miss Helen Squire: "In Dreamland" 321	
1893 SLA	Florence Pash: "Day-dreams" 291	
1893 SLA	Mrs S.E. Waller: "A Dreamer" 451	
1893 DG	Miss Nora Davison: "Solitude" 21	
1893 NG	Mrs Alma Tadema: "Many stitches, many thoughts" 10 (ill)	
1893 NSPW	Miss Maude Goodman: "Memories" 31	
1893 NSPW	Miss Blanche Gottschalk: "Leaves of Memory" 136	
1893 NSPW	Miss Alice Squire: "A Tranquil Hour" 430	
1893/4 SBA	Isabel C. Pyke-Nott: "Dolce far Niente" 450	
1893/4 IPO	Miss Harriet E. Ryder: "Pensive thoughts" 53	
1893/4 IPO	Miss Edith M. Cannon: "La Pensierosa" 140	
1894 RA	Caroline Gotch: "Day-dreams" 1	
1894 SLA	M.E. Kindon: "Happy thoughts" 237	
1894 RA	Isabel C. Pyke-Nott: "A reverie" 143	
1894 RA	Susan Tooth: "Memories" 1249	
1894 NG	Miss Mary L. Gow: "Dreams of the Future" 196	
1894 SBA	Flora M. Reid: "Memories of the Past" 48	
1894 SBA	Beatrice Frederickson: "Morning Meditation" 297	
1894/5 IPO	Miss Anna Nordgren: "Day Dreams" 330	
1894/5 IPO	Miss Janet Fisher: "Day Dreams" 522	
1895 SLA	Maude Turner: "A Reverie" 33	
1895 SLA	Nellie Hadden: "In wonderland" 37	
1895 SLA	J. Archer: "In Maiden Meditation" 191	
1895 SLA	Helen Stratton: "Day-dreams" 276	
1895 SLA	S.K. Tooth: "Day-dreams" 286	
1895 SBA	Mrs Nancy Knaggs: "Solitude" 490	
1895 RA	Miss J.D.S. Aldworth: "Thoughts" 1029	
1895 RA	Miss M.A. Heath: "Her own sweet thoughts for company" 946	
1895 RA	Miss E.C. Woodward: "Day-dreams" 1357	
1895 NG	Miss Anna Nordgren: "Thoughts and stitches" 298	
1895 NSPW	Miss Josine Rappard: "A Quiet Evening Hour" 188	
1895/6 IPO	Mme. Arsène Darmesteter: "Distraite" 371	
1896 NSPW	Miss Marie L. Angus: "Quietude" 153	
1896 SLA	Mrs Lydia B. Matthews: "Sad thoughts" 208	
1896 RA	Minna Tayler: "Reflections" 899	
1896 SLA	Mrs E.A. Frank: "Pale Memories and Half-dreamed Dreams of Bliss" 252	
1896 RA	Mary E.T. Morgan: "Reverie" 1120	
1896 RA	Emmeline T. Clarke: "Happy memories" 1135	
1896 RA	Ethel Kirkpatrick: "Day-dreams" 1549	
1896 RA	Nelly Cook: "The restless unsatisfied longing" 1225	
1896/7 IPO	Mrs Mary F. Field: "In Pensive Mood" 161	
1897 RA	Ada Knight: "Memories" 119	
1897 SLA	F. Mabelle Pearse: "Acquainted with Grief" 422	
1897 RA	Jane A. Ram: "Dreams of ambition" 365	
1897 RA	Margaret Collyer: "A brown study" 865	
1897 SLA	Maud M. Whitmore: "A Reverie" 479	
1897 RA	Florence A. Fuller: "Summer reverie" 893	
1897 SLA	Jane Barrow: "In Maiden Meditation" 512	
1897 RA	Lily Kirkpatrick: "A Quiet Hour" 1057	
1897 SBA	Kate Hitchcock: "Daisy Dreams" 117	
1897 SBA	Miss Nellie Sansome: "Contemplation" 368	
1898 NSPW	Mrs H. Creamer: "Meditation" 638	
1898 NSPW	Miss Harriet Halhed:"The thoughts of youth are long, long thoughts" 513	
1898 SLA	Florence A. Fuller: "Summer Reverie" 36	
1898 SLA	Emily Osborn: "In Dreamland" 51	
1898 SLA	Theodosia Eagleston: "Meditation" 90	
1898 SLA	Florence Small (Mrs Deric Hardy): "A Reverie" 303	

```
1898 SLA      Mrs Alfred Elias: "Meditation" 432
1898 RA       Henriette Ronner: "Memories and Anticipation" 110
1898 RA       Isabel C. Pyke-Nott: "Reverie" 600
1898 RA       Florence Pash: "Meditation 1859" 830
1898 RA       Constance E. Smith: "Quiet Moments" 857
1898 RA       Lily Kirkpatrick: "Day-dreams" 907
1898 RA       Annie L. Henniker: "Sweet hopes that come with spring" 934
1898 RA       Madeleine M. McDonald: "Day dreams"1093
1898 RA       Helena M. Swaffield: "An idea" 1489
1898 SBA      Florence Castle: "Absorbed" 284
1898 SBA      Miss Louie G. Goshawk: "Day Dreams" 391
1899 SM       Miss Edith Scannell: "Day Dreams" 26
1899 SM       Miss Sara West: "A Memory" 130
1899 SM       Miss Jessica Lawther: "Daydreams" 176
1899 SWA      Lota Bowen: "Reflection" 25
1899 SWA      Agnes Kershaw: "Meditation" 205
1899 RA       Amy Drucker: "A reverie" 1333
1899 SWA      Mrs F. Pash Humphrey: "Meditation" 335
1899 RA       Rose Mackay: "Meditation" 995
1899 SWA      Annette Elias: "Solitude" 388
1899 RA       Meg Wright: "Reverie" 236
1899 SM       Mrs M.H. Earnshaw: "Memories" 16
1899 NG       Mrs A.L. Swynnerton: "A Dream of Italy" 213 (Metropolitan
                  Museum, New York)
1900 SWA      E. Thomas Hale: "In Memoriam" 320
1900 RA       Miss M.B. Worsfold: "Why so pensive, gentle maiden?" 1480
1900 RA       Miss E. Gregory: "An empire of dreams" 1658
1900 RA       Miss Anna A. MacRory: "Idle Dreams" 616
1900 RA       Mrs Lucy B. Smith: "Reverie" 1370
1900 NG       Mrs A.L. Swynnerton: "The Unrelenting Past" 37 (National
                  Gallery of Canada)
1900 SM (Autumn) Miss Rosabella Drummond: "Day Dreams" 59

Waiting:-
1870 SFA      Ellen Blackmore: "Expectation" 2
1870 SFA      Mrs Charretie: "Expectation" 240
1870 SBA      Miss C. Farrier: "Expectation" 880
1870 DG       Janetta C. Russell: "Waiting, watching, hoping still" 92
1871 SFA      Ellen Partridge: "Will he come?" 110
1871 SFA      Mary Bleaden: "Expectation" 312
1871 SFA      Miss Hunter:"Waiting" 440
1872 RA       Mrs Charretie: "Expectation" 841
1873 SLA      Miss E. Manton: "Will he come?" 11
1873 SLA      Miss Mitchell: "Waiting" 253
1873 SBA      Miss E. Clacy: "Expectation" 622
1873 OWS      Miss Margaret Gillies: "Suspense"
                      "But surely in the far, far distance
                      I can hear a sound at last" 76
1873 SBA      Miss F.D. Binfield: "Waiting" 589
1873 RA       Mrs Sophie Anderson: "Father's late" 573
1873 SBA      Miss P. Wignell: "Waiting for papa" 257
1874 SLA      S.L. Kilpack: "Waiting the Return of the Boats" 17
1874 SLA      Helen J.A. Miles: "Waiting for Father" 80
1874 SLA      Miss Freeman Kempson:"Waiting for Father" 134
1874 SLA      Kate Belford: "Will he come?" 206
1874 SBA      Miss B. Macarthur: "Waiting" 303
1874 DG       Adelaide Maguire: "Looking out for mother" 622
1874 DG       Mrs H. Champion: "Expectation" 213
1874 RA       Miss A.E. Donkin: "Waiting" 1423
1875 SLA      Miss E.S. Guinness: "Watching" 194
1875 SLA      M.E. Greenhill: "Weary of Waiting" 427
```

```
1875 DG(oil)  Ellen Partridge: "Waiting, Fearing" 388
1875 SBA      Miss Maude Goodman: "Waiting" 817
1875 SBA      Jane M. Bowkett: "Disappointment" 166
1876 SLA      Mrs Backhouse: "Watching" 57
1876 RA       Miss A. Squire: "Expectation" 863
1876 SLA      Alice Percival Smith: "Waiting" 593
1876 DG       Blanche Macarthur: "Weary, so weary of waiting
                      Longing for sympathy sweet" 378
1877 SLA      Louisa Wren: "Watching" 220
1877 SLA      Clemence Pruysvander Hoeven: "Watchful" 237
1877 RA       Louise Jopling: "Weary waiting" 1372 (Sotheby's Belgravia
                      March 25, 1975)
1877 SLA      Ellen Partridge: "He cometh not" 248
1877 DG(b&w)  Rosa Koberwein: "Waiting" 595
1877 SLA      Ellen T. Letts: "Waiting for the Boats" 318
1877 DG       Julia C. Smith: "Waiting" 619
1878 SLA      Mrs John Smith: "Waiting 195
1878 DG(b&w)  Alice Squire: "Hope Deferred" 439
1878 SLA      Mrs Frederick Vulliamy: "The Broken Tryst" 324
1878 RA       Rosalie M. Watson: "Anxiously waiting" 735
1878 DG       Mrs Rowland Lawford: "Waiting" 282
1878 DG       Elizabeth Manton: "Waiting" 395
1878 DG       Linnie Watt: "Waiting" 112
1879 SLA      Julianna Lloyd: "A Study - 'Waiting'" 84
1879 SLA      Helen J.A. Miles: "Waiting" 199
1879 SLA      Miss M. Brooks: "Expectation" 342
1879 RA       Rosalie M. Watson: "He cannot come" 728
1879 SLA      Marion Walker: "Waiting" 628
1880 RA       Miss E. Ballantyne: "Waiting" 990
1880 SLA      Margaret Kerr: "Waiting" 16
1880 RA       Miss Annie L. Beal: "Watching" 91
1880 RA       Miss A.H. Fenton: "Late" 19
1880 SLA      Mrs Ernest Hobson: "He's Coming!" 90
1880 SBA      Mrs H. Champion: "Expectation" 745
1880 SLA      Florence Bonneau: "Watching" 612
1881 SLA      Catherine J. Atkins: "Anxiously waiting" 191
1881 GG       Mrs E. Hume: "Lingering Hope  202
1881 SLA      Mary Mason: "Waiting" 321
1881 DG       Margaret Hickson: "Waiting" 42
1881 SLA      E.H. Adelina Sharp: "Waiting" 673
1881 GG       Miss Maud Naftel: "Waiting" 313
1882 SLA      Rosa Koberwein: "Waiting" 222
1882 SLA      Madame Giampietri: "Waiting" 588
1882 SLA      Fannie Moody: "Anticipation" 589
1882 RA       Farnces Redgrave: "The breadwinner's return" 599
1882 SLA      Katie Sturgeon: "Waiting" 63
1883 NSPW     Miss Emily Farmer: "Waiting" 804
1884 SLA      Katherine D.M. Bywater: "Expectation" 306
1884 SLA      Ethel E. Ellis: "Waiting and Watching" 309
1885 DG(oil)  Maria Brooks: "Waiting" 194
1885 SBA      Miss Emily M. Merrick: "Waiting" 118
1885 SBA      Miss C. Popert: "Waiting" 707
1885 DG       Mary Eley: "Still she waited" 363
1886 SLA      Helen Power: "A Long Wait" 364
1886 SLA      Miriam J. Davis: "Waiting for the Boats" 412
1886 SBA      M. Christina Connell: "Waiting" 426
1886 RA       Edith Hume: "Waiting" 842
1886 RA       Rosalie M. Watson: "Waiting" 1220
1886/7 SBA    Miss C.M. Noble: "Expectancy" 347
1887 GG       Miss Nettie Huxley: "Tout vient à qui sait attendre" 15
1887 SLA      Alice Gow Stewart: "Waiting" 283
1887 GG       Miss Rosalie Watson: "Waiting for Darby" 354
```

```
    1887 RA        Beatrice A. Rust: "Waiting" 1068
    1887 SLA       Nellie Hadden: "Waiting" 401
    1887 DG        Agnes Fraser: "They also serve who only stand and wait"
                       197
    1887 NSPW      Alice B. Woodward: "Waiting" 553
    1888 RA        Mary Macarthur: "If absence parts, Hope ready to console,
                          whispers,
                       Be soothed, the absent shall return" 603
    1888 SLA       Florence Pash: "Waiting" 556
    1889 NSPW      Miss K. Sturgeon: "Watching and waiting" 658
    1889 SBA       Constance E. Plimpton: "Waiting" 440 (ill.)
    1889 RA        Louise Jopling: "Hope" 874
    1890 SBA       Mrs E. Hume: "Is father coming?" 835
    1890 RA        Miss E.M. Moore: "Watching" - head 1976
    1890 RA        Mrs L.J. Price: "Expectant" 1426
    1890 SBA       Miss Lilian Young:"Waiting for Father" 249
    1890 RA        Miss Dora Hitz: "Hope deferred maketh the heart sick" 1314
    1891 SLA       Fannie Moody: "Will he come?" 249
    1891 RA        L. Martina Wood: "Anticipation" 1697
    1892 SBA       Miss M.E. Edwards: "Anticipation" 23
    1892 RA        Fannie Moody: "Weary waiting" 682
    1892 SLA       E.A. Walker: "Waiting" 239
    1883 NG        Miss Marian Alexander: "Waiting" 226
    1893 RA        Fannie Moody: "Expectancy" 2
  1893/4 IPO       Miss Katherine Willis: "Waiting" 554
    1894 RA        Ruth Garnett:"Waiting for father's bus" 1057
    1895 SLA       Ida Lovering: "Expectation" 210
    1895 SLA       Nora Locking: "Waiting" 368
    1896 RA        Maud Porter: "Hope deferred" 914
  1896/7 IPO       Miss Mary Lever Burdekin: "Expectation" 84
    1897 SLA       Blanche Gottschalk: "Expectation" 371
    1897 SLA       Kate Earle: "Waiting" 439
    1897 RA        Marthe Abran: "Waiting" 797
    1897 RA        Ellen Clacy: "The sound of the beloved's footsteps" 1000
    1898 SLA       Edith Scannell: "Waiting" 22
    1898 RA        Isabel White: "Waiting" 955
    1898 RA        Agnes Kershaw: "Waiting" 1098
    1899 RA        Anna Wingate: "The  wasted vigil" 439
    1899 SBA       Charlotte M. Alston: "Expectation" 505
    1899 NSPW      Miss Florence Pash: "Waiting" 205
    1900 RA        Miss N. Sansom: "Waiting" 1415
    1900 SBA       Nora Davison: "Waiting for Father" 467
    1900 NSPW      Miss H. Maggoun:"Weary waiting" 385
    1900 SBA       Ada M. Shrimpton: "A weary wait" 417
```

Reference should be made to O2,P2,R2,V2 for works with poetical titles
on these themes.

```
T3. 1870 RA        Mrs M.E. Freer: "Renounced" 357
                       (Described in the "Art Journal" of 1870 (p.168) as
                       "a theme falling completely within woman's sympathy.
                       The picture is painted expressly to point the contrast
                       between celibacy and matrimony")
    1871 SFA       Mrs Crawford: "La Fiancée" 411
    1871 RA        Mrs Lee Bridell: "An Arab Marriage" 36
                       (The artist exhibited a work with the same title at
                       the Society of Female Artists in 1873, no.40)
  1872 DG(oil) Mrs Charretie: "The Bride" 314
    1873 RA        Mrs A. Bowden: "The bride" 404
```

1873 NSPW	Elizabeth Murray: "The Greek Betrothal" 117	
1874 RA	Mrs Staples (Miss M.E. Edwards): "The first romance" 1334	
1874 RA	Miss F. Ward: "The bridal morn" 1387	
1875 SLA	Florence Bonneau: "An Old Love Letter" 514	
1875 RA	Mrs M.E. Staples: "He loves me, - loves me not?" 534 (ill. in "Academy Notes" op.cit. 1875, p.37)	
1875 SLA	Mrs Paul J. Naftel: "The Bride" 378	
1875 RA	Miss M. Backhouse: "Oh! my luv's like a red red rose etc". 827	
1875 RA	Mrs M.E. Staples: "The Record" 27 (ill. in "Academy Notes" op.cit. 1875, p.25)	
1875 SLA	Mrs M.E. Staples: "The First Romance" 454	
1876 SLA	Eliza A. Melville" "First Love" 251	
1876 SBA	Miss A.M. Wilson: "He loves me; he loves me not" 164	
1877 SLA	Madame Ballot: "Lady and Lovers" 703	
1877 RA	Sophie Anderson: "The Proposal" 465 (depicting three girls reading a letter, presumably a proposal of marriage to one of them, according to the "Art Journal" 1877, p.269)	
1878 SLA	Mrs Frederick Vulliamy: "The Broken Tryst" 324	
1878 SLA	Elizabeth Westbrook: "Does He love Me?" 349	
1878 DG	Kate Greenaway: "Darby and Joan" 553	
1878 RA	Ellen Conolly: "Darby and Joan" 624	
1879 SLA	Edith de Lancy West: "St. Valentine's Eve" 374	
1879 SLA	Miss S. Wadham: "The Bride" 567	
1880 NSPW	Elizabeth Murray: "Jewish Marriage Festival in Morocco" 74	
1881 SLA	Rosalie W. Watson: "The Rendezvous" 77	
1881 SBA	Mary Hayllar: "Wedding Presents" 372	
1882 SLA	Bertha Newcombe: "A Flirtation" 240	
1882 RA	Blanche Jenkins: "The first kiss" 752	
1882 DG	Annette L. Riviere: "Darby and Joan" 589	
1883 SLA	Marrion Reid: "Journeys end in lovers meeting" 64	
1883 SBA	Mary Hayllar: "The Rendezvous" 179	
1883 SLA	E. George Turnbull: "Valentines" 628	
1884/5 IPO	Miss Dorothy Tennant: "The death of love" 817	
1884 GG	Miss Dorothy Tennant: "Broken-hearted" 140	
1884 GG	Maria Brooks: "A love story: The Letter 1554 A Trial 1555 Happier than ever" 1556 (ill. in "Academy Notes" op.cit. 1884, p.71)	
1885 SLA	Alma Broadbridge: "The Love Letter" 279	
1886 SBA	Jane K. Humphreys: "Men are deceivers ever" 155	
1886 SLA	F.A Howarth: "Married for Money" 111	
1886 RA	Harriette Sutcliffe: "Something the heart must have to cherish" 469	
1886 SLA	Kate Street: "Romance" 128	
1886/7 IPO	Julia B. Folkard: "The love letter: - 'The Death of Hope and the Birth of Joy'" 604	
1887 SBA	Maria Luke: "Darby and Joan" 421	
1887 SLA	Eliza F. Manning: "A Lover's Quarrel" 4	
1887 GG	Miss Rosalie Watson: "Waiting for 'Darby'" 354	
1887 NEAC	Miss E. A. Armstrong: "First Love" 2	
1887/8 IPO	Mrs Louisa Starr Canziani: "Love in Her Eyes Sits Dreaming" 435	
1888 SLA	Kathleen Shaw: "The Wedding Ring" 223	
1888 NSPW	Miss Kate Bennett: "A love token" 1	
1888/9 IPO	Miss Mary Macarthur: "First at the Tryst" 507	
1889 NSPW	Miss Jessie Scott-Smith: "A summer Love-Dream" 30	
1889 RA	Miss Maude Goodman: "Two love stories" 208	

```
1889 RA        Edith Sprague: "Une lettre d'amour" 873
                   "Quelle charmante place elle occupe longtemps etc."
1889 RA        Miss Maude Goodman: "Un chant d'amour"
                   "If music be the food of love, play on" 955
1890 SLA       H. Ethel Rose: "A Love Story" 246
1890 SBA       Mrs Sophie Anderson: "The Love-Letter" 505
1890 RA        Jessica Hayllar: "Fresh from the altar" 972 (depicting the
                   reception after a wedding; photograph in Witt Library)
1890 RA        Miss M. Irwin: "A love-letter" 369
1890 NG        Miss E. Halle: "Love's first low whispering" - bas relief
                   413
1891 SLA       Zona Vallance: "The course of true love never runs smooth"
                   503
1891 SLA       Helen Donald Smith: "He loves me, he loves me not" 157
1891 SBA       Maud Pilkington: "Sweetheart" 35
1891 DG        Frances C. Fairman: "Darby and Joan" 114
1892 SLA       Julia B. Matthews: "Darby and Joan" 111
1892 SLA       Jessie Hall: "Darby, dear, we are old and grey" 125
1892 SLA       Elizabeth Bywater: "A love-gift" 394
1892 SLA       A. Manville Fenn: "St. Valentine's Day" 242
1892 SBA       Eva Hollyer: "A Tiff" 327
1893 NSPW      Miss Julia B. Matthews: "Darby and Joan" 502
1893 SLA       Ida Lovering: "Courtship" 257
1893 SBA       Mary Groves: "A love story" 182
1893 SLA       Jessie Hall: "He loves me! he loves me not!" 274
1893/4 NG      Fanny Moody: "Darby and Joan" 20
1894 RA        Amy C. Brewer: "Love in idleness" 445 (ill. in "Academy Notes"
                   op. cit. 1894, p.106)
1984 SLA       Julia B. Folkard: "The First Love Letter" 181
1894 NG        Mrs H.M. Stanley: "Love's whisper" 66
1894 SLA       Maude Walker: "A Billet Doux" 366
1895 NG        Mrs Alma Tadema: "Love's Curse" 126
1895 RA        Miss M.I. Naylor: "A tired love" 729
1896 SLA       Katherine D.M. Bywater: "A Love-token" 168
1896 NG        Mrs Dorothy Stanley: "Blinded by love" 52
1896 NG        Mrs Alma Tadema: "The Ring" 73
1896 SLA       Mrs Emily Barnard: "The Bride" 10
1896 RA        Marie J. Naylor: "A tired love" 293
1897 NG        Miss Blanche Jenkins: "An Offering of Love" 115
1897 RA        Miriam I. Davis: "The bridal dress" 816
1897 RA        Ellen Clacy: "The sound of the beloved's footsteps" 1000
1897 NSPW      Miss Gertrude Demain Hammond: "Cupid's First Shaft" 78 (ill)
1897 SLA       M.E. Kinden: "A Love Philtre" 387
1897 SLA       Bethia Clarke: "The Tryst" 421
1900 RA        Mrs D. Hardy (Miss Florence Small) : "A bride" 220
1900 RA        Miss Nina Hardy: "A love-song" 22
1900 RA        Miss Annie L. Henniker: "Trysting" 25
```

Reference should be made to Q2,R2,V2 for similar works with poetical
titles exhibited over these decades.

U3. Correspondence and news:-
```
1871 SBA       Mrs J.F. Passmore: "Sad news from abroad" 484
1872 SLA       Adelaide A. Maguire: "Her first letter" 269
1873 RA        Miss J. Naftel: "The letter" 887
1874 SLA       Mrs Bridell Fox: "News from Baby's Father" 554
1874 SBA       Miss C.M. Noble: "The emigrant - A letter from home" 16
1874 SLA       Clara Biller: "A Lady Writing a Letter" 541
1875 RA        Mrs J.L. Cloud: "The latest news" 543
```

1876 SLA Mary James: "Reading a Letter" 401
1877 RA Miss Sophie Anderson: "The Proposal" 465
 (depicting three girls reading a letter, according
 to the "Art Journal" 1877, p.269)
1877 SLA Helena Hartog: "News from Afar" 315
1877 SLA A. Lenox: "As cold water to a thirsty soul, so is good
 news from a far country" 398
1877 SLA Miss A. Carter: "The Letter" 578
1883/4 IPO Beatrice Meyer: "The letter" 465
1884 RA Cathinca Amyot: "Interesting news" 100 (ill. "Academy
 Notes" op.cit. 1884, p.10)
1884 SLA Mrs H. Champion: "The Letter" 477
1884 RA Maria Brooks: "A love story. no.1 'The Letter'" 1554
1884 SLA Miss A. Carter: "Old Letters" 511
1884/5 IPO Mrs Stuart Bowkett: "Old Letters" 144
1884 OWS Miss Margaret Gillies: "The letter" 206
1885 RA Miss F. Small: "Welcome news" 59
1886 SLA Julia B. Folkard: "Good News at last" 342
1887 RA Beatrice A. Rust: "Sad News" 1183
1889 RA Anna Nordgren: "News from afar" 37
1889 RA Mary Groves: "Good news or bad?" 263
1889 SLA Beatrice Rust: "Sad News" 114
1889 SLA Mary H. Fores: "The letter writer"
 "Uncertain, coy, and hard to please" 316
1890 SLA Charlotte J. Weeks: "Pleasant News!" 230
1891 SLA M.I. Davis: "Sad Tidings" 246
1891 SBA Nellie M. Ketchlee: "Arrears of Correspondence" 368
1891 SLA Florence Pash: "Good News" 532
1892 RA Ellen Clacy: "The letter" 843
1893 SLA Mrs Patty Townsend Johnson: "The latest news" 445
1894 NSPW Miss M. Winifrid Freeman: "The Important Letter" 336
1894 NG Miss Flora M. Reid: "The latest News" 104
1896 NSPW Anna Nordgren: "The letter" 240
1896 RA Jane Barrow: "Bad News" 974
1897 SLA Mabel Cole: "A letter" 2
1898 RA Fanny Sugars: "The letter" 348
1899 RA Mabel Hankey: "Old letters, don't destroy them" 1440
1899 SBA Miss Annie Taverner: "News from afar" 396
1899 RA Catherine Barnard: "The letter" 1113
1899 NG Mrs R.B. Lawrence Smith: "The letter" 361
1899 RA Mary M. Govan: "The letter" 687
1900 NG Mrs F. Harvey Moore: "News from the Front" 263
1900 RA Miss C.L. Christian: "The letter" 410
1900 RA Miss E.E. Lucas: "Anxious news" 346
Love letters are given under T3

Reading:-
1871 SFA Rebecca Coleman: "The Last Chapter" 63
1872 SBA Miss M.L. Gow: "The new story book" 563
1876 DG(oil) Mary S. Cassatt: "A Novel Reader" 417
1876 DG(oil) Flora Ward: "The third volume" 397
1877 SLA Flora Ward: "The third volume" 281
1878 SLA Catherine J. Atkins: "An Interesting Story" 168
1880 RA Mrs L. Alma Tadema: "A Good Book" 130
1880 SLA Henrietta Miller: "Girl Reading (portrait sketch)" 168
1880 SBA Florence Martin: "The Novel Reader" 129
1882 RA Mary Drew: "Half an hour with the poets" 247 (ill. in
 "Academy Notes" op. cit. 1882, p.25)
1882 RA Edith Ballantyne: "The last new novel" 529
1883 SLA Amy Giampietri, née Butts: "The Reading Interrupted" 61

1883 NSPW Elizabeth Folkard: "The last chapter" 727
1883/4 SBA Mrs H. Champion: "A Moving Story" 756
1884 SLA Emmie Stewart Wood: "The Third Volume" 522
1884 RA Agnes Schenk: "Girl reading" 63
1884 RA Edith Gourlie: "A fair librarian" 1156
1887 SLA Florence Pash: "The First Volume" 243
1888 SLA T. Von Pretzelwitz:"The Reading Girl" 249
1888 RA Ida Verner: "The Reader" 1452
1889 SLA Mary Gemmell: "The Reader" 89
1889 SBA Charlotte M. Noble: "An Uninteresting Book" 417
1889 RA Fanny Duncan: "The newspaper" 730
1890 RA Miss F. Reason:"The forbidden book" 1287
1890 RA Miss A. Tarry: "The Picture-book" 33
1891 RA Gertrude Martineau: "The picture book" 767
1891/2 IPO Miss Alice E. Manly: "An Interesting Chapter" 288
1892 SLA Mary Macarthur: "A Bookworm" 235
1892 RA Helen Squire: "A little bookworm" 379
1892 RA Maud Walker: "A novel" 1031
1892/3 IPO Mrs M. Murray Cookesley: "A thrilling Tale" 563
1893 SBA Mary Groves: "A love story" 182
1893 NSPW Miss Ellen Gertrude Cohen: "The last Chapter" 601
1893/4 IPO Miss Charlotte Pöhlmann: "La lecture" 156
1894 NG Mrs Marie S. Stillman: "Love sonnets" 122

1894 RA Harriette Sutcliffe: "A new Book" 715
1895 SBA Miss Jane W. Henry: "Of reading books there is no end" 189
1895 SBA Miss M.C. Walker: "A New Book" 461
1895/6 IPO Miss Blanche Gottschalk: "The Second Volume" 76
1896 RA Helena Blackburne: "A little bookworm" 1024
1897 SLA Ellen Annie Bowler: "The Reading Girl" 129
1897 NG Mrs Kate Perugini: "The story book" 59
1898 RA Hilda Putt: "The good book" 416
1898 SBA Miss Mary Woodward: "A Story Book" 365
1899 RA Laura T. Alma-Tadema: "The new book" 847
1900 SBA Miss Ethel Gertrude Smith: "An interesting chapter: 203

Parting and Return and the Home:-
1872 SLA Marian Croft: "Going Home" 54
1872 OWS Miss Margaret Gillies: "The Farewell and the Return" 115
1872 RA Mlle Henriette Browne: "During the war" 384
1872 RA Miss M.E. Edwards: "Good-bye" 651
1873 SLA Miss J. Deffell: "Homeward Bound" 262
1873 SLA Adelaide A. Maguire: "Home from Sea" 368
1873 SLA A.E. Burrow: "Far from Home" 233
1874 SLA A.L.: "The End of the Voyage: 'There is a happy land,
 Far, far away'" 232
1874 RA Miss E.S. Guinness: "Going Home" 746
1875 SLA Miss F. Featherston: "The Return Home" 390
1876 SLA Miss E.H. Howard: "Homewards" 71
1876 SLA Elizabeth M. Gore: "On the way home" 31
1876 SLA Elise Paget: "Toiling Home" 40
1876 RA Miss Alice Havers: "They homeward wend their weary way"
 551 (National Museum of Wales, Cardiff)
1877 SLA Blanche Macarthur: "The Wanderer's Return" 264
1877 RA Constance Phillott: "Homewards" 864
1877 SLA Mrs M.E. Staples: "From the Old Home" 286
1878 SLA Anne G. Salter: "A Visit to the Ruined Home" 334
1878 RA Harriet Kempe: "Going home" 778
1879 SLA Mrs Marrable:"Going Home - Tyrol" 56
1880 OWS Miss Margaret Gillies: "The Parting" 202

1882 SLA	Fanny Stable: "An English Home" 297
1882 SLA	Miss Edith A. Crosley: "Home" 281
1883 RA	Anna Lea Merritt: "War" 560 (ill. in "Academy Notes" op. cit. 1883, p.53)
1884 RA	Jessie Macgregor: "For those in peril on the sea" 95 (ill. in "Academy Notes" op.cit. 1884, p.9)
1884 SLA	K. Sturgeon: "Homeward Bound" 618
1885 SLA	Blanche Macarthur: "The Last Day in the Old Home" 277
1887 SLA	Kate Macaulay: "Returning Home" 2
1888 SLA	Mrs Paul Naftel: "Home, Sweet Home" 149
1889 RA	Louise Jopling: "A last look at the old home" 667 (ill. in "Academy notes" 1889, p.64)
1889 SLA	Rose Barton: "Homewards" 419
1889 SLA	Mrs P.J. Naftel: "Home after work" 429
1890 RA	Miss N. Locking: "Be it ever so humble, there's no place like home" 844
1890 SLA	Helen Wight: "Homewards" 177
1890 SLA	Fanny W. Currey: "Homewards" 559
1891 RA	Emmie Wood: "The road home" 146
1891 OWS	Miss Edith Martineau: "Bringing Father home" 151 (ill.)
1892 SLA	Blanche Baker: "An English Home" 342
1891 SLA	Mrs Tisie Angell: "Nearing Home" 469
1891 SLA	Maude Angell: "A Parting Glance" 486
1892 RA	Nelly Erichsen: "Going home" 1142
1892 SLA	Rosa Fryer Hensman: "Parting" 195
1893 SLA	Helen O'Hara: "Homeward Bound" 147
1893/4 SBA	Florence Fitzgerald: "The old home" 94
1895 RA	Mrs L. Alma-Tadema: "The pain of parting" 656
1896 RA	Edith B. Dawson: "The old home" 1067
1896 SLA	Mrs R. Hyde: "Homewards" 304
1896 RA	Florence Fitzgerald: "Homeward bound" 390
1897 NG	Nora Davison: "The Eve of Departure" 287
1897 SLA	Jessie Hall: "Homeward" 40
1898 SLA	E.A. Bowler: "The Way Home" 78
1899 RA	Forence H. Moore: "Homeward" 449

Motherhood and childhood:-

1871 SLA	Miss Alyce Thornycroft: "Found at last!" 394 (depicting a mother finding her lost child - "Art Journal" 1871, p.91)
1873 SBA	Miss Jessie Macleod: "The nursery" 626
1874 SLA	Julia Pocock: "The Golden Age" 578
1874 SLA	Miss Ellen Furness: "Infancy" sculpture 587
1874 RA	Miss C. Nottidge: "Childhood" sculpture 1485
1875 SLA	A.J. Crozier: "The Young Mother" 120
1877 SLA	Emily Desvignes: "The Mothers" 284
1877 SLA	Madame Ballot: "Mother and Child" 333
1878 OWS	Miss Margaret Gillies: "A Mother and Child" 179
1879 RA	Sarah Terry: "Childhood" sculpture 1450
1880 SLA	Margaret Thomas: "Childhood" 343
1882 SBA	Susan Ruth Canton: "The Death of the First Born" 772
1882 SLA	Miss Kate Tayler: "Happy Days of Childhood" 230
1883 OWS	Miss Margaret Gillies: "A Mother and Child" 276 (ill.)
1883 SBA	Miss C.M. Noble: "Minding Baby" 371
1885 GG	Mrs Alma Tadema: "A Mother's Pride" 50
1887 RA	Harriet Kempe: "The new Baby" 1268
1887 RA	Margaret Isabel Dicksee: "A dawning life" "One generation passeth away and another cometh" 109
1888 SLA	M.E. Kindon: "The Mother" 299
1888 SLA	Jessie Macgregor: "The Mother and Child" 347
1888 DG(oil)	Miss Fanny Moody: "Maternal Cares " 10
1889/90 IPO	Miss F. Duncan: "Mother and Child" 428

```
1890 RA        Mrs G.M. Warren: "The age of innocence" 1672
1891 SLA       Agnes G. King: "An Anxious Mother" 15
1891 RA        Edith Berkeley: "Childhood's happy hours" 813
1891 RA        Emmeline Halse: "Babyhood" (studies in wax) 1999
1891 RA        Emmeline Halse: "Babyhood" (studies in wax) 2011
1892 SLA       Blanche Macarthur: "Our Mother" 207
1892 RA        Mrs L. Alma Tadema: "Hush-a-bye" 762
1892 SLA       Fannie Moody: "Maternal Cares" 214
1892 SLA       A.J. Coles: "Youth" 338
1893 RA        S. Isabel Dacre: "The mother" 157
1893 RA        Alice Manly: "Maternal Cares" 995
1893 RA        Caroline Gotch: "Motherhood" 948 (ill. in "Academy Notes"
                  op.cit. 1893, p.133)
1893 RA        Ellen Mary Rope: "Mother and child" sculpture 1692
1894 SLA       Margaret K. Harte: "The Young Mother" 193
1894 RA        Alice Tarry: "The anxious mother" 664
1894 RA        Maude Goodman: "Hush!" 702 (ill. in "Academy Notes" op.cit.
                  1894, p.122)
1895 SLA       Florence Small: "Mother and Child" 105
1895 OWS       Miss Martineau: "Nursery Rhymes" 55 (ill.)
1895 OWS       Miss Constance Phillott: "Broken Toys" 45 (ill.)
1896 NG        Miss Nina Hardy: "Lullaby" 122
1896 SLA       Ada E. Tucker: "The Age of Innocence" 345
1897 RA        Nora Hartley: "A mother of eight" 876
1897 RA        Lily Kirkpatrick: "Mother and child" 1042
1898 SLA       Fannie Moody (Mrs Gilbert King): "A Fond Mother" 3
1898 RA        Ellen M. Rope: "The kingdom of the Child" medallion 1856
1898 SLA       R. Galpin: "Childhood" 126
1898 SLA       Con Gore Booth: "Mother and Child" 408
1899 RA        Frances Burlison: "Mother and Child" statuette, bronze 1976
1900 SWA       F. Mabelle Pearse: "Mother and Child" 345
1900 SWA       J.B. Constable: "Mother and Child" 412
1900 SWA       Edith Maryon: "The Mother" 477
1900 OWS       Miss Rose Barton: "Hush-a-bye" 182 (ill.)
```

Refer to O2,X2 for works with poetical titles on this theme.

Activities such as getting dressed, going for walks, playing musical
instruments, sewing, eating meals, praying and going to balls and the
opera were also represented over these years.

```
V3. 1870 SFA        A.L.: "The Amazon" 161
    1870 DG         Mrs H. Champion: "A Young Wife" 94
    1870 SFA        Miss Elise La Monte: "The Bridesmaid" 311
    1870 DG         Mrs H. Champion: "The Maid of Honour" 84
    1870 SFA        Mrs George Monckton: "The Nun" 359
    1871 SBA        Miss Adelaide Claxton: "The ladies" 737
    1871 SFA        Mrs Crawford: "La Fiancée" 411
    1872 DG(oil)    Mrs Charretie: "The Bride" 314
    1872 SLA        Mrs H. Campbell: "The Nun" 405
    1872 RA         Miss M. Backhouse: "Maidenhood" 1088
    1873 SLA        Mrs M. Backhouse: "The Little Housewife" 12
    1873 SLA        Mrs Charretie: "A Lady of the last century" 274
    1873 DG(oil)    Sophia Beale:"Woman" 124
    1873 RA         Mrs A. Bowden: "The bride" 404
    1874 SLA        Florence Claxton: "The Nun" 299
    1875 SLA        A.J. Crozier: "The Young Mother" 120
    1875 SLA        Mrs Paul J. Naftel: "The Bride" 378
    1876 SLA        Alice Egg: "A lady of the sixteenth Century" 284
    1876 SLA        Miss Margaret Kerr: "A Nun" 384
    1876 SLA        Fanny Crawford: "A Bridesmaid" 39
    1877 SBA        Miss B. Jenkins: "A Sailor's Wife" 237
```

1877 SBA	Mme. D. Cordier: "An Italian Matron" 571	
1877 SLA	Emily Desvignes: "The Mothers" 284	
1877 SLA	Madame Ballot: "Mother and Child" 333	
1877 RA	Mrs Alma Tadema: "A blue-stocking" 974	
1877 RA	Charlotte Dubray: "La coquette" terra cotta 1513	
1877 DG	Miss A.J. Crozier: "La Connaisseuse" 38	
1877 DG(oil)	Kate Clarke: "Womanhood" 405	
1877 DG(b&w)	Alice M. Hannay: "Girls of the Future" 510	
1878 RA	Blanche Jenkins: "The Widow" 108	
1878 RA	Annie G. Fenton: "An English girl three hundred years ago' 35	
1878 OWS	Margaret Gillies: "A Mother and Child" 179	
1879 SLA	Miss S. Wadham: "The Bride" 567	
1879 SLA	Alice Squire: "The little Housewife" 809	
1879 RA	Kate Perugini: "A little woman" 34	
1879 DG	Ellen Clacy: "The Young Wife" 8	
1880 NSPW	Lady Lindsay of Balcarres: "Girlhood" 198	
1881 SLA	Besie Haynes: "A Little Housewife" 352	
1881 RA	Edith Savile: "A young widow" 172	
1881 RA	Florence Tiddeman: "A Sister of Charity" 1346	
1882 RA	Elizabeth Walker: "A daughter of Eve" 915	
1882 SLA	Héné Wheelwright: "The Nun" 738	
1882 DG	E. Hipkins: "A thrifty Housewife" 501	
1883 GG	Mrs C.A. Sparkes: "Mother and Child" 213 (for the accompanying quotation see X2)	
1883 SLA	Marian Croft: "A Maid of Honour" 24	
1883 SLA	Mrs H. Champion: "The Debutante" 117	
1883 SLA	Isabel Berkeley:"A Patrician Lady" 283	
1883 SLA	Amy Giampietri (née Butts): "The Fair Petitioner" 582	
1883 DG(oil)	Virginia Adey: "A Spinster" 225	
1883 SBA	Adelaide A. Burnett-Nathan: "A Nondescript Girl doing nothing" 128	
1883/4 SBA	Anna Pulvermacher: "Maiden Widowed" 148	
1885 RA	Caroline W. Brook: "The debutante" 1005	
1885 RA	Miss M. Drew: "A Maid of Honour" 3	
1885/6 IPO	Miss Anna Nordgren: "The little housewife" 382	
1886 DG	Edith Berkeley: "A Domestic Martyr" 291	
1886 SLA	Lucy J. Tuck: "A Blue-Stocking" 120	
1886 SBA	Elise Paget: "Girlhood" 569	
1886/7 IPO	Miss M.E. Edwards: "The Green Leaf and the Sere" 106 (The work is illustrated in the catalogue; it depicts two women, one old and one young)	
1886 SBA	Lillie Trotman: "Maidenhood" 716	
1886 RA	Miss C.M. Demain Hammond: "A blue-stocking" 1510	
1887 SLA	Mme Schwartz: "The Young Widow" 314	
1887 RA	Ada F. Gell: "La coquette" statuette 1831	
1888 SLA	Mrs E. Barnard: "She" 513	
1888 SLA	M.E. Kindon: "The Mother" 299	
1888 SLA	Mary Fores: "La Fille du Regiment" 338	
1888 SLA	Miss Jessie Macgregor: "The Mother and Child" 347	
1888 SLA	Kate Perugini: "The Daughter of the House" 524	
1888 SLA	Amy Hunt: "La Grandmère" bust 567	
1888 SBA	Florence Pash: "Sisters" 272	
1888 RA	Kate Harlin: "A city maiden" 1657	
1888 RA	Amy H. Hunt: "Die Hausfrau" head 1989	
1888/9 IPO	Miss M. Constance Stacpoole: "A Young Connoisseuse" 437	
1889 RA	Margaret K. Harte: "Die Grossmutter" 289	
1889 SBA	Mrs L. Bentley-Smith: "The Housewife" 127	
1891 RA	Bessie Percival: "An industrious housewife" 165	

```
1891 RA      Helen Jackson: "A child of our grandmother Eve" 1273
1891 SLA     Agnes G. King: "An Anxious Mother" 15
1891 SLA     Ada Holland: "An  English Girl" 47
1891 SLA     Mrs Edith F. Grey: "A Daughter of Eve" 127
1891 SLA     Eva Methuen: " A Daughter of Egypt" 164
1892 SLA     Edith Sprague: "A lady of letters" 441
1892 SLA     F. Fryer Hensman: "The Widow" 456
1893 SBA     Miss Ada M.Shrimpton: "Maidenhood" 480
1893 RA      S. Isabel Dacre: "The mother" 157
1893 RA      Caroline Gotch: "Motherhood" 948
1893 RA      Ellen Mary Rope: "Mother and Child" sculpture 1692
1894 RA      Catherine J. Atkins: "The dowager" 1102
1894 SBA     Mrs G.B. Rosher: "Girlhood" 292
1894 SLA     Margaret K. Harte: "The Young Mother" 193
1895 SLA     Mrs A.L. Swynnerton: "Mater Triumphalis" 221 (Luxembourg,
                  Paris)
1895 SLA     Florence Small: "Mother and Child" 105
1896 SLA     Edith E. Downing: "Woman - an idea" 268
1896 SLA     Mrs Emily Barnard: "The Bride" 10
1896 RA      Anna Nordgren: "The toilworn sisters" 962
1897 SBA     Miss A.M. Shrimpton: "Maidenhood" 489
1897 RA      Lily Kirkpatrick: "Mother and child" 1042
1898 RA      Gertrude Hayes: "A Geisha" 1583
1898 SLA     Fannie Moody (Mrs Gilbert King): "A Fond Mother" 3
1898 SLA     Con Gore Booth: "Mother and Child" 408
1899 SWA     M.E. Kindon: "The Poetess" 422
1899 RA      Frances Burlison: "Mother and Child" bronze statuette 1976
1900 NG      Miss F.A. De Biden Footner; "When womanhood and childhood
                  meet" 178
1900 SWA     Mrs Emily Barnard: "A Reservist's Wife" 84
1900 RA      Mrs D. Hardy (Miss Florence Small): "A Bride" 220
1900 SWA     F. Mabelle Pearse: "Mother and Child" 345
1900 SWA     J.B. Constable: "Mother and Child" 412
1900 SWA     Edith Maryon: "The Mother" 477

W3. 1809 BI  Mrs Hakewill: "The Flower Girl" 108
    1814 BI  Mrs Ansley: "A Flower Girl" 82
    1818 RA  Miss Drummond: "Portrait of an actress" 556
    1826 RA  Miss Rose Emma Drummond: "Portrait of an actress" 107
    1827 RA  Miss Rose Emma Drummond: "Portrait of an actress" 872
    1830 RA  Miss Rose Emma Drummond: "Portrait of an actress" 526
    1833 RA  Miss Rose Myra Drummond: "Portrait of an actress" 950
    1835 BI  Miss Emma Jones: "Basket women of Covent Garden Market" 424
    1835 BI  Miss Emma Jones: "La Petite Vendageuse" 510

X3. 1841 NSPW Miss Laporte: "The Lace Maker" 289
    1843 SBA  Mrs V. Bartholomew: "Lace-woman" 603
    1847 SBA  Miss E. Montague: "The Water-Cress girl" 694
    1848 RA   Mrs W. Carpenter: "A lace-maker" 234

Y3. 1850 BI  Miss Jordan: "Buy my Primroses" 332
    1850 SBA Miss E.N. Fielding: "The Matchwoman" 552
    1851 SBA Miss S.E. Townsend: "The Lace Maker" 691
    1854 SBA Mrs Hurlstone: "Moorish Flower-Seller" 128
    1855 SBA Mary Baker: "A Flower Girl" 675
    1857 SBA Miss H.E. Hillier: "The flower girl" 675
    1858 SFA Adèle Kundt: "The Flower Girl" 393*
    1858 RA  Miss A. Burgess: "The little match-girl" 827
    1858 SFA Mrs Thornycroft: "The Flower Girl" - marble 536
    1858 SBA Miss K Swift: "The flower girl" 434
```

```
     1859 SFA      Miss A. Burgess: "De Jolies Fleurs, Messieurs - a study
                      of a Normandy Girl" 102
     1859 SFA      Mrs V. Bartholomew: "Flower Girl" 112
     1862 SBA      Miss Emma Brownlow: "A Bernese flower girl" 553
     1862 SFA      Miss Ellen Partridge: "The Lace Maker" 42
     1862 SFA      Rose Rayner: "Flower Girl" 148
     1864 SBA      Miss Eliza Turck: "Flower girl of Antwerp" 370
     1864 SFA      Miss J. Deffell: "Lace Maker and her Grandchildren" 149
     1865 SBA      Miss Anna Blunden: "The Lace Maker" 528
     1865 SFA      Miss M. Lloyd: "Bretonne Fruitseller" 149
     1865 SFA      Miss A. Burgess: "French Flower Girl" 28
     1866 SBA      Mary Gibbs: "The lace maker" 280
     1866 SFA      Miss A. Burgess: "An Orange Girl" 102
     1866 SFA      Mrs Levison Neumann: "A Poor Girl selling Flowers" 180
     1867 SFA      Miss A. Burgess: "Boulogne Fruit Girl" 124
     1867 SBA      Miss Horncastle: "The Neapolitan flower-girl" 504
     1867 BI       Miss C. Ricketts: "Please buy a Bouquet" 230
     1867 NSPW     Emily Farmer: "The Primrose Seller" 95
     1867 NSPW     Mrs Clarendon Smith: "Child Selling flowers" 192
     1869 SFA      Mrs Profaze: "A Flower Girl" 477
     1870 SFA      Mrs Profaze: "A Flower Girl" 440
     1871 SFA      Miss G. Swift: "Belgian Lace Maker" 400
     1872 SLA      Mrs Profaze: "A Fruit Girl" 363
     1872 SBA      Miss E. Gilbert: "Lace-making, Buckinghamshire" 645
     1873 SLA      Miss A. Carter: "Lace-making at Drewsteighton" 29
     1873 SLA      Mrs G. Monckton: "La Vendeuse de légumes" 166
     1873 SLA      Mrs Profaze: "Buy me Flowers" 263
     1874 SLA      Mrs E.K. Beeby: "Poor Peggy hawks nosegays from street to
                      street,
                      Till - think of that, who find life so sweet -
                      She hates the smell of roses" - Hood 143
     1874 SLA      Mrs Backhouse: "Buon giorno
                      Signora mia! Volete prendere
                      Dei piccoli fiori della Campagna" 219
     1875 SLA      P.M. Cobbett: "Little Fruit Girl" 418
     1876 SLA      A.E. Burrow: "Italian Flower Girl" 204
     1876 SLA      Mrs Profaze: "'Nelly' the Flower Girl" 258
     1877 SLA      Miss Margaret Kerr: "A London Flower Girl" 145
     1879 SLA      Mrs Bridell Fox: "Flower Girls of Old Pompeii" 274
     1879 SLA      Edith de Lancy West: "I'm Betsy Bloom, the flower girl,
                      Out in all the showers etc." 302
     1879 SLA      Gertrude E. Gauntlett: "The Orange Girl" 434

Z3. 1880 SBA      Miss E.S. Guinness: "Spinsters in Brittany" 784
                      (The artist exhibited a work with the same title in
                      1881 (SLA no.465))
     1881 RA       Madena Moore: "Tired Fingers" 945
     1882 RA       Emma Squire: "Spinning" 100
     1882 DG       Lucy J. Tuck: "Study of an old seamstress" 427
     1883 DG(oil)  Maria Brooks: "The sempstress" 383
     1883 DG(oil)  Virginia Adey: "A spinster" 225
  1883/4 IPO       Flora M. Reid: "A Seamstress"
                      "With fingers weary and worn,
                      With eyelids heavy and red" 686
     1884 SLA      Mrs A. Elias: "Lace Making, Normandy" 251
     1884 SLA      Mrs Hussey: "Lace-makers, St. Margherita" 648
     1886 RA       Katinka Kondrup: "The Seamstress" marble statuette 1789
     1886 RA       Lily Rose: "The Song of the Shirt" terra cotta statuette 1866
     1886 RA       Emma Squire:      "Spinning" 1233
```

```
1886 DG        Mary Macarthur: "Spinning" 338
1887 SLA       Beatrice Smallfield: "A Pattern Girl" 123
1889 DG        Miss Mary Mason: "The Seamstress"
                    "Tho' bright the sun, and fine the day,
                    I must sew while others play" 54
1890 SLA       N. Cundell: "Fashion's Victims" 15
1891 RA        Margaret Bird: "The Song of the Shirt" 170
1891 SLA       Frances Fairman: "Spinning" 198
1892 SBA       Mrs Parker: "Lacemakers" 392
1893 NG        Miss Ruth Garnett: "La Petite Dentellière" 123
1894 NG        Miss Effie Stillman: "Girl spinning" (bas relief) 441
1894 NG        Miss Flora M. Reid: "A Flemish Lacemaker"
                    "Weary and worn and sad" 218
1897 RA        Harriet Halhed: "The spinster" 1031
1898 RA        Constantia M.M. Dale: "Flemish lace-makers" 783
1898 RA        Mary E. Postlethwaite: "It is not linen you are wearing out,
                    But human creatures' lives" 745
```

```
Other trades were occasionally represented between 1880 and 1900:-
  1880 RA        Alice Havers: "Blanchisseuses" 1465 (Walker Art Gallery,
                      Liverpool)
  1884 DG(oil)   Mary Macarthur: "La Vivandière" 49
1884/5 IPO       Miss Marion Noble: "A Milkmaid" 677
  1884 SLA       Emmie Stewart Wood: "The Maid of all-work" 561
  1893 NSPW      Miss Kate Sadler: "A Flower Girl" 65
  1896 RA        Marie J. Naylor: "A little flower girl" 817 (ill. in
                      "Academy Notes" op.cit. 1896, p.120)
  1899 RA        Harriet C. Foss: "A flower maker" 642
```

```
A4. 1803 RA        Miss Scott: "Portrait of herself" 765
    1804 RA        Miss A. Trewinard: "Portrait of herself" 705
    1804 RA        Miss A. Smith: "Portrait of herself" 774
    1806 RA        Mrs Bell: "Portrait of herself" 184
    1806 RA        Mrs Wells: "Portrait of herself" 719
    1810 RA        Miss Betham: "A frame containing portraits of the Rev. W.
                        and Mrs R.G. Betham, Miss Duncan and herself" 578
    1813 RA        Miss M. Allen: "Portrait of herself" 450
    1813 RA        Mrs Briane: "Portrait of herself" 672
    1814 RA        Miss C. D'Arce: "Portraits of herself and two sisters" 418
    1816 RA        Mlle de Suchemont: "Portrait of herself" 475
    1820 RA        Miss M.: "Portrait of herself" 746
    1824 RA        Miss Seabrook: "Portrait of herself" 594
    1824 RA        Miss Daniel: "Portrait of herself" 657
    1829 RA        Miss Kearsley: "Portrait of the artist" 139
```

```
B4. 1818 RA        Eliza Jones: "Miss Emma Smith" 860
    1822 RA        Miss Sharpe: "Portrait of Miss Mainwaring (Honorary
                        exhibitor of no.643)" 639
```

```
C4. 1806 RA        Mrs Green: "Portrait of an artist" 748
    1808 RA        Mrs Ross: "Portrait of a young artist" 628
    1810 RA        Mrs Singleton: "Portrait of an artist" 616
    1813 RA        Mrs Green: "Portrait of an artist" 423
    1813 RA        Mrs Read: "Portrait of an artist" 563
    1826 RA        Mrs Havell: "Portrait of an artist" 705
    1828 SBA       Mrs Pearson: "Let me sketch, Mama" 110
    1829 BI        Mrs Carpenter: "The Young Artist" 55
```

D4. 1826 RA Eliza Jones: "Francis Chantrey Esq. R.A." 598
 1828 RA Mrs Carpenter: "William Collins Esq. R.A." 419

E4. 1830 BI Miss Alabaster: "The artist's painting room" 379
 (According to E.C. Clayton op.cit. this was "an
 interior of her studio, with portrait of herself"
 (vol. 2, p.73))
 1830 RA Mrs Browne: "Portrait of the artist" 770
 1832 SBA Miss C. Kearsley: "Portrait of Miss C.K." 675
 1834 RA M.A.D.: "Portrait of herself" 846
 1837 RA Mrs L. Goodwin: "Portrait of herself" 500

F4. 1830 RA Mrs Pearson: "Portrait of Miss Heaphy" 205
 1831 RA Miss C.S. Smith: "Portrait of Miss E.E. Kendrick" 924
 1836 SBA Mrs L. Goodman: "Portrait of Miss Fanny Corbaux" 117
 1838 RA Mrs G.R. Ward: "Portrait of Miss Sharpe" 822
 1839 SBA Miss Margaret Gillies: "Portrait of Miss Myra Drummond" 724
 1844 RA Mrs L. Goodman: "Portrait of Miss Fanny Corbaux" 498
 1846 RA Miss Kipling: "Portrait of Miss Ward" 774
 1848 RA Mrs H. Moseley: "Miss Henrietta Ward" 961
 1848 SBA Miss M. Tekusch: "Portrait of Miss Fox" 713
 1849 RA Miss Margaret Gillies: "Miss Howitt" 762

G4. 1833 SBA Mrs Carpenter: "Portrait of the late R.P. Bonington" 68
 1839 RA Miss H. Kearsley: "George Augustus Wallis, Esq., Member of
 the Royal Academy of Painting at Florence" 1200
 1840 RA Mrs Turnbull: "Portrait of George Cruikshank" 838
 1841 RA Mrs Turnbull: "V. Bartholomew Esq." 921
 1842 RA Eliza Jones: "The late lamented Sir F. Chantrey R.A." 929
 1843 RA Mrs Turnbull: "George Catlin Esq." 830
 1847 RA Mrs Carpenter: "John Turner Esq." 296

H4. 1830 SBA Miss M.A. Sharpe: "Girl Sketching" 721
 1832 NSPW Mrs E.C. Wood: "The Sketch" 80
 (for the accompanying quotation see U1)
 1839 BI Mrs Fanny McIan: "Eine Frankfurter Künstlerin" 49

I4. 1830 SBA Miss C. Watson: "Drawing" 554
 1831 SBA Miss Sambourne: "From a Bust of an Artist" 523
 1834 NSPW Miss Laporte: "Portrait of an Artist" 343
 1835 RA Jessica Landseer: "Portrait of a student of the R.A." 611
 1837 RA Emily Schmack: "Portrait of a French Artist" 109
 1841 SBA Miss Steers: "Drawing" 710
 1844 RA Mrs Criddle: "The Young Artist" 831
 1844 SBA Miss M.A. Sharpe: "The Little Artist" 716
 1849 RA Miss M.A. Cole: "The perplexed artist" 182
 1849 SBA Miss Eliza Fox: "The Future Artist" 218

J4. 1851 RA Mrs E.G. Richards: "Portrait of the artist" 166
 1853 RA Susan Durant: "Bust, in marble, of the artist" 1449
 1863 RA Mrs C. Newton: "Mrs Charles Newton" 464 (National Portrait
 Gallery)

K4. 1853 SBA Miss Scott: "Portrait of Mrs Brookbank" 645
 1856 SBA Mrs Croudace: "Portrait of Mrs Loudan" 636
 1856 SBA Miss M.A. Sharpe: "Miss Seyffarth" 638
 1858 RA Miss E. Sharpe: "Miss Seyffarth" 657
 1860 RA Mrs Carpenter: "Miss Durant" 443
 1862 RA Mrs A. Melville: "Mrs Thornycroft" 422

```
     1866 SFA       Mrs Goodman: "Portrait of Mme Bodichon" 255
     1866 SFA       Mrs Thornycroft: "H.R.H. the Princess of Wales" sculpture
                        403
     1868 RA        Mrs F. Lee Bridell: "Madame Bodichon" 573
     1868 RA        Miss C. Nottidge: "Miss Backhouse" 1145
     1869 SFA       Mrs Goodman: "Portrait of Mrs Paterson" 392
     1869 RA        Mrs Samwells: "Miss H. Thornycroft" 1042

L4.  1859 RA        Madame Puntita: "Portrait of an artist" 752
     1859 RA        Miss Florence Claxton: "Sketches from the life of an artist"
                        980
     1861 SFA       Mme Chosson: "Les Petits Artistes" 74
     1864 SBA       Miss Gilbert: "Amateur Art" 915
     1866 SFA       Adelaide Burgess: "Rêverie d'Artiste" 273
     1868 DG        Miss Rebecca Coleman: "In the studio" 53
     1868 SBA       Ambrosini Jerome: "Do you think it like?" 126
     1869 RA        Mrs Egley: "An artist" 1035

M4.  1851 RA        Mrs H. Moseley: "John Tenniel" 967
     1863 SFA       Mrs Carpenter: "John Gibson Esq. R.A." 154
     1869 RA        Mrs C. Smith: "Henry Warren Esq. K.L. President of the
                        Institute of Painters in Watercolours" 670

N4.  1870 DG(oil) Louisa Cook: "Myself" 94
     1882 RA        Ellen Godfrey: "Portrait of the artist" 472
     1883 SLA       Elizabeth T. King: "My Portrait" 706
     1885 SLA       Caroline Paterson: "The Artist at Work" 646
     1888 NEAC      Lillie Delissa Joseph: "Myself" 75
     1888 RA        Anna Bilinska: "Portrait of the artist" 1326
     1890 SLA       E.G. Cohen: "My best Self" 65
     1890 RA        Miss M.J. Naylor: "Portrait of the artist" 171
     1891 SPP       Mrs Lily D. Joseph: "Portrait of the Artist" 61
     1891 NG        Miss Milly Childers: "Portrait of the Artist" 44
     1891 RA        Marie Seymour Lucas: "Marie Seymour Lucas" terra cotta bust
                        2086
   1891/2 IPO       Mrs Arthur Raphael: "Portrait of the Artist" 503
     1892 RA        Anna Bilinska: "Portrait de l'auteur" 502
     1892 SPP       Portrait of the Artist by the Hon. Mrs Norman Grosvenor" 1
     1892 RA        Mariette Cotton: "Portrait of the artist" 644
     1893 SLA       J. Rappard: "The Artist" 206
     1893 RA        Myra E. Luxmoore: "The Artist" 818
     1894 SPP       Miss Emily Goodchild: "Portrait of the Artist" 170
     1894 RA        Edith Sprague: "Myself" 1261
     1895 SPP       Mrs Lily Delissa Joseph: "Portrait  of the Painter" 75
     1895 SPP       Miss Sophie T. Stern: "Myself, 'as in a looking-glass'" 112
     1895 RA        Miss B.M. Cregeen: "Portrait of the artist" 1344
     1896 SM        Mrs Murray- Cookesley: "Portrait of the Artist"343
     1896 RA        Lilian Edmonds: "Portrait of the artist" 710
     1897 SM (Spring) Mrs Evelyn Corbould-Ellis: "The Artist" 32
     1897 SM (Autumn) Fanny Way: "Myself" 250
     1898 SPP       Violet Dunn Gardner: "Portrait of Herself" 187
     1898 RA        Lily Wrangel: "Portrait of the artist" 131
     1898 RA        Dora Mann: "The artist" 1269
     1899 SM        Miss Ross E. Thomas: "Myself" 101
     1899 SBA       Miss E.S. Shaw: "Portrait of herself" 405
     1900 SM        Miss K. Winifred Collyer: "Portrait of Artist" 298
     1900 NG        E. Dorothea Dudgeon (Mrs Philip Stretton): Group of minia-
                        tures no.6 "The Artist" 447
     1900 SM        Miss Fanny Way: "Myself" 303
```

```
     1900 SM        Miss Maud Coleridge: "'The Artist' (by herself)" 150
     1900 SBA       Miss Lydia Pringle: "Portrait of the Artist" 184
     1900 SPP       Thérèse Schwartze: "Portrait of the Artist" 78
     1900 SM (Autumn) Miss Dorothy Cox: "Portrait of the Artist" 107

04.  1871 RA        Mrs Thornycroft: "H.R.H. The Princess Louise" sculpture 1271
     1872 RA        Miss C.M. Brown: "Mrs Alma Tadema" 724
     1872 RA        Miss Alyce Thornycroft: "Mrs Thornycroft" 976
     1873 SLA       Miss Alyce Thornycroft: "Mrs Thornycroft" 261
                        (probably the same as the preceding work)
     1873 RA        Miss M.S. Tovey: "Miss Jessie Macgregor" 901
     1875 RA        Mrs Thornycroft: "H.R.H. Princess Louise, Marchioness of
                        Lorne, executed for H.M. the Queen" sculpture 1248
     1877 SLA       Ellen Partridge: "Miss Pierrepont" 253
     1878 RA        Madame De La Croix: "Mlle Charlotte Vital-Dubray" 1295
     1880 RA        Miss A.L. Robinson: "Miss S. Isabel Dacre" 265
     1882 RA        Ellen Montalba: "H.R.H. The Princess Louise, Marchioness
                        of Lorne" 124 (ill. in "Academy Notes" op.cit. 1882,
                        p.15).
     1884 GG        Miss Emily Osborn : "Portrait of Madame Bodichon, to be
                        presented by some friends to Girton College" 197
     1887 RA        Helen Montalba: "Miss Clara Montalba" 128
     1887 RA        Emeline Deane: "Mlle Anna Bilinska" 426
     1887/8 IPO     Jessica Hayllar: "Finishing Touches' 6 (a portrait of her
                        sister Edith, before an easel.  See "Connoisseur"
                        May 1974, vol. 186, p.7)
     1889 RA        Annabel Downes: "Miss Rae" 304
     1891 SLA       Alyce Thornycroft: "Mrs Thornycroft" 552
     1891 RA        Dora Noyes: "Mrs Cecil St. John Mildmay" 364
     1894 NG        The Hon. Mrs Grosvenor: "Portrait of Miss Lisa Stillman" 10
     1894 RA        Evangeline Stirling: "Miss Beale" bust 1792
     1895 NG        Miss Kate Morgan: "Mrs Martineau" 14
     1895 NG        Miss S.M. Lyall: "Miss L. Stillman" 197
     1895 RA        Miss B.C. Smallfield: "Mrs Bridell-Fox" 1219
     1896 SPP       The Hon. Mrs Norman Grosvenor: "Miss Helen Cridland" 10
     1896 NG        Miss Lisa Stillman: "Mrs Leigh Smith" 157
     1896 RA        Edith L. Clink: "Isabel C. Pyke-Nott" 1334
     1897 SM(Spring) Miss Pattie Taylor: "Mrs Ward" 44
     1897 NG        Mary L. Gow: "Mrs Alma-Tadema" 64
     1897 RA        Evelyn C.E. Pyke-Nott: "Isabel, daughter of J.H. Pyke-Nott
                        Esq" 1459
     1897 RA        Kathleen Behenna: "H.R.H. Princess Louise Marchioness of
                        Lorne" 1548
     1897 SM(Autumn) Kathleen Behenna: "H.R.H. Princess Louise, Marchioness
                        of Lorne" 68
                        (probably the same as the preceding work)
     1898 SPP       Mary L. Gow: "Mrs Alma Tadema" 162
     1899 NG        Miss Lisa Stillman: "Mrs Stillman" 362
     1899 SWA       Emily Osborn : "Portrait of Madame Bodichon" 339
     1900 NG        Miss Lisa Stillman: "Madame Mary Darmestaeter" 383
     1900 SM        Miss Florence Cooper: "The Marchioness of Granby" 275
     1900 RA        Miss M. Lewis: "Mrs Massey" 1504
     1900 SPP       Miss Maud Porter: "Miss Ethel Wright" 128

P4.  1873 SLA       Mrs Bridell Fox: "Sketching from Nature" 97
     1873 SLA       Mrs Emma Brownlow King: "Village Artist Restoring the
                        Shrine - a scene in Brittany" 325
     1874 RA        Miss C. Nottidge: "A Reminiscence of a Florentine Painter"
                        sculpture 1486
```

```
1876 SLA      Clara Stanley: "The Amateur Artist" (painted on marble)
                 14
1876 DG       Ellen G. Hill: "The first drawing lesson" 167
1878 DG       Linnie Watt: "Sketching" 260
1878 DG(oil)  Edith E. Hipkins: "A tidy wood-engraver" 308
1879 RA       Florence Martin: "The art student" 399
1879 SLA      Mrs Agnes Nicholl: "Our Special Artist" 527
1879 OWS      Mrs Allingham: "The Young Artist" 203
1880 DG(b&w)  Julia Pocock: "In the Studio" 545
1882 SLA      Kate E. Elliott: "Nottingham School of Art: students at
                 work" 236
1883 SLA      Helen Knapping: "The National Gallery - Student's Day" 493
1883 DG(oil)  Gertrude Martineau: "At work in the studio" 158
1883 GG       Mrs John Collier: "An Artist at work" 143
1884/5 IPO    Mrs E. Williams: "The Studio, from the Side Entrance" 293
1884 RA       Florence Martin: "The Life School" 106
1885 SLA      Annie S. Manville Fenn: "Is it Like?" 357
1885 NSPW     Caroline Patterson: "A Young Artist" 213
1886 SBA      Edith A. Findlay: "In the Studio" 231
1886 GG       Madame A. Darmesteter: "The Young Engraver" 304
1888 SBA      Miss Constance E. Plimpton: "An Art Student" 297
1888 RA       Kate Hayllar: "Finished and framed" 1179
1891 SBA      M.E. Hill Burton: "A Painter of Humble Life" 79
1891 RA       Ruth Wimbush: "Students day in the National Gallery" 915
1893 RA       Isa Verner: "In a studio" 320
1893/4 IPO    Miss Beatrice Meyer: "The First Commission" 119
1895 SBA      Miss Georgiana L. Lloyd: "Rejected by the R.A." 21
1897 RA       Minna Tayler: "A studio reflection" 401
1897 RA       Lilian Edmonds: "An art student" 41
1897 RA       Fanny Stable: "In the studio" 832
1898 SLA      E. Folliott Powell: "Is It Like Her?" 381
1900 RA       Miss C.M. Pott: "The trial proof" 1563

Q4. 1872 RA   Mrs North: "R. Redgrave Esq. R.A." 1333
    1877 RA   Jane Escombe: "An Etcher biting" 445 (This work which is in
                 the Ipswich Borough Collection, is a portrait of the
                 Suffolk etcher, Edwin Edwards)
    1878 SLA  Jessie Frier: "In the Studio of John Pettie Esq. R.A." 204
    1888 RA   Ethel Webling: "John Ruskin Esq". 1546
    1893 RA   Emma C. Guild: "G.F. Watts Esq. R.A." bust 1665
    1894/5 IPO Mrs Harry Hine: "Portrait of Harry Hine, R.I." 101
    1899 SM   Miss Ethel Webling: "G.F. Watts Esq. R.A." 158
```

R4. A complete list of all works on these themes exhibited by women in the
 nineteenth century would be extremely long. To give an idea of the con-
 stant popularity of such subjects, those exhibited between 1800 and
 1810, 1850 and 1860 and 1890 and 1900 will be given.

```
     1800-1810:-
     1801 RA   Miss E. Farhill: "A Faggot Girl" 1010
     1802 RA   Mrs G.J.H.: "Cottager's child" 397
     1802 RA   Mrs Wheatley: "A girl with sticks" 443
     1802 RA   Mrs Wheatley: "A girl with eggs" 444
     1805 RA   Miss M.C. Brown: "Gleaners" 114
     1805 RA   Miss Russell: "A Young Rustic" 334
     1806 RA   Mrs Wheatley: "A reaper" 151
     1806 RA   Mrs Wheatley: "A girl returning from milking" 167
     1807 RA   Miss M.A. Flaxman: "A drawing of Swiss Peasants" 625
     1807 RA   Miss M.A. Flaxman: "A drawing of Swiss Peasants" 626
```

1807	BI	Miss M.C. Brown: "The Gleaner" 65
1807	BI	Miss Maria Spilsbury: "Cottagers drinking tea" 21
1807	BI	Miss Maria Spilsbury: "Inside of a cottage" 58
1807	BI	Miss Maria Spilsbury: "A Farmyard" 68
1807	BI	Mrs Wheatley: "Going to Market" 172
1808	RA	Miss A. Leach: "A benevolent cottager" 327
1808	RA	Mrs Alexander Pope: "Cottagers going to market" 113
1808	BI	Mrs Mee: "A beggar woman and children" 281
1808	BI	Miss Maria Spilsbury: "An Industrious Family clothed" 113
1808	BI	Mrs J. Hakewill: "A Peasant Boy" 56
1808	BI	Mrs J. Hakewill: "A Shepherd Boy" 63
1808	BI	Miss Maria Spilsbury: "The inside of a Hampshire cottage" 72
1809	BI	Mrs J. Hakewill: "The wood-boy" 106
1810	RA	Miss M.A. Flaxman: "A Fisherman's cottage" 55
1810	RA	Miss Trotter: "A beggar relating his story at the cottage-door" 371

1850-1860:-

1850	OWS	Nancy Rayner: "The Gleaners" 104
1850	BI	Mrs Carpenter: "The Gleaner's Child" 147
1850	BI	Miss M. Read: "The cottage girl, a study from nature" 263
1850	RA	Miss Eliza Goodall: "A Farm-house kitchen" 94
1851	RA	Caroline Smith: "Roman Peasant boy" 656
1851	SBA	Miss G. Swift: "The Basket-Maker - a sketch" 84
1851	PG	Miss S.F. Hewitt: "Wood Gatherers" 358
1851	NSPW	Jane S. Egerton: "Contadina" 350
1851	BI	Miss Eliza Goodall: "Cottage children" 119
1851	BI	Mrs C. Smith: "A Neapolitan Old Woman" 406
1852	RA	Miss Weigall: "German bean gatherers" 653
1852	RA	Mrs Croudace: "Russian peasant woman, from Toola, on pilgrimage to the holy city of Kiev" 723
1852	RA	Jessie Macleod: "The return from the vineyards - peasant of Fohr, Middle Rhine" 1121
1852	SBA	Mrs C. Smith: "Irish Market Boy" 306
1852	SBA	Mrs C. Smith: "Irish Beggars" 393
1852	SBA	Miss Johnson: "Peasant Girl" 637
1852	SBA	Ambrosini Jerome: "An Italian Fruit Girl" 40
1852	BI	Miss Jessie Macleod: "Study from Nature, a girl of Andernach" 384
1852	BI	Miss Jessie Macleod: "Studies from Nature, Bauer Children of the Village of Weisenthurne, Middle Rhine" 393
1852	BI	Mrs C. Smith: "An old Irishwoman" 489
1852	BI	Miss E.E. Bundy: "Wayfarers, a simple meal" 492
1853	SBA	Sarah Norton: "Gipsy" 279
1853	SBA	Ambrosini Jerome: "Roman contadina" 357
1853	RA	Susan Rowe: "Head of a gipsy child" 801
1853	RA	Mrs Croudace: "Oulianka, peasant girl of the Ukraine, Russia" 964
1853	NSPW	Jane S. Egerton: "Jeune Paysanne" 361
1853	BI	Miss S. Norton: "Gipsy and child" 435
1854	RA	Miss Emma Brownlow: "Fisherman's children, looking out for the boat" 308
1854	RA	Mlle H. Feillet: "Group of Spanish Peasants - Fontarabia" 1221
1854	SBA	Mrs C. Smith: "Fortune Teller" 41
1854	SBA	Miss Emma Brownlow: "La fille du poissonnier" 93
1854	SBA	Elizabeth Lawson: "A Fortune Teller" 343
1854	SBA	Sarah Norton: "Cottager's Daughter" 389
1854	SBA	Elizabeth R. Lawson: "The shepherdess" 489

1854 BI	Miss E.E. Bundy: "Une Paysanne de la Normandie" 7	
1854 BI	Ambrosini Jerome: "A Minstrel Girl of Nettuno, Southern Italy" 369	
1854 BI	Miss Barlow: "Gipsy Girl" 544	
1855 SBA	Mrs Croudace: "Oulianka, Russian Peasant Girl of the Ukraine" 650 (probably the same work as that exhibited by the artist in 1853 (RA no.964))	
1855 SBA	Mrs Croudace: "Nikito, a study from life of a Russian serf" 727	
1855 BI	Miss E.M. Fielding: "A Connemara Peasant" 104	
1855 BI	Miss F. Young: "The Cottage of Content" 396	
1856 RA	Mrs Johnstone: "The cottage girl" 685	
1856 RA	Miss Emma Brownlow: "A village school, near Portel, France" 992	
1856 SBA	Ambrosini Jerome: "A Minstrel Girl of Nettuno " 147	
1856 PG	Miss S.F. Hewitt: "Hop-pickers" 237	
1856 PG	Miss Robins: "French Fish Girl at a Well" 222	
1856 PG	Miss Robins: "A French Girl spinning" 230	
1856 BI	Miss Hunter: "The Village Toilet" 77	
1856 BI	Mrs C. Smith: "Old Irish-woman" 381	
1856 BI	Miss Jessie Macleod: "A Harvest Home in a Scottish Farm-house" 497	
1856 NSPW	Sarah Setchel: "Sketch for a Picture of an English Cottage Home" 321	
1857 OWS	Miss Eliza Sharpe: "Une paysanne de Montmorency" 102	
1857 OWS	Miss Margaret Gillies: "The Beggar Girl" 225	
1857 SBA	Miss A. Cole: "A Newhaven fishwife" 464	
1857 SFA	Miss Kirby: "Italian Peasant, - study from nature" 191	
1857 SFA	Eliza Irvine: "The Cottager's Home" 9	
1857 SFA	Elizabeth Lawson: "The Contented Cottager" 68	
1857 SFA	Kate Swift: "The Fisherman at Home" 78	
1857 SBA	Miss Jessie Macleod: "A harvest home in a Scottish farm house" 515	
1857 SBA	Mary Lander: "A fisher boy" 525	
1857 SBA	Miss Jessie Macleod: "The return from the vineyards, peasants of Fahu, Middle Rhine" 634	
1857 SBA	Jane Tyley: "A reaper of Alsace" 645	
1857 BI	Ambrosini Jerome: "Gleaners waiting for the last load" 376	
1857 BI	Miss Emma Brownlow: "Le Fuseau" 432	
1857 BI	Miss Kate Swift: "The Fisherman at Home" 492	
1857 RA	Miss E. Smith: "Gleaner" 176	
1858 SFA	Miss Kate Swift: "Gleaners" 28	
1858 SFA	Emily Burford: "The weary Gleaner" 62	
1858 RA	Mrs M. Robbinson: "Straw rope-twisting in the Highlands" 368	
1858 SFA	Miss J. Deffell: "Italian Fisherman" 89	
1858 SFA	Emily Harrison: "Little Welsh Gleaners" 224	
1858 SFA	Harriet C. Hillier: "The Gleaner" 233	
1859 SBA	Mrs Fisher: "The gleaner's rest" 4	
1859 SBA	Miss Jessie Macleod: "Little gypsies" 426	
1859 SBA	Miss S. Raincock: "The young mother with her distaff" 453	
1859 RA	Miss Emma Brownlow: "La pauvre aveugle" 180	
1859 RA	Mme Elizabeth Jerichau: "Danish shepherd with dog and sheep" 526	
1859 SFA	Emily Morier: "The fern gatherers" 28	
1859 SFA	Mrs J.W. Mathews: "The gipsy woman" 50	
1859 SFA	Sarah J. Hewett: "Hop picking at Seven Oaks, Kent" 77	
1859 SFA	Ellen Blackwell: "The little beggar" 153	
1859 SFA	Mrs Elizabeth Murray: "The outcast" 249	
1860 RA	Miss C. Davis: "Going to market, Antwerp" 369	

```
1860 SBA      Miss Emma Brownlow: "La pauvre aveugle" 480
1860 SBA      Hope J. Stewart: "Italian Peasants" 437
1860 PG       Mary Gibbs: "A Gleaner" 352
1860 SFA      Miss E. Partridge: "The Straw-plaiter" 33
1860 SFA      Mrs Margaret Robbinson: "Straw-rope twisting in the
                  Highlands" 53
                  (probably the same work as that exhibited by the
                  artist in 1858 (RA no.368))
1860 SFA      Miss Cordelia Walker: "The Watercress Gatherers" 56
1860 SFA      Miss James: "A Gleaning" 162
1860 SFA      Miss F. Hewitt: "The Gleaners" 200

1890-1900:-
1890 OWS      Miss Edith Martineau: "Taking up the Mangolds, Surrey"
                  68 (ill.)
1890 NSPW     Miss M.E. Kindon: "Study of a Breton Peasant" 557
1890 NSPW     Ada M. Shrimpton: "La Contadina" 461
1890 SBA      Miss Minna Taylor: "After the day's toil" 561
1890 NG       Miss Dorothy Tennant: "Street Arabs at play" 170
1890 RA       Miss S. Birch: "A French fisher-girl" 101
1890 RA       Miss W. Marshall: "A Bretonne" 39
1890 SLA      Mrs Mary Miller: "A Gypsy Girl" 374
1890 SLA      A.F. Williams: "The Gleaners Home" 480
1890 SLA      A.M. Shrimpton: "La Paysanne" 486
1891 RA       Alice Gray: "Grinding Corn" 241
1891 RA       Minna Bolingbroke: "Behind the plough" 1318
1891 RA       Mary Swainson: "A peasant of Bereisgau" bust 2016
1891 SBA      Mrs F. Travers: "Reaping corn" 191
1891 SBA      Margaret Bird: "The Net-Menders" 287
1891 SBA      Alice Gray: "A Hand-Loom Weaver" 377
1891 SLA      Mrs Alice Bach: "The return from the field" 57
1891 SLA      Kathleen Shaw: "Gipsies" 270
1891 SLA      Linnie Watt: "Little Rustics" 271
1891 SLA      Florence A. Saltmer: "Potato Hoeing" 272
1891 SLA      L.M. Felton: "Head of an Italian Peasant" 278
1891 SLA      M.E. Kindon: "Field Workers" 310
1891 SLA      Annie T. Colquhoun: "Gleaners" 475
1891 SLA      Jessie Macgregor: "A Peasant's Home in Switzerland" 555
1892 SBA      Flora M. Reid: "A Flemish Market Place" 67
1892 RA       Elizabeth Nourse: "A babe in the wood: a peasant child of
                  Borst, Austria" 329
1892 RA       Eugénie Salanson: "A Brittany fisher-girl" 582
1892 RA       Edith Hume: "Les blanchisseuses d'Etretat" 630
1892 SLA      A.M. Youngman: "A Gleaner" 25
1892 SLA      Annie Hall: "French Fisher-girl" 241
1892 SLA      Rosa Freyer Hensman: "The Fisherman's Wife" 256
1892 SLA      G.M. Francis: "Now the labourer's task is o'er" 315
1892 SLA      S.F. Wright: "French Peasant shelling peas" 316
1893 RA       Edith Corbet: "Goat girl" 27
1893 RA       Joan Adams: "The labourer's larder" 33
1893 RA       Isa Thompson: "Fisher-folk" 288
1893 RA       Blanche Matthews: "Breton child" 338
1893 RA       Dora Noyes: "Haymaking" 437
1893 RA       Marie Seymour Lucas: "Waifs and Strays" 694
1893 RA       Sarah Birch: "A fisherman's wife" 713
1893 RA       Ella M. Bedford: "A Breton Maid" 880
1893 RA       Edith D. Brinton: "Market-day" 1107
1893 RA       Alice Squire: "A cottage Home" 1153
1893 SBA      Alexandra Mann: "A Little Cottage Girl" 213
1893 SLA      M. Lancaster Lucas: "A milkmaid" 8
```

1893 SLA Constance M. Pott: "Tyrolean Peasant" 231
1894 NG Miss Flora M. Reid: "The latest news" 104
 (The illustration in the catalogue depicts vegetable
 sellers in a market)
1894 NG Miss Emily Little: "A Fisherman's Home in Sussex" 292
1894 NG Mrs M.J. Moberley: "The Miller's Daughter" 275
1894 NG Miss Henrietta S. Montalba: "Venetian Fisher-Boy catching
 a crab" sculpture 418
1894 SBA Miss A.B. Atkinson: "A Tuscan Peasant" 114
1894 SBA Miss Ethel Kirkpatrick: "Unloading Fish: Whitby" 392
1894 RA Miss Flora M. Reid: "Market-place, Bruges" 647
1894 SLA The late C.M. Beresford: "Roman Peasant returning from
 Market" 120
1894 SLA The late C.M. Beresford: "Valtelina Peasant carrying
 Faggots" 122
1895 RA Mrs M.R. Corbet: "Potato harvest in the dales" 561
1895 RA Miss S.W.M. Fallon: "Mending nets" 883
1895 RA Miss E. Watson: "In a market garden" 879
1895 NSPW Miss Kate Greenaway: "Gleaners going home" 32
1895 NSPW Mrs M. Murray-Cookesley: "Beggar Girl, Bethlehem" 662 (ill.)
1895 SBA Edith L. Clink: "Dutch Peasant" 179
1895 NG Miss Flora M. Reid: "In the Market Place" 308
1895 SLA Madame Louisa Starr Canziani: "A Peasant Maid" 292
1896 NG Miss M. Winifride Freeman: "The Fish Girl" 296
1896 RA Helena M. Swaffield: "Peeling potatoes" 446
1896 RA Kathleen Shaw: "An Athenian Beggar" bust 1857
1897 RA Isa Thompson: "The lone reaper" 479
1897 SLA Sophie T. Pemberton: "Brittany Peasant" 337
1897 SBA Ada Clarke: "Rod-Peeling, Ely" 32
1897 SLA A. Maud Ansell: "Gleaners" 399
1897 SBA Miss Flora M. Reid: "Market-day, Dieppe" 208
1897 SBA Janet Boothroyd: "Picardy Peasant Girl" 334
1897 SBA Miss Helen Whitfield: "A Peasant Girl" 490
1898 SLA Joan H. Drew: "Field Labour" 220
1898 NG Miss Catherine J. Atkins: "A Breton Fisher-maiden" 399
1898 SLA Edith Martineau : "A Sower" 357
1898 NG Hilda Montalba: "Swedish Peasant Girl, Weaving" 411
1898 NG Miss Flora M. Reid: "A Norwegian Hen-Wife" 69
1898 SBA Miss E. Thomas Hale: "The Farmer's Girl" 314
1898 SBA Vivian Rolt: "Carting Hay, Amberley" 378
1898 RA E. Beatrice Bland: "Ploughing" 840
1898 RA Emma Squire: "Wanderers" 978
1899 SWA Frances E. Nesbitt: "A Breton Market Woman" 174
1899 RA Lucy E. Kemp-Welch: "Harvesters" 585
1899 SWA Mabel A. Royds: "Dutch Peasant Woman" 401
1899 RA Evelyn Harke: "A summer's ploughing" 702
1899 RA Hilda Chalk: "Sowing" 714
1899 SBA S. Florence Farmer: "Gipsies" 197
1899 SBA A. Madeline Lewis: "Threshing: Selham" 312
1899 SBA Miss W.J.M. Mackenzie: "Fagot-Gatherer" 439
1899 SBA Miss Janet Fisher: "Peeling Potatoes" 489
1899 NG Miss Mary Swainson: "A Peasant Woman" sculpture 433
1900 SWA Agnes Pringle: "A Gipsy" 75
1900 NSPW Miss T. Mary Scott: "The Gleaners" 416
1900 NSPW Miss Annie Taverner: "The Gleaner" 100
1900 NSPW Miss Jane M. Dealy: "Haymakers, Andermatt" 242 (ill.)
1900 SBA Florence A. Neumegen: "Etude de paysanne" 229
1900 SBA Alice Rishgitz: "Washing Place: "Pont Aven. Brittany" 321
1900 RA Mrs M.R. Corbet: "Mending nets" 835
1900 RA Miss Florence Fitzgerald: "Wood-gaterers" 987

```
     1900 RA      Miss M. Furniss: "Fish sale on the quay" 1260
     1900 RA      Miss G.E. Hayes: "Washing-sheds, Avranches" 1572
     1900 RA      Miss R. Levick: "Fishermen hauling in a net" sculpture
                       group 1968
     1900 RA      Miss H. Montalba: "A peasant girl from the mountains,
                       Feltre" 524 (ill. in "Academy Notes" op.cit. 1900
                       p.108)
     1900 RA      Miss Flora M. Reid: "The miller's frau" 804
     1900 RA      Miss M.A. Sloane: "The Weaver" 1566
     1900 RA      Miss M.A. Sloane: "Butter-market, Dordrecht" 1571
     1900 RA      Mrs H.G. Stormont: "Sheep-milking, Walcheren" 927
     1900 RA      Miss L.G. Williams: "A little peasant" sculpture 1940

S4.  1829 SBA     Miss Fanny Corbaux: "Orphans" 671
     1835 BI      Miss Eliza Jones: "Orphan Sisters" 259
     1838 RA      Mary Francis: "The orphan girl; an ideal statue" 1259
     1839 RA      Mary Francis: "Statue in marble of an Orphan Flower Girl"
                       1304
     1843 SBA     Miss A.J. Desanges: "The Orphan" 91
     1851 PG      Miss L. Roberts: "Little Janie, a child of the London Orphan
                       Asylum, Clapton" 440
     1858 SFA     Mrs Backhouse: "The Orphan" 221
                       (for the accompanying quotation from Tennyson see
                       F2d)
     1864 SBA     Miss J. Childs: "The orphans" 926
     1864 RA      Mme Jerichau: "The foundlings"
                       "When my father and mother forsake me, then the Lord
                       will take me up" (Psalm 27, verse 10) 376
     1867 SFA     Kate Swift: "The Orphans" 215
     1869 SFA     Julia Pocock: "The Foundling" 84
     1872 SLA     Miss Alberta Brown: "The Orphan" 378
     1873 SLA     Mrs Gustave Frank: "A Waif" 320
     1873 SLA     Lady Coleridge: "Waif" - a portrait 339
     1873 SLA     E.F. Letts: "The Orphans" 401
     1875 SLA     Florence Bonneau: "The Orphan" 560
     1876 DG(oil) Marie Cornelissen: "A Foundling" 69
     1877 RA      Mrs M.E. Staples: "The foundling" 1367
     1878 SLA     E. Welby: "Motherless" 550
     1879 RA      Marie Cornelissen: "Foundling Hospital: Sunday morning" 450
     1879 SLA     E.S. Guinness: "The Little Orphan" 508
     1879 SLA     Agnes Leyschen: "The Orphans" 564
     1880 DG      E.S. Guinness: "Two Orphans" 570
     1881 SBA     Mrs W.M. Barnard: "A mitherless Bairn" 593
     1881 DG(b&w) Fanny Sutherland: "The beggar girl" 128
     1881 SLA     E. S. Guinness: "Two Orphans" 439
     1884 SLA     Blanche Macarthur: "The Orphans - a Letter of Introduction" 387
     1884 RA      Henriette Corkran: "A little outcast" 46
     1884 RA      Hannah B. Barlow: "Orphans" group, terra cotta 1812
     1885 SLA     Ida Lovering: "Motherless" 255
     1889 SBA     Miss Flora M. Reid: "The Orphan's Harvest" 422
     1891 SLA     Nora Locking: "Two Orphans" 317
     1892 RA      Margaret Bird: "Orphans" 374
     1893 RA      Marie Seymour Lucas: "We are but little children weak,
                       Nor born to any high estate" 728
                       (illustrated in W.S. Sparrow op.cit. supplement)
     1893 RA      Marie Seymour Lucas: "Waifs and strays" 694
   1893/4 IPO     Mrs Emily Elias: "Orphans" 466
     1895 SLA     Fannie Moody: "Orphans" 326
     1896 NG      Miss Flora M. Reid: "Poor Motherless Bairns" 224
```

1898 SLA	H. Corkran: "A Little Waif" 305	
1898 SLA	S.T. Pemberton: "A Little Waif" 436	
1899 SWA	Hilda Fairbairn: "Orphans" 36	
1899 SBA	Miss Nellie Sansom: "Motherless"	

"Voyez-vous cet enfant au teint pâle et livide,
Comme elle lève vers vous son regard suppliant?"
(From "La Charité") 507

1899 RA	Miss M.E. Edwards: "Waifs from the Great City: their glimpse of Heaven" 763	
1900 RA	Miss Emma Belloc: "An orphan" 676	
1900 SWA	A. Mongredien: "An Orphan" 14	
1900 SWA	Kate Sowerby: "Orphans" 401	

T4. 1879 RA Alice Havers:"Stone pickers" 495 (ill. in "Academy Notes" op.cit. 1879, p.49)

1879 SLA	Miss Beresford: "A Son of Toil" 34	
1879 RA	Grace Hastie: "Hard Times" 858	
1880 GG	Miss Dorothy Tennant: "Homeless" 156	
1882 RA	Alice Havers: "Trouble" 801 (ill. in "Academy Notes" op.cit. 1882, p.68)	
1882 SBA	Miss Flora M. Reid: "A Son of Toil" 477	
1882 SBA	Gertrude Crockford: "Homeless" sculpture 771	
1883 RA	Louise Jopling: "Saturday night: searching for the bread-winner"	

Pay-night, drink-night, crime-night" 823

1883 SLA	Alice Manville Fenn: "Hard Times" 637	
1883/4 IPO	Alice Havers: "The Rights of the Poor" 468	
1884/5 IPO	Mrs Adrian Stokes: "The Harvest of the Poor" 379	
1885/6 IPO	Miss Nellie Erichsen: "Daughters of Toil" 587	
1885/6 IPO	Miss Dora Noyes: "There's little to earn and many to keep" 396	
1885/6 IPO	Mrs Adrian Stokes: "Homeless" 328 (ill.)	
1886 SLA	C.J. Atkins: "A British Workman" 17	
1886 RA	Ida W. Clarke: "Labour" bronze group 1860	
1886 SBA	Mrs Heitland Browne: "One of the unemployed" 374	
1886 SLA	Sybil C. Parker: "Hard Times" 293	
1887 SLA	A. Manville Fenn: "Hard Times" 282	
1887 SLA	Rose Barton: "Hard Times" 526	
1887 RA	Janetta R.A. Pitman: "Starved out" 956	
1887 RA	Dorothy Tennant: "A Socialist" 1014	
1888 SLA	Mabel Moultrie: "Riches and Poverty" 317	
1890 NSPW	Miss Helena J. Maguire: "Sons of Toil" 274	
1890 SNPW	Miss E. Emily Murray: "Life was too hard" 231	
1890 RA	Miss L. Swainston: "A toiler of the fields" 1096	
1891 RA	Emma M. Boyd: "To the workhouse" 576	
1891 RA	Emmeline P. Steinthal: "A worker" bust 1971	
1892 NSPW	Mrs Murray: "Homeless" 645	
1893 SBA	Louise Parker: "A Daughter of Toil" 137	
1893 SLA	Jessie Hall: "Hard Times" 158	
1894 SLA	Mildred A. Butler: "Hard Times" 141	
1894 SLA	Lillian Rowney: "A Worker" 166	
1895 RA	Miss K. McCausland: "A horny-handed son of toil" 435	
1895 SLA	Josephine Christy: "A Son of Toil" 61	
1895 SBA	Miss E.G. White: "A study of an old worker" 445	
1896 OWS	Miss Rose Barton: "Out of Work" 10	

(The picture shows a man sitting on a bench in despair with his wife and two children beside him; it is illustrated in the catalogue)

1898 RA	Annie Cullum:"Hard Times" 697	
1899 SWA	Clare Atwood: "The Collar Factory" 333	
1900 RA	Mrs Estelle Nathan: "The coal heavers" 1527	

ALPHABETICAL NOTES - FRANCE

A. 1800 Mme Bruyère : "L'Amitié qui console l'Amour" 60
 1802 Mme Auzou (née Desmarquest) : L'Amour dissipant les alarmes"
 7 (+ see note 18)
 1802 Mme Coswai : "Eros ou l'Amour, débrouillant le Chaos ; sujet
 tiré de la Théogonie de Hésiode" 963
 1804 Emilie Bounieu : "Venus blessée par Diomède, est soutenue par
 Iris qui l'entraîne loin du camp des Grecs, et la
 conduit vers le char du dieu Mars" 58
 1804 Mlle Mayer : "Le mépris des richesses, ou l'Innocence entre
 l'Amour et la Fortune" 319
 1806 Mlle Emilie Bounieu : "Pygmalion amoureux de sa statue" 56
 1806 Mlle Constance Mayer : "Venus et l'Amour endormis, caressés
 et réveillés par les zéphyrs" 375
 1806 Mme Nanine Vallain : "Sapho chantant un hymne à l'Amour"
 516
 1808 Mlle Rosalie De La Fontaine : "L'Amour n'ayant pu blesser
 Pandrose"
 "Il vient se plaindre à Venus qui le console en
 lui conseillant de cacher ses ailes pour réussir.
 Dans le lointain, Pandrose montre à ses compagnes
 une flèche de l'Amour qu'elle vient de briser" 153
 1808 Mlle Constance Mayer : "Le flambeau de Vénus" 417 (+ see note
 23)
 1808 Mme Chaudet : "Une jeune fille"
 "Elle est à genoux devant la statue de Minerve, et
 lui fait le sacrifice des dons de l'Amour" 121
 1810 Mme Veuve Chaudet : "Dibutade venant visiter le portrait de son
 amant et y déposer des fleurs" 159 (discussed and
 illustrated in C.P. Landon's "Annales du Musée .."
 Salon de 1810 p 54, Plate 34. This work was re-
 exhibited in 1814 (no. 208) - see C.P. Landon's
 "Annales du Musée .." Salon de 1814 p 101)

B. 1802 Mme Mongez (née Angélique Levol) : "Astyanax arraché à sa mère"
 207 (+ see note 5)
 1806 Mlle Henriette Lorimier : "Jeanne de Navarre" 362 (+ see vol.
 I p 176)
 A work with the same title was exhibited in 1814
 no. 1378
 1808 Mme Auzou : "Agnès de Méranie" 11
 1808 Mme Servières (née Le Thiers) : "Agar dans le désert" 552

C. 1817 Mme Servières : "Louis XIII et Mlle de La Fayette" 694 (+
 see note 38)
 1817 Mlle Louise Mauduit : "Fondation des Enfans-Trouvés" 561
 (+ see note 37)
 1819 Mme Sophie Lemire : "Isemburge, reine de France, adoptant les
 enfans d'Agnès de Meranie" 745 (+ see note 31)
 1819 Mme Servières : "Blanche de Castille, mère de St. Louis et.
 régente de France, délivrant les prisonniers
 enfermés dans les cachots du chapitre de
 Chastenay, près Paris" 1030 (+ see note 33)

D. 1810 Mlle Béfort : "Une jeune Thébaine pansant son père blessé"
 30 (+ see note 29) Also exhibited in 1814, no.
 41
 1810 Mlle De Georges : "Anne de Boulen, avant d'être conduite à
 l'échafaud, bénit sa fille" 204
 1814 Mlle Guillemard : "Trait de Clémence de Henri IV"
 "Il accorde aux prières de la marquise de Verneuil

et de sa fille la grâce du comte d'Entragnes,
qui avoit été condamné à mort" 490

1814 Mme Sophie Lemire : "Rodolphe de Hapsbourg et Anne de
Hohemberg, sa femme, au berceau de leur fils ainé
expirant" 625 (discussed and illustrated in C.P.
Landon's "Annales du Musée .." Salon de 1814
p 48, Plate 34)

1814 Mlle De Georges : "Valentine de Milan, veuve de Louis d'
Orléans"
"Elle montre l'armure de son époux au jeune
'Dunois', fils de ce prince, et lui fait jurer
qu'il vengera sa mort" 1356

1814 Mme *** : "Henri IV chez Elisabeth, reine d'Angleterre"
"Il lui fait le récit des malheurs de la Saint-
Barthélemi - Sujet tiré de la 'Henriade'" 9

1817 Mme Dabos : "Milton, dans ses derniers momens, soigné par une
de ses filles, appelée Débora" 186

1817 Mme De Romance (Adèle Romany) : "Marie Antoinette, Reine de
France, à la Conciergerie"
"S.M. vient de relire sa dernière lettre à Madame
Elisabeth. Les accessoires du tableau sont d'après
la tradition" 237

1819 Mme Demanne : "Françoise de Foix, comtesse de Chateaubriant"
314 (+ see vol. 1 p 179)

1819 Mlle Duvidal : "Ste Clotilde, reine de France"
"Elle demanda à Dieu la guérison de son second
fils, tombé dangereusement malade après avoir
reçu le baptême. Un rayon céleste indique qu'
elle sera exaucée" 419

1819 Mlle Hoguer : "La Bénédiction maternelle" 601 (+ see vol.1
p 179)

1819 Mlle Lescot : "François Ier"
"Ce prince accorde à Diane de Poitiers la grâce
de M. Saint-Vallier, son père, condamné à mort"
(M.d.R.) 764 (Musée National du Château de
Fontainebleau)

1819 Mlle Louise Mauduit : "Henriette de France, femme de Charles
1er, roi d'Angleterre" 799 (+ see note 35)

E. 1810 Mlle De Georges : "Anne de Boulen, avant d'être conduite à l'
échafaud, bénit sa fille" 204

1810 Mme Giacomelli : "Léonidas partant pour les Thermopyles, fait
ses adieux à sa famille" 368

1812 Mlle Rosalie Caron : "Gabrielle de Vergy"
"Venant de recevoir une lettre de Mlle de Coucy,
elle est attendrie des témoignages d'amitié qu'
elle contient. Livrée toute entière à sa tendresse,
elle prend ses tablettes et ne peut se refuser au
plaisir de relire les vers que Raoul a faits pour
elle. Ensevelie dans ses pensées, elle ne s'
aperçoit pas qu'elle est surprise par son mari" 170

1812 Mme De M*** : "Serment d'amour d'un chevalier avant son départ
pour la Terre-Sainte" 274 (a work with the same
title was exhibited by the artist in 1814 , no. 1358)

1812 Mme Lemire : "Mad. de la Vallière, retirée aux Carmélites,
donnant des instructions de piété à Mlle de Blois,
sa fille" 1333 (illustrated in C.P. Landon's "Annales
du Musée .." Salon de 1812 vol.1, Plate 63)
Perhaps the same work as that exhibited, with only
slight variations in the title, in 1814, no. 626

1812 Mme De M*** : "Jeanne, fille de Raimond III, comte de Toulouse"
"Ayant épousé Alphonse, comte de Poitiers et frère

de St. Louis, elle fait ses adieux aux tombeaux de
ses pères" 272
A work with the same title was exhibited by the
artist in 1814, no. 1357

1812 Mme Auzou : "S.M. l'Impératrice, avant son mariage, et au
moment de quitter sa famille, distribue les
diamants de sa mère aux Archiducs et Archiduchesses
ses frères et soeurs. La scène se passe dans la
chambre à coucher de S.M. à Vienne" 22

1814 Mlle Bouteiller : "Charles VII"
"Prêt à partir pour aller combattre les Anglais,
il fait lire à Agnès Sorel ces vers qu'il vient
de tracer avec la pointe de son épée"
"Gente Agnes qui tant loin m'evance ,
Dans le mien cuer demorera
Plus que l'Anglois en nostre France" 146

1814 Mlle Forestier : "La princesse de Nevers, à l'abbaye de
Granville"
"Ayant voulu visiter la cellule de Cécile d'
Autichamps, la princesse aperçoit un métier de
broderie. Tandis qu'elle y admire une Ste Cécile
en extase, elle découvre dans un coin de la broderie
et sous les traits d'un archange, le portrait du
sire de la Touraille : Cécile confuse tombe à
genoux, et cherche à cacher avec la main le portrait
que la princesse contemple avec émotion et surprise"
(Mémoir du sire de la Touraille, tom.2 chap.7) 400

1817 Mlle Leduc : "Adelaide de Coucy"
"Elle surprend son frère Raoul écrivant sur ses
tablettes les vers qu'il composait pour Gabrielle
de Vergy, et se dispose elle-même à les copier" 508

1817 Mme Auzou : "Boucicault et Mlle de Beaufort"
"Le maréchal de Boucicault, au moment de partir
pour l'armée avec Charles VI, presse Mademoiselle
de Beaufort de lui signer une promesse de mariage.
Ils sont avertis de l'arrivée de la Reine Isabeau
qui s'opposait à leur union" 20

1819 Mlle Buet : "Les adieux d'un chevalier à sa dame" 188 (+ see
note 29)

1819 Mme Demanne : "Françoise de Foix, comtesse de Châteaubriant" 314
(+ see vol.1 p179)

1819 Mlle Sarrazin de Belmont : "Paysage, clair de lune"
"Servilieu rappellé dans sa patrie, après un long
exile, vient déposer les restes de sa femme Fulvie
dans le tombeau de ses ancêtres" 1021

1819 Mlle Hoguer : "La Bénédiction maternelle" 601 (+ see vol.1 p179)

1819 Mlle Aurore de Lafond : "Clotilde de Vallon Chalys, poétesse du
15e siecle" 665 (+ see vol.1 p181)

1819 Mlle Rivière : "Henri IV, quittant Gabrielle" 1674

F. 1812 Mme Auzou : "Diane de France et Montmorency"
"Diane de France, fille de Henry II et de Diane
de Poitiers, étoit aimée du fils du connétable, et
le payoit de retour. Les jeunes gens se voyaient
souvent chez la duchesse de Brissac qui favorisoit
leur amour. Le roi les sachant un jour seuls dans
l'appartement de la duchesse, lui manifesta son
mécontentement et ses craintes. La duchesse, pour
justifier la confiance qu'elle avoit dans les jeunes
gens, introduit le roi et Diane de Poitiers dans
son appartement. Le moment est celui où le roi entre
et surprend les jeunes gens sans être aperçu. Diane

tient une marguérite sur laquelle elle vient de
déposer un baiser. Montmorency attend le don de
cette fleur, gage de l'amour de son amie" 23
(discussed and illustrated in C.P. Landon's
"Annales du Musée .." Salon de 1812, vol.1, p
22, Plate 8)
A work with precisely the same subject, but with
a differently worded descriptive passage, was
exhibited by the artist in 1814, no. 23

1812 Mlle Elizabeth Harvey : "Edwy et Elgiva"
"En 953 Edwy, petit-fils d'Alfred Le Grand, monta
sur le trône à l'âge de dix-huit ans ; il possédoit
la plus belle figure ; à la même époque vivoit une
belle princesse du sang royal, nommée Elgiva, qui
avoit fait une si vive impression sur le coeur du
jeune roi, qu'il épousa malgré ses anciens conseillers,
et quoiqu'elle fût sa parente.
Le jour de son couronnement la noblesse s'étoit
rassemblée dans une grande salle où elle s'abandonnoit
aux excès de la table, tandis qu'Edwy, attiré par
des plaisirs plus doux, rechercha la reine dans l'
appartement de sa mère ; il s'y livroit à l'amour
que lui inspiroit Elgiva, lorsque Dunstan entraînant
Odo, archevêque de Cantorbéry, avec lui, força l'
appartement où étoit la reine, l'accabla d'injures
en l'arrachant des bras d'Edwy, à qui il fit les
reproches les plus insultants" 468 (discussed and
illustrated in C.P. Landon's "Annales du Musée .."
Salon de 1812 vol.2 p 29, Plate 20)

1812 Mlle Le Duc : "Madame de Maintenon"
"Un maçon qui se mêloit d'astrologie, travaillant
à l'hôtel d'Albert, où logeoit Mad. veuve Scaron,
entre dans son appartement. Frappé de son air de
grandeur et de sa beauté, il lui dit d'un ton
prophétique : 'Vous monterez, Madame, où vous ne
croyez pas monter'" 549
A work with precisely the same theme, but a differently
worded title was exhibited by the artist in 1814
no. 609

1814 Mlle Delaval : "Trait de la jeunesse de Henri IV"
"Avant de quitter la Béarn, ce prince visita sa
nourrice, et lui faisant ses adieux, écrivit sur une
pierre à la porte de la maison, ces mots en béarnais :
Asiont Enric quei estnt neourrit ; ici Henri a été
nourri" 272

1814 Mlle Le Duc : "Trait de bonté de Henri IV"
"Pendant qu'il faisoit le siège de Paris, on lui
amena deux paysans qu'on alloit pendre pour avoir
conduit des voitures de vivres aux assiégés. Ils lui
demandèrent grâce. 'Allez en paix', leur dit le roi,
en leur donnant l'argent qu'il avoit sur lui ; 'si
le Béarnais en avoit davantage, il vous le donneroit'"
607

1814 Mlle Le Duc : "François Ier chez la belle Feronnière"
"Elle est occupée à lui broder une écharpe" 608

1817 Mme Servières : "Marguerite d'Ecosse et Alain Chartier"
"Marguerite d'Ecosse, dauphine de France, prisait
beaucoup les ouvrages d'Alain Chartier, poète
célèbre du 14e siècle, secrétaire des finances sous
Charles VII, et l'un des hommes les plus laids de
son temps. Le trouvant un jour endormi dans une des

salles du Louvre, la dauphine s'approcha
doucement et lui donna un baiser, ne voulant pas,
dit-elle, perdre cette occasion de rendre hommage
à une bouche d'où il était sorti de si belles
choses" 695
Also exhibited in 1819, no. 1031

1817 Mme Auzou : "Novès et Alix de Provence"
"Novès, jeune troubadour, s'était introduit dans
l'oratoire de la jeune comtesse, et se disposait
à lui chanter une romance ; la nourrice d'Alix
veut le faire sortir. La jeune personne cherche
à l'adoucir par ses caresses, et Novès parvient
à la gagner en lui laissant voir une croix d'or
dont il orne son chapelet" 19

1819 Mme Ancelot : "Henri IV et Catherine de Médicis"
"Henri n'étant encore que roi de Navarre, et se
préparant à la guerre, fit une visite à Catherine
de Médicis. Cette Reine s'était entourée des plus
jeunes et des plus jolis femmes de sa cour , afin
de distraire Henri de ses desseins et de lui faire
commettre quelqu'indiscretion dont elle put
profiter ; mais, Henri devinant son projet, dit à
Sully qui l'accompagnait : 'Voilà un escadron plus
redoutable que ceux du Duc de Mayenne ;- cependant
les femmes qui ont tout pouvoir sur Henri, ne
feront jamais faire de sottises au roi de Navarre"
11

1819 Mlle Caron : "Marguerite de Valois et le connétable de Bourbon"
"La princesse est surprise au moment où lisant l'
Histoire Romaine, elle s'écrie : 'Ah ! quel monstre !
cet infâme Néron fait mourir le vertueux Thraséas !'
·-'Eh quoi', lui dit-il, 'plaindrez-vous des maux
étrangers, et n'aurez-vous nulle pitié de ce que
vous causez à ceux qui vous adorent?'
- 'Que vous m'avez fait peur !' lui dit la princesse
étonnée de le voir si près d'elle"
(Sujet tiré de l'Histoire de la Reine de Navarre) 196

1819 Mlle Caron : "Saint-Louis conduisant Henri IV au temple du destin"
"Il lui fait connaître les héros qui sortiront de sa
race" (Sujet tiré de La Henriade, chant 7e) 197

1819 Mlle Forestier : "Les filles de Milton faisant la lecture à leur
père aveugle" 449

1819 Mme Mongez : "Saint Martin partage son manteau pour en couvrir
un pauvre" 844 (discussed and illustrated in C.P.
Landon's "Annales du Musée .." Salon de 1819, vol.1
p 53, Plate 30)

1819 Mlle Ribault : "Louis XIV, travaillant avec Louvois chez Madame
de Maintenon"
"Depuis l'époque de son mariage avec Mme de Maintenon,
Louis XIV venait tous les jours chez elle ; il y
travaillait avec ses Ministres, pendant que Mme de
Maintenon s'occupait à la lecture ou à quelque
ouvrage manuel ; quelquefois, se retournant vers elle,
il lui disait en souriant : 'Eh bien !, Madame, que
pense là-dessus votre solidise?'" 949

G. 1810 Mlle Bounieu : "Galatée"
"Mala me Galatea" Eglog de Virg. 111
1812 Mme Chaudet : "Un Amour tenant un arc" 200
1812 Mlle Forestier : "Sacrifice à Minerve"
"Une jeune fille brule sur l'autel de cette Déesse
les armes et le bandeau de l'Amour, qui la supplie

vainement" 1310
- 1812 Madame Blankenstein : "Vénus désarmant l'Amour" 1303
- 1812 Adèle de Romance (ci-devant Romany) : "Daphnis ayant apporté à Philis un oiseau, elle l'en recompense par un baiser" 290
- 1812 Mlle Mayer : "Une jeune naiade veut éloigner d'elle une troupe d'Amours qui cherchent à la troubler dans sa retraite" 631 (illustrated in C.P Landon's "Annales du Musée .." Salon de 1812 vol. 1 Plate 58)
- 1814 Mme Rumilly : "Vénus et l'Amour" 1391
- 1814 Mlle Philiberte Ledoux : "Une jeune femme cachant l'Amour" 606
- 1817 Mme Cheradame (née Bertaud) : "Les Filles de Minée travaillant le jour d'une fête en l'honneur de Bacchus" "Alcithoé raconte à ses soeurs l'histoire de Pirame et Thisbé. En punition de leur désobéissance, elles furent changées en chauves-souris" 157 (discussed and illustrated in C.P. Landon's "Annales du Musée .." Salon de 1817 p 58, Plate 40)
- 1819 Mlle Adèle Déchalas : "Céphale et Procris" 274
- 1819 Mlle Béfort : "Céphale et Procris" 1590

H.
- 1810 Mme Blankenstein : "Vierge et l'enfant Jesus" 95
- 1812 Mme Blankenstein : "Vierge avec l'Enfant Jesus" 100
- 1812 Mlle Delon : "La Vierge et l'Enfant Jesus" 267
- 1814 Mlle Augustine Cochet : "St. Jean prêchant dans le Désert" 1410
- 1819 Mlle Le Grand de Saint-Aubin : "Saint Jean dans le désert, portrait du frère de l'auteur" 734
- 1819 Mme Rumilly : "La Vierge, l'enfant Jésus et Saint-Jean" 1010
- 1819 Mlle Volpelière : "Une Sainte Famille" 1192

I. Artists to 1817 :-
- 1806 Mme Kugler (veuve Weyler) : "Un cadre renfermant les portraits de Jean Racine, de Gaspard de Crayer etc." 282
- 1806 Mme Vallain : "Sapho chantant un hymne à l'Amour" 516
- 1808 Mme Bruyère (née Le Barbier) : "Sapho assise sur le rocher de Leucade" 81
- 1808 Mme Dabos : "Voltaire et Belle-et-Bonne" "Belle-et-Bonne, pour célébrer le jour de la naissance de Voltaire, lui présente des Immortelles. Voltaire lui dit, en l'embrassant : 'Mademoiselle, c'est la vie et la mort qui s'embrassent'" 142
- 1808 Mme Dabos : "J-J Rousseau avec Thérèse" (Sujet tiré des 'Confessions') 143
- 1817 Mme Dabos : "Milton, dans ses derniers momens soigné par une de ses filles, appelée Débora" 186
- 1817 Mme Servières : "Marguerite d'Ecosse et Alain Chartier" 695 (+ see F)

J. 1819 Mlle Forestier : "Les filles de Milton faisant la lecture à leur père aveugle" 449
- 1819 Mlle Aurore de Lafond : "Clotilde de Vallon Chalys, poétesse du 15e siècle" "Elle composa, près d'un siècle avant Marot, des poésies pleines de génie, de sentiment et de grâce. Quatre aimables et jeunes compagnes partageaient ses

goûts et ses travaux. C'est au milieu d'elles
qu'elle est représentée. Elle leur lit une épître
adressée à Béranger de Surville son époux, qui, la
première année de leur union, l'avait quittée pour
aller servir Charles VII" 665

1819 Mlle Julie Philipault : "Racine lisant Athalie devant Louis XIV
 et Mme de Maintenon" (M.d.R.) 895 (Louvre)

1819 Mlle Sarazin de Belmont : "Paysage au soleil couchant"
 "Homère compose son Iliade" 1020

1819 Mme Servières : "Marguerite d'Ecosse et Alain Chartier" 1030
 (+ see I)

1819 Mlle Volpelière : "Virgile composant la dixième églogue" 1191

K. 1824 Mlle Revest : "Le Poussin et la Dominiquin"
 "Les ennemis du Dominiquin avaient fait rebuter et
 reléguer dans un galetas le tableau de la communion
 de Saint Jérome. Le Poussin, arrivé à Rome, veut
 voir cet ouvrage - frappé d'admiration, il se met
 à le copier. Le Dominiquin survient, et le Poussin
 baise avec respect la main qui a créé ce chef-
 d'oeuvre" 1426

1827 Mlle Ribault : "Mignard faisant le portrait de Mme de Maintenon,
 née Françoise d'Aubigné"
 "Les procédés de Louis XIV envers Madame de
 Maintenon, ne laissant aucun doute sur leur secret
 mariage, Mignard désira savoir du roi s'il pouvait
 peindre revêtue du manteau doublé d'hermine. Sainte
 Françoise le mérite bien, repondit Louis XIV"
 (Historique) 856

1827 Mme Dehérain : "Raphael présente au Pérugin par son père"
 "Le Pérugin, en voyant les dessins de Raphael,
 encore enfant, prédit sa gloire" (Vasari, Vie de
 Raphael) 285

1827 Mme Mutel : "La mort de Masaccio - sur porcelaine"
 "Tommaso Guidi de San Giovanni, surnommé Masaccio,
 peintre Florentin, mourut subitement, en 1443, comme
 il était occupé à peindre à fresque la chapelle des
 Brancacci, dans l'église des Carmès à Florence. On
 attribue sa mort à l'effect du poison" 1705

L. For details of the following see Volume 1 pp 185-7

1822 Mlle Aurore de Lafond : "Fleurette à la fontaine de Garenne" 758

1822 Mme Servières : "Inès de Castro et ses enfans se jettent aux
 pieds du roi don Alphonse pour obtenir la grâce de
 don Pèdre" 1190

1822 Mme Servières : "Valentine de Milan" 1191

1822 Mlle Louise Revest : "Episode de l'escalade de Genève, arrivée
 le 12 décembre 1602" 1078

1824 Mlle Volpelière : "Trait d'une jeune princesse de la Souabe"
 1758

1824 Mlle Grandpierre : "Vue d'une partie du château de Fontaine-
 bleau" 798

1824 Mlle Adèle Lauzier : "Sapho" 1048

1827 Félicie de Fauveau : "Christine, reine de Suède, refusant de
 faire grâce à son grand écuyer Monaldeschi" 1785

1827 Mme Bouteiller : "Madame de la Fonchais, née Desilles" 154

1827 Mme Mutel : "La mort de Masaccio" 1705

1827 Mlle Sarazin de Belmont : "Vue de Castelluccio, dans la Calabre"
 938

M. 1822 Mlle Blanchard : "Un Christ" 109

1822 Mme Dumeray : "Une tête de Vierge" 404

1822 Mlle Duvidal : "Eve" 452
1822 Mlle Duvidal : "Saint-Jean-Baptiste" 453
1824 Mlle Blanchard : "Une vierge" (M.I.) 159
1824 Mlle Blanchard : "Notre-Dame de bon secours" 160
1824 Mme Cornillot : "Une Sainte Famille" 371
1824 Mlle Alexandrine Delaval : "La Vierge et l'Enfant Jésus" 463
1824 Mlle Revest : "Ruth et Noémi" 1425

N. 1830 Mlle Delaval : "L'origine de conter fleurette"
 "Henri IV, n'étant encore que prince de Béarn, passait
 son temps auprès d'une bergère nommée Fleurette" 60
 1830 Mme Auzou : "Napoléon et Marie-Louise à Compiègne" 477
 1831 Mme Beloya Collin : "Scène tirée de l'histoire de Russie, sous
 Pierre-le-Grand"
 "Pierre-le-Grand, rentré seul dans sa tente, accablé
 par la douleur de voir la position désespérée de son
 armée, après la fameuse bataille de Pruth, et en
 proie à de cruelles inquiétudes, défendit qu'on
 entrât dans sa tente. Catherine, qui avait affronté
 les horreurs de la guerre, avait le droit de parler.
 Elle entre malgré la défense ; elle persuade à son
 époux de tenter la voie de la négociation. Comme
 c'est la coutume de tout l'Orient, quand on demande
 une audience aux souverains, de ne les aborder qu'
 avec des présens, elle rassembla le peu de
 pierreries qu'elle avait apportées dans ce voyage
 guerrier, et les offrit au czar pour les envoyer au
 grand-visir" 118
 1831 Mlle A. Delaval : "Henri et Fleurette"
 "Henri IV n'étant encore que prince de Béarn, aima
 Fleurette, jeune béarnaise. Il était sans cesse à l'
 entretenir de son amour - voilà - dit-on, l'origine
 de l'expression, 'conter fleurette'" 533
 1831 Mme Dehérain : "Louis XIV et Mlle de La Vallière" 504
 1831 Mlle F. Sommé : "Le Tasse et la princesse Eléonore" 1939
 1831 Mlle Emma Laurent : "Eléonore d'Est"
 "Retirée dans sa bibliothèque, et relisant les
 ouvrages du Tasse, Eléonore s'arrête un moment pour
 penser à leur célèbre et malheureux auteur, victime
 de l'envie" 1246
 1831 Mme Verdé-Delisle : "Charles VII et Agnès Sorel"
 "Charles, voulant retenir Agnès Sorel à sa cour, fit
 tirer son horoscope par Merlin, fameux astrologue.
 Celui-ci lui prédit qu'elle serait la maîtresse d'
 un grand roi. Agnès dit en souriant 'Si cela est,
 Sire, je prie Votre Majesté de me permettre de passer
 en Angleterre afin que je puisse remplir ma destinée,
 n'y ayant pas apparence que la prédiction regarde
 Votre Majesté, à qui il reste à peine le tiers de
 son royaume" 2068
 1831 Mme Dehérain : "La toilette de Ninon" 503
 (reviewed in "L'Artiste" 1831 vol.1 p 291)
 1833 Mlle L. Collin : "Episode de la vie de Henri II"
 "Henri II, roi d'Angleterre, craignant la fureur
 jalouse d'Eléonore de Guienne, son épouse, fait
 bâtir dans le palais de Woodstock des passages
 secrets qui le conduisaient près de Rosamonde, sa
 maîtresse. Pendant une absence du roi , Eléonore
 découvre l'endroit où est cachée Rosamonde ; elle
 s'y rend avec ses gardes, la fait arracher de son
 sit, et la force à boire du poison" 455
 1833 Mme Dehérain : "Louis XIV et Mlle Mancini"

"Louis XIV, cédant aux conseils de sa mère,
consentit à l'éloignement de la nièce du cardinal
Mazarin. Au moment de leur séparation, le roi ne
pouvant contenir sa douleur, Hortense Manzini lui
dit : 'Vous êtes roi, vous pleurez, et je pars'"
(Mémoires de Mme de Motteville) 627

1833 Mme Frapart : "Louis XV et Mme Dubarry"
"Mme Dubarry, désirant le renvoi des ministres
Choiseul et Praslin, se plaisait à faire sauter,
devant le roi, des oranges, en disant : 'Saute
Choiseul, saute Praslin'. Elle obtint, par cette
plaisanterie réitérée, le changement des deux
ministres" 995

1833 Mlle Grandpierre : "Marion de Lorme et le chevalier de Grammont"
"Mademoiselle, lui dit le chevalier, vous avez peur
que Brissac ne me trouve avec vous, j'y ai mis bon
ordre : il est au bout de la rue qui promène mon
cheval. Je ne suis entré ici qu'à l'aide de mon
manteau" (Dictionnaire de l'Amour) 1130

1834 Mme Frapart : "Louise de Savoie"
"Elle présente à François 1er, Mlle d'Héilli, qui
fut depuis duchesse d'Etampes" 786

1834 Mlle A. Martin : "Agnès Sorel"
"Prince, ce n'est pas à moi que vous devez des
excuses, mais à ces infortunés" 1344

1836 Mlle Amélie Legrand de Saint-Aubin : "Klotilde"
"Aurélien, déguisé en mendiant, est chargé de
remettre à Khlothilde un anneau que lui envoyait
Khlovigh. Aurélien arrive aux portes de la ville
de Genève, y trouve Khlotilde avec sa soeur.
Khlothilde s'empresse de laver les pieds d'Aurélien :
celui-ci se penche vers elle et lui dit tout bas :
'Maîtresse, Klovis roi des Francs m'envoye vers toi :
si c'est la volonté de Dieu, il désire vivement
t'épouser et pour que tu me croyes voici son
anneau'. Khlothilde l'accepte et une grande joie
reluit sur son visage" (Chateaubriand "Etudes
historiques") 1194

1837 Mme Fanny Geefs, née Corre : "La veuve Scarron"
"Elle rencontra un jour un maçon nommé Barbe, qui se
mêlait d'astrologie, et qui lui prédit qu'elle était
destinée à devenir reine de France, et lui dit en lui
montrant le château de Versailles qu'elle en
deviendrait la souveraine" (Histoire des reines de
et régentes de France) 823

1837 Mme Olympe de Lernay : "La captivité du Tasse"
"Sa passion pour Eléonore d'Est, dont la famille
régnait à Florence, fut la cause des rigueurs qu'
on exerçait contre lui.
L'instant que le peintre a choisi est celui où le
Tasse écrit à celle qui occupe ses pensées" 1214

1838 Mlle Léonide Provandier : "Adieux de Charles VI à Odette de
Champdivers" 1452

1838 Mme Desnos : "Madame de la Vallière"
"Avant d'entrer au couvent, elle vient se jeter
aux pieds de la reine pour obtenir son pardon" 303

1839 Mlle Adrienne Grandpierre : "Le Czar Pierre 1er"
"Sachant que Catherine lui était infidèle, il entra
chez lui, et brisant une belle glace: 'Tu vois, dit-
il, que d'un seul coup j'ai fait rentrer cette
glace dans la poussière, dont elle était sortie'.
L'impératrice comprit l'allusion et lui répondit :

'Il est vrai - mais pour avoir détruit le plus
bel ornement de votre palais croyez-vous qu'il
en devienne plus brillant?'" 922

1839　Mlle Pauline Perdrau : "Sainte Clotilde"
"Sainte Clotilde avait perdu un fils âgé de
quelques mois lorsque Clovis partit pour se
battre à Tolbiac. Après ce départ, la sainte se
retira dans le tombeau de son fils pour y prier ;
là, Dieu lui envoie une vision dans laquelle Clovis
lui apparaît à la tête de son armée, invoquant le
Dieu de Clotilde" (Vies des Saints) 1629

O.　1833　Mme Saint-A... L : "Saint François montrant à la Vierge ses
stigmates ; dessin" 3191

1835　Mlle Ellenrieder : "Sainte Cécile" 711

1836　Mme Tridon, née Satler : "Quatre miniatures" including a
"Sainte Cécile" 1738

1837　Mme Adrienne Duport : "Sainte Catherine de Sienne" 624

1837　Mlle Georgine Gérard : "Sainte Thérèse d'Avila (Espagne)"
"Enfin la lecture des confessions de St.-Augustin
mit un terme aux épreuves par lesquelles elle avait
dû passer pour arriver au calme céleste qui la
fuyait depuis tant d'années. Elle fut frappée des
rapports existans entre les égaremens du grand
docteur et les siens, et un jour qu'elle pleurait
en lisant le passage où il rapporte comment la
grâce descendit en lui, elle aussi entendit
distinctement la voix de Dieu qui lui dit; 'Désormais
tu ne converseras plus qu'avec les anges'" (Histoire
de Sainte Thérèse, par elle-même) 822

1837　Mlle A. Perlet : "Peintures sur porcelaine" including a
"Sainte Catherine" 1414

1839　Mlle Fanny Geefs : "Sainte Cécile" 357

1839　Mlle Clotilde Gérard : "L'enfance de Sainte Thérèse d'Avila" 849

1839　Mme Ernestine C De Lonez : "Sainte Catherine" 1399

1839　Mlle Félicie Morvanchet : "Sainte Marane et Sainte Cyre,
anachorètes"
"Ces deux vierges étaient soeurs, nées vers le
commencement du Ve siècle, à Bérée, en Syrie. L'
amour de Dieu s'étant emparé de leurs coeurs, elles
quittèrent la maison paternelle, et allèrent s'
enfermer dans un enclos de murailles, hors des portes
de la ville. Tout ce que les pénitences ont de plus
rigoureux leur semblait léger. Cependant, Cyre, plus
délicate que sa soeur, ne put supporter comme elle
ces austérités, qui altérèrent sa santé au point de
ne pouvoir presque marcher, et de se tenir courbée
vers la terre" (Vies des Saints) 1551

1839　Mlle Pauline Perdrau : "Sainte Clotilde" 1629 (+ see N)

P.　1831　Mme De Bay : "Christine de Suède chez le Guerchin"
"La Reine Christine étant allée voir Le Guerchin fut
tellement éprise d'admiration à la vue de ses
ouvrages, qu'elle lui tendit la main et prit la
sienne, voulant, disait-elle, toucher une main qui
opérait de si belles choses" 464

1831　Mme Ve Deschamps : "Le Tasse - porcelaine" 560

1831　Mlle Emma Laurent : "Eléonore d'Est"
"Retirée dans sa bibliothèque, et relisant les
ouvrages du Tasse, Eléonore s'arrête un moment pour
penser à leur célèbre et malheureux auteur, victime
de l'envie" 1246

1831 Mlle F. Sommé : "Le Tasse et la princesse Eléonore" 1939
1831 Mlle F. Sommé : "Rubens et sa famille" 1941
1831 Mlle A. Pagès : "Justine de Lévis, poète du 14e siècle" 2809
1831 Mlle M. Gaume : "Portraits de MM Charles Nodier et Alphonse
 Lamartine - camées sur porcelaine" 3063
1833 Mme Piron de Chavarri : "Tête d'Euripide, en grisaille" 1927
1833 Mlle Voullemier : "Le prince de Ligne chez J-J Rousseau"
 (Mémoires du Prince de Ligne, chapitre : "Mes
 deux conversations avec J-J Rousseau", tom.II p 148)
 2420
1833 Mme Verdé-Delisle : "Voltaire enfant, présenté à Ninon de L'
 Enclos par l'abbé de Châteauneuf" 3214
1834 Mme Frapart : "Marguerite d'Ecosse et Alain Chartier"
 "Marguerite d'Ecosse, femme du dauphin, depuis
 Louis XI, passant dans une salle du Louvre, voit
 Alain Chartier endormi, Voulant rendre hommage à ce
 savant, elle s'approche de lui et le baise. Les
 personnes de sa suite paraissent surprises de cette
 action - elle leur dit : 'Ce n'est pas l'homme que
 j'ai embrassé : mais la bouche qui a prononcé de
 si belles choses'" 785
 For a previous example of this theme, by Mme
 Servières, see I and J
1834 Mme Paulinier : "Portrait de Rembrandt demi-nature, porcelaine"
 1485
1835 Mme Brune : "Silvio Pellico, à Venise"
 "Il est visité dans sa prison par la fille du geôlier.
 'Lorsque nous avons parlé ensemble de religion' me
 disait-elle, 'je prie plus volontiers et avec une foi
 plus vive'" 269
1835 Mme Dehérain : "Bernard de Palissy" 547
1836 Mme Elise-C Boulanger : "Jean-Jacques fait le bonheur de petits
 savoyards qui, faute d'argent, ne peuvent s'acheter
 quelque chétives pommes qu'ils mangent déjà des
 yeux ; aquarelle" ("Rêveries de Jean-Jacques" -
 neuvième promenade) 213
1836 Mme Elise-C Boulanger : "Berquin surprend deux petites filles
 lisant son Ami des Enfans ; aquarelle" 215
1836 Mme Elise-C Boulanger : "Bernardin de Saint-Pierre, chez de bons
 paysans qu'il aimait à visiter, observe leurs moeurs
 et cause avec eux ; aquarelle" (Etudes de la Nature)
 216
1837 Mme Olympe de Lernay : "La captivité du Tasse" 1214 (+ see N)
1838 Mme Elise C. Boulanger : "Voltaire lisant 'Candide' à Mme de
 Pompadour ; aquarelle" (Jules Janin : "Contes
 nouveaux") 172
1838 Mme Dehérain : "Beethoven composant sa symphonie en 'la'" 445
1838 Mlle Adèle Ferrand : "Milton dictant le 'Paradis Perdu' à ses
 filles" 672
1838 Mme Haudebourt-Lescot : "Le lien d'un ménage"
 "En 1762, quand parut l''Emile' de Rousseau, ce livre
 fut lu avec enthousiasme ; l'éloquence du philosophe
 étant parvenue au coeur des mères, toutes voulurent
 être la nourrice de leurs enfans ; mais ce ne fut
 qu'une mode qui passa avant le sévrage" 899
1838 Mlle Irma Martin : "Clotilde de Surville rêvant à ses poésies ;
 étude" 1247
1839 Mlle Adèle Ferrand : "Milton à ses derniers momens" 718
1839 Mlle Elise Journet : "Maria Tintorella dans l'atelier de son
 père" 1110

Q. 1831 Mme L. Thurot : "Jeanne d'Arc"

"Les inquisiteurs cherchaient à la convaincre d'un
pacte avec Satan, et l'interrogeaient sur les
apparitions des saintes, que son imagination vive
croyait réelles. Elle répondit un jour : Sainte
Catherine et Sainte Marguerite m'ont éveillée en me
disant : ne prends nul souci de ton martyre, tu iras
enfin au royaume du Paradis. La mitre et le san-
benito dont l'inquisition revêtait les condamnés
marchant au supplice sont auprès de Jeanne d'Arc"
1991

1833 Mlle L. Collin : "Episode de la vie de Henri II" 455
(+ see N)

1833 Mme Frapart : "Les adieux de Louis XIV à Mme Henriette d'
Angleterre mourante" 994

1833 Mme Mathon de Fogères : "Anne de Boulen, seconde femme de Henri
VIII et l'une de ses victimes reçoit la nouvelle de
sa disgrâce" 1703

1833 Mlle A. Pagès : "Condamnation d'Anne de Boulen"
"Le roi Henri VIII, son époux, ne pouvant surmonter
sa nouvelle passion pour Jeanne Seymour, l'une des
dames d'honneur de la reine, l'accusa faussement d'
infidelité. Le moment choisi est celui où, renfermée
dans la tour de Londres, et ayant entendu sa
sentence, elle dit au lieutenant de la tour, avec
sérénité et gaité : 'L'exécuteur est très-expert,
à ce que j'ai appris et j'ai le cou très-mince'. Elle
en prend la mesure et sourit. Ses regards se portent
sur sa fille Elisabeth d'Angleterre" (Hume, "Histoire
d'Angleterre") 1828

1835 Mme Haudebourt-Lescot : "Mort de Marie de Clèves, femme de Henri
1er, prince de Condé ; aquarelle"
"Catherine de Médicis craignant l'ascendant que la
belle Marie avait pris sur Henri III, prit si bien
ses mesures, que Marie mourut presque subitement
le 30 octobre 1574, à dix-huit ans et dans tout l'
éclat de sa beauté" 1040

1835 Mlle Legrand de St-Aubin : "Inès de Castro"
"Don Pèdre, fils aîné d'Alphonse, roi de Portugal,
avait épousé secrètement Inès de Castro, célèbre
par sa beauté. Le père instruit de ce mariage, vole
à Coïmbre dans le monastère où était Inès, pour l'
immoler à son orgueil et à sa vengeance. Les larmes,
la beauté, les prières touchantes d'Inès, et surtout
la vue des jeunes princes, ses enfans, attendrirent
et désarmèrent le roi ; mais d'indignes et cruels
favoris lui ayant fait un crime de sa tendresse,
Alphonse prononça de nouveau l'arrêt de mort d'
Inès. 1355" 1326

1835 Mlle A. Martin : "Jeanne d'Arc"
"Le sire de Luxembourg, dont Jeanne avait été
prisonnière, passant à Rouen, alla la voir dans sa
prison avec le comte de Warwick et le comte de
Strafford. 'Jeanne, lui dit-il en plaisantant, je
suis venu te mettre à rançon, mais il faut promettre
de ne t'armer jamais contre nous'. - 'Ah mon Dieu !
vous vous riez de moi, dit-elle, vous n'en avez pas
le vouloir ni le pouvoir; je sais bien que les
Anglais me feront mourir, croyant après ma mort
gagner le royaume de France ; mais fussent-ils cent
mille goddems de plus qu'à présent, ils n'auront
pas le royaume '. Irrité de ces paroles, le comte

de Strafford tira sa dague pour la frapper, et ne fut arrêté que par le comte de Warwick" (Sujet tiré des "Ducs de Bourgogne") 1524

1835 Mlle O. Rossignon : "Elisabeth chez la comtesse de Nottingham "
"Elisabeth avait donné au comte d'Essex une bague qu'elle portait, en lui disant que si jamais il perdait sa faveur, il n'avait qu'à la lui envoyer, et qu'à la vue d'un gage si cher tout serait pardonné. Essex, condamné à mort, fit remettre secrètement cet anneau à la comtesse de Nottingham, en la priant de le remettre à Elisabeth. La comtesse en fut détournée par son mari, ennemi du comte, et le malheureux Essex périt.
Au lit de mort, la comtesse déchirée de remords, révéla à la reine ce secret important. Cet aveu fit éprouver à la reine une révolution terrible. Elle repoussa la main de la mourante avec indignation, lui lança des regards effrayans, l'accabla de reproches durs, et sortit en disant : 'Dieu peut vous pardonner, mais moi je ne vous pardonnerais jamais'" 1885

1837 Mlle Coraly Fourmond : "Frédégonde et Grégoire, évêque de Tours"
"Frédégonde, en proie à une maladie cruelle, déchirée par les remords de ses crimes, et tourmentée de la crainte de la mort, a mandé Grégoire, évêque de Tours, persuadée que ce ministre des autels pouvait lui rendre la santé, la vie même: 'Mon père, lui dit-elle, délivrez-moi des tortures qui me dévorent, éloignez la mort qui vient à moi'. - 'Reine, lui répondit le prélat, Dieu seul opère de tels miracles ; pour moi, je ne puis que le prier pour vous - je ne suis qu'un pauvre pécheur'" 748

1838 Mlle Blanchard : "Des femmes grecques réfugiées sur un rocher"
"Se voyant poursuivies par les Turcs, qui viennent de massacrer leurs époux et leurs pères, elles prennent la résolution de se précipiter dans les flots avec leurs enfans" (M.I.) 135

1838 Mlle Léonie Mauduit : "Marie Stuart, la veille de sa mort ; aquarelle"
"La reine distribue à ses fidèles serviteurs les objets précieux qui lui restent, et les prie de les garder par amour pour elle" 1263

1838 Mlle Mélina Thomas : "Anne de Boleyn, prisonnière dans la tour de Londres, se confesse à l'archevêque de Cantorbéry" 1678

1838 Mlle Mélina Thomas : "Charlotte Corday"
"Interrogée dans sa prison par un membre du tribunal révolutionnaire, elle lui répond : 'Dieu seul est mon juge'" 1679

1839 Mme Olympe M. de Lernay : "Jane-Gray"
"Et comme on lui avait refusé ses femmes pour l'assister à ses derniers momens, ce fut le bourreau qui détacha sa coiffe et coupa ses beaux cheveux" (Histoire d'Angleterre) 1354

1839 Mme E. Raulin : "La communion de Marie Stuart"
"Au moment où la reine, descendue avec ses femmes dans son oratoire, se dispose à communier et tient entre ses mains l'hostie que le pape lui a fait parvenir, les soldats qui l'attendent pour la conduire au supplice frappent rudement à la porte" 1747

1839 Mme Anna Rimbaut : "Le général Marceau et Blanche de Beaulieu"
"Au moment où Marceau allait rejoindre son armée,
il apprit la condamnation à mort de Blanche, qu'il
avait sauvée dans les guerres de la Vendée, et
dont il était éperdument amoureux : il courut à la
prison de Nantes : 'Blanche, dit-il, je vous
sauverai si vous voulez être ma femme'.
Un prêtre, condamné comme elle, les bénit avant de
partir pour l'échafaud. Le lendemain de cette triste
union, la tête de Blanche tombait. On voyait à sa
bouche une rose que lui avait donnée Marceau. La
grâce arrivait, mais trop tard !" ("La Rose Rouge",
par M. Alexandre Dumas) 1791

Mary Stuart and Joan of Arc were also represented in the following
works :-

1830 Mme Ve Deschamps : "Marie Stuart ; porcelaine" 559
1833 Mme Dehérain : "Vision de Jeanne d'Arc"
"Une vision mystérieuse arma le bras de Jeanne
d'Arc" (Chateaubriand, "Etudes historiques") 626
1835 Mme Frapart : "Marie Stuart à la cour de France"
"Ainsi que son bel age croîssait, ainsi vit-on
en elle sa belle beauté, ses grandes vertus croître
de telle sorte que venant sur les 13 ou 14 ans, elle
déclama publiquement devant le roi Henri, la reine
et les savans, une oraison en latin qu'elle avait
faite (cette reine écrivait et parlait avec facilité
six sortes de langues)" (Mémoires de Brantôme) 834

R. 1833 Mlle Langlois : "Diane de Poitiers visitant, dans la cathédrale
de Rouen, le tombeau du sénéchal Louis de Brèze,
son époux ; aquarelle" 1424
1834 Mlle L. Collin : "Thomas Morus, arrêté par ordre de Henri VIII,
se sépare de sa fille dans la salle basse de la
prison de Londres" 359
1834 Mme Verdé-Delisle : "Thomas Morus, chancelier d'Angleterre,
résiste aux prières de sa femme qui le conjure de
renoncer à la religion catholique,et d'obéir aux
ordres du Roi"
"Henri VIII , amoureux d'Anne de Boulen, ayant
rompu les liens qui l'attachaient à l'église romaine,
voulut vainement forcer Thomas Morus à l'imiter.
Lorsqu'il eut été condamné à mort, sa femme,
accompagnée de ses enfans, vint le trouver dans sa
prison et le conjura d'obéir au roi : 'Combien d'
années, lui dit-il, pensez-vous que je puisse
encore vivre ?' 'Plus de vingt ans',répondit-
elle . 'Ah ! ma femme, lui dit-il, veux-tu donc que
je change l'éternité contre vingt ans'" 1893
1835 Mme Haudebourt-Lescot : "La duchesse d'Angoulême, mère de
François Ier,et Marguerite de Valois, sa soeur,
recevant la fatale nouvelle de la perte de la
bataille de Pavie ; aquarelle" 1041
1835 Mlle Revest : "Clotilde, femme de Clovis, confie ses deux
petits-fils à l'ambassadeur de Childebert, qui sous
prétexte de les faire monter sur le trône, les
envoie chercher pour les faire périr" (Premier
volume de l'Histoire des Gaules) 1826
1835 Mlle O. Rossignon : "Elisabeth chez la comtesse de Nottingham"
1885 (+ see Q)
1836 Mlle Eugénie Gallian : "Un espagnol de la vallée de Lého (Haut-
Aragon)"

"Il est averti par un de ses compatriotes que l'
-ennemi est à l'entrée de la vallée, et que même
on s'y bat : il vient lui rappeler son serment
de prendre les armes, et le forcer à quitter sa
jeune femme. Celle-ci, malgré son vif chagrin,
sentant que le devoir appelle son mari, élève sa
pensée vers le Très-Haut, et le prie de conserver
les jours de celui qui l'aime tant" 788

1837 Mlle L. Collin : "Charles VIII à Milan"
"Ce prince voulut voir son cousin Galéas, duc de
Milan, que Ludovic, son oncle et son tuteur, tenait
prisonnier dans son palais, ainsi que la jeune
duchesse, soeur d'Alphonse de Naples, que Galéas
avait épousée ; il était mourant d'un poison que
lui avait fait donner Ludovic. Au moment où Charles
VIII allait quitter le malade, la jeune duchesse
trompe la vigilance de ses gardes, se jette aux
pieds du roi et implore son appui" (Guerre d'Italie
sous Charles VIII) 376

1837 Mlle Irma Martin : "Edouard IV chez Elisabeth Gray"
"Elisabeth se jette aux pieds du roi, et le supplie
de rendre à ses enfans leurs biens confisqués après
la mort de son époux tué à la bataille de St. Alban.
Edouard, touché des larmes et de la beauté de la
jeune veuve, lui accorde la grâce qu'elle demande"
1288

1839 Mlle Coraly de Fourmond : "Une femme attente à la vie de
Cromwell" 777 (+ see vol.1 p189)

1839 Mlle Sophie Hubert : "La prière"
"Au retour d'une expédition lointaine, Raoul, le
dernier seigneur de Kernisen, fit naufrage et
périt : ce cruel événement plongea cette noble
famille dans une profonde douleur ; depuis lors et
chaque fois que l'ouragan brisait les vagues
furieuses sur les rochers de Penoador, le vieux
sire de Kernisen se rendait à sa chapelle, et là,
entouré de ses filles, il priait la Vierge de
détourner d'autrui le coup qui l'avait frappé
lui-même" (Anciennes chroniques) 1040

1839 Mlle Pauline Perdrau : "Sainte Clotilde" 1629 (+ see N)

1839 Mlle Octavie Rossignon : "Révolte des Strélitz (en 1678)"
"Le moment choisi par l'artiste est celui où les
strélitz, ayant reconnu Vangad, le traînent vers
le palais des czars et menacent d'y mettre le feu
si on ne leur livre le plus jeune des princes
Nariskin. Le patriarche, confiant dans une image
de la Vierge qui passait pour miraculeuse, prend
cette image d'une main, et le jeune prince de l'
autre, et se présente ainsi aux révoltés, entouré
des princesses en larmes et demandant grâce ; mais
les strélitz s'emparent du prince, le condamnent,
ainsi que le médecin Vangad, au supplice des dix
mille morceaux, et les massacrent sous les yeux
de toute la cour épouvantée" (Voltaire -
"Histoire de Russie") 1833

S. In addition to those listed above :-
1830 Mme Rumilly : "Brunehaut"
"Chassée de la cour de son fils, abandonnée de ceux
qui la conduisaient, elle s'arrête, au déclin du
jour, sur les bords de l'Aube, aperçoit dans l'onde
les haillons dont elle est couverte, et frémit en

voyant pour la première fois son front sans
couronne.
Un pâtre qui revient des champs s'arrête pour
la considérer etc." 574

1837 Mlle Marie de la Piédra : "Adieux d'Elisabeth Gray, veuve d'
Edouard IV, à son fils le duc de York, au sanc-
tuaire de Westminster Abbey"
"L'on convint que le cardinal Bourchier, primat,
et Botherham, archevêque de York, tâcheraient d'
abord d'obtenir de la reine, par la persuasion,
qu'elle envoyât son fils à la cour - elle y
résista long-temps : mais voyant que le conseil
menaçait, en cas de refus, d'en venir à la force,
elle obéit enfin, et disant à son fils un éternel
adieu, elle le remit entre les mains des deux
prélats" (Hume, "Histoire d'Angleterre") 1453

T. 1831 Mme Beloya Collin : "Scène tirée de l'histoire de Russie, sous
Pierre-Le-Grand" 118 (+ see N)
1831 Mme A. Dupont : "La femme du général C ***"
"Déguisée en paysanne, elle fait passer à son mari,
prisonnier de guerre, des moyens d'évasion" 682
1833 Mme Frapart : "Louis XV et Mme Dubarry" 995 (+ see N)
1836 Mlle Adèle Martin : "Don Henri, déguisé en pèlerin et
accompagné de deux hommes de sa suite, déguisés
comme lui, vient consulter Duguesclin, prisonnier
à Toulouse"
"Ils sont introduits par un breton. Le geôlier,
pensant qu'ils devaient être des gens de qualité ou
des espions, fit part à sa femme de l'intention où
il était d'en avertir le prince de Galles. Celle-ci
plus généreuse prévient le prisonnier des projets
de son mari, et les rassure en leur remettant des
clefs dont elle s'est emparé" (Vie de Duguesclin)
1311
1836 Mme Rude (née Frémiet) : "Entrevue de M. le Prince et de
Mademoiselle, duchesse de Montpensier, à l'hôtel du
maître des comptes De La Croix, après le combat de
la grande barricade du faubourg Saint-Antoine"
(Guerres de la Fronde, 2 juillet, 1652) 1641
(Musée de Dijon)
1837 Mlle L. Collin : "Charles VIII à Milan" 376 (+ see R)

U. 1830 Mlle Delaval : "L'origine de conter fleurette" 60 (+ see N)
1831 Mlle A. Delaval : "Henri et Fleurette" 533 (+ see N)
1831 Mme Verdé-Delisle : "Henri IV fait tirer l'horoscope de Louis
XIII, par La Rivière, son médecin astrologue" 2070
1831 Mme Debay (jeune) : "Henri IV faisant chevalier son fils Louis
XIII" 2713
1839 Mme Elise-C Boulanger : "Bataille d'Ivry ; aquarelle"
"Henri IV, entouré de sa famille, explique au
Dauphin (Louis XIII) convalescent, comment s'est
passée la bataille ; il lui indique sur le plan les
mouvemens avec des soldats en bois. Gaston d'
Orléans est à la droite du Roi, et sur le devant du
tableau Marie de Médicis, avec Henriette de France,
depuis Reine d'Angleterre" 222

Four other works may be included in this category :-
1831 Mlle F. Sommé : "Rubens et sa famille" 1941
1833 Mme Rude-Frémiet : "Adieux de Charles Ier, roi d'Angleterre,
à ses enfans" 2107 (Musée de Dijon)

1835 Mme Darbois : "Bataille de Seucf"
 "Le grand Condé est renversé avec son cheval dans
 un fosse. Son fils, le duc d'Enghien, qui combattait
 à ses côtés, accourt pour le relever, et est lui-
 même blessé au bras en s'acquittant de ce devoir"
 486
1835 Mlle Perlet : "Les enfans de Charles Ier ; porcelaine" 1692

V. Mlle Cogniet : "Portrait d'Ali-Hamet, ancien mameluck de l'ex-
 garde, blessé deux fois à la main droite, le 28
 juillet, en combattant avec les Parisiens" 356
 Mlle Emma Laurent : "Portrait du général Kléber" 540
 Mlle Emma Laurent : "Portrait du maréchal Ney" 541
 Mlle de Saint-Omer : "Le colonel Poque, blessé à Rambouillet
 dans la mission dont il fut chargé, le 3 août, pour
 arrêter les diamans de la couronne, est représenté
 sur une chaise longue, soigné par Mme sa soeur"
 "Dans le fond de l'appartement, est le buste de
 Lafayette et une épée envoyée au colonel Poque, par
 les Béarnais ses compatriotes, en honneur de sa
 conduite dans cette circonstance" 575
 Re-exhibited in 1831 with a differently worded
 title, no. 1876

W. 1831 Mme S. Rude : "Le Sommeil de la Vierge" 1864 (Musée de Dijon)
 1831 Mlle Blanchard : "Une Assomption" 2687
 1833 Mlle de Fourmond : "La chaste Suzanne" 3034
 1834 Mme Dehérain : "Le Christ au jardin des Oliviers" 490
 1835 Mlle Blanchard : "Une assomption" (M.d.R.) 154
 1835 Mme Dehérain : "Jésus apparait à la Madeleine" 546
 1835 Mlle D'Hébrard : "Une vierge ; porcelaine" 610
 1835 Mlle Ellenrieder : "La Vierge et l'enfant Jesus" 710
 1835 Mlle de Fourmond : "La Vierge et l'enfant Jesus" 807
 1835 Mme Grassis de Predl : "La naissance de Jésus-Christ" 984
 1835 Mlle Henry : "La Vierge et l'enfant Jésus" 1057
 1836 Mme Dehérain : "Madeleine au désert"
 "Exaltée par la prière, elle ressent d'avance les
 joies du ciel" 491
 1837 Mme Isaure Bigot : "Judith ; grande miniature" 129
 1837 Mme Dehérain : "Marthe et Marie"
 "Marie se tenait assise aux pieds de Jésus pour
 écouter sa parole. Marthe, occupée des soins de
 la maison, dit au Seigneur : 'Ne considérez-vous
 point que ma soeur me laisse toute la peine?'..
 'Marthe, Marthe, dit Jesus, vous vous empressez
 et vous troublez dans le soin de beaucoup
 de choses, cependant une seule est nécessaire :
 Marie a choisi la meilleure part, qui ne lui
 sera point ôtée'" (St. Luc, chap. X) 483
 1837 Mlle Amélie Legrand de St. Aubin : "La Vierge et l'Enfant-
 Jésus" 1157
 1838 Mme Dehérain : "Le Christ intercesseur" 444
 1839 Mme H. Dehérain : "Education de la Vierge" 517
 1839 Mlle Méloë Lafon : "Une assomption" 1183
 (This work received several favorable criticisms.
 See "L'Artiste" 1839 vol.2 p 291 by Jules Janin ;
 also 'L'Art en Province' 1839 vol.4 p 53 by M.Ad.
 Michel. According to "L'Artiste" 1839 vol.3 p
 116 see received a gold medal for this picture)

X. 1840 Mme Elise Clément Boulanger : "Un tournoi ; aquarelle" 147
 (+ see B1)

1840 Mme Charlotte Hay : "Charles VI, roi de France, récompensant
 les soins de la nourrice du Dauphin, en lui
 donnant la coupe d'or dont il se servait
 journellement" (M. de Barante, "Histoire de
 Bourgogne") 814

1841 Mlle Irma Martin : "Visite de Christophe Colomb à Eléonore de
 Portugal, femme de Jean II, roi de Portugal"
 "Christophe Colomb, au retour du son premier voyage
 d'Amérique, se rend auprès de la reine Eléonore qui
 avait manifesté le désir de le voir ; elle le reçut
 entourée de quelques unes de ses dames d'honneur.
 Colomb lui raconte ses aventures, et lui fait voir
 différens objets rapportés par lui de ses
 découvertes du nouveau monde" (Vie de Christophe
 Colomb) 1396

1841 Mme Eugène Mathieu : "Henri IV recevant les chevaliers de l'
 Ordre du Saint-Esprit"
 "Cette planche fait partie de l'ouvrage intitulé :
 'Galerie historique de Versailles', publié par
 M. Gavard) 2235

1842 Mme Debay jeune : "Henri IV faisant chevalier son fils Louis
 XIII" 2713

1843 Mme Latil (née Henry) : "Faux mariage de don Juan de Padella le
 fameux chef des Communéros, avec Dona Maria Pacheco
 en présence de la reine Jeanne-la-Folle, dans les
 appartements secrets de l'Alcazar de Tordesilas" 712

1845 Mme Marie-Elisabeth Cavé : "Plan de la Bataille d'Ivry"
 "Gaston d'Orléans range ses soldats par bataillon -
 Marie de Médicis contient avec peine Henriette d'
 Angleterre qui veut s'emparer des canons. Aussi ,
 boude-t-elle sur l'épaule de sa mère. La petite
 Marie a fait un prisonnier qu'elle va placer dans
 sa voiture" 277

1845 Mlle Hélène Feillet : "Embarquement de Lafayette en 1777, au
 port de los Pasages (Espagne), lors de son premier
 voyage pour l'Amérique" 580

1847 Mme Marie-Elisabeth Cavé : "Convalescence de Louis XIII" 288
1847 Mme Marie-Elisabeth Cavé : "Un tournoi" 289

1848 Mlle Henriquetta Girouard : "Louis XV et la duchesse de
 Châteauroux"
 "Tout à coup la duchesse de Châteauroux reçoit
 l'ordre de s'éloigner de la cour - ordre d'un roi
 décelant dans son repentir ce qu'il avait décelé
 dans ses fautes, une âme faite pour être subjugée"
 (Lacretelle jeune, "Histoire du XVIIIe siècle") 1995

1848 Mlle Henriquetta Girouard : "Louis XV après le départ de la
 belle duchesse de Châteauroux"
 "Il se recueillait fréquemment dans son cabinet
 de travail pour admirer ses traits chéris" 1996

1848 Mme Clotilde Juillera: : "Philippe Mélanchton, ami de Luther et
 réformateur laïque (1520)" 2461 (+ see A1)

1849 Mme Juillerat (née Clotilde Gérard) : "Le grand Condé, battu
 à la porte Saint-Antoine par les troupes du roi
 sous les ordres de Turenne" 1152

Y. 1840 Mme Anna Rimbault-Borrel : "Catherine de Médicis et Marie-
 Stuart chez Nostradamus"
 " ... Et sur cette blonde tête, mon père, dit
 Catherine, en présentant Marie au prophète, voyez-
 vous planer quelque grand malheur ?
 Nostradamus ouvrit alors son livre des destinées,
 et étendant la main sur l'enfant effrayée : "J'y

vois du sang, Madame', répondit-il d'une voix
grave et lente" (Chronique du XVIe siècle) 1402

1840 Mlle Elise Journet : "Eustache Lesueur" 910 (+ see vol.1 p194)

1841 Mme Edmond Flood : "Une aventure en mer"
"Madame Denoyer, après avoir passé plusieurs
années dans une de nos colonies, revint en France
avec son mari et ses deux enfants. Les matelots
pour s'emparer de leur fortune, assassinent M.
Denoyer, et abandonnent la malheureuse mère, ses
enfants et sa fidèle négresse dans une barque
fragile. Ils sont, pendant sept jours, le jouet
d'une mer furieuse, privés de nourriture, et c'
est alors tout espoir leur paraît perdu, que la
négresse, dont le courage n'avait pas failli,
aperçoit un navire ; ils ont le bonheur d'être vus,
et sont recueillis à bord de ce bâtiment. Huit
jours après, ils débarquaient à la Nouvelle-
Orléans" (France maritime) 722

1841 Mlle Claire Laloua : "Agnès de Méranie"
"Philippe-Auguste avait épousé Ingelburge,
princesse de Danemarck ; il s'en sépara le
lendemain de ses noces et obtint un divorce ;
puis il épousa Agnès de Méranie. Cependant le
pape voulut le forcer à quitter Agnès et reprendre
Ingelburge . Comme on s'assemblait pour une nouvelle
revision demandée par le roi, tout à coup il courut
reprendre sa première femme, abandonnant Agnès qui
mourut de chagrin" 1159

1841 Mme Sophie Rude : "La duchesse de Bourgogne arrêtée aux portes
de Bruges"
"En 1436, les Brugeois se révoltèrent : le duc
Philippe-le-Bon leur demanda de laisser partir sa
femme et son fils ; ils y consentirent ; mais
tandis qu'elle sortait de la ville, escortée par
Guillaume et Simon de Lalaing, les révoltés conduits
par Jean Lekart arrêtèrent sa voiture et en
arrachèrent la femme de sire Roland et la veuve
du sire de Horn récemment massacrés par eux. La
duchesse tremblante et tenant son fils serré contre
son sein, put cependant continuer sa route au
milieu des cris des injures" (Barente : "Histoire
des ducs de Bourgogne") 1763 (Musée de Dijon)

1841 Mme D'Arquinvilliers : "Résurrection d'un jeune enfant devant
la statue miraculeuse de Notre-Dame de Pontoise"
(Chronique de Pontoise, année 1748) 47

1841 Mlle Adèle Tardieu : "Madame Elizabeth (10 mai 1794)" 1859
(+ see vol. 1 p193)

1842 Mlle Athalie du Faget : "Assassinat de Gustave III, roi de
Suède, dans un bal masqué ; porcelaine" 644

1842 Mlle Clara Filleul : "La folle du Luxembourg" 673 (+ see vol.1
p193)

1842 Mme Latil, née Henry : "Adieux de Gabrielle d'Estrées et de
Henri IV"
"Le roi vient d'accompanger Gabrielle jusqu'à la
barque qui doit la conduire de Melun à Paris, où
elle se rend pour y faire ses dévotions. Ce fut
peu de jours après qu'elle mourut empoisonnée, sans
avoir revu le roi" 1139

1843 Mme Clémentine de Bar : "Sainte Perpétue dans sa prison" 30
(+ see note 122)

1843 Mlle Elise-Marie-Thomase Journet : "Lavoisier en prison"
663 (+ see note 112)

1844 Mlle Anne-Marie-Elisa Anfray : "Antoine Allegri, dit le
 Corrège"
 "Après avoir reçu à Parme un paiement de soixante
 écus en quadrins, il voulut porter à Correggio cet
 argent, dont il avait besoin, et partit à pied avec
 cette charge, par un soleil brûlant. A son arrivée,
 harassé de fatigue et de chaleur, il se mit au lit
 avec une fièvre très violente qui termina ses
 jours" (Vasari - "Vie des Peintres") 30

1844 Mme Anne-Charlotte Jodin : "Anna Boleyn, la veille de son
 exécution, reçoit les embrassements d'Elisabeth,
 sa fille" 978

1844 Mlle Octavie Rossignon : "Silvio Pellico au Spielberg" 1573
 (+ see note 127)

1845 Mme Marie-Elisabeth Cavé : "Episode"
 "Les Russes approchaient du château. Nous primes
 les armes en gens résolus. Cependant les mots de
 pillage et de massacre circulaient parmi nos
 domestiques. Mes deux jeunes filles effrayées
 revêtirent des habits de paysannes et prirent la
 fuite au hasard. Le lendemain on les retrouva à
 six lieues de là, toutes deux endormies au bord
 d'un bois, sous la garde d'un chien de ferme qui
 les avait suivies" (Extrait des "Mémoires du
 comte de **") 276

1846 Mme Louise Desnos : "Interrogatoire et condamnation de la
 princesse de Lamballe (3 septembre 1792)" 527 (+
 see note 114)

1848 Mlle Elise Allier : "Cazotte et sa fille à la prison de l'
 Abbaye" 41 (+ see note 117)

1848 Mlle Elise Allier : "Cazotte sauvé par sa fille" 42 (+ see
 note 118)

1848 Mlle Elise Allier : "Mort d'Elisabeth Cazotte" 43 (+ see
 note 119)

Z. 1844 Mlle Virginie Dautel : "Mlle de La Vallière au couvent de la
 Visitation, à Chaillot" 456 (+ see note 123)

 1844 Mme Z. Empis : "Paysage historique"
 "En 1631, Marie de Médicis, retenue prisonnière
 à Compiègne, sous la garde du maréchal d'Estrées,
 se promenait sur les étangs de la forêt, avec le
 père Suffren, son confesseur, et quelques personnes
 de sa maison" ("Mémoires sur l'Histoire de France")
 636

 1844 Mlle J. Fabre d'Olivet : "Les protestantes des Cévennes" 646
 (+ see note 124)

 1844 Mlle Claire Pillault : "Valentine de Milan"
 "Rien ne m'est plus, plus ne m'est rien" 1448
 (Valentine de Milan was also portrayed in 1844 by
 Mme d'Arquinvilliers : "Valentine de Milan ;
 tête d'étude" no. 41)

 1845 Mme Juillerat (née Clotilde Gérard) : "La toilette d'Anne
 Autriche"
 "La reine étant à sa toilette, et en présence de
 Gaston d'Orléans, de la princesse Marie de Mantoue
 et de quelques familiers, M. le duc de Bouillon
 arrive précipitamment pour la prévenir que le
 cardinal de Richelieu, afin d'agrandir sa
 domination, veut s'emparer du Dauphin, depuis Louis
 XIV. A cette nouvelle, la reine s'écrie : 'Mon fils !
 me l'enlever !'" (Mémoires du temps) 909
 (Anne d'Autriche was also portrayed in 1848 by Mlle

Estelle-Félicie-Marie Barcscut in "Une lecture chez Anne d'Autriche" no. 194)

1848 Mme A-D Amsinck : "Premier envahissement des sables d' Escoublac"
"En 1785, plusieurs familles de laboureurs et pêcheurs bretons trouvèrent, après une courte absence, leurs habitations englouties sous les sables. Deux ans plus tard, ce terrible fléau ensevelit en entier le village d'Escoublac" (Pitre-Chevalier - "Histoire de Bretagne") 51

1848 Mlle Elise Allier : "Mort d'Elisabeth Cazotte" 43 (+ see note 119)

A1. 1840 Mlle Virginie Dautel : "Un saint en méditation, étude" 367
1840 Mme Désaugiers : "Saint Lucien ; tête d'etude" 433
1840 Mlle Augusta Lebaron : "Sainte Geneviève"
"Sa mère allant à l'église en un jour de fête solennelle, voulut l'obliger de rester à la maison. Geneviève la conjura en pleurant de lui permettre d'y aller aussi, et comme elle continuait de lui faire de vives instances, cette femme entra en colère et lui donna un soufflet. Son emportement fut puni sur-le-champ ; elle perdit la vue, et demeura aveugle près de deux ans. Enfin se souvenant de la prédiction de saint Germain, et poussée par un mouvement extraordinaire de foi, elle dit à sa fille de lui apporter de l'eau du puits, et de faire le signe de la croix dessus. Geneviève lui en ayant apporté, elle s'en lava les yeux deux ou trois fois et recouvra la vue entièrement" (Vie des Saints) 1017
1841 Mme C. de Bar : "L'aumône de Sainte Elisabeth" 76
1841 Mme Paul Juillerat : "Sainte Elisabeth, reine de Hongrie, dans une de ses promenades, rencontre un petit mendiant qu'elle ramène à son château" 1081
1841 Mme Leroux de Lincy : "Jeune Martyre ; étude" 1294
1841 Mlle Liénard : "Baptême de saint Louis, dans l'église collégiale de Poissy, par Albéric, archevêque de Reims"
"Le moment représenté est celui où le prélat, accompagné de ses assistants, après avoir quitté le pluvial et l'étole violette, pour se revêtir du pluvial et de l'étole blanche, légués par Saint Rémy à ses successeurs, pour ne servir qu'au baptême, va procéder à la troisième immersion et remettre le royal enfant au parrain qui se dispose à le recevoir.
Derrière l'auguste famille est placé le connétable Dreux de Mello, IVe du nom, revêtu de la cotte cramoisie et tenant l'épée de Charlemagne la pointe élevée" 1316
1841 Mlle Caroline Swagers : "Sainte Catherine de Sienne, religieuse de l'ordre de Saint-Dominique" 1857
1842 Mme Rose d'Arquinvilliers née de Parron : "Sainte Cécile" 30
1842 Mme Rose d'Arquinvilliers née de Parron : "Saint Louis et la reine Blanche venant prier sur le tombeau de Saint Gauthier, dans l'abbaye de Saint-Martin, près Pontoise" (Chronique de Pontoise) 31
1842 Mme Louise Desnos : "Consécration de sainte Geneviève à Dieu"
" ... Saint Germain laissant sa main sur la tête de l'enfant, la conduisit à l'église, et elle.y passa toute la nuit seule et dans la prière. Le lendemain l'evêque retourna vers elle et lui dit :

'Rappelle-toi ce que tu m'as promis hier'.-' Je
m'en souviens reprit la jeune fille, et j'y
persiste'. Alors Saint Germain prenant une pièce
d'airain marquée du signe de la croix, qui se
trouva là par ordre du ciel, il la donna à
Geneviève en disant : 'Prends cette pièce d'
airain et en mémoire de moi porte-la toujours
suspendue à ton cou et ne souffre aucun orne-
ment ou d'or ou d'argent, ou de pierre précieuse ;
car si le plus petit ornement profane occupait
ton esprit, ceux du ciel ne feraient plus ton
unique parure'" (Actes de sainte Geneviève,
Recueil des Bollendistes" tome 1, p 138) 545

1842 Mme Empis : "Vue de la forêt de Pongebaud (Auvergne) : paysage
historique"
"En 533, Brachion, esclave de Sigiswald, duc d'
Auvergne, chassait un sanglier dans la forêt de
Pongibaud. La bête se réfugia près d'un saint
ermite nommé Emilien, sans que les chiens ôsassent
la poursuivre. Le jeune homme étonné s'approcha, et
se trouva en face du vénérable vieillard, qui l'
exhorta à se consacrer à Dieu" (Grégoire de
Tours) 629

1842 Mlle Maria de Glatigny : "Catherine de Suède"
"Les vertus et la grande piété de cette princesse
la firent mettre au rang des saintes (XIVe siècle)"
806

1842 Mlle Camille de Lagrange : "Sainte Geneviève, patronne de
Paris" 1099

1842 Mlle Eugénie Lalouette : "Sainte Thérèse" 1109

1842 Mlle Henriette Mulard : "Sainte Victoire, vierge et martyre"
1403

1843 Mme Clémentine de Bar : "Sainte Perpétue dans sa prison" 30
(+ see note 122)

1843 Mlle Adèle Ferrand : "Sainte Geneviève" 417

1843 Mlle Eugénie Lalouette : "Sainte Elisabeth, reine de Hongrie,
distribuant des aumônes" 699

1843 Mlle Augusta Le Baron : "Sainte Bernardin de Sienne"
"Bernardin, sorti d'une des premières familles de
la république de Sienne, naquit à Massa en 1380. Il
était encore enfant lorsqu'il perdit son père et
sa mère. Une de ses tantes, nommée Diane, se
chargea de son éducation ; c'était une femme
vertueuse qui lui inspira une grande piété envers
Dieu et une dévotion particulière envers la
Sainte Vierge. Le jeune Bernardin charmait par sa
modestie, sa douceur et son humilité. Dès ses
premières années, il montrait une grande compassion
envers les pauvres. Sa tante en ayant un jour renvoyé
un sans lui rien donner, parce qu'il n'y avait qu'un
pain dans la maison pour le dîner de toute la
famille, il en fut sensiblement touché . 'Pour l'
amour de Dieu, dit-il à sa tante, donnons quelque
chose à ce pauvre homme, autrement je ne pourrai
ni dîner ni souper du jour ; j'aime mieux me passer
de dîner que ce pauvre'" ("Abrégé de la vie des
Pères, des Martyrs et autres principaux Saints",
par M. Godesland) 719

1843 Mlle Henriette-Clémentine Mulard : "Sainte Solange, patronne
du Berry" 889

1844 Mlle E. Decret : "Sainte Geneviève priant Dieu en gardant son
troupeau" 471

1844 Mlle Clémence Dimier : "Saint Jean écrivant l'Apocalypse dans
 l'île de Pathmos"
 10 - Un dimanche, je fus ravi en esprit
 (Apocalypse de saint Jean, chap.1 S II) 560
1844 Mlle Z. Ducluseau : "Sainte Geneviève" 588
1844 Mlle Caroline Duval : "Saint Charles Borromée" 620
1844 Mlle Virginie Dautel : "Mlle de La Vallière au couvent de la
 Visitation, à Chaillot" 456 (+ see note 123)
1844 Mlle J. Fabre D'Olivet : "Les protestantes des Cévennes" 646
 (+ see note 124)
1844 Mlle Amanda Fougère : "Saint Paul ; tête d'étude" 705
1844 Mme Désirée-Angeline Jeanron : "Sainte Catherine d'Alexandrie"
 970
1844 Mlle Augusta Lebaron : "Sainte Marane et sainte Cyre"
 "Ces deux vierges étaient deux soeurs nées vers
 le commencement du Ve siècle à Berée, en Syrie,
 d'une famille illustre dans le pays. Occupées de
 leur salut, elles mirent toute leur gloire à
 mépriser le siècle présent et à ne vivre que pour
 l'éternité. Pour s'en rendre la voie plus facile,
 elles quittèrent la maison paternelle, et allèrent
 s'enfermer dans un petit enclos de murailles hors
 les portes de la ville. Ce fut dans ce lieuque ces
 victimes innocentes de la pénitence commencèrent
 un sacrifice qui dura autant que leur vie ; elles
 firent bâtir, à côté de leur petit enclos, une
 cellule pour celles de leurs servantes qui voulurent
 les suivre et marcher sur leurs traces dans la
 carrière d'une mortification si rigoureuse. Il y
 avait à cette maison une fenêtre qui donnait sur l'
 enclos des deux soeurs, et c'était par-là qu'elles
 examinaient les actions de celles qui avaient
 voulu les imiter, et les animaient au service de
 Dieu.
 Il n'est guère possible de pousser plus loin les
 rigueurs de la pénitence que le firent ces deux
 soeurs ; elles n'avaient ni cellules ni toit ;
 elles demeuraient tout le jour exposées aux injures
 de l'air ; elles recevaient seulement un peu de
 nourriture, c'est-à-dire du pain et de l'eau, par
 la petite fenêtre dont il est parlé. Voilà la
 manière dont elles vécurent, et dans laquelle elles
 ont passé quarante-deux ans . Une vie si admirable
 les a rendues l'ornement de leur sexe et l'example
 de celles qui se proposent d'arriver au comble de
 la perfection" (Vie des Saints, tome II) 1117
1844 Mlle Octavie Paigné : "Extase de sainte Elisabeth de Hongrie ;
 pastel" 2087
1845 Mlle Clémentine Dondey de Santény : "Saint Mathieu, apôtre et
 évangeliste" 488
1845 Mlle Amanda Fougère : "Sainte Cécile" 626
1845 Mlle Marie Glatigny : "Saint Dommole evêque (VIe siècle)" 726
1846 Mme Joséphine Calamatta : "Sainte-Cécile" 287
1846 Mlle Félicité Chastanier : "Sainte Geneviève enfant" 356
1846 Mlle Elisa Bourdier : "Sainte Thérèse" 227
1846 Mlle Amanda Fougère : "Le petit Saint Jean" 687
1846 Mme Elisabeth Lemercier : "Sainte Hélène, mère de Constantin"
 "Pour satisfaire la dévotion qu'elle avait de visiter
 les lieux consacrés par les mystères de J-C, elle
 partit l'an 316 ... Lorsqu'elle fut arrivée à
 Jérusalem, elle découvrit le sépulchre du Sauveur ..
 Elle donna ses soins pour la construction de la

superbe église du Saint-Sépulchre" (Vie des
Saints) 1175

1846 Mme Emma Leroux de Lincy : "Sainte Julie" 1195

1846 Mlle Adèle Poissant : "Sainte Catherine, martyre ; dessin" 2052

1847 Mme Clémentine de Bar : "Trait de l'enfance de sainte Thérèse"
> "La jeune sainte, encore enfant, mais déjà passionnée
> pour le ciel, emmenait à l'écart son frère Rodrigue
> pour lire la 'Vie des Saints' . Les exemples des
> martyrs les enflammèrent tellement, qu'ils résolurent
> un jour de s'enfuir chez les infidèles, afin d'y
> verser leur sang pour la foi.
> On sait que les Maures d'avaient pas encore été
> expulsés d'Espagne à cette époque.
> La jeune sainte est représentée au moment où,
> plongée en extase, elle médite son pieux projet"
> ("Vie de sainte Thérèse" par M. Villefort) 69

1847 Mme Anna Clément : "Sainte François d'Assise priant" 348

1848 Mlle Emilie-Marguerite Hoffmann : "Jeanne d'Arc ; dessin" 2281

1848 Mme Sophie Jobert : "Sainte Geneviève ; dessin" 2401

1848 Mme Sophie Jobert : "Sainte-Cécile ; dessin" 2402

1848 Mme Clotilde Juillerat : "Philippe Melanchton, ami de Luther
et réformateur laïque (1520)"
> "Nulle part il ne se sentait plus heureux qu'
> auprès de sa Catherine et de ses enfants. Un
> voyageur français ayant trouvé un jour le 'maître
> de la science en Allemagne' berçant d'une main son
> enfant, et de l'autre tenant un livre, s'arrêta
> surpris. Mais Melanchton, sans se déranger, lui
> expose avec tant de chaleur le prix des enfants
> devant Dieu, que l'étranger sortit de la maison
> plus savant, dit-il, qu'il n'y était entré"
> ("Histoire de la Réformation du XVIe siècle" par
> M. d'Aubigné) 2461

1848 Mlle Lise Lemarchant : "Cinq miniatures ; même numéro" 2892
2. "Saint François d'Assise en méditation"

1848 Mlle Pauline Malherbe : "Un saint en méditation" 3115

1849 Mme Clémentine de Bar : "Sainte Geneviève, patronne de Paris" 60

1849 Mme Lavalard (veuve J-B) : "Napoléon rendant témoignage à l'
Evangile"
> "Le voici sur cette table, le livre par excellence
> (et ici l'Empéreur le toucha avec respect). Je ne
> me lasse de le dire, et toujours avec le même
> plaisir" ("Captivité de Sainte Hélène") 1250

B1. 1840 Mme Elise Clément Boulanger : "Un tournoi ; aquarelle"
> "Louis XIII, Gaston d'Orléans son frère, et de
> jeunes seigneurs, enfans comme eux, ont simulé
> une passe d'armes dans une des cours du Louvre ;
> tandis que le vaincu est emporté loin du théâtre
> de sa défaite, le jeune roi vainqueur, va recevoir
> sous un dais porté par quatre petits gentilshommes
> la récompense du triomphe. La main de la plus belle
> lui est livrée ; il est aussi couronné par elle.
> Sur le devant du tableau, d'autres enfans réparent
> les désastres du tournoi, les brides du cheval où
> se sont engagés des noeuds difficiles à défaire. La
> petite princesse Marie (Louise de Gonzague) arrive
> toute fière avec le casque du vaincu sur sa tête.
> Plus loin une gouvernante tient le plus petit des
> enfans ; près d'elle, et comme pour montrer l'
> exiguité des chevaliers qui ont concouru aux luttes
> du tournoi, Rubens prend un croquis de la scène qui

se passe sous ses yeux" 147
The artist also exhibited "Un tournoi" without
the quotation, in 1847, no. 289

1840 Mlle Elise Journet : "Eustache Lesueur" 910 (+ see vol.1
p194)

1840 Mllc Mélina Thomas : "Gresset lisant à sa soeur l'épître qu'
il lui avait adressée sur sa convalecence" 1555

1840 Mme Verdé de Lisle : "Lully enfant chez Mlle de Montpensier"
"Lully, à peine âgé de douze ans, employé dans les
cuisines de 'Mademoiselle', venait de composer l'air
'au Clair de la Lune', qu'il faisait chaque jour
chanter en choeur par tous les cuisiniers ;
'Mademoiselle', agréablement surprise de cette
harmonie, voulut faire entendre le jeune marmiton
musicien à Lambert, maître de musique de la chambre
du roi, qui, reconnaissant de suite les heureuses
dispositions de Lully, obtint qu'il serait admis au
nombre des pages de 'Mademoiselle', et voulut lui-
même, par son talent, contribuer à développer le
génie de cet artiste devenu si célèbre" 1607

1842 Mlle A. Pagès : "Justine de Lévis, poète du 14e siècle" 2809

1844 Mlle Anna-Marie-Elisa Anfray : "Antoine Allegri, dit le
Corrège" 30 (+ see Y)

1844 Mlle Octavie Rossignon : "Silvio Pellico au Spielberg" 1573 (+
see note 127)

1844 Mme Adine Verdé de Lisle : "Rubens enfant montrant ses premiers
croquis à son père et à sa famille" (Henry Berthoud
- "Vie de Rubens") 1750

1845 Mme Brune : "Léonard de Vinci peignant le portrait de La Joconde,
Bramante présente Raphael au grand artiste"
"Vasari assure que Léonard, pour conserver la
grâce d'expression de son modèle, lui faisait donner
des récréations musicales" 233

1845 Mme Marie-Elisabeth Cavé : "Enfance de Paul Veronèse"
"Paul Veronèse étudia la peinture dans l'atelier
de son père et de son oncle Bastide, sculpteur ;
mais il avait aussi chez sa mère son atelier
particulier, où il passait ses moments de loisir et
se livrait à toute l'effervescence de son génie.
Aussi, sa jeune soeur et un de ses petits camarades
l'appelaient-ils : signor Maestro. Il était pour eux
un oracle, et sa mère, dit-on, s'illuminait de joie
en l'écoutant" 275

1845 Mme Marie-Elisabeth Cavé : "Enfance d'Haydn"
"Il naquit le 31 mars 1732, au village de Bohrren.
Son père, pauvre charron, savait jouer quelques
airs de harpe. Dès l'âge de trois ans le petit
Joseph les répétait en mesure en soufflant dans une
espèce de flûte ; quelquefois avec sa soeur, qui
jouait du tambour de basque, ils s'introduisaient
dans les parcs des châteaux et ils faisaient danser
les enfants" 278

1845 Mme Marie-Elisabeth Cavé : "Enfance de Lawrence"
"Les premières années de Lawrence se passèrent dans
l'auberge de son père qui, fier de ses dispositions
précoces, en parlait à ses hôtes de manière à les
en fatiguer. Mais dès que le bel enfant blond
paraissait, on était séduit et les dames aimaient à
poser devant lui. Un membre du parlement l'ayant
vu dessiner les traits de sa femme, l'amena à
Londres et se chargea de son éducation" 279

1845 Mlle Elise-Marie-Thomase Journet : "Brauwer et Craesbeke"
 "Craesbeke, né à Bruxelles, étoit boulanger :
 il fut s'établir à Anvers, où il fit connoissance
 avec Brauwer. Ayant tous deux les mêmes goûts, ils
 furent bientôt liés d'amitié. Dès que Craesbeke
 avoit vuidé son four, il se rendoit chez son ami,
 où il examinoit sa manière d'ébaucher et de finir
 ses ouvrages. La journée finie, ils alloient
 ensemble boire et fumer. Craesbeke essaya de peindre:
 ses essais plurent à Brauwer qui l'aida de ses
 leçons. Le boulanger quitta son premier métier et
 égala presqu'autant son maître dans ses tableaux
 qu'il l'avait imité dans ses moeurs" (Descamps
 - "La vie des peintres flamands", tome II) 898
1847 Mlle Adèle Grasset : "Silvio Pellico dans sa prison, à Venise"
 "La fille du géolier baise un passage de la Bible
 qu'il vient de lui expliquer" 748
1848 Mlle Elisa Allier : "Cazotte et sa fille à la prison de l'
 Abbaye" 41 (+ see note 117)
1848 Mlle Elise Allier : "Cazotte sauvé par sa fille" 42 (+ see
 note 118)
1848 Mlle Elisa Allier : "Mort d'Elisabeth Cazotte" 43 (+ see note
 119)
1848 Mme Ernestine Bigarne : "Le Tasse dans la prison de Ferrare" 371

C1. 1840 Mme Louise Desnos : "Le denier de la veuve" (St. Marc, ch.12)
 "41 Jésus étant assis vis à vis du tronc, prenait
 garde de quelle manière le peuple y jetait de l'
 argent ; et plusieurs gens riches y en mettaient
 beaucoup.
 42 Il vint aussi une autre veuve, qui y mit
 seulement deux petites pièces qui faisaient le
 quart d'un sou.
 43 Alors Jésus ayant appelé ses disciples, leur
 dit : Je vous dis en vérité que cette pauvre veuve
 a plus donné que tous ceux qui ont mis dans le tronc.
 44 Car tous les autres ont donné de leur abondance ;
 mais celle-ci a donné de son indigence même, tout ce
 qu'elle avait, ce qui lui restait pour vivre" 439
1840 Mlle Célestine Faucon : "Etude de Vierge" 351
1840 Mlle Sophie Hubert : "Agar dans le désert"
 "Or, quand l'eau de la cruche eut manqué, elle mit
 l'enfant sous un arbrisseau, et elle s'en alla à
 la portée d'une flèche, et s'assit vis-à-vis - car
 elle dit : 'Que je ne voie pas mourir l'enfant'. S'
 étant donc assise, elle éleva sa voix et pleura"860
1840 Mlle Méloé Lafon : "Le Magnificat"
 "En ce jour-là, Elizabeth vint au-devant de Marie
 et la salua du titre de Mère de Dieu. Alors Marie,
 transportée d'un saint ravissement à la vue des
 hautes merveilles que le Tout-Puissant avait faites
 en sa faveur, entonna le sublime cantique du
 'Magnificat'" (Evangile selon Saint Luc ch. 1, v.4)
 964
1840 Mme Céleste Pensotti : "Marguerite chez Marthe" 1264
1840 Mlle E. Serret : "Marie Madeleine au tombeau de Jésus-Christ"
 1501
1840 Mlle Mélina Thomas : "Agar dans le désert"
 "L'Ange lui ayant indiqué la source, elle y porta
 son enfant, et le rendit à la vie" (Genèse ch. 2)
 1554
1841 Mme A. Brune : "Moïse sauvé des eaux"

" ... Alors Pharaon fit ce commandement : "Jetez
dans le fleuve tous les enfans mâles des Hébreux'
En ce même temps, la fille du roi d'Egypte vint
pour se baigner accompagnée de ses femmes. Elles
trouvèrent une corbeille au milieu des roseaux
et l'apportèrent à la princesse, qui, l'ayant fait
ouvrir, y trouva un jeune enfant qu'elle adopta et
nomma Moïse, c'est-à-dire sauvé de l'eau.
La soeur de Moïse, qui s'était tenue à l'écart,
s'étant approchée, lui dit : "Vous plaît-il que
j'aille quérir une femme des Hébreux pour nourrir
ce petit enfant?' .." (Genèse) 247
(Described in "L'Artiste" 1841 vol.7 p 264)

1841 Mlle Irma Martin : "Moïse exposé sur les eaux" 1395
1841 Mme Meynier : "L'adoration des bergers" 1441
1841 Mme Meynier : "Notre-Dame-des-Petits-Enfans" 1442
1841 Mlle E. Serret : "Agar dans le désert" 1813
1842 Mme Juliette de Bourge : "Quatres portraits - miniatures"
 1. "Une Vierge - étude" 235
1842 Mme Brune, née Pagès : "La fille de Jaire"
 "41 - Alors il vint à lui un homme appelé Jaire,
 qui était un chef de synagogue, et se prosternant
 aux pieds de Jésus, il le suppliait de venir en
 sa maison.
 42 - Parce qu'il avait une fille unique, âgée d'
 environ douze ans, qui se mourait.

 49 - Comme il parlait encore, quelqu'un vint dire
 au chef de synagogue : Votre fille est morte, ne
 donnez point davantage de peine au maître.
 50 - Mais Jésus ayant entendu cette parole, dit au
 père de la fille : Ne Craignez point, croyez
 seulement, elle vivra.
 51 - Etant arrivé au logis, il ne laissa entrer
 personne que Pierre, Jacques et Jean, avec le père
 et la mère de la fille.
 52 - Et comme tous ceux de la maison la pleuraient,
 en se frappant la poitrine, il leur dit : Ne pleurez
 point, cette fille n'est pas morte, mais seulement
 endormie.
 53 - Et ils se moquaient de lui, sachant bien qu'
 elle était morte.
 54 - Jésus la prenant donc par la main, lui cria :
 Ma fille, levez-vous.
 55 - Et son âme étant retournée dans son corps, elle
 se leva à l'instant" (Evangile selon Saint Luc, ch.
 viii) 267

1842 Mme Joséphine Calamatta : "La Vierge et l'Enfant Jésus" 281
1842 Mlle Anaïs Colin : "Une Sainte-Famille" 396
1842 Mlle Eugénie Lalouette : "Le sommeil de Jésus" 1108
1842 Mlle Irma Martin : "Moïse"
 "Jocabel, après avoir reçu de la fille de Pharaon
 son propre fils pour le nourrir, s'empresse de le
 porter à Amrain, son époux, et ensemble ils
 remercient le Seigneur de leur avoir conservé leur
 enfant" 1331
1842 Mlle Blanchard : "Une Assomption" 2687
1843 Mme Joséphine Calamatta : "La Vierge et l'Enfant-Jésus bénissant
 l'ordre des Dominicains" 163
1843 Mme Joséphine Calamatta : "Laban accorde sa fille Rachel à
 Jacob" 164
1843 Mme Empis : "Le lac de Génézareth ; paysage historique"

"24 - Or, il s'éleva sur le lac une si grande
tempête que la nacelle étoit couverte de flots,
et Jésus dormoit.
25 - Ses disciples vinrent à lui et l'éveillèr-
ent en lui disant : Seigneur, sauve-nous, nous
périssons.
26 - Et il leur dit : Pourquoi avez-vous peur,
gens de peu de foi ? Alors s'étant levé, il parla
fortement aux vents et à la mer, et aussitôt il
se fit un grand calme" (Evangile selon Saint
Matthieu, ch. VIII) 406

1843 Mlle Sophie Hubert : "Sujet tiré de la Bible"
"4 - Il m'a enseigné et m'a dit : 'Que ton coeur
retienne mes paroles, garde mes commandements, et
tu vivras.
5 - Acquiers la sagesse, acquiers la prudence,
n'en oublie rien, et ne te détournes pas des
paroles de ma bouche" (Proverbe de Salomon,
ch. IV) 629

1843 Mme Irma Martin : "Les saintes femmes au tombeau du Christ"
"Celui que vous cherchez n'est plus ici" 846

1843 Mme Claire Pillaut : "Madeleine aux pieds de Marie"
"Marie lui rendit les bras et lui dit : ma fille
approchez-vous ; je vous attendais.
A ces paroles ... Madeleine vint se précipiter
devant elle, et cachant son visage dans les
vêtements de la Vierge, elle ne put pendant
longtemps que pleurer avec abondance" ("Les
Lys d' Israel", t. II, p 130) 953

1843 Mlle Clémence Sollier : "Saint Jean Baptiste" 1542
1844 Mme J. Calamatta : "Sainte Famille" 253
1844 Mme J. Calamatta : "Tête de Christ" 255
1844 Mlle Henriquetta Girouard : "La Madeleine repentante" 799
1844 Mlle Henriquetta Girouard : "Etude de Vierge" 800
1844 Mlle Claire Pillault : "Marthe et Marie-Magdeleine"
"28 - Lorsqu'elle eut ainsi parlé, elle s'en
alla et appela tout bas Marie, sa soeur, en lui
disant : Le Maître est venu, et il vous demande.
29 - Ce qu'elle n'eut pas plutôt oui, qu'elle se
leva et l'alla trouver" (Evangile selon Saint
Jean ch. XI s. 3) 1447

1844 Mlle E. Serret : "Jésus-Christ chez Simon"
"47 - Beaucoup de péchés lui sont pardonnés, parce
qu'elle a beaucoup aimé" (Evangile selon Saint
Luc, ch. III, v. 5) 1634

1844 Mme Hortense de Vivefay Wyatt : "Le repos de la Vierge" 1799
1845 Mlle Elisa Bertrand : "Le Christ au jardin des Oliviers, sujet
entouré d'une guirlande de fleurs" (M.I.) 108
1845 Mme Amélie Champein : "La Vierge et l'Enfant-Jésus" 289
1845 Mlle Eugénie Lalouette : "La mort de la Vierge" 959
1845 Mme Emma Leroux de Lincy : "Un Christ ; étude" 1092
1845 Mlle Eugénie Joséphine-Charlotte de Marcol : "Tobie"
"Le jeune Tobie reçoit la bénédiction de son père
au moment de son départ pour aller chercher une
dette chez Gabellus ; il est conduit et ramené
par un ange qui promet de veiller sur lui" 1158

1845 Mme Rullier : "Le pressentiment de la croix"
"L'Enfant-Jésus bénit la croix que lui présente
saint Jean ; la Vierge émue presse l'Enfant-Jésus
sur son coeur" 1490

1845 Mlle Clémence Sollier : "Saint Jean-Baptiste" 1542
1846 Mme Aimée Brune, née Pagès : "La fille de Jephté"

"29 - L'Esprit du Seigneur se répandit donc sur
Jephté ; et allant par tout le pays de Galaad, de
Manasse, de Maspha de Galaad il passa jusqu'aux
enfants d'Ammon,
30 - Et fit voeu au Seigneur, en disant : si vous
livrez entre mes mains les enfants d'Ammon,
31 - J'offrirai en holocauste au Seigneur le
premier qui sortira de la porte de ma maison, et qui
viendra au devant de moi, lorsque je retournerai
victorieux des enfants d'Ammon,
32 - Jephté passa ensuite dans les terres des
enfants d'Ammon pour les combattre, et le Seigneur
les livra entre ses mains.

.

.

34 - Mais lorsque Jephté revenait par Maspha dans
sa maison, sa fille qui était unique, car il n'
avait point d'autres enfants qu'elle, vint au-devant
de lui en dansant au son des tambours.
35 - Jephté l'ayant vue déchira ses vêtements et
dit : ah ! malheureux que je suis ! ma fille, car
j'ai fait un voeu au Seigneur, et je ne pourrai me
me dispenser de l'accomplir.
36 - Sa fille lui répondit : mon père si vous avez
fait voeu au Seigneur, faites de moi toit ce que
vous avez promis ...
37 - Accordez-moi seulement la prière que je vous
fais, laissez-moi aller sur les montagnes pendant
ces deux mois. Elle s'en alla donc avec ses
compagnes et ses amies, et elle pleurait sa
virginité sur les montagnes" ("Juges", Ch. XI, s.
4 et 5) 271

1846	Mme Marie-Elisabeth Cavé : "La Consolation" 322 (+ see vol. 1	
	p 195)	
1846	Mme Marie-Elisabeth Cavé : "Le songe" 323 (+ see vol. 1 p195)	
1846	Mme Fanny Geefs : "La Vierge consolatrice des affligés" 737	
1846	Mlle Henriquetta Girouard : "La Vierge et l'Enfant-Jésus" 775	
1847	Mlle Elisa Bertrand : "Guirlande de fleurs autour d'une tête de	
	Vierge" (M.I.) 132	
1847	Mme Amélie Champein : "La Sainte-Famille au Egypte" 299	
1847	Mlle Henriquetta Girouard : "Le sommeil de l'Enfant-Jésus" 721	
1847	Mme A. Guillot-Saguez : "La Madone et l'Enfant-Jésus, avec	
	saint Louis et saint Amélie de Hongrie" (Commandé	
	par la Reine) 793	
1847	Mme Eugénie Latil : "Mater dolorosa" 964	
1847	Mme Emma Leroux de Lincy : "Education de la Vierge" 1076	
1847	Mme Lavalard : "Le Christ, consolateur ; dessin"	
	"Femme, pourquoi pleures-tu ?" (Evangile selon	
	saint Jean) 1851	
1848	Mlle Elisa Bertrand : "La Vierge allaitant l'enfant-Jésus" 329	
1848	Mlle Léonie Biton : "La Madeleine au désert" 396	
1848	Mme Laure Bruyère : "L'Annonciation" 678	
1848	Mme Laure Bruyère : "L'Assomption" 679	
1848	Mme Calamatta : "Eve" 715	
1848	Mme Amélie Champein : "L'Enfant-Jésus" 804	
1848	Mme Anna Clément : "Ecce homo" 903	
1848	Mlle Maria Glatigny : "Madeleine en prière" 2003	
1848	Mlle Maria Glatigny : "Figure d'ange" 2004	
1848	Mlle Maria Glatigny : "Des anges en prière" 2005	
1848	Mlle Adèle Humbert : "La Madeleine" 2331	
1848	Mlle Augusta Le Baron : "Saint-Jean-Baptiste précurseur" 2741	
1848	Mlle Lise Lemarchant : "Cinq miniatures ; même numéro"	

```
                        1. "Une Sainte-Famille" 2892
    1848   Mlle Juliette Lévis : "Tête de Vierge ; pastel" 2989
    1848   Mme Anne Metcalfe : "La sainte Vierge" 3284
    1848   Mlle Pauline Pons de l'Hérault : "La Vierge du Rosaire ;
                    aquarelle" 3753
    1848   Mlle Pauline Pons de l'Hérault : "La Reine des anges ;
                    aquarelle" 3754
    1849   Mme Latil, née Eugénie Henry : "Saint Jean le Précurseur"
                    "Pour moi , je vous ai baptisé dans l'eau, mais
                    pour lui , il vous baptisera dans le Saint
                    Esprit" (Evangile selon Saint Marc, ch. I, v.
                    8) 1235
```

D1. Other allegorical works of the 1830s and 1840s :-
```
    1838   Mme J. Rullier : "Les trois vertus théologales" 1570
    1846   Mme Josephine Calamatta : L'Homme entre la Religion et la
                    Volupté" 288
    1846   Mme Héloise Leloir : "Espérance ; aquarelle" 1992
    1846   Mme Héloise Leloir : "Charité ; aquarelle" 1993
    1846   Mme Anaïs Toudouze : "Quatre aquarelles ; même numéro"
                    1. "La Charité" 2086
    1848   Mme Clementine de Bar : "L'ange conducteur de l'enfance"
                    "Bon ange, est-ce bien là mon chemin?" 178
```

E1. 1850 Henriette Durand : "Sainte-Catherine" 942
```
    1850   Mme Joséphine Calamatta : "Saint Antoine et l'Enfant Jésus" 438
    1850   Mme Jeanron : "Saint Jean" 1633
    1852   Mme Joséphine Calamatta : "Sainte Véronique" 209
    1852   Mme de Guizard : "Sainte Affre, martyre, patronne d'Augsbourg"
                    601 (+ see note 134)
    1852   Mlle Caroline Thévenin : "Sainte Cécile" 1177
    1853   Mlle Caroline Thévenin : "Sainte Geneviève enfant" 1103
    1853   Mme Verdé de l'Isle née Adine Pérignon : "Sainte Geneviève" 1152
    1855   Mlle Marie-Marguerite Chenu : "Conversion de saint Cyprien de
                    Carthage" 2724
    1855   Félicie de Fauveau : "Le Martyre de sainte Dorothée - groupe,
                    marbre, avec fond d'architecture" 5120
    1855   Mme Dallemagne (née Augustine-Philippe De Cagny) : "Sainte
                    Anne et la Sainte Vierge enfant" 2832
    1855   Mme de Guizard (née Clémence-Dufresne) : "Sainte Geneviève"
                    "Pendant le siège de Paris, sainte Geneviève, guidée
                    par une inspiration céleste, conduisit les assiégés
                    à Troyes où ils trouvèrent en abondance les secours
                    et les approvisionnements qu'elle leur avait promis"
                    3257
    1857   Mme Thérèse Lacuria : "Sainte Catherine d'Alexandrie"
                    "Sainte Catherine, appelée par les Grecs AEcatherine,
                    glorifia Jésus-Christ en confessant généreusement la
                    foi à Alexandrie, sous Maximin II. Catherine était
                    de sang royal ; elle avait de rares connaissances,
                    et confondit une assemblée de philosophies paiens
                    avec lesquels Maximin l'obligea de discuter" (Vie
                    de Sainte Catherine) 1497
    1857   Mlle Marie-Elisabeth;Ernestine Philippain : "Sainte-Geneviève,
                    patronne de Paris" 2145
    1857   Mlle Alida Rabe : "L'apôtre saint Paul en prison à Rome"
                    "J'ai bien combattu ; j'ai achevé ma course ; j'ai
                    gardé la foi" (2e Epître de saint Paul à Timothée,
                    ch. IV, v.7) 2235
```

F1. 1852 Mme Louise Desnos : "Enfance du Tintoret"
```
                    "Jacques Robusti, surnommé Le Tintoret, naquit à
```

Venise en l'an 1512. Son père, appelé Robusti, était
teinturier, ce qui fit donner le surnom de Tintoret
à son fils. Il n'était encore qu'un jeune enfant
qu'on le voyait continuellement dessiner sur les
murailles avec du charbon et des teintures, ce qui
fit résoudre ses parents à l'abandonner à son
inclination" 351

1855 Mme veuve Cavé (née Marie-Elisabeth) : "Convalescence de Louis
 XIII ; aquarelle"
 "Henri IV sur le plan de la bataille d'Ivry apprend
 les manoeuvres à ses enfants" 2673

1855 Mme veuve Cavé (née Marie-Elisabeth) : "Un tournoi d'enfants ;
 Louis XIII et Gaston d'Orléans - aquarelle"
 (Appartient à l'Etat) 2674

1857 Mme Lefèvre-Deumier (née Marie-Louise Roulleaux-Dugages) :
 "Virgile enfant - statue, marbre" 2977

G1. 1850 Mlle Henriquetta Girouard : "La Chaste Suzanne - étude" 1320
1850 Marguerite-Zéolide Lecran : "Jésus révélant à sa mère les
 souffrances de sa passion" 1892
1850 Mlle Pauline Maréschal : "La parabole du semeur"
 "En ce temps-là, Jésus proposa cette parabole au
 peuple" 2111
1850 Mlle Pauline Pons : "Histoire de la Vierge, page de Missel ;
 miniature sur parchemin" 2514
1850 Mlle Pauline Pons : "La Sainte-Famille ; miniature sur
 parchemin" 2515
1850 Mlle Coraly de Fourmond : "Le Christ et les petits enfants" 1128
1853 Mme Brune née Aimée Pagès : "La Sainte-Vierge offrant des fleurs
 dans le temple" 191
1853 Mme de Guizard née Clémence Dufresne : "Le Christ"
 "Je suis la voie, la vérité et la vie ; nul ne peut
 venir au Père que par moi" (Evangile selon Saint-
 Jean, ch. IV, v. 6) 577
1855 Mme veuve Cavé (née Marie-Elisabeth) : "Un triptyque et ses
 pendentifs, représentant les sept sacrements"
 (Appartient à l'Etat) 2671
1855 Mme veuve Cavé (née Marie-Elisabeth) : "La Sainte-Vierge après
 la mort de N.S. Jésus-Christ" 2672 (Musée de Rouen)
1855 Félicie de Fauveau : "Crucifix ; argent" 5119
1855 Mlle Louise Eudes de Guimard : "La captivité de Babylone" 3045
1855 Mlle Elie Wagner : "Résurrection" 4200
1857 Mlle Marie-Anne-Herminie Bigé : "Jésus-Christ et la Samaritaine"
 224
1857 Mme Amélie Champcin : "La Sainte Vierge" 475
1857 Mlle Marie Chenu : "La fille de Jephté" 507
1857 Mme Clémence Dufresne de Guizard : "La Madeleine aux pieds du
 Christ" 1276
1857 Mme Thérèse Lacuria : "Magnificat" 1498
1857 Mlle Marguerite-Zéolide Lecran : "Le sommeil de Jésus" 1655
1857 Mme Céleste Pensotti : "Madeleine" 2109
1857 Mme Marguerite de Saint Vidal : "Le Christ consolateur" 2381
1859 Mlle Marie-Anne-Herminie Bigé : "Moïse sauvé des eaux" 268
1859 Mlle Marie-Anne-Herminie Bigé : "Les saintes femmes au tombeau
 du Christ" 269
1859 Mme Laure de Châtillon : "L'éducation de Jésus" (M. d'Etat) 570
1859 Mme Dallemagne (née Augustine-Philippe de Cagny) : "Laissez
 venir à moi les petits enfants" 756
1859 Mlle Henriquetta Girouard : "La Vierge et l'Enfant-Jésus" 1286
1859 Mme Anna Pinel : "L'ensevelissement du Christ" 2462
1859 Mlle Caroline-Héloïse Vuitel : "La Vierge et l'Enfant-Jésus"
 2995
1859 Mlle Adélaïde Wagner : "Sainte Famille" 2999

H1. 1857 Mme Marsand, née Méloé Lafon : "La Foi, L'Espérance et
 la Charité sur les débris d'un temple païen" 1840

 1857 Mme Sophie Rude : "La Foi, l'Espérance et la Charité" 2354

 1857 Mme Léon Bertaux : "La Foi, l'Espérance et la Charité -
 benitier platre" 2734

 1859 Mlle Marie Chénu : "La Charité" 588

 1859 Mme Léon Bertaux : "Les trois Vertus théologales ; bénitier
 bronze (M. de l'Empéreur) 3081

I1. Others :-

 1861 Mlle Marie-Léonide Poisson : "Sainte Anne instruisant Marie"
 2570

 1863 Mlle Marie Cadet-Fontenay : "Sainte Claire" 320

 1863 Mme Collard, née Marie-Anne-Herminie Bigé : "Sainte-
 Catherine" (Destinée à l'église de Mouy (Oise)) 435

 1863 SR Mlle Amanda Fougère : "Sainte Julitte, Martyre" 174 (+ see
 note 139)

 1863 SR Mlle Amanda Fougère : "St. Jean-Baptiste offrant une colombe
 à l'enfant Jésus" 175

 1863 SR Mlle Amanda Fougère : "Sainte Elisabeth de Hongrie visitant
 les pauvres" 176

 1863 SR Mme Honorine Sélim : "Sainte-Thérèse, novice" 532

 1864 Mme Collard, née Marie-Anne-Herminie Bigé : "Sainte Catherine
 condamnée à mourir de faim est nourrie par les
 anges" 422

 1864 Mme Collard, née Marie-Anne-Herminie Bigé : "Mariage mystique
 de sainte Catherine" 423 (Destiné à la chapelle de
 Sainte-Catherine de Mouy (Oise))

 1864 Mlle Marie-Louise-Marguerite de Launay : "Saint Bernard
 méditant la croisade" 1118

 1864 Mme Marie-Alexandre Dumas : "Les litanies du saint nom de
 Jésus et les litanies de la sainte Vierge présentées
 par les saints et les saintes ; dessin" 2150

 1865 Mme Dehaussy (née Adèle Douillet) : "Sainte Cécile entourée
 de plusieurs saints" 600

 1865 Mlle Léonie Dusseuil : "Sainte Clotilde implore du ciel la
 guérison de son fils" 742

 1865 Mlle Louise-J Sarrazin de Belmont : "Saint Jérome - paysage"
 1926

 1866 Mlle Thérèse Donnet-Thurninger : "Sainte Agnès, vierge
 et martyre" 598

 1866 Mme Juliette de Bourge : "Portrait de saint François-de-
 Sales ; miniature" 2085

 1866 Mme Dehaussy née Adèle Douillet : "Saint François d'Assise ;
 dessin aux trois crayons" 2168

 1868 Mme Sophie Aizelin : "Sainte Marthe ; pastel" 2592

 1868 Mlle Louise Eudes de Guimard : "Saint Pierre ressuscitant
 Thabita, d'après la peintre executée par l'auteur
 dans la Salle du Thers-Ordre des dames auxiliatrices
 du Purgatoire ; aquarelle" 2860

 1868 Mme Alfred Saulnier née Régnier : "Saint Jean Baptiste ;
 faïence" 3303

 1868 Mme Léon Bertaux : "Saint-Matthieu - statue, plâtre"
 (Modèle de la statue exécutée pour la nouvelle
 façade de l'église Saint-Laurent, à Paris) 3421

 1868 Mme Léon Bertaux : "Saint Mathieu - Saint Philippe ; statue
 pierre" (Monuments publics)

 1869 Mme Adélaïde Salles-Wagner : "Sainte Madeleine bercée par
 les anges" 2127

J1. 1863 Mlle Eugénie Hautier : "Catherine de Médicis chez René-le-
 Florentin"

> "La reine enfonce des épingles dans le coeur de
> ses ennemis représentés par de petites figurines
> de cire ; sorte de maléfice appelé 'envoustement',
> fort en pratique à cette époque" 888

1863 Marcello : "Bianca Capello; buste marbre"

> "Issue d'une grande famille vénitienne, Bianca Capello
> s'enfuit à l'âge de dix-huit ans, accompagnée d'un
> jeune Florentin, en emportant les joyaux de sa
> famille. Réfugiée à Florence, elle devint la maîtresse
> de François de Médicis, supposa un enfant, se
> débarrassa des complices de sa supercherie, et se
> fit épouser par son amant. Devenue grande duchesse
> de Toscane, Bianca Capello aurait voulu empoisonner
> son beau-frère, le cardinal de Médicis ; mais son
> mari ayant pris par mégarde du mets préparé, elle se
> résigna à mourir avec lui" 2471 (Musée des Beaux-Arts
> Marseille)

1863 SR Mlle Moisson Desroches : "Jeanne la Folle, mère de Charles
> V, née en 1482, morte en 1555" 745 (+ see note 140)

1866 Mlle Marie-Marguerite Apoil : "Elisabeth de France, reine d'
> Espagne ; émail" 2010

1866 A. Marcello : "Marie Antoinette à Versailles ; buste, marbre"
> 2880

1866 A. Marcello : "Marie Antoinette au Temple ; buste, marbre"
> 2881

1867 Mlle Marie-Virginie Boguet : "Portrait de la princesse de
> Lamballe (Marie-Louise de Carignan) ; miniature" 1638

1867 Mme Sophie Jobert : "Jeanne D'Arc à Poitiers"

> "Elle logeait chez la femme d'un avocat et toute la
> ville y allait pour la voir et l'entendre. Ses
> examinateurs y vinrent aussi afin de l'interroger
> et de la confondre ; mais ils subirent comme les
> autres l'ascendant qu'elle exerçait autour d'elle,
> et ils écrivirent docilement sous sa dictée sa
> lettre aux Anglais. <u>Elle avait pris possession de
> ses juges eux-mêmes</u>" (M. Michelet) 803

1867 Mlle Anna-Marguerite Pitolet : "L'Impératrice Joséphine –
> porcelaine" 2012

1867 Mlle Marie Solon : "Portrait de la marquise de Pompadour ;
> miniature" 2069

1868 Mlle Elise Moisson-Desroches : "La princesse Farrakanoff
> noyée dans sa prison par suite d'une crue subite
> des eaux de la Newa en 1777" 1783

1868 Mme Joséphine Fortin : "Madame Elisabeth ; buste plâtre"
> 3595

1869 Mme Laure de Châtillon : "Jeanne-d'Arc voue ses armes à la
> Vierge" 460 (Musée de Compiegne)

1869 Mme Joséphine Fortin : "Charlotte Corday ; statuette,
> marbre" 3434

K1. 1861 Mlle Eugénie Hautier : "L'atelier de Van Loo"

> "Van Loo montre, à un amateur, le tableau de
> 'Diane et Endymion' qu'il peignit pour sa réception
> à l'Académie en 1731" 1460

1861 Mlle Marie-Virginie Boguet : "Murillo ; porcelaine" 338

1863 Mlle Nélie Jacquemart : "Molière chez le barbier Gély,
> à Pézénas"

> "Pendant le temps que Molière habitait Pézénas, il
> se rendait assidûment chez un barbier de cette ville
> dont la boutique était le rendez-vous des òisifs,
> des campagnards et des agréables
> C'est là que Molière a saisi les types du Bourgeois-

 gentilhomme, du médecin Diafoirus et de son fils,
 des Clitandre et des Don Juan" 982

1863 Mme Sophie Jobert : "Jeunesse de Rousseau"
 "J-J Rousseau, servant à table chez le comte de
 Gouvon, à Turin, donne l'explication d'une devise
 écrite en vieux français sur la tapisserie : 'Tel
 fiert qui ne tue pas'" 1006

1863 Mme Héloïse Vuitel : "Haroun-al-Raschid et le poète"
 "Haroun-al-Raschid ayant fait périr son visir
 Giafar Barmécide, défendit qu'on prononçat son nom
 devant lui. Un vieux poète osa enfreindre cette
 défense. Le calife le fit condamner à mort et lui
 demanda pourquoi il avait contrevenu à ses ordres.
 'Seigneur, répondit le vieillard, le roi des rois
 est bien puissant ; mais il y a quelque chose de
 plus puissant ... les bienfaits'. Haroun, frappé
 de cette répartie, lui donna un vase d'or, et le
 poète s'écria : 'O Barmécide, voilà encore un
 présent que je te dois !'" 968

1864 Mlle Louise Eudes de Guimard : "Milton dictant 'Le Paradis
 Perdu' à ses filles" 666

1866 Mlle Nélie Jacquemart : "Le cabaret de 'la Pomme de Pin'"
 "Molière lisant une scène des 'Femmes savantes' à
 Corneille et à Boileau" 1000

1866 Mme Louise Astoud-Trolley : "Beethoven ; médaillon, plâtre"
 2620

1868 Mlle Marie Pasquiou-Quivoron : "Cervantes, dans sa prison
 concevant son 'Don Quichotte'" 1927

1868 Mlle Christine de Post : "Ossian" 2045

1868 Mme Louise Astoud-Trolley : "Beethoven, médaillon, bronze"
 3401 (possibly the same as that exhibited by the
 artist in 1866 - see above)

L1. 1861 Mlle Adélaide Wagner : "Elie au désert" 3100

1861 Mme Marie-Henriette Bertaut : "Jésus montré au peuple et
 insulté" 246 (probably "Le Christ aux Outrages"
 in the Louvre)

1861 Mme Laure de Châtillon : "Le Christ enfant, la Vierge et
 Saint Jean" (M.d'Etat) 594

1861 Mlle Adèle Crauk : "La Vierge immaculée" 760

1861 Mme Dallemagne (née A-P de Cagny) : "Le mariage de la
 Vierge" (M. d'Etat) 776

1861 Mlle Elise Moisson-Desroches : "Mater-dolorosa" 2261

1861 Mlle Marie-Léonide Poisson : "Sainte Anne instruisant
 Marie" 2570

1861 Mme Léon Bertaux : "Assomption de la Vierge ; groupe plâtre"
 3177

1863 Mlle Christine de Post : "Ruth et Noémi" 1525

1863 Mme Léon Bertaux : "Assomption de la Vierge ; bas-relief,
 bronze" 2238

1863 SR Mme Dentigny (née Henriette Nolet) : "Agar chassée par
 Abraham" 114

1863 SR Mme Dentigny (née Henriette Nolet) : "Le Christ en prière
 au jardin des oliviers" 113

1863 SR Mlle Lohner : "La Madeleine" 334

1863 SR Mme Honorine Sélim : "Le Fil de la Vierge" 531

1863 SR Mlle Elisabeth Voiart : "Sainte Famille ; aquarelle" 589

1863 SR Mathilde Haour : "Enfance du Christ" 727

1864 Mlle Mathilde Aïta de la Pénuela : "Fille des Pharaon" 17

1864 Mme Carteron née Valléray : "La Vierge de Notre-Dame-des
 Victoires" 321

1864 Mme Dallemagne née Augustine-Philippe de Cagny : "La Sainte

Famille" 484

1864 Mme Lemée née Léontine Roullin : "L'éducation de la
Vierge" 1186

1864 Mme J. Constance de Valmont : "Jésus venant d'instruire les
docteurs" 3361

1865 Mme Amélie Champein : "La Vierge et l'Enfant-Jésus" 411 (M.
la Maison de l'Empereur et des Beaux-Arts)

1865 Mme Collard (née Marie-Anne-Herminie Bigé) : "Judith venant
decouper la tête d'Olopherne" 484

1865 Mlle Marie-Virginie Boquet : "Marthe et Marie ; sépia" 2308

1865 Emma Guyon : "Tête de Christ ; gravure sur bois" 3336

1866 Mme Laure de Châtillon : "La Sainte-Famille" 381

1866 Mlle Amélie-Léonie Fayolle : "Le Christ au jardin des
Oliviers" 699

1866 Mlle Nelie Jacquemart : "Jésus Christ et les disciples
d'Emmaus" (Saint-Luc, "Evangile") 999

1866 Mlle Marguerite Buret : "L'archange Gabriel ; émail" 2099

1866 Mlle Suzanne Duchosal : "La Madone ; émail" 2197

1867 Mlle Marie-Alexandre Dumas : "Les anges missionnaires, après
la mort du Christ ; dessin" 1741

1867 Mme la comtesse de Miltke-Hvitfeldt : "Tête du Christ -
- deux têtes de saints ; aquarelle" 1954

1868 Mme Augustine Dallemagne : "La Vierge au Roseau" 632

1868 Mlle Marguerite-Zéolide Lecran : "Je suis l'Agneau de
Dieu" 1497

1868 Mlle Sophie Unternahrer : "Jésus ressuscitant la fille
de Jaire" 2422

1868 Mlle Louise Eudes de Guimard : "Saint Pierre ressuscitant
Thabita, d'après la peintre exécutée par l'auteur
dans la Salle du Thers-Ordre des dames auxiliatrices
du Purgatoire ; aquarelle" 2860

1868 Mme Alfred Saulnier née Régnier : "Saint Jean Baptiste ;
faïence" 3303

1869 Mme Henriette Dentigny née Nolet : "Le Christ au jardin
des Oliviers" 709

M1. 1863 Mme Laure de Châtillon : "Les Filles de la croix : la
Foi, l'Espérance et la Charité" (M. d'Etat) 377

1863 Mme Tiger née Félicie Défert : "Foi, Espérance et Charité"
532

1865 Mlle Mathilde Aita de la Pénuela : "La Foi" 18

1865 Mme Claude Vignon : "Les quatre Vertus cardinales ; bas-
reliefs" 3559

1866 Mme Dentigny née Henriette Nolet : "La Foi" 553

N1. 1878 Mme Jeanne de Beaumont-Castries : "Jeanne Darc ; -buste
plâtre" 4045

1879 Mme Louise Dubreau : "Jeanne d'Arc" 1068

1883 Mlle E. Lanson : "Jeanne d'Arc ; buste, plâtre" 3832

1884 Mlle E. Petit : "Jeanne d'Arc, captive ; bas-relief, plâtre"
3813

1884 UFPS Mme Pauline Chaville : "Jeanne d'Arc" 43

1885 UFPS Mlle Léonide Bourges : "Jeanne d'Arc enfant" 39

1887 Mlle I. Risler : "Jeanne d'Arc" 2032 (ill.)

1889 Mme Ida Risler-Cousin : "Jeanne d'Arc; aquarelle" 3780

1891 UFPS Mlle Léonide Bourges : "Première vision de Jeanne d'Arc,
à l'âge de treize ans"
"Pendant qu'elle était dans le jardinet de son
père, lequel touchait à l'église, elle entendit
une voix belle et douce .." (Ducoudray - "Histoire
de France") 87

1891 Mlle M. Smith : "Jeanne d'Arc ; - étude" 1534

1892 SN Mlle V. Rehm : "Jeanne d'Arc" 1341

1893 Mme V-E Demont-Breton : "Jeanne à Domrémy" 554 (Musée de Lille)

1894 Mme L. Signoret-Ledieu : "Visions de Jeanne d'Arc ; - plâtre" 3593

1895 Mme L. Signoret Ledieu : "Jeanne d'Arc" 3493

1895 SN Mme Camille-Cornelie Isbert : "Miniatures"
1. "Jeanne Darc enfant" 1528

1895 SN , Mlle Camille Claudel : "Jeanne enfant ; buste marbre" 20

1895 SFA Camille Isbert : "Jeanne d'Arc enfant ; miniature" 169

1895 SFA Victorine Rhem : "Jeanne d'Arc - miniature" 181

1896 Mlle M. Perrier : "Jeanne d'Arc" 1568 (ill.)

1896 Mlle J. Jozon : "Jeanne d'Arc, enfant" 3549

1896 Mme L. Signoret-Ledieu : "Jeanne d'Arc" 3842

1897 Mme H-S De Mond : "Jeanne d'Arc" 581 (ill.)

1898 SFA Mme Valentine Isbert : "Six miniatures, compositions décoratives destinées à un missel de la Sainte-Vierge" including :
137 - Nôtre-Dame de la Délivrance (Eglise élevée en actions de grâce, à la fin de la guerre de Cent ans. Jeanne d'Arc triomphante montre le dernier vaisseau anglais qui s'éloigne de la France à la Religion pleurant sur les malheurs de la guerre)

1900 Mlle L. Signoret-Ledieu : "Jeanne d'Arc au siège de Saint-Pierre-le-Moutier" 2141

01. 1870 Mme Louise Astoud Trolley : "Charlotte Corday ; buste plâtre" 4248

1870 Mlle Léonie Dusseuil : "Marie Antoinette au Temple, le 22 janvier 1793"
"Après la mort du roi, la famille ayant passé la nuit dans les larmes, les deux enfants s'endormirent au matin" 954

1872 Mme Stéphanie Aubert : "Mme Elisabeth de France ; - pastel" 30

1872 Mlle Marie-Mathilde-Virginie Demasur : "Marie-Antoinette ; - miniature" 489

1873 Mlle Marie-Amélie-Julie-Delphine Boquentin : "Madame Elisabeth de France ; - miniature" 144

1873 Mlle Marie-Virginie Boquet : "La princesse de Lamballe ; - miniature" 145

1873 Mme Marthe Parratt : "La princesse de Lamballe ; - émail" 1158

1875 Mme Lucie Mansuy-Dotin : "Diane de Poitiers ; - émail" 2543

1876 Mlle Juliette- Eléonore Le Bouteiller : "Marie-Antoinette ;- porcelaine" 2653

1876 Mlle Juliette-Eléonore Le Bouteiller : "Madame Elisabeth ; - porcelaine" 2654

1877 Mlle Marie Fresnaye : "La fille d'Apollodore projete l' érection d'un monument à la mémoire de son père - statuette, plâtre" 3798

1878 Mlle Clémence-Jeanne Eymard de Lanchâtres : "Françoise de Foix ; - buste plâtre" 4235

1879 Mme M. Zetterstrom : "Charlotte Corday devant le tribunal révolutionnaire" 3032

1879 Mlle Victorine-Augustine Dujardin : "Charlotte Corday ; - fusain" 3531

1879 Mme Lucie Soyer née Dejoux : "Diane de Poitier ; - émail" 4620

1879 Mlle Clémence-Jeanne Eymard de Lanchâtres : "Françoise de Foix ; - buste, bronze" 5009

1884 UFPS Mme la comtesse du Chaffault : "Marie de Médicis ; émail

de Limoges" 42

1886 Mlle Ella Casella : "La reine Elisabeth : - médaillon
cire" 3616

1886 Mme Elisa Bloch : "Virginius ; - groupe, plâtre"
"... Virginie, fille du centurion Virginius, d'une
grande beauté, excitait les désirs du décemvir
Appius Claudius, qui, ne pouvant triompher de sa
vertu, employa un stratagème dont le succès devait la
faire tomber entre ses mains, .. Il se servit d'un de
ses clients qui réclama la jeune fille comme son
esclave devant le tribunal du décemvir. - A peine
Appius Claudius eut-il prononcé en faveur de son
client, que Virginius accourant de l'Armée, saisit
un couteau sur l'étal d'un boucher, et, pour sauver
sa fille de l'esclavage et du déshonneur, le lui
plongea dans le coeur en s'écriant : 'Appius, c'est
par ce sang innocent que je dévoue ta tête aux dieux
infernaux'" 3527
A work with the same title, but without the quotation,
was exhibited in 1888 as a bronze group (no. 3813)
and again in 1889 at the UFPS (groupe bronze,
réduction en tiers, no. 3)

1887 Mme L. de Châtillon : "Les funérailles de Béatrix" 517

1888 SI Mme Elina Yvetot : "Charlotte Corday" 692

1891 UFPS Mlle Mathilde Durnerin : "Mme de Lamballe" one of 3
miniatures, no. 274

1892 Juana Romani : "Bianca Capello" 1453

1895 SFA Victorine Rhem : "Vittoria Colonna ; miniature" 183

1896 SN Mme Marthe-Marie Bouquet : "Miniatures"
2. "Marie Antoinette" 1291

1897 SN Mlle Marguerite Parguez : "Miniatures"
2. "La reine Hortense"
3. "Marie-Antoinette" 1676

1897 Mlle J. Romani : "Faustolla da Pistoia" 1453

1898 UFPS Mlle Jeanne Saglier : "Miniatures"
3. "Marie Antoinette" 492

1899 Mlle A-L De Coninck : "Rose Doise ; victime d'une erreur
judiciaire" 572

The death of R. Lacordaire was depicted by Jeanne Gadou-Boyer in
"Derniers moments du R.P. Lacordaire ; -miniature" ("Je ne puis
plus le prier - mais je le regarde" - Dernières paroles du R.P.
Lacordaire) 1875 no. 2302

P1. 1870 Mlle Joséphine Houssay : "Charles-Quint et la duchesse d'
Etampes"
"Il tire habilement un beau diamant de son doigt
et la laisse tomber comme par mégarde. - La
duchesse le ramasse et le lui présente. 'Gardez-
le, lui dit-il galamment, je suis trop heureux d'
avoir l'occasion d'orner une si belle main'"
(Anquetil : "Histoire de France") 1388

1870 Mme Elisabeth-Félicité Dénecheau : "Marion Delorme ;
buste argile" 4428

1875 Mlle Pauline Laurens : "Béatrix" 1258

1877 Mlle Elisa Bellamy : "Ninon de Lenclos ; - faïence" 2276

1878 Mme Joséphine Calamatta (née Houdon Raoul-Rochette) :
"Philippa de Hainaut"
"Edouard III, roi d'Angleterre, rentre triomphant à
Londres, après la bataille de Halidown-Hill; le 19
juillet 1333, qui réunit définitivement l'Ecosse
à l'Angleterre. La reine, Philippa de Hainaut,

assiste avec ses enfants au triomphe du roi et l'
acclame à son passage" 388

1878		Mme Félicie Schneider : "La chanson d'Yseult" 2032
1885		Mme Thérèse de Champ-Renaud : "Pierre-le-Grand chez Mme de Maintenon, à Saint-Cyr"

"Ayant été pris du désir de voir Mme de Maintenon,
il monta chez elle, et, sans s'arrêter aux obser-
vations de ses femmes, qui lui disaient que leur
maîtresse était au lit, il entra : comme tous les
rideaux étaient fermés, il ouvrit d'abord ceux de
la fenêtre, puis ceux du lit, regarda Mme de
Maintenon avec curiosité, et, au bout de cinq
minutes, sortit sans lui avoir adressé la parole"
513

1887		Mme L. de Châtillon : "Les funérailles de Béatrix" 517
1889		Mme J. Itasse : "Laure de Novès ; - médaillon bronze" 4528
1889	UFPS	Mme Pauline Chaville : "Lesbie" 132
1897		Mme M. Boyer-Breton : "Rencontre de Dante et de Béatrix" 243
1898	SN	Mlle Mathilde Pélissier : "Mme de Pompadour" no. 3 of a group of miniatures, no. 1772

Q1.	1873	SR	Mme Victoria-Ernestine Versel : "Saint-Jean prêchant dans le désert" 84
	1873	SR	Mlle Léonie De L'Arbre : "Saint Jean (porcelaine) 381
	1873		Mlle Louise Lescuyot : "Ste Elisabeth ; - émail" 947
	1874		Mme Fina Nicolet : "St. Marguerite d'Antioche ; - statue pierre" 3071
	1875		Mme Anne de Fossa : "Sainte Agnès" 830
	1877		Mlle Marguerite-Noémi Dupuy : "Sainte Cécile" 778
	1877		Mlle Jeanne Lemaire : "Saint-Jérome" 1312
	1877		Mme Marie-Elizabeth Brandeis : "St. Michel ; - faïence" 2365
	1877		Mme Anna Lemarchard : "Saint Philippe ; - émail" 3037
	1877		Mme Marie-Pagnon : "Martyre chrétienne ; - porcelaine" 3240
	1877		Mme Fina Nicolet : "St. Georges ; - statue, plâtre"

"St. Georges, ayant terrassé le dragon, reporte à
Dieu sa victoire" 4038

1878		Mlle Lucie-Sebastienne Adam : "Saint Jean-Baptiste ; - statue, plâtre" 3991
1878		Mme V. Léonie Halévy : "Sainte-Nitouche ; - marbre" 4320
1878		Mme Fina Nicolet : "Saint Georges ; - statue, pierre" 4486

"Après avoir terrassé le dragon, saint Georges rendit
grâce à Dieu de sa victoire" 4486

1879		Mlle Angèle Marmonier :"Saint Jean-Baptiste" 2028
1879		Mlle Berthe Massé : "Sainte Monique" 2053
1879		Mlle Hermine Waternau : "Saint-Jean-Baptiste" 2994
1879		Mlle Marguerite Défert : "Sainte Cécile ; -porcelaine" 3444
1880		Thérèse, vicomtesse de Clairval : " Chrétienne allant au martyre" 784
1880		Mme Camille Deschamps : "Saint François d'Assise guérissant un jeune aveugle" 1132
1880		Mlle Angèle Marmonier : "Sainte Elisabeth" 2483
1880		Mlle Lucie-Sébastienne Adam : "Sainte-Geneviève, patronne de Paris ; - statue plâtre" 6045
1881		Mme M. Boyer : "Tête de Saint Jean ; buste, plâtre" 3655
1882		Mme A. Beauvais : "La Tentation de Saint-Antoine" 151
1882		Mlle L. Malézieux : "Jeune Martyre" 1750
1884	UFPS	Mme Binet-Ménard : "Sainte-Geneviève guérissant sa mère aveugle"

"Elle fit le signe de la Croix sur l'eau qu'elle
venait de puiser, sa mère se lava les yeux avec cette
eau et recouvra la vue" 25

1885 Mlle Adeline Gales : "Saint-Jean ; - statuette, plâtre"
 3719

1885 UFPS Mme Delphine de Cool : "Sainte Catherine, émail de Limoges"
 75

1886 Mme Marguerite-Fanny Dubois-Davesnes : "Sainte Geneviève ; -
 bas-relief, plâtre" 3836

1886 Mme la duchesse Maria de Palmella : "Sainte-Thérèse ; -
 buste, marbre" 4383

1889 Mme Pauline Chaville : "St. Georges" 133

1889 UFPS Mme Claire Noble-Pigeaud : "Sainte Anne d'Evenos - fusain"
 512

1890 Mme M. Thimuir : "Le Stigmatisé de l'Alverne ; - statue
 platre" 4540

1890 Mlle J. Itasse : "Saint Sébastien ; - haut-relief, plâtre"
 4031

1891 Mlle S-B Dodson : "Une martyre" 522

1891 Mlle M. Forget : "Sainte Cécile, martyre" 635

1891 UFPS Mme Adèle Dehaussy : "Saint Jean-Baptiste" 208

1891 SN Mme Elisabeth Nourse : "Le Pardon de Saint François d'
 Assise" 707

1891 UFPS Mme Marie Métivet-Jacob : "Sainte Magdeleine" 558

1891 UFPS Mlle Pierrette Gringoire : "Martyre" 354

1892 Mlle L-S Adam : "Sainte Geneviève - statue, pierre" 2203

1893 Mlle R. De Coninck : "Sainte Elisabeth de Hongrie ; - le
 miracle des roses" 519

1893 SN Mlle Angéline Garnier : "Sainte Cécile faïence" 1220

1894 SN Mme Marie Cazin : "Saint Jean (bas relief bronze)" 26

1894 SN Mme Marie Cazin : "Saint Marc (bas relief bronze)" 27

1895 Mlle L. Le Roux : "Sainte Anne" 1181 (ill.)

1895 Mlle M-M Louvet : "Sainte Elisabeth de Hongrie soignant
 les lépreux ; émail" 2512

1895 SFA L. Herman : "Saint Paul ermite ; lithographie" 186

1896 SN Mlle Ottilie Roederstein : "Saint Jean (détrempe)" 1066

1896 SN Marie-Joséphine Jonnart née Aynard : "Sainte Véronique ; -
 enluminure" 1469

1896 SN Marie-Josephine Jonnart née Aynard : "Sainte Hélène ; -
 enluminure" 1470

1896 SN Marie-Josephine Jonnart née Aynard : "Sainte Luce ; -
 enluminure" 1473

1897 Mme M-J Cranney-Franceschi : "Martyre" 2838

1897 Mlle A. Maniel : "Le miracle de Saint Maclou, légende
 bretonne" 3174 sculpture

1898 SN Mme Madeleine Lemaire : "Sainte Roseline (le miracle des
 roses)" 744

1898 SN Elisée Visconti : "Saint Sébastien" 1245

1898 SN Jehanne-Marie Boudou : "Miniatures"
 3. "Sainte Cécile" 1368

1898 SN Isabel-E Smith : "Miniatures"
 4. "Sainte Cécile" 1834

1898 Mlle J. Tailleferie : "La mort d'un saint" 1915

1898 Mlle J. Itasse : "Tête de saint Sébastien" 3526

1899 Mme R. du Bois : "Première prédication de saint Jean" 3240

1900 Charlotte Besnard : "St. Elisabeth de Hongrie"

R1. 1870 Marie Spartali Stillmann : "Corinne, poète thébaine ;
 aquarelle" 4110

1870 Mme Julie Morizot : "Sapho ; statuette terre cuite" 4748

1873 Mlle Fanny-Marguerite Dubois-Davesnes : "Marivaux ; -
 buste, marbre" 1628

1875 Mme Armand Emilie Leleux née Giraud : "Madame Du Barry
 apporte de la musique à copier à J-J Rousseau" 1326

```
1875        Mlle Théa Ranvaud : "Lord Byron ; - porcelaine" 2669
1876        Mme Marie-Claire Sacre : "Sapho ; - porcelaine" 2921
1876        Madeleine Lemaire : "Corinne" 1277
1877        Mlle Marie de Nugent : "Homère au Parnasse ; - émail" 3224
1879        Mme Armand-Emilie Leleux née Giraud : "Voltaire offre à
                déjeuner à Mme d'Epinay sur la terrasse des Délices,
                près de Genève" 1869
1881        Mlle C-H. Huitel, dite Vuitel : "Clotilde du Surville"
                1175
1881        Mme F. Mezzara : "Socrate ; statuette, plâtre" 4117
1882        Mme L. Bertaux : "Chardin ; statue pierre " (Monuments
                Publics)
1882        Mme A-E Leleux : "Mme d'Epinay faisant faire son portrait"
                1635
1884 UFPS   Mme Léon Bertaux : "François Boucher - buste plâtre, modèle
                de marbre pour l'Opéra" 260
1885        Mme Léon Bertaux : "François Boucher ; - buste, marbre" 3361
                (Destiné à l'Académie Nationale de Musique)
1885 UFPS   Mme Léon Bertaux : "François Boucher, buste marbre pour l'
                Opéra" 1
1889        Mlle E-E Greatorex : "La première palette du Titian" 1211
1890        Mme J. Marcellus : "Mozart ; - statuette, bronze" 4198
1891        Mme V. Demont-Breton : "Giotto" 480
1891 UFPS   Mlle Jeanne-Marie de Saint-Père : "Le salon de Sapho ;
                miniature" 698
1892        Fanny Dubois-Davesnes : "Clotilde ; buste en plâtre" 2539
1895        Mme M-J Cranney-Francheschi : "Sapho" 2997
1895        Mlle B-A Moria : "Mme de Sévigné" 3370
1896        Mlle R. de Vériane : "Jean Goujon enfant" 3879
1897        Mme M. Boyer-Breton : "Rencontre de Dante et de Béatrix" 243
1897        Mme M. Syamour : "Sapho endormie" 3405 sculpture
1897        Miss K. Tizard : "Giotto" 3428
1898 SN     Jehanne-Marie Boudou : "Miniatures"
                1. "Sapho" 1368
1898 SN     Jeanne Denné-Ceyras : "Miniatures"
                1. "Sapho" 1443
1898 UFPS   Mme Agnès Kjellberg de Frumerie : "Sapho, encrier plâtre" 10
1898 SI     Mme Elisabeth- Désirée Firnhaber : "Sapho" 211
1899        Mlle L. Lacaze-Dory : "Caton" 3612
1899        Mme M. Syamour : "Sapho endormie" 3949
1899        Miss K. Tizard : "Giotto" 3968
1900        Mlle Renée de Vériane : "Jean Goujon ; - statue, marbre"
                2169

S1. 1870    Mlle Marguerite-Fanny Dubois-Davesnes : "Le Christ ; buste
                plâtre"
                " ... et jetant les yeux sur Jérusalem, il pleura
                sur elle" 4454
1870        Mme Adèle Dehaussy : "Tête de Christ" 763
1870        Mlle A. Lemarchard : "La Vierge au lis ; émail" 3707
1870        Mme Alfred Saulnier née Elise Régnier : "Mater dolorosa ;
                faïence" 4065
1870        Mme Louise de Urriza : "La Vierge et la Madeleine ; pastel"
                4158
1872        Mme Benigna de Callias : "Vierge ; faïence" 247
1872        Mme Benigna de Callias : "Vierge ; faïence" 248
1872        Mlle Geneviève-Irma Chanson : "La Resurrection ; - émail" 289
1872        Mlle Geneviève-Irma Chanson : "La Vierge et l'enfant Jésus;
                - émail" 290
1872        Mme Marie Glachant : "Jésus-Christ ; - miniature" 711
1873 SR     Mme Victoria-Ernestine Versel : "Saint Jean prêchant dans
                le désert" 84
```

1874		Mlle Marie Roux : "La Sainte-Vierge ; porcelaine" 2539
1875		Mme Adélaide Salles-Wagner : "La Vierge et l'enfant Jésus" 1795
1875		Marcello : "Redemptor mundi" 3256 sculpture
1875		Mme Anna Lemarchand : "La Vierge et l'Enfant Jésus ; - émail" 2486
1875		Mme Anna Lemarchand : "La mise au tombeau ; - émail" 2487
1877		Mme Marie Canoby : "La Sainte-Famille ; - faïence" 2424
1877		Mme Amélie Jouve : "Ecce homo ; - faïence" 2909
1877		Mlle Marie-Amélie de Vaux-Bidon : "Jésus chargé de sa croix ; - porcelaine" 3510 (pour l'église de Châtillon-sur-Loing)
1877		Mme Léonie Huzel : "Le baiser de Judas ; - porcelaine" 2882
1879		Mme Adèle Dehaussy : "La mère des douleurs" 868
1879		Mlle Hermine Waternau : "Saint-Jean-Baptiste" 2994
1879		Mlle Blanche Mulotin de Merat (née Blanche) : "Coeur adorable de Marie ; - aquarelle" 4252
1879		Mlle Nelly-Caroline Thionville : "Le Christ au tombeau; - porcelaine" 4654
1879		Mlle Angèle Marmonier : "Saint Jean Baptiste" 2028
1880		Mme Josephine Calamatta : "L'enfant Jésus initiant sa mère au mystère de la croix" 586
1880		Mme Adèle Dehaussy : "Le Christ consacrant" 1035
1882		Mlle M-A Robiquet : "Mort de la Vierge" 2321
1882		Mlle M. Saulnier : "Saintes Femmes" 2401
1885		Mlle Vera Bapkine : "Saint-Jean-Baptiste ; - bas-relief plâtre" 3325
1885		Mlle Jeanne Itasse : "Saint Jean-Baptiste ; - statue, plâtre" 3846 (ill)
1885	UFPS	Mlle Thérèse Pomey : "Mater dolorosa" 209
1886		Mlles Gabrielle et Maria Grellet : "La Vierge, saint Jules et saint Louis" 2904
1886	UFPS	Mlle Delbarre : "Sainte-Anne et la Sainte Vierge ; aquarelle" 102
1887	UFPS	Mlle Blanche Odin : "La Vierge et l'enfant Jésus, aquarelle" 223
1888		Mlle M. Forget : "Apparition du Christ à la Madeleine" 1010
1889		Mlle M. Forget : "Le Madone et l'enfant" 1049
1889		Mlle K. Fornier : "Marie de Nazareth" 1050
1889	UFPS	Mlle Nelly Constant : "Saint Jean Baptiste enfant" buste plâtre" 10
1890		Mlle L. Adam : "Saint Jean-Baptiste ; - statue bronze" 3434
1890		Mlle Nelly Constant : "Saint-Jean-Baptiste enfant ; buste marbre" 3716
1890		Mme S-E Ewald : "La Vierge et les Saints ; - cire" 3835
1890		Mme C. Nazem : "Mater-Dolorosa ; - médaillon, plâtre" 4302
1891	UFPS	Mme Adèle Dehaussy : "Ecce Homo" 207
1891	UFPS	Mme Adèle Dehaussy : "Saint Jean-Baptiste" 208
1891	UFPS	Mme Clémence Guéneau de Mussy : "Mater Dolorosa" 359
1891	UFPS	Mlle Marie-Marguerite Louvet : "Vierge à la délivrance ; émail" 508
1891	UFPS	Mlle Marguerite-Fanny Dubois-Davesnes : "Tête de Christ, bas-relief, plâtre" 13
1892	SN	Mlle A. D'Anéthan : "Les Saintes Femmes" "Elles se disaient entre elles : Qui nous ôtera la pierre qui ferme l'entrée du sépulchre" (Sainte Marc ch. XVI) 12
1893		Mlle M. Fresnaye : "Le sommeil de l'Enfant-Jésus ; - bas-relief, plâtre" 2874
1893		Mme E. Gwyn-Jeffreys : "Vierge à l'enfant ; statue, bronze" 2950

1893 SN Mlle Ottilie Roederstein : "Laissez venir à moi les petits
 enfants" 895

1894 Mme E-K Baker : "Les filles de la Sainte-Vierge" 76

1895 Mlle L. Le Roux : "Sainte Anne" 1181 (ill.)
1895 SI Mme Ernesta Urban : "Une Assomption" 1504
1895 Mme C-E Wentworth : "Christ en croix" 1933 (ill.)
1895 SN Louise-Alexandra Desbordes : "Le Christ" 417
1895 SN Mme Jeanne Mairet-Mermet : "Mater Dolorosa - miniature" 1571
1896 Mlle B. Burgkan : "Sainte Anne, éducatrice" 854
1896 SN Mme Antoinette Vallgren : "Saint-Jean-Baptiste (haut-
 relief ; terre cuite)" 137
1897 Mlle E. Darbour : "La Vierge au lys" 447
1897 Mme V. Demont-Breton : "Le divin apprenti" 506 (ill.)
1897 Mme E. Lonblad : "Après l'Annonciation" 1069
1897 Mlle M. Fresnaye : "Le sommeil de l'Enfant Jésus" 2958
 sculpture
1898 Mme E.K. Thompson Baker : "Une madone" 86
1898 Mme M. Boyer-Breton : "La Vierge au chemineau" 292 (ill.)
1898 SN Marie Sienkiewicz : "La Vierge" 1124
1898 SFA Mme Louise Desbordes : "Le Christ" 31
1898 SFA Mme Valentine Isbert : "Six enluminures, compositions
 décoratives destinées à un missel de la Sainte-
 Vierge :
 132 - Notre-Dame de la Garde (La Religion gardant
 le port de Marseille)
 133 - Notre-Dame de Bon Secours (La Vierge consola-
 trice des misères humaines)
 134 - Notre-Dame de Liesse (Ange célébrant la
 gloire de Marie)
 135 - Notre-Dame de Grâce (La Vierge jette des fleurs
 sur la côte de France)
 136 - Notre-Dame de la Croix (Ange pleurant la
 passion de Jésus)
 137 - Notre-Dame de la Délivrance (Eglise élevée en
 actions de grâce, à la fin de la guerre de Cent
 ans, Jeanne d'Arc triomphante montre le dernier
 vaisseau anglais qui s'éloigne de la France à la
 Religion pleurant sur les malheurs de la guerre)
1898 UFPS Mlle Ernestine Darbour : "La Vierge aux lis" 144
1898 UFPS Mlle Elisabeth Sonrel : "La Vierge consolée" 516
1898 Mlle L. Bichot : "Regina virginium" 3170
1899 Mme V. Demont-Breton : "Alma Mater" 615
1899 Mlle S. Leudet : "Gethsemani" 1224 (ill.)
1899 Mme W.B. Newman : "Tête de madone" 1472
1899 Mlle S. Waters : "La Vierge au rosier" 1985
1900 Mme Léon Bertaux : "En Egypte ; - Vierge en enfant ; -
 groupe marbre" 1837
1900 Mlle M-B Mouchel : "Le roseau brisé" 973 (ill.)

T1. 1870 Mme Claire Nancy née Rey : "Salomé" 2071
1870 Mme Marie-Esther Guérin : "Les filles de Sion, captives à
 Babylone" 1276
1872 Feue Mme Marie-Anne-Herminie Collard : "Suzanne au bain" 362
1873 SR Mlle Christine de Post : "Les Vierges folles voyant s'
 éteindre leurs lampes" 322
1874 Mme Marie-Félicie Arnaud : "Mater Redemptoris ; - bas-
 relief, plâtre bronzé" 2643
1876 Mme Claire Pillault : "La Madeleine ; - miniature" 2838
1876 Mlle Charlotte-Gabrielle Dubray : "La fille de Jephté,
 pleurant sur le montagne ; - statue, plâtre" 3238

```
1877        Mlle Elisabeth-Jane Gardner : "Ruth et Noémi" 889
1877        Mlle Marie Juliette Aubaud : "Renvoi d'Agar et d'
                  Ismaël ; - porcelaine" 2231
1878        Mlle Elisa Drojat : "Agar et Ismaël" 780
1878        Mlle Marie Petiet : "Marie-Madeleine au désert" 1775
1879        Mlle Sarah-Paxton-Ball Dodson : "Deborah" 1023
1879        Mlle Anna Chataignier : "Agar et Ismaël dans le désert"
                  608
1879        Mme Juliette Jobard : "La Madeleine" 1653
1880        Mlle Claudie : "Judith" 791
1880        Mme Charlotte Gabrielle Besnard-Dubray : "Judith présen-
                  tant la tête d'Holopherne aux habitants de
                  Béthulie" 6102
1881        Mlle Claudie : "Hérodiade" 478
1881        Mlle M. Petiet : "La Magdaleine" 1833 (ill.)
1881        Mme A. Salles-Wagner : "La fille de Jaire, après sa
                  résurrection" 2098
1881        Mme M-C Brunet-Kessel : "Abigail ; haut-relief, marbre"
                  3668
1882        Mme A. Salles-Wagner : "Les Filles de Jérusalem" 2390
1883        Mme F. Ghislaine : "Sainte Marie-Madeleine" 1036
1884        Mme A. Salles-Wagner : "Eve consolée par ses enfants"
                  2142 (ill.)
1884 UFPS   Mlle Christine de Post : "Les Vierges folles à la porte
                  fermée" 199
1884 UFPS   Mme Adelaide Salles-Wagner : "La Consolation d'Eve" 217
1885        Mlle Ida-Louise-Wilhelmine Erickson : "Judith ; - statue
                  plâtre" 3659
1885 UFPS   Mme Marguerite Pillini : "Expulsée" 205
1886        Mlle Jeanne Pharaon : "Eve regardant Cain et Abel
                  endormis" 1868
1886        Mlle Ida  Erickson : "Salomé triomphant ; - statue,
                  plâtre" 3857
1886 UFPS   Mlle Christine de Post : "Marthe et Marie après la Mort
                  de Lazare"
                  "Quand Marthe apprit que Jésus venait, elle alla au
                  devant de lui ; mais Marie demeura assise à la
                  maison !" (Evangile selon Saint-Jean, ch. XI, v.
                  20) 251
1887        Mme L. Signoret-Ledieu : "Ruth ; statuette plâtre" 4494
1889        Mme L. Thiriet : "Judith ; - buste plâtre" 4977
1890        Mlle E.F. Pell : "Salomé" 1864
1890 UFPS   Mlle Blanche Moria : "Sainte Madeleine, profil" terre
                  cuite 14
1890        Mlle J. Romani : "Hérodiade" 2075
1891        Mlle M. Prévot : "La femme adultère" 1358
1891        Mlle J. Romani : "Judith" 1421
1891        Mlle J. Romani : "Magdeleine" 1422
1891 UFPS   Mme Marie Métivet-Jacob : "Sainte Magdeleine" 558
1892 SN     Mlle A D'Anethan : "Les Saintes femmes"
                  "Elles se disaient entre elles : Qui nous ôtera la
                  pierre qui ferme l'entrée du sépulchre" (Saint
                  Marc ch. XVI) 12
1894        Mme M-D-W Robinson : "Les cinq vierges folles" 1572
1894 SN     Alice Feurgard : "Eve ; gouache" 1378
1895 SN     Mlle Alix d'Anethan : "Ruth glane dans le champ de
                  Boaz" (Livre de Ruth, ch. II) 34
1895 SN     Mlle Ottilie Roederstein : "Madeleine au pied de la croix"
                  1057
1896        Virginie Demont-Breton : "Ismaël" 628 (ill.)
1896        Mlle G. Achille-Fould : "Madeleine se convertissant" 5
                  (ill.)
```

1896		Mlle B. Burgkan : "Sainte Anne, éducatrice" 854
1896		Mme M. Caire : "Salomé" 378
1896		Mlle A-E Klumpke : "La toilette d'Esther" 1108 (ill.)
1896		Mlle M. Smith : "Judith" 1842
1896		Mlle M. Smith : "Ismael" 1843
1896		Mme H. Descat : "Suzanne surprise" 3389 (ill.)
1896	SI	Elise-Desirée Firnhaber : "Eve" 393
1896	SN	Marie-Josephine Jonnart née Aynard : "Eve - enluminure" 1475
1897		Mme F. Ducrot-Icard : "Trop tard ! Les Vierges folles" 2914 sculpture
1897		Mlle M. Pownall : "La Madeleine" 3308 sculpture
1897		Mme L. Signoret-Ledieu : "Salomé" 3390 sculpture
1897		Mme A-L Wolseley : "Ruth" 3462
1898		Mme W-B Newman : "La vierge folle" 1528
1898		Mme veuve M-F Raphael : "Eve" 1686
1898		Mlle J. Romani : "Salomé" 1745 (Luxembourg, Paris)
1898		Mme M-J Cranney-Franceschi : "Salomé" 3293
1898		Mme F. Marc : "Eve chassée du Paradis" 3642
1899		Mlle B. Burgkan : "Hérodiade" 327
1899		Mme F. Ducrot-Icard : "Jahel" 3424

U1.	1870		Mme Honorine Selim : "La dernière heure de Judas Iscariote, 6016" 2624
	1876		Mme C. Genevay : "Le triomphe de David ; - faïence" 2469
	1878		Mlle Elisabeth-Jane Gardner : "Moïse exposé sur le Nil" 973 (Westerly Memorial and Library Ass., Rhode Island)
	1879		Mme Fanny Crozier : "Judas ; - buste, plâtre" 4931
	1883		Mme M. Cazin : "David ; - buste, bronze" 3439
	1884	UFPS	Mme Fanny Crozier : "Judas ; - buste plâtre" 271
	1886		Mlle Marguerite Jacquelin : "Job ; - étude" 1237
	1886		Mlle Descat : "Abel ; statue, plâtre" 3796 (ill.)
	1891		Mme H-V-C Luminais : "Saint Michel, archange, chassant Lucifer du ciel" 1084
	1894		Mme E. Bloch : "Moïse ; - la loi ; - statue plâtre" 2797
	1895		Mlle Angèle Delasalle : "Cain et les filles d'Hénoc" 554
	1895		Mlle E-J Gardner : "David, berger" 796 (ill.)

V1.	1880		Mlle Marie Petiet : "Diane endormie" 2968 (ill.)
	1884		Mme A. Enault : "Diane" 982
	1885		Mme Eugénie Sche(? illegible) ith : "Diane ; - médaillon, terre cuite" 4219
	1886		Mme Marguerite Ruffo : "Diane ; - pastel" 3307
	1886		Mlle Anne Manuela : "Diane surprise ; - statue, marbre" 4251
	1886	UFPS	Mme Marguerite Ruffo : "Diane, pastel" 271
	1887		Mlle A. Dubos : "Diane" 808
	1887		Mlle M-G de Sardent : "Diane ; - buste plâtre" 4473
	1889		Mme M. Cazin : "Diane" 511
	1889	UFPS	Mlle Joséphine Houssay : "Une suivante de Diane ; pastel" 312
	1891	UFPS	Mlle Anna Chataignier de Volvreux : "Diane" 150
	1891		Mlle A. Manuela : "Diane ; - statuette, marbre" 2716
	1891		Mme L. Signoret-Ledieu : "Nymphe de Diane ; - statuette marbre" 2885
	1891		Mme M. Syamour : "Diane ; - statue, plâtre" 2902
	1892	SI	Mlle Nathalie Kireevsky : "Diane" 648
	1895	SN	Mme Mary Mac-Monnies : "Diane (étude de composition décorative)" 833
	1897		Mlle A. Delasalle : "Diane au repos" 484 (ill.)
	1897		Mlle J. Houssay : "Une suivante de Diane" 852
	1897		Mlle P. Testard : "Diane chasseresse" 3412
	1900		Mlle Nilda Boéro : "Diane ; buste plâtre" 1855

W1. 1870 A Marcello : "La Pythie ; statue, bronze" 4713

 1872 Mlle Henriette Osborne-O'Hagan : "Ondine ; - dessin" 1190

 1877 Mlle Marie Lafont : "La sibylle de Delphes ; - faïence" 2948

 1877 Mme Marie Rélin née Calot : "Psyché ; - miniature" 3329

 1877 Mlle Constance Gérard : "Psyché ; camée sur sardoine" 4206

 1878 Mlle Charlotte-Gabrielle Dubray : "Euterpe ; - statue, plâtre" 4209

 1878 Mme Emma-Marie-Léonie François : "Dans un cadre : Méduse camée sur cornaline"(and others) 4643

 1878 Mlle Marie Fresnaye : "Sibylle ; - statue, plâtre" 4270

 1883 Mlle E. Couteau : "Méduse, tête d'étude" 3505

 1883 Mme H. Luminais : "Psyché" 1570 (ill.)

 1884 Mme H. Descat : "Une Ondine ; statue plâtre" 3458

 1886 Mme Hélène-Victorine-Charlotte Luminais : "Psyché" " ... Lorsqu'elle passa le Styx, il y avait dans la barque un roi, un philosophe, un général, des soldats Les femmes environnèrent Psyché .. ; elle ne dit à personne qu'elle fut vivante .." (Lafontaine, "Amours de Psyché", liv. II) 1527

 1886 Mme Adélaide Salles-Wagner : "L'antique légende de Loreley" 2120

 1888 Mlle B-A Moria : "Electre ; - buste plâtre" 4358

 1889 Mme M. Zambago-Cassaretti : "Méduse ; - buste plâtre" 5055

 1889 UFPS Mlle Lily Paepke : "Les trois Parques ; porcelaine" 519

 1890 Mme H.V.C. Luminais : "Le Rêve de Psyché" 1553

 1890 Mlle E. Gwyn-Jeffreys : "Medée enchantant le dragon ; - statue, plâtre" 3973

 1891 SN Mlle L. Lee-Robbins : "Les trois Parques" 576 (ill.)

 1893 SN Mme Marie Cazin : " Clotho ; figurette plâtre" 38

 1895 Mme V-L Duquenoy : "Tête de Méduse" 3056

 1896 Mme M-G Duhem : "Les Vigiles" 729

 1896 SFA Mme Louise-Alexandra Desbordes : "Méduse, légende des Algues" 15

 1897 Mlle C. Berlin : "La Muse" 137 (ill.)

 1897 Mme L. Bertaux : "Psyché sous l'empire du mystère" 2701 sculpture (Luxembourg, Paris)

 1897 Mlle M. Ducoudray : "Psyché" 2913 sculpture

 1898 Mme H-S Du Mond : "Ondine" 730

 1898 SN Mlle Kate Carl : "L'Amour et Psyché" "Surprise ... Psyché se laisse aller sur ses genoux" - Apulée 234

 1898 SI Mme John-M Clark : "Le Destin" 123

 1898 SFA Mme Louise Desbordes : "Méduse, légende des Algues" 30

 1898 UFPS Mlle Camille Berlin : "La Muse" 46

 1899 Mlle C. Henriot : "Circé" 974

 1899 SN Camille Claudel : "Clotho (La Parque qui répand le fil de la vie) ; statuette marbre" 27 (ill.)

 1899 Mme F. Marc : "Une Parque" 3708

 1900 Mlle M. Guyon : "Les Parques" 634

 1900 Mlle A. Kaub : "L'homme sur sa route trouvant la Fatalité" 719 (ill.)

X1. 1870 Mlle Andrée : "Vénus blessée ; faïence" 3006

 1870 Mlle Caille : "Jupiter et Calisto ; faïence" 3184

 1870 Mme Bénigna de Callias : "Persée ; faïence" 3187

 1870 Mme Lina Hugard : "Enlèvement de Céphale ; faïence" 3602

 1870 Mlle Elise de Maussion : "Actéon métamorphosé en cerf ; porcelaine" 3801

 1870 Mme Louise Hesse : "La mort d'Euryale ; statue plâtre" "... Par la lance mortelle Déjà frappé de mort,Euryale chancelle ,

Tel languit un pavot courbé par la tempête"
(Virgile : "Enéide") 4597

1872 Mlle André : "Amours vendageurs : - faïence" 11
1872 Mlle André : "Amours nageurs ; - faïence" 12
1873 Mme Delphine de Cool : "La nymphe Echo ; - statue, plâtre"
 (Ovide, "Métamorphoses", liv. III) 1585
1874 Mme Louise Astoud-Trolley : "Erigone ; - statue plâtre"
 "Pour séduire Erigone, Bacchus se métamorphose en
 raisin" 2646
1874 Claude Vignon : "Bacchus enfant ; statue, terre cuite" 3188
1875 Juliette, Comtesse de Germiny : "Léda ; - porcelaine" 2323
1875 Mlle Anna Jumon : "Télémaque dans l'île de Calypso ; -
 éventail, aquarelle" 2423
1875 Mme Fanny Aragon : "Faune ; - buste, marbre" 2843
1875 Mme Fanny Aragon : "Bacchante ; - buste, marbre" 2844
1875 Mlle Eugénie-Giovanna Dubray : "Didon, reine de Carthage ;
 buste, plâtre" 3049
1875 Claude Vignon : "Daphné" 3441
1876 Mme Lucie Mansuy-Dotin : "Persée délivre Andromède ; -
 émail" 2724
1876 Mlle Jeanne Roche : "Ariadne et Bacchus ; - faïence" 2905
1876 Mme Marguerite de Saint-Priest : "Primavera ; - statue,
 plâtre" 3595
1876 Mme Eléonore Escallier : "Salon de l'Aurore et des Muses :
 six dessus de portes ; - panneaux décoratifs"
 (Monuments publics)
1877 Mlle Joséphine Houssay : "Primavera" 1071
1877 Mlle Jeanne-Céline Du Liège : "Nymphes et amours ; -
 émail" 2637
1877 Mlle Marie Lafont : " Antiope ; - faïence" 2947
1877 Mlle Louise Lefrançois : "La Vénus de Syracuse ; - porcel-
 aine" 3020
1877 Mme Marguerite de Saint-Priest : "Primavera ; statue
 marbre" 4127
1881 Mme H. Lumenais : " Erato" 1489 (ill.)
1881 Baronne H. de Preuschen : "Evohe Bacche ! panneau décoratif"
 1924
1881 Mlle J. de Montégut : "Une jeune bacchante ; buste plâtre"
 4133
1882 Mlle E. Gardner : "Daphnis et Chloe" (ill.)
1884 Mme A. Beauvais : "Echo" 148 (ill.)
1884 UFPS Mme Besnard : "Nymphe des bois, buste plâtre" 263 bis
1885 Mlle Marguerite Arosa : "Andromède" 67 (ill.)
1885 Mlle Nina-Gordon Batchelor : " 'Amour désarmé" 156
1885 Mme Camille Isbert : "Huit miniatures"
 6. "Cérès, allégorie" 1908
1885 Mme Sarah Bernhardt : "Mars enfant ; - buste marbre" 3358
1885 Mlle Marie Fresnaye : "Fauna ; - statue, plâtre" 3710
1885 Mlle Mathilde Thomas : "La chèvre Amalthée ; - groupe,
 plâtre" 4265 (ill.) (also exhibited as a bronze group
 in 1886 no. 4593)
1885 Mlle Eugénie Becker : "Amours à la fontaine ; une bague
 onyx noir" 4343
1885 UFPS Mme Marguerite Pillini : "Philémon et Baucis" 204
1886 Mme Marie Denise : "Primavera ; - buste, terre cuite" 3787
1886 Mlle Antonia Banuelos : "Coryse" 106
1886 Mlle Louise Nicolas : "Nymphe" 1746
1888 Mme D. Parny : "Andromède ; statue bronze" 4498
1890 UFPS Mme Gabrielle Labat-Robert : "Nymphe au Coffret" (Email de
 Limoges) 411
1890 UFPS Mme Gabrielle Labat-Robert : "Nymphe à la lyre" (Email de
 Limoges) 411 bis

1890 UFPS Mlle Lucy Lee-Robbins : "Andromède" 440
1890 UFPS Mlle Lily Paepke : "Amour endormi ; porcelaine" 577
1890 UFPS Mlle Tolla Gertowicz : "Morphée, roi des songes. Figure
 décorative, plâtre" 4
1890 Mlle M. Coribelli : "L'Amour captif ; - statuette, terre
 cuite" 3640
1890 Mlle J. Delorme : "Ursus - buste plâtre" 3768
1890 Mlle M. Fresnaye : "Naïade ; bas-relief, plâtre" 3882
1890 Mlle T-A Ruggles : "Orphée jeune ; - statue plâtre" 4453
1891 Mlle T. Pomey : "Phoebe passant devant le Soleil" 1340
1892 Mme M-J Cranney-Franceschi : "Galatée ; statue, plâtre"
 2456
1892 SN Mme Besnard : "Coré"
1893 Mme C-M Benedicks-Bruce : "Philémon et Baucis ; - têtes en
 cire" 2564
1893 Mlle F. Ducrot : "Désespoir d'Oenone ; - statue plâtre"
 2814
1894 Mme L. Coutan : "Sirius ; - statue plâtre" 2961
1895 Mme M. Loine : "Primavera" 1221 (ill.)
1895 Juana Romani : "Primavera" 1650 (Luxembourg, Paris)
1895 Mlle A. Jacob : "Penelope" 2401 (ill.)
1896 Mme M. Dube : "Nymphe aux bois" 703
1896 Mlle J. Itasse : "Bacchante" 3539
1896 Mme N. Tarnowska-Andriolli : "Amour endormi" 3855
1896 SN Mlle Elisabeth-Marie Gobert : "Léa ; tête d'étude, émail"
 1422
1897 SN Mme Marthe Marlef : "Bacchante" 1606
1897 SN Mme Marthe Marlef : "Nymphe accroupie" 1607
1897 Mlle M. Fresnaye : "Bacchante" 2959 sculpture
1897 Mlle J. Itasse : "Tête de Bacchante" 3068 sculpture
1898 SN Mme Valère Phili Pelle : "Miniatures"
 no. 5 "Bacchante" 1773
1898 SN Mme Marie Cassavetti : "Vénus et Adonis mournant (group
 plâtre bronze) 28
1898 UFPS Mme Isabelle Hervé : "Andromède" 274
1898 UFPS Mme Clovis Hugues-Royannez : "La Mort de Tiphaine" statue
 plâtre" 5
1898 UFPS Mlle Ida Matton : "Supplice de Loke, mythologie scandinave ;
 plâtre" 13
1898 UFPS Mme Emma-Camille Nallet-Poussin : "Bacchante, buste plâtre"
 20
1899 Mme E. Huillard : "Léda" 1009
1899 SN Camille Claudel : "Maquette de la statue de Persée ; plâtre
 grandeur nature" 29
1899 Mlle J. Itasse : "Bacchante" 3595
1899 Mlle G-S Stanhope : "Pan" 3942
1900 Mlle C-A Curtis-Huxley : "Mercure enfant" 1915
1900 Mlle F-C Lesley : "Tête de satyre" 2038
1900 Mlle G-S Stanhope : "Héro et Léandre" 2147

Y1. 1876 Mlle Adèle Pennel : "Minerve ; - camée sur sardonyx" 3682
1884 UFPS Mme la comtesse du Chaffault : "Minerve ; émail de Limoges"
 41
1885 Mme Marie Anselma (née Lacroix) : "Junon ; - panneau
 décoratif" 49
1886 Mme Adélaide Salles-Wagner : "Hébé" 2121
1886 Mlle Joséphine Houssay : "La dispute d'Arachne et de
 Minerve Athène ; Ovide" 1205
1888 SI Mme Elina Yvetot : "Junon, composition" 691
1889 SI Mme Adelaide Salles-Wagner : "Hebe" 225
1889 UFPS Mlle Marguerite Louvet : "Hebe" 433

Z1. 1870 Mlle Marie-Virginie Boquet : "Deux aquarelles; même numéro"

1. "La Musique ; aquarelle"
2. "La Danse ; aquarelle" 3112

1870 Mme Blanche Genevay : "L'Innocence couronnée par l'Amour ;
émail" 3485

1872 Mlle Elisabeth Galtier-Boissière : "La Musique, panneau,
époque Louis XV ; - faïence" 665

1873 Mlle Marie Cozette de Rubempré : "L'Espérance ; -
médaillon, plâtre" 1870

1874 Mme Adélaide Salles-Wagner : "La Vérité entraînée par le
Mensonge" 1636

1874 Mlle Lucie-Sébastienne Adam : "Le Printemps ; - statue
plâtre" 2629

1874 Mme Hortense-Heuse Hazard : "L'Espérance ; - statuette
marbre" 2920

1874 Mlle Marie Cozette de Rubempré : "L'Espérance ; -
médaillon, bronze" 3130

1875 Mlle Marie Lebrun : "Les trois âges" 1283

1875 Mlle Jeanne Houry : "L'Automne ; - faïence" 2389

1875 Mme Léon Bertaux : "Le Printemps ; - buste, marbre" 2873

1876 Mlle Gabrielle Maigneau : "La Musique" 1379

1876 Mlle Anna Jumon : "Le Printemps ; - éventail, aquarelle" 2596

1876 Mme Fina Nicolet : "La Consolation ; - groupe plâtre" 3512

1876 Mlle Lucie-Sébastienne Adam : "L'Automne ; - statue, plâtre"
3030

1876 Mlle Constance-Joséphine Gérard : "L'Innocence ; - camée sur
sardoine" 3669

1877 Mme Joséphine Calamatta : "Idylle" 365

1877 Mlle Sarah-Paxton-Ball Dodson : "L'Amour ménétrier" 724

1877 Mlle Marie-Virginie Boquet : "La poésie lyrique ; miniature"
2335

1877 Mlle F. Caille : "L'Amour vainqueur ; - faïence" 2409

1877 Mlle F. Caille : "L'Automne ; - faïence" 2410

1877 Mlle Jane Conin : "Musique ; - faïence" 2507

1877 Mlle Antoine Oderieu : "La Source ; - porcelaine" 3226

1878 Mme Fina Nicolet : "La Consolation ; - groupe marbre"
"Consolez-vous les uns les autres" 4487

1878 Mme Signoret : "L'Innocence, - buste, plâtre teinté" 4587

1879 Mme Gabrielle Celos, née Dammouse : "La Musique" 558

1879 Mlle Alice Coleby : "Science et Musique" 691

1879 Mlle Sarah-Paxton-Ball Dodson : "La danse ; - projet de
frise" 1024

1880 Mlle Sarah Bernhardt : "La jeune fille et la mort"
269 (ill.)

1880 Anselma (Mme Marie-Lacroix) : "L'aurore et la nuit"
(Esquisse d'un plafond exécuté à l'hôtel de M.M.)
7236

1881 Mlle L-A Desbordes : "Le Songe de l'eau qui sommeille" 694

1881 Mlle L-A Desbordes : "La Nuit" 695

1881 Mlle M. Fresnaye : "La République présidant à l'instruction
de ses enfants ; médaillon plâtre" 3900

1881 Mme V. Gautier : "Son altesse l'Amour ; statuette marbre"
3919

1881 Mme L. Signoret : "Le Soir ; buste plâtre" 4290

1882 Louise Abbéma : "Les Saisons" 1

1882 Mme E. Bloch : "L'Age d'or ; groupe plâtre" 4119

1883 Mme M. Cazin : "La Fortune ; - buste bronze" 3440

1883 Mme H. Descat : "L'Innocence ; - statue plâtre" 3554

1884 UFPS Mlle Marguerite Pillini : "Printemps et Hiver" 194

1884 UFPS Mme Elisa Bloch : "L'âge d'or ; groupe plâtre" 264

1885 Mme Henrietta Pallu Du Parc : "Automne ; - panneau décoratif"
1905

1885 Mme Marie de Knizi : "Jeunesse ; - tête, terre cuite" 3862

1885 Mlle Jeanne Landmann : "Jeunesse ; gouache" 2944

1885 Mme Fina Nicolet : "Les Saisons ; - bas-relief, plâtre"
 4056

1885 Mme Fina Nicolet : "Les Saisons ; - bas-relief, plâtre"
 4057

1885 Mme Henriette Descat : "Innocence ; - statue marbre" 3605

1885 Mlle Eugénie Becker : "L'Amour, l'Inconstance, et la
 Fidélité ; boutons pendants d'oreilles, sur fond
 rouge" 4344

1885 UFPS Mme Nallet-Poussin : "Une Ame fervente" 181

1886 Mlle Louise Abbéma : "Tragédie ; - comédie" 1

1886 Mme Jacqueline Comerre-Paton : "La chanson des bois" 568

1886 Mme Matylda Godebski : "Invocation ; - buste, plâtre" 3963

1886 Mme Olga Wisinger-Florian : "Idylle" 2459

1886 Mlle Elisabeth de Driessch : "Huit miniatures"
 5. L'Aurore
 6. Le Jour
 7. La Nuit
 8. Le Temps 2782

1886 Mlle Anne-Charlotte Rome : "Le Printemps; - émail" 3296

1886 Mlle Thérèse Caillaux : "L'Horticulture ; - statue bronze"
 3588

1886 UFPS Mlle Marguerite Pillini : "Autrefois et Aujourd'hui" 244

1886 UFPS Mlle Herminie Waternau : "Le Temps passé" 319

1887 Mlle E-J Gardner : "Innocence" 990

1887 UFPS Mlle Pillini : "Idylle" 234

1887 UFPS Mme Descat : "Innocence, marbre" 11

1887 UFPS Mme Descat : "Candeur, bronze" 12

1888 Mme A-M Vallgrenn : "Sancta simplicitas ; - plâtre" 4715

1889 Mme M. Pillini : "Les trois âges ; - triptyque" 2150

1889 Mme H. Descat : "L'Age d'Or ; statue plâtre" 4288

1890 Mlle L. Abbéma : "Japon" 2

1890 UFPS Mme Marie-Adrien Lavieille : "La Charité" 436

1890 Mlle E. Gwyn-Jeffreys : "Le Menuet ; - statuette plâtre"
 3974

1890 Mlle M. Goepp-Guyon : "La femme et la chimère" 1069 (ill.)

1890 Mlle P Maillot : "La Céramique ; haut-relief plâtre" 4193

1890 Mlle B. Moria : "Invocation ; - bas-relief, marbre" 4284

1890 Mlle L. Morin : "Le Soir ; -buste, plâtre" 4287

1890 Mme C. de Saint-Gervais : "Vespera ; - statue plâtre" 4462

1891 Mme M. Goepp-Guyon : "Musique" 789

1891 Mme E. Desca : "Electricité ; - statuette, plâtre" 2459

1891 Mlle P. Maillot : "La Céramique ; - haut-relief, bronze" 2713

1891 Mlle P. Maillot : "La Mosaïque ; - statue, plâtre" 2714

1891 UFPS Mlle Lucie-Marie-Henriette Boillat : "La Poésie. Eventail.
 Composition décorative. Aquarelle" 74

1891 UFPS Mme Léonie de Loghadès : "Innocence, étude ; pastel" 496

1891 UFPS Mlle Blanche Moria : "Invocation, bas-relief, plâtre bronzé"
 23

1891 UFPS Mme Emma-Camille Nallet-Poussin : "Candeur, bas-relief
 plâtre" 25

1891 UFPS Mme Natalie de Tarnowskisch-Andriolli : "L'arrivée du
 printemps, bas-relief plâtre" 30

1892 Mlle A. Casini : "La Charité ; groupe plâtre" 2394 (ill.)

1892 Mme L. Signoret-Ledieu : "Le Travail et l'Etude, groupe
 plâtre" 3085

1893 Mme M-G Duhem : "Innocence" 632

1893 Mme C-J Fosse : "La comédie ; buste, plâtre" 2859

1893 Mlle J. Delorme : "Innocence ; - buste, plâtre" 2774

1893 Mlle M. Fresnaye : "Source et ruisseau ; - bas-relief
 plâtre" 2873

1893 Mme M Mascère : "Jeunesse" 1191

```
1893 SN      Mme Marie Cazin : "La Science et la Charité ; - groupe
                  faisant partie d'un monument élevé par souscrip-
                  tion à la mémoire des Drs. H. Cazin et P
                  Perrochaud (bronze)" 31
1893 SN      Mme Marie Cazin : "La Valse (groupe plâtre)" 37
1894         Mlle M. Perrier : "Age d'Or" 1441 (ill.)
1894         Mlle M. Brach : "La source ; - marbre" 2837
1894         Mme veuve L. Bureau : "Jeunesse ; - buste marbre" 2858
1894         Mme F. Marc : "L'aube ; - statue marbre" 3348
1894         Mme M. Syamour : "Musique d'Amour ; - haut-relief,
                  plâtre" 3618
1895 SI      Mme John M. Clark : "L'Illusion" 269
1895 SFA     Victorine Rhem : "La Fortune et l'Enfant ; miniature" 180
1895 SFA     Iacounchikoff : "L'Irréparable ; miniature" 193
1895 SFA     Iacounchikoff : "L'Effroi ; miniature" 194
1895 SFA     Iacounchikoff : "Le Parfum ; miniature" 197
1895 SFA     Iacounchikoff : "L'Inspiration ; miniature" 198
1896         Mlle L. Abbéma : "Parfums ; plafond" 1
1896         Mme A. Jacob : "Le passé et l'avenir" 1060 (ill.)
1896         Mme C. Moutet-Cholé : "Harmonie" 1476
1896         Mlle J. Rongier : "Floraison" 1719 (ill.)
1896         Mlle M. Fresnaye : "Source et ruisseau" 3458 (ill.)
1896 SI      Mme John-M Clark : "Jeune fille et chimère. Etude pour un
                  grand panneau" 213
1897         Mme M-A Demagnez : "Poésie" 2882 sculpture
1897         Mme A-F Gell : "La victoire" 2983 sculpture
1897         Mlle M. Térouanne : "Ars longa, vita brevis" 1624 (ill.)
1898 SN      Mme Bonnal : "Printemps, allégorie (pastel)" 1365
1898 SFA     Mme Louise Desbordes : "La Nuit" 27
1898 UFPS    Mme Marie-Adélaide Baubry-Vaillant : "La Nuit, étude de
                  nu ; pastel" 29
1898 UFPS    Mme Isabelle Hervé : "1800 et 1900, étude" (and other
                  miniatures) 274
1898 UFPS    Mlle Eugénie Noury-Roger : "Les Saisons ; émaux décoratifs"
                  422
1898         Mme U. Colin-Libour : "Charité" 507 (ill.)
1898         Mlle J. Rongier : "Jeunesse" 1748 (ill.)
1898         Mlle M. Blanchon : "La Danse" 3176
1899         Mlle I Thoresen : "Pax" 3967
1899         Mlle B-A Moria : "Vers l'infini" 3769
1900         Mlle Suzanne Bizard : " Vers l'idéal ; statue plâtre" 1846
1900         Mlle B-A Moria : "Vers l'infini" 2078
1900         Mlle C. Oulevay : "L'Aurore" 2084
1900         Mlle A. Kaub : "L'Homme sur sa route trouvant la Fatalité"
                  719 (ill.)

A2. 1814     Mlle Rosalie  Caron : "Mathilde et Malek-Adhel au tombeau
                  de Montmorency" (Sujet tiré du roman de Mad. Cottin)
                  175
    1814     Mme Davin : "Mort de Malek-Adhel"
                  "Le prince respire encore ; la vierge s'écrie : Mon
                  Dieu, mon Dieu, je vous bénis ! - O quelle voix, dit-
                  il en s'efforcant de se soulever, quelle voix vient
                  entourer ma mort de délices ! - Mon fils, répond le
                  pieux Guillaume, donnez à d'autres pensées le peu
                  d'instants qui vous restent ; car ils peuvent vous
                  obtenir une vie et une félicité sans terme. -
                  Avec elle ? mon père, dit-il, en pressant la main
                  de Mathilde de sa main languissante" 236
    1817     Mlle Rosalie Caron : "Mathilde surprise dans les jardins de
                  Damiette par Malek-Adhel" (Sujet tiré du roman de
                  Madame Cottin) 139
```

B2. 1812 Mme Rumilly : "Velléda"
"Assise dans un lieu écarté et sauvage, Velléda espère
par ses chants attirer celui qu'elle aime. Elle
suspend ses accords pour écouter s'il n'arrive
point ... Sa parure annonce le désordre de son esprit."
821
(Velléda is the druidess in Chateaubriand's "Les
Martyrs" 1809, books IX,X)

 1814 Mme *** : "Henri IV chez Elisabeth, reine d'Angleterre"
"Il lui fait le récit des malheurs de la Saint-
Barthélemi - sujet tiré de la 'Henriade'" 9 (Voltaire)

 1817 Mlle Sarasin de Belmont : "Paysage, effet du soir"
"Le jour n'étant pas encore à sa fin, la famille de
Lasthènes, Demodocus et Cymodocée allèrent se reposer
sous les arbres qui avoisinaient les champs où les
serviteurs de Lasthènes rentraient d'abondantes
moissons. Les soeurs d'Eudore, assises aux pieds
de leurs parens, tressaient des couronnes pour une
fête prochaine" (Martyrs, liv. 2) 690

 1819 Mme Berger, née Désoras : "Deux jours de mariage"
"Le comte Almaviva avec Rosine dans une barque
conduite par Figaro, se livre au bonheur de posséder
enfin celle qu'il a tant désirée" 51

 1819 Mme Berger, née Désoras : "Deux ans de mariage"
"Rosine, épouse délaissée, cherche le moyen de
ramener son époux, le comte Almaviva, qui bientôt
succombe à l'ennui et s'endort en faisant de la
musique. Le petit page Chérubin, à la porte, écoute
sa belle marraine" 52
(both subjects taken from Beaumarchais' "Le Mariage
de Figaro")

 1819 Mlle Lescot : "Le naufrage de Virginie" (M.I.) 768
(from Bernardin de Saint-Pierre's "Paul et
Virginie")

 1819 Mme Ruller : "Julie et St. Preux au rocher de la Meilleraie"
"Le moment est celui où Saint-Preux montre à Julie
leurs chiffres et différens vers qu'il avait autrefois
gravés dans ce lieu solitaire, en lui rappelant tout ce
qu'il y souffrit loin d'elle;Julie, émue, se détourne
en lui disant : 'Allons-nous-en, mon ami ; ce
lieu n'est pas bon pour moi'" (Nouvelle Héloïse,
lettre 17, tôme 5) 1007 (Rousseau)

C2. 1812 Adèle de Romance (ci-devant Romany) : "Portrait de Mad.
Raucourt, dans le rôle d'Aggripine, au moment où
elle dit à Néron : asseyez-vous, Néron" 292
(ill. in Witt library)

 1812 Mlle Jenni Désoras : "Sargines, élève de l'Amour"
"L'instant représenté est celui où la jeune Sophie
d'Apremont lit ce passage du jeune banncret. 'C'
est que vous ayme à mourir'. Sagines, redit plusieurs
fois ces mots, d'une voix tremblante, en regardant
Sophie" 305
("Sargines, élève de l'Amour" was a lyrical comedy
in four acts, with words by Monvel, music by
Dalayrac, first performed in 1788)

 1819 Mlle Inès d'Esménard : "Portrait de Mlle Duchesnois (artiste
sociétaire du théâtre Français, dans le rôle d'
Electre)"
"Témoin du crime affreux que poursuit ma vengeance,
oh nuit ! dont tant de fois je troublai le silence ,

Insensible témoin de mes vives douleurs ,
Electre ne peut plus te confier des pleurs .
.
.
Favorisez, grands dieux, un si juste courroux ,
Electre vous implore, et s'abandonne à vous"
(Crébillon, acte 1er, scène 1er) 425

1819 Mlle Inès d'Esménard : "Portrait de Mlle Mars, artiste
du théâtre Français"
"Elle est représentée dans le rôle d'Agnès, au
moment où elle lit devant son tuteur 'les maximes
du mariage'" (Molière : "Ecole des femmes" acte
3ième, scène 2ième) 426

1819 Mlle Félicie Varlet : "Portrait de Mlle Volnais, actrice
du Théâtre Français" (Rôle d'Adélaide du Guesclin)
1135

1822 Mme Dabos : "Portrait de M. Philippe, dans 'Le Vampire'" 1695

D2. 1822 Mlle Fontaine : "Mariage d'Angélique et Médor" 478
1824 Mlle Robineau : "Malvina ; paysage, clair de lune" 1458
(Ossian)

E2. 1822 Mlle Legrand de St.-Aubin : "Mathilde dans son oratoire"
"Me voici prête à m'unir à toi, Maleck-Adhel, pour
l'éternité ; je n'attends qu'un mot : est-tu à mon
Dieu ? Troublé, hors de lui, le prince s'écrie :
Mathilde, que me demandes-tu ? Mon éternelle
félicité et la tienne, répond la vierge avec des
regards divins ; voudrais-tu me les refuser ?
Peut-être allait-il céder lorsque le bruit d'une
marche précipitée vient tout-à-coup effrayer la
princesse" 839

1822 Mlle Legrand de St.-Aubin : "Baptême et mort de Malek-
Adhel"
"L'archevêque se hâte de répandre sur le prince
mourant l'eau sainte du baptême ; le prince quitte
la main de Mathilde pour embrasser la croix :
Aussitôt la lumière divine descend par torrens dans
son âme : 'Célestes clartés, dit-il, je vous ai
vues ; foi, espérance, amour, je me livre à vous'"
840

1822 Mme de Servières : "Maleck-Adhel attendant Mathilde au
rendez-vous qu'elle lui a donné dans le tombeau
de Josselin de Montmorency" 1193

1824 Mlle Rosalie Caron : "Mathilde et Malek-Adhel surpris dans
le tombeau de Montmorency par l'archevêque de Tyr"
"La porte s'ouvrit tout à coup, et l'Archevêque
parut. Il jeta un cri horrible. Mathilde ne songea
alors qu'au danger du Prince, et se précipitant
vers Guillaume : 'Ah ! mon père, lui dit-elle,
contenez-vous ; un mot peut le perdre ; venez,
sortons d'ici'" (Sujet tiré du roman de Mme Cottin)
275

F2. 1822 Mlle Inès D'Esménard : "Sujet tiré du Renégat du vicomte
d'Arlincourt"
"Agobar, percé de plusieurs coups de poignard, est
au moment d'expirer. Eziida tâche de le ramener à
la religion. Le rosaire suspendu à sa poitrine se
détache et tombe sur le sein du renégat, qui s'en

saisit et le porte à ses lèvres d'abord par amour ..
puis l'y reporte par piété" 465

1824 Mlle Legrand de Saint-Aubin : "Eudore et Cymodocée" (Tiré
des 'Martyrs' de M. de Chateaubriant) 1111

1827 Mlle Grandpierre : "Sujet tiré du roman de la princesse de
Clèves (de Mme de la Fayette)
"La Dauphine faisait faire des portraits de toutes
les belles personnes de la cour ; elle demanda un
autre portrait de Mme de Clèves, pour le voir auprès
de celui que l'on achevait. Après les avoir regardés,
elle s'entretint avec Mme de Clèves, qui vit M. de
Nemours prendre ce portrait ; elle en fut si troublée
que la Dauphine, remarquant qu'elle ne l'écoutait
pas, lui demanda ce qu'elle regardait. M de
Nemours se tourna à ces paroles, il rencontra les
yeux de Mme de Clèves" 479

1827 Mme Rullier : "Sujet tiré d'un épisode d''Atala'"
"La jeune Indienne de la tribu des Natchez, fille
de Réni et de Celuta, faisant sécher sur un arbre
le corps de son enfant, mort dans le désert" 924

G2. 1822 Mlle d'Hervilly : "Sujets tirés de Guzman d'Alfarache,
roman de Lesage" 702

1822 Mlle Sarrazin de Belmont : "Gilblas et don Alphonse" 1165

1824 Mlle Grandpierre : "Scène du roman de Gilblas de
Santillane"
"L'Aventurier Camille, feignant de l'aimer, lui vole
un diamant en ayant l'air de faire un échange" 799

1824 Mme Haudebourt-Lescot : "L'avis au lecteur du roman de
Gil-Blas" (Ce tableau appartient à S.A.R. Madame) 866

1824 Mlle D'Hervilly : "Quatre sujets tirés de Gusman d'
Alfarache (Roman de Lesage)"
1. "Gusman, après avoir quitté la maison paternelle
pour chercher fortune, ne sachant où passer la nuit,
se couche sur les marches d'une chapelle ; il est
réveillé par de jeunes paysannes dansant et jouant
des castagnettes"
2. "Gusman malade est rencontré par un muletier qui
l'engage à monter sur un de ses mulets"
3. "Gusman trouve dans l'arrière cour d'une
hôtellerie, la peau d'un jeune mulet fraichement
écorché. Il appelle son camarade le muletier, qui
en avait mangé la veille, le prenant pour du veau,
et se moque de lui"
4. "Gusman vole des confitures de son maître. Le
cardinal le surprend le bras dans le coffre qu'il
vient de forcer" 900

1827 Mme Haudebourt : "L'explication du tableau du mariage de
vengeance" (Gilblas) 536

1827 Mme Haudebourt : "Gilblas chez l'hôte Corcuello" 537

1827 Mme Haudebourt : "Gilblas présenté au licencié Sédillo" 538

H2. 1827 Mlle Grandpierre : "Sujet de Quentin-Durward (Walter-Scott)"
"La comtesse Isabelle tendit la main à Quentin qui
la baisa avec respect, et elle lui dit : 'Il faut
que nous quittions ces bons amis, ... que vous
changiez d'habits et que vous me suiviez, à moins
que vous ne soyez las de protéger une infortunée.."
478

1827 Mme Morlay (née Transon) : "Sujet tiré de l''Officer de
Fortune' (Walter Scott)"
"Annette Lyle calme, par les accords de sa harpe, les

accès d'Allan Mac-Aulay. Près d'elle est Lord
Menteith, officer anglais, ami d'Allan" 753

1827 Mlle Gallemant Demarennes : "Scène tirée d'Ivanhoé, de
Sir Walter Scott"
"Rebecca ne peut reconnaître Briant de Bois
Guilbert à cause du soin qu'il prend de se couvrir,
et le jugeant d'après ses vêtemens, qui étaient
ceux d'un des brigands auxquels elle attribuait
encore sa captivité, elle détache son collier et
ses bracelets, les lui présente en disant : 'Prenez
ceci, et, pour l'amour du ciel, ayez pitié de mon
vieux père et de moi'. 'Belle fleur de la Palestine,
répondit le templier en refusant les joyaux qu'elle
lui offrait, j'ai fait voeu de préférer toujours
la beauté aux richesses" 1479
(This work was also included in the "Catalogue des
Ouvrages de Peinture, Sculpture et Gravure,
appartenans à la Société des Amis des Arts" for
1827, no. 32)

1827 Mlle De Fauveau : "Sujet tiré du roman de l'Abbé, par
Walter Scott" 1784 sculpture

I2. 1822 Mme Chéradame, née Bertaud : "La fée Urgèle ou ce qui plait
aux dames"
"Le chevalier Robert vient d'être condamné par la
reine Berthe à épouser la vieille" 231

1822 Mlle Alexandrine Delaval : "Alexis"
"Il vient de célébrer la beauté de Daphné qu'il
aime sans le lui dire ; il s'aperçut que son
secret est découvert ; Daphné et Chloé, sa compagne,
écoutaient ses chants" (Idylles de Gessner) 323

1822 Mme Adèle Romany de Romance : "Philis courronnant de
fleurs Daphnis" (Idylle de Gessner) 335

1822 Mlle Duvidal : "L'enfant et la Fortune, fable de Lafontaine"
"Sur le bord d'un puits très-profond ,
Dormait, étendu de son long,
Un enfant, etc." 455

1822 Mlle Fontaine : "Une scène de la romance de M. Desprez"
"C'est alors que ma grand-tante
Nous compta, le coeur saisi,
L'histoire affreuse et constante
D'Enguerand, sit de Crecy.
'Tenez, voyez, nous dit-elle,
Sur le penchant du coteau
Cette tour qui chancele.
C'est là son château'" 477

1822 Mlle Laure de Beaume : "Sujet pris dans le Mariage
enfantin"
"L'auteur a représenté le moment où la jeune
mariée se cache dans sa corbeille" 1716

1824 Mme Guimet, née Bidauld : "Danae exposée sur les flots
avec son fils Persée"
"O mon fils, il n'est plus d'espoir :
Déjà le gouffre nous dévore ;
Sur mon sein je te presse encore,
Mais je ne dois plus te revoir" (M. Casimir
Delavigne) 854

1824 Mlle Legrand de Saint-Aubin : "La Belle au bois dormant"
1112

1824 Mme Sauvageot : "La poule aux oeufs d'or, fable de
Lafontaine" 1529

J2. 1830 Mme Verdé Delisle : "Un sujet tiré de Walter Scott
(Péveril du Pic)" 2258

 1830 Mme Verdé Delisle : "Marie-Stuart au château de Look-
leven (sujet tiré de l'Abbaye, de Walter-Scott)"
260

 1830 Mme Debay : "Un sujet du château de Kenilworth" 506

 1830 Mme Verdé Delisle : "Un sujet tiré de Walter Scott
(Le Château de Kenilworth)" 590

 1831 Mlle L.C. : "Marie-Stuart au château de Lochleven"
"Catherine Seyton profite de son ascendant sur
le page Roland, pour lui faire jurer aux genoux
de la reine qu'il fera tous ses efforts pour la
faire sortir de prison. Marie - émue, lui donne
sa main à baiser, et Catherine prie le ciel de
favoriser l'entreprise" ("L'Abbé" - Walter
Scott) 255

 1831 Mlle L.C. : "Charles II réfugié à Woodstock" (Walter
Scott) 256

 1831 Mlle L.C. : "Louis XI consulte son astrologue sur la
fidélité de Quentin Durward" (Walter Scott) 257

 1831 Mme Meynier : "La fiancée de Lammermoor" (Walter
Scott) 1489

 1831 Mme Verdé-Delisle : "Weyland, déguisé en colporteur, s'
introduit près d'Amy Robsart" (Château de
Kenilworth, roman de Walter Scott) 2071

 1833 Mlle Rosalie Caron : "Miss Alice Lee et Charles II"
"Charles, déguisé sous les vêtemens d'une
femme du peuple, fuyait les poursuites de Cromwell.
Il rencontre à la fontaine, près le château de
Woodstock, la fille de sire Henri Lee, qui venait
puiser de l'eau. 'Si vous vouliez accepter mon
aide, votre besogne serait plus tôt faite', lui
dit Charles, en posant une main aussi large que
dure sur la tête de la jeune fille, effrayée de
cette rencontre inattendue" ("Woodstock" ou "Le
Cavalier" - Walter Scott) 344

 1833 Mlle A. Martin : "Sujet tiré de la prison d'Edimbourg" 1683

 1833 Mme Verdé-Delisle : "Magnus Troil et ses filles allant
visiter la vieille Norna dans sa tour" ("Le
Pirate" par Walter Scott) 3213

 1834 Mlle Le Grand de St.-Aubin : "Charles II, avant de partir
de la loge de Woodstock, prend congé de Sir Henry
Lee"
"Adieu, mon digne ami, dit le roi, pensez à moi
comme à un fils, comme à un frère d'Albert et d'
Alice, qui, à ce que je vois, sont impatiens de
me voir partir ; donnez-moi la bénédiction d'un
père, et je pars.
Que le Dieu qui fait régner les rois bénisse
votre majesté (dit Sir Henry, en s'agenouillant et
levant vers le ciel son visage vénérable et ses
mains jointes), qu'il la garantisse des dangers
auxquels elle est exposée, et la remette, au temps
qu'il a fixé, en possession de la couronne qui lui
appartient" 1212

 1838 Mlle Anna Borrel : "Jeannie Deans chez Reuben Butler"
"Avant de partir pour demander la grâce de sa
soeur, Jeannie Deans va faire ses adieux à Reuben
Butler, son fiancé. Après le départ de Jeannie,
Reuben trouva sous sa Bible quelques pièces d'or
qu'elle y avait glissées à son insu" (Walter Scott,

```
                        "La Prison d'Edimbourg") 158
   1838      Mlle Claire Laloua : "Minna Troil, accompagnée de son père
                        et de sa soeur, chez Norna de Fitful-Head" (Walter
                        Scott "Le Pirate") 1038
   1839      Mme Mélanie Goetz : "Marie-Stuart" (sujet tiré de l''Abbé'
                        - Walter Scott) 892
   1839      Mlle Pauline Tanera : "Sujet tiré de 'La Fiancée de
                        Lammermoor' (Walter Scott)" 1952
   1840      Mlle Héloise Colin : "Sujet tiré du 'Pirate' de Walter
                        Scott" 284
   1840      Mlle Héloise Colin : "Sujet tiré de 'Woodstock' de Walter
                        Scott" 285
   1840      Mme Verdé de Lisle : "La sauve-garde" (Walter Scott : "Le
                        Monastère") 1608
   1841      Mme Rimbaut-Borrel : "Arrestation d'Effie Deans" 1694
                        (+ see note 176)
   1842      Mme Léonie Taurin : "Sujet tiré de l'Antiquaire ;
                        aquarelle (Walter Scott)" 1748
   1846      Mme Le Provost : "La fiancée de Lammermoor" 1192
   1848      Mlle Caroline Thévenin : "Flora Mac-Ivor et Rose
                        Bradwardine ; pastel" (Walter Scott - "Waverley")
                        4244
   1848      Mme Anaïs Toudouze : "La fiancée de Lammermoor ; aquarelle"
                        4285

K2. 1831      Mlle Le Duc : "Louis XIV et Mme de la Vallière"
                        "Louis XIV attribuait la tristesse de Mme de la
                        Vallière à un refroidissement pour lui. Etant allé
                        plusieurs fois chez cette dame sans la rencontrer,
                        les soupcons de Louis prirent une nouvelle force.
                        Il interrogea un valet qui lui apprit que la
                        duchesse s'était réservé un cabinet dans lequel elle
                        se renfermat tous les matins. Voulant pénétrer ce
                        mystère, le roi se procure une clé de ce cabinet, et
                        à l'heure où la duchesse y était, il y entre tout-
                        à-coup ... Louis reste immobile en apercevant Mme
                        de La Vallière seule à genoux sur un prie-Dieu au-
                        dessus duquel est attaché le portrait de sa mère,
                        et tenant à la main la croix de cristal qu'elle
                        avait reçue d'elle" (Tiré du roman de Mme de
                        Genlis) 1305
   1833      Mme Dehérain : "Vision de Jeanne d'Arc"
                        "Une vision mystérieuse arma le bras de Jeanne d'
                        Arc" ( Chateaubriand : "Etudes historiques") 626
   1833      Mlle Grandpierre : "Marion de Lorme et le chevalier de
                        Grammont"
                        "Mademoiselle, lui dit le chevalier, vous avez peur
                        que Brissac ne me trouve avec vous, j'y ai mis bon
                        ordre : il est au bout de la rue qui promène mon
                        cheval, Je ne suis entré ici qu'à l'aide de mon
                        manteau" (Dictionnaire de l'Amour) 1130
   1833      Mlle Henry : "Quasimodo sauvant la Esmeralda des mains de
                        ses bourreaux" (Episode de "La Notre-Dame de Paris")
                        1233
   1833      Mme Meynier : "Sujet tiré de Notre-Dame de Paris" 1724
   1834      Mme Clément : "Gelsomina se jetant aux pieds du doge pour
                        obtenir de lui la grâce de son amant, Jacopo
                        Frontoni" (Sujet tiré du "Bravo", roman de
                        Fenimore Cooper) 333
   1834      Mlle E. Goblain : "Don Juan et Marie-Anne de Neubourg"
                        "Don Juan fait à la reine des reproches sur la
```

légèreté de sa conduite, lors d'une réception
faite à l'archevêque ; Marie est assise sur son
canapé, le bras enfoncé dans l'un des coussins,
tandis que l'autre brise et jette autour d'elle
des violettes et des jacinthes qu'elle prend dans
une corbeille qui est à ses pieds ; accoutumé à
des éclats bruyans, don Juan est ému de cette
peine silencieuse : 'Marie, regards-moi, mais ne
pleurez plus, vos larmes me font mal ;' et pressant
la main de Marie dans la sienne, il découvre son
visage, elle lève sur lui des yeux remplis de
larmes, veut parler et ne peut qu'éclater en
sanglots" ("L'Amirante de Castille" par Mme la
duchesse d'Alrantès) 866

1835 Mlle Biet : "Luxe et Misère"
" . . . Elle vend enfin sa psyché, et ne conserve
plus que ses bijoux faux, comme souvenir de sa
prospérité passée" ("L'Inévitable , conte de
Daniel Le Lapidaire", par Michel Masson) 146

1836 Mlle Amélie Legrand de Saint-Aubin : "Klotilde"
(Chateaubriand, " Etudes historiques") 1194
(+ see N)

1837 Mlle Herminie Descemet : "Anne d'Autriche et Marie de
Gonzague"
"Après l'émeute de Cinq-Mars, en 1642, Anne d'
Autriche, rentrée dans son appartement, se laisse
aller à de tristes souvenirs et révèle à Marie
l'amour de Buckingham : 'Oui, je te le dis à toi,
je l'ai aimé, je l'aime encore dans le passé plus
qu'on ne peut aimer d'amour. Eh bien ! il ne l'a
jamais su, jamais deviné. Ce visage, ces yeux ont
été de marbre pour lui, tandis que mon coeur brûlait
et se brisait de douleur ; mais j'étais reine de
France ..'" ("Cinq Mars", chap. XV, Alfred de
Vigny) 522

1837 Mlle Adèle Martin : "La reine Marie Leczinska se fait
présenter les nièces de la duchesse de Mazarin, que
sa mort laissait sans asile"
" Cette princesse les reçut avec une bonté touchante,
en leur disant que si la duchesse leur avait tenu
lieu de mère, son intention était de la remplacer"
("La Duchesse de Châteauroux" par Mme Sophie Gay)
1285

1837 Mme Fournier, née Monsaldy : "Portraits pour les oeuvres de
M. de Chateaubriant" (gravure) 2052

1838 Mlle Anna Borrel : "Valentine de Milan et Odette de
Champs-Divers"
"Valentine de Milan ayant appris l'amour du duc
d'Orléans, son mari, pour Odette, la fit venir.
'C'est donc vous, lui dit-elle, qui avez voulu
me faire tort de l'amour de monseigneur, et qui croyez,
après cela, qu'il n'y a qu'à vous agenouiller pour
que je vous pardonne'. Odette se releva vivement :
'J'ai mis un genou en terre, Madame, parce que vous
êtes une grande princesse, et non pour que vous me
pardonniez, car grâce au ciel, je n'ai aucune
faute à me reprocher envers vous'" (Alexandre Dumas :
"Isabel de Bavière") 157

1838 Mme Elise C. Boulanger : "Voltaire lisant 'Candide' à Mme
de Pompadour ; aquarelle" (Jules Janin "Contes
nouveaux") 172

1838 Mlle Léonie Mauduit : "La fileuse de la tour de Montlhéry ;
 aquarelle"
 " ... Reprenant son fuseau avec plus d'ardeur que
 jamais, quand elle voyait une larme couler lentement
 sur la joue amaigrie de Berthe, elle lui disait de sa
 douce voix : ' ne pleure pas nourrice, ne pleure pas,
 et sois sûre que notre Rodolphe viendra nous
 délivrer quand tout ce lin sera filé'"(Albert de
 Saint-Amand) 1264

1839 Mme Anna Rimbaut : "Le général Marceau et Blanche de
 Baulieu" 1791 (+ see Q) (from "La Rose Rouge"
 by Alexandre Dumas)

1842 Mlle Elisa Anfray : "Marie de Mantoue"
 " . . . La reine (Anne d'Autriche) continuait à
 fermer et à r'ouvrir, en jouant, la nouvelle couronne,
 les diamants ne vont bien qu'aux cheveux noirs, dit-
 elle ; voyons, donnez votre front, Marie .. Mais
 elle va à ravir, continua-t-elle" (Alfred de Vigny -
 "Cinq Mars) 20

1843 Mlle Léonide Provandier : "Jeune bretonne"
 (Sujet tiré des "Derniers Bretons" par M. Emile
 Souvestre) 981

1843 Mme Eugénie Latil : "Faux mariage de don Juan de Padilla,
 le fameux chef des Communeros, avec dona Maria
 Pacheco, en présence de la reine Jeanne-la-Folle
 dans les appartements secrets de l'Aléazar de
 Tordesilas"
 "Le prince maure Abbas, après avoir, sous les
 habits d'un moine, uni Maria Pacheco à don Juan
 de Padilla, suivant les rites chrétiens du seizième
 siècle, fait trois fois le tour du lit nuptial en
 l'aspergeant d'eau bénite. Le perfide Moreno encourage
 son action sacrilège dans la vue des malheurs qui
 doivent s'en suivre pour le couple abusé. La reine
 Jeanne, revenue momentanément à la raison, a voulu
 servir de mère à la jeune Maria ; elle la presse dans
 ses bras, et sourit mélancoliquement aux regards
 passionnés qu'échangent les deux amants. La fidèle
 Inès, agitée d'un vague pressentiment, vit les
 mouvements des deux traitres avec inquiétude"
 ("Ligue d'Avila" par M. le comte Victor du Hamel) 712

1844 Mlle Clara Henry : "Blanca après le départ d'Abou-Hamet"
 "Elle passoit le reste de ses jours parmi les ruines
 de l'Alhambra. Elle ne se plaignoit point, elle ne
 pleuroit point, elle ne parloit jamais d'Abou-Hamet :
 un étranger l'auroit crue heureuse" (Chateaubriand -
 "Aventure du dernier Abencérage") 922

1844 Mme J. Calamatta : "Eudore et Cymodocée"
 "Eudore, condamné à être exposé dans le cirque avec
 Cymodocée, sa fiancée, pour être dévoré par les
 bêtes féroces, lui passe au doigt, l'anneau de
 mariage au moment de mourir" (Chateaubriand - "Les
 Martyrs") 254

1845 Mlle Rosa Bonheur : "Les trois mousquetaires" 157

1845 Mlle Irma Martin : "Le Bravo en prison"
 "Jacopo Frontoni, dit le Bravo, accusé d'avoir ôté la
 vie au vieux pêcheur Antonio, est pour ce crime
 retenu prisonnier et condamné à mort. Il déclare au
 père Anselmo, qui est venu pour le confesser, qu'il
 est innocent de ce crime ainsi que de tout autre.
 Geselmina, la fille du géolier, qui était entrée

furtivement dans la prison, en entendant déclarer
l'innocence de celui qu'elle aimait, s'évanouit
de joie dans ses bras" (Cooper - "Le Bravo")1167

1848 Mlle Elisa Allier : "Cazotte et sa fille à la prison de l'
Abbaye" 41 (+ see note 117)

1848 Mlle Elisa Allier : "Cazotte sauvé par sa fille" 42 (+ see
note 118)

1848 Mlle Elisa Allier : "Mort d'Elisabeth Cazotte" 43 (+ see note
119)
(the latter three from Michel Masson's "Les Enfants
Célèbres")

1848 Mlle Estelle-Félicie-Marie Barescut : "Une lecture chez
Anne d'Autriche"
"La reine était au milieu de ses femmes, Mmes de
Guitaut, de Sable, de Montbazon et Mme de Guiménée.
Dans un coin était cette camériste espagnole dona
Estafana, qui l'avait suivie de Madrid ; Mme de
Gueménée faisait la lecture, et tout le monde
écoutait avec attention la lecture, afin de pouvoir,
tout en feignant d'écouter, suivre, le fil de ses
propres pensées.
Ces pensées, toutes dorées qu'elles étaient par
un dernier reflet d'amour, n'en étaient pas moins
tristes. Anne d'Autriche, privée de la confiance
de son mari, poursuivie de la haine du cardinal, qui
ne pouvait lui pardonner d'avoir repoussé un
sentiment plus doux, Anne d' Autriche avait vu
tomber autour d'elle ses serviteurs les plus dévoués,
ses confidents les plus intimes, ses favoris les
plus chers" (Alexandre Dumas - "Les Trois Mousque-
taires") 194

1848 Mme Constance Jacquet de Valmont : "Numa au tombeau de
Pompilius" (Florian) 2371

1848 Mlle Marie de Poltoratzky : "Cinq-Mars ; aquarelle"
"Louis XIII, fatigué du joug que lui avait imposé
Richelieu, et cherchant, sans le trouver, un
prétexte pour l'éloigner des affaires, s'en était
ouvert à Cinq-Mars. Celui-ci en parle à la toilette
de la reine, où il se trouve réuni avec d'autres
mécontents ; et après avoir peint l'état moral du
roi, il ajoute ces mots :
- 'Enfin, madame, l'orage gronde dans son coeur, mais
ne brûle que lui ; la foudre ne peut pas sortir'.
- 'Eh bien ! qu'on la fasse donc éclater',s'écria le
duc de Bouillon.
- 'Celui qui la touchera peut en mourir', dit Monsieur.
- 'Mais quel beau dévouement !' reprit la reine.
- 'Que je l'admirerais !' dit Marie à demi-voix.
- 'Ce sera moi', reprit Cinq-Mars.
- 'Ce sera nous' , dit M. de Thou à son oreille"
("Cinq-Mars", chap. XVII - La Toilette) 3747

L2. 1841 Mlle J. Fabre D'Olivet : "Retour d'Olivia"
"Après avoir été séduite par Thornhill, Olivia,
repentante, revient dans sa famille. Elle y est
accueillie par les reproches de sa mère" (Goldsmith
- "Le Vicaire de Wakefield") 675

1847 Mme Héloise Leloir : "Deux aquarelles"
2. "Clarissa Harlowe" 1860 (Richardson)

M2. In 1842, two women artists illustrated different translations of the
same German story : -

Mlle Irma Martin : "Ondine donne à son époux le baiser qui
 doit le faire mourir"
 "Ondine était une fille des eaux qui ne pouvait
 acquérir une âme que si elle était aimée et épousée
 par un mortel. Ce fut au chevalier Huldebrand qu'
 elle dut ce présent céleste ; comme il ne lui resta
 pas toujours fidèle, Ondine, suivant son destin,
 retourna sous les eaux. D'après la loi des Ondins
 elle devait faire périr son époux s'il contractrait
 un nouveau mariage. Huldebrand épousa Bertha, et au
 moment où il allait se rendre auprès d'elle, Ondine
 apparait voilée au chevalier. 'O mon bien aimé, dit-
 elle, ta dernière heure a sonné ! Laisse-moi te voir
 encore, ma chère Ondine, s'écria-t-il, si tu as le
 choix de mon supplice fais-moi mourir par un baiser'.
 Elle souleva son voile, et déposa un baiser céleste
 sur le front de son époux, et leurs âmes ne tardèrent
 pas à se réunir pour ne se séparer jamais" (Conte
 allemand traduit par M. de Lamotte-Fouqué) 1332

Mme Anna Rimbaut-Borrel : "Ondine et Huldebrand"
 "Ondine, fille des eaux, était venue séjourner parmi
 les mortels ; mais, elle ne devait avoir une âme
 que lorsqu'elle connaîtrait l'amour. Le chevalier
 Huldebrand, qu'elle aime, apprend de sa bouche qu'
 elle n'existera plus sur terre, et retournera pour
 toujours près des Ondines, ses soeurs, aussitôt qu'
 il cessera d'être constant" ("Ondine". traduction de
 l'allemand, par Mme de Montolieu) 1608

(See O2 for illustrations of Goethe)

N2. 1837 Mme Elise Boulanger : "Mort de Geneviève" "Le dern-
 ier jour, Geneviève pria André de lui apporter plus
 de fleurs qu'à l'ordinaire ; d'en couvrir son lit,
 et de lui faire un bouquet et une couronne .. Joseph
 entra en ce moment, elle lui tendit la main et le fit
 asseoir auprès d'elle ; elle passa son autre bras
 autour du cou d'André, et appuya sa joue froide
 contre la sienne" ("André", George Sand) 182

1838 Mlle J. Volpelière : "La jeune Noun recevant la première
 leçon de guitare d'Indiana" 1781

1843 Mme veuve Lavalard : "Geneviève la fleuriste"
 "Au moins, lui avait dit le médecin, vous mourrez
 sans trop souffrir ; vous n'aurez pas la force d'
 accoucher .. En effet, pendant ce dernier mois,
 Geneviève ne souffrit plus : elle n'avait pas la
 force de quitter son fauteuil : mais elle lisait
 l'Ecriture sainte ou se faisait apporter des fleurs
 dont elle parsemait sa table ... Elle regardait
 doucement le ciel et ses fleurs, puis elle se
 penchait vers elles et leur parlait à demi-voix d'
 une manière étrange et enfantine : - Vous savez que
 je vous aime, leur disait-elle, Vous me connai-
 ssez, vous avez un langage, et je vous comprends.
 Nous sommes soeurs" (George Sand - "André") 714

1844 Mme Sophie Jobert : "Rigolette" (Eugène Sue - "Les Mystères
 de Paris") 976

1844 Mme Sophie Jobert : "Fleur-de-Marie" (Eugène Sue - "Les
 Mystères de Paris") 977

1845 Mlle Augusta Lebaron : "Fleur-de-Marie" 1007

1846 Mlle Alexandrine Martin : "Consuelo" 1265

1846 Mlle Adèle Ferrand : "Enfance de Paul et Virginie" 647

1846 Mlle Adèle Ferrand : "Réception de la lettre de la
 tante de Virginie" 648

1846 Mlle Adèle Ferrand : "La dribe"
 "Des cris perçants portèrent surtout l'inquiétude
 d'Emile vers un point que la végétation lui
 cachait ; mais bientôt il vit paraître vers le
 rivage opposé un homme vigoureux qui emportait un
 enfant à la nage ... J'irais à son aide, j'irai !
 s'écria Emile ému jusqu'aux larmes, et prêt encore
 une fois à s'élancer de l'arbre" (George Sand -
 "Le Péché de M. Antoine") 1068

1847 Mme Héloise Leloir : "Deux aquarelles"
 1. "Virginie" 1860

1848 Mme Marie-Louise-Clémence Sollier : "Manon Lescaut"
 "Premier jour de captivité" 4160

1848 Mlle J. Fabre d'Olivet : "Rosa et Gertrude"
 "Après que nous eûmes attendu quelque temps devant
 l'allée de la maison, mes deux compagnons s'
 assirent sur les marches du perron extérieur,
 accablées qu'elles étaient, l'une de fatigue, l'
 autre de faiblesse et de douleur" (R. Topffer :
 "Rosa et Gertrude") 1575

1849 Mlle Ernestine Schwind : "Les deux bessons, la petite
 Fadette" (Roman de George Sand) 1826

1852 Mme Pensotti née Céleste : "Le bouquet de déclaration"
 "Elle ne me voit point ... c'est bon" (George
 Sand : "François Le Champi") 1012

02. 1831 Mme Verdé-Delisle : "Une scène de Louise ou La Réparation"
 (Vaudeville de M. Scribe) 2069

 1833 Mlle Le Grand de St.-Aubin : "Marino-Faliero"
 (Voir, pour l'explication du sujet, "L'Art", 1188
 page 86) 1538

 1835 Mlle Zoé de Plinval : "Marguerite dans sa prison un peu
 avant sa dernière entrevue avec Faust" 1752

 1837 Mme Cordelier Delanoue (née Amélie Cadeau) : "Une scène du
 Misantrope"
 "Alceste : ' Ah ! que le coeur est double, et sait
 bien l'art de feindre.
 Mais, pour le mettre à bout, j'ai des moyens tout
 prêts.
 Jetez ici les yeux, et connaissez vos traits ;
 Ce billet découvert suffit pour vous confondre.'
 Célimene : 'Voilà donc le sujet qui vous trouble
 l'esprit ?'"
 (Acte IV, scene III Molière) 384

 1838 Mlle M. Lafon : "Mort de Desdemona" (Shakespeare, "Othello")
 1030

 1839 Mme Bourlet de La Vallée (née Espérance Langlois) : "Faust
 et Marguerite"
 "Faust, redevenu jeune, beau et plein de passions
 violentes, par le pouvoir de Mephistopheles, séduit
 Marguerite, dont il tue le frère qui le provoque en
 duel. Tandis qu'il emploie la fuite et la ruse pour
 échapper à la vengeance des lois, Marguerite elle-
 même, condamnée comme infanticide, ne doit sortir de
 son cachot que pour marcher au supplice. Vainement
 Faust, introduit par Mephistopheles auprès de la
 condamnée, cherche à la dérober à la mort en l'
 entraînant avec lui ; la jeune fille, réconciliée avec
 le ciel, repousse courageusement le dangereux secours

de son coupable amant, dont, en ce moment même,
Mephistopheles s'empare en lui montrant le pacte
par lequel il lui a livré son âme" 240

1839 Mlle Augustine Frilet de Châteauneuf : "Louis XI cherchant
 à savoir le secret de Marie de Commines, et celle-ci
 implorant la grâce de Nemours" ("Louis XI" tragédie
 par M. Casimir Delavigne) 806

1839 Mlle Sophie Hubert : "Desdemone"
 "Desdemone - 'Ma mère avait auprès d'elle une pauvre
 moresse, elle était éprise et son bien-aimé l'aban-
 donna ; elle devint folle ... Elle avait une chanson
 du saule ... c'était une vieille chanson, mais qui
 exprimait bien son malheur ... Cette chanson, ce
 soir, ne veut pas me sortir de l'idée'
 (Après avoir rêvé, elle chante à mi-voix) :
 'Au pied d'un saule,'etc." ("Othello", acte IV
 scène 3) 1041

1839 Mme Tripier Le Franc : "Portrait de Mme Léontine Volnys,
 dans le rôle de dona Florinde" ("Don Juan d'
 Autriche" par M.C. Delavigne) 1986

1841 Mme C. de Bar : "Esther"
 "Le moment représenté est celui où Esther tombe aux
 pieds de Dieu et lui demande d'épargner son peuple"
 " . . . O mon souverain roi,
 Me voici donc tremblante et seule devant toi"
 (Racine - "Esther") 75

1843 Mlle Félicie Défert : "Sujet tiré du Malade Imaginaire,
 acte 1, scène 7"
 "Après que Belinde vient d'entourer son mari d'
 oreillers, la maligne Toinette lui en met un
 rudement sur la tête, en disant : 'Et celui-ci
 pour vous garder du serein'.
 Argan se débat en colère, et, lui jetant les
 oreillers, s'écrie : 'Ah coquine, tu veux donc
 m'étouffer ! ..." 520

1845 Mlle Félicie Défert : "Le Bourgeois Gentilhomme"
 "M. Jourdain s'apercevant que Nicole écoute son
 entretien avec Dorante, au sujet de la belle
 marquise, lui donne un soufflet en s'écriant :
 'Ouais ! vous êtes bien impertinente (à Dorante),
 sortons, s'il vous plaît' etc." (Acte III, scène VI)
 422

1848 Mme Laure Delaune : "Hamlet ; dessin"
 "Hamlet - 'Qu'ordonnes-tu ? de frapper ? j'obéis.
 Mon père, tu le vois. Grâce ! je suis son fils'"
 (Acte V, scène VII) 1183

1849 Mme Louise-Constance-Rose de Parron : "Marie de Commines
 et le dauphin (Charles VII)"
 "Le Dauphin : 'Ah ! qu'il est doux d'apprendre !
 Je le sens près de vous '
 Marie : 'Commençons..'"
 (Casimir Delavigne - "Louis XI" acte 2, sc. 2) 1008

P2 1830 Mlle Louise Marigny : "Le meunier, son fils et l'âne" 172
 1830 Mlle Louise Marigny : "Perette" 173
 1831 Mme Negelen : "Malvina ; dessin" 1570 (possibly the heroine
 ofMme Cottin's novel)
 1831 Mlle Louise Marigny : "Le meunier et son fils" 1447
 1831 Mme Meynier : "L'amour mal récompensé" ("Idylle" Gessner)
 1491
 1831 Mlle F. Robert : "Laure, dessin"
 (Sujet tiré des poésies de Pétrarque) 3151

1835 Mme Rullier : "Psyché et le vieux pêcheur, près du
 Torrent (sujet tiré de La Fontaine) 1913

1838 Miss Henriette Kearsley : "Sujet tiré du Purgatoire, du
 Dante" 1010

1841 Mlle Grasset : "Khodjistè écoutant les contes de son
 perroquet ; sujet tiré du 'toutinamè' ou lionc
 du perroquet ; conte persan" 900

1842 Mlle Godefroid : "Sujet tiré des Mille et une Nuits"
 823

1844 Mlle Joséphine Van Dyck : "Vert-Vert" 1723

1845 Mme Adèle de la Porte : "Veille et sommeil"
 " ... Médor, le bon chien, fait merveille
 A servir de coursier dans les tournois d'enfants.
 Il court ainsi chargé par les bois et les champs,
 Se couche au pied d'un arbre et veille
 Près de son fardeau qui sommeille" ("Vieux conte")
 442

Q2. 1831 Mlle M. Vidal : "Le vieux sergent en 1815" (Sujet tiré d'
 une chanson de Béranger) 2103

1831 Mlle A. Grandpierre : "La Mère aveugle, sujet tiré d'une
 chanson de Béranger" 979

1831 Mme Meynier : "La grand'-mère"
 "Comme vous, maman, faut-il faire ?
 Eh, mes petits enfants, pourquoi ,
 Quand j'ai fait comme ma grand'-mère,
 Ne feriez-vous pas comme moi?" (Béranger) 1492

1831 Mlle A. Pagès : "La grand'-mère ; tiré d'une ballade de
 M.V. Hugo" 2810

1831 Mlle Juramy : "La Folle de la Vallée"
 "
 Owal, malgré mes pleurs, loin de moi s'est enfui,
 Et ma triste raison s'est enfuite avec lui !
 " 3136

1833 Mme Beaudin : "Don Juan et Haïdée" (Scène tirée de Lord
 Byron) 118

1836 Mlle J. Volpelière : "Zuleika, fiancée d'Abydos" (Don
 Juan, chap. 1er) 1833

1837 Mlle Zodalie-Michel Ducluseau : "A la grâce de Dieu ;
 sujet tiré de la romance de M. Henry Lemoine" 594

1838 Mme Elise C. Boulanger : "Sujet tiré de 'Jocelyn' ;
 aquarelle"
 "Et j'instruis les enfans du village, et les heures
 Que je passe avec eux sont pour moi les meilleures"
 (A de Lamartine) 170

1838 Mme Adrienne Duport : "Ondine"
 "J'habite au fond de l'eau, dont j'adore le bruit ;
 Sous le cristal mouvant je repose la nuit :
 La perle et le corail qui roulent avec l'onde
 Couronnent dans le jour ma chevelure blonde.
 Viens avec moi dans le creux du rocher ,
 Sous la cascade qui s'épanche ,
 Sous la poussière humide et blanche
 Ou j'aime tant à me cacher" (M. le comte Jules
 de Rességuier) 597

1838 Mlle Julie Fabre D'Olivet : "Mère et soeur" "J'ai
 tant prié Dieu pour mon frère ;
 Il reviendra, mère, ne pleurez pas !" (Rom. d'Ed.
 Bruguière) 654

1838 Mme Serret : "O mon ange, veillez sur moi !" ("Romance" de
 Mme Duchambre) 1632

1841 Mlle Héloise Colin : "Sujet tiré des Chants du Crépuscule, de M. Victor Hugo ; aquarelle" 373

1842 Mme Léonie Taurin : "Le poète mourant ; aquarelle"
"Le poète chantait : quand la lyre fidèle
S'échappa tout à coup de sa débile main ,
Sa lampe mourut ; et comme elle ,
Il s'éteignit le lendemain" (Millevoye -
"Elégies") 1747

1842 Mlle A. Pages : "La grand'-mère ; tiré d'une ballade de M.V. Hugo" 2810

1844 Mme Pauline Van Dyck : "Médora attendant le retour de Conrad" (Lord Byron) 1724

1848 Mme Adèle Legros : "Tombe d'un moineau"
"L'oiseau sous les fleurs enterré
N'étonnait pas par son plumage ,
N'enchantait pas par son ramage ,
Mais il aimait .. il fut pleuré" (Arnaud) 2839

R2. 1866 Mme Pauline Michault : "Le neveu de Rameau" (M. Jules Janin) 1367

1868 Mlle Angèle Dubos : "Dona Carmen" 842

1870 Mme Adèle Dehaussy : "Bravo" 762

1876 Mlle Caroline-Juliette Fabre : "Atala ; - porcelaine" 2416

1877 Mme Madeleine Lemaire : "Manon" 1315

1877 Mlle Lola de Ruiz : "Lucia" (Manzoni : "Les Fiancés") 3385

1878 Mme Gabrielle Maigneau : "Souvenir de la Esmeralda" 1485

1879 Mlle Irma Boniface : "Jean Valjean" (V. Hugo, "Les Misérables") 338

1880 Miss Kate Bayard : "Paméla" 193

1886 Mlle Margaret-Bernardine Hall : "Fantine" (Victor Hugo, "Les Misérables") 1152

1888 Mme C. Saint-Gervais de la Salle : "Paul et Virginie" buste plâtre 4622

1889 Mme M. de Kernisy : "Manon ; - terre cuite" 4548

1889 UFPS Mlle Dora Hitz : "Pêcheurs d'Islande - Pierre Loti" 310

1890 Mme M-M Réal del Sarte : "Manon Lescaut" 2007 (ill.)

1890 UFPS Mme Magdeleine Réal del Sarte : "Manon Lescaut" (L'Abbé Prévost) 611 (probably the same as the preceding)

1891 SN Mme Camille-Blayn-Métra : "Petite Fadette (pastel)" 1171

1895 SFA Amélie Valentine : "Salambô" 90

1896 SN Marlef : "Manette Salomon (pastel)" 1521 (Petit Palais, Paris)

S2. 1887 UFPS Mme Gabrielle Lacroix : "Illustrations pour les contes de Mme d'Aulnoy" 172

1889 UFPS Mme Gabrielle Lacroix : "Illustrations pour les contes de Mme d'Aulnoy" 366

1895 SFA Cécile Chennevière : "Illustration pour 'La Mouche', d' Alfred de Musset
"Illustration pour le 2e volume des 'Mousquetaires' d'Alexandre Dumas" 122

1898 SFA Mme J. Robaglia : "Illustrations pour les 'Confidences d' une Aïeule' d'Abel Hermant" 191

1898 SFA Mme J. Robaglia : "Illustrations de 'Le Baiser gascon, l' Illusion' (Georges d'Esparbès)" 192

T2. 1859 Mme Adine Verdé Delisle : "Don Quichotte chez la duchesse"
"Au moment de desservir, quatre demoiselles entrent,
l'une portant un bassin, l'autre une aiguière, la
troisième une boule de savon. La première enchâsse

le bassin sous le menton de Don Quichotte, la
demoiselle au savon frotte à tour de bras le menton
et le visage jusqu'aux yeux. Quand la demoiselle
barbière eut noyé le patient sous un pied d'écume,
elle feignit de manquer d'eau et se retira" 838

1859 Mlle Amanda Fougère : "Fabiola et Syra"
"Fabiola resta quelques instants comme anéantie par
la lecture et les paroles de l'esclave chrétienne ..
mais bientôt la grâce, comme une rosée céleste,
pénètre ce coeur, si altier il n'y a qu'un moment,
et la jeune payenne commence à croire aux grandes
vérités de la foi" ("Fabiola" par le cardinal
Wiseman) 1115

1859 Mlle Eugénie Hautier : "Don Quichotte lisant ses romans
de chevallerie" 1415

1889 SI Mlle Ida Silfverberg : "Le Jardin de Bébé (tiré d'un roman
d'Ouida)" *247

U2. 1850 Mme Sophie Jobert : "Schéhérazade" (Mille et une Nuits) 1647

1864 Mme Binet née Anna-Marie Ménard : "Le rat de ville et le
rat des champs" (Lafontaine) 3116

1866 Mme Marie Barsac : "Le Jardinier et son seigneur"
"La fille du logis, qu'on vous voie, approchez"
(La Fontaine) 80

1869 Mlle Marie-Rosa Bonheur : "Les deux taureaux et la
grenouille ; aquarelle" (La Fontaine) 2535

1877 Mme Eugénie Brielman : "Le rêve de Cendrillon ; - éventail
gouache" 2377

1877 Mlle Louise Galichet : "Le mariage de Melusine ; - éventail"
2723

1877 Mme Emilie-Armand Leleux née Giraud : "La Belle-au-bois-
dormant ; - éventail, gouache" 3026

1879 Mme Armand-Emilie Leleux, née Giraud : "Cendrillon" 1670

1883 Mme J. Paton-Commerre : "Cendrillon" 1841 (ill.)

1884 UFPS Mlle Julie Feurgard : "Cendrillon" 99

1885 UFPS Mlle Louise Mercier : "La Cigale, aquarelle" 174

1885 UFPS Mlle Louise Mercier : "La Fourmi ; aquarelle" 175

1886 Mlle Sophie Schaeppi : "Cendrillon ; - faïence" 3323

1886 Mlle Anna Latry : " Cendrillon ; - statue, plâtre" 4139

1891 UFPS Mme Diane Baret : "La cigale ; - porcelaine"
"La cigale ayant chanté
Tout l'été
Se trouva fort dépourvue
Quand la bise fut venue" 25

1891 UFPS Mme Gabrielle Lacroix : "Illustrations pour 'Fortunio' (conte
de fées) ; - aquarelles" 437

1891 UFPS Mme Gabrielle Lacroix : "Illustrations pour le conte de
fées, la 'Princesse Belle-Etoile'" 438

1896 SN Amy Atkinson : "Cendrillon" 27

1897 Mme G. Achille-Fould : "Cendrillon" 7

V2. 1863 SR Mme Ernestine de Pelleport : "Ophélie, tiré de l'Hamlet, de
Shakespeare" 447

1865 Mme Victoire Régnier : "Le romance du saule" 1793

1868 Mme Augustine Dallemagne : "Ophélia" 633

1870 Mme B. Esther de Rayssac : "Jessica"
" . . . Vous êtes assez dissimulée, ma chérie, par
votre charmant costume de garçon .." (Shakespeare :
"Le Marchand de Venise", acte II, scène VI) 2387

1878 Mme Madeleine Lemaire : "Ophélie" 1398

1884 UFPS Mlle Louise Tourniol : "Hamlet ; plâtre bronzé" 282

```
1886          Mlle Marguerite Arosa : "Ophelia ; pastel" 2508
1886          Mme Emma-Camille Nallet-Poussin : "Ophélie ; -
                   buste, terre cuite" 4360
1886 UFPS Mme Nallet-Poussin : "Ophélie, buste terre cuite"
                   "Ophélie, devenue folle de désespoir, cueille
                   des fleurs sur les bords d'une rivière, tombe
                   dans les eaux et y trouve la mort" 18
1886          Mlle Nina-Gordon Batchelor : "Alas ! poor Yorrick .." 129
1887          Mlle L-A Landré : "Ophélie" 1376
1890 UFPS Mlle Madeleine Fleury : "Ophélie" 307
1890          Mme M. Lemaire : "Ophélie" 565
1893          Mme A. Manuela : "Ophélie ; - statuette marbre" 3143
1894 SN   Louise-Alexandra Desbordes : "Ophélie" 370
1894 SN   Alice Feurgard : "Ophélie ; - gouache" 1377
1894          Mme E. Huillard : "Ophelia" 949
1896          Mlle J. Romani : "Desdemona" 1717
1897 SN   Augustine Labarthe Du Tilloy : "Ophelia (port.)" 1550
1898          Mlle G. Achille-Fould : "Les joyeuses commères de
                   Windsor ; comédie de Shakespeare" 10 (ill.)
1900          Mme A. Oppenheim : "Roméo et Juliette" 1007 (ill.)
1900          Mlle A. Sédillot : "Ophélie" 1202 (ill.)

W2. 1864     Mlle Elise Moisson Desroches : "Derniers moments d'Anne
                   de Boleyn" ("Henri VIII", tragédie de M-J
                   Chénier) 3270
    1870     Mme Victorine Arnous Des Saulsays, née Beaufils :
                   "Mephistopheles et le docteur Faust ; faïence" 3021
    1877     Mme Marie Mathieu : "Fanchon regrettant ses montagnes"
                   1447 (comédie-vaudeville in 3 acts)
    1877     Mlle Marthe-Caroline Frémier : "Faust et Marguerite ; -
                   éventail, aquarelle" 2708
    1879     Mlle Jeanne Allèbre : "'Mascarille' des Précieuses
                   Ridicules ; - buste, plâtre" 4752
    1881     Mme Armand Emilie Leleux : "Les Femmes Savantes" 1407
    1884 UFPS Mme Jeanne d'Entremont : "Mascarille ; buste plâtre" 273
    1887 UFPS Mme Delphine de Cool : "L'Avare" 78
    1887 UFPS Mme Bloch : "Cathos et Madelon, précieuses ridicules,
                   groupe plâtre (Molière, scène VII)" 9
    1889 UFPS Mme Magdeleine Réal-Del-Sarte : "Mascarille ('L'étourdi'
                   Molière) ; - aquarelle" 549
    1891 UFPS Mlle Marguerite Hain : "Souvenir de  Faust" 368
    1896 SN   Mlle Daisy Devil : "La prière d'Elisabeth ; - 'Tann-
                   häuser' ; - miniature" 1368
    1897     Mlle M. Brach : "La folie de Marguerite" 2751
    1898     Mme G. Dumontet : "La jeunesse de Triboulet" 3379
    1898 SN   Jeanne Catulle : "Miniatures"
                   3. "Coquelin à l'acte III"
                   4. "La déclaration, dans 'Cyrano de Bergerac'" 1409

X2. 1853     Mlle Rosalie Thévenin : "L'ange exilé ; pastel"
                   " . . . . il fut des anges révoltés.
                   Dieu sur leur front fait tomber sa parole ,
                   Et dans l'abime ils sont précipités
                   Doux, mais fragile, un seul, dans leur ruine,
                   Contre ses maux garde un puissant secours ;
                   Il reste armé de sa lyre divine .." (Béranger) 1104
    1869     Mme Anaïs Beauvais née Lejault : "Le pêcheur"
                   "Du sein de la vague émue, une femme s'élance ..
                   moitié de gré, moitié de force, il tomba ; et
                   jamais on ne le revit plus" (Goethe, "Ballade") 160
    1869     Mme Delphine de Cool : "Le Réveil ; groupe décoratif, plâtre"
                   "Et joyeux, le satyre enfant
```

Rit et folàtre avec la Source" (M. Théodore
de Banville) 3324

1873 Mme Céleste Compte-Calix : "Mariana" 334

1877 Mme Marie Duclos-Cahon : "Une eau-forte"
 "On n'entendait que l'eau courir dans la feuillée .."
 (Pour "Les Vaincus", du docteur A.C...) 4401

1885 Mlle Marguerite Verroust : "Le 'Duz' ; - esprit du matin"
 "O fille des champs, lui disait-il, tu es belle comme
 le rosée du matin
 Le jour levant est ravi quant il te regarde ; ne le
 sais-tu pas ?
 Le soleil lui-même est ravi ; et qui donc sera ton
 époux ?"
 (De La Villemarque, "Chants bretons") 2388

1885 Mlle Julia Marest : "La marquise Nina"
 "Dans le froufrou clair du surah
 Rose sous la blancheur exquise
 S'attarde à son miroir, un beau soir d'Opéra.
 Quel rêve d'amour la fascine ?
 Son chien, sa fille ou son amant ?
 Non, mais Nina trouve charmant
 De ressembler enfin à Nana Veloutine" (P.C.) 1666

1885 Mlle Clarisse Bernamont : "Métamorphose ; - aquarelle"
 "Croquemitaine, un jour, oublia son fardeau.
 Bébés, ne pleurez plus ; à vos places, ces roses,
 Où butine l'insecte, où gazouille l'oiseau
 D'un rayon de soleil, un matin, sont écloses" L.G.
 2543

1885 Mme Hortense Richard : "Deux porcelaines"
 2. "Mimi Pinson"
 "Mimi Pinson porte une rose
 Une rose blanche au côté ;
 Cette fleur dans son coeur éclose ,
 Landerirette !
 C'est la gaîté.
 Quand un bon souper la réveille
 Elle fait sortir la chanson
 De la bouteille ;
 Parfois il penche sur l'oreille
 Le bonnet de Mimi Pinson" (Alfred de Musset) 3147

1885 UFPS Mme Inès Debetz de Beaufond : "L'Aïeule et l'Orpheline" 18

1885 UFPS Mme la comtesse du Chaffault : "Scène tirée de la Jérusalem
 Delivrée (Armide présentée par Eustache à Godefroy) ;
 émail de Limoges" 58

1886 Mlle Lucie Signoret-Ledieu : "Une épave du 'Vengeur' ; statue
 plâtre"
 "Au cri : Vive la République !
 Sombra le vaisseau le Vengeur" 4551

1887 UFPS Mlle Marguerite Verroust : "'Le Duz' ; - esprit du matin"
 305 (this work carried the same quotation as that
 exhibited by the artist at the Salon in 1885 ; see
 above)

1889 UFPS Mme Marie-Adrien Lavieille : "L'Aïeule et l'Enfant -
 'Contemplations' de V. Hugo" 385

1890 UFPS Mme Alice Guyard-Charvet : "Angélique"
 "Elle eut au moins couvert son beau visage et ses
 mains, si les liens qui l'attachaient au dur rocher
 le lui eussent permis ; elle ne le put couvrir que de
 ses larmes et baisser la tête ... !" (Arioste,
 "Roland furieux" chant X) 351

1891 UFPS Mme Fournier Del Florido : "Illustrations des couplets de la

Chanson de Majali (Mireille) ; dessins " 317

1898 SN Jeanne Denné-Ceyras : "Miniatures"
 4. "Zuleika (étude)" 1443 (heroine of Byron's
 "The Bride of Abydos")

1899 Mme veuve M-F Raphael : "Britomart et Amoret" 1622

1900 Mlle C. Blakeney : "Isabella" 137

Y2. 1850 Léonie Lescuyer : "Trois miniatures, même numéro"
 1. "Fleur d'automne"
 "Le livre de la vie est un livre suprême
 Que l'on ne peut fermer ni rouvrir à son choix,
 Le passage adoré ne s'y lit qu'une fois ,
 Et le feuillet fatal se tourne de lui-même ;
 On voudrait s'arrêter à la page où l'on aime,
 Et la page où l'on meurt est déjà sous nos doigts"
 (Lamartine) 2006

1852 Mme Adèle de la Porte : "Une couronne de roses suspendue à
 une branche de saule"
 "De roses qu'elle aimait, je couvrirai sa tombe"
 (Bertin) 1068

1852 Mme Félicie Schneider (née F. Fournier) : "Les dernières
 fleurs d'automne ; pastel"
 "
 Toute herbe aux champs est glanée :
 Ainsi finit une année ,
 Ainsi finit nos jours !" (Lamartine) 1147

1885 Mlle Marie-Aimée Robiquet : "Cimetierre de Saint-Brelade ;
 - Jersey"
 "Sur la grève, la mer s'endort ,
 Et du flot bleu le doux murmure
 Berce un autre sommeil ... la Mort !" 2111

1887 UFPS Mlle Clarisse Bernamont : "Dernières fleurs, aquarelle"
 "En fuyant loin de nous, l'été nous abandonne ,
 Tous ces derniers bijoux, de son trésor de fleurs
 Sont un riant adieu des beaux jours que l'Automne
 Effeuillera bientôt dans ses doigts destructeurs" 28

1893 Mme C-E Wentworth : "La foi"
 "Déjà dans la coupe sacrée ; J'ai bu l'oubli des maux
 et mon âme enivrée
 Entre au céleste port .." Lamartine 1804 (ill.)

1896 SN Alice-Marie-Thérèse : "Triste aurore"
 "J'ai vu sous le soleil tomber bien d'autres choses
 Que la feuille des bois et l'écume des eaux,
 Bien d'autres s'en aller que le parfum des roses
 Et la chant des oiseaux" - A de Musset 481

Others : -

1873 Mme Léon Bertaux : "Jeune fille au bain ; - statue, plâtre"
 "Elle est là, sous la feuillée,
 Eveillée
 Au moindre bruit de malheur ;
 Et rouge, pour une mouche
 Qui la touche,
 Comme une grenade en fleur" (V. Hugo, "Les Orientales"
 xix) 1522

1874 Mme Adélaide Salles-Wagner : "Les fiancés"
 "M'aimeras-tu toute la vie ,
 Ou bien un jour ne m'aimeras-tu plus?" (A Matthieu)
 1638

1878 Mlle Louise Abbéma : "Lilas blanc"
 "Le front baigné d'aurore, ingénument superbe,
 Au travers des lilas, elle a fait sa moisson ,

 Et tandis qu'en ses mains tombait la blanche gerbe,
 La plaine a tressailli de son plus doux frisson"
 (Ed. Blau) 3

1879 Mlle Gabrielle-Marie-Thérèse Desvignes : "Le dindon"
 "Moi je me pare ;
 Moi je me carre ;
 Moi je suis gras et beau !
 " (A Montgolfier) 986

1885 Mlle Fanny Duncan : "Le rêve inexprimé qui s'efface à
 l'aurore !" (Victor Hugo) 879

1885 Mlle Consuelo Fould : "Marchande de fromage"
 "Profil de vierge, fin visage
 Tel que Raphael les aimait ...
 Une marchande de fromage
 Du paradis .. de Mahomet" (J-B Lan) 1002

1886 Mlle L. Gallet : "Buste ; - plâtre"
 "Va, petit mousse,
 Le vent te pousse .." 3919

1886 UFPS Mme Marie Gilsoe : "C'est ici le combat du jour et de la
 nuit" (Victor Hugo) 138

1889 SI Mme Tournay : "Curiosité"
 "
 "Emue, elle sourit à l'avenir lointain
 Qu'évoquera bientôt la rustique pythie" 261

1890 UFPS Mme Esther Huillard : "Elle t'ouvre ses bras d'aurore, elle
 t'appelle !
 Et la rose d'amour de ses seins nus, fleurit !"
 (Jean Rameau, "Chanson des Etoiles") 381 bis

Z2 1800 Mme Adélaide Binart (femme Lenoir) : "Portrait du C. Sage,
 démonstrateur de chimie à la Monnaie" 32

 1800 Mlle Julie Charpentier : "Portrait du C. François
 Montgolfier" 407

 1801 Mme Isabel Pinson : "Portrait du Cit. T..., médecin, membre
 de l'Institut" 274

 1802 Mlle Julie Charpentier : "Buste en plâtre, d'un Naturaliste
 arrivant d'Egypte" (Il a eu l'occasion de vérifier
 une observation intéressante d'Hérodote ; c'est ce qui
 fait le sujet du Bas-relief dont le socle est orné.
 On y voit un crocodile épargnant un oiseau (le
 petit pluvier), en reconnaissance des services qu'il
 en reçoit. Ce petit oiseau entre en effet dans la
 gueule du crocodile, et le débarrasse des insectes
 dont sa langue se couvre pendant qu'il dort. Les trois
 pyramides de Gize, forment le fond du Bas-relief) 408

 1804 Mlle Julie Charpentier : "Buste en plâtre d'un membre de l'
 institut national" 614

 1804 Mlle Julie Charpentier : "Buste en plâtre de M. Marcel,
 directeur de l'imprimerie impériale" 615

 1806 Mme Bruyère (née Lebarbier) : (Portrait de M.Paget, légis-
 lateur" 76

 1806 Mme Bruyère (née Lebarbier) :Portrait de M. Rolland,
 inspecteur général des Ponts et Chaussées" 77

 1810 Mme De Romance (Adèle) : "Portrait de M.S. *** chirurgien
 en chef de la garde impériale" (Il se dispose à
 donner une leçon de botanique à son fils) 239

 1810 Mme Davin née Mirvault : "Portrait en pied de S.E. Asker
 Kan, ambassadeur de Perse" 189 (Versailles)

 1812 Mme Bertault (née Chéradame) : "Portrait de M. le chevalier
 Auger officier de la légion d'honneur, commandant des
 palais des Tuileries et du Louvre" 60

1814 Mme Davin (née Mirvault) : "L'ambassadeur de Perse,
 Askerkan" 240 (same as that exhibited in 1810 ?)

A3. 1814 Mme Dumeray : "Aquarelles, dont l'une représente le
 portrait du Roi" 369

1814 Mlle Julie Philipault : "Portrait de S.A.R. Mad. la
 duchesse d'Angoulême" 753

1817 Mme Foullon Vachot : "Portrait en pied de Sa Majesté"
 (Tableau commandé par la ville de Lille) 335

1817 Mme Foullon Vachot : "Portrait en buste de Sa Majesté"
 1073

1817 Mlle Louise Bouteiller : "Portrait en pied de Charles
 X (pour la chambre de commerce de Nantes)

1819 Mme Dumeray : "Portrait de S.A.R. la princesse Paul
 de Wurtemberg" 384

1819 Mlle Godefroid : "Portraits en pied des princesses Louise
 et Marie d'Orléans (Mademoiselle et Mademoiselle
 de Valois) 518

1819 Mlle Louise Bouteiller : "Portrait de S.A.R. Madame la
 duchesse d'Angoulême" 160

1822 Mlle Aurore de Lafond : "S.A.R. Mme la Duchesse de
 Berry, au berceau de sa fille alors âgée de
 9 mois" (Ce tableau appartient à S.A.R.) 757

1822 Mlle Louise Bouteiller : "Portrait en pied de M. le général
 Frotte" (M.d.R.) 158

1822 Mlle Iaser : "Portrait de S.A.R. la Princesse de Danemarck"
 716

1827 Mme Morlay (née Transon) : "Escalier de la Salle des
 Maréchaux, aux Tuileries" (Le prince de Croy-
 Solre, capitaine des gardes du corps, descend cet
 escalier avec plusieurs officiers de sa compagnie)
 752

1827 Mlle de Bouteiller : "Portrait en pied de S.A.R. Madame
 la Dauphine" (M.d.R.) 1610

B3. 1800 Mme Gabrielle Capet : "Portrait de Mlle Mars aînée, artiste
 du théâtre de la République" 66

1800 Mme Charpentier : "Portrait de Mme Delille, artiste de
 l'Odéon" 85

1800 Mlle Julie Charpentier : "Buste en plâtre de Mme Scio" 409

1802 Mme Chézy Quévanne : "Portrait de Nanette Stocker, grandeur
 naturelle" 61

1802 Mlle Eugénie Delaporte : "Portrait en pied du cit. Lafond,
 dans le costume de Tancrède, répétant son rôle dans
 sa loge" 71

1806 Mlle La Casette : "Portrait de Mlle Crespi, dans les
 cantatrice villane - miniature" 283

1808 Mlle Jenni Désoras : "Portrait de M. Lainez, artiste de
 l'Opéra" 177

1810 Mme veuve Chaudet : "Portrait de Mad. Talma, artiste du
 Théâtre Français" 164

1812 Mlle Bertault : "Portrait de Mad. Auger" 61

1812 Mlle Cochet : "Portrait de Mlle Sophie, artiste du théâtre
 de l'Impératrice" 214

1812 Adèle de Romance (ci-devant Romany) : "Portrait de Mad.
 Fleury, artiste du théâtre de S.M.l'Impératrice" 291

1812 Adèle de Romance (ci-devant Romany) : "Portrait de Mad.
 Raucourt, dans le rôle d'Agrippine, au moment où elle
 dit à Neron : asseyez-vous Néron" 292 (ill. in Witt
 library)

1812 Mme Noel : "Portrait d'un artiste du Vaudeville, miniature"
 680

1814	Mlle Soph.-Clémence Delacazette : "Portrait de Mad. Morandi, dans le rôle de Suzanne" 256
1814	Mme Adèle De Romance (Romany) : "Portrait de Mlle Raucourt dans le rôle d'Agrippine" 294
1814	Mme Adèle De Romance (Romany) : "Portrait de Mlle Emilie Leverd dans le rôle de Roxelanc" 295
1814	Mme Adèle De Romance (Romany) : "Portrait de Mad. Granier dans le rôle de Colinette à la Cour" 296
1819	Mlle Inès d'Esménard : "Portrait de Mlle Duchesnois (artiste sociétaire du Théâtre Français, dans le rôle d'Electre) 425 (+ see C2)
1819	Mlle Inès d'Esménard : "Portrait de Mlle Mars, artiste du Théâtre Français" 426 (+ see C2)
1819	Mlle Félicie Varlet : "Portrait de Mlle Volnais, actrice du Théâtre Français (rôle d'Adélaide du Guesclin)" 1135
1822	Mme Dabos : "Portrait de M. Philippe, dans 'Le Vampire'" 1695
1824	Mlle Eugénie Lebrun : "Portrait de Mme Montano, artiste du théâtre de l'Odéon" 1066
1827	Mlle de Beaurepaire : "Portrait de Larive, ancien acteur du Théâtre- Français" 155
1830	Mlle Moré : "Portrait de Mlle Taglioni" 451

C3.	1831	Mme Demarcy : "Portrait de Mlle A.B.., artiste du Vaudeville miniature" 548
	1831	Mme De Romance Romany : "Mlle P., costume de Zerline (opéra de Fra Diavolo)" 556
	1831	Mlle Sainte-Omer : "Mlle F artiste du théâtre de ..., effrayée d'une balle entrée chez elle" 2608
	1831	Mlle M. Gaume : "Portraits de MM Charles Nodier et Alphonse Lamartine ; camées sur porcelaine" 3063
	1831	Mme Haudebourt-Lescot : "Portrait de M. Auber" 3072
	1831	Mme Haudebourg : "Portrait de M. Belloni" 3201
	1833	Mlle F. Robert : "Portrait de Mme Ch. Nodier ; dessin" 2033
	1836	Mlle Hélène Feillet : "Portrait de Mlle Juana Cano, première boléra du théâtre del Principe, à Madrid" 678
	1839	Mme Tripier Lefranc : "Portrait de Mme Léontine Volnys, dans le rôle de dona Florinde" 1986
	1842	Mme Pauline Appert : "Portrait de Mme Capdeville, artiste du théâtre royal de l'Opéra-Comique ; miniature" 27
	1842	Mme Fanny Geefs : "Portrait de Mlle Drouart, artiste" 755
	1844	Mlle Elisa-Apollina Deharme : "Portrait du jeune Renaud de Vilback, compositeur" (one of three portrait miniatures) 1919
	1844	Mlle Elisa Guillaume : "Portrait de Mme Anaïs Ségalas" 894
	1848	Mlle Fanny Gilbert : "Portrait de Mlle L. Lavoye, de l'Opéra Comique, dans le rôle de la Syrène" 1955
	1848	Mlle Marie Moulin : "Trois miniatures" Portrait de M. Alfred Musset 3411
	1848	Mme Céline Parmentier : "Portrait de Mlle Duclos dans le rôle d'Ariane, d'après Largillière ; porcelaine" 3517

D3.	1859	"Sept miniatures" including a "Portrait de S.M. l'Empereur Napoléon III" 1895
	1867	"Portrait de S.M. l'Empereur, miniature à l'huile" 1891
	1869	"Portrait du prince Impérial, miniature" (Appartient à S.M l'Impératrice) 2908
	1870	"Portrait de S.M. l'Impératrice ; miniature" 3700

E3.	1861	"Portrait de S.M. l'Empereur ; miniature" 2285
	1863	"Portrait de S.M. l'Impératrice ; miniature" 2149 (perhaps the portrait, signed and dated 1861, now in the R:W. Norton Art Gallery)

```
        1865      "Portrait de S.A.I. le prince Napoléon ; miniature" 2672
        1866      "Portrait de S. Exc. M. le maréchal comte Randon, ministre
                       de la guerre ; miniature" 2426
```

F3. Five other small-scale portraits should be mentioned :-
```
        1850      Mlle Stéphanie Goblin : "Cadre de miniatures" including
                       "Portrait du roi, Louis Philippe" 1333
        1855      Mlle Sidonie Berthon : "Portrait de M. Nacquart, président
                       de l'Académie impériale de Médecine ; miniature" 2543
        1861      Mlle Marie Solon : "Huit miniatures" including
                       "Portrait de S.A. le Prince Impérial"
                       "Portrait de S.M. la reine de Naples" 2899
        1870      Mlle Hélène Nold : "Le Prince Impérial ; porcelaine"3865
```

G3. 1873 "Portrait de M. Dufaure, ministre de la Justice" 774
```
        1875      "Portrait du marquis de la R ... , député, ancien
                       commandant des mobiles de la Loire-Inférieure" 1098
        1876      "Portrait du général de Palikao" 1082
        1876      "Portrait du comte de Chambrun" 1083
        1877      "Portrait du général d'Aurelle de Paladines" 1105

        1877      "Portrait du vicomte Henry G..." 1106
        1878      "Portrait du duc Decazes" 1200
        1878      "Portrait du baron G de Montesquieu" 1201
        1879      "Portrait du comte de Saint-A..." 1622
```
H3. Other portraits of important figures :-
```
        1850      Mlle Coraly de Fourmond : "Portrait du prince Jérome
                       Bonaparte, frère de l'Empereur, maréchal de France,
                       gouverneur des Invalides" 1127
        1857      Mlle Amélie-Léonie Fayolle : "Portrait de M. le général
                       Maizière, secrétaire général de la grande chancell-
                       erie de l'ordre impérial de la Légion d'Honneur" 948
        1861      Mme Elisabeth Jerichau : "Portrait de S.M. Caroline-Amélie,
                       reine douairière de Danemarck" 1667
        1863 SR   Mathilde Duckelt : "Portrait de son altesse sérenissime le
                       prince Frédéric de Schleswig-Holstein Augustenburg"
                       717
        1865      Mlle Marie-Cécile Donnier : "Portrait de M. Gressier, maire
                       du 6e arrondissement de Paris" 681
        1869      Mlle Esther Wilson : "Portrait du général Grant, président
                       des Etats Unis" 2424
```

I3. "Le poète Jasmin", a plaster bust, signed and dated 1855
 is in the Musée d'Agen
 "L'Impératrice Eugénie", a marble statuette, was commissioned
 by the Ministry of the Interior in 1854
 A marble bust of Henri-Joseph Paixhans (1783-1854), "lieute-
 nant général", was exhibited at the Salon of 1857 (no. 2979);
 A marble version was commissioned in 1858 (Versailles)
 A "Portrait de l'Impératrice Eugénie", a marble bust, was
 exhibited in 1859 (no. 3345)
 A "Portrait de M. Alfred Busquet", a bronze bust, was
 exhibited at the Salon of 1859 (no. 3346) and another version
 at the same Salon (no. 3347)
 In 1859 she executed a stone bust of "M. Angran d'Alleray,
 lieutenant civil" which is in the Palais de Justice de Paris.

J3. 1850 Mme L-C-T-R de Pavron Haussmann : "Portrait de Mlle Félix
 Miolan, artiste de l'Opéra-Comique" 1469
 1850 Mme Antoine Lapoter : "Mlle Rachel, Mlle Félix, Mlle Rebecca,
 trois miniatures" 1783
 1853 Mme O'Connell : "Portrait de Mlle Rachel" 887
```

1857     Mme Doux (née Lucile Fournier) : "Portrait de Mlle Stella
          Colas, de la Comédie Française" 801

1857     Mme Herbelin : "Huit miniatures"
          4. "Portrait de M.A. Dumas fils" 1339

1857     Mllc Sophaya Dubouloz : "Portrait de M. Puget, de l'
          Académie impériale de musique" 818

1857     Mme O'Connell : "Portrait de Mlle Rachel" 2009

1857     Mlle Fanny Dubois-Davesnes : "Portrait de M. Béranger ;
          buste, plâtre" 2861

1859     Mme Herbelin : "Six miniatures"
          2."Portrait de Rossini" 1457

1859     Mme Camille Isbert : "Onze miniatures"
          "Portrait de Mlle Estelle Grisi" 1578

1859     Mme Claire Pillaut : "Deux miniatures"
          "Portrait de M. Gounod" 2451

1859     Mlle Fanny Dubois-Davesnes : "Béranger ; buste plâtre"
          (M. d'Etat) 3200

1861     Mme Frédérique O'Connell : "Portrait de Mlle Rachel après
          sa mort ; dessin au crayon noir" 2396

1861     Mlle Fanny Dubois-Davesnes : "Béranger ; buste, marbre" 3312

1863     Mme Dameron née Olympe Capoy : "Portrait de M. Alexandre
          Dumas, buste plâtre" 2317

1863     Mlle Fanny Dubois- Davesnes : "Scribe, de l'Académie
          française ; buste terre cuite" 2340

1863 SR  Mlle Jeanne Favre : "Portrait de Mme Doche (Vaudeville)" 165

1863 SR  Mlle Jeanne Favre : "Portrait de Mme Judith (Comédie
          Francaise)" 166

1863     Mathilde Duckelt : "Portrait de M. Jules Janin" 718

1864     Mme O'Connell : "Portrait de M.A. Dumas fils" 1448

1865     Mlle Elisa-Apollina Deharme : "Portrait de Mlle Adelina
          Patti, du théâtre impériale des Italiens ;
          miniature" 2407

1865     Mlle Fannie Dubois-Davesnes : " Scribe ; buste, marbre" 2958

1866     Mlle Sargines Angrand-Campenon : "Portrait de Mme Borelli-
          Delahaye, artiste du Théâtre Impérial de l'Odéon ;
          pastel" 2006

1866     Mlle Pauline-Marie Croizette : "Portrait de Mlle Germa,
          artiste du théâtre de l'Ambigu ; pastel" 2149

1866     Mlle Fanny Dubois-Davesnes : "Portrait de Mlle Marie Roze,
          artiste du Théâtre de l'Opéra-Comique ; buste, plâtre"
          2745

1867     Mme O'Connell : "Portrait de Rachel, de la Comédie  Française"
          1152

1867     Mlle Cécile Bassard : "Portrait du docteur Emile Chève, l'un
          des fondateurs et propagateurs de la méthode de
          musique Galin-Paris-Chève ; miniature" 1601

1867     Mlle Fanny Dubois-Davesnes : "Scribe ; buste marbre" 2230

1869     Mlle Ernestine Philippain : "Portrait de Mlle Ricci, artiste
          du  Théâtre Italien" 1924

1869     Mme Armande Pin : "Portrait de Mme Blanche Jouvan, artiste
          dramatique ; miniature" 3051

1869     Mlle Pauline Bouffé : .Portrait de Mme Rose Chéri ; buste,
          marbre" 3260

1869     Mlle Pauline Bouffé : "Portrait de M. Bouffé, rôle de 'Pauvre
          Jacques' ; buste, terre cuite" 3261

1869     Mme Delphine de Cool : "Portrait de M. Théodore de Banville ;
          médaillon bronze" 3323

1870     Mme Pierrette Bédier née Favre : "Portrait de Mlle Marie
          Perrier, du Théâtre des Bouffes ; miniature" 3055

1870     Mlle Alice Peignot : "Portrait de Mme Laurence  Grivot, du
          Théâtre du Vaudeville ; porcelaine" 3907

| | 1870 | Mlle Pauline Bouffé : "Portrait de M. Bouffé, artiste dramatique ; buste, terre cuite" 4293 |
|---|---|---|
| | 1870 | Mme Constance Dubois : "Portrait de M. Michelet ; buste terre cuite" 4451 |
| | 1870 | Mlle Charlotte Dubray : "Portrait de M. Ernest Daudet ; buste, marbre" 4457 |
| | 1870 | Mlle Charlotte Dubray : "Portrait de Mlle Belza Delpha, buste, marbre" 4458 |

K3. 1819     Mlle Louise Mauduit : "Portrait de feue Madame de Fumel, supérieure générale des dames de l'institution du saint Enfant-Jésus" 810

      1845     Mlle Anaïs Chirat : "Portrait de Mme la supérieure de la Charité à Lyon" 323

      1848     Mlle Irma Gabourd : "Portrait de la soeur Galtier, supérieure des filles de la Charité" 1839

      1850     Mme Anna Clément : "Portrait de la Soeur V... des dames de Sainte-Marie, supérieure des soeurs de la paroisse Saint-Séverin" 585

      1857     Mlle Amanda Fougère : "Portrait de Jeanne-Marie Rendu (en religion, soeur Rosalie)" 1030

      1859     Mlle Adèle Tinel de Kérolan : "Portrait de Mme la supérieure des Dames de la Présentation du couvent de R..." 1661

      1864     Mlle Amanda Fougère : "Portrait de Mme Sainte-Athanase, abbesse de Jouarre" 734

      1868     Mlle Léonie Dusseuil : "Portrait de Mme la supérieure générale des soeurs de ***" 907

L3. 1870     "Portrait de M. Ernest Daudet ; buste marbre" 4457

      1870     "Portrait de Mlle Belza Delpha ; buste marbre" 4458

      1873     "Le Général Renault ; - buste, marbre" 1632

      1877     "Portrait de M. Birbeck ; - buste, bronze" 3741

      1878     M.       Stanley ; - buste bronze" 4210

      1886     "Raymond Duez ; - buste, plâtre" 3513

M3. 1879     "Eugène Gautier, compositeur ; - médaillon bronze" 4800

      1881     "Sophie Arnould ; buste marbre" 3622

      1882     "Sophie Arnould ; buste marbre" (Monuments Publics)

      1884 UFPS     "Sophie Arnoult ; modèle du marbre de l'Opéra" 261

      1889 UFPS     "Médaillon plâtre ; modèle du portrait exécuté en bronze pour le tombeau du compositeur E. Gautier"2

N3. 1873     Mlle Jeanne de Saint-Aubin : "Portrait de Mlle Isabel de Madrazo" 1309

      1878     Mlle Léonie Dusseuil : "Mme la comtesse de ***, fondatrice et supérieure des religieuses de ***, explique à ses filles les constitutions de l'Ordre" 851

      1887     Mlle J. Itasse : "Portrait de Mlle Marie Salle, 'la terpsichore française' - buste, marbre" 4106

      1887     Mme E-C Nallet-Poussin : "Portrait de Mlle M.M... de l'Académie nationale de musique ; buste plâtre" 4336

      1887     Mme A. Enault : "L'abbesse de Jouarre" 866 (ill.)

      1889     Mlle C. Hildebrand : "Portrait de Mme de Witt, née Guizot" 1342 (ill.)

      1892     Mme C. Hugues-Royannez : "Miss Maud Gonne" 279 (ill.)

      1892 SN     Mme O. Roederstein : "Portrait du docteur Elisabeth Winterhalter" 872

      1893     Mlle M. Fournets-Vernaud : "Portrait de Mme le docteur Conta" 730

      1894     Mlle M. Godin : "Portrait de Mme Ryckbusch, surintendante des Mai ...." 840

      1896 SN     Mlle Marie Huet : "Portrait de Miss Maud Gonne" 1445

1897 SN    Mlle Ottilie-W Roederstein : "Portrait de Mlle Docteur
Winterhalter" 1072

1899    Mme M-M-L Boyer-Breton : "Portrait de Mlle Bonnefois,
directrice de l'"Ecole foraine" 279 (ill.)

03. 1873    Mlle Anna Latry : "Portrait de Mme Blanche Pierson,
artiste dramatique ; - buste, terre cuite" 1743

1875    Mlle Anne Latry : "Portrait de Mlle V. Angelo, artiste du
Théâtre du Gymnase ; - buste, marbre" 3195

1877    Mme Ve Léonie-Hannah Halévy : "Portrait de Mme Krauss,
dans le rôle de Rachel, de la 'Juive' ; -
buste, marbre" 3851

1878    Mme Jeanne Andrée : "Portrait de M.F. Berton, artiste
dramatique ; - buste, plâtre" 4009

1878    Mme Pauline Richard-Bouffé : "Portrait de M.G. Worms,
sociétaire de la Comédie-Française - buste, plâtre"
4547

1879    Mlle Léonie Ehrman : "Portrait de Mme F... , sociétaire de
la Comédie-Française" 1155

1881    Mlle B. Polonceau : "Portrait de Mme Crosnier, de l'Odéon,
dans le rôle de Mme de Betteville dans Charlotte
Corday" 1902

1881    Mlle M.A. Viteau : "Portrait de M. Lepers (des Folies
Dramatiques) dans le rôle de Favart" 2373

1882    Mlle J. de Filippi : "Portrait de Mme Elise Picard de
l'Odéon" 1031

1882    Mlle R. Pont-Jest : "Portrait de Lucien Guitry ; buste
plâtre" 4763

1883    Mme Charlotte Julien : "Portrait de Mme ... , artiste
lyrique ; aquarelle" 2923

1884 SI    Mlle Marie Besson : "Portrait de Mme Sarah Bernhardt ;
porcelaine" 141

1886    Mme Jeanne Fichel : "Portrait de Mme Grivot, du Gymnase"
933

1887    Mlle C. Aderer : "Portrait de Mlle Nancy Martel, dans le
'Lion Amoureux'" 17

1887    Mlle K. Morgan : "Désirée Delobelle dans 'Fromont jeune et
Risler aîné'" 1731

1893    Mlle J. Fontaine : "Portrait de Mlle Persoons, de la
Comédie Française, dans le Mercure galant" 719

1894    Mme J. Philippart-Quinet : "Portrait de Mlle Renée du
Minil, de la Comédie.Française" 1452

1894    Mlle J. Rongier : "Portrait de Mlle Martha Petrini, de
l'Opéra-Comique" 1578

1896    Mlle S. Leudet : "Portrait de Mme Gabrielle Krauss" 1252

1896 SFA    Marlef : "Portrait de Mlle Rachel Boyer, de la Comédie-
Française" 66

1896 SFA    Marlef : "Portrait de Mlle Peppa Invernizzi, de l'Opéra" 67

1898    Mlle J. Rainouard : "Portrait de Mlle S. Laisné, de l'
Opéra-Comique" 1679

1898    Mme R. de Pont-Jest : "Mlle Jeanne Laurent, du Vaudeville
et du Gymnase" 3773

1898 SFA    Mme Louise Desbordes : "Mme Sarah Bernhardt dans les
'Mauvais Bergers'" 29

1899    Mme R. de Pont-Jest : "Portrait de M. de Max, dans le rôle
du duc de Reichstadt (le Roi de Rome)" 3846

P3. The following list excludes those mentioned in the text :-

1872    Mlle Angèle Daubrive : "Portrait de M.J. Janin, de l'
Académie Française ; porcelaine" 440

1873    Mme Victorine Cazamajor : "Auber ; - miniature" 252

1873        Mme Josephine Houssay : "Portrait de M. Sully-Prudhomme" 746

1875        Mme Eugénie de Tannenberg : "Portrait du comte de Montes-
                quiou ; - porcelaine" 2761

1879        Mme Julie Cougny née Morizot : "Le compositeur Edmond
                Guion ; - buste plâtre bronzé" 4917

1879        Mlle Thérèse Schwartze : "Portrait de A.G.C. Van Duyl,
                auteur" 2747 (ill. in Walter Shaw Sparrow op.cit.
                p 275)

1879        Mme Julie Cougny née Morizot : "Le pamphlétaire Claude
                Tillier ; - buste (pour son tombeau)" 4918

1881        Mlle J. Itasse : "Portrait de Hilaire Belloc ; bas-relief
                plâtre" 3997

1885        Mme Mathilde Weber : "Portrait de M. François Coppée ; -
                miniature" 3265

1886        Mme Alice Toulet : "Portrait de M. Octave Mirbeau" 2301

1886        Mme Marie Brouard née Bernau : "Portrait de M. Clovis
                Hugues ; - porcelaine" 2610

1886        Mme Marie Brouard née Bernau : "Portrait de M.  Guy de
                Maupassant ; - porcelaine" 2611

1888        Mlle A. Brewster : "Portrait de M. Charles Brace" 377 (ill.)

1888        Mlle J. Rongier : "Portrait de M. César Franck" 2180 (ill.)

1889 SI     Mme  Ernesta Urban : "Portrait de Paul Alexis" 266

1890        Mme M. Bon : "Portrait de Pierre Loti" 263

1894        Mme J. Chenu : "Portrait de Félix Barrias" 420

1898 SN    Jeanne Catulle : "Miniatures"
                1. "M. Paul Hervieu"
                2. "M. Edmond Rostand" 1409

1898 SN    Mme Berthe Vodep Voyot-Deplante : "Un portrait porcelaine ;
                A. Daudet" 1876

Q3. 1872    Mlle Clotilde Bricon : "S.S Pie IX ; - émail" 207

1872        Mme Marie  Glachant : "Portrait de S.S. Pie IX ; - minia-
                ture" 710

1873        Mlle Clotilde Bricon : "Portrait de N.S.P. le Pape Pie
                IX ; - émail" 182

1878        Mme Nouna Binet (née Allard) : "Portrait de M.F. Passy,
                membre de l'Institut" 237

1878        Mlle Julie-Félicie-Caroline Berton-Samson : "Portrait du
                général Giuseppe Garibaldi ; buste, marbre" 4055

1878        Mlle F-M Dubois-Davesnes : "Le père Lacordaire ; - bas-
                relief, plâtre" 4207

1879        Mme Caroline Commanville : "Portrait du baron Jules
                Cloquet, membre de l'Institut" 714

1879        Mme Jeanne de Beaumont-Castries : "L'amiral Coligny ; -
                buste, plâtre bronzé" 4792

1880        Mme la baronne Clémence de Pagès née comtesse de
                Corneillan : "Philippe de Girard, inventeur de la
                machine à filer le lin. ; - buste, terre cuite"
                6543

1882        Mlle J. Houssay : "Portrait de Désiré Nisard de l'Aca-
                démie Française" 1369

1884 UFPS Mme Julia Buchet : "Portrait de Max Dreyfus" 37

1884 UFPS Mlle Marguerite Pillini : "Portrait de Son A.R. le prince
                de Naples" 193

1885        Mlle Cléonice Gennadius : "Portrait de M. George Canning ;
                - buste plâtre (Destiné à la chambre des députés
                à Athens) 3742

1885        Mlle Eugénie Chevallier : "Six gravures en bois : "Portraits
                de MM les généraux D'Aurelles de Paladine ; Wimpfen,
                La Motterouge ; duc d'Aumale ; et MM Henri Martin
                et Anatole de la Forge" (Pour l'Histoire de France"

```
 d'Henri Martin) 4661
 1886 Mlle Emmeline Deane : "Portrait de S.E. le cardinal
 Newman ; - fusain" 2731
 1887 UFPS Mlle de Vernon : "Portrait de M. le général Boulanger,
 ministre de la Guerre, émail" 303
 1887 UFPS Mme Martin-Coutan : "Buste de M. Jules Jouy, plâtre" 13
 1888 Mme L-M Coutan : "Portrait de M. le général Boulanger ;
 buste bronze" 3963
 1889 UFPS Mme Anna Nallet-Poussin : "Monsieur Carnot, Président de
 la République - médaillon plâtre teinté" 30
 1890 SN Mlle Agathe Thouin : "Portrait de M. Carnot" 1209
 1892 Mme V. Parlaghy : "Portrait de M. Lajos de Kossuth, dic-
 tateur de Hongrie en 1848" 1315 (ill.)
 1893 Mlle M. Godin : "Portrait de S.M. Alphonse XIII, roi
 d'Espagne" 811
 1898 UFPS Mlle Marie De Gradowsky : "L'Empereur Nicolas II et Félix
 Faure ; gravure" 247
 1898 SN Isabel-E. Smith :
 1. "Portrait de M. Félix Faure, Président de la
 République Française"
 2. "Portrait de M. William B. Mackinley, Président
 des Etats-Unis" 1834
 1899 Mme J. Mazeline : "Portrait de Félix Faure , président de
 la République" 1374
 1899 Mme C. de Wentworth : "Portrait de Sa Sainteté Léon XIII"
 2001

R3. 1801 "Une jeune femme interrompue dans ses occupations
 par les jeux des enfans qui l'entourent" 154
 1801 "Un enfant sur les genoux de sa mère - sa bonne lui
 fait lécher les pieds par un carlin" 153
 1802 "Une jeune femme allaitant son enfant" 113
 1802 "Une jeune femme embrassant son enfant" 115
 1804 "Un enfant amené par sa nourrice devant sa mère,
 qu'il ne veut pas reconnaître" 199
 1804 "Une mère nourrice présentant le sein à son enfant,
 que lui amène une gouvernante" 202 (E.Cognacq Collection)
 1806 "La tendresse maternelle" 220
 1808 "Une jeune fille près de sa mère malade, priant Dieu
 pour la rétablissement de sa santé" 253
 1810 "Une jeune communiante recevant les félicitations de
 sa mère" 362
 1814 "Une jeune fille"
 "Elle vient faire part à sa mère d'un bouquet et d'
 une lettre qu'on lui a envoyés. La mère, satisfaite
 de sa confiance, lui en témoigne son contentement,
 et lui représente le danger de recevoir de tels
 presents" 426
 1814 "Une jeune fille donnant à boire du lait à son chat"
 430 (Musée Fragonard, Grasse)
 1814 "Une mère de famille entourée de ses enfants" 429
 1817 "Le Bonheur du Ménage" 375
 1817 "Tableau de Famille" 377
 1822 "Les Tourterelles" 575 (illustrated in C.P. Landon's
 "Annales du Musée .." Salon de 1822 vol. 1, p 98
 Plate 64 ; the work represents a woman, presumably
 a mother, with four female children playing indoors
 with two doves on strings)
 1822 "La crèche ou les litanies de l'Enfant-Jésus" 576
 1822 "Instruction d'une mère à sa fille avant la
 première communion" 577 (discussed and illustrated
```

inC.P.Landon's "Annales du Musée .." Salon de
1822 vol. 2 p 16, Plate 8)

1824    "Une accouchée, ou le dernier venu" 755

S3. 1801    "Deux jeunes époux lisant leurs correspondance d'
amour" 152

1802    "Une jeune fille dans un paysage. Elle pleure, en
voyant le chiffre de son amant gravé sur un tronc
d'arbre" 114

1804    "Une dame assise devant sa toilette lisant une
lettre ; derrière elle est sa femme de chambre qui
l'écoute" 200 (Charpentier Sale, Paris, June 10 1954)

1804    "Une dame assise devant sa toilette"
"Elle se trouve mal après avoir fait lecture d'une
lettre qu'elle tient à sa main ; sa femme de
chambre lui fait respirer un flacon" 201 (Louvre)

1808    "Une jeune femme venant de recevoir une lettre de
son époux" 254

1810    "Le petit messager ou l'occupation interrompue" 365

1817    "La lecture d'une lettre" 376

T3. 1804    "La prière du matin" 203

1806    "La Rosière recevant le baiser de protection de la
dame du lieu" 218

1810    "Une jeune communiante recevant les félicitations
de sa mère" 362

1814    "La prière du matin" 432

1822    "Oraison à la Vierge" 574

1822    "La crèche ou les litanies de l'Enfant-Jésus" 576

1822    "Instruction d'une mère à sa fille avant la première
communion" 577 (see R3)

U3. 1810    "Le prélude d'un concert" 364

1814    "Un concert" 428

V3. 1808    "Une jeune fille près de sa mère malade, priant Dieu
pour le rétablissement de sa santé" 253

1814    "Une jeune fille près de sa grand-mère malade" 431

W3. 1800    "Un déjeuné d'enfans" 90

1800    "Une petite fille jouant avec un chat" 91

1801    "un enfant endormi dans un berceau, etc." 62 (Musée
de Rochefort)

1801    "Un enfant qui montre les images d'un livre" 64

1802    "Un jeune enfant montrant les images d'un livre" 901

1802    "Une jeune fille donnant à manger à des poulets" 903
(discussed and illustrated in C.P.Landon's "Annales
du Musée .." an X vol. 3 p 241 Plate 67)

1802    "Portraits de deux jeunes enfans" 902

1804    "Une petite fille déjeunant avec son chien" 97

1804    "Une jeune fille jouant avec des sérins" 98

1804    "Un petit garcon faisant boire une canne de papier
dans une terrine" 100

1804    "Un enfant armé d'un fusil et d'un sabre" 103

1808    "Une jeune fille pleure un pigeon qu'elle chérissait
et qui est mort" 122 (Musée d'Arras)

1810    "Le dépit d'une jeune fille en pénitence, au pain et
à l'eau" 160

1812    "Une petite fille déjeunant avec son chien et lui
faisant faire la révérence" 199 (discussed and illus-
trated om C.P. Landon's "Annales du Musée .." Salon de

1812 vol. 1 p 88, Plate 65)
(Viktor Sale Dorotheum Vienna May 30 - June 3
1921)

1814      "Une petite fille en pénitence, au pain et à l'
          eau, qui déchire son livre" 207
1817      "Une petite fille qui mange des cerises ; étude" 151
1817      "Deux petites filles"
          "La plus âgée fait des châteaux de cartes pour amuser
          la plus jeune" 153

X3.  Other instances :-
1802      Mlle Jenny Legrand : "Une petite fille donnant à manger à
          des poulets" 178
1806      Mme Benoist (née La Ville Le Roux) : "Deux jeunes enfans"
          "Ils viennent de se baigner, et regardent un nid d'
          oiseaux que l'un d'eux a trouvé" 20
1806      Mlle Désoras (Jenny) : "La petite fille au chat, ou la
          malice" 153
1806      Mlle Ledoux : "Une petite fille tenant un pigeon" 336
1806      Mlle Legrand : "Un intérieur"
          "Une petite fille donne à manger à des lapins" 345
1808      Mlle Legrand : "Une jeune fille .." 374
1810      Mlle Cochu : "Une jeune bergère assise sur une roche,
          donnant la becquée à ses petits oiseaux" 175
1810      Mlle Delafontaine : "Portrait en pied d'un enfant donnant
          à manger à son chat" 211
1810      Mlle Le Grand : "Une jeune paysanne donne à manger à des
          petits poussins, sous un hangar rempli de divers
          ustensiles" 489
1812      Mme Charpentier : "Une jeune fille tenant un nid de
          fauvettes" 184
1812      Mme Pasteur : "Un enfant à son dejeuner. Son chien attend
          sa part ordinaire" 706
1817      Mlle Rosalie Delafontaine : "Un Enfant jouant avec un
          oiseau" 218
1819      Mlle Philiberte Ledoux : "Une petite fille tenant une
          colombe" 727
1822      Mme Adèle Romany de Romance : "Un jeune enfant arrêtant
          un chien de chasse près de s'élancer" 336
1822      Mme d'Hervilly : "Une laitière partageant son dejeuner
          avec son chien" 698

Y3.  Mme Constance  Marie Charpentier :-
1801      "La jeunesse bienfaisante" 59
1804      "Une mère convalescente soignée par ses enfans" 94
1804      "Portrait d'une jeune personne montrant à lire à
          sa soeur" 95
1806      "Un tableau de famille"
          "Un aveugle entouré de ses enfans, est consolé de
          la perte de la vue par les jouissances des quatre
          autres sens" 94
1812      "Une mère recevant la confidence de sa fille" 183
1812      "Une jeune fille tenant un nid de fauvettes" 184
1814      "Une dame recevant la confidence de sa fille" 198

Mlle Jenny Le Grand :-
1801      "Petite fille jouant à la maman ; tableau représen-
          tant des ustensiles de ménage" 219
1802      "Une petite fille donnant à manger à des poulets" 178
1802      "Une petite fille occupée à lire les Fables d'
          Esope" 180
1806      "Portrait d'une petite fille tenant un panier rempli

de fleurs des champs" 343
1806   "Un intérieur"
    "Une petite fille donne à manger a des lapins" 345
1808   "Une jeune fille" 374
1810   "Une jeune paysanne donne à manger à des petits
    poussins, sous un hangar rempli de divers ustensiles"
    489
1810   "Un enfant dans un intérieur rustique" 490
1814   "Ustensiles de ménage et légumes"
    "On y voit une jeune femme jouant avec son enfant" 614
1819   "Intérieur"
    "On y voit une vieille femme riant du dégoût qu'
    éprouve un enfant en regardant des huîtres" 731
1819   "Intérieur rustique"
    "Une petite fille donne à manger à des poulets" 732
1819   "Intérieur d'écurie"
    "Un vieillard et un enfant donnent à manger à des
    lapins" 733
    (The artist won a third class medal in 1819)

Mlle Philiberte Ledoux :-
1806   "Une petite fille tenant un pigeon" 336
1806   "Un petit garçon tenant une balle" 337
1810   "Une petite fille devant son miroir" 482
1810   "Un petit garçon ôtant sa chemise" 483
1814   "Une petite fille faisant sa toilette" 605
1819   "Une petite fille tenant une colombe" 727
1819   "Un jeune enfant près d'une pomme et d'une poignée
    de verges" 728

Mme Rumilly :-
1812   "La prière ou la première leçon de l'enfance" 819
1822   "Sortie d'une distribution de prix au lycée Charle-
    magne"
    "Un enfant, piqué d'émulation en voyant le triomphe
    de ses camarades, dit à son père : 'Papa, à l'année
    prochaine'" 1156
1824   "Une distribution de prix"
    "Un jeune homme qui a reçu un prix, en fait hommage
    à son pere" 1511
1824   "Une jeune mère fait la lecture à sa fille" 1512

Mme Marie-Guilhelmine Benoist, née Leroulx de la Ville :-
1802   "Portrait d'une jeune femme avec son enfant" 17
1802   "Une jeune fille portant deux pots de fleurs. Portrait"
    18 (ill. in Mlle Marie-Juliette Ballot op.cit. oppos-
    ite p 160)
1804   "Une jeune fille chantant pour distraire son vieux
    père aveugle" 19
1806   "Deux jeunes enfans"
    "Ils viennent de se baigner, et regardent un nid
    d'oiseaux que l'un d'eux a trouvé" 20
1806   "Le sommeil de l'enfance et celui de la vieillesse"
    21
1810   "Lecture de la Bible"
    "Un vieux soldat suisse endort l'enfant de sa fille,
    pendant que celle-ci lui lit la Bible" 35
    (Musée de Louviers)
1810   "Portraits de deux petites filles qui regardent une
    collection de papillons" 36

There were many other works on this theme :-
1800  Mme Morin : "Une femme tenant un enfant - miniature" 278
1801  Mme Davin-Mirvault : "Un Enfant préférant les armes à tous

les objets de son éducation" 78

| | |
|---|---|
| 1801 | Mlle Guéret (cadette) : "Portrait de femme avec deux enfants" 168 |
| 1801 | Mlle Sophie Guillemard : "Tableau de famille" 170 |
| 1802 | Mme Dabos : "Une petite fille se cachant derrière un rideau transparent" 63 |
| 1802 | Mme Davin, née Mirvault : "Un jeu d'enfans" 67 |
| 1804 | Mme Auzou : "Un enfant à son déjeuner" 9 |
| 1804 | Mlle Garnier : "Portrait d'enfant jouant avec un violon" 911 |
| 1804 | Mlle Pantin : "La mère confidente" 918 |
| 1806 | Mlle De La Fontaine : "Portrait de femme avec son enfant" 133 |
| 1806 | Mme Pinson : "Une femme endormant son enfant" 422 |
| 1806 | Mlle Rivière : "Portrait d'un Enfant dans un Jardin" 441 |
| 1806 | Mme Varillat (née Tornézy) : "La mère satisfaite" 533 |
| 1808 | Mlle Mullen : "Portrait d'une dame avec son enfant" 445 |
| 1808 | Mlle Isabelle Pinson : "Une mère posant sur la tête de sa fille le chapeau virginale" 479 |
| 1808 | Mme Servières (née Le Thiers) : "Portrait d'une dame et de son enfant" 553 |
| 1808 | Mlle Nanine Vallain : "Portrait d'un écolier venant de recevoir des prix" 590 |
| 1810 | Mme Bidou, née Libour : "Une jeune mère formant son enfant à la piété" 89 |
| 1810 | Mme De Romance (Adèle) ci-devant Romany : "L'amitié fraternelle" 237 |
| 1810 | Mlle Lescot : "Un capucin donnant une relique à baiser a une petite fille" 518 |
| 1812 | Mlle Capet : "Portrait d'un jeune étudiant" 167 |
| 1812 | Mlle Joséphine Degeorges : "Un tableau de famille" 247 |
| 1812 | Mlle Alexandrine Delaval : "Jeune fille conduisant sa mère aveugle" 258 |
| 1814 | Mme Haudebourt-Lescot : "Un vieillard et une jeune fille se chauffant" 649 |
| 1817 | Mme Auzou : "La Vieille Bonne , ou les Contes de revenans" 18 (Paris, Private Collection) |
| 1817 | Mme Auzou : "Deux jeunes filles jouant à qui rira la dernière" 21 |
| 1817 | Mme Dabos : "Le Rameau" "Une jeune femme revenant de la messe, tient un enfant dans ses bras" 187 |
| 1817 | Mlle Aurore De Lafond : "Une Scène Maternelle" 214 |
| 1817 | Mlle Rosalie Delafontaine : "Une Jeune Fille tressant une couronne de bleuets" 217 |
| 1817 | Mlle Rosalie Delafontaine : "Un Enfant jouant avec un oiseau" 218 |
| 1819 | Mme Deromance (Adèle Romany) : "Un soin maternel" 325 |
| 1819 | Mlle Lescot : "Un capucin faisant baiser une relique à une petite fille" (M.I.) 775 |
| 1819 | Mlle Lescot : "Le premier pas de l'enfance" (M.I.) 767 |
| 1819 | Mlle Lescot : "Le vieillard et ses enfants" "Il sépare les dards et les rompt sans effort. Vous voyez, reprit-il, l'effet de la concorde ; Soyez joints, mes enfans, que l'amour vous accorde.." (M.I.) 774 (Musée de Dijon) |
| 1822 | Mme Haudebourt-Lescot : "La mère malade" 672 |
| 1822 | Mme Haudebourt-Lescot : "Un enfant se regardant dans un miroir" 670 |
| 1822 | Mlle Louise Revest : "Une femme avec son enfant jouant de l'orgue" 1079 |
| 1824 | Mme Dabos : "Une jeune personne qui a remporté un prix du Conservatoire vient se jeter dans les bras de sa grand'mère" 399 |

1824        Mme Haudebourt-Lescot : "Une jeune fille consultant
                une fleur" 873

1824        Mme Haudebourt-Lescot : "Un père jouant aux cartes avec
                son enfant" 876

1827        Mme Haudebourt : "La sollicitude filiale" 539

1827        Mme Haudebourt : "Une jeune fille au bord d'un ruisseau"
                541

1827        Mlle Pagès : "Etude de femme faisant jouer son enfant" 777

1827        Mme Haudebourt : "L'enfant malade" 546

Z3. 1804       Mme Charpentier : "Une mère convalescente soignée par ses
                enfans" 94

1804        Mme Benoist : "Une jeune fille chantant pour distraire son
                vieux père aveugle" 19

1806        Mme Charpentier : "Un tableau de famille"
                "Un aveugle entouré de ses enfans, est consolé de la
                perte de la vue par les jouissances des quatre autres
                sens" 94

1812        Mlle Alexandrine Delaval : "Jeune fille conduisant sa mère
                aveugle" 258

1822        Mme Haudebourt-Lescot : "La mère malade" 672

1822        Mlle Vollemier : " Soeurs de charité visitant un malade" 1335

1824        Mme Haudebourt-Lescot : "La jeune malade" 867

1824        Mlle Laurent : "Une convalescente au bain" 1046

1824        Mme Petit Jean, née Trimolet : "Une jeune femme partage
                ses soins entre son mari malade et son enfant au
                berceau" 1341

1827        Mme Haudebourt : "L'enfant malade" 546

1827        Mme Haudebourt : "Le médecin de campagne près du malade" 544

(For Mlle Gerard's two works on the theme see V3)

A4. Mlle Gerard's works on these themes have already been listed. See
S3

1802        Mme Auzou (née Desmarquest) : "Deux jeunes filles lisant
                une lettre" 6

1802        Mme Eulalie Morin : "Epreuve de l'Anneau" 213

1802        Adèle Romance (dite Romany) : "Une jeune femme donnant une
                leçon de lyre à son amant" 253

1808        Mme Chaudet : "Une jeune fille"
                "Elle est à genoux devant la statue de Minerve, et lui
                fait le sacrifice des dons de l'Amour" 121 (discussed
                and illustrated in C.P. Landon's "Annales du Musée .."
                Salon de 1808 vol. 2 part 3 p 24 Plate 16)

1812        Mme Benoist : "La disuese de bonne aventure"
                "Une vieille femme assise près d'une fontaine, dit la
                bonne aventure à une jeune fille qui est venue le
                consulter. Un jeune homme écoute attentivement les
                prédictions adressées à sa maîtresse" 44 (Le paysage
                et l'architecture sont de M. Mougin)

1812        Mlle Bounieu : "Jeune dame s'accompagnant du luth, et
                répétant, pour charmer l'ennui de l'absence, 'Suivez
                l'honneur, mais ne m'oubliez pas'" 130

1812        Mme Charpentier : "L'absence. Etude de femme" 185

1812        Mlle Forestier : "Sacrifice à Minerve"
                "Une jeune fille brûle sur l'autel de cette Déesse les
                armes et le bandeau de l'Amour, qui la supplie
                vainement" 1310

1814        Mlle Philiberte Ledoux : "Une jeune femme cachant l'Amour"
                606

1814        Mlle Pfeninger : "Une mariée" 1385

1819        Mme Dabos : "Le billet doux" 256

| 1819 | Mme Dabos : "L'attente, ou viendra-t-il ?" 257 |
|------|------|
| 1819 | Mlle Sohier : "Une repasseuse" |
| | "Elle fait signe à son amant de ne point réveiller sa mère" 1043 |
| 1822 | Mme Haudebourt;Lescot : "Deux jeunes filles lisant un billet-doux" 674 |
| 1822 | Mlle Sarrazin de Belmont : "Scènes de mariages grecs" 1166 |

| B4. | 1800 | Mme Auzou (née Desmarquest) : "Un portrait de femme, préludant sur le piano" 10 |
|-----|------|------|
| | 1800 | Mme Gabrielle Capet : "Portrait d'une femme âgée tenant un livre" 68 |
| | 1800 | Mme Chaudet : "Une jeune femme occupée à coudre" 92 |
| | 1800 | Marie-Eléonore Godefroy : "Portrait d'une jeune personne à son piano ; dessin" 171 |
| | 1800 | Mme Morin : "Une femme assise dans un jardin - dessin" 277 |
| | 1801 | Mme Chaudet : "Une jeune femme occupée à filer" 63 |
| | 1801 | Mlle Guillemard (Sophie) : "Portrait d'une jeune personne distraite de sa leçon de musique" 171 |
| | 1801 | Mlle Constance Mayer : "Portrait d'une femme assise dans son appartement" (dessin au crayon noir) 240 |
| | 1801 | Mme Pinson (Isabelle) : "Une jeune femme grecque filant" 272 |
| | 1801 | Mme Villers (née Nisa) : "Etude d'une femme à sa toilette" 365 |
| | 1801 | Mme Villers (née Nisa) : "Etude d'une jeune femme assise sur une fenêtre" 364 |
| | 1802 | Mlle Lemoine (Marie-Victoire) : "Une jeune personne faisant un fromage" 185 |
| | 1802 | Adèle Romance, dite Romany : "Portrait d'une jeune personne tenant une corbeille de fleurs" 254 |
| | 1802 | Adèle Romance, dite Romany : "Portrait d'une jeune personne près d'un piano tenant un cahier de musique" 255 |
| | 1802 | Mlle Gibert (Julie) : "Deux femmes à leur toilette" 743 |
| | 1804 | Mme Chaudet : "Portrait d'une dame tenant son voile" 104 |
| | 1804 | Mme Dabos : "La paresseuse" 112 |
| | 1804 | Mme Dabos : "Portrait d'une dame en costume de voyage" 113 |
| | 1804 | Mme Dessalle : "Une baigneuse - étude d'après nature" 128 |
| | 1804 | Mlle L. Moine : "Une jeune jardinière coupant du lilac" 301 |
| | 1804 | Mlle Levache Désoras : "Le Catéchisme" 308 |
| | 1804 | Mme Romany (Adèle, née Romance) : "Une jeune personne hésitant à toucher du piano devant sa famille" 405 |
| | 1804 | Mme Romany (Adèle, née Romance) : "Portraits de M. et Mme *** écoutant leur fille toucher une sonate" 406 |
| | 1804 | Mme Romany (Adèle, née Romance) : "Portrait d'une jeune fille cueillant des fleurs" 407 |
| | 1804 | Mme Varillat : "Une jeune fille cherchant à lire son sort dans une reine-marguérite" 506 |
| | 1804 | Mme Varillat : "Une jeune femme sortant des bains" 508 |
| | 1804 | Mlle Garnier : "Une jeune fille à sa toilette" 910 |
| | 1806 | Mme Auzou (née Desmarquets) : "Le portrait de Mme D*** pinçant de la harpe" 9 |
| | 1806 | Mme Dabos : "Une baigneuse" 122 |
| | 1806 | Mlle Léthiers (Eugénie) : "Portrait d'une dame à son piano" 358 |
| | 1806 | Mme Pinson : "Une jeune femme devant une glace" 421 |
| | 1806 | Mlle Rivière : "Femme brodant, tête d'étude" 440 |
| | 1806 | Mme Giacomelli : "Une baigneuse" 599 |
| | 1806 | Mme D'Anne : "La diseuse de bonne aventure" 697 |
| | 1808 | Mlle Bounieu : "Une jeune femme assise sur une fenêtre" 66 |
| | 1808 | Mme Davin née Mirvault : "Une dormeuse" 149 |

| 1808 | Mme Lucile Foullon : "Une jeune personne à sa toilette" 218 |
|------|--------------------------------------------------------------|
| 1808 | Mlle Julie Charpentier : "Portrait en plâtre d'une dame tenant un papier dans ses mains" 651 |
| 1810 | Mlle Mauduit : "Une baigneuse" 552 |
| 1810 | Mlle Rivière : "Portrait de femme tenant un livre" 690 |
| 1812 | Mme Chaudet : "Portrait d'une dame en novice" 201 |
| 1812 | Mlle Hélène Cochu : "Une jeune Napolitaine accordant sa mandoline dans l'intérieur d'un couvent" 215 |
| 1812 | Mme Dabos : "Jeune fille faisant sa prière" 235 |
| 1812 | Mlle Mauduit : "Une jeune femme lisant une lettre. Figure d'étude" 624 |
| 1812 | Mlle Lucie Hoguer : "Portrait en pied d'une dame dans son cabinet d'étude" 477 |
| 1812 | Mlle Volpelière : "Une baigneuse" 973 |
| 1814 | Mme Dabos : "Une partie de masques" "Une jeune femme est accostée par un Pierrot" 230 |
| 1814 | Mme Davin : "Une dormeuse" 238 |
| 1817 | Mlle Lescot : "Une diseuse de bonne aventure" 528 |
| 1817 | Mlle Ribault : " Une cantatrice ; tête d'étude" 648 |
| 1819 | Mme Chéradame, née Bertaud : "Une jardinière" 222 |
| 1819 | Mme Demanne : "Religieuses en prière" "L'Intérieur de ce tableau représente la partie latérale de l'église d'un couvent situé sur le bord de la mer" 315 |
| 1819 | Mme Demanne : "Cloître souterrain d'un couvent de religieux" 316 |
| 1819 | Mme Deromance (Adèle Romany) : "Une jeune femme dans l'intérieur d'un appartement" 326 |
| 1819 | Mlle Galliot : "Une jeune Anachorète en méditation" 472 |
| 1819 | Mlle Lescot : "Des religieuses en prière" (M.I.) 769 |
| 1819 | Mlle Lysinka Rue : "Une miniature, portrait de femme pinçant de la harpe" 1676 |
| 1822 | Mlle Rosalie Caron : "Une jeune femme sortant du bain, figure d'étude" 194 |
| 1822 | Mme Adèle de Romance : "Une jeune femme appuyée sur une corbeille de fleurs" 333 |
| 1822 | Mme Haudebourt-Lescot : "Une jeune dame et sa fille portant des secours à une famille indigente" 677 (discussed and illustrated in C.P. Landon's "Annales du Musee .." Salon de 1822 vol. 1 p 63, Plate 37) |
| 1822 | Mlle Muller : "La dame de charité" 963 |
| 1822 | Mlle Louise Revest : "Une femme avec son enfant jouant de l'orgue" 1079 |
| 1822 | Mlle Voulemier : "Soeurs de charité visitant un malade" 1335 |
| 1824 | Mme Dabos : "Deux jeunes femmes dans la boutique d'un pâtissier" 398 |
| 1824 | Mlle Vollemier : "Le confessional" 1740 |
| 1824 | Mme Haudebourt-Lescot : "Une jeune fille consultant une fleur" 873 |
| 1827 | Mme Dehérain : "La lescture de la Bible" 286 |
| 1827 | Mme Joubert (née Drolling) : "Une religieuse" 603 |
| 1827 | Mlle Straub : "Vieille femme protestante lisant sa Bible" 975 |

| C4. 1810 | "Une prédication dans l'église Saint-Laurent, hors des murs de Rome" 511 |
|----------|--------------------------------------------------------------------------|
| 1810 | "Une station de Piférari devant une madone" 512 |
| 1810 | "Autre tableau du même sujet" 513 |
| 1810 | "Un capucin donnant une relique à baiser à une petite fille" 518 |
| 1812 | "Le baisement de pieds, dans la basilique de Saint-Pierre, à Rome" 576 |

1812        "Un mendiant à la porte d'un couvent où l'on fait aux pauvres la distribution des vivres" 578

1814        "La confirmation par un evêque grec, dans la basilique de Sainte-Agnès hors des murs à Rome" 646

1814        "Le baisement des pieds de la statue de Saint Pierre, dans la basilique de Saint-Pierre, à Rome" 647 (Musée National du Château de Fontainebleau)

1814        "Un épisode de la foire de Grotto-Ferrata, pris sur nature" 648

1814        "Des piferari jouant de leurs instruments devant une madone" 650

1817        "Voeu à la madone pendant l'orage" 530 (Musée Bertrand, Châteauroux)

1817        "Une Frascatane exhorté par un capucin au moment de partir pour le supplice" 766 (Louvre)

1819        "Des religieuses en prière" (M.I.) 769

1819        "Intérieur du cloître de la Trinité-des-Monts, à Rome" 770

1819        "Un capucin faisant baiser des reliques à une petite fille" (M.I.) 775

1822        "Les prières aux stations" 679

1824        "Un Juif lisant la Bible" 871

1824        "Un capucin expliquant, à deux jeunes gens, le sujet d'un bas-relief" 874

1824        "La bénédiction des chambres, aux fêtes de Paques" 878

D4. 1835      Mme Rullier : "Une première communiante ; tête d'étude" 1914

1839      Mlle J. Fabre D'Olivet : "La veille de la première communion"
"Une paysanne remet à sa jeune soeur une croix d'or, dernier souvenir de leur mère" 703

1845      Mlle Clara Nargeot : "La première communiante" 1258

1848      Mlle Zoë Plinval : "Une jeune fille avant sa première communion reçoit la bénédiction de sa grand'-mère" 3732

E4. Other works on religious themes :-

1830      Mme Delisle Verdé : 'La lecture de la Bible" 259

1830      Mme Sauvageot née Galliot : "Un vieillard et un enfant à la porte d'un église ; étude d'après nature" 311

1833      Mlle Du Faget : "Napolitaine priant auprès d'une croix ; aquarelle" 757

1833      Mme Fol-Straub : "Une soeur grise méditant sur sa lecture" 953

1835      Mme J. Colin : "Le baptême ; aquarelle" 404

1835      Mme H. Colin : "Une religieuse morte, avec la cérémonie des funérailles ; aquarelle" 408

1836      Mlle Amélie Cogniet : "Une pélerine ; tête d'étude" 365

1836      Mlle Caroline Swagers : "La quêteuse ; étude" 1710

1836      Mme Verdé de Lisle : "Le jour de la dîme au couvent de Saint-Wendrille (Normandie)" 1800

1837      Mlle Anna Borrel : "Une religieuse ; étude" 160

1837      Mlle Adèle Ferrand : "La prière" 684

1837      Mme Fanny Geefs, née Corre : "Jeune fille conduisant ses soeurs à l'église" 814

1838      Mlle Herminie Descemet : "Méditation religieuse ; tête d'étude" 496

1840      Mlle Eliza Besuchet : "La prière ; étude" 91

1840      Mlle Théodolinde Dubouche : "Etude de religieuse" 470

1841     Mlle Adèle Ferrand : "La rosière" 689

1841     Mlle Sophie Hubert : "Jeune puritaine" 1010

1841     Mlle Hélène Feillet : "Une espagnole à l'église" 684

1841     Mme de Sénevas de Croix-Menil : "Les pèlerines" 1807

1841     Mlle Caroline Trincks : "Jeune fille allemande dans une église - étude" 1908

1842     Mlle Amélie Cogniet : "La confession" 386

1842     Mlle Eugénie Pénavère : "La prière du soir" 1461

1842     Mlle Marie-Ernestine Serret : "Une religieuse carmélite ; étude" 1709

1843     Mlle Elisa Allier : "La confession" 10

1843     Mme Clémentine de Bar : "La sainte lecture ; portraits de deux jeunes soeurs ; étude" 31

1843     Mme Leroux de Lincy : "Une pèlerine ; étude" 795

1844     Mlle Adèle Ferrand : "La sortie de l'église" 670

1844     Mlle Laure Foirestier : "La prière" 694

1844     Mlle Louise Guyot : "Offrande à la Vierge" 900

1844     Mme Mathilde Lagache : "Le chapelet" 1054

1844     Mlle  Ernestine Schwind : "La prière" 1623

1844     Mme Julie de Sénevas de Croix-Mesnil : "La pieuse lecture" 1633

1845     Mlle Elise Allier : "Un pèlerin " 9

1845     Mme Adélaide Ducluzeau : "La fin de la messe"  506

1845     Mlle Caroline Duval : "La prière du soir" 542

1845     Mlle L. Riverent : "Le chapelet ; étude" 1091

1846     Mlle Adèle Ferrand : "Le catéchisme" 643

1848     Mme Sophie Clément : "Intérieur de couvent à Rome" 905

1848     Mlle Augustine Godard : "La prière" 2023

1848     Mlle Caroline Swagers : "Une novice dominicaine" 4198

1849     Mlle Elisa Anfray : "La prière ; étude" 17

1849     Mlle Zoë Frémy : "La prière" 789

1849     Mlle Henriquette Girouard : "La confession" 910

1849     Mlle Léontine Tacussel : "Le sacrement de pénitence" 1871

1849     Mlle Lina Vallier : "La prière : 'Donnez-nous aujourd'hui notre pain quotidien'" 1974

## F4. Other works about love and marriage :-

1830     Mme De Bay : "La mariée de village" 465

1833     Mme Romany de Romance : "Jeune femme occupée de la plus douce espérance" 2056

1833     Mlle Swagers : "La mariée ; tête d'étude" 2226

1835     Mme J. Colin : "Le mariage ; aquarelle" 405

1836     Mme Frapart : "Une jeune femme s'échappe du bal pour lire une lettre ; elle est observée par la personne qui la lui a remise" 776

1837     Mme Brune, née Pagès : "Un voeu" 230

1837     Mlle Athalie Du Faget : "Le prétexte d'un rendez-vous, un jour de fête" 666

1838     Mlle Henry : "Mal d'amour" "Pour la guérir, une jeune fille consulte une sorcière" 911

1840     Mlle Zerline Barsac : "Il n'est plus là ..." 49

1843     Mlle Adèle Ferrand : "La demande en mariage" 418

1843     Mme Joséphine Gotzel : "Le rêve d'un chaste amour" 522

1848     Mlle Irma Martin : "'Aimez-moi'; étude de jeune fille" 3185

1850     Mlle Louise Eglé : "Le billet ; étude" 984

## G4. Other maternities :-

1830     Mme Rumilly : "Une jeune mère enseigne à lire à son fils" 225 (the artist exhibited a work with the same title in 1831 no. 1866)

| 1831 | Mlle E.L. Revest : "Une jeune femme jouant de la mandoline pour endormir son enfant" 3084 |
|------|------|
| 1831 | Mme Rumilly : "Portrait d'une dame et de sa fille" 1867 |
| 1833 | Mlle Duprat : "Cadre de miniatures renfermant : 2. Une jeune mère" 786 |
| 1833 | Mlle Le Bot : "L'anxiété maternelle" 1478 |
| 1833 | Mlle Swagers : "Une jeune mère agaçant son enfant" 2227 |
| 1833 | Mlle Volpelière : "Une veuve et ses enfans" 2418 |
| 1834 | Mlle A. Martin : "La mère malade" 1345 |
| 1835 | Mme Collas : "La bonne mère" 409 |
| 1837 | Mlle Claire Laloua : "Jeune mère appuyée sur le berceau de son enfant malade" 1060 |
| 1838 | Miss Henriette Kearsley : "La jeune mère" 1011 (+ see note 183) |
| 1838 | Mme Bonvoisin : "Une mère de famille à la Place Royale" 148 |
| 1839 | Mme Adrienne Duport : "L'heureuse mère" 643 |
| 1839 | Mme la baronne de Sénevas de Croix-Ménil : "La mère du marin" 1925 |
| 1840 | Mlle Héloïse Colin : "Une femme de Rome allaitant son enfant ; aquarelle" 286 |
| 1840 | Mme Haudebourt-Lescot : "Une jeune mère et son enfant ; scène italienne" 810 |
| 1842 | Mme Louise Rang : "Costumes algériens" "Une jeune femme et son enfant jouant avec une esclave négresse" 1574 |
| 1844 | Mlle Jenny Dabry : "Une jeune mère ; étude" 436 |
| 1844 | Mlle Adèle Ferrand : "La jeune mère" 671 |
| 1844 | Mme Eugénie Janin : "La jeune mère ; intérieur d'une ferme de Hesse" 965 |
| 1844 | Mlle Augustine Picard : "Le dévouement filial" 1439 |
| 1846 | Mlle Adèle Ferrand : "La jeune mère" 649 |
| 1846 | Mme Eugénie Latil : "La vraie mère" 1087 |
| 1847 | Mlle Joséphine Blanchard : "Jeune mère - pastel" 1681 |
| 1848 | Mlle Adèle Langrand : "Une jeune mère" 2650 |
| 1848 | Mlle Zoë Plinval : "Une jeune femme montrant des gravures à des enfants" 3733 |
| 1850 | Mme Anaïs Toudouze : "La jeune mère" 2939 |

| H4. 1831 | Mlle Revest : "Une jeune femme soignant un blessé pendant les journées de juillet" 1758 |
|------|------|
| 1834 | Mlle A. Martin : "La mère malade" 1345 |
| 1835 | Mme Brune : "L'aumône de l'invalide" 270 |
| 1835 | Mme J. Colin : "La grand'mère malade" 403 |
| 1835 | Mlle J. Ribault : "Un jeune villageois soutient sur ses genoux sa mère malade" 1829 |
| 1837 | Mlle Henry : "Une jeune malade dans une étable" 941 |
| 1837 | Mlle Claire Laloua : "Jeune mère appuyée sur le berceau de son enfant malade" 1060 |
| 1840 | Mlle Octavie Rossignon : "L'enfant malade" 1439 |
| 1840 | Mme la baronne de Sénevas de Croix-Ménil : "Le convalescent" 1500 |
| 1841 | Mlle Stéphanie Seron : "L'enfant convalescent" 1809 |
| 1842 | Mlle Anaïs Chirat : "Six tableaux ; même numéro" 2. "La femme malade" 360 |
| 1842 | Mlle Valentine D'Anican : "La fille de l'aveugle morte de la peste - aquarelle" 461 |
| 1843 | Mlle Caroline Thévenin : "La jeune malade" 1131 |
| 1847 | Mme Henriette Franquebalme : "L'enfant malade ; intérieur de grande-chasse" 655 |
| 1848 | Mlle Amanda Fougère : "Convalescente" 1739 |
| 1848 | Mme Azémia Védastine Guillot d'Oisy : "La convalescence ; portraits de famille" 2154 |

1849      Mme Marie-Elisabeth Cavé : "Les plaisirs de la
                  convalescence" 340

In addition four works were about blindness, recalling three on
the subject exhibited earlier (see Z3) :-

1835      Mlle Frilet de Châteauneuf : "Un aveugle et une jeune
                  fille ; étude" 842

1835      Mlle Marguerite de Montfort : "Vieillard aveugle et
                  jeune fille" 1504

1842      Mlle Valentine D'Anican : "La fille de l'aveugle morte
                  de la peste ; aquarelle" 461

1849      Mme Léonie Taurin née Mauduit : "La jeune aveugle égarée ;
                  mine de plomb" 1878

I4. 1830      Mlle Louise Marigny : "Une tireuse de cartes" 174

1831      Mlle A. Cadeau : "Une lecture" 262

1831      Mme De Bay : "Jeune fille endormie" 466

1831      Mme Frappart : "Le duo" 846

1831      Mme Meynier : "La leçon de toilette" 1490

1831      Mlle A. Pagès : "Le sommeil" 1587

1831      Mlle A. Pagès : "Le réveil" 1588

1831      Mme Debay : "La visite du médecin " 3187

1833      Mlle Du Faget : "Jeune femme écrivant une lettre" 758

1833      Mme Pastureau : "Jeune fille du grand duché de Bade
                  découvrant dans les cartes les indices d'un sort
                  prospère" 1850

1833      Mme Rumilly : "Scène de famille" 2110

1834      Mme Couet : "Intérieur d'une salle à manger"
                  "La servante surprise" 380

1834      Mlle A. Grandpierre : "La Confidence" 904

1834      Mme Rang : "Tableau de famille" 1599

1835      Mlle Perlet : "Le coucher ; porcelaine" 1693

1835      Mlle Perlet : "Le sommeil ; porcelaine" 1694

1835      Mlle Zoë de Plinval : "La lecture" 1751

1835      Mlle C.  Swagers : "La jeune coquette ; tête d'étude" 2007

1836      Mme Lagache : "Une diseuse de bonne aventure" 1096

1836      Mlle Adèle Martin : "Scènes familières" 1312

1836      Mlle Eugénie Pénavère : "La lecture du matin" 1423

1837      Mlle Adèle Martin : "Les voyageuses" 1286

1837      Mlle Adèle Ferrand : "La lecture" 685

1838      Mlle Héloïse Colin : "Jeunes filles au bain" 325

1838      Mme A. Verdé de Lisle : "Jeune fille portant une corbeille"
                  1782

1838      Mme A. Verdé de Lisle : "Jeune fille coiffée d'un chapeau
                  de paille" 1783

1839      Mlle Zuline Barsac : "Le sommeil de la grand'mère" 90

1839      Mme Félicité Beaudin : "Le repos" 99

1839      Mlle Eugénie Henry : "La dormeuse" 1006

1839      Mlle Julie Ribault : "Scène de famille" 1772

1842      Mlle Héloïse Colin : "Intérieur de famille" 398

1842      Mlle Célestine Faucon : "Jeune femme à sa toilette" 650

1842      Mlle Marie-Ernestine Serret : "Portraits de famille" 1710

1843      Mme Leloir née Héloïse Colin : "La musique ; aquarelle" 1297

1844      Mlle Laure Foirestier : "Une causerie" 695

1844      Mlle Adèle Grasset : "Jeune fille étudiant" 848

1844      Mme Eugénie Janin : "Le repos" 966

1844      Mme veuve Lavalard : "Portrait d'une dame âgée" 1107

1844      Mme veuve Lavalard : "Jeune fille tournant un feuillet
                  de livre de musique" 1106

1845      Mme Joséphine Calamatta : "Femme à sa toilette" 244

1845      Mme  Eugénie Grun née Charpentier : "Intérieur de famille"
                  775

| | | |
|---|---|---|
| | 1845 | Mlle Clara Nargeot : "La toilette de bal" 1259 |
| | 1845 | Mlle Amanda Fougère : "Vieille femme - étude" 627 |
| | 1845 | Mlle Anaïs Colin : "La lecture du soir ; aquarelle" 1750 |
| | 1845 | Mlle Anaïs Colin : "Deux aquarelles" |

```
 1845 Mlle Clara Nargeot : "La toilette de bal" 1259
 1845 Mlle Amanda Fougère : "Vieille femme - étude" 627
 1845 Mlle Anaïs Colin : "La lecture du soir ; aquarelle" 1750
 1845 Mlle Anaïs Colin : "Deux aquarelles"
 1. "Janvier, le jour de l'an"
 2. "Février, l'entrée au bal" 1751
 1845 Mlle Anaïs Colin : "Deux aquarelles"
 2. "Septembre, scène de famille" 1752
 1846 Mme Anaïs Toudouze, née Colin : " Quatre aquarelles ;
 même numéro"
 1. "La charité"
 2. "Le sommeil"
 4. "La toilette" 2086
 1846 Mlle Adèle Humbert : "Vieille femme ; étude" 956
 1846 Mme Marie-Elisabeth Cavé : "Le Lever" 324
 1846 Mlle Adèle Ferrand : "La lettre" 644
 1846 Mlle Pauline Malherbe : "Repos de famille" 1251
 1846 Mme Héloïse Leloir : "Charité ; aquarelle" 1993
 1847 Mlle Laure Foirestier : "La grand'mère" 618
 1847 Mme Héloïse Leloir : "Scène de famille ; aquarelle" 1860
 1847 Mme Arsène Morlot-Darcy : "La bonne aventure" 1213
 1848 Mlle Elisa Anfray : "Scène d'intérieur" 77
 1848 Mlle Estelle-Félicie-Marie Barescut : "La promenade" 196
 1848 Mlle Amélie Degalasse : "La tricoteuse" 1136
 1848 Marie Delaunaye : "Une diseuse de bonne aventure" 1181
 1848 Mlle E. Gautier : "La promenade" 1903
 1848 Mlle Elisa Habert : "Le lever" 2312
 1848 Mlle Cécile Humbert : "La lecture ; intérieur villageois"
 2333
 1848 Mme Sophie Jobert : "La promenade" 2400
 1848 Mme Mathilde Lagache : "La lecture" 2561
 1848 Mlle Adèle Langrand : "Le repos" 2651
 1848 Mme Héloïse Leloir : "Le hamac ; aquarelle" 2885
 1848 Mme Juliette- Eléonore Philippe : "Jeune femme à son
 lever ; étude à pastel" 3644
 1848 Mme Clara Thenon-Nargeot : "La leçon de danse" 4239
 1849 Mlle Amélie Degalasse : "La lecture" 498
 1849 Mlle Louise Eudes de Guimard : "Le sommeil" 983
 1849 feue Mlle Marie-Louise-Clémence Sollier : "Une jeune
 baigneuse ; pastel" 1846
 1850 Mlle Marie-Louise Foirestier : "La tricoteuse" 1089
 1850 Mme C-J-A de Guizard : "Une lecture" 1438
 1850 Mme Mathilde Lagache : "La toilette ; tête d'étude" 1734
 1850 Mlle Euphémie-Thérèse Didiez : "Retour de promenade ;
 fleurs" 853

J4 1836 Mlle J. Volpelière : "Une vénitienne" 1832
 1836 Mme Kermel née Nennet du Vigneux : "Jeune juive ; étude"
 1074
 1837 Mme L. Rang : "Mauresque à sa toilette ; étude faite d'
 après nature, à Alger" 1512
 1838 Mlle Laure Coinchon : "Portrait d'une jeune dame espagnole"
 312
 1838 Mlle Camille Eudes : "Femme d'Alger ; étude" 653
 1840 Mlle C. Amic : "Une Italienne ; étude" 10
 1840 Mlle Héloïse Colin : "Une femme de Rome allaitant son
 enfant ; aquarelle" 286
 1840 Mme Haudebourt-Lescot : "Une jeune mère et son enfant ;
 scène italienne" 810
 1840 Mme Haudebourt-Lescot : "Une jeune Italienne s'abritant du
 soleil sous son tambour de basque" 811
```

| 1840 | Mme Soyer : "Une glaneuse anglaise" 1518 |
|------|------|

1840      Mlle Hélène Feillet : "Une espagnole à l'église" 684

1841      Mlle Caroline Trincks : "Jeune fille allemande dans une église ; étude" 1908

1841      Mlle Hélène Feillet : "Une gitana en San'Isidoro ; environs de Madrid" 685

1842      Mlle Célestine Faucon : "L'Andalouse ; étude" 651

1842      L..De..M.. (Mme Clara) : "Une Normande ; étude au pastel" 1079

1842      Mme Louise Rang : "Costumes algériens" "Une jeune femme et son enfant jouant avec une esclave négresse" 1574

1842      Mme Louise Reynard : "Portrait d'une jeune Allemande ; miniature" 1600

1842      Mlle Coraly de Fourmond : "Une bohémienne arabe" 704

1843      Mme Joséphine Gotzel : "Jeune orientale" 521

1844      Mlle Virginie Dautel : "Une juive ; étude" 457

1844      Mlle Anaïs Colin : "Femme mauresque ; aquarelle" 1892

1844      Mlle Anaïs Colin : "Femme mexicaine ; aquarelle" 1893

1844      Mlle Théodolinde Dubouche : "Une Andalouse ; pastel" 1927

1844      Mme Anne-Charlotte Jodin : "Jeune Espagnole ; étude au pastel" 1990

1845      Mlle Elisa Bourdier : "Une Espagnole" 198

1845      Mlle Coraly de Fourmond : "Jeune femme turque" 641

1845      Mlle Esther Paris-Persenet : "Etude de mulâtresse ; un jeune enfant lui présente un miroir" 1294

1845      Mlle Anaïs Colin : "Deux aquarelles" 1. "Mai, femmes espagnoles" 1752

1846      Mme Mathilde Lagache : "Jeune fille flamande faisant de la dentelle" 1045

1846      Mlle Pauline Van-Geenan : "Cinq miniatures ; même numéro" 1. "Une Alsacienne" 2096

1847      Mlle Amanda Fougère : "Jeune fille mauresque" 640

1848      Mlle Louise Eglé : "Une Espagnole ; pastel" 1523

1848      Mlle Guersant : "Jeune fille italienne ; pastel" 2123

1848      Mlle Emilie-Marguérite Hoffmann _ "Suissesse ; étude" 2277

1849      Mme E. Cabart née Serret : "Femme italienne ; étude" 295

1849      Mme J. Calamatta : "Portrait d'Espagnole" 302

1849      Mlle Louise Eglé : "Une grecque ; tête d'étude ; pastel" 651

1849      Mlle Louise Eglé : "Une allemande ; tête d'étude ; pastel" 652

1849      Mlle Amanda Fougère : "La jeune fille napolitaine" 755

1849      Mlle Eugénie Hautier : "Une mauresque ; étude" 1011

1849      Mlle Herminie Pons de l'Hérault : "Jeune fille de la Spezzia" 1686

K4. In addition to those that have already been given in E4, G4, H4 :-

1830      Mlle Saint-Omer : "Le dépit d'un écolier" 228

1830      Mlle Saint-Omer : "Le frère" 229

1830      Mlle Saint-Omer : "La soeur" 230

1831      Mme Gautherin : "Deux petites filles s'amusant à se parer de bijoux qu'elles trouvent à leur disposition" 893

1834      Mme la Baronne J. de Sénevas : "La consolation" 1772

1834      Mlle Cogniet : "La petite vielleuse" 347

1834      Mme Filon : "Un enfant endormi dans son berceau" 713

1835      Mme Boulanger : "Jeune enfant pleurant une chèvre, sa nourrice ; aquarelle" 220

1837      Mme Elise-C Boulanger : "Les enfants du moissonneur ; aquarelle" 179

1837      Mme Elise-C Boulanger : "Le matin de Noël" 180 (+ see note 315)

1837      Mme Elise- C Boulanger : "Les oeufs de Pâques ; aquarelle"

181

| 1837 | Mme Brune, née Pagès : "Une naissance dans une famille de pêcheurs, à Honfleur" 229 |
| 1841 | Mlle Henriquetta Girouard : "Jeune fille pleurant la mort de son oiseau ; étude" 843 |
| 1841 | Mme Lavalard, née Berthelot : "Jeune fille faisant une couronne de bleuets ; étude" 1216 |
| 1842 | Mme Elise Clément Boulanger : "Les étrennes" 229 |
| 1842 | Mme Clotilde Juillerat : "L'Enfant rêveur" 1040 |
| 1843 | Mme Mélanie Desportes : "La petite vielleuse savoyarde et sa soeur" 349 |
| 1843 | Mlle Pauline Logerot : "Jeunes enfants venant chercher de l'eau à une source" 815 |
| 1844 | Mlle Adèle Ferrand : "Les petits enfants" 672 |
| 1845 | Mlle Célestine Faucon : "Petite joueuse de vielle" 570 |
| 1845 | Mlle Augustine Picard : "La pénitence ; étude de jeune fille" 1336 |
| 1845 | Mlle Amélie Roussel : "La petite indolente" 1479 |
| 1845 | Mme Edouard Dubufe : "Un enfant ; statue en marbre" 2080 |
| 1847 | Mme Aimée Brune : "Doux passe-temps de l'enfance" 252 |
| 1847 | Mme Clara Nargeot-Thénon : "Les oeufs de Pâques" 1228 |
| 1847 | Mme Anaïs Toudouze : "L'éducation paternelle" 1972 |
| 1848 | Mme Marie-Elisabeth Cavé : "Le mardi-gras" 788 |
| 1848 | Mlle Louise Eudes de Guimard : "Une petite baigneuse" 1554 |
| 1848 | Mlle Elise Fournier-Bernard : "Jeune fille tressant une couronne de pâquerettes ; étude" 1780 |
| 1848 | Mme Juliette-Eléonore Philippe : "Jeune fille jouant avec un chien ; étude au pastel" 3645 |
| 1848 | Mlle Léonie Prin : "La toilette de la poupée" 3800 |
| 1848 | Mme Anaïs Toudouze : "Le premier pas ; aquarelle" 4284 |
| 1849 | Mlle Laure Foirestier : "La recréation" 731 |
| 1849 | Mlle Louise-Eudes de Guimard : "Un enfant de Paris, 24 février, 1848" 982 |
| 1849 | Mme Arsène Morlot : "Frère et soeur" 1509 |
| 1849 | Mlle Rosalie Thévenin : "Instituteur et élève ; pastel" 1893 |
| 1850 | Mlle Amanda Fougère : "Déjà coquette" 1121 |
| 1850 | Mlle Louise Eudes de Guimard : "Passetemps du jeune âge" 1436 |
| 1850 | Pauline Malherbe : "Veilleuse ; étude de jeune fille" 2098 |
| 1850 | Mlle Pauline Caron-Langlois : "Jeune fille" 472 |
| L4. 1836 | Mme Desnos : "Espérance et regrets" 534 |
| 1836 | Mlle Augusta Lebaron : "L'attente ; étude" 1153 |
| 1837 | Mlle Alexandrine Delaval : "Les deux chasseresses, ou la mélancolie" 503 |
| 1837 | Mme Lagache-Corr : "Les mauvais pensées" 1054 |
| 1837 | Mlle Caroline Swagers : "Une jeune rêveuse ; étude" 1706 |
| 1839 | Mme Leprévost : "Les regrets" 1348 |
| 1840 | Mlle E. Serret : "La méditation ; tête d'étude" 1502 |
| 1840 | Mlle Caroline Swagers : "La rêveuse ; tête d'étude" 1531 |
| 1842 | Mlle Anaïs Chirat : "Six tableaux ; même numéro" 1. "La méditation" 360 |
| 1843 | Mme Josephine Gotzel : "L'heureuse rêverie" 523 |
| 1844 | Mlle Irma Martin : "Le doux souvenir" 1276 |
| 1845 | Mlle Amanda Fougère : "Vieille femme ; étude" 628 |
| 1845 | Mme Eugénie Grün née Charpentier : "Un souvenir ; étude" 776 |
| 1845 | Mme Céleste Pensotti : "Rêverie du soir" 1305 |
| 1845 | Mme Sophie Rude : "Jeune femme après le bain, s'abandonnant à des pensées mélancoliques" 1486 |
| 1846 | Mme Marie-Elisabeth Cavé : "Les premiers ennuis" 325 |
| 1846 | Mme Héloïse Leloir : "Espérances ; aquarelle" 1992 |
| 1847 | Mme Fanny Geefs : "Espérance" 687 |

1847          Mme Fanny Geefs : " Regrets" 688

1848          Mlle Louise Eudes de Guimard : "La réflexion, tête d'
                 étude de jeune fille" 1555

1848          Mlle Amanda Fougère : "Douleur et consolation" 1737

1848          Mlle Amanda Fougère : "Souvenir" 1738

1848          Mme Céleste Pensotti : "Indulgence et repentir"
                 "Qui est-ce qui peut dire j'ai purifié mon
                 coeur?" 3578

1848          Mlle Ernestine Schwind : "Innocence et fidelité - pastel"
                 4113

1848          Mme Anaïs Toudouze, née Colin : "Le vrai bonheur" 4283

1848          Mme Verdé-Delisle : "Pensée" 4430

1848          Mme Verdé-Delisle : "Souvenir" 4431

1849          Mlle Laure Foirestier : "Le découragement" 732

1849          Mlle Amanda Fougère : "Rêverie" 753

1849          Mlle Louise-Eudes de Guimard : "Déjà rêveuse ; jeune
                 paysanne de Basse-Normandie" 984

1850          Mme Anaïs Toudouze : "La méditation" 2940

1850          Mlle Louise-Eudes de Guimard : "Tristesse et résignation"
                 1435

1850          Mlle Pauline Caron-Langlois : "Une triste nouvelle" 473

1850          Mlle Louise Thuillier : "Rêverie" 2916

(For similar works with poetical quotations in their titles, see
vol. 1 pp 207-8 )

M4. 1852      Mlle Caroline Thévenin : "Le presbytère" 1178

1853          Mlle Henriette Browne : "Lecture de la Bible" 187

1855          Mme Marie Barsac : "Le Bénédicité" 2487

1857          Mme Henriette Browne : "Les puritaines" 394

1857          Mme Henriette Browne : "Le catéchisme" 395

1857          Mlle Louise Eudes de Guimard : "Une soeur de la
                 providence" 911

1857          Mlle Célina Lefébure : "Lecture de la Bible"
                 "Une femme malade se fait lire la Bible par un
                 enfant" 1659

1859          Mme Louise-Marie Becq de Fouquières : "La prière" 188

1859          Mme Henriette Browne : "Les soeurs de charité" 433

1859          Mme Henriette Browne : "Une soeur" 434 (Walker Art
                 Gallery, Liverpool)

1859          Mlle Louise Eudes de Guimard : "La prière de l'enfant" 1011

1859          Mme Emma Gaggiotti-Richards : "Une religieuse carmélite" 1178

1859          Mlle Henriette de Lonchamp : "Offrande à la Sainte Vierge"
                 (M. d'Etat) 2021

1861          Mlle Léonide-P-E Bourges : "La prière" 384

1861          Mme Doux (née Lucile Fournier) : "A l'église" 918

1861          Mme Elisabeth Jérichau : "La lecture de la Bible" 1657

1861          Mme Henriette Véron : "La Châtelaine ; statuette terre
                 cuite" 3651

1863          Mme Hélène-Marie Antignu : "L'histoire sainte" 42

1863          Mlle Louise Eudes de Guimard : "Une procession de la
                 Fête-Dieu bourg de Batz (Bretagne)" 657

1863          Mme Armand Leleux née Emilie Giraud : "Baisement des
                 pieds de la statue de Saint-Pierre, un jour
                 de béatification, dans le basilique de Saint-
                 Pierre, à  Rome" 1170

1863          Mlle Henriette de Longchamp : "Offrande à Sainte Gene-
                 viève" 1227

1863          Mme Ernestine Quantin : "Souvenir du couvent de F..." 1549

1863          Mme Schneider née Félicie Fournier : "La sortie du couvent"
                 1696

1864          Mlle Mathilde Haour : "La leçon du catéchisme" 3203

| 1865 | Mlle Mathilde Aita de la Penuela : "La Foi" 18 |
|---|---|
| 1865 | Mlle Louise de Brienne : "La prière" 298 |
| 1865 | Mme Marie Barsac : "Les plaintes au curé" 102 |
| 1866 | Mme Uranie Colin-Libour : "La 'Bible'" 428 |
| 1866 | Mme Dentigny née Henriette Noblet : "La Foi" 553 |
| 1866 | Mlle Angèle Dubos : "La prière" 619 |
| 1866 | Mme Tourny née Ernestine Hochet de Latesrie : "Enfant offrant des fleurs à la madone" 1855 |
| 1867 | Mme Louise-Marie Becq de Fouquières (née Dedreux) : "La Bénédicité" 94 |
| 1867 | Mme B-Esther de Rayssac : "Une pénitente de Port-Royal" 1266 |
| 1868 | Mlle Marie Allan : "Jeune fille en prière" 21 |
| 1868 | Mme Léontine Lemée née Roulin : "Offrande à la Madone" 1546 |
| 1868 | Mlle Elise Moisson-Desroches : "Le chapelet" 1784 |
| 1869 | Mme Marie Anselma : "Le Jeudi-Saint" 49 |
| 1869 | Mlle Elisa Drojat : "Une première communiante" 779 |
| 1869 | Mme Claire Nancy : "Jeune fille dans son oratoire" 1783 |
| 1870 | Mlle Virginie Bourdon : "Lecture de la bible" 349 |
| 1870 | Mlle Mathilde Robert : "La prière" 2450 |
| 1870 | Mlle Hermance Saint-Paul : "Méditation religieuse" 2531 |

| N4. 1855 | Mlle Amélie Lindegren : "Déclaration d'amour" 1980 |
|---|---|
| 1865 | Mme Armand Leleux (née Emilie Giraud) : "Le baiser furtif" 1314 |
| 1866 | Mme Marie Anselma : "Une fiancée à Novogorod" 29 |
| 1866 | Mme Armand Leleux, née Emilie Giraud : "Le contrat de mariage" 1191 |
| 1866 | Mme Léon Bertaux : "Les caresses fatales ; statue plâtre" 2637 |
| 1869 | Mme Adélaide Salles-Wagner : "Chagrin d'amour" 2128 |
| 1870 | Mme Marie-Virginie Boquet : "La Prière de l'Amour" 305 |
| 1870 | Mlle Marie-Louise-Eugénie Rabier : "Une ruse d'amour ; porcelaine" 3978 |

| O4. 1853 | Mlle Louise Eudes de Guimard : "Une mère et ses enfants ; souvenir de Normandie" 433 |
|---|---|
| 1855 | Mme Grün (née Eugénie Charpentier) : "Femme et enfant valaques" 3218 |
| 1855 | Mlle Céline Lefébure : "La jeune mère" 3525 |
| 1861 | Mlle Léonide-P-E Bourges : "La jeune mère" 383 |
| 1861 | Mlle Henriquetta Girouard : "L'attention maternelle" 1313 |
| 1861 | Mme Elisabeth Jérichau : "Les délices d'une mère" 1659 |
| 1861 | Mlle Sabine Méa : "Une femme et son enfant ; étude" 2176 |
| 1863 SR | Mlle Amélie Fayolle : "Souci et inquiétude" 167 (+ see vol. 1 p 210 ) |
| 1864 | Mlle Pauline-Elise-Léonide Bourges : "Sollicitude maternelle" 230 |
| 1864 | Mlle Lucie Destigny : "Une mère désolée" 3166 |
| 1865 | Mlle Sophie Unternahrer : "Jeune femme et son enfant" 2104 |
| 1866 | Mme Félicie Andiat : "Jeune mère" 44 |
| 1867 | Mme Marie Barsac : "Jeune mère" 70 |
| 1869 | Mme Claire Nancy : "L'amour maternel" 1784 |
| 1870 | Mlle Isidorine Mikulska : "La Jeune Mère" 1983 |
| 1870 | Mlle Jeanne Saint-Aubin : "Une Jeune Mère" 2519 |

| P4. 1853 | Mme Verdé de l'Isle, née Adine Pérignon : "Petite fille jouant avec un chien" 1153 |
|---|---|

1855      Mme Sophie Jobert : "La réprimande" 3416
1855      Mlle Erica Lagier : "Fraternité" 2084
1855      Mlle Erica Lagier : "Le portrait du papa" 2085
1857      Mme Henriette Browne : "La leçon" 397
1857      Mme la baronne de Lagatinerie, née Eugénie Gallian :
         "Deux soeurs, pastel" 1517
1859      Mlle Louise Eudes de Guimard : "La petite institutrice" 1012
1859      Mlle Louise Eudes de Guimard : "La tâche ; petite fille
         cousant" 1013
1859      Mlle Amanda Fougère : " Frère et soeur" 1117
1859      Mlle Alexandrine Jeannis : "L'enfant d'adoption" 1616
1861      Mlle Léonide-P-E Bourges : "Petite fille jouant à la
         poupée" 385
1861      Mlle Léonide-P-E Bourges : "Le départ pour l'école" 386
1861      Mme Uranie-Alphonsine Colin-Libour : "La leçon de lecture"
         672
1861      Mme Doux (née Lucile Fournier) : "La leçon de lecture" 919
1861      Mme Elisa Drojat : "Enfant caressant un chat" 925
1861      Mme Elisa Drojat : "La Pénitence" 924
1863      Mme Uranie-Alphonsine Colin-Libour : "Pendant les vacances"
         432
1863      Mme Uranie-Alphonsine Colin-Libour : "Etudiant de première
         année" 433
1863      Mlle Elisa  Drojat : "La réprimande" 604
1863      Mlle Aimée Dumas : "Pour ma mère !" 624
1864      Mlle Marie-Léonide Poisson : "La leçon mal apprise" 3310
1865      Mlle Félicie Mégret : "La leçon" 1477
1866      Mme Uranie Colin-Libour : "La soeur aînée" 429
1866      Mme Jeanne-Madeleine Colle-Lemaire : "Enfant jouant avec
         un chien" 431
1866      Mlle Louise Eudes de Guimard : "Les deux soeurs" 676
1866      Mme Tourny née Ernestine Hochet de Latesrie : "Enfant
         offrant des fleurs à la madone" 1855
1867      Mme Jeanne-Madeleine Colle-Lemaire : "Une crèche" 358
1867      Mme Alix de Laperelle : "La fille du maître d'école ;
         étude" 862
1867      Mme Augustine Dallemagne : "Première impression de l'
         enfant ; pastel" 1716
1867      Mme Marie de Tourmont : "La leçon de lecture ; aquarelle"
         2085
1868      Mme Félicie Andiat : "Enfance et vieillesse" 66
1868      Mme Marie Barsac : "La petite garde-malade" 126
1868      Mlle Pauline-Elise-Léonide Bourges : "La poupée" 321
1868      Mme Elisa Desgroux : "La petite distraite" 758
1868      Mme Agathe Doutreleau : "La berceuse, prisonnière du petit
         frère" 823
1868      Mlle Pietronella Peters : "Les soeurs" 1972
1869      Mlle Louise Eudes de Guimard : "Le départ pour l'école" 892
1869      Mlle Léontine Saulson : "En pénitence" 2133
1870      Mme Désirée Chaix : "La petite liseuse" 517

Q4. 1852      Mme Eugénie Grun : "La première visite" 591
1852      Mme Emilie Rougemont : "La ballade" 1111
1855      Mlle Elise Wagner : "La mandoline" 4199
1857      Mme Aizelin (née Sophie Berger) : "La lecture du matin,
         pastel" 21
1857      Mme Henriette Browne : "La grand'mère" 396
1857      Mlle Pauline Caron : "La partie de dames" 442
1857      Mme Marie Chosson : "Les images" 524
1857      Mme Marie Chosson : "La lecture" 525
1857      Mlle Amanda Fougère : "Jeune fille tricotant" 1028

| | |
|---|---|
| 1857 | Mlle Amanda Fougère : "Un regard vers la ville" 1029 |
| 1857 | Mme Gozzoli (née Laure Foirestier) : "Le piano" 1227 |
| 1857 | Mme Sophie Jobert : "Le choix d'une coiffure" 1447 |
| 1857 | Mlle Marguerite-Zéolide Lecran : "La veillée" 1656 |
| 1857 | Mme Rougemont(née Emilie Gohin) : "Une chanteuse" 2319 |
| 1857 | Mme Clara- Agathe Thénon : "La lecture, pastel" 2517 |
| 1859 | Mme Aizelin née Sophie Berger : "Coquetterie ; pastel" 18 |
| 1859 | Mme Henriette Browne : "La toilette" 435 |
| 1859 | Mme Doux (née Lucile Fournier) : "Le déjeuner" 908 |
| 1859 | Mme Gozzoli (née Laure Foirestier) : "Les images" 1323 |
| 1859 | Mme Eugénie Grün : "La lecture" 1356 |
| 1859 | Mme Herbelin (née Jeanne-Mathilde Habert) : "Six miniatures" 5. "La lecture" 1457 |
| 1859 | Mme Sophie Jobert : "La leçon de philosophie" 1625 |
| 1859 | Mme Lehaut (née Mathilde Bonnel de Longchamp) : "Sept miniatures" including "La lecture" 1895 |
| 1861 | Mme Uranie-Alphonsine Colin-Libour : "La toilette" 670 |
| 1861 | Mlle Cécile Darnard : "La toilette" 789 |
| 1861 | Mme Mathilde Ducket : "La tireuse de cartes" 947 |
| 1861 | Mme Doux (née Lucile Fournier) : "La toilette du dimanche" 917 |
| 1861 | Mlle Henriquetta Girouard : "La toilette" 1314 |
| 1861 | Mme Elisa Drojat : "Jeune fille lisant" 923 |
| 1861 | Mme Armand Leleux (née Emilie Giraud) : "Le petit lever" 1916 |
| 1861 | Mme Armand Leleux : "La confidence" 1917 |
| 1861 | Mme Armand Leleux : "La lecture de la gazette" 1918 |
| 1861 | Mlle Eugénie Morin : "La Visite ; aquarelle" 2309 |
| 1861 | Mlle Eugénie Morin : "La Promenade ; aquarelle" 2308 |
| 1861 | Mme Victorine Régnier : "Jeune fille lisant" 1571 |
| 1863 | Mlle Pauline-Elise-Léonide Bourges : "La veille prolongée" 246 |
| 1863 | Mme Uranie-Alphonsine Colin-Libour : "La partie de quilles" 431 |
| 1863 | Mme Aizelin née Sophie Berger : "Jeune femme sortant du bain ; pastel" 1917 |
| 1863 SR | Mme Félicie Audiat : "La Fête de la grand'mère" 10 |
| 1863 SR | Mme Eléonore de Ladvignière : "Jeune fille arrosant une plante exotique" 271 |
| 1864 | Mlle Fideline Choel : "Tireuse de cartes ; pastel" 2086 |
| 1864 | Mme Sophie Jobert : "La partie de cartes" 1007 |
| 1864 | Mme Armand Leleux née Emilie Giraud : "La visite du médecin" 1178 |
| 1864 | Mme Armand Leleux née Emilie Giraud : "Répétition de musique" 1179 |
| 1864 | Adélaide Wagner : "L'adieu" 1958 |
| 1864 | Mme Becq de Fouquières , née Louise-Marie de Dreux : "La leçon de lecture ; pastel" 2021 |
| 1865 | Mme Marie Barsac : "La ménagère" 103 |
| 1865 | Louise Granmaison : "Liseuse" 947 |
| 1865 | Mlle Henriette Grosso : "Liseuse" 969 |
| 1865 | Mme Alix de Laperrelle : "Après la lecture" 1225 |
| 1865 | Mme Elise Puyroche-Wagner : "Le bon livre -fleurs" 1766 |
| 1865 | Mme Elise Puyroche-Wagner : "Le mauvais livre ; fleurs" 1767 |
| 1865 | Mlle Louise Eudes de Guimard : "Jeune fille arrosant des fleurs" 770 |
| 1866 | Mlle Marie Chosson : "La tricoteuse" 402 |
| 1866 | Mlle Lucie Destigny : "La visite à la perruche" 573 |
| 1866 | Mme Lucile Doux : "Jeune fille faisant de la frivolité" 608 |
| 1866 | Mlle Célina Lefébure : "Le conte de la grand'mère" 1162 |
| 1866 | Mme Armand Leleux, née Emilie Giraud : "La toilette" 1192 |

| 1866 | Mme Nancy née Claire Rey : " Dame vénitienne à sa toilette" 1434 |
| 1866 | Mlle Sophie Unternahrer : "La toilette" 1876 |
| 1866 | Mme Louise-Aline Ve Midy : "Jeune fille lisant ; pastel" 2416 |
| 1867 | Mme Lucile Doux : "La toilette" 506 |
| 1867 | Mlle Elisa Drojat : "Jeune fille faisant un bouquet" 509 |
| 1867 | Mme Eugénie Grun : "La lecture" 703 |
| 1867 | Mme Alix de Lapérelle : "La tricoteuse ; étude" 863 |
| 1867 | Mme Armand Leleux (née Giraud) : "Le déjeuner" 938 |
| 1867 | Mme Paule Malherbe : "Le repos" 1025 |
| 1867 | Mme Adélaïde Salles-Wagner : "Le jeu du solitaire" 1356 |
| 1867 | Mlle Cornélie Wyatt de Vivefay : "Jeune fille lisant une lettre ; aquarelle" 2106 |
| 1867 | Mlle Eulalie Cantot : "Baigneuse ; groupe terre cuite" 2163 |
| 1868 | Mme Hélène-Marie Antigna : "Une tricoteuse de Pornic" 41 |
| 1868 | Mme Marie Barsac : "Le repos" 125 |
| 1868 | Mlle Pauline-Elise-Léonide Bourges : "Le déjeuner" 320 |
| 1868 | Mlle Marie Brosset : "Femme travaillant" 362 |
| 1868 | Mme Henriette Browne : "Le réveil" 366 |
| 1868 | Mme Lucile Doux : "Causerie musicale ; scène d'intérieur" 827 |
| 1868 | Mlle Mathilde Duckett : "La samaritaine" 859 |
| 1868 | Mlle Louise Eudes de Guimard : "Le hamac" 934 |
| 1868 | Mme Fanny Geefs : "Confidence" 1051 |
| 1868 | Mlle Henriette Grosso : "Avant le bal" 1159 |
| 1868 | Mme Sophie Jobert : "Les nouvelles du régiment" 1328 |
| 1868 | Mme Alix de Laperelle : "Un jour de fête" 1431 |
| 1868 | Mme Armand Leleux : "La migraine" 1536 |
| 1868 | Mlle Marie Pichon : "Tricoteuse" 1991 |
| 1868 | Mary Stevenson : "La mandoline" 2335 |
| 1868 | Mme Ernestine Tourny née Hochet de Latesrie : "La lecture" 2404 |
| 1868 | Mlle Victorine Beaufils : "L'étude ; faïence" 2641 |
| 1868 | Mme la marquise de Mun née De Ludre : "Baigneuse ; aquarelle" 3158 |
| 1868 | Mme Louise-Joséphine Roussel : "La veillée; pastel" 3282 |
| 1869 | Mlle Mathilde Aito de la Pennuela : "La liseuse" 17 |
| 1869 | Mme Marie-Hélène Antigna : "Oh ! elle dort !" 53 |
| 1869 | Mlle Angèle Dubos : "Le thé" 790 |
| 1869 | Mlle Alix Duval : "L'étude" 864 |
| 1869 | Mlle Alix Duval : "Le bouquet" 865 |
| 1869 | Mlle Cécile Ferrère : "La dormeuse" 923 |
| 1869 | Mme Armand Leleux (née Emilie Giraud) : "Le maître de chant" 1473 |
| 1870 | Mlle Livia Besley : "Jeune fille composant un bouquet" 245 |
| 1870 | Mme Jenny Bibron née Belloc : "Jeune femme appuyée sur une harpe" 253 |
| 1870 | Mme Pauline-Elise-Léonide Bourges : "La diseuse de bonne aventure" 350 |
| 1870 | Uranie Colin-Libour : "La leçon de chant" 612 |
| 1870 | Mme Marie Dumesnil : "La Liseuse" 918 |
| 1870 | Mlle Angèle Dubos : "Après le bal" 889 |
| 1870 | Mlle Jeanne Samson : "Brodeuse" 2558 |
| 1870 | Mme Amélie-Léonie Fayolle : "La toilette" 1020 |
| 1870 | Mlle Cécile Ferrère : "La Romance" 1035 |
| 1870 | Mlle Delphine Malbet : "La toilette" 1842 |
| 1870 | Mlle Berthe Morisot : "Jeune femme à sa fenêtre" 2040 |
| 1870 | Mlle Henriette Pecqueur : "Jeune femme à sa toilette" 2198 |
| R4. 1852 | Mme Fanny Gilbert : "L'attente" 543 |
| 1855 | Mme Coeffier (née Marie-Pauline Lescuyer) : "Résignation" |

```
 2764
 1855 Mme Fanny Geefs : "L'attente" 329
 1855 Mlle Charlotte Krail : "Premier chagrin" 2082
 1855 Mlle M. Gillies : "L'affligée" 1022
 1857 Mme Marie Barsac : "La distraite" 116
 1857 Mlle Nina Bianchi : "Rêverie ; étude au pastel" 210
 1857 Mlle Louise Eudes de Guimard : "Un rêve du ciel" 910
 1857 Mlle Célina Lefébure : "Rêverie" 1662
 1861 Mme Doux (née Lucile Fournier) : "La résignation" 915
 1861 Mme Doux (née Lucile Fournier) : "L'attente" 916
 1861 Mlle Alice Grégoire : "Penserosa ; buste marbre" 3387
 1864 Mme Victorine Régnier : "Rêverie" 1613
 1864 Adélaide Wagner : "Un rêve" 1959
 1864 Mme Aizelin née Sophie Berger : "Le recueillement ;
 pastel" 1998
 1864 Mlle Marie-Léonide Poisson : "Une désillusion" 3309
 1865 Mlle Léonie Dusseuil : "Rêverie" 743
 1865 Mme Fréderique Augusta O'Connell : "Rêverie" 1618
 1866 Mlle Paule-Marie Malherbe : "Découragement" 1293
 1866 Mme Lucile Doux : "Résignation" 2190
 1866 Mme Lemée née Léontine Roulin : "Rêverie ; pastel" 2358
 1868 Mme Fanny Geefs : "L'attente" 1052
 1868 Mme Félicie Andiat : "Repentir" 65
 1868 Mlle Célina Lefébure : "Rêverie" 1503
 1868 Mlle Marie Mathieu : "Rêverie" 1722
 1868 Mlle Marie Mathieu : "Reverie" 1722
 1868 Mme la marquise de Mun née De Ludre : "Rêverie ; aquarelle"
 3157
 1869 Mlle Marie-Joséphine Nicolas : "Le rêve" 1802
 1869 Mlle Harriett Osborne-O'Hagan : "La pensée ; dessin" 3010
 1870 Mme Amélie-Léonie Fayolle : "Rêverie" 1021
 1870 Mme Pauline Malherbe : "Le premier chagrin" 1845
 1870 Mlle Henriette Pecqueur : "Rêverie" 2197

S4 1852 Mlle Henriette Bertaut : "Femme d'Alger ; étude" 93
 1853 Mme Grün (née Eugénie Charpentier) : "Jeune Bretonne ; étude"
 565
 1855 Mlle Nina Bianchi : "Italienne, étude ; pastel" 2550
 1855 Mme Grün (née Eugénie Charpentier) : "Femme et enfant
 valaques" 3218
 1855 Mme Grün (née Eugénie Charpentier): "Jeune bretonne" 3219
 1859 Mme Emma Gaggiotti-Richards : "Une dame italienne" 1177
 1861 Mme Henriette Browne : "Une femme d'Eleusis" 461
 1861 Mme Henriette Browne : "Une joueuse de flûte (intérieur
 de harem ; Constantinople 1860)" 463
 1861 Mme Henriette Browne : "Une visite (intérieur de harem ;
 Constantinople 1860)" 462
 1861 Mme Elisabeth Jerichau : "Halgierda, costume de fiancée
 à Rejckjawick (Hollande)" 1661
 1861 Mlle Pauline Malherbe : "Marchandes irlandaises" 2082
 1863 Mme Collard née Marie-Anne-Herminie Bigé : "Italiennes des
 environs de Naples" 436
 1864 Mlle Marie-Cécile Donnier : "Une polonaise" 3170
 1866 Mme Marie Anselma : "Une fiancée à Novogorod" 29
 1866 Mme Nancy née Claire Rey : "Dame vénitienne à sa toilette"
 1434
 1866 Mme Herbelin : "Portrait d'une jeune grecque ; dessin" 2286
 1866 Mme Mac-Nab née Marie D'Anglars : "Jeune femme italienne ;
 dessin" 2385
 1866 Mlle Eugénie Morin : "Une Italienne ; miniature" 2434
 1867 Mme Henriette Browne : "Jeune fille de Rhodes" 230
```

| | | |
|---|---|---|
| 1867 | | Daisy Ruffo : "Dame vénitienne ; dessin" 2046 |
| 1868 | | Mme Jenny Bibron née Belloc : "Une femme de la Ververa" 238 |
| 1868 | | Mlle Célina Lefébure : "Italienne" 1502 |
| 1868 | | Mme Mathilde Lehaut née Bonnet de Longchamps : "Deux fixés ; même numéro" 1. "Une Mauresque" 1526 |
| 1868 | | Mme Emma Roslin née Blanche : "Jeune Napolitaine" 2174 |
| 1868 | | Mme Adélaide Salles-Wagnes : "Jeune marocaine" 2233 |
| 1868 | | Mlle Helmine Bost : "Italienne ; pastel" 2672 |
| 1868 | | Mme Adèle Dehaussy : "Jeune italienne ; dessin" 2805 |
| 1868 | | Mlle Anaïs Fabre : "Une Florentine ; porcelaine" 2862 |
| 1868 | | Mlle Caroline-Marie Lombard : "Une italienne ; dessin" 3072 |
| 1868 | | Mme veuve Louise-Aline Midy : "Italienne ; pastel" 3133 |
| 1869 | | Mme Anna, vicomtesse Reille : "Femme fellah" 2015 |
| 1869 | | Mme Marie de Tocqueville : "Femme arabe" 2273 |
| 1869 | | Mlle Eugénie Venot d'Auteroche : "Jacintha, femme des environs de Naples" 2326 |
| 1870 | | Uranie Colin-Libour : "Italienne" 611 |
| | | |
| T4. | 1855 | Mlle Caroline Thévenin : "La jeune malade" 4042 |
| | 1857 | Mlle Célina Lefébure : "Lecture de la Bible" "Une femme malade se fait lire la Bible par un enfant" 1659 |
| | 1859 | Mlle Louise Eudes de Guimard : "Une veuve" 1015 |
| | 1861 | Mme Elisabeth Jérichau : "Jeune fille priant pour sa mère malade" 1664 |
| | 1863 SR | Mlle Sabine Méa : "Les dernières volontés d'une mère" 389 |
| | 1864 | Mme Roslin (née Emma Blanche) : "La soeur malade" 1673 |
| | 1864 | Mlle Lucie Destigny : "Une mère désolée" 3166 |
| | 1865 | Mlle Pauline-Elise-Léonide Bourges : "La veuve" 272 |
| | 1865 | Mlle Alida Stolk : "Une pensée près de la tombe d'un enfant" 2013 |
| | 1869 | Mme Louise-Marie Becq de Fouquières née Dedreux : "La convalescence" 168 |
| | | |
| U4. | 1873 | Mme Hélène-Marie Antigna : "La jeune mère" 20 |
| | 1873 | Mme Adélaide Salles-Wagner : "Le baiser de la mère" 1321 |
| | 1875 | Mme Uranie Colin-Libour : "La Jeune Mère" 486 |
| | 1875 | Mlle Alix Duval : "La Jeune Mère" 752 |
| | 1877 | Mme Marie-Joséphine Nicolas : "Joie maternelle" 1594 |
| | 1877 | Mme Alix-Louis Enault : "La première prière" 799 (illustrated in "L'Art" 1877 vol. 3 p 85) |
| | 1878 | Mme Juliette Peyrol (née Bonheur) : "Le baiser maternel" 1787 |
| | 1879 | Mlle Alein Perdrion : "Jeune mère ; porcelaine" 4343 |
| | 1881 | Mlle B. Pierson : "Monsieur, Madame et Bébé" 1870 |
| | 1881 | Virginie Demont-Breton : "Femme de Pêcheur venant de baigner ses enfants" 675 |
| | 1882 | Mme V. Demont-Breton : "La famille" 799    (ill.) |
| | 1882 | Mme U. Colin-Libour : "Italienne et son enfant" 614 |
| | 1883 | Mme V. Demont-Breton : "La plage" 740 (ill.) |
| | 1884 | Mme V. Demont-Breton : "Le Calme"   731    (ill.) |
| | 1885 | Mlle Amélie Casini : "Jeune mère ; - groupe, plâtre" 3445 |
| | 1886 | Mme M. Chapniz : "The little mother ; fusain" 2661 |
| | 1888 | Mlle E-J Gardner : "Deux mères de famille" 1071 (ill.) |
| | 1888 | Mme L-A Laurent : "Tendresse maternelle" 1519 |
| | 1888 | Mlle E. Nourse : "Une mère !" 1925 |
| | 1889 | Mlle T de Champ-Renaud : "Jeune mère" 530 (ill.) |
| | 1889 | Mlle Keyser : "Le repos" 1453 (ill.) |
| | 1889 | Mme C-G Besnard : "Mère et enfant ; - groupe plâtre" 4049 |
| | 1889 UFPS | Mlle Dora Hitz : "Mère et enfant" 307 |
| | 1890 SN | Mme Caradori : "Heureuse maternité" 176 |

```
1890 SN Mme J. Delance-Feurgard : "Au bois" 262 (ill.)
1890 SN Mme J. Delance Feurgard : "Premiers pas" 263 (ill.)
1890 SN Mme C. Besnard : "Mère et Enfant ; buste plâtre"
 1242 (ill.)

1891 SN Mme D. Hitz : "Mère et enfant" 473 (ill.)
1891 SN Mme Chadwick Lowstadt : "Jeune mère et sa fille" 621
1891 SN Mme Marie Cazin : "Jeune mère" 1015
1891 Mlle D. Ruruhjelm : "Deuil maternel" 663
1891 Mlle A-E Klumpke : "Enseignement maternel" 900 (ill.)
1891 Mme M-A Lavieille : "Maternité" 971 (ill.)
1891 UFPS Mlle Anne-Elisabeth Klumpke : "Enseignement maternel" 423
1892 Mme C-A Lord : "Une mère ; - portrait" 1105
1893 Mme U-A Colin-Libour : "La toilette de bébé" 425
1893 Mme H-M Trevor : "La mère du marin" 1716
1894 Mlle K. Morgan : "Mère et enfant ; - Midi" 1338
1894 Mme M. Pillini : "Le premier-né" 1471
1895 Mme B. Girardet-Imer : "Bonheur maternel" 3129 sculpture
1895 Mme M. Caire : "Taquinerie" 358 (ill.)
1895 SN Hélène Buttner : "Maternité ; pastel" 1343
1896 Mme P Delacroix-Garnier : "Loin de Paris" 598 (ill.)
1896 Mlle I. Matton : "Maman" 3670
1896 SI Lucie Conkling : "Jeune mère"*231
1896 SN Mme Fanny Fleury : "Maman et bébé" 521
1896 SN Mlle Elisabeth Nourse : "Mère et fillette hollandaises" 966
1897 SN Mlle Elisabeth Nourse : "Mère et bébé" 958
1897 SN Anna Maria Reutz : "Une mère et ses enfants ; - étude" 1059
1897 SN Mme Clémence Roth : "Mère et enfant" 1099
1897 Mlle L-A Landré:"Jeune mère" 955 (ill.)
1898 Mme P. Delacroix-Garnier : "Heureuse mère" 597 (ill.)
1898 SN Mlle Elisabeth Nourse : "Maternité" 940
1899 Mme Thompson, EK Baker : "Mère et enfant" 82
1899 Mlle L. Defries : "La mère" 577
1899 Mme P. Delacroix-Garnier : "Les joies maternelles" 584
1899 Mlle A. Nordgren : "Amour maternel" 1480
1899 Mlle B.M. Roos : "Mère et enfant" 1698
1899 Mlle C-H Simpson : "Mère et enfant" 1815
1899 Mlle M. Smith : "Amour maternel" 1822
1899 SN Mme M. Sienkiewicz : "Maternité" 1323
1899 SN Mlle E. Nourse : "Plein été" (ill.)
1900 Mme Mattié Dubé : "La petite mère" 456
1900 Mlle L-A Landré : "Amour maternel" 746 (ill.)
1900 Mlle Suzanne Leudet : "Maternité" 827
1900 Mlle Cornelia F. Maury : "La mère et l'enfant ; dessin" 1651
1900 Mme Delacroix-Garnier : "La tentation" 387 (ill.)
1900 Mme M. Dubé : "La petite mère" 456
1900 MlleL-A Landré : "Amour maternel" 746 (ill.)
1900 Mlle S. Leudet : "Maternité" 827

V4. 1874 Mme Ernestine Tourny : "Une fiancée" 1725
 1874 Agnès Börjesson : "L'adieu des nouveaux-mariés" 220
 1876 Mme Alix Louis Enault née Duval : "L'invocation de la
 mariée" 754
 1876 Mme Mathilde Scamps : "Il m'aime un peu .. pas du tout !.."
 1851
 1877 Mlle Cathinca Engelhart : "Le pauvre amour !" 800
 1877 MmeFélicie Schneider : "La fiancée du croisé" 1936
 1878 Mlle Louise-Amélie Landré : "Reviendra-t-il ? ; souvenir
 de Granville (Manche)" 1302
 1885 Mlle Laurence Krafft : "Premier rendez-vous" 1388
```

1885 Mlle Lucie Jacta : "Deux miniatures"
    1. "La fiancée" 2913

1886 Mlle Alphonsine de Challié : "L'amour vient sans qu'on
    y pense" 478

1886 UFPS Mme Gabrielle Effé : "L'anneau de fiançailles, étude" 126

1886 UFPS Mlle Georgette Meunier : "Souvenir de mariée" 209

1888 Mme E. Muraton : "Galante aventure" 1898

1888 Mme M. Pillini : "Les fiancés ; - Finistère" 2034

1888 Mme M-A Viteaux : "Mariage civil" 2481

1889 Mlle E. Herland : "Le matin d'une noce ; Bretagne" 1333
    (ill.)

1889 UFPS Mlle Hélène De Lajallet : "Allant du rendez-vous" 369

1890 Mlle E. Herland : "Le voeu" 1199

1891 UFPS Mme Marguerite Pillini : "Le départ de l'épousée (Finis-
    tère)" 659

1891 UFPS Mme Berthe Perrée : "Fiancée !" 648

1891 Mme C-M-B Perrée : "Fiancée" 1295

1893 Mlle L. Boéro : "L'amour heureux ; buste, plâtre" 2605

1894 Mme A. de Frumerie : "L'amour et l'hymen ; groupe plâtre"
    3114

1895 Mlle C. Berlin : "Séduction" 163

1895 Mlle M. Guyon : "Chanson d'amour" 909

1896 Mlle L-A Landré : "L'éveil du coeur" 1138 (ill.)

1896 SI Elise Désirée Firnhaber : "Fiancée" *395

1896 SFA Mlle Georges Achille-Fould : "C'est de lui" 5

1897 SN Mlle Ottilie-W Roederstein : "Le mariage" 1071

1898 Mlle L. Malbet : " Avant la noce" 1367

W4. 1872 Mme Madeleine Lemaire : "La sortie de l'église ; -
    aquarelle" 996

1873 Mme Louise-Marie Becq de Fouquières née de Dreux :
    "Les psaumes" 79

1873 Mme Félicie Schneider : "Actions de grâces" 1340 (ill in
    Witt library)

1873 Mme Pauline Malherbe : "Regarde ... Dieu nous protège !"
    995

1876 Mme Marie-Joséphine Nicolas : "Le rosaire" 1540

1877 Mme Denyse Bernard : "Le chapelet" 180

1878 Mlle Charlotte Du Motel (née Poterin) : "La prière" 818

1879 Mlle Louise-Alexandra Desbordes : "Souvenirs de première
    communion" 948

1879 Mlle Jeanne Rongier : "Les petites friandises du couvent"
    2584

1879 Mlle Marie-L Stone : "L'angélus" 2799

1879 Mlle Florence Koechlin : "Religieuse" 3896

1880 Mme L-M Becq de Fouquières : "Jeune religieuse" 222

1880 Mme Moina Binet : "Religieuse" 340

1880 Mlle Jeanne Burgain : "Vieille femme de Villerville
    récitant son chapelet" 550

1880 Mlle Joséphine Houssay : "La prière" 1874

1881 Mme A. Gahery-Ulric : "En prière" 928

1883 Mlle N. Robiquet : "Avant le catéchisme" 2083 (ill.)

1884 UFPS Mme Jeanne d'Entremont : "La prière ; étude" 91

1885 Mlle Julie Crouan : "En carême" 662

1885 Mlle Victorine-Louise Meurent : "Le jour des Rameaux" 1755

1885 Mme Emma-Camille Nallet-Poussin : "Une âme fervente" 1842

1885 UFPS Mme Nallet-Poussin : "Une âme fervente" 181

1886 Mlle Helen-W Phelps : "Au cloître" 1869

1886 UFPS Mlle Marthe Breton : "Vieille femme disant son chapelet" 42

1886 UFPS Mlle Jeanne Sallet : "En prière" 273

1887 Mme I de Beaufond : "Communiante" 142

1887 Mlle A. Régnault : "Soeur quêteuse" 1995

```
1887 Mlle J. Rongier : "L'entrée au couvent" 2065 (ill.)
1887 Mlle A. Casini : "L'Angélus ; - statue, plâtre" 3743
1887 UFPS Mme Inès de Beaufond : "Communiante" 16
1887 UFPS Mme Delphine de Cool : "Le jour de la première communion,
 aquarelle" 79
1888 Mme D. de Cool : "La lecture de la Bible" 629
1888 Mlle J. Lefebvre : "A l'oratoire" 1569
1889 Mlle G. Dupont-Binard : "A l'église" 926 (ill.)
1889 Mlle B. Mathews : "La première communion" 1828 (ill.)
1889 Mlle Christine Sundberg : "La Prière" 2522
1889 Mlle J. Rongier : "Les relevailles" 2326 (ill.)
1889 UFPS Mlle Dora Hitz : "Dans la chapelle" 308
1890 UFPS Mme Marthe Boyer-Breton : "Jeune fille en prière" 99
1890 UFPS Mme Elise Firnhaber : "Jeune Puritaine" 303
1890 UFPS Mme Magdeleine Réal-Del-Sarte : "La Révérence" 612
1890 Mlle M. Fleury : "La novice" 927
1890 Mme M-A Lavieille : "Prière pour l'absent" 1407
1890 Mme M. Pillini : "Le Jeudi saint en Bretagne" 1919
1890 Mme C-E Wentworth : "Le chapelet" 2433
1891 UFPS Mlle Marie Bermond : "Communiante" 49
1891 UFPS Mlle Claire Dufour : "Femme en prière" 261
1891 UFPS Mme Marie-Adrien Lavieille : "Prière pour l'absent" 458
1891 Mme C-E Wentworth : "Prière" 1703 (ill.)
1891 Mme Marguerite Souley-Darqué : "Le chapelet" 1152
1892 Mme F. de Mertens : "Le Repos du dimanche" 1200 (ill.)
1892 Mme M. Pillini : "Sortie de la grand'messe (Finistère)"
 1365 (ill.)
1892 Mme C.E. Wentworth : "Pour les pauvres" 1691 (ill.)
1892 Mlle A-M Jacob : "La Bible" 903 (ill.)
1893 Mme J. Choppart-Mazeau : "La Bible" 398
1893 Mme M-G Duhem : "Fleurs pour la Vierge" 631 (ill.)
1893 Mlle L-A Du Mond : "Les puritaines" 634 (ill.)
1893 Mlle A. Gonyn de Lurieux : "Soeur lisant ses prières" 816
1893 Mlle T. Pomey : "Laudate, pueri, Dominum" 1445
1893 Mlle M. Taylor Green : "Maintenant et à l'heure de notre
 mort" 1679
1894 Mme J. Chenu : "Le pain bénit" 421
1894 Mme M-G Duhem : "Une âme à Dieu" 664 (ill.)
1894 Mme L-A Du Mond : "Première Pâques" 667
1894 Mme G. Dumontet : "A l'église" 668
1894 Mme L. Michaud : "En prière" 1306
1894 Mme W-B Newman : "Le pain béni ; - Finistère" 1380
1894 Mlle E-A Rey : "Dans l'église" 1545
1894 Mlle E-W Roberts : "Prière à la Vierge" 1566 (ill.)
1895 Mlle W-B Newman : "La neuvaine" 1431 (ill.)
1895 Mme M-G Duhem : "La promenade des soeurs" 656 (ill.)
1895 Mlle L-A Landré : "Miserere mei, Domine" 1078 (ill.)
1895 Mlle L. Ramsay-Lamont : "Une lecture sainte" 1588 (ill.)
1895 Mlle E. Herland : "Un baptême à Rosporden (Bretagne). La
 cérémonie du porche" 948 (ill.)
1895 SI Mme Elise-Désirée Firnhaber : "Piété" 532
1895 SN Phoebe A. Bunker : "Prière (étude)" 216
1895 SN Mlle Elisabeth Nourse : "Première communion" 950
1896 Mlle M. Carpentier : "Les chandelles" 401
1896 Mlle L. Ramsay-Lamont : " Dans la cour du couvent ; une
 heure de loisir" 1659 (ill.)
1896 Mme T. Schwartze : "Communiantes luthériennes" 1807
1896 Mme C-E Wentworth : "Dévotion à Saint-Antoine" 2052 (ill.)
1896 SI Mme John-M Clark : "La prière" *215
1896 SFA Mme Marie- Geneviève Duhem : "La Bréviaire" 25
1897 Mme B. Mackay : "Première communiante" 1092
1897 Mlle E. Sonrel : "Les Rameaux" 1576 (ill.)
```

```
1897 Mme C. de Wentworth : "Un cierge à Sainte Geneviève" 1750
1898 Mme A-V Barbosa : "Matin de la Saint-Jean" 97
1898 Mme J-L-L Brouilhony : "Le bénédicité" 315
1898 Mme U. Colin-Libour : "Charité" 507 (ill.)
1898 Mlle B. Demanche : "La prière du soir" 625
1898 UFPS Mme Pauline Delacroix-Garnier : "A l'église ; aquarelle"
 159
1898 UFPS Mme Mathilde Marganne : "Lecture pieuse ; pastel" 377
1898 UFPS Mlle Blanche Roullier : "La Prière ; pastel" 487
1898 UFPS Mme Agnès Kjellberg de Frumerie : "La soeur aveugle ;
 plâtre 8
1898 UFPS Mlle Jeanne Brossard : "En prière ; pastel" 79
1898 Mme la Vsse de Sistello : "Communiante, Portugal" 1866
1898 SN Mme Marie Duhem : "Les communiantes" 435
1898 Mme L-G Woodward : "Les cloîtres" 2089
1898 Mme H. Luminais : "Prière ! (petit ange)" 3624
1899 Mlle G. Achenbach : "La prière" 5
1899 Mlle M. Garay : "Procession de la Fête-Dieu, à Bidarray
 (pays basque)" 830
1900 Mme Emma Herland : "Chez les soeurs du Saint-Esprit" 658
1900 Mlle J. Brossard : "Prière" 199
1900 Mlle E. Sonrel : "Préparatifs de fête au béguinage
 (Bruges)" 1228 (ill.)
1900 Mme M. Fournets-Vernaud : "La messe de l'aïeule" 536
1900 Mlle A. Gardiner : "Les vêpres, au Béguinage (Bruges)" 562
1900 Mme A-M Gow-Stewart : "Le Bénédicité" 598
1900 Mlle E. Herland : "Chez les soeurs du Saint-Esprit" 658
 (ill.)
1900 Mlle M. Roussin : "La lecture de la Bible" 1158
1900 Mme E. Gruyer-Brielman : "Prière pour l'absent" 135 (ill.)

X4. 1876 Mme Lydie-Adèle Laurent-Desrousseaux : "Convalescence"
 1213
1878 Mme Henriette Browne : "Convalescence" 355
1878 Mme Louise Robins : "Portrait d'un malade ; gouache" 3756
1878 Mlle Sarah Bernhardt : "Après la tempête"
 (According to the "Gazette des Beaux-Arts" it depicts
 an old woman holding a child who is either dead or
 has fainted - 1876 vol. 14 p 136)
1879 Mme Alix-Louis Enault : "Visite à la convalescente" 1161
1881 Mme E. Roslin : "L'enfant malade" 2045
1881 Mlle J. Duboulan : "L'invalide" 781
1882 Mlle d'Anéthan : "L'Enfant Malade" 32
1884 Mlle J. Zillhardt : "Convalescence" 2484
1884 SI Mme Emma-Camille Nallet-Poussin : "Etrennes à la convalsc-
 ente" 223
1886 Mlle Berthe Burgkan : "Veuve" 396
1886 Mme Uranie Colin-Libour : "La veuve" 556
1886 Mlle Marie-Rose Escolier-Mamon : "Au cimetierre" 897
1886 Mme Emma-Camille Nallet-Poussin : "La convalescente" 1737
1886 Mme Marguerite Ruffo : "La veuve" 2096
1886 Mme Marie Cazin : "Convalescente" 2653 (Musée des Beaux-Arts
 Tours)
1886 Mlle Elisabeth Dumas : "Convalescente ; - pastel" 2792
1886 UFPS Mme Nallet-Poussin : "La Convalescente" 229
1887 Mlle I. Rado-Reizmann : "L'angoisse d'une veuve" 1976
1888 Mlle J. Marest : "Une morte" 1730
1888 Mme F. Schneider : "Petite convalescente" 2259 (ill.)
1889 Mlle D. Hitz : "Les Femmes des naufragés" 1350
1889 UFPS Mlle Marguerite Espénan : "En deuil" 227
1890 UFPS Mme Marguerite Pillini : "La Jeune Veuve" 604
```

```
1890 UFPS Mlle Amélie Valentino : "Convalescence" 696
1890 Mme F Jean de Mertens : "En deuil" 1274
1891 Mme A. Enault : "Premier deuil" 584
1891 Mlle D. Furuhjelm : "Deuil maternel" 663
1891 UFPS Mlle Anna Bilinska : "Le Deuil" 67
1891 UFPS Mlle Berthe Burgkan : " Veuve" 121
1891 UFPS Mme Alice Cazelles : "La butte Pinson. Deuil (Seine-et-
 Oise) ; aquarelle" 145
1891 UFPS Mlle Madeleine Fleury : "La Veuve" 307
1892 Mme M. Smith : "L'Enfant malade" 1548
1893 Mlle M. d'Andlau : "En convalescence" 18
1894 Mlle M-S Galland : "En deuil, à Pont-Aven ; - terre
 cuite" 3118
1896 Mme L. Arden : "Et je suis resté seul" 48
1896 SFA Mlle Madeleine Fleury : "La Veuve" 52
1897 Mme E. Huillard : "Convalescence" 858
1897 Mme L. Lempicka : "Petite convalescente" 1017
1897 Mme L-A Muntz : "Le veuf et sa fille" 1240
1897 Mlle M. Smith : "Au cimetierre" 1571
1898 Mme M. Dubé : "Avant l'enterrement" 703 (ill.)
1898 UFPS Mlle Berthe Burgkan : "Convalescence ; pastel" 86
1899 Mlle A. Stolz : "Veuve" 1842
1899 Mlle M-A Demagnez : "In memoriam" 3390
1900 Mlle E.H Macfarlane : "Deuil" 859

Y4. 1872 Mlle Alix Duval : "La sieste" 583
 1872 Mlle Claire-Alphonsine Gillet : "La lettre d'une amie" 689
 1872 Mlle Eva Gonzalès : "L'indolence" 723
 1872 Mme Alix de Laperelle-Poisson : "Jeune fille" 929
 1872 Mlle Félicie Mégret : "Le déjeuner" 1082
 1872 Mme Marie-Joséphine Nicolas : "Le goûter" 1171
 1872 Mlle Jeanne Samson : "La toilette" 1379
 1873 Mme Marie de Chevarrier née de Pène : "Le lever ; -
 miniature" 287
 1873 Mlle Alix Duval : "Un duo" 535
 1873 Mme Armand Leleux : "Le déjeuner chez la tante" 921
 1873 SR Mme Marie-Louise Ravenez : "La lecture" 63
 1873 Mlle Jeanne Samson : "Dans la serre" 1326
 1873 Mme Félicie Schneider : "Actions de grâces" 1340 (ill.)
 1874 Mme Armand Emilie Leleux : "L'ordonnance du médecin" 1163
 1874 Mlle Marie-Alphonsine Fresnay : "Le Sommeil ; - buste, haut-
 relief plâtre" 2869
 1875 Mme Marie Bracquemond : "La lecture" 287
 1875 Mlle Louise Eudes de Guimard : "La lecture du soir ; -
 portrait de Mlle M.J..." 777
 1875 Mlle Isidorine Mikulska : "Le repos" 1482
 1876 Mme Laure de Châtillon : "Le sommeil" 411
 1876 Mlle Eva Gonzalès : "Le petit lever" 931 (ill. in Claude
 Roger-Marx op.cit.)
 1876 Mlle Marie Pichon : "Passe-temps" 1639
 1876 Mlle Jeanne Salanson : "Le déjeuner" 1841
 1876 Mlle Jeanne Salanson : "La lettre" 1842
 1876 Mme Annette Lemarchand : "Femme couchée" 2670
 1877 Mlle Marguerite Escallier : "Un dimanche matin" 806
 1877 Mlle Blanche Larible : "Le thé" 1215
 1877 Mme Marie-Mathilde Ménault née Chauvet : "Après le théâtre"
 1477
 1877 Mme Camille Moreau : "Nos intimes" 1545
 1877 Mlle Jeanne Samson : "Passe-temps" 1908
 1877 Mlle Jeanne Samson : "Coquetterie" 1909
 1877 Mlle Amanda Sidwall : "Lecture intéressante" 1971
```

| 1877 | Mlle Charlotte-Gabrielle Dubray : "La coquette ; - buste, terre-cuite" 3740 |
| 1878 | Mlle  Eva Gonzalès : "En cachette" 1047 |
| 1878 | Mlle Eva Gonzalès : "Le panier à ouvrage" 3046 (the latter two are illustrated in Claude-Roger Marx op.cit.) |
| 1878 | Mme Marie-Hélène Antigna : "Le sommeil de midi" 42 |
| 1878 | Mlle Fanny Duncan : "Après le déjeuner" 822 |
| 1878 | Mlle Alide Stolk : "Goûter" 2092 |
| 1879 | Mlle Jeanne Bôle : "A la promenade" 328 |
| 1879 | Mlle Cornelia Conant : "Vie de famille" 719 |
| 1879 | Mlle Angèle Dubos : "La chanson nouvelle" 1061 |
| 1879 | Mlle Eva Gonzalès : "Une loge aux Italiens" 1405 (Louvre) |
| 1879 | Mlle Louise Lalande : "Le repas" 1743 |
| 1879 | Mlle Pauline Laurens : "Une page attachante" 1795 |
| 1879 | Mlle Elizabeth Mathé : "La tricoteuse" 2060 |
| 1879 | Mme Marie Mathieu : "Une romance" 2063 |
| 1879 | Mlle Louise Milliet : "La danse" 2154 |
| 1879 | Mme Camille Prévost-Roqueplan : "Retour du bal" 2476 |
| 1879 | Mme Mathilde Robert : "Le roman" 2566 |
| 1879 | Mme Emma Roslin, née Blanche : "La leçon de danse" 2596 |
| 1879 | Mlle Sophie Unternahrer : "Le bain" 2888 |
| 1879 | Mlle Sophie Beale : "La lecture sérieuse ; - aquarelle" 3130 |
| 1879 | Mme  Caroline David : "La sérénade ; - aquarelle, " 3430 |
| 1879 | Mme Lucile Doux : "Confidence" 1032 |
| 1879 | Mlle Louise Durussel : "La lecture ; - porcelaine" 3549 |
| 1879 | Mlle Fanny Gamboginée Taillefer : "La sérénade" 3657 |
| 1879 | Mlle Jeanne Mocquart : "Le repos ; - porcelaine" 4213 |
| 1879 | Mme Marguerite Ruffo : "La promenade ; - aquarelle" 4547 |
| 1880 | Mme E-C Belbeys : "Déjeuner" 229 |
| 1880 | Mme E-C Belbeys : "Dessert" 230 |
| 1880 | Mlle  Gabrielle Blondel : "Une lettre" 370 |
| 1880 | Mlle Jeanne Bôle : "Avant la danse" 386 |
| 1880 | Mme Louise Chanton (baronne Tristan-Lambert) : "Dans la cuisine" 696 |
| 1880 | Mme Uranie Colin-Libour : "Coquetterie" 833 |
| 1880 | Mlle L-A Desbordes : "La fête de l'absent" 1119 |
| 1880 | Mlle Marie Epinette : "Une triste nouvelle" 1353 |
| 1880 | Mlle Emily Faller : "La veillée" 1381 |
| 1880 | Mme Jeanne Fichel (née Samson) : "La toilette" 1417 |
| 1880 | Mme Marie Gabrielle : "Une confidence" 1515 |
| 1880 | Mme Armand Emilie Leleux : "Confidences" 2261 (illustrated in Walter Shaw Sparrow op.cit. p 220) |
| 1880 | Mlle Louise Mercier : "La leçon de musique" 2584 (ill.) |
| 1880 | Mme Hermine Waternau : "Après la danse" 3887 |
| 1881 | Mlle L. Abbéma : "L'heure de l'étude" 2 (ill.) |
| 1881 | Mme L-T Alma Tadema : "Une dévideuse" 23 |
| 1881 | Mlle H. Backer : "L'andante" 68 |
| 1881 | Mme C. Deschamps : "Une bonne récette" 701 |
| 1881 | Mme E. Miraton : "Les deux intimes" 1711 |
| 1881 | Mlle M. Petiet : "Tricoteuse endormie" 1834 (illustrated in "L'Art" 1881 vol. 3 p 8) |
| 1881 | Mlle M. Picoche : "Après le bal ; nature morte" 1864 |
| 1881 | Mme L-L Williams : "Un cercle de connaissances" 2423 |
| 1881 | Mlle A. Latry : "La toilette après le bain ; statuette, plâtre" 4035 |
| 1882 | Mme V-E Demont-Breton : "La Famille" 798 |
| 1883 | Mlle L. Breslau : "Le thé de cinq heures" 358 (ill) |
| 1883 | Mme U. Colin-Libour : "Souvenir de bal" 565 |
| 1883 | Mme F. Fleury : "Coquetterie" 944 (ill.) |
| 1883 | Mme M. Petiet : "Le Petit Journal" 1890 (illustrated in |

"L'Art" 1883 vol. 2 p 197)

| | | |
|---|---|---|
| 1883 | | Mlle B-A Pierson : "Chez la modiste" 1923 |
| 1884 | | Mlle M. Arosa : "Baigneuse" 41 |
| 1884 | | Mme E-C Gonzalès : "Le repos" 1075 |
| 1884 | | Mme M. Lavieille : "L'Anniversaire" 1435 (ill.) |
| 1884 | | Mlle F. Mégret : "Jeune femme lisant" 1678 |
| 1884 | | Mme Annie Ayrton : "Liseuse ; pastel" 2513 |
| 1884 | | Mlle Emma-Marie Formige : "La lecture" 2784 |
| 1884 | UFPS | Mme Annie Ayrton : "Liseuse ; pastel" 12 |
| 1884 | UFPS | Mme Jeanne d'Entremont : "Jeune fille ; étude" 92 |
| 1884 | UFPS | Mlle Marie Epinette : "La toilette" 93 |
| 1884 | UFPS | Mme  Juliette Jobard : "Le Bain" 133 |
| 1884 | UFPS | Limosin d'Alheim : "La toilette" 156 |
| 1884 | UFPS | Mlle Jeanne Sallet : "Tricoteuse" 220 |
| 1884 | UFPS | Marie Pichon : "La charité (éventail)" 190 |
| 1884 | UFPS | Mlle Valentino : "A une vente de charité" 262 |
| 1885 | | Louise Daniel : "Liseuse" 679 |
| 1885 | | Mme M. Worms : "Promenade" 2470 (ill.) |
| 1885 | | Mlle Louise Breslau : "Chez soi" 362 (ill.) |
| 1885 | | Mlle Jeanne Chenu : "La sieste" 542 |
| 1885 | | Louise Daniel : "Liseuse" 679 |
| 1885 | | Mlle Marie Deveulle : "Le repos" 808 |
| 1885 | | Mme Héloise Huitel dite Vuitel : "Le livre intéressant" 1295 |
| 1885 | | Mlle Lella Lamont : "La tricoteuse" 1431 |
| 1885 | | Mme Céleste Moutet-Cholé : "Prête pour le bal" 1829 |
| 1885 | | Mme Mathilde Worms, née Jacob : "Promenade" 2470 |
| 1885 | | Mme Emma Lowstadt Chadwick : "Femme endormie ; - aquarelle" 2528 |
| 1885 | | Mlle Lina Morin : "Après le bal ; - buste plâtre" 4941 |
| 1885 | UFPS | Mlle Elisabeth Keyser : "Avant le bal" 139 |
| 1885 | UFPS | Mlle Hélène Lajallet : "Une Matinée dans le Parc" 145 |
| 1885 | UFPS | Mme Marguerite Ruffo : "La lettre, aquarelle" 234 |
| 1885 | UFPS | Mlle Caroline Morin : "Après la bal" 14 sculpture |
| 1886 | | Mme Rita Guerma : "Coquetterie ; buste plâtre" 3997 |
| 1886 | | Mme Clémence-Marie-Berthe Perrée : "Un jour de fête" 1834 |
| 1886 | | Mlle Amélie Valentino : "Une visite" 2339 |
| 1886 | UFPS | Mlle Feurgard : "Au piano" 129 |
| 1886 | UFPS | Mlle Georgette Meunier : "La Mandoline" 210 |
| 1886 | UFPS | Mlle Winnaretta Singer : "Au piano, étude" 281 |
| 1886 | UFPS | Mlle Tribou : "Lecture sérieuse" 308 |
| 1887 | | Mlle A. Banuelos : "Réveil" 103 |
| 1887 | | Mme E-L Chadwick : "Five o'clock " 483 |
| 1887 | | Mlle M. Fairchild : "Confidences" 884 |
| 1887 | | Mlle L-A Landré : "Une lecture attachante" 1377 |
| 1887 | | Mme G. Meunier : "Souvenir de bal" 1677 |
| 1887 | | Mme E-C Nallet-Poussin : " Coquetterie" 1770 |
| 1887 | | Mme M. de Taverner : "Avant la danse" 2271 |
| 1887 | | Mlle H. Waternau : "La leçon de musique" 2458 |
| 1887 | UFPS | Mlle Georgette Meunier : "Souvenirs de bal" 199 |
| 1887 | UFPS | Mlle Blanche Moria : "Joueuse de mandoline ; tête d' étude" 202 |
| 1887 | UFPS | Mlle Pillini : "La charité au village" 233 |
| 1888 | | Mlle L-J Cadart : "Fin de journée" 461 |
| 1888 | | Mlle K-A Carl : "Le choix d'une romance" 491 |
| 1888 | | Mlle F. Duncan : "Le Journal" 902 |
| 1888 | | Mlle M. Guyon : "La violoniste" 1242 (ill.) |
| 1888 | | Mme M-E-D Lacote : "Chez la costumière" 1446 |
| 1888 | | Mlle L-A Landré : "Jeune femme lutinant un masque" 1473 |
| 1888 | | Mme C. de Maupeou : "Modes d'autrefois" 1773 |
| 1888 | | Mlle T. Paraf-Javal : "Parée pour le bal" 1951 |
| 1888 | | Mlle G. Pomaret : "Repos" 2051 |

```
1888 Mlle C. Richey : "Une liseuse" 2140
1888 Mlle O Roederstein : "Une étudiante" 2170
1888 Mlle F-H Throop : "Le réveil" 2378
1888 Mlle M. Turner : "Au travail ; - portraits" 2413 (ill.)
1888 Mlle J. Zillhardt : "Quiétude" 2576
1888 Mlle A. Manuela : "Le réveil ; - buste bronze" 4389
1889 Mlle M. Filippi de Baldissero : "Un dîner de famille" 1021
1889 Mlle D. Hitz : "Une lettre d'Islande" 1349
1889 Mlle T. Boursier : "Autour du foyer ; - groupe plâtre"
 4087
1889 Mme A. Weitz : "Au travail" 2724 (ill.)
1889 Mlle E. Nourse : "Entre voisines" 2021 (ill.)
1889 Mme Maximilienne Guyon : "Après le bain - pastel" 3312
1889 Mme Maximilienne Guyon : "Départ pour la promenade ; sous
 le Directoire ; aquarelle" 3313
1889 SI Mme Madeleine Saint-Héran : "Tricoteuse" 224
1889 SI Mme Marie Grandmougin : "Doux sommeil" 134
1889 UFPS Mme Doutreleau D'Amsinck : "Réveil" 194
1889 UFPS Mlle Marie Filippi de Baldissero : "Un dîner de famille" 246
1889 UFPS Mme Jeanne Jacquemin : "Jeune femme endormie" 324
1889 UFPS Mlle Rosa Leclle : "Au retour du théâtre" 392
1890 SN Mlle L. Lee-Robbins : "Sommeil" 562 (ill.)
1890 SN Mme M. Lemaire : "Sommeil" 564
1890 Mlle E. André : "La lecture" 36
1890 Mme M. Beaumetz-Petiet : "Jeune fille au travail" 127
1890 Mme J. Camuzet : "Liseuse ; étude" 437
1890 Mlle E. Hart : "La fin d'un livre" 1175
1890 Mlle E. Herland : "Confidence" 1200 (ill.)
1890 Mme H. Le Roy D'Etiolles : "Le dimanche" 1486
1890 Mlle J. Marest : "La lettre" 1599
1890 Mlle M. Leroy : "Baigneuse ; statue plâtre" 4156
1890 UFPS Mme Isabelle Desgrange : "Lecture" 229
1890 UFPS Mlle Estelle Rey : "Lecture terminée" 621
1890 UFPS Mlle Marguerite Turner : "Avant le menuet ; pastel" 691
1890 UFPS Mme Frédérique Vallet : "Coquetterie" 697
1890 SN Mme D. Hitz : "Jeunes Filles Bretonnes cousant" 482
1891 Mlle A. Beaury-Saurel : "Travail" 89 (ill.)
1891 Mlle L. De Hem : "Le thé" 465
1891 SN Mlle M-L-C Breslau : "Jeune fille à sa toilette" 129 bis
1891 Mlle E. Herland : "La lecture du 'Petit Journal'" 823
1891 Mlle R-M Lancelot : "La famille ; bas-relief, plâtre" 2642
1891 Mme C. Moutet-Cholé : "Le premier bal" 1219
1891 Mlle A. Nordgren : "La toilette" 1244
1891 Mlle M. Turner : "La fin du conte" 1618 (ill.)
1891 UFPS Mlle Louisa-Cécile Descamps-Sabouret : "Un Passage intéress-
 ant" 223
1891 UFPS Mlle Claire Dufour : "Passe-temps. Etude ; pastel" 264
1891 UFPS Mlle Marguerite Espénan : "Jeune fille lisant" 279
1891 UFPS Mlle Anna-Elisabeth Klumpke : "Avant la fête" 424
1891 UFPS Mlle Anna-Elisabeth Klumpke : "La lecture ; pastel" 428
1891 UFPS Mlle Lucy Lee-Robbins : "Dimanche matin" 464
1891 UFPS Mlle Louise Mercier : "La liseuse au chat " 550
1891 SI Mme Marguerite Souley-Darqué : "Confidences" 1149
1891 SI Mme Marguerite Souley-Darqué : "Réveil" 1148
1892 Mlle E. Desjeux : "La lecture" 548 (ill.)
1892 Mlle M. Duenes d'Alheim : "En famille" 608
1892 Mlle Dufau : "Chez l'horticulteur" 609
1892 Mlle A-V Guysi : "Confidences" 839 (ill.)
1892 Emma Herland : "Lettre au bon ami" 865
1892 Mlle Nanny Feit : "La vieille tricoteuse ; pastel" 1871
1892 Mme M. Dubé : "La fleur fanée" 594 (ill.)
```

| | | |
|---|---|---|
| 1892 | | Mme U. Colin-Libour : "Jeune femme à sa toilette" 428 (ill.) |
| 1892 | | Mme M-M Réal del Sarte : "Après le bal" 1408 (ill.) |
| 1892 SN | | Mme D. Hitz : " Réveil" 559 |
| 1892 SN | | Mme D. Hitz : "Repos" 560 |
| 1892 SN | | Mlle L. Lee Robbins : "Five o'clock" 654 |
| 1892 SN | | Mlle L. Lee Robbins : "A sa toilette" 655 |
| 1892 SN | | Mlle E. Nourse : "Le Repas en famille" 775 |
| 1892 SN | | Mlle E. Nourse : "La toilette du matin" 776 |
| 1893 | | Mlle M. Besson : "Lecture" 153 |
| 1893 | | Mme T. Claudius-Jacquet : "A la maison" 409 |
| 1893 | | Mlle A. Delasalle : "Repos" 535 |
| 1893 | | Mme V-E Demont-Breton : "Le foyer" 553 |
| 1893 | | Mme M-A Lavieille : "Romance sans paroles" 1057 (ill.) |
| 1893 | | Mme H. Le Roy d'Etiolles : "Liseuse" 1122 |
| 1893 | | Mme C. Moutet-Cholé : "L'anniversaire" 1315 |
| 1893 | | Mme E. Muraton : "La sieste" 1322 |
| 1893 | | Mlle I-E de Schulzheim : "Etude" 1600 |
| 1893 | | Mlle M. Brach : "Le lever ; - statuette, marbre" 2635 |
| 1893 SN | | Marie Sauvan : "Jeune femme à sa toilette ; pastel" 1383 |
| 1894 | | Mlle M. Besson : "Intimité" 180 |
| 1894 | | Mme Choppard-Mazeau : "Tristes nouvelles" 436 |
| 1894 | | Mme A. Constantin : "At home (à la maison)" 471 |
| 1894 | | Mlle E. Darbour : "Retour du premier bal" 510 |
| 1894 | | Mme P. Delacroix- Garnier : "Une liseuse" 556 |
| 1894 | | Mlle J-M Favier : "At home" 723 |
| 1894 | | Mlle B. Jouvin : "Une tireuse de cartes" 1004 |
| 1894 | | Mme M-A Lavieille : "Jour de fête" 1084 |
| 1894 | | Miss C-A Lord : "Le sommeil" 1197 |
| 1894 | | Mme F. de Mertens : "Liseuse" 1294 (ill.) |
| 1894 | | Mme L. Raiwez : "Five o'clock tea !" 1514 |
| 1894 | | Mme M-D-W Robinson : "Jour de fête" 1573 |
| 1894 | | Mlle H-M Trevor : "Five o'clock tea, à Saint-Yves" 1752 |
| 1894 | | Mme L. Van Parys : "La fin du livre" 1788 |
| 1894 | | Mme L. Signoret-Ledieu : "Coquetterie ; - buste, bronze" 3594 |
| 1894 SN | | Mme Fanny Fleury : "La toilette" 455 |
| 1894 SN | | Mme Madeleine Lemaire : "Lecture intéressante" 716 (ill in Witt Library) |
| 1894 SN | | Julia Marest : "Jeune femme écrivant une lettre" 762 |
| 1895 | | Mme A. Gonyn de Lurieux : "Vieille femme faisant du tricot" 851 |
| 1895 | | Mlle J. Houssaye : "Musique d'ensemble" 974 |
| 1895 | | Mme E. Huillard : "La lettre" 977 |
| 1895 | | Mme E. Roos : "Au foyer" 1653 |
| 1895 | | Mlle M. Turner : "At home" 1851 |
| 1895 | | Mme Jeanne Dérigny : "Liseuse ; pastel" 2211 |
| 1895 | | Mlle M. Perrier : "Eveil" 1512 (ill.) |
| 1895 SI | | Mlle Claire Dufour : "Liseuse" 436 |
| 1895 SI | | Mme Elise-Désirée Firnhaber : "Repos" 533 |
| 1895 SI | | Mme Madeleine Saint-Héran : "Travail et lecture" 1349 |
| 1895 SFA | | Jehanne Mazeline : "Avant le Bal ; aquarelle" 123 |
| 1895 SN | | L-C Breslau : "Jeune fille brodant un métier" 197 |
| 1895 SN | | Mme Lilla-Cabot-Perry : "Jeune violoncelliste" 981 |
| 1896 | | Mlle L. Canuet : "La lettre" 390 |
| 1896 | | Mme C. Moutet-Cholé : "Harmonie" 1476 (ill.) |
| 1896 | | Mme A. Constantin : "Les dernières nouvelles" 501 |
| 1896 | | Mme M. Guyon : "La diseuse de bonne aventure" 991 |
| 1896 | | Mlle C-H Dufau : "Passe-temps" 721 |
| 1896 | | Mme E. Muraton : "Une famille" 1484 |
| 1896 | | Mme J-C Philippar-Quinet : "Five o'clock" 1585 |
| 1896 | | Mme E. Roos : "En famille" 1722 |
| 1896 | | Mme E. Stevens : "Une jeune travailleuse" 1864 |

```
1896 SI Lucie Conkling : "Femme à sa toilette" *229
1896 SI Claire Dufour : "Au piano (étude d'intérieur)" *322
1896 SI Mlle Julie Manet : "Jeune fille au piano" 696
1896 SFA Mme Laure Brouardel : "Une Visite" 8
1896 SFA Mme Laure Brouardel : "Jeune fille lisant une lettre" 10
1896 SN Mary Franklin : "La toilette" 536
1896 SN Mlle Elisabeth Nourse : "Heures d'été" 964
1896 SN Mlle Ottilie Roederstein : "Une femme liseuse" 1069
1896 SN Anne-Douglas Sedgwick : "Liseuse" 1609
1896 SN Emma Lowstadt-Chadwick : "La lecture (gravure à épreuve
 unique)" 1680
1896 SN Mme Charlotte-Gabrielle Besnard : "Le sommeil (masque de
 femme)" 16
1897 Mlle L. Abbéma : "Musique" 1 (ill.)
1897 Mlle M. Carpentier : "Liseuse" 326
1897 Mlle M. Constantin : "Repos" 415
1897 Mme A. Gonyn de Lurieux : "Jeune fille jouant à la
 guitare" 755
1897 Mlle A-L Lewis : "Liseuse" 1049
1897 Mme M-L Lucas : "Après la bal" 1083
1897 Mme M-M-E de Mazet : "Vieille femme lisant" 1160
1897 Mme E. Muraton : "Prêt à sortir" 1244
1897 Mme F. Vallet : "Retour du bal ; portrait de Mme M.A.." 1676
1897 Mlle M. Gerson : "Le sommeil" 2989
1897 SN Mlle Kate Carl : "La lettre" 239
1897 SN Mlle Kate Carl : "Le five o'clock" 240
1897 SN Mme Lucy Lee-Robbins : "Une tasse de thé" 780
1897 SN Mlle Elisabeth Nourse : "Un humble ménage" 957
1897 SI Elise-Désirée Firnhaber : "Joueuse de guitare" *376
1898 Mlle M-L Arrington : "La jeune ménagère" 44
1898 Mme E. Coulin : "La visite" 533
1898 Mme P. Delacroix-Garnier : "Une liseuse" 598
1898 Mlle C-H Dufau : "Jeux d'été" 720
1898 Mme C. Fould : "Chez la sorcière ; le talisman" 838
1898 Mme N. Guillaume : "Jeune fille lisant" 978
1898 Mlle M. Jouanne : "La toilette" 1103
1898 Mlle J. Lapointe : "Repos" 1178
1898 Mme W-B Newman : "Soir de fête" 1529
1898 Mme F. Vallet : "Intimité" 1993 (ill.)
1898 Mlle B. Girardet-Imer : "La veille de Noël" 3459
1898 Mlle R. Vériane : "Le réveil" 3913
1898 SN Mlle Lucie-Antoinette Désaille : "Femme à sa toilette
 (pointe sèche)" 1920
1898 SN Jeanne Contal : "La première lettre ; pastel" 1420
1898 SN Mlle Laure-Louise Bandement : "Avant le bal ; miniature sur
 ivoire" 1347
1898 SI Mme Elisabeth-Désirée Firnhaber : "La lettre" *212
1898 UFPS Mlle Henriette Decours : "Chez la Modiste ; pastel" 152
1898 UFPS Mme Jeanne Duval-Daussin : "Avant la promenade" 201
1898 UFPS Mme Jeanne Duval- Daussin : "Sommeil" 202
1898 UFPS Mme Jeanne Elliker-Renoux : "Hors de Bal ; pastel" 203
1898 UFPS Mme Jeanne Fichel : "Souvenir de Bal" 219
1898 UFPS Mlle Emilie Landau : "Liseuse ; pastel" 308
1898 UFPS Mme Camille Métra-Hubbard : "La Lecture" 389
1898 UFPS Mlle Jeanne Saglier : "Femme à sa toilette"; miniature" 492
1898 UFPS Mlle Elisabeth Sonrel : "Le thé ; aquarelle" 518
1898 UFPS Mlle Malvina Brach : "Le lever, petite statuette marbre" 2
1898 UFPS Mme Berthe Bourgonnier-Claude : "Après la lettre" 63
1898 UFPS Mlle Jenika Cabarrus : "Le Dernier Chapitre ; pastel" 88
1898 UFPS Mlle Madeleine Carpentier : "Au Spectacle ; pastel" 103
1898 UFPS Mme Gabrielle Debillemont-Chardon : "Une vitrine
```

```
 contenant cinq miniatures"
 "Le retour du bal" 151
 1898 SFA Mlle Madeleine Carpentier : "Lecture ; pastel" 16
 1898 SFA Mlle Clarisse Bernamont : "Sommeil" 118
 1899 Mlle L. Boulanger : "Coquetterie suranné" 263
 1899 Mlle L. Canuet : "Coquetterie" 363
 1899 Mlle Z. Durruthy : "Doux sommeil" 719
 1899 Mlle J-M Favier : "Mélodie" 770
 1899 Mlle C. Green : "Le petit déjeuner" 906
 1899 Mlle L-C Herreshoff : "L'intimité" 981
 1899 Mlle J. Houssay : "La lettre" 1000
 1899 Mme H. Luminais : "L'épouse" 1268
 1899 Mlle E-H Macfarlane : "Une confidence" 1279
 1899 Mlle M. de Montille : " Fait divers sensationnel" 1430
 (ill.)
 1899 Mme C. Moutet-Cholé : "Lecture" 1455 (ill.)
 1899 Mme G. Olivier : "Envoi à une amie" 1489
 1899 Mme B. Paymal-Amouroux : "Faits divers" 1515
 1899 Mlle L. Ribot : "La lecture" 1655
 1899 Mlle M. Térouanne : "Intimité" 1878
 1900 Mme U. Colin-Libour : "Le réveil" 319
 1900 Mlle Henriette Desauty : "Brodeuse" 418
 1900 Mlle M. Besson : "La fin du roman" 122 (ill.)
 1900 Mlle B. Bocquet : "A la recherche d'un plaisir" 140
 (ill.)
 1900 Mme U. Colin-Libour : "Le réveil" 319 (ill.)
 1900 Mlle J-A Dawson : "Un repas du soir" 371
 1900 Mlle L. Defries : "La leçon" 383
 1900 Mlle M-A-R Delorme : "Avant le bain" 404
 1900 Mlle B-M Demanche : "Après la journée" 406
 1900 Mme H. Desauty : "Brodeuse" 418
 1900 Mme G. Dupont-Binard : "La tricoteuse" 467
 1900 Mlle M. Godin : "La romance" 585
 1900 Mlle C-L Goodwin : "Le goûter" 592
 1900 Mlle L.C. Herreshoff : "Le repos" 659
 1900 Mlle G. Leese : "Jeune fille lisant" 789
 1900 Mlle J. Leluc : "Fin de journée" 800
 1900 Mlle A. Nordgren : "La lettre" 995
 1900 Mlle S. Watkins : "La leçon interrompue" 1348
 1900 Mme B. Paymal-Amouroux : "Celle qu'on n'écoute pas" 1032
 (ill. ; girl playing the piano)

Z4. 1872 Mme Adèle Dehaussy : "Italienne" 462
 1872 Mlle Mathilde Robert : "Une Bordelaise" 1328
 1873 Mme Lucile Doux : "Fille juive de Salonique (Turquie d'
 Europe)" 494
 1876 Mlle Angèle Dubos : "La sultane" 699
 1876 Mlle Mathilde Robert : "Une Niçoise" 1752
 1876 Mlle Laure-Justine-Joséphine Alix : "Italienne ; - porce-
 laine" 2101
 1876 Mlle Aimée-Eugénie Delville-Cordier : "Jeune moresque,
 d'Alger ; - miniature" 2347
 1876 Mme Charlotte de Saint-Gervais : "Négresse ; - buste
 bronze" 3594
 1877 Mme Delphine de Cool : "Une jeune orientale" 541
 1877 Mme Louise-Marie Becq de Fouquières : "Jeune fille de
 Kerfuntun (Finistère) ; - pastel" 2274
 1877 Mlle Suzanne Brunel : "Italienne ; - aquarelle" 2395
 1877 Mlle Aimée-Eugénie Delville-Cordier : "Femme juive
 d'Alger ; - miniature" 2580
 1878 Mlle Irma Boniface : "Une parisienne" 278
 1878 Mlle Sophie Unternahrer : "Petite fille tartare" 2167
```

```
1879 Mlle Pauline Chaville : "Jeune fille de Brides (Savoie)"
 619
1879 Mlle Teresa Mazzarolli : "Avant le travail ; - jeune fille
 vénitienne" 2080
1879 Mme May Nieriker : "Négresse" 2246
1879 Mlle Ida Risler : "Petite fille d'Atina" 2557
1879 Mme Marie Cazin : "Femme romaine" 3313
1879 Mme Berthe Augustine-Aimée-Marie Desseaux : "Jeune
 Bretonne ; - pastel" 3491
1879 Mlle Florence Koechlin : "Italienne" 3895
1879 Mlle Henriette-Gabrielle Lesage : "Orientale ; - faïence"
 4052
1879 Mlle Giovanna Dubray : "Italienne ; - buste plâtre" 4985
1881 Mlle P. Chaville : "Jeune Espagnole" 449
1881 Mlle G. Dawis : "Dame flamande" 618
1882 Mme U. Colin-Libour : "Italienne et son enfant" 614
1883 Mlle M. Bashkirtseff : "Parisienne" 126
1884 UFPS Limosin d'Alheim : "Une Vénitienne" 157
1885 Mlle Geneviève Dupont-Binard : "Italienne ; - étude" 885
1886 Mlle Lucie Caffart : "Italienne ; - porcelaine" 2621
1886 Mlle Flore Bégouen : "Alsacienne ; - buste plâtre" 3492
1886 Mme Anna-Céline Nathan née Léon : "Jeune fille italienne ;
 buste plâtre" 4366
1887 Mme A. Boulian : "Une Bordelaise" 318
1887 Mme E-R Harrison : "Portrait d'une dame australienne" 179
1889 UFPS Mlle Marie Doineau : "Une Parisienne" 191
1889 UFPS Mme Mathilde Turquel : "Italienne" 624
1890 UFPS Mme Gabrielle Debillemont : "Cinq têtes d'étude"
 "Tunisienne" 203
1891 Mlle N. Feit : "Vieille Italienne" 605
1891 UFPS Mlle Louisa-Cécile Descamps-Sabouret : "Une Parisienne,
 pendant l'été de 1890. Dessin aux trois crayons" 227
1891 UFPS Mme Isabelle Cadilhon-Venat : "Une Béarnaise" 129
1891 UFPS Mlle Berthe Burgkan : "Femme corse ; pastel" 127
1891 UFPS Mme Henry Leroy : "Une Parisienne ; porcelaine" 485
1891 Mlle M. Porter : "L'Américaine" 1348
1893 Mme A. Biernacka : "Une Parisienne" 159
1893 Mme F. Carlyle : "Une dame hollandaise" 340
1893 Mme M-A Lucas-Robiquet : "Femme de Biskra" 1160
1894 Mme H. Le Roy D'Etiolles : "Tête de femme mérovingienne"
 1163
1894 Mme M. Guyon : "Une Parisienne" 897
1894 Mlle M. Porter : "Portrait d'une petite Anglaise" 1493
1896 Mme M. Guyon : "Parisiennes"992
1896 Miss K. Shaw : ".Jeune fille grecque" 3840
1896 SN Mlle Elisabeth Nourse : "Mère et fillette hollandaises"966
1897 SI Jeanne Piolat : "Tête parisienne" *909
1897 Mlle H-M Trévor : "Femme hollandaise" 1654
1898 Mlle L. Canuet : "Jeune Venitienne" 378
1898 Mme A. Nordgren : "La vieille Johanna - Suédoise" 1538
1898 Mlle M. Constantin : "Japonaise" 517
1898 Mlle M. Perrier : "Parisienne de Montmartre" 1607
1898 UFPS Mlle Manuelita Grimaud : "Miniatures"
 4. "Etude de Russe" 249
1899 Mme A. Oppenheim : "Mauresque" 1491
1900 Mlle H. Morisot : "Une Parisienne" 967
```

A5. The following are a selection :-
```
1872 Mme Alix de Laperelle-Poisson : "Jeune fille" 929
1874 Mme Adélaide Salles-Wagner : "La leçon de lecture" 1637
1876 Mlle Cécile-Berthe Lafosse : "La filleule" 1156
```

| 1877 | Mme Uranie Colin-Libour : "La leçon de lecture" 524 |
|------|------|
| 1877 | Mme Agathe Doutreleau d'Amsinck : "Un gros chagrin" "Petit frère a du bobo !..." 730 |
| 1877 | Mlle Angèle Dubos : "Heureux âge !" 748 |
| 1878 | Miss Eva Gonzalès : "Miss et bébé" 1046 (ill. in Claude Roger-Marx op.cit.) |
| 1878 | Mlle Sophie Unternahrer : "Petite fille tartare" 2167 |
| 1879 | Mme Joséphine-Claire-Edmond Langlois : "La leçon de lecture" 1758 |
| 1879 | Mlle Anna Nordgren : "La petite travailleuse" 2261 |
| 1879 | Mlle Ida Risler : "Petite fille d'Atina" 2557 |
| 1879 | Mlle Marie-Cécile Thorel : "La petite soeur de charité" 2846 |
| 1879 | Mlle Elise Voruz : "Le livre défendu" 2874 |
| 1881 | Mlle A. de Challié : "L'écolière" 418 |
| 1881 | Mme V. Demont-Breton : "Le pissenlit" 676 (ill.) |
| 1881 | Mme E. Roslin , née Blanche : "L'enfant malade" 2045 |
| 1881 | Mlle E. J. Gardner : "Loin du pays" 942 (ill.) |
| 1881 | Mlle M. Bianchi : "Enfant tenant un oiseau mort ; statue marbre" 3628 |
| 1882 | Mlle d'Anéthan : "L'Enfant Malade" 32 |
| 1882 | Mme V. Demont-Breton : "Le Premier Pas" 798 (reviewed in "L'Art" 1882 vol. 3 p 148) |
| 1882 | Mlle A. Sidwal : "La première leçon" 2465 |
| 1884 | Mlle E.J. Gardner : "La coupe improvisée" 1002 (ill.) |
| 1884 SI | Mme Doutreleau : "Petit a du bobo" 345 |
| 1884 UFPS | Mme Jeanne d'Entremont : "Jeune fille - étude" 92 |
| 1885 | Mme Mathilde Bianchi : "Petite fille ; - buste, terre cuite" 3369 |
| 1885 UFPS | Mme Charlotte- Gabrielle Besnard : "Un Enfant, statuette bronze" 4 |
| 1885 | Mlle Jeanne Landmann : "Jeunesse ; - gouache" 2944 |
| 1885 | Mme Marie de Knizi : "Jeunesse ; - tête, terre cuite" 3862 |
| 1886 | Mlle Margaret-Bernardine Hall : "Bébé" 1153 |
| 1886 | Mme Lydic-Adèle Laurent : "La leçon du tricot" 1382 |
| 1886 | Mme Marie Cazin : "Jeunes filles ; - groupe bronze" 3624 |
| 1887 | Mlle C. Beaux : "Les derniers jours de l'enfance" 154 |
| 1887 | Mlle G. Dupont-Binard : "Le choix de son coeur" 835 (ill.) |
| 1888 | Mlle Ellen K. Baker : "Un nourrisson" 112 |
| 1888 | Mme J. Delance-Feurgard : "La crèche" 762 (ill.) |
| 1888 | Mme U. Colin-Libour : "Charité ; - intérieur d'une crèche" 619 (Musée d'Angoulême) |
| 1888 | Mme F. Schneider : "Petite convalescente" 2259 (ill.) |
| 1888 | Mlle B. Hewit : "Les soeurs" 1291 |
| 1889 | Mme J. Delance-Feurgard : "La pouponnière" 768 (ill.) |
| 1889 | Mlle E-J Gardner : "Portrait de bébé" 1116 |
| 1889 | Mlle E-J Gardner : "Dans le bois" 1117 (ill.) |
| 1889 | Mlle E. Koch : "Petite soeur" 1458 |
| 1889 SI | Mme Marguerite Souley-Darqué : "La leçon de lecture" 251 |
| 1890 SN | Mlle L. Breslau : "La Petite Brodeuse" 139 |
| 1890 | Mme U. Colin-Libour : "Chez le nounou" 575 (ill.) |
| 1890 | Mme A-D Laurence : "La petite ménagère" 1389 |
| 1890 | Mlle V. Olsen : "Les camarades" 1812 |
| 1890 | Mlle J. Romani : "Jeunesse" 2076 |
| 1891 | Mlle A. Nordgren : "Quand on est jeune" 1243 |
| 1891 | Mlle E. Hart : "Les adieux aux vacances" 809 |
| 1892 | Mme M. Smith : "L'Enfant malade" 1548 |
| 1892 | Mlle E-J Gardner : "L'Escapade" 734 (ill.) |
| 1892 | Mme U. Colin-Libour : "En nourrice ; la manège" 429 (ill.) |
| 1893 | Mme M. Mascère : "Jeunesse" 1191 |
| 1893 | Mme E. Herland : "Encore un pas" 901 |

1893  Mlle L. Mercier : "Frère et soeur" 1238
1894  Mlle L. Mercier : "Petite écolière" 1290
1894  Mlle M. Porter : "Portrait d'une petite Anglaise" 1493
1894  Mlle L. Romani : "L'infante" 1577
1894  Mme M-J Cranney-Franceschi : "La petite soeur ; - groupe
      plâtre" 2963
1894  Mme E. Burkhardt : "Jeune curieuse" 327
1895  Mlle W.B. Newman : "En pénitence" 1430 (ill.)
1895  Mme M-G Duhem : "Enfants de choeur" 657
1895  Mme P Delacroix-Garnier : "Deux sourires" 548 (ill.)
1895  Mlle F. Charderon : "Le préféré" 410 (ill.)
1895  Mlle H. Richard : "Dernier soutien"  (ill.)
1895  Mlle E. Herland : "Premier aveu" 949 (ill.)
1895 SN L.C Breslau : "Jeune fille et enfants" 195
1896  Mlle F. Charderon : "Le Réveil" 436 (ill.)
1896  Mlle F. Charderon : "Le Sommeil" 435 (ill.)
1896 SI Lucie Conkling : "Jeune fille" *230
1896 SFA Mlle Madeleine Carpentier : "La grande soeur" 11
1896 SFA Mme Amélie Valentino : "La leçon de lecture" 101
1896 SN Mlle Elisabeth Nourse : "La leçon de lecture" 965
1897  Mme U. Colin-Libour : "La grande soeur" 406
1898  Mlle J. Rongier : "Jeunesse" 1748 (ill.)
1898  Mme V.E. Demont-Breton : "Dans l'eau bleue" 633 (ill.)
1898  Mme U. Colin-Libour : "Charité" 507 (ill.)
1898 SN Mme Ida Ericson-Molard : "Berceuse ; esquisse bronze, bas-
     relief" 54
1899  Mlle M. Besson : "La petite boudeuse" 183
1899  Mlle S. Pemberton : "Retour à l'école" 1524
1899  Mme V-S. H. Roos : "Une petite convalescente" 1697
1899  Mme L. Coutan-Montorgueil : "Enfant" 3355
1899  Mme A. Maeterlinck née Lefèvre : "Le sommeil de l'enfant"
      3697
1899  Mlle M. Perrier : "Le déjeuner à l'école primaire communale,
      cantine scolaire de la ville de Paris" 1542 (ill.)
1900  Mme H. Thompson , E.K Baker : "Jeune fille aux lys" 56
1900  Mme Cayton Vasselon : "Petite fille lisant" 269
1900  Mme C-A Dyonnet : "Portrait de jeune fille" 478
1900  Mlle V. Wesselitsky : "Sa dernière poupée" 1360
1900  Mlle C. Monginot : "Bébé" 2074 sculpture (ill.)
1900  Mme M. Thomas-Soyer : "Age innocent" sculpture 2154
1900  Mme V. Demont-Breton : "Premier audace , premier frisson"
      413 (ill.)
1900  Mlle M-A-M Delorme : "Avant le bain" 404 (ill.)

B5. 1877  Mme Joséphine Calamatta : "Chère grand'mère" 366
1878  Mme Henriette Browne : "Une grand'mère" 354
     (Illustrated in "L'Art" 1878 vol. 3 opposite p 136)
1880  Mlle Jeanne Burgain : "Vieille femme de Villerville réci-
     tant son chapelet" 550
1880  Emma Herland : "Grand'mère et petite fille" 1830
1884 UFPS Mlle Jeanne Sallet : "Le livre de grand'mère" 221
1885  Mlle Amanda Sidvall : "La fête de la grand'mère" 2253
1885  Mlle Marie-Laurence-Galbrund : "Portrait de vieille femme ;
     - pastel" 2957
1885 UFPS Mme Inès Debetz de Beaufond : "L'Aïeule et l'Orpheline" 18
1886  Mlle Jeanne Itasse : "Tête de vieille femme ; - buste
     bronze" 4076
1886 UFPS Mlle Marthe Breton : "Vieille femme disant son chapelet" 42
1887  Mme U. Colin-Libour : "L'aïeule" 574 (Musée de Sète)
1887  Mlle C. de Maupeou : "L'écheveau de grand'mère ; - étude"
     1634
1887  Mlle G-M-M Valade : "L'aïeule" 2344

```
1887 Mlle M. Fresnaye : "L'Aïeule ; groupe plâtre" 3985 (ill.)
1888 Mme M-A Lavieille (née Petit) : "L'aïeule et l'enfant" 1530
1890 Mlle M. Houghton : "Le soir de la vie" 1222
1890 Mllc E-J Gardner : "La réponse au petit-fils" 1007 (ill.)
1891 Mme J. Choppart-Mazeau : "Les soins de l'aïeule" 354
1891 Mlle N. Feit : "Vieille Italienne" 605
1891 Mlle L-A Laurent : "Visite à grand'mère" 963
1891 Mme M. Pillini : "Les noces d'or ; - Bretagne" 1325
1891 UFPS Mme Gabrielle Debillemont : "La grand'mère" 203
1891 UFPS Mlle Anna-Elisabeth Klumpke : "La Grand'mère ; pastel" 426
1892 Mlle Nanny Feit : "La vieille tricoteuse ; pastel" 1871
1892 SN Princesse Lwoff : "Grand'mère" 694
1893 Mlle L. De Hem : "Chez grand'mère ; - Flandre" 525
1895 Mme A. Gonyn de Lurieux : "Vieille femme faisant du
 tricot" 851
1895 Mlle W-B Newman : "En pénitence" 1430 (ill.)
1895 SN Esther-Stella Sutra née Isaacs : "Vieillesse" 1184
1896 Mme A. Jacob : "Le passé et l'avenir" 1060 (ill.)
1896 Mlle H. Putt : "La grand'mère" 1642 (ill.)
1896 Mlle M-L-C Wable : "Tête de vieille" 2020
1897 SN Mlle Ottilie-W Roederstein : "Les trois générations" 1070
1897 Mme M-M-E de Mazet : "Vieille femme lisant" 1160
1898 Mlle A-L de Coninck : "Les noces d'or" 584
1898 Mlle A. Delasalle : "La grand'mère ; portrait" 609
1899 Mlle H. Desportes : "La grand'mère ; intérieur" 637
1899 Mlle C. Fiérard : "L'étude chez grand'mère" 779
1899 Mlle J. Lelièvre : "L'aïeule" 1184
1900 Mlle H-E Amiard : "Tête de vieille" 26
1900 Mme M. Fournets-Vernaud : "La messe de l'aïeule" 536
1900 Mme A. Gonyn de Lurieux : "Les derniers jours" 590
1900 Mlle L. Ollivier : "Grand'mère" 1005
1900 Mlle M. Perrier : "L'aïeule" 1048 (ill.)
1900 Mlle M-M Wetmore : "Portrait de vieille femme" 1361

C5. 1881 Mlle C. Dubray : "Captive ; plâtre" 3835
 1882 Mlle L. Malézieux : "Jeune Martyre" 1750
 1882 Mlle M. Fresnaye : "Captive ; statue plâtre" 4394
 1891 Mlle S-B Dodson : "Une martyre" 522
 1891 UFPS Mlle Pierrette Gringoire : "Martyre" 354
 1897 Mme M-J Cranney-Franceschi : "Martyre" 2838
 1898 Mlle M. Smith : "Captive" 1869

D5. 1872 Mme Adélaide Walles-Wagner : "Pensierosa" 1376
 1873 Mme Jenny des Andigny : "Pensées" 12
 1874 Mlle Alix Duval : "Rêverie" 678
 1874 Mlle Cécile Ferrère : "Méditation" 714
 1874 Mme Jeanne Samson : "Rêverie" 1644
 1875 Mme Euphémie Muraton : "Un souvenir" 1530 (ill.)
 1875 Mlle Eugénie Salanson : "Rêverie" 1789
 1876 Mlle Adolphine Bonomé : "Pensées" 223
 1876 Mlle Joséphine Houssay : "Mélancolie" 1046
 1876 Mlle Béatrix Meyer : "Un doux rêve gâté" 1458
 1876 Mme Fina Nicolet : "La consolation ; - groupe plâtre" 3512
 1877 Mlle Lucie Delorme : "Premier chagrin" 667
 1877 Mme Lucile Doux : "Un jour d'ennui" 732
 1877 Mme Lydie-Adèle Laurent-Desrousseaux : "Inquiétude" 1236
 1877 Mlle Edwige Mary : "Un moment d'anxiété" 1432
 1878 Mlle Marie Dubreuil : "Espoir" 798
 1878 Mme Marie-Louise Pétros : "Le découragement" 1785
 1878 Mlle Eugénie Le Bouviez : "Regrets et souvenirs ; - groupe
 plâtre" 4387
 1879 Mlle Aline Boulian : "Seule !" 381
```

| | | |
|---|---|---|
| 1879 | | Mlle Louise Breslau : " Tout passe ! ..." 408 |
| 1879 | | Mme Uranie Colin-Libour : "La pensée" 700 |
| 1879 | | Mlle Noella Corneloup-du-Colombier : "La première peine" 737 |
| 1879 | | Mlle Lucie Delorme : "Rêverie" 917 |
| 1879 | | Mlle Marie Dubreuil : "Insouciance" 1070 |
| 1879 | | Mlle Victorine-Augustine Dujardin : "La rêverie" 1086 |
| 1879 | | Mlle Amelie Lacazette : "Douleur" 1716 |
| 1879 | | Mlle Pauline Laurens : "Rêverie" 1796 |
| 1879 | | Mlle Edwige Mary : "La foi et le désespoir" 2049 |
| 1879 | | Mlle Marie Petiet : "Rêverie" 2386 |
| 1879 | | Mlle Eugénie Salanson : "L'attente" 2679 |
| 1879 | | Mme Félicie Schneider : "Seule !" 2729 |
| 1879 | | Mlle Rosa Venneman : "L'attente" 2925 |
| 1879 | | Mme Berthe Colombel : "Mélancolie ; - éventail aquarelle" 3395 |
| 1879 | | Mlle Jeanne Guillot : "Le doute ; - aquarelle" 3779 |
| 1879 | | Mlle Alice-Marguerite Hardy : "La rêverie ; - porcelaine" 3802 |
| 1879 | | Mlle Eudoxie Poinsot : "Nostalgie ; - porcelaine" 4384 |
| 1879 | | Mlle Eugénie Lebouvier : "Le rêve ; - statue plâtre" 5159 |
| 1880 | | Mlle Harriet Backer : "Solitude" 126 |
| 1880 | | Mlle Ellen-K Baker : "Dolce far niente" 143 |
| 1880 | | Mme Marie Cazin : "Tristesse" 4338 |
| 1880 | | Mme Louise Collomb née Agassis : "L'attente" 842 |
| 1880 | | Mme Delphine de Cool (née Fontin) : "Première peine" 863 |
| 1880 | | Mme Alix-Louis Enault : "Peines de coeur" 1348 |
| 1880 | | Mme L. Héreau : "Souvenir" 1829 |
| 1880 | | Mlle Lucy Jaquet : "Dolorosa" 1946 |
| 1880 | | Mme Hermine Waternau : "Méditation" 3886 |
| 1881 | | Mlle J. Houssay : "Méditation" 1166 |
| 1881 | | Mlle E. Koch : "Un malheur" 1256 |
| 1881 | | Mlle E-J. Gardner : "Loin du pays" 942 (ill.) |
| 1881 | | Mme E. Bloch : "L'espérance ; statue, plâtre" 3635 |
| 1882 | | Mme M. Cazin : "Tristesse ; masque bronze" 4191 |
| 1883 | | Mme U. Colin-Libour : "L'abandonnée" 564 (Musée d'Amiens) |
| 1883 | | Mlle L. Krafft : "L'abandonnée" 1317 |
| 1883 | | Mme H-E Keyser : "Méditation" 1309 (ill.) |
| 1883 | | Mme Emma-Marie François : "Résignation ; camée agate" 4326 |
| 1884 | | Mme Marie Cazin : "Méditation" 2620 |
| 1884 | SI | Mme Denise Dupuis : "Rêverie" 197 |
| 1884 | UFPS | Mlle Elisabeth Keyser : "Méditation" 137 |
| 1885 | | Marie Cazin : "Le Regret ; statue bronze" 3450 |
| 1885 | | Mme Marguérite Herpin-Masseras : "Songeuse" 1262 |
| 1885 | | Mlle Amélie Lacazette : "Rêverie" 1403 |
| 1885 | | Mme la Princesse Terka Jablonowska : "Rêverie" 2911 |
| 1885 | UFPS | Mme Marie Baron Humbert : "L'Attente" 137 |
| 1885 | UFPS | Mme Aimable Beuscher : "Regret de la Patrie" 36 |
| 1885 | UFPS | Mme Martin-Sabson : "Méditation" 171 |
| 1885 | UFPS | Mlle Rose Vennemann : "Solitude" 260 (Musée d'Histoire Naturelle d'Auxerre) |
| 1886 | | Mlle Julia Brouilhony : "Seule !" 362 |
| 1886 | | Mme Uranie Colin-Libour : "Far-niente" 557 |
| 1886 | | Mlle Berthe Daudet : "Douce attente ; - étude du temps de Goya" 664 |
| 1886 | | Mlle Julie Feurgard : "L'attente" 923 |
| 1886 | | Mlle Madeleine Fleury : "Tristesse" 947 |
| 1886 | | Doris Hitz : "Pensive" 1200 |
| 1886 | | Mlle Louise Ollivier : "Méditation" 1775 |
| 1886 | | Mlle Laurence Krafft : " Rêverie ; - fusain" 2991 |
| 1886 | | Mme Charlotte-Gabrielle Besnard : "Tristesse ; - buste plâtre" 3512 |

| 1886 | | Mlle Fanny Crozier : "Misère ! - plâtre" 3736 |
|---|---|---|
| 1886 | | Mlle Edith-Gwyn Jeffreys : "Penserosa ; - buste plâtre" 4088 |
| 1886 | | Mlle Suzanne de Taillasson : "Rêverie ; - buste plâtre" 4570 |
| 1886 | | Mme Josepha-Aguiré de Vassilicos : "Résignation ; - buste, terre cuite" 4637 |
| 1886 | SI | Mme Ernesta Urban : "Souvenir" 381 |
| 1886 | UFPS | Mlle Berthe Delorme : "Rêverie" 106 |
| 1886 | UFPS | Mlle Montassier : "Mélancolie, dessin" 216 |
| 1887 | | Mme J. Buchet : "Rêverie" 384 |
| 1887 | | Mme M. Escolier-Mamon : "Souvenir" 874 (ill.) |
| 1887 | | Mme L-A Laurent : "A quoi pense-t-elle ?" 1420 |
| 1887 | | Mlle E. Loomis : "Préoccupation" 1538 |
| 1887 | | Mlle C. Richey : "Seules !" 2022 |
| 1887 | | Mlle M. Roosenboom : "Souvenir" 2069 |
| 1887 | | Mlle A. Casini : "Tristesse ; buste plâtre" 3744 |
| 1887 | | Mlle F. Franchini : "La Contemplation ; buste plâtre" 3979 |
| 1887 | UFPS | Mme Julia Buchet : "Rêverie" 51 |
| 1887 | UFPS | Mme la princesse Terka Jablonowska : "Un dessin ; rêverie" 161 |
| 1888 | | Mlle Ellen K. Baker : "Rêverie" 111 |
| 1888 | | Mlle M-N Flandrin : "Résignation" 994 |
| 1888 | | Mlle G de Pomaret : "Tristesse" 2050 |
| 1888 | | Mlle T. Schwartze : "Pensive" 2272 |
| 1889 | | Mme N. Lallemand : "Seule ! ; statue plâtre" 4569 |
| 1889 | SI | Mlle Henriette Authier : "La rêveuse" 15 |
| 1889 | UFPS | Mlle Jeanne Bonnefoi : "Clair souvenir d'une sombre époque" 72 |
| 1889 | UFPS | Mlle Jeanne Foulon : "Résignation" 257 |
| 1889 | UFPS | Mlle Dora Hitz : "L'attente" 304 |
| 1889 | UFPS | Mlle Marguerite Pillini : "L'Attente" 536 |
| 1889 | UFPS | Mlle Estelle Rey : "Réflexion" 560 |
| 1889 | UFPS | Mlle Marie Robiquet : "Insouciance" 562 |
| 1889 | UFPS | Mme Irène Darloy Savaton : "Consolation . Etude" 586 |
| 1889 | UFPS | Mlle Hélène Vernès : "L'Attente . Etude" 637 |
| 1890 | SN | Mme E. de Sparre : "Découragée" 832 |
| 1890 | | Mlle S. Bolling : "Rêverie" 260 |
| 1890 | | Mme A. de Challié : "Désespérance" 480 |
| 1890 | | Mlle L. Crapo-Smith : "Toute seule !" 635 |
| 1890 | | Mlle L. de Hem : "Vieux souvenir" 1190 |
| 1890 | | Mlle J. Houssay : "Distraite" 1223 |
| 1890 | | Mme E. Huillard : "Première déception" 1230 |
| 1890 | | Mlle L-A Landré : "Un doux souvenir" 1361 |
| 1890 | | Mme M-J Nicolas : "Vrai bonheur" 1784 |
| 1890 | | Mme A. Salles-Wagner : "Doux rêve" 2140 |
| 1890 | | Mlle M. Turner : "Prededitazione" 2324 (ill.) |
| 1890 | | Mme E. Bloch : "Le rêve ; buste plâtre" 3542 |
| 1890 | UFPS | Mme Gabrielle Debillemont : "Cinq têtes d'études" "Rêverie" 203 |
| 1890 | UFPS | Mme Esther Huillard : "Première deception" 374 |
| 1890 | UFPS | Mme Louise Marcotte : "Rêveuse" 512 |
| 1890 | UFPS | Mme Berthe Perrée : "Rêve rose" 598 |
| 1890 | UFPS | Mlle Jeanne Rongier : "Rêve rose" 627 |
| 1890 | UFPS | Mlle Alice Ronner : "Souvenirs" 628 |
| 1890 | UFPS | Mlle Marguerite Turner : "Seule !" 689 |
| 1890 | UFPS | Mlle Marguerite Turner : "Premeditazione" 690 |
| 1890 | UFPS | Mlle Marguerite Verroust : "Contemplation" 712 |
| 1890 | UFPS | Mlle Blanche Moria : "Rêverie ; statue plâtre" 13 |
| 1891 | | Mlle A. de Challié : "Résignation" 319 |
| 1891 | | Mlle A. Delasalle : "Attente" 470 (ill.) |
| 1891 | | Mlle J. Donnadieu : "Farniente" 523 |

1891   Mlle B. Jouvin : "L'abandonnée" 890
1891   Mlle A-E Klumpke : "Le rêve" 901
1891   Mme S. Bernhardt : "Souvenir ; - tête marbre" 2274
1891   Mme E. Bloch : "Le Rêve ; - buste, marbre" 2291
1891   Mlle L. Morin : "Rêverie ; - buste plâtre" 2773
1891 UFPS Mlle Anna-Elisabeth Klumpke : "De vieux souvenirs" 425
1891 SI  Mme Marguerite Souley-Darqué : "Songeuse" 1147
1891 SI  Mme Ernesta Urban : "Pensierosa" 1181
1891 UFPS Mlle Anna-Elisabeth Klumpke : "Seule ! ; pastel" 429
1891 UFPS Mme Léonie de Loghades : "Rêverie - pastel" 498
1891 UFPS Mlle Ida de Schulzenheim : "Attente" 711
1891 UFPS Mlle  Ida de Schulzenheim : "Les Abandonnés" 710
1891 UFPS Mlle Linah Morin : "Rêverie, buste plâtre" 24
1892   Mme Th. de Champ-Renaud : "Quiétude" 368
1892   Mme E-W Roberts : "Bienheureux ceux qui pleurent, parce
        qu'ils seront consolés" 1447
1892 SN Mlle M. Langlois-Carié : "Rêverie - tête de femme" 630
1893   Mlle M. Carpentier : "Rêverie" 344
1893   Mlle J. Donnadieu : "Quiétude" 600
1893   Mme M-J Muntz : "Chagrins" 1321
1893   Mme J-D Philippar-Quinet : "Nonchalance" 1408
1893   Mlle M. Porter : "Souvenirs" 1448
1893   Mme J. Ravier : "Rêverie" 1484 (ill.)
1893   Mme M-M  Réal Del Sarte : "Rêverie" 1485 (ill)
1893   Mlle I-E de Schulzenheim : "Attente" 1599
1893   Mlle E. Curtois : "Le songe d'une nuit d'été ; - statue,
        plâtre teinté" 2744
1893 SN Mme Winnaretta Singer : "Spleen" 972
1894   Mlle A. Delasalle : "Illusions perdues" 562
1894   Mme E. Macfarlane : "Pensée" 1220
1894   Mme A. Nordgren : "La délaissée" 1388
1894   Mlle J. Romani : "Pensierosa" 1576 (ill. in Witt Library)
1894   Mlle M. Turner : "Premier chagrin ; - panneau décoratif" 1765
1894   Mme F. Vallet : "Si je n'étais captive .." 1777
1894   Mme J. Marcel : "Rêveuse ; - buste plâtre" 3349
1894 SN Mme Marthe de Tavennier : " Résignation" 1106
1895   Mlle A. Préolot : "Lassitude" 1565
1895 SI  Mary  Camfrancq : "Solitude" 206
1895 SFA Mary Camfrancq : "Solitude" 9
1895 SFA L. Herman : "Méditation ; lithographie" 188
1895 SFA Iacounchikoff : "Quiétude" 195
1895 SN Katherine-Gilbert Abbot : "Anxiété" 2
1895 SN Hélène Buchmann : "Rêverie" 215
1896   Mme U. Colin-Libour : "Nonchalance" 489
1896   Mlle B-M Demanche : "L'heure heureuse" 621
1896   Mlle L. Le Roux : "L'heure de l'attente" 1243 (ill.)
1896   Mlle M. Brach : "L'attente" 3270
1896   Mlle M. de la Fizelière-Ritti : "Méditation" 3443
1896   Mlle J. Jozon : "La Douleur" 3550
1896   Mlle I. Matton : "Farniente" 3669
1896   Mme M. Syamour : "La méditation" 3853
1896 SI  Mme John-M Clark : "Rêve d'Automne" *211
1896 SI  Mme John-M. Clark : "Souffrance" *212
1896 SI  Mme M. Greuillet : "Rêverie" 491
1896 SFA Mme Jenny Villebesseyx : "Souvenir" 105
1896 SN Cecilia Beaux : "Rêverie" 81
1896 SN Alice Marie-Thérèse : "Lassitude" 482
1896 SN Ellen Starbuck : "En méditation" 1160
1896 SN Eugénie Macfarlane : "Souvenir ; pastel" 1515
1897   Mlle Z. Durruthy : "Encore seule !" 593 (ill.)
1897   Mlle J. Rainouard : "Rêverie" 1392

```
1897 Mlle M. Laniel : "Rêverie" 3098
1897 SI Elise-Désirée Firnhaber : "Mélancolie" *375
1897 SI Elise-Désirée Firnhaber : "Méditation" *377
1897 SI Elise-Desiree Firnhaber : "Doux souvenir" *378
1897 Mlle M-M-L Léglize : "Lassitude" 1001
1898 Mlle C. Berlin : "Dans le rêve" 162
1898 Mlle Z. Durruthy : "Consolation" 746
1898 Mlle C. Henriot : "Douloureuse" 1014
1898 Mme E-V Roos : "Doux rêves" 1751
1898 Miss A-M Shrimpton : "Rêves du passé" 1855 (ill.)
1898 Mlle H. Stoffregen : "Un souvenir ; - étude" 1894
1898 Mlle M. Fresnaye : "Farniente" 3419
1898 SN Olga Kornéa : "Rêverie ; pastel" 1637
1898 SN Mlle Laure-Louise Bandement : "Miniatures"
 1. "Rêverie" 1348
1898 SN Mlle Campbell Macpherson : "Rêverie" 804
1898 SN Elisabeth von Eicken : "Solitude" 453
1898 SN Mme Helena-Arsène Darmesteter : "Distraite" 366
1898 SN Mlle Kate Carl : "Moments de rêves" 236
1898 SI Mme Elisabeth-Désirée Firnhaber : "Douloureuse (étude)" *213
1898 SI Mme Elisabeth-Désirée Firnhaber : "Pensive (étude)" *214
1898 UFPS Mlle Zélie Durruthy : "Seule ! ! !" 195
1898 UFPS Mme Marie-Louise Grix : "Solitude" 252
1898 UFPS Mlle Gabrielle Hatin : "Souvenirs ; aquarelle" 267
1898 UFPS Mlle Marguerite Sibertin-Blanc : "Méditation ; pastel" 512
1898 UFPS Mlle Jeanne Tarride : "Mélancolie ; pastel" 525
1898 UFPS Mlle Malvina Brach : "L'Attente ; marbre" 3
1898 UFPS Mlle Julia Beck : "Solitude" 39
1898 SFA Mlle Léonie Dusseuil : "Recueillement" 40
1898 SFA Mlle Jenny Fontaine : "Rêverie" 55
1898 SFA Mme Sauvan Deluze : "Rêverie" 83
1899 Mlle H. Andrews : "Souvenir triste" 34
1899 Mme Pl Coeffier : "Souvenir" 476
1899 Mme U. Colin-Libour : "Souvenirs" 484 (ill.)
1899 Mme F. de Mertens : "Dolorita" 1391
1899 Mlle L. Reynolds : "Les souvenirs du passé" 1653
1899 Mme F. Vallet : "Rêveuse" 1928 (ill.)
1899 Mme M. de la Fizelière-Ritti : "Souvenir" 3455
1899 Mlle M. Gerson : "La mélancolie" 3517
1899 SN Mlle C. Macpherson : "Premiers rêves" 980 (ill.)
1899 SI Clara Kaselack : "Solitude" *88
1900 Mlle C. Fiérard : "Rêverie" 514
1900 Mlle E. Hart : "En exil" 642 (ill.)
1900 Mlle M. Jamin : "Dans le rêve" 697
1900 Mme C. Moutet-Cholé : "Méditation" 976
1900 Mlle A. Sédillot : "Mélancolie" 1202
1900 Mlle M.O. de Sota Y Calvo : "Angoisse" 1232
1900 Mme M. Syamour : "Méditation" 2149 sculpture
1900 Mme E. Gruyer-Brielman : "Prière pour l'absent"
 (illustrated but not listed in the catalogue)

E5. 1800 Mme Romance dite Romany : "Portrait de l'auteur avec ses
 deux enfants" 323
 1802 Mme Louise Kugler : "Portrait de l'Auteur" 145
 1802 Mlle Pantin : "Portrait de l'Auteur, miniature" 219
 1802 Harriet : "Portrait de l'auteur" 972
 1804 Mme Davin-Mirvault : "Portrait en pied de l'auteur" 115
 1804 Mme Nanine Vallain : "Portrait de l'auteur" 470
 1806 Mlle Auger : "Portrait en pied de l'auteur" 7
 1806 Mlle Charrin : "Portrait de l'auteur et celui de sa soeur"
 97
 1806 Mme Duméray (née Binant) : "Un cadre de miniatures, parmi
```

lesquelles est le portrait de l'auteur" 171

| | | |
|---|---|---|
| | 1806 | Mme Lucile Foullon : "Portrait de l'auteur" 205 |
| | 1806 | Mlle Garnier : "Portrait de l'auteur" 212 |
| | 1806 | Zoë de la Roche : "Portrait de l'auteur" 563 |
| | 1808 | Mlle Capet : "Tableau représentant feue Mme Vincent (élève de son mari)" 89 (+ see vol. 1 p.236a ) |
| | 1808 | Mlle Charlu : "Portrait de l'auteur" 109 |
| | 1808 | Mme Duméray (née Brinau) : "Portrait de l'Auteur" 195 |
| | 1808 | Mlle Eugénie Pichorel : "Portrait de l'auteur, miniature" 473 |
| | 1810 | Mme Bidou, née Libour : "Portrait de l'auteur" 90 |
| | 1810 | Mme De Romance (Adèle) : "Portrait en pied de l'auteur dans son atelier" 238 |
| | 1810 | Mlle Hue de Bréval : "Plusieurs miniatures, dont l'une est le portrait de l'auteur" 431 |
| | 1812 | Mlle Mauduit : "Portrait de l'auteur" 625 |
| | 1814 | Mlle Hue de Bréval : "Plusieurs portraits en miniature, parmi lesquels est celui de l'auteur" 531 |
| | 1814 | Mlle Revest : "Portrait en pied de l'auteur" 783 |
| | 1817 | Mme Berger (née Désoras) : "Portrait en pied de l'Auteur et de son époux" 1039 |
| | 1822 | Mme Drouot : "Portrait de l'auteur, grande aquarelle" 378 |
| | 1822 | Mme Sem : "Portrait de l'auteur" 1185 |
| | 1827 | Mlles Dufour : "Portraits des auteurs" 354 |
| | 1827 | Mlle de Garancière : "Portrait de l'auteur" 424 |
| | 1827 | Mme Haudebourt-Lescot : "Portrait de l'auteur" (In a review of a number of "Portraits" exhibited as no. 547 at the Salon of 1827, A. Jal mentions a self-portrait which may have been the self-portrait, signed and dated 1825, now in the Louvre. See A. Jal (Esquisses, croquis, pochades ou tout ce qu'on voudra sur le salon de 1827" Paris 1828 pp 290-1, 335) |
| F5. | 1804 | Mlle Thibault : "Portrait de Mme Giacomelli" 461 |
| | 1806 | Mme Chaudet : "Portrait de Mme Augustin" 102 |
| | 1808 | Mlle Capet : "Tableau représentant feue Mme Vincent (élève de son mari)" 89 (+ see vol. 1 p236a) |
| | 1812 | Mlle Bertault : "Portrait de Mad. Auger" 61 |
| | 1819 | Mme Charpentier : "Portrait de Mlle G ***, peintre" 213 |
| | 1822 | Mlle Boucharlat : "Portrait de Mme Pigault-Lebrun" 142 |
| G5. | 1800 | Mme Auzou (née Desmarquest) : "Le portrait en pied du C. Régnault" 9 |
| | 1800 | Mlle Gabrielle Capet : "Portrait du C. Houdon, sculpteur, membre de l'Institut national, travaillant un bronze de Voltaire ; miniature" 67 (Lefebvre de Sancy Collection) |
| | 1801 | Mme Gabrielle Capet : "Portrait du citoyen Houdon, sculpteur, membre de l'Institut, travaillant au buste de Voltaire ; miniature" 50 (presumably the same as the preceding) |
| | 1801 | Mme Davin-Mirvault : "Portrait du Cit. Suvée, directeur de l'Ecole Française des Beaux-Arts, à Rome" 77 |
| | 1802 | Mlle Capet (Marie-Gabrielle) : "Portrait du cit. Pallière, peintre ; pastel" 44 |
| | 1804 | Mlle Gabrielle Capet : "M.R..., architecte ; pastel" 82 |
| | 1812 | Mlle Julie Charpentier : "Buste du père de l'auteur, inventeur de la gravure imitant le lavis" 1032 |
| | 1817 | Mlle Julie Charpentier : "Gérard Audran, célèbre graveur" (buste en marbre, commandé par S.E. le ministre de l'Intérieur) 803 |

| | | |
|---|---|---|
| | 1819 | Mlle Alexandrine Delaval : "Portrait de feu Piggiani, fondeur de la statue équestre de Henri IV" 309 |
| | 1819 | Mlle Julie Philipaut : "Portrait de M. M***, peintre" 896 |
| | 1819 | Mlle Julie Charpentier : "Buste en marbre de M. Vien, célèbre peintre français" (M.I.) 1230 |
| | 1822 | Mme Augustin : "Portrait de M. Abel de Pujol, peintre d' histoire" 33 |
| | 1822 | Mme Augustin : "Portrait de M. Blondel, peintre d'histoire" 35 |
| | 1822 | Mlle Inès d'Esménard : "Portrait de M. Redouté, grande miniature" 467 (a work with the same title was exhibited by the artist in 1824, no. 633) |
| | 1822 | Mme Hersent : "Portrait de M. le Cher M***, entouré de quelques-uns de ses élèves" 694 |
| H5. | 1800 | Mlle Isabelle Pinson : "Une jeune personne dans son atelier, regardant dans son porte-feuille" 309 |
| | 1801 | Mlle Henriette Lorimier : "Portrait en pied d'une jeune artiste" 234 |
| | 1804 | Mlle Pantin : "Portrait d'une dame artiste" 919 |
| | 1812 | Madame Desperiers : "Une jeune personne s'occupant de l' étude des Beaux-Arts" 307 (The artist exhibited a work with the same title in 1814, no. 312) |
| | 1819 | Mme Duméray : "Portrait d'une jeune artiste" 387 (The artist exhibited a work with the same title in 1824, no. 574) |
| | 1822 | Mme Davin-Mirvault : "Une jeune élève de M. Frédéric Massimino" 289 |
| | 1830 | Mlle Coraly Bonal : "Une jeune femme dans son atelier" 21 |
| I5. | 1802 | Mme Charpentier : "Deux jeunes filles dans un paysage dont une dessinant" 960 |
| | 1806 | Mme Chardon : "Une femme dessinant un paysage d'après nature" 93 |
| | 1814 | Mme Charpentier : "Une jeune personne dessinant le paysage" 199 |
| J5. | 1802 | Mlle Bounieu : "Une femme occupée à peindre, miniature" 35 |
| | 1802 | Mlle Bouder : "Portrait d'une jeune fille occupée à peindre" 957 |
| | 1804 | Mme Pinson : "Une femme à son chevalet, avec une petite fille près d'elle" 370 |
| K5. | 1806 | Mme Pinson : "Une jeune fille dessinant" 423 |
| | 1810 | Mlle Rivière : "Portrait de femme dessinant" 691 |
| L5. | 1812 | Mlle Pantin : "Une jeune personne faisant son portrait" 700 |
| M5. | 1853 | Mme Brune née Pagès : "Jeune femme peignant" 192 |
| | 1859 | Mme Herbelin : "Six miniatures" including "Jeune fille dessinant ; étude" 1457 |
| N5. | 1831 | Mlle A. Cogniet : "Intérieur d'atelier" 361 |
| | 1834 | Mlle Le Grand de St. Aubin : "Intérieur d'atelier" 1213 |
| | 1836 | Mlle Caroline Thévenin : "Un atelier" 1727 (The same artist also exhibited "Le prix de Rome" in 1840 no. 1547) |
| | 1845 | Mlle Célestine Faucon : "Intérieur d'atelier" 571 |

| 1850 | Mme Caroline Fath (née Berger) : "Intérieur de peintre" 1044 |
| 1852 | Mme Adèle Dehaussy : "Le repos du modèle, intérieur d'atelier" 321 |
| 1857 | Mme Adèle Dehaussy : "La première séance du portrait ; intérieur d'atelier" 709 |

O5. 1831    Mlle V. Comte : "Un cadre contenant un camée représentant ..... , le portrait de l'auteur etc. ; peints sur porcelaine" 394

| 1831 | Mme Ve Dumeray : "Portrait de l'auteur ; aquarelle" 667 |
| 1833 | Mlle Inès d'Esménard : "Portrait de l'auteur" 861 |
| 1833 | Mme Rang : "Portrait de l'auteur" 1963 |
| 1838 | Mlle Elisa Besuchet : "Portrait de l'auteur" 110 |
| 1839 | Mme Félicité Beaudin : "Portrait de l'auteur" 102 |
| 1840 | Mme Herbelin : "Dix portraits et études ; miniatures" 3. "Portrait de l'auteur" 830 |
| 1841 | Mme Céleste Pensotti : "Portrait de l'auteur" 1552 |
| 1841 | Mlle Ernestine Hardy de Saint-Yon : "Portrait de l'auteur" 1773 |
| 1842 | Mlle Clémence Dimier : "Portrait de l'auteur" 567 |
| 1844 | Mlle Armide Lepeut : "Portrait de l'auteur" 1173 |
| 1845 | Mlle Armande Tappes : "Portrait de l'auteur" 1563 |
| 1845 | Mlle Stéphanie Goblin : "Trois miniatures" 2. "Portrait de l'auteur" 1841 |
| 1846 | Mme Sommé : "Portrait de l'auteur" 1645 |
| 1847 | Mlle Mathilde Loyer : "Portrait de l'auteur ; pastel" 1871 |
| 1848 | Mlle Augustine-Alexandrine-Louise Despreaux : "Portrait de l'auteur; pastel" 1255 |
| 1848 | Mlle Léonie Lescuyer : "Trois miniatures ; même numéro" 1. "Portrait de l'auteur" 2955 |
| 1848 | Mme Florence Duthoit : "Portrait de l'auteur - statuette en plâtre" 4736 |
| 1849 | Mme Eugène-Buboys Désaugier : "Portrait de l'auteur ; pastel" 540 |
| 1849 | Mme Léopold Schlezel : "Portrait de l'auteur" 1823 |
| 1850 | Henriette-Perrard Lebrun : "Portrait de l'auteur" 1873 |
| 1850 | Mlle Marie Pottier : "Portrait de l'auteur" 2522 |
| 1852 | Mme Frédérique-Auguste O'Connell : "Portrait de l'artiste" 974 |
| 1855 | Mme O'Connell (née Frédérique-Auguste Miéthe) : "Portrait de l'artiste" 3737 |
| 1855 | Mlle Mathilde Edith de Penuela : "Portrait de l'auteur" 617 |
| 1855 | Mme Archinard (née Fanny-Marguerite Rouvier) : "Portrait de l'auteur et de son fils ; pastel" 2024 |
| 1857 | Mme Bédie (née Pierrette Favre) : "Miniatures" 1. "Portrait de l'auteur" 144 |
| 1857 | Mlle Henriquetta Girouard : "Portrait de l'auteur" 1200 |
| 1859 | Mme Emma Gaggiotti-Richards : "Portrait de l'auteur" 1179 |
| 1859 | Mlle Eugénie Morin : "Portrait de l'auteur ; miniature" 2209 |

P5. 1843    Mme Félicie Beaudin : "Portrait de Mlle Félicie de Fauveau" 57
         (A review in "L'Artiste" (1843 vol. 3 p 275) stated that this work was done in her studio in Florence. The artist was portrayed in 15th century clothes)

| 1843 | Mme Irma Martin : "Portrait de Mme Rimbaut-Borel" 847 |
| 1844 | Mlle Amélie Fleury : "Portrait de Mlle Félicie F.." 691 (possibly Félicie de Fauveau) |
| 1850 | Mlle Sidonie Berthon : "Quatre miniatures" including a "Portrait de Mme de Mirbel, peint de souvenir" 202 |
| 1857 | Mme Herbelin née Jeanne-Mathilde Habert : "Huit miniatures" |

1. "Portrait de Mlle Rosa Bonheur" 1339

Q5. 1833     Mlle Duprat : "Cadre de miniatures"
             3. "Portrait de M.S...., peintre" 786

1833     Mlle Tarault : "Portrait de M.H. sculpteur en ivoire" 3208
1834     Mme Bonvoisin : "Portrait de M.B. peintre" 170
1834     Mme Bruyère : "Portrait de M.B.... ; peintre de
             fleurs" 238
1843     Mlle Clémentine Martin Buchère : "Hommage à Redouté ;
             aquarelle" 1314
1844     Mme E. Duboys Désaugiers : "Portrait de M... , artiste" 530
1844     Mme Edouard Dubufe : "Buste de M. Paul Delaroche ; marbre"
             2206
1850     Léonie Lescuyer : "Trois miniatures"
             2. "Portrait de M. Victor Huguenin, statuaire" 2006
1853     Mme Herbelin::"Trois miniatures" including
             "Portrait de M. Isabey père" 601
1855     Mlle Louisa Durand : "Portrait de M. Constantin, peintre
             en émail" 2051
1857     Mme Herbelin née Jeanne-Mathilde Habert : "Huit miniatures"
             8. "Portrait de M. Eugène Delacroix" 1339
1857     Mme la baronne de Lagatinerie née Eugénie Gallain : "Port-
             rait de M. Viollet-le-Duc, pastel" 1518
1857     Mme Noémi Constant : "Portrait de M. Lefuel, membre de
             l'Institut, architecte de l'Empereur ; buste
             marbre" 2800
1857     Mme Noémi Constant : "Pierre Gavarni ; tête d'étude, terre
             cuite" 2801

R5. 1863       Mlle Marguerite-Zéolide Lecran : "Intérieur d'atelier" 1137
1863       Mme Perrine Viger-Duvignau : "Intérieur d'atelier" 1853
1863 SR    Emma Chausset : "Atelier de M. Gudin " 74
             (A work with the same title was exhibited by the
             artist in 1864, no. 372)
1866       Mme Vernhes née Elise Dausse : "Coin d'atelier ; étude"
             1902
1867       Mme Armand Leleux (née Giraud) : "Le portrait - miniature;
             (intérieur d'atelier)" 937
             (A work with the same title was exhibited by the
             artist in 1869 no. 1472)
1868       Mme Bertha Formstecher : "Intérieur d'atelier" 998
1869       Mme Pauline Wissant : "Un coin d'atelier" 2430
1872       Mlle Pauline-Elise-Léonide Bourges : "Intérieur d'atelier"
             196
1877       Mme Annie Ayrton : "Un coin 'de mon atelier'" 77
1877       Mlle Louise Daniel : "Dans l'atelier" 603
1878       Mme Marie Deveulle : "Un coin d'atelier" 751
1879       Mlle Louise Eudes de Guimard : "Intérieur d'atelier" 1175
1880       Mlle Jane Conin : "Un coin d'atelier" 859
1880       Mlle Germaine Dawis : "Avant la séance" 1012
1880       Mme Amélie Deschamps : "Un coin d'atelier" 1129
1882       Mme F. Fleury : "Dans l'atelier" 1047
1884       Mlle A-L Malbet : "Un coin d'atelier" 1608
1884       Mme Laurentine Aridas : "Un coin de mon atelier" 3506
1886       Mlle Anna Petersen : "Le coin de l'atelier" 1847
1886 SI    Mme Béatrice Berriat-Blanc : "Atelier et Plein Air" *36
1886 UFPS Mme Delphine de Cool : "Un coin d'atelier, aquarelle" 89
1886 UFPS Mme Gabrielle Lacroix : "Un atelier, aquarelle" 166
1887       Mlle H. Bouwens Van der Boyen : "Dans l'atelier" 333
1887 UFPS Mlle Mélanie Collet : "Un coin d'atelier", étude d'

```
 aquarelle" 83
1888 Mlle Z. Akhotchinska : "Un coin d'atelier" 18
1888 Mlle B. Art : " Atelier de moulage" 55
1888 Mlle C-L-B Berlin : "Dans mon atelier" 200
1888 Mlle L. Ehrmann : "Dans l'atelier" 938
1888 Mlle A. Gros : "Intérieur d'atelier" 1205
1888 SI Mme Béatrice Berria-Blanc : "Attendant le modèle" 80
1889 Mlle A. d'Anéthan : "Atelier de Couture" 35
1889 Mlle L. Attinger : "Mon atelier" 59
1889 Mme A. Gless : "Un coin d'atelier" 1182
1889 Mlle S. de Nathusius : "Toilette de l'atelier" 1989
1889 Mlle J. Pharaon : "Coin d'atelier" 2133
1889 Mlle Marie Moreau : "Un coin d'atelier, fusain" 3615
1889 UFPS Mlle Christine Bourgeois : "Un coin d'atelier" 76
1890 Mlle M. Carpentier : "Avant la séance" 452
1890 Mlle D. Furuhjelm : "Atelier Blanc-Garin ; à Bruxelles" 977
1890 UFPS Mme T. Maillard : "Coin d'atelier" 489
1890 UFPS Mme Frédérique Vallet : "Dans l'atelier, pochade ; pastel"
 702
1891 UFPS Mlle Zdenka Braunerovna : "Intérieur d'atelier" 94
1891 UFPS Mlle Marguerite Espénan : "Dans l'atelier" 280
1891 UFPS Mlle Joséphine Houssay : "Un atelier de peinture" 391
1892 Mlle M-L Bion : "Mon atelier" 169
1892 SI Mlle Henriette Authier : "Un coin d'atelier (le jour du
 modèle vivant)" *56
1892 SI Mlle Fanny Bertie : "Five o'clock dans l'atelier" 118
1893 Mme A. Mac-Ritchie : "Dans l'atelier" 1176
1893 Mlle J. Taconet : "Un accident à l'atelier" 1664
1894 Mme J. Diffre : "Intérieur d'atelier" 627
1895 Mlle M-A-R Delorme : "Un coin d'atelier" 563
1895 Mlle M-A-R Delorme : "Studio" 564
1895 Mme J. Diffre : "A l'atelier" 623
1895 SFA Emma de Sparre : "Un coin de mon atelier" 82
1896 SFA Mlle Madeleine Carpentier : "A l'Atelier" 13
1897 SN Mlle Weiss : "Intérieur d'atelier" 1776
1898 SFA Mlle Léonide Bourges : "L'atelier du graveur Paul Rajon" 170
1898 UFPS Mlle Antoinette Chavagnat : "Un coin d'atelier" 115
1898 SFA Mme Madeleine Foyot-D'Alvar : "Coin d'atelier" 58
1898 UFPS Mme Adèle Dehaussy : "Intérieur d'atelier" 155
1900 Mlle Marthe Voulquin : "Un coin d'atelier" 1334

S5. 1878 Mme Armand-Emilie Leleux (née Giraud) : "La leçon de
 dessin" 1392
 1884 Mlle Emma-Marie Formigé : "La leçon de dessin" 2783
 1884 UFPS Houssay : "La petite classe de dessin" 125
 1891 Mlle M. Price : "Un cours de dessin" 1360

T5. 1870 Mlle Marie de Cambray : "Jeune fille dans un atelier" 456
 1880 Mme Marie Mathieu : "Une artiste en 1796" 2539
 1881 Louise Breslau : "Le Portrait des Amis" 289 (ill.)
 1884 Mlle J. Houssay : "Chercheuse d'images" 1234
 (Impossible to be certain what this depicted, but as
 Houssay was fond of portraying artists - see
 R5 1891 and S5 1884 for instance - the work may be
 tentatively included in this section)
 1885 Mme Emma-Lowstadt Chadwick : "La Graveuse" 503
 1885 Mme Thérèse Pomey : "Jeune fille peignant ; - portrait" 2017
 1885 Mlle Jeanne Rongier : "Une aquarelliste" 2122
 1890 Mme B. Mackay : "Jeune fille peignant à l'aquarelle" 1562
 1891 SN Mlle J. Marest : "Jeune femme dessinant" 633 (ill.)
 1893 Mme F. Vallet : "L'artiste" 1735 (ill.)
 1894 Mlle Chalus : "A l'atelier" 402 (ill.)
```

1894 SN   Mlle Jeanne Baudouin : "Une future artiste" 1232
1895      Mme C. Chalus : "Un début" 401 (ill.)
1895      Mlle A. Bertrand : "Dans l'atelier" 2022 (ill.) (one of
              six miniatures)
1897      Mlle M. Turner : "Portrait" 1671 (ill.)
1897 SN   Laetitia de Witzleben : "Portrait d'une artiste" 1784
1898 UFPS Mlle Léonide Bourges : "Une de mes élèves" 62 bis
1899      Mlle M. Térouanne : "Portrait" 1877 (ill.)
1900      Mlle Caroline Thurber : "L'amateur" 1283 (ill.)
1900      Mlle A-M Shrimpton : "Artiste" (illustrated but not listed
              in the catalogue)

U5. 1864  Mlle Marie Chosson : "Le premier portrait" 392
    1864  Mme A-Uranie Colin-Libour : "L'amateur" 419
    1864  Mme Laure-Marie Gozzoli : "Le dessin" 848
    1869  Mlle Anna Formstecher : "Une recréation artistique" 954
    1875  Mlle Clémentine Tompkins : "Un début artistique" 1892
    1877  Mme Julie Cavaille née Massenet : "Le premier portrait'
              415
    1878  M. Ellen Staples : "The finishing touch ; dessin à la
              plume" 3858
    1880  Mme Félicie-Hélène Colin : "Les paysagistes au Bas-Meudon"
              828
    1880  Camille Deschamps : "Jeune artiste" 1133
    1880  Mlle Jeanne Montion : " Chez l'artiste ; - aquarelle" 5432
    1885  Mlle Jeanne Rongier : "Une séance de portrait, en 1806" 2121
    1887  Mme S. Deshayes : "Genre" 756
    1888  Mlle A D'Anéthan : "Les aquarelles" 32
    1890  Mlle T-C Jacquet : "Artiste !" 1254
    1890 UFPS Mlle Herminie Tribou : "La première palette" 684
    1895  Mme C. Moutet-Cholé : "Chez l'artiste" 1408 (ill.)
    1896 SI  Mme Amedée Guérard : "Peintre.Paysagiste en voyage" 500
    1897 SI  Mme Berria-Blanc : "En peignant" *86
    1897 SI  Mme Berria-Blanc : "Aquarelliste" *90
    1897 SI  Mme Berria-Blanc : "Un pastel"*93
    1898 UFPS Mlle Marguerite Turner : "La Statuette ; pastel" 538

V5. 1876  Mme Anaïs Beauvais née Lejault : "Le repos du modèle" 113
    1885  Mme Fanny Fleury : "Le repos du modèle" 988
    1885  Mlle Thérèse Paraf-Javal : "Le modèle" 1906
    1889  Mlle M. Turner : "Cherchant la pose" 2593 (ill.)
    1890  Mlle L-A Landré : "Le repos du modèle" 1360
    1890 SN  Mme Marie Marshall : "Le modèle au repos ; pastel" 1103
    1891  Mlle J. Houssay : "Le modèle" 836
    1891 UFPS Mlle Jeanne Foulon : "Le Repos du modèle" 313
    1894  Mme U. Colin-Libour : "Le repos du modèle" 461
    1895  Mme F. Vallet : "Cherchant la pose" 1859 (ill.)
    1897  Mme A. Beauvais-Landelle : "Le repos du modèle" 106
    1897  Mlle M-M-L Léglize : "Le repos du modèle" 1002
    1897 SN  Mme Fanny Fleury : "Le modèle ; pastel" 1421

W5. 1861  Mme Lehaut (Mathilde Bonnel de Longchamps) : "Trois
              miniatures" including a
              "Portrait de l'auteur" 1901
    1861  Mme Aglae-Apollinie Sabatier : "Miniatures" including a
              "Portrait de l'auteur" 2765
    1861  Mlle Octavie Fleury : "Six miniatures" including a
              "Portrait de l'auteur" 1135
    1863  Mme Dentigny (née Henriette Nolet) : "Portrait de l'auteur"
              558
    1863  Mme Eléonore Escallier : "Portrait de l'auteur" 652
    1863  Mme Giard née Claire Couverchel : "Portrait de l'auteur" 780

1863        Mlle Elisa Koch : "Portrait de l'auteur" 1035

1863        Mlle Adèle Crauk : "Portrait de l'auteur ; pastel" 2019

1863 SR   Mlle Elisabeth Voiart : "Portrait de l'auteur" 588

1864        Mlle Mathilde Aita de la Penuela : "Portrait de l'auteur"
              18

1865        Mme Juliette Jobard : "Portrait de l'auteur" 1121

1869        Mme Laure Riu : "Portrait de l'auteur ; médaillon bronze"
              3668

1870        Mlle Rose Lafuge : "Portrait de l'auteur" 1542

1870        Mlle Marie-Charlotte Julien : "Portrait de l'auteur ;
              dessin" 3621

1870        Mlle Marie-Ernestine-Rosa Ponsard : "Portrait de l'auteur ;
              pastel" 3960

1872        Mlle Marie Gouget : "Portrait de l'auteur ; - dessin" 732

1873        Mlle Alexandrine Kuniska : "Portrait de l'auteur" 823

1874        Mme Eugénie Parmentier : "Portrait de l'auteur ; - minia-
              ture" 2453 (Luxembourg, Paris)

1874        Mme Eugénie Sieffert : "Portrait de l'auteur ; - porce-
              laine" 2564

1875        Mlle Elisa Koch : "Portrait de l'auteur" 1158

1876        Mme Claire Mallon née Masson : "Portrait de l'auteur" 1391

1876        Mlle Victorine Meurent : "Portrait de l'auteur" 1457

1876        Mlle Rose-Marie de Vomane : "Portrait de l'auteur" 2047

1876        Mlle Eugénie-Caroline Desenclos : "Portrait de l'auteur ; -
              miniature" 2351

1877        Mlle Louise Abbéma : "Le déjeuner dans la serre" 1
              ("La jeune artiste s'est représentée sur cette toile
              entourée de son père, de sa mère et de quelques amis.
              Toutes les personnages sont réunis dans une serre
              décorée de plantes grasses" ("L'Art" 1877 vol. 1 p
              264))

1877        Mlle Marie-Aurore Arnal : "Portrait de l'auteur ; - porce-
              laine" 2226

1877        Mme Adèle Dehaussy : "Portrait de l'auteur" 2567

1877        Mme Adrienne Peytel née Louchet : "Portrait de l'auteur"
              3279

1878        Mlle Marie-Gabrielle Bouilh : "Portrait de l'auteur ; -
              porcelaine" 2493

1878        Mlle Jeanne Bonaparte : "Portrait de l'auteur ; - médaillon
              plâtre" 4063

1879        Mlle Gabrielle de Bessey : "Portrait de l'auteur" 265

1879        Mlle Nelly Carre : "Portrait de l'auteur ; - étude ; -
              émaux" 3304

1880        Mlle Céline Favre : "Portrait de l'auteur ; pastel" 4693

1880        Mlle Adélie-Marie Kermabon : "Portrait de l'auteur ;
              miniature" 5037

1882        Mlle Marguerite Bouteilloux : "Portrait de l'auteur -
              porcelaine" 2892

1882        Mlle Marie Félissis-Rollin : "Portrait de l'auteur" 3175

1882        Mlle Elise Joly : "Portrait de l'auteur" 3374

1883        Mlle L. Eudes de Guimard : "Portrait de l'auteur" 902

1883        Mme C. Nadal : "Portrait de l'auteur" 1785

1883        Mlle M-W Ridley : "Portrait de l'auteur" 2052

1883        Mme Matyld Aubry : "Portrait de l'auteur, porcelaine" 2499

1883        Mlle Marguérite Ferret : "Portrait de l'auteur" 2788

1883        Claude Vignon : "Portrait de l'artiste ; buste en marbre"
              4298 (Petit Palais, Paris)

1884 UFPS Mme Louise Goussaincourt : "Portrait de l'auteur ;
              médaillon plâtre" 274

1885        feue Mlle Marie Bashkirtseff : "Portrait de l'auteur" 151
              (Luxembourg, Paris)

(This work was acclaimed as "vraiment remarquable par une fermeté d'exécution qu'on ne peut guère en général attendre d'une femme" in "L'Art" 1885 vol. 1 p 214)

| | |
|---|---|
| 1885 | Mme Maria Brunel : "Portrait de l'auteur ; - médaillon bronze" 3407 |
| 1885 | Mlle Augustine-Hélène Dehaussy : "Portrait de l'auteur" 2600 |
| 1887 | Mlle A. Bilinska : "Portrait de l'auteur" 234 (ill.) |
| 1887 | Mlle Amélie Beaury-Saurel : "Portrait de l'auteur" 2585 (Illustrated in "L'Art" 1887 no. 43 p 10) |
| 1887 | Mlle B. Fabrizj : "Portrait de l'auteur" 883 |
| 1888 | Mlle A. Lacazette : "Portrait de l'auteur" 1443 |
| 1888 | Mlle T. Schwartze : "Mlle Thérèse Schwartze faisant son portrait" 2271 |
| 1888 SI | Mme Marie-Amélie Bénard : "Portrait de l'Auteur" 64 |
| 1889 | Mlle H. Foss : "Portrait de l'auteur" 1054 |
| 1889 | Mlle M. Guyon : "Portrait de l'auteur" 1276 (ill.) |
| 1889 | Mlle A. de Lagercrantz : "Portrait de l'auteur" 1494 (ill.) |
| 1889 | Mlle M. Naylor : "Portrait de l'auteur" 1993 |
| 1889 | Mme J. Rudhardt : "Portrait de l'auteur" 2371 |
| 1889 | Mlle L. Thornam : "Portrait de l'auteur" 2557 |
| 1889 | Mme L. Davray : "Portrait de l'auteur ; buste, terre cuite" 4264 |
| 1889 | Mme Fanny Briès : "Portrait de l'auteur ; aquarelle" 2916 |
| 1889 | Mlle Fanny Fritsch : "Portrait de l'auteur" 3217 |
| 1889 | Mlle Jeanne Philippar : "Portrait de l'auteur ; fusain" 3694 |
| 1889 UFPS | Mlle Amélie Beaury-Saurel : "Portrait de l'Auteur ; fusain" 44 |
| 1889 UFPS | Mme Esther Huillard : "Portrait de l'Auteur" 313 |
| 1889 UFPS | Mlle Lucie Lee-Robbins : "Portrait de l'Auteur" 396 |
| 1889 UFPS | Mme Joséphine Walbecq : "Portrait de l'Auteur" 649 |
| 1890 SN | Louise Breslau : "Portrait de l'auteur" 963 |
| 1890 | Mlle B. Berthoud : "Portrait de l'auteur" 195 |
| 1890 | Mlle K. Carl : "Portrait de l'auteur" 446 |
| 1890 | Mlle M. Fairchild : "Portrait de l'auteur" 886 |
| 1890 | Mlle H. Ford : "Portrait de l'auteur" 937 |
| 1890 | Mme A. Debriège : "Portrait de l'auteur ; - buste, plâtre" 3752 |
| 1890 UFPS | Mme Baubry-Vaillant : "Portrait de l'auteur ; pastel" 41 |
| 1890 UFPS | Mme Alexandrine de Lamansky : "Portrait de l'auteur ; porcelaine" 421 |
| 1890 UFPS | Mme Henriette de Teheran : "Mon Portrait ; pastel" 669 |
| 1890 UFPS | Mlle Joséphine Thier : "Portrait de l'auteur" 674 |
| 1890 UFPS | Mlle Tolla Gertowicz : "Portrait de l'auteur ; buste, plâtre bronze" 6 |
| 1891 | Mlle E. Desjeux : "Portrait de l'auteur" 498 |
| 1891 SI | Henriette Authier : "Mon portrait" 39 |
| 1891 UFPS | Mlle Joséphine-Marie Arnaud : "Mon Portrait" 10 |
| 1891 UFPS | Mlle Louisa-Cécile Descamps-Sabouret : "Mon Portrait ; pastel" 226 |
| 1891 UFPS | Mlle Reine Launay : "Mon portrait" 454 |
| 1891 UFPS | Mlle Lucy Lee-Robbins : "Portrait de l'auteur" 466 |
| 1891 UFPS | Mlle Estelle-Andrée Rey : "Portrait de l'auteur" 681 |
| 1892 | Mlle H. Morisot : "Portrait de l'auteur" 1242 |
| 1892 | Mme V. Parlaghy : "Portrait de l'auteur" 1316 |
| 1892 | Mlle L-R Wahl : "Portrait de l'auteur" 1677 |
| 1892 SN | Mlle L. Lee-Robbins : "Portrait de l'Auteur" 656 |
| 1893 | Mme A. Darmesteter : "Portrait de l'auteur" 493 (illustrated Walter Shaw Sparrow op.cit. supplement) |
| 1894 | Mlle A. Beaury-Saurel : "Portrait de l'auteur" 117 (ill.) |
| 1894 | Mme C. Moutet-Chole : "Portrait de l'auteur" 1359 (ill.) |
| 1894 SN | Mlle Ottilie Roederstein : "Mon propre portrait à la |

détrempe" 981

| | | |
|---|---|---|
| 1894 | SN | Mme Isabelle Cadilhon-Venat : "Portrait de l'auteur" 1271 |
| 1894 | SN | Mlle Claire Dufour : "Portrait de l'auteur ; pastel" 1355 |
| 1895 | | Mlle E. Darbour : "Portrait de l'auteur" 514 |
| 1895 | | Mlle J-M Favier : "Portrait de l'auteur" 724 (ill.) |
| 1895 | | Mlle M. de La Fizelière : "Mon Portrait ; sculpture" 3080 |
| 1895 | | Mme Mathilde de la Broise : "Portrait de l'auteur ; émail" 2071 |
| 1895 | | Mme Hélène Cornée- Vétault : "Portrait de l'auteur ; pastel" 2159 |
| 1895 | SN | Diana Cid-Garcia : "Portrait de l'auteur" 277 |
| 1896 | | Mlle E. Mathé : "Portrait de l'auteur" 1369 |
| 1896 | SN | Marceline Hennequin : "Portrait de l'auteur ; pastel" 1431 |
| 1897 | | Mme M. Guyon : "Portrait de l'auteur" 808 |
| 1897 | | Mme J. de Montchenu : "Portrait de l'auteur" 1205 |
| 1897 | | Mlle H. Morisot : "Mon portrait" 1222 |
| 1897 | SN | Mlle Lucy Trowbridge : "Portraits de ... et de l'auteur" 1762 |
| 1898 | | Mlle M. Besson : "Portrait de l'auteur" 193 |
| 1898 | | Mlle M. de Montille : "Portrait de l'auteur" 1483 (ill.) |
| 1898 | | Mme A. Voisin : "Mon portrait" 3926 |
| 1898 | UFPS | Mlle Berthe De Ploeuc : "Portrait de l'auteur ; pastel" 454 |
| 1899 | | Mlle M. Constantin : "Portrait de l'auteur" 491 (ill.) |
| 1899 | | Mme C- A Dyonnet : "Mon Portrait" 729 |
| 1899 | | Mme A. Maire : "Portrait de l'auteur" 3703 |
| 1900 | | Mlle Camille Berlin : "Portrait de l'auteur" 103 |
| 1900 | | Mlle Jhane Joly : "Portrait de l'auteur" 707 |
| 1900 | | Mlle A-M Ruiz : "Portrait de l'auteur ; - une réception" 1171 |
| 1900 | | Amélie Beaury-Saurel : "Portrait de l'auteur ; fusain" 1401 |
| 1900 | | Mme Louise Jopling : "Portrait de l'artiste - pastel" 1588 |

| | | | |
|---|---|---|---|
| X5. | 1863 | SR | Mme Amélie Burdin : "Portrait de Mme Bichel" 56 |
| | 1866 | | Mlle Rosalie Riesener : "Portrait de Mme la duchesse de C.C. - Marcello" 1653 |
| | 1876 | | Mlle Jeanne Rougelet : "Portrait de Mlle Nicolas ; - buste, bronze" 3585 |
| | 1878 | | Mlle Louise Abbéma : "Portrait de Mlle Sarah Bernhardt; médaillon bronze" 3990 |
| | 1879 | | Mlle Sarah Bernhardt : "Portrait de Mlle L. Abbéma ; buste, marbre" 4797 |
| | 1881 | | Mlle M. Prévot : "Portrait de Mlle Louise Abbéma" 1929 |
| | 1881 | | Mlle B. Vegman : "Portrait de Mme J.B." 2319 (ill.) |
| | 1884 | SI | Claire Denysse : "Jane Caylus, artiste" 124 |
| | 1884 | SI | Mlle Marie Besson : "Portrait de Mme Sarah Bernhardt ; porcelaine" 141 |
| | 1885 | | Mlle Blanche-Marie-Joséphine Jacques-Leseigneur : "Portrait de Mlle Louise B..., buste plâtre" 3850 (possibly Louise Breslau) |
| | 1886 | | Mlle Adolphine Bonomé : "Portrait de Mme Colin-Libour ; - miniature" 2583 |
| | 1886 | | Mlle L. Breslau : "Portrait de Mlle J.F..." 336 (ill) (Julie Feurgard)   (Musée des Beaux-Arts, Lausanne) |
| | 1886 | | Mlle Emmeline Deane : "Portrait de Mlle Anna Bilinska" 678 |
| | 1886 | | Mme Jenny Gaupillat : "Marie Bashkirtseff ; - buste, terre cuite" 3935 |
| | 1886 | | Mlle Anna Monis de Aragao : "Portrait de Mme Léon Bertaux ; - porcelaine" 3157 |
| | 1888 | | Mlle L. Breslau : "Portrait de Mlle Schaeppi peignant des faïences" 368 |
| | 1888 | | Mlle J. Guyon : "Portrait de Mlle Maximilienne Guyon" 1241 |

| 1888 | | Mlle M. Arosa : "Portrait de Mlle Huet" 54 (ill.) |
|------|------|--------|

1888        Mlle M. Arosa : "Portrait de Mlle Huet" 54 (ill.)

1889        Mme N. Lallemand : "Portrait de Mme Beaury-Saurel ; buste plâtre" 4568

1889        Mme Séverine Legrand : "Portrait de Mme Vital-Dubray ; miniature" 3483

1890        Mlle M. Fletcher : "Portrait de Mme Darmesteter" 926

1891 UFPS  Mlle Marie Besson : "Portrait de mon cher maître Sarah Bernhardt dans 'Théodora'" 61

1891 UFPS  Mlle Anna Delattre : "Portrait de Mlle Van Parys" 9 sculpture

1893        Mlle G. Achille-Fould : "Rosa Bonheur" 5 (Musée des Beaux-Arts, Bordeaux)

1893        Mme J. Borde-Guyon : "Portrait de Mme Maximilienne Guyon" 207

1896 SFA   Mlle GeorgesAchille-Fould : "Rosa Bonheur ; étudo" 1

1895 SFA   Souley-Darqué : "Portrait de Mme Camille Isbert" 77

1898 SFA   Mme Souley-Darqué : "Portrait de Mlle Valentine Isbert" 96

1899        Mlle A-E Klumpke : "Portrait de Mlle Rosa Bonheur" 1069 (ill.)

1899        Mlle J. Tournay : "Mlle Arosa, dans son atelier" 1909

Y5.  1861      Mme Elisabeth Jérichau : "Portrait de M J-A Jérichau, directeur de l'Académie des Beaux-Arts à Copenhague" 1668

1863        Mlle Emma Chausset : "Atelier de M. Gudin" 74 (The artist exhibited a work with the same title in 1864, no. 372)

1864        Mme la comtesse de Nadaillac née Delessert : "Portrait de M. Baudry ; aquarelle" 2373

1865        Mlle Fannie-Marguerite Dubois-Davesnes : "A Desboeufs, statuaire ; buste, marbre" 2959

1865        Mme Louise Astoud-Trolley : "Portrait du sculpteur Auguste Préault; médaillon en bronze" 2851

1867        Mlle Alix Duval : "Portrait de M. Ch. Duval, architecte" 548

1867        Mme Alexandrine Joannis : "Portrait de M. l'Abbé Lagarde, architecte de Sainte-Geneviève" 802

1873        Mme Miriame Franck : "Wiertz, peintre belge ; - buste plâtre" 1664

1873 SR    Mlle Henriette Grosso : "M. Chaplin ; pastel" 214

1874        Mme Anaïs Beauvais : "Portrait de M. Barre, statuaire" 108

1877        Mlle Eugénie Salanson : "Portrait de M.L. Cogniet" 1894

1879        Mme Bernardine Meddy : "Il Bosco, à l'Académie de France, à Rome" 2086

1880        Mme Léonie-F Halévy : "F. Halévy ; statue pierre" 6399

1884        Mlle T. Schwartze : "Portrait de M. Harpignies" 2191 (ill.)

1886        Mme Marie-Louise Petros-Sclivanioti : "Une gravure ; portrait de M.J. Lefebvre" 5301

1887        Mlle L. Breslau : "Le sculpteur Carriès dans son atelier" 342 (ill.)

1888        Mlle A. Beaury-Saurel : "Portrait de M. Félix Voisin" 162 (ill.) (The artist also executed a portrait of Jean-Paul Laurens which is in the Luxembourg)

1891 SN    Eleanor Norcross : "A.N. dans l'atelier" 704

1891        Mlle H-M Trévor : "Portrait du statuaire F. Bogino" 1606

1891 UFPS  Mme Auguste-Noémie-Jenny Dide : "Monument à Seghers, peintre de fleurs" 235 bis

1892 SN    Mlle C. Claudel : "Buste du sculpteur Rodin" 1482

1892 SN    Louise Ribot : "Mon Père dans son Atelier" 850

1892        Mme J. Berthault : "Portrait de mon oncle M.J. Lenepveu" 141 (ill.)

1894        Mme M. Lwolff : "M. Philippart, artiste peintre ; - buste, plâtre" 3328

1894 SN    Mme Antoinette Vallgren : "Le peintre Wispiansky ; buste plâtre" 119

1895        Mme L-A Southwick : "Portrait de M.L." 1765 (ill.)

1897        Mme J. Chatrousse née Lechelle : "Portrait d'Emile Chatrousse, statuaire" 372

1898 SFA   Mlle Léonide Bourges : "L'atelier du graveur Paul Rajon" 170

1900        Mme M. Brach : "Portrait de M. Henner" 1865

Z5. For Mlle Legrand's representations of children see Y3. Other works are :-

1806           "Un Intérieur (Une femme épluche des légumes)" 344
1808           "Une Villageoise" 375
1808           "Une vieille femme" 376
1812           "Un intérieur rustique" 1327
1812           "Etude d'une maison de paysan" 1329
1814           "Une marchande de poissons, et différens ustensiles" 613
1817           "Une Marchande de poissons" 509

A6. Mme Haudebourt's work has already been considered in vol.1 pp.226-8. The following are relevant in this context :-

1810           "Un mendiant" 515
1810           "Un petit mendiant" 516
1810           "Un mendiant à la porte d'un couvent où l'on fait aux pauvres une distribution de vivres" 578
1817           "Etude de pauvres" 533
1819           "Un pauvre et son enfant" 772
1819           "Le marchand de tisane" (M.I.) 771
1824           "Une paysanne faisant une corbeille" 881
1824           "Un paysan buvant" 882

B6. 1806     Mme Davin-Mirvault : "Une glaneuse" 128
1812        Mme Servières : " Etude d'après un mendiant de Rome" 846
1814        Mme Davin : "Le faucheur" 237
1814        Mme Davin : "Une glaneuse" 1351
1819        Mlle Volpelière : "Tête d'étude d'une jeune mendiante" 1190
1822        Mlle d'Hervilly : "Un aveugle à genoux joue de la vielle ; son fils implore l'assistance des passans" 697
1822        Mlle d'Hervilly : "Un petit mendiant à genoux, effet de nuit" 702
1822        Mme d'Hervilly : "Une laitière partageant son déjeuner avec son chien" 698
1822        Mlle Julie Volpelière : "Une jeune paysanne suisse" 1333
1824        Mme Royannez de Valcourt : "Une glaneuse" 1509
1827        Mme Dehérain : "Femme des environs de la ville d'Eu" 288
1827        Mme Dehérain : "Un pêcheur raccommodant ses filets" 289
1827        Mlle Emma Laurent : "Paysanne des Vosges" 646
1827        Mlle Revest : "Une jeune paysanne napolitaine" 850
1827        Mlle Volpelière : "Un jeune berger" 1047

C6. 1831     Mme J. de S... : "Petits Paysans normands" 174
1831        Mme Tripier Le Franc : "Femmes des environs de Rome" 2002
1831        Mme Tripier Le Franc : "Jeune paysanne des environs de Paris" 2003
1833        Mlle Alauzet : "Une laitière" 16
1833        Mlle A. Martin : "Tableaux de genre ; même numéro" 1684
1833        Mlle Volpelière : "Deux petits paysans" 2419
1834        Mme Clément : "Des glaneuses" 336

| | |
|---|---|
| 1834 | Mme Thurot : "Paysanne des environs de Paris" 1833 |
| 1835 | Mlle Demarcy : "Moissonneuse des environs de Paris ; miniature" 589 |
| 1836 | Mme Drouin : "Tête de jeune paysanne ; étude" 553 |
| 1837 | Mme Elise-C. Boulanger : "Les enfans du moissonneur ; aquarelle" 179 |
| 1839 | Mme Mathilde Lagache : "Une paysanne anversoise" 1185 |
| 1839 | Mme Laure de Léomenil : "Une Gipsy" 1324 |
| 1839 | Mlle J. Volpelière : "Une 'Gipsy'" 2097 |
| 1840 | Mlle Eugénie V. Henry : "Courage et piété d'un bûcheron" 821 |
| 1840 | Mme Soyer : "Une glaneuse anglaise" 1518 |
| 1840 | Mlle Voullemier : "Jeune paysanne ; étude" 1648 |
| 1841 | Mme Sophie Jobert : "Le repos pendant la moisson" 1049 |
| 1841 | Mlle Eugénie Lalouette : "Portrait d'une villageoise" 1165 |
| 1841 | Mlle Eugénie Lalouette : "Portrait d'une villageoise" 1166 |
| 1841 | Mlle Augustine Picard : "Le retour d'un montagnard" 1579 |
| 1842 | Mlle Célestine Faucon : "La petite glaneuse" 649 |
| 1842 | Mlle Coraly de Fourmond : "Une bohémienne arabe" 704 |
| 1842 | Mlle Augusta Le Baron : "Le savetier" 1157 |
| 1842 | Mlle Pauline Malherbe : "La petite glaneuse" 1308 |
| 1842 | Mlle Octavie Peignet : "Paysanne lorraine ; pastel" 1452 |
| 1842 | Mlle Octavie Peignet : "Paysanne lorraine ; pastel" 1453 |
| 1843 | Mlle Coraly de Fourmond : "Une jeune paysanne normande" 454 |
| 1843 | Mme C.P. : "La famille du pêcheur" 903 |
| 1843 | Mlle Léonide Provandier : "Jeune Bretonne" 981 |
| 1843 | Mlle Caroline B. : "Un pâtre au coucher du soleil ; pastel" 1194 |
| 1844 | Mme E. Leroux de Lincy : "Jeune paysanne ; étude" 1186 |
| 1844 | Mme Jules Herbelin : "Six miniatures" 6. "Portrait d'une paysanne de la Bourgogne" 1981 |
| 1845 | Mlle Sophie Jobert : "Repos de bohémiens à la fin de la journée" 885 |
| 1845 | Mme Jules Herbelin : "Cinq miniatures" 1. "Etude, d'après nature, d'une bergère bourguignonne" 1851 |
| 1846 | Mlle Cécile Humbert : "Jeune pâtre en prière" 957 |
| 1847 | Mlle Amanda Fougère : "Le repas de l'ermite" 638 |
| 1847 | Mlle Amanda Fougère : "Petite villageoise" 639 |
| 1847 | Mme Anaïs Toudouze : "La danse bretonne, environs de Quimper (Finistère) ; aquarelle" 1971 |
| 1848 | Mlle Estelle-Félicie-Marie Barescut : "Petite paysanne à la maraude ; étude" 195 |
| 1848 | Mlle Estelle-Félicie-Marie Barescut : "La fille du braconnier" 197 |
| 1848 | Mlle Rosa Bonheur : "Le meunier cheminant" 464 |
| 1848 | Mme Julienne Delisle : "Paysanne auvergnate de Pont-Gibaut, dessiné à l'estompe d'après nature" 1207 |
| 1848 | Mlle Amélia Devroye : "Jeune paysanne de Saint-Lumine, costume breton ; pastel" 1278 |
| 1848 | Mme Valentine Milh : "La fille du pêcheur" 3322 |
| 1848 | Mlle Caroline Swagers : "Une jeune paysanne en prière" 4199 |
| 1848 | Mlle Louise Thuillier : "Miette, jeune fille provençale" 4260 |
| 1848 | Mlle Louise Thuillier : "Jeune fille provençale à la fontaine" 4261 |
| 1848 | Mlle Emilie Ratte : "La petite glaneuse" 5161 |
| 1849 | Mlle Rosa Bonheur : "L'abordage nivernais ; le sombrage" 204 (M.I.) |
| 1849 | Mlle Henriette Cappelaere : "Pâtre" 311 |
| 1849 | Mlle Henriette Cappelaere : "Pêcheuse" 312 |

1849       Mlle Amanda Fougère : "Petit paysan" 754

1849       Mlle Louise-Eudes de Guimard : "Déjà rêveuse ; jeune paysanne de Basse-Normandie" 984

1850       Mlle Honorine Bouvret : "Retour du marché ; étude" 373

1850       Mme Lefèvre-Deumier : "Jeune pâtre de l'île de Procida ; modèle plâtre" 3482

D6. Other examples are :-

1833       Mlle E. Pénavère : "L'orpheline" 1866

1836       Mme Dehérain : "Pauvre enfant" 493

1836       Mlle Clothilde Gérard : "Mendiant et son enfant endormi ; étude" 818

1836       Mlle Caroline Swagers : "La quêteuse ; étude" 1710

1837       Mlle Adèle Ferrand : "Les deux orphelines" 683

1838       Mlle de Montfort de Marguerie : "La tombe du mendiant" 1308

1840       Mlle Pauline Malherbe : "La pauvre aveugle" 1151

1841       Mme Thérèse Sabattucci : "Tronc pour les pauvres ; plâtre" 2113

1842       Mlle Bathilde Goblain : "Trait de bienfaisance"
"Un enfant abandonné dans le quartier de la Cité fut trouvé par une petite fille de son âge qui revenait de l'école. Celle-ci l'amena à sa mère qui, malgré sa pauvreté, l'adopta" 815

1844       Mlle Amanda Fougère : "Mendiant espagnol ; étude" 706

1844       Mlle Coraly de Fourmond : "Les petits écoliers charitables" 715

1844       Mme Julie de Sénevas de Croix-Mesnil : "Mendiants allemands" 1632

1846       Mme Clémentine de Bar : "Le départ de l'orpheline" 70

1846       Mlle Sophie Claude : "L'aumône partagée" 385

1847       Mme D. Amsinck : "Petits mendiants" 7

1847       Mlle Amanda Fougère : "Deux orphelines" 637

1849       Mme Marie-Elisabeth Cavé : "L'orpheline et son petit-frere" 338

1849       Mme Léonie Taurin née Mauduit : "La jeune aveugle égarée ; mine de plomb" 1878

E6. 1853       Mlle Amélie Lendegren : "Les orphelins" 754

1855       Mlle Henriette Browne : "Ecole des pauvres, à Aix (Savoie)" 2641

1857       Mlle Elisa Drojat : "Pauvres enfants" 807

1859       Mlle Alexandrine Jeannis : "L'enfant d'adoption" 1616

1859       Mlle Pauline Malherbe : "Les orphelins" 2075

1861       Mme D. Amsinck : "La charité, s'il vous plaît !" 40

1861       Mme Elisabeth Jérichau : "Enfants trouvés" 1660

1861       Mme Elisabeth Jérichau : "Le sommeil des enfants pauvres" 1663

1861       Mlle Lina de Weiler : "Les orphelins du musicien" 3115

1861       Mme Léon Bertaux : "Pour les pauvres, s'il vous plaît ; groupe formant un tronc, bronze" 3179

1863       Mlle Louise Eudes de Guimard : "Aïeule et orpheline" 659

1865       Mme Adèle de la Porte : "La faim brave tous les dangers" 616

1865       Mlle Amélie-Léonie Fayolle : "La pauvre fille" 805

1865       Mlle Amanda Fougère : "Quête pour les orphelins" 841

1865       Mlle Marie Choisson : "Petite mendiante ; pastel" 2368

1866       Mme Tourny née Ernestine Hochet de Latesrie : "Enfants pauvres" 1856

1866       Mme Laurence Guillon : "Petit malheureux ; dessin" 2273

1866  Marie de  Tourmont : "Les orphelines, en Limousin ;
     aquarelle" 2582

1867  Mme Marie Anselma : "Une pensionnaire de l'orphelinat
     d'Amsterdam" 29

1869  Mlle Amélie-Léonie Fayolle : "Un petit sou, s'il vous
     plaît !" 917

1873  Mlle Louise Eudes de Guimard : "Le dernier morceau de
     pain" 317

1873  Mme Cecilia Rosabel : "Mendiante bourbonnaise sur les
     marches de la chapelle Notre-Dame ; - pastel" 1288

1875  Mlle Magdeleine Nicolas : "Poveretta" 1540

1876  Mme Agathe Doutreleau née Amsinck : "J'ai froid ! ..
     J'ai faim !" 684

1876  Mme Virginie Letorsay née Taine : "Les trois mendiantes
     d'Orsay ; - dessin à la plume" 2687

1877  Mme Ve Louise Bureau : "L'orpheline ; - statuette plâtre"
     3620

1877  Mlle Jenny Touzin : "Un petit sou, s'il vous plaît ? ;
     groupe, terre cuite" 4161

1878  Mlle Amélie Lacazette : "Mendiant granvillais" 1273

1879  Mlle Antonia Banuelos : "Mendiants" 140

1879  Mlle Marie-Cécile Thorel : "La petite soeur de
     charité" 2846

F6. 1852  Mlle Louise Eudes de Guimard : "La soeur aînée ; enfants de
     Pointel (Basse-Normandie)" 423

1853  Mlle Delphine Bernard : "Moissonneuses ; pastel" 92

1853  Mlle Delphine Bernard : "Une bohémienne ; pastel" 93

1853  Mme Grün (née Eugénie Charpentier) : "Jeune Bretonne ;
     étude" 565

1853  Mme Roland née Anna Linsler : "Petit pâtre bourguignon" 1010

1855  Mlle Delphine Bernard : "Petite glaneuse" 2541

1855  Mlle Rosa Bonheur : "La fenaison (Auvergne)" 2587

1855  Mme Eméric (née Honorine Bouvret) : "Le retour du marché"
     3036

1855  Mme Grün (née Eugénie Charpentier): "Jeune bretonne" 3219

1855  Mlle Julie Outrebon : "Gitana" 3741

1855  Mlle Asta Hansteen : "Un jeune ouvrier" 2018

1857  Mlle Célina Lefébure : "Bohémien et sa fille" 1660

1857  Mlle Pauline Malherbe : "Une gitana" 1814

1857  Mme Rougemont (née Emilie Gohin): "Pâtre des Abruzzes" 2318

1859  Mlle Emma Blanche : "Jeune bohémienne ramassant du bois dans
     une forêt" 280

1859  Mlle Léontine de Blavette : "Laitière du Perche" 281

1859  Mlle Célina Lefébure : "Les petits ramasseurs de bois" 1864

1861  Mlle Marie-Hélène Antigna : "Chercheuse de bois mort" 59

1861  Mme Becq de Fouquières : "Gitana ; pastel" 176

1861  Mlle Eugénie Hautier : "Intérieur rustique" 1462

1861  Mme Elisabeth Jerichau : "Paysans polonais quittant leur
     village" 1666
     (Praised by Théophile Gautier in his "Abécédaire
     du Salon de 1861" p 234)

1861  Mme Louise-Zoé Coste Meynier : "Le retour du laboureur" 2240

1863  Mlle Amélie-Léonie Fayolle : "Femme de la campagne de
     Rome" 679

1863  Mme Collard née Marie-Anne-Herminie Bigé : "Italiennes des
     environs de Naples" 436

1863 SR  Mme Ernestine de Pelleport : "Jeune fille portant des blés
     etc." 446

1864  Mme Marie Anselma : "Femme de Gaussan (Aude)" 39

1864  Mlle Cécile Darnaud : "Une bretonne ; tête d'étude" 498

| 1864 | Mlle Louise Eudes de Guimard : "Femmes de la campagne de Rome ; effet de crépuscule" 667 |
| 1864 | Mlle Amélie-Léonie Fayolle : "Filles des champs" 696 |
| 1864 | Mlle Amélie Nivet-Fontaubert : " Départ pour le marché (Limousin)" 1435 |
| 1864 | Mlle Alice Grégoire : "Villageoise de Hongrie ; buste, terre cuite" 2633 |
| 1865 | Mlle Uranie Colin-Libour : "Les Bohémiens" 482 |
| 1865 | Mme Lucile Doux : "La gardeuse de lapins" 688 |
| 1865 | Mlle Marie-Alexandrine Mathieu : "L'étuvée : matelotte nivernais" 1464 |
| 1865 | Mlle Ernestine Philippain : "Ramoneur" 1697 |
| 1865 | Mlle Marie Collart : "Une fille de ferme" 485 |
| 1865 | Mlle Agathe Doutreleau : "Pâtres bretons en hiver" 687 |
| 1865 | Mme Tourny (née Ernestine Hochet de Latesrie) : "Les vendangeurs" 2088 |
| 1866 | Mme Agathe Doutreleau : "Les vanneurs" 605 |
| 1866 | Mlle Amanda Fougère : "Jeune paysan en voyage" 736 |
| 1866 | Mme Ernestine Froidure de Pelleport : "Paysanne portant des fruits" 757 |
| 1866 | Mme Alix de Laperrelle : "La petite fille du bûcheron - étude" 1634 |
| 1866 | Mme Emilie Ray : "Paysanne porteuse d'eau" 1620 |
| 1866 | Mme Herbelin : "Portrait d'une jeune paysanne ; aquarelle" 2285 |
| 1867 | Mlle Elisa Kock : "La petite fermière" 827 |
| 1867 | Mme Ernestine Tourny : "Paysan napolitain" 1479 |
| 1868 | Mlle Amélie-Léonie Fayolle :"Jeunes pâtres romains" 960 |
| 1868 | Mlle Amanda Fougère : "Retour de la ferme" 1004 |
| 1868 | Mlle E-J Haldeman : "Une paysanne" 1198 |
| 1868 | Mlle Pauline Michault : "'Gitana' dans sa mansarde" 1766 |
| 1868 | Mlle Caroline Pockels : "Paysanne allemande" 2023 |
| 1869 | Mlle Pauline Elise-Léonide Bourges : "Petite Bohémienne" 306 |
| 1869 | Mlle M. Collart : "La Source" 523 |
| 1869 | Mlle M. Collart : "Le fournil" 524 (These two works were reviewed in the "Gazette des Beaux-Arts" 1869 vol. 1 pp 510-11) |
| 1869 | Mlle Amanda Fougère : "Paysan normand" 961 |
| 1869 | Mlle Amanda Fougere : "Une gitana" 962 |
| 1869 | Mlle Ernestine Friedrichsen : "Le retour du laboureur polonais" 980 |
| 1869 | Mme Alix Laperrelle, née Poisson : "La petite braconnière" 1365 |
| 1869 | Mme Alix Laperrelle : "La bûcheronne" 1366 |
| 1869 | Mme Madeleine Morin : "Une femme traînant un fagot" 1755 |
| 1869 | Mlle Henriette Pecqueur : "Retour des champs" 1878 |
| 1869 | Mlle Ernestine Philippain : "Une paysanne russe" 1925 |
| 1869 | Mme Joséphine-Louisa Pittoud : "Pêcheuse" 1952 |
| 1869 | Mlle Caroline Pockels : "En campagne" 1958 |
| 1869 | Mlle Eugénie Venot d'Auteroche : "Jacintha, femme des environs de Naples" 2326 |
| 1869 | Mlle Wilhelmine Bost : "Jeune paysanne ; pastel" 2545 |
| 1869 | Mlle Elisa Mayer : "Intérieur rustique ; faïence" 2960 |
| 1870 | Mme Madeleine Morin : "Gardeuse de dindons" 2037 |
| 1870 | Mme Elise Orlias née Canoby : "Femme et enfant ramassant du bois ; forêt de Fontainebleau" 2127 |
| 1870 | Mlle Léonide Poisson : "Petite villageoise" 2310 |
| 1870 | Mlle Léonide Poisson : "Retour des champs" 2311 |
| 1870 | Mlle Mary Stevenson : "Une Contadina di Fobello ; vel Sesia (Piémont)" 2675 |

| | |
|---|---|
| 1870 | Mme Ernestine Tourney née Hochet de Latesrie : "Retour des champs" 2764 |
| 1870 | Mme Lina de Weiler : "Bohémienne en Croatie" 2948 |
| 1870 | Mme Louise-Marie Becq de Fouquières : "Enfants bretons" 3053 |
| 1870 | Mme Louise-Marie Becq de Fouquières : "Femmes de Bretagne" 3054 |
| 1870 | Mme Jeanne-Mathilde Herbelin née Habert : "Petite bergère ; dessin aux trois crayons" 3577 |
| 1870 | Mme Octavie Richard née Ricois : "Jeune bretonne - pastel" 3999 |
| 1872 | Marie Collart : "Le vieux verger" 363 (Reviewed in the "Gazette des Beaux-Arts" 1876 vol. 14 p 136) |
| 1872 | Mme Louise-Marie Becq de Fouquières née De Dreux : "Maison de pêcheur à Douarnenez (Finistère); - aquarelle" 89 |
| 1872 | Mme Louise-Marie Becq de Fouquières née De Dreux : "Intérieur à Poul-Dahut (Finistère) ; - aquarelle" 88 |
| 1873 | Mlle Pauline-Elise-Léonide de Bourges : "Glaneuses" 163 |
| 1873 | Mlle Louise Eudes de Guimard : "Jeune paysanne" 549 |
| 1873 | Mlle Eudoxie Gavarret : "Paysanne de Pont-Aven (Finistère) ; - aquarelle" 612 |
| 1873 SR | Mme Jeanne Nevers : "Pêcheur de sardines" 265 |
| 1873 SR | Mme Louise-Anne de Urriza : "Une vigneronne (pastel)" 85 |
| 1875 | Mlle Léonide Bourges : "Laveuses au bord du Tibre, à Rome" 278 |
| 1875 | Mlle Jeanne Scapre : "Retour des champs " 1815 |
| 1875 | Mme Eudoxie Gavarret : "Gardeuse de vaches, côtes de Bretagne ; - aquarelle" 2320 |
| 1876 | Mme Marie Dieterle née Van Marcke : "Un pâturage normand" 673 |
| 1876 | Mme Emilie-Armand Leleux née Giraud : "Le déjeuner à la ferme" 1270 |
| 1876 | Mme Louise-Marie Becq de Fouquières née De Dreux : "Bigoudenne de Pont-L'Abbé (Finistère) ; - pastel" 2142 |
| 1876 | Mme Marie de Chevarrier née de Pêne : "Paysanne de la campagne de Rome ; - miniature" 2268 |
| 1876 | Mlle Agathe Jumon : "Gitana ; miniature" 2594 |
| 1876 | Mlle Madeleine Wymbs : "Paysanne de la Messandrie, à Noirmoutier (Vendée)" 3027 |
| 1877 | Mlle Léonide Bourges : "Bûcheronnes ; - effet de neige" 286 |
| 1877 | Mlle Léonide Bourges : "Le premier froid" 287 |
| 1877 | Mme Marie Cazin née Guillet : "Village de pêcheurs" 419 |
| 1877 | Mlle Caroline Courtin : "Une ferme à Honfleur (Calvados)" 580 |
| 1877 | Mlle Mathilde Robert : "Bohémienne" 1811 |
| 1877 | Mlle Lucie Haas : "Bergerade ; - éventail, aquarelle" 2821 |
| 1877 | Mme Henriette Jacott-Cappelaere : "Un intérieur breton ; - lavis" 2891 |
| 1877 | Mlle Jeanne Clémence Jobard : "Le retour de labourage ; - faïence" 2904 |
| 1877 | Mme Rita-Pauline Ruffin : "Intérieur de ferme, à Assigny (Seine-Inférieure) ; - fusain" 3383 |
| 1878 | Mme Jeanne Limosin d'Alheim : "Poissonnerie en Provence" 20 |
| 1878 | Mlle Léonide Bourges : "Laveuses" 317 |
| 1878 | Mlle Léonide Bourges : "Petite fagotière" 318 |
| 1878 | Mlle Hélène Du Dousquet : "Retour du marché" 796 |
| 1878 | Mlle Emily-Florence Spear : "Une paysanne à la fontaine" 2084 |

| 1878 | Mme M. Zetterstrom : "Paysanne suédoise" 2319 |
|---|---|
| 1878 | Mme Louise  Gabillot Van Parys : "La Paysanne" 2956 |
| 1878 | Mlle Léonide Marchal : "Un paysan" 3424 |
| 1878 | Mme Claude Vignon : "Pêcheur à l'épervier ; - statue plâtre" 4630 |
| 1879 | Mlle Claudie : "Bohémienne" 657 |
| 1879 | Mlle Léonide Marchal : "Un vanneur" 2016 |
| 1879 | Mme Félicie Schneider : "Faneuse" 2730 |
| 1879 | Mlle Marie-L Stone : "L'angélus" 2799 |
| 1879 | Mme Berthe-Augustine-Aimée-Marie Desseaux : "Jeune Bretonne ; - pastel" 3491 |
| 1879 | Mlle Marie-Claire Le Sueur : "La bûcheronne ; - porcelaine" 4059 |
| 1879 | Mme Emily Mac-Kay : "Les charbonniers (effet de lune) ; - fusain" 4109 |
| 1879 | Mlle Claire d'Orgeval : "Tête de paysanne ; - porcelaine" 4290 |
| 1879 | Mlle Suzanne Piaud : "Le retour du marché" 4359 |
| 1879 | Mlle Joséphine Thier : "Moissonneuse au repos ; - porcelaine" 4649 |

| G6. | 1880 | Mme Adolphine Bonomé : "Retour du marché" 406 |
|---|---|---|
| | 1880 | Mme Marie Brodbeck : "Bergerie" 509 |
| | 1880 | Mme M. Collart : "La Chaumière" 836 (ill.) |
| | 1880 | Mlle Suzanne Brunel : "Intérieur de ferme normande" 536 |
| | 1880 | Mme Martha Clerc : "Une paysanne" 798 |
| | 1880 | Mlle Elise Voruz : "Casseur de pierres" 3864 |
| | 1880 | Mme Hermine Waternau : "Bohémienne - aquarelle" 6018 |
| | 1881 | Mme V. Demont-Breton : "Femme de pêcheur venant de baigner ses enfants" 675 (Reviewed in "L'Art" 1881 vol. 2 p 234 ; illustrated on page 232. The work won a third class medal) |
| | 1881 | Mme J. Fichel née Samson : "La moisson du matin" 882 |
| | 1881 | Mme M. Robert : "Pêcheuse à Saint-Sébastien" 2022 |
| | 1881 | Mlle E. Salanson : "La jeune pêcheuse" 2091 |
| | 1881 | Mlle E. Salanson : "La paysanne" 2092 |
| | 1881 | Mme A. Salles-Wagner : "Gitana hongroise" 2099 |
| | 1881 | Mlle L. Schjelderup : "Paysanne norwégienne endormie" 2128 |
| | 1882 | Mlle L. Breslau : "Pêcheuse guettant la marée ; baie du Mont-Saint-Michel" 379 (ill.) (Highly praised in "L'Art" 1882 vol. 2 p 187) |
| | 1882 | Mme V. Demont-Breton : "La famille" 799 (ill.) |
| | 1882 | Mlle J. Itasse : "Paysanne ; - buste plâtre" 4503 |
| | 1882 | Claude Vignon : "Le pêcheur à l'épervier ; statue bronze" 4923 |
| | 1883 | Mlle M-W Lesley : "Vieux fermier ; Nantucket " 1507 |
| | 1883 | Mlle Marie Petiet : "Allant au marché" 1891 |
| | 1883 | Mme L. Williams : "La camaraderie" 2447 (ill.) |
| | 1883 | Mme V. Demont-Breton : "La plage" 740 (Musée de Douai) |
| | 1884 | Mme M. Briffault : "Ferblantier de village" 360 |
| | 1884 | Mme Uranie Colin-Libour : "Intérieur normand" 569 |
| | 1884 | Mme A de La Perrelle-Poisson : "Bouvière - étude" 1399 |
| | 1884 | Mlle Marie Petiet : "Vieille femme d'Aulus (Ariège)" 1897 (ill.) |
| | 1884 | Virginie Demont-Breton : "Le calme" 731 (ill.) |
| | 1884 | Mme J. Ross : "Raccommodeuses de filets à Concarneau (Finistère)" 2089 |
| | 1884 | Mlle E. Salanson : "La  Récolte de Varech" 2138 (ill.) |
| | 1884 | Mlle M. Verroust : "Jeune fille Bretonne" 2369 |
| | 1884 | Mlle M-D Webb : "Paysanne bretonne" 2435 |
| | 1884 | Mlle M-D Webb : "Les Raccommodeuses de filets" 2436 |

| | | |
|---|---|---|
| 1884 | | Mlle Angela Wislocka : "Une Paysanne polonaise" 3226 |
| 1884 | UFPS | Mlle Léonide Bourges : "Pendant la moisson" 29 |
| 1884 | UFPS | Mlle Léonide Bourges : "Petite Bretonne de Roscoff" 30 |
| 1884 | UFPS | Mme Yolande Dalbert : "La Glaneuse" 66 |
| 1884 | UFPS | Mlle Fanny Duncan : "La femme du pêcheur" 82 |
| 1884 | UFPS | Mlle Clémence Richey : "Petite bretonne" 201 |
| 1884 | UFPS | Mlle Jeanne Sallet : "Jeune bohémienne ; dessin" 222 |
| 1884 | UFPS | Mme Baronne de Retchen Weyler : "Pêcheurs de crevettes" 255 |
| 1884 | UFPS | Mme Signoret : "Aux champs, statue plâtre" 280 |
| 1884 | SI | Mme Miros (Michel) : "Ramoneur" 72 |
| 1884 | SI | Mme Aline-Marguerite Sisos : "Laitière limousine" 201 |
| 1885 | | Mlle Clara Nordgren : "Paysanne suédoise" 1603 |
| 1885 | | Mlle Marie Petiet : "Plumeuses d'oies" 1962 (ill.) |
| 1885 | | Emma Herland : "Pêcheuses de crevettes ; baie du Concarneau" 1258 (ill.) |
| 1885 | | Mlle Sigrid Bolling : "En route pour la pêche du soir" 299 |
| 1885 | | Mme Emma-Lowstadt Chadwick : "Bretonne conduisant une chèvre" 502 |
| 1885 | | Mlle Elisabeth Jane Gardner : "Un coin de ferme" 1052 (ill.) |
| 1885 | | Mme Mary Kempton Trotter : "Paysanne bretonne" 1304 |
| 1885 | | Mlle Louise-Amélie Landré:"Vanneurs bretons ; - Perros-Guirec (Côtes-du-Nord)" 1440 |
| 1885 | | Mme Lydie Laurent-Desrousseaux : "Raccommodeuse de filets" 1480 |
| 1885 | | Mme E. Venat d'Auteroche : "La cueillette du Houblon à Percey (Haute-Marne)" 2376 (ill.) |
| 1885 | | Mme Céleste Moutet-Cholé : "Pêcher" 1836 |
| 1885 | | Mme Euphémie Muraton : "La laitière" 1837 |
| 1885 | | Mme Suzanne de Nathusius : "Paysanne saxonne" 1845 |
| 1885 | | Mlle Ida Risler : "Un petit savoyard" 2093 |
| 1885 | | Mlle Eugénie Salanson : "La ramasseuse d'épaves" 2182 (ill.) |
| 1885 | | Mlle Eugénie Salanson : "La fille du pêcheur" 2183 (ill.) |
| 1885 | | Mme Vesta Schallenberger Simmons : "Enfants bretons" 2256 |
| 1885 | | Mlle Marie Weber : "Moissonneuse" 2448 |
| 1885 | | Mlle Henriette Liqueur : "Villageoise ; - pastel" 2995 |
| 1885 | | Mlle Jenny Nystrom : "Vieille femme de la Creuse ; - pastel" 3071 |
| 1885 | | Mme Thérèse Quinquand née Caillaux : "La pêcheuse ; - statue plâtre" 4127 |
| 1885 | | Mme Thérèse Quinquand née Caillaux : "Vieux marin ; - buste plâtre" 4128 |
| 1885 | | Mme V. Demont-Breton : "Les loups de mer" 761 (Gent Museum) |
| 1885 | UFPS | Mme Pauline Chaville : "Père Lambert, étude de pêcheur" 56 |
| 1885 | UFPS | Mlle Marguerite Dumont : "Départ pour la pêche" 102 |
| 1885 | UFPS | Mme Marguerite Pillini : "Le Départ, pêcheurs de l'Adriatique" 208 |
| 1885 | UFPS | Mme Charlotte-Gabrielle Besnard : "Berger, médaillon haut relief" 5 |
| 1886 | | Mlle E. Salanson : "Avant la pêche" 2116 (ill.) |
| 1886 | | Mme M. Collart : "Scène d'hiver ; semaine de Noël" 558 (ill.) |
| 1886 | | Mlle Ellen-K Baker : "La ramasseuse de moules" 97 |
| 1886 | | Mme Marie Collart : "Bergerie ; - effet du matin" 559 |
| 1886 | | Mme Fanny Fleury : "Petites Bretonnes" 945 |
| 1886 | | Mme Louise Gabillot Van Parys : "Bretonne en prière" 982 |
| 1886 | | Mme Emma Herland : "Le déjeuner du potier ; - intérieur de ferme bretonne" 1187 |
| 1886 | | Dora Hitz : "Gardeuse de chèvres ; - costume valaque" 1199 |
| 1886 | | Mme Joséphine-Claire Langlois, née Roelly : "Pêcheuse de moules" 1345 |
| 1886 | | Mme Marguerite Pillini : "Dans les champs" 1892 |

```
1886 Mlle Eugénie Salanson : "Avant la pêche" 2116 (ill.)
1886 Mlle Emilie Desjeux : "Intérieur de ferme ; - fusain" 2758
1886 Mlle H-F-A Loder : "La bonne récolte (Hollande); -
 aquarelle" 3091
1886 Mme Marthe de Peslouan : "La Berrichonne ; - pastel" 3226
1886 Mlle Thérèse Pomey : "Il pleut, bergère" 3246
1886 Mlle Thérèse Caillaux : "Faucheur aiguisant sa faux ; -
 statue plâtre" 3589
1886 Mme Marguerite-Fanny Dubois-Davesnes : "Paysanne de la
 Creuse ; - buste, terre cuite" 3835
1886 UFPS Mme Adrine-Lavieille : "Moissonneuse" 1
1886 UFPS Mlle Elisabeth Keyser : "Dans les Champs" 161
1886 UFPS Mme Peyre : "Bretonne, étude" 241 bis
1886 UFPS Mme Claude Signard : "Moissonneuse Franc-Comtoise" 279
1886 UFPS Mlle Fanny Dubois-Davesnes : "Paysanne de la Creuse, buste
 terre cuite" 10
1887 Mme S. Deshayes : "Genre" 756
1887 Mlle Breslau : "Lande des fleurs"
 (Reviewed in the "Gazette des Beaux-Arts" 1887 vol.
 35 p 498)
1887 Mlle M. d'Etcheverry : "Scène d'intérieur à la campagne" 878
1887 Mlle A. Brewster : "Un incident au village" 349 (ill.)
1887 Mlle E-J Gardner : "La fille du fermier" 989 (ill.)
1887 Mme E-R Harrison : "Une matelotte d'Etaples" 180
1887 Mme J-F Mertens : "Bohémienne à San-Remo" 1667 (ill.)
1887 Mlle L. Ollivier : "Bohémienne" 1815
1887 Mlle A. Klumpke : "Catinou, la montagne Noire (Tarn)" 1320
 (ill.)
1887 Mme Félicie Schneider : "Moissonneuse" 2157
1887 Mme P Desmarres : "Paysanne lorraine ; - buste plâtre" 3873
1887 Mme M-C Desplanques : "Paysanne berrichonne ; buste plâtre"
 3880
1887 Mme Lallemand : "Paysanne bretonne ; buste plâtre" 4138
1887 UFPS Mme Gabillot Van-Parys : "Bretonne en prière" 150
1887 UFPS Mlle Nallet-Poussin : "Bergère, étude" 215
1887 UFPS Mme Nallet-Poussin : "Retour à la ferme" 216
1887 UFPS Mlle Pillini : "Le chiffonnier de Quimper" 236
1887 UFPS Mlle Pillini : "Paysan, étude" 237
1887 UFPS Mme Marthe Saint-Michel-Rivet : "Bretonne" 263
1887 UFPS Mme Souley-Darqué : "Intérieur de pêcheurs à Capri" 272
1887 UFPS Mme Marie Taylor : "Laitière des environs de Cherbourg;
 statuette plâtre" 282
1888 Mlle B. Burgkan : "Une bohémienne" 435
1888 Mme E-L Chadwick : "Gardeuse de moutons" 528
1888 Mme J. Comerre-Paton : "Faneuse" 625 (ill.)
1888 Virginie Demont-Breton : "Le bain" 786 (Luxembourg, Paris)
1888 Mlle M-N Dupuy : "Vieille beauceronne ; - étude" 913
1888 Mlle C-M Gredelne : "Le réveillon de l'ouvrier" 1187
1888 Mlle E. Herland : "L'aumône ; - Bretagne" 1286 (ill.)
1888 Mlle E. Loomis : "Vie rustique ; - Picardie" 1669 (ill.)
1888 Mlle J. Romani : " Gitane" 2177
1888 Mlle G. Timkin : "La moisson" 2384
1888 Mlle R. Venneman : "Rentrée à la ferme" 2448
1888 Mlle H. Waternau : "Un coin de marché" 2519
1888 Mlle A. Casini : "Cribleuse ; statue plâtre" 3885
1889 Mlle A. Barney : "Paysanne Polonaise" 118
1889 Virginie Demont-Breton : "L'homme est en mer" 796 (ill. in
 Witt library)
1889 Mlle E-J Gardner : "Dans le bois" 1117 (ill.)
1889 Mlle E. Nourse : "Dans la bergerie ; - à Barbizon" 2021
1889 Mlle A-S Petersen : "Paysanne danoise" 2118
```

```
1889 Mlle A. Casini : "Botteleur ; - statuette, plâtre" 4139
1889 Mme H. Descat : "Retour des champs ; - statue plâtre" 4289
 (ill.)
1889 Mme A. Wegl : "La fille des champs ; - statuette plâtre"
 5046
1889 UFPS Mlle Marthe Breton : "Femme de pêcheur" 84
1889 UFPS Mlle Adrienne Brierre : "Vieux savatier" 88
1889 UFPS Mlle Adrienne Brierre : "Paysannes octogénaires" 89
1889 UFPS Mme Caroline Espinet : "Pêcheur de sardines (Morbihan)" 233
1889 UFPS Mlle Magdeleine Fleury : "Intérieur breton" 253
1889 UFPS Mme Frances Fraser : "Un lavoir en Bretagne" 260
1889 UFPS Mlle Dora Hitz : "La Fille du pêcheur" 301
1889 UFPS Mlle Dora Hitz : "Jeune fille bretonne ; étude" 303
1889 UFPS Mme Jeanne Jacquemin : "Une maison de pêcheur" 325
1889 UFPS Mme Alice Regnauld-Marais : "Ramoneur ; aquarelle" 553
1889 UFPS Mlle Marie Robiquet : "Dans les champs ; aquarelle" 568
1889 UFPS Mme Henriette Descat : "Retour des champs" 14
1889 UFPS Mlle Hélène Vernès : "Barbara ; Paysanne de la Forêt-
 Noire" 34
1889 SI Mme Marie Derondel : "Jeune bretonne" 85
1889 SI Mlle Marie Grenu : "Le repos des faneurs" *135
1890 Mme M. Aub : "Vieille paysanne" 52
1890 Mme M. Caire : "La famille aux champs" 427 (ill.)
1890 Mme E-C Gonzalez-Condé : "Vieille paysanne ; - intérieur
 à Anvers-sur-Oise" 593
1890 Mlle M-A Marcotte : "Une fillette des champs" 1592 (ill.)
1890 Mlle B. Mathewes : "La fille du fermier" 1638
1890 Mme M. Pillini : "Le Jeudi saint en Bretagne" 1919
1890 UFPS Mme Mary Aub : "Bohémienne, tireuse de Tarots" 27
1890 UFPS Mme Mary Aub : "Vieille paysanne" 29
1890 UFPS Mme Mary Aub : "Vieille femme" 30
1890 UFPS Mme Noémie de Beauvais : "Vieille conteuse berrichonne" 51
1890 UFPS Mlle Jeanne Cheilley : "Etude bretonne" 162
1890 UFPS Mlle Isabelle Doré : "Paysanne bretonne, étude" 252
1890 UFPS Mlle Anna Klumpke : "Une Paysanne ; pastel" 409 bis
1890 UFPS Mlle Marguerite Pélard : "La femme du pêcheur, éventail ;
 aquarelle" 584
1891 UFPS Mme Adrienne-Suzanne-Nanny : "Chargeur de varech ; plage
 de Saint Pair" 3
1891 UFPS Mlle Marguerite Arosa : "Laveuses (Bretagne)" 16
1891 UFPS Mlle Berthe Burgkan : "Jeune Champenois à la soupe ; pastel"
 125
1891 UFPS Mlle Berthe Burgkan : "Octogénaire champenoise"122
1891 UFPS Mme Marie Derondel : "Fillette bretonne, allant au marché"
 217
1891 UFPS Mme Camille Deschamps : "Gardeuse d'oies dans les Landes"
 229
1891 UFPS Mlle Isabelle Doré : "Un Paysan" 243
1891 UFPS Mme Nathalie Laurentz : "Tête de paysan" 454 bis
1891 UFPS Mlle Pauline O'Rorke : "Vieille bretonne" 620
1891 UFPS Mlle Marguerite Pélard : "La Gardeuse de Chèvres ; éventail ;
 aquarelle" 634
1891 UFPS Mme Teresa Pérate : "Jeune Fille du canton de Berne ; pastel"
 642
1891 UFPS Mme Teresa Pérate : "Vieille Femme de Picardie ; étude ;
 fusain" 643
1891 UFPS Mme Marguerite Pillini : "Laveuses bretonnes (Finistère)"
 660
1891 UFPS Mlle Estelle-Andrée Rey : "Jeune bretonne" 682
1891 UFPS Mme Louise Savoy : "Pêcheuse de crevettes grises (Calvados)";
 704
```

1891 UFPS  Mme Charles-Paule Séailles : "Paysanne ; fusain" 719
1891 UFPS  Mme Frédérique Vallet : "La Femme du pêcheur" 765
1891 UFPS  Mme Fanny Crozier : "Bretonne, buste plâtre" 8
1891 SI    Mlle Anna Boch : "Moisson en Flandre" *113
1891 SI    Mlle Anna Boch : " Cueillette" *114
1891      Mme M. Harrison : "La vieille au fagot ; - forêt de
              Fontainebleau" 808
1891      Mlle F. Ducrot : "Bûcheron ; - statue marbre" 2482
1892      Mlle J. Taconet : "Maison de paysans, à Saint-Vigor" 1567
1892      Miss I. Thompson : "Fisherfolk ; - pêcheuses" 1601
1892      Mlle B. Imer : "Un Pêcheur du Pollet (Dieppe) ; buste
              plâtre" 2715
1892      Mme N. Tarnowska-Andriolli : "Faucheur ; statue, plâtre"
              3106
1892      Mlle A. Bilinska : "Paysan polonais ; pastel" 1756
1892      Mlle A V Guysi : "Confidences" 839 (ill.)
1892      Mme M. Loire : "Souvenir de Normandie" 1100 (ill.)
1892 SI    Mlle Marie Derondel : "Etude de vieille paysanne" 360
1892 SI    Mme Doutreleau : "Pâtres en hiver" 379
1892 SI    Mlle Anna Boch : "Le retour de la pêche" 154
1892 SI    Mlle Jeanne Cheilley : "Ramasseuses de bois (Etude d'
              hiver) - aquarelle" 267
1892 SI    Mme Jeanne Cheilley : "Retour de l'herbe ; étude" 268
1893      Mme M. Pillini : "Bretonne du Morbihan" 1425
1893      Mme H-M Trevor : "La mère du marin" 1716
1893      Mlle J. Andiffred : "Etude de paysan ; - plâtre" 2522
1893      Mme E.C Nallet-Poussin : "Bohémienne ; buste plâtre" 3231
1894      Mme G. de Bigot : "Tête de pêcheur" 187
1894      Mme S. Blackstone : "Venant du marché" 201
1894      Mme V-E Demont-Breton : "Fils de pêcheurs" 577
1894      Mme M. Guyon : "Un rôdeur" 896 (ill.)
1894      Mme J. Houston : "Un intérieur hollandais" 945
1894      Mme Loire : "Ramasseuses de pommes de terre" 1190
1894      Mme M. Pillini : "Les Bretonnes le dimanche" 1470 (ill.)
1894      Mme I-M Ross : "Au marché" 1589
1894      Mme Bartin-Audiffred : "Etude de paysan ; - statue bronze"
              2738
1894      Mlle G. de Fargues : "Enfant pêcheur ; - statuette bronze"
              3073
1894      Mme M. Thomas-Soyer : "Retour des champs ; - statuette
              bronze" 3638
1895      Miss F-A Saltmer : "La Fenaison à Surrey" 1705
1895      Mme S-W Talcott : "Paysanne hollandaise" 1794
1895      Mlle M. Fresnaye : "Gardeuse d'oies" 3095
1895      Mme C-M Bénédicks-Bruce : "Blanchisseuses de rivière ;
              aquarelle" 2012
1895      Mme F. de Mertens : "Paysans en prière ; Val-Thoré (Tarn)"
              1346 (ill.)
1895 SI    Mlle Claire  Dufour : " Femme du peuple" *437
1895 SI    Mme Jeanne Firmin-Badois : "Vieille paysanne reprisant
              un sac" *524
1895 SI    Mme Madeleine Saint-Héran : "La Miette, paysanne du
              Bourbonnais" *1346
1895 SFA   Fanny Fleury : "Jeunes filles de Pont-Aven" 31
1895 SFA   Frédérique Vallet : "Les Filles du Pêcheur" 91
1895 SN    Mlle Elisabeth Nourse : "Le repos des faneuses" 952
1895 SN    Mlle Elisabeth Nourse : "Intérieur breton" 953
1895 SN    Mlle Elisabeth Nourse : "Fillette bretonne" 954
1895 SN    Mlle Elisabeth Nourse : "Fillette bretonne" 955
1896 SFA   Mme Marie-Geneviève Duhem : "Gardeuse d'oies" 28
1896 SFA   Mme FannyFleury : "Famille Bretonne" 41

```
1896 SN Mary Macrae : "Le rémouleur" 1518
1896 Mlle A. Bouillier : "Aux champs" 276
1896 Mlle E-G Cohen : "La petite pêcheuse" 484
1896 Mlle E. Desjeux : "Rémouleur" 644 (ill.)
1896 Mlle I. Doré : "Bretonne ; étude" 694
1896 Mlle E-J Gardner : "Dans les champs" 873
1896 Mme M-S Greene : "Paysanne hollandaise" 946
1896 Mlle C. Hildebrand : "Paysanne de l'Anjou ; bords de la
 Loire" 1039
1896 Mme W-B Newman : "La fille du marin" 1498
1896 Mlle M. Pillini : "Le dimanche en Bretagne" 1603
1896 Mlle M. Pillini : "Jeune fille bretonne" 1604
1896 SI Mme Marie Derondel : "Jeune Bergère" *303
1896 SI Mme Amedée Guerara : "La Chevrière (souvenir de la Creuse)"
 *493
1897 Mlle L. Malfiâtre : "Pêcheuses ; mer du Nord" 1108
1897 Mlle A. Watkins-Hathway : "La femme d'un pêcheur" 1734
1897 Mlle M. Briand : "Vieux paysan" 2756
1897 Mlle B. Girardet-Imer : "La braconnier" 2993
1897 Mlle C. Monginot : "Un faucheur" 3220 (ill.)
1897 Mlle M. Arosa : "La pêche à la Senne (Bretagne)" 35
1897 Mlle S. Bolling : "Pêcherie de saumon en Norvège" 198
1897 Mlle A-L De Coninck : "Bretonne à l'église" 466
1897 Mlle C-H Dufau : "Fils de mariniers" 573 (ill.)
1897 Mlle F-A Fuller : "Travail d'été ; fille à la brouette" 681
 (ill.)
1897 SI Mme C. Espinet : "Batteuses de blé" *369
1897 SI Mme C. Espinet : "Moissonneurs" *370
1897 SI Mme Pauline Rita-Rey : "Lavandières, Ile de Brehan" *992
1898 Mme G de Bigot : "Le pêcheur" 204
1898 Virginie Demont-Breton : "Hommes de mer" 632 (ill.)
1898 Mlle J-B Maillart : "Jeune Bretonne ; étude" 1363
1898 Mme F. de Mertens : "Raccommodeur de filets ; Martignes" 1445
1898 Mlle C. Shuttleworth : "Le marché" 1856
1898 Mlle H-M Trévor : "Intérieur breton" 1972
1898 Mme A. Woodward : "Récolte de pommes de terre en Hollande"
 2088
1898 Mlle B-A Moria : "Bretonne" 3694
1898 Mlle M. Wolf : "Bretonne" 3939
1898 Maximilienne Guyon : "Sur la grande route" 990
1898 Virginie Demont-Breton : "Hommes de mer" 632 (Musée d'
 Amiens)
1898 Virginie Demont-Breton : "Dans l'eau bleue" 633 (Petit
 Palais, Paris)
1898 SFA Mlle Louise-Marie Guichard : "Bretonne ; dessin" 182
1898 SFA Miss F.P. Plimsoll : "Laitière hollandaise" 184
1898 SFA Miss F.P Plimsoll : "Paysanne à la pompe" 185
1898 UFPS Mme Cécile Chennevière : "Allant traire les vaches ;
 aquarelle" 118
1898 UFPS Mlle Suzanne-Marie-Hortense Dupuy : "Marin Breton ; pastel"
 193
1898 UFPS Mlle Manuelita Grimaud : "Miniatures"
 3. "Etude de tête bretonne" 249
1898 UFPS Mme Eugénie Gruyer-Brielman : "Miniatures" including
 "Tête de bretonne" 255
1898 UFPS Mme Isabelle Hervé : "Vieille femme, souvenir d'Auvergne ;
 aquarelle" 273
1898 UFPS Mlle Marguerite Joseph : "L'Attente du troupeau ; aquarelle"
 287
1898 UFPS Mlle Marguerite Joseph : "La Récolte des pommes de terre ;
 aquarelle" 288
1898 UFPS Mlle Jeanne Lapointe : "Bretons" 309
```

1898 UFPS Mlle Marie Villedieu : "Tête de vieille paysanne ; pastel"
545
1898 UFPS Mlle Charlotte Monginot : "Un Faucheur ; statue plâtre" 16
1898 UFPS Mlle Charlotte Monginot : "Paysanne, statue plâtre" 18
1898 SN   Mlle Campbell Macpherson : "Retour de la pêche" 803
1899      Mlle G. Achenbach : "Pendant la moisson" 6
1899      Mme J-L-L Brouilhony : "Concarneau ; femme de pêcheur" 301
1899      Mme M. Caire : "Le rémouleur " 351
1899      Mlle Ch.Chauchet : "Intérieur breton dans les environs de
Quimperlé" 435
1899      Mlle A. Delasalle : "Le terrassier" 594
1899      Mlle J. Lauvernay : "Vieux pêcheur breton" 1144
1899      Mlle E.B. Macfarland : "Pêcheuses nettoyant des poissons"
1277
1899      Mlle J. Mellor : "Pêcheuse hollandaise" 1378
1899      Mlle C. Morgand : "Pêcheur" 1434
1899      Mlle L. Ramsay-Lamont : "Glaneuse" 1619
1899      Mlle S. Watkins : "Petite Hollandaise" 1987
1899      Mme M-L Barbier-Saint-Hilaire née Delahaye : "Au lavoir"
3179 sculpture
1899      Mme G. Dumontet : "Le soir du haleur" 3429
1899      Mme A. Forestier-Barbe : "Batelier" 3462
1899      Mlle M. Gallaud : "Vieux chemineau" 3490
1899 SI   Mlle Marie Botkine : "Paysanne tourangeoise" *17
1900      Mlle E-A-S-M Belloc : "Pêcheuse faisant un filet" 94
1900      Mlle E-Y Diéterlé : "Semeur ; - figure, plâtre" 1938
1900      Angèle Delasalle : "La Forge" 392
1900      Mme J. Cerbelaud-Pigelet : "Pêcheuse de Saint-Jaent
(Bretagne)" (illustrated, but not listed in the
catalogue)
1900      Mme G. de Bigot : "La bergère" 129
1900      Mlle L. Boulanger : "Petites faneuses" 175 (ill.)
1900      Mlle M. Calvès : "Récolte du goémon" 242
1900      Mlle I. Cay : "Tête de vieille Bretonne" 267
1900      Mlle C. Chauchet : "Apprêt de poissons par la mère
Closmadeuc, environs de Saint-Brieuc" 293
1900      Mme E-L Cooper : "Intérieur hollandais" 329
1900      Mlle A. Delasalle : "La forge" 392
1900      Mlle M. Joseph : "Bretonne" 710
1900      Mlle A de F Parsons : "Famille de pêcheurs, à Volendam
(Hollande)" 1026
1900      Mme G. Pignon : "Souvenir de Bretagne" 1064
1900      Mlle M. Gallaud : "Bretonne" 1971

H6. In addition to those just mentioned in the text :-
1880      Mme A. Doutreleau D'Amsinck : "Sans mère : sans foyer (1870-
1)" 1215
1881      Mlle G de Pomaret : "Recréation à l'orphelinat" 1903
1884      Mlle M-M Rignot-Dubaux : "Orpheline" 2045
1885 UFPS Mme Inès Debetz de Beaufond : "L'Aïeule et l'Orpheline" 18
1888      Mlle E. Keyser : "L'orphelinat de Meudon ; - le couvent
des soeurs de la Présentation" 1406 (ill.)
1888      Mme E. Strong : "Les orphelines" 2342
1889      Mme Inès de Beaufond : "L'orpheline" 159
1889      Mme E. Elias : "Les enfants de l'orphelinat militaire ; -
Angleterre" 959
1889      Mlle T. Schwartze : "Orphelinat bourgeois à Amsterdam" 2449
1889 UFPS Mme Inès de Beaufond : "L'orpheline" 40
1889 UFPS Mme Emily Elias : "Les enfants d'un Orphelinat militaire -
Angleterre" 224 (probably the same work as that
exhibited by the artist at the Salon)

```
1890 Mlle M-M Abary : "Une orpheline ; - étude" 1
1892 Marie Podlewska : "L'orpheline ; pastel" 2104
1897 Mlle L. Le Roux : "Sans aïeux" 1028 (ill.)

I6. 1880 Virginie Allart : "Mendiante" 34
1882 Mlle E-L Aréra : "Mendiants" 41
1882 Mme L. Signoret : "Qui donne aux pauvres prête à Dieu ;
 statue plâtre" 4845
1883 Mme M-J Nicolas : "Le pauvre de Villiers" 1799
1883 Mme Pillini : "Pauvre aveugle" 1925 (ill.)
1883 Mlle M. Bouvy : "Une 'Pauvrette' ; statue, terre cuite" 3383
1885 Mme Marie Macnab , née d'Anglard : "Pour les pauvres !" 1634
1885 Mlle Marie Fresnaye : "Un petit sou ; statue plâtre" 3711
 (ill.)
1886 Mlle M-A Robiquet : "Johanna la folle" 2035 (ill.)
1886 Mlle Félicie Fennebresque : "Un vieux mendiant ; - émail"
 2824
1887 Mme M. Pillini : "La charité au village" 1911 (ill.)
1887 Mlle G. Aguttes : "Un enfant du faubourg ; buste plâtre"
 3567
1888 Uranie Colin-Libour : "Charité ; intérieur d'une crèche" 617
1888 Mme J. Delance-Feurgard : "La crèche" 762 (ill.)
1888 Mlle C-M Gredelne : "Le réveillon de l'ouvrier" 1187
1888 Mlle M. Simpson : "Le déjeuner du pauvre" 2299
1888 Mlle A-M Bann'heol : "Enfant pauvre ; - buste plâtre"
 3759
1889 Mme M. Marcotte : "Intérieur pauvre ; Flandres" 1787 (ill.)
1889 Mlle E. Herland : "Pauvre aveugle" 1334
1889 Mlle M-M Marquis : " Charité s'il vous plaît !" 1801
1889 UFPS Mme la comtesse Louise de Courville : "Petite mendiante" 151
1890 Mme P. Dubron : "La lutte pour la vie" 829
1890 UFPS Mlle Marthe Delagrange : "Mendiant italien" 206
1890 UFPS Mme Pauline Dubron : "La lutte pour la vie" 258
1890 UFPS Mme Pauline Junot : "Le Travail" 405
1890 SN Mme M. Cazin : "Secours aux Malades ; bas-relief plâtre"
 1246
1891 Mme G. Bigot : "Tête de mendiant" 149
1891 Mlle P. Dubrule : "Tête de mendiant" 543
1891 SN Mlle Jeanne Bosc : "Petite mendiante ; - étude (pastel)" 978
1891 Mlle M. Heyermans : "Hospice des vieillards à Bruxelles" 827
1891 Mlle M. Heyermans : "Le réfectoire" 828
1892 Mme A. Casini : "La charité - groupe plâtre" 2394 (ill.)
1892 Mme C-E Wentworth : "Pour les Pauvres" 1691 (ill.)
1892 Mme M. Marcotte : "Un vieux" 1152 (ill.)
1893 Mlle M-S Galland : "Une pauvrette de Trégune (Finistère) ;
 buste" 2884
1893 Mlle M. Laniel : "Notre pain quotidien ; - statue platre"
 3048
1893 Mme J. Nejbert : "Fardeau quotidien ; - statue, plâtre"
 3234
1894 Mme J. Berthault : "Vieille mendiante" 166
1894 Mme C-M Thorel : "Mendiants" 1738
1895 Mlle S-B Holden : "J'ai eu faim" 969
1895 Miss C-A Lord : "Faim et Froid" 1225
1895 SN Mme Marthe de Tavennier : "Misère" 1188
1895 SN Marie Duènes d'Alheim : " Asile de nuit à l'impasse du
 Maine" 1414
1896 SFA Rongier :"'Christo in Pauperibus' . Les Pauvres" 86
1896 Mme S. Brunet : "Le mendiant" 335
1896 Mlle E. Herland : "Pour le petit reposoir , s'il vous
 plaît" 1027 (ill.)
1896 Mlle L. Ludina : "Sans asile" 1297
```

```
1896 Mme L-A Muntz : "Leçon de chant des aveugles" 1488
1896 SI Claire Dufour : "Voleuses et Mendiants" *324
1897 Uranie Colin-Libour : " Charité" 507
1897 SN Mme Clara-J McChesney : "Le pauvre" 281
1897 Mlle Marc Mangin : "Soupes populaires" 1120
1898 Mme L. Arden : "Les pauvres" 43
1898 Mme S. Brunet : "Mendiant à la pipe" 328
1898 Mme J. Comte : "Petite mendiante" 514
1898 Mlle M. Ducoudray : "Une humble" 3374
1898 UFPS Mlle Yvonne Keszler : "Misère" 290
1899 Mlle M. Ducoudray : "Une humble" 3423
1900 Mlle Léonie Michaud : "Fleurs du pauvre" 941
1900 Mlle Louise Ribot : "Mendiants" 1121
1900 Mlle Juliette Strarosch : "Petite vagabonde" 1241
1900 Mme M- A Marcotte : "Chez les Pauvres" 889
1900 Emma Herland : "Chez les soeurs du Saint-Esprit" 658
 (ill.)
1900 Mme G. Morin : "Une épave" 965
1900 Mme J. Bisson : "Epave" 1845
```

```
J6. 1812 Mlle Sohier l'aînée : "Une servante tricotant dans sa
 cuisine" 857
1814 Mlle Jenny Legrand : "Une marchande de poissons, et
 différens ustensiles" 613
1817 Mlle Jenny Legrand : "Une Marchande de poissons" 509
1822 Mme Haudebourt-Lescot : "Une marchande de toile" 675
1824 Mme Haudebourt-Lescot : "La marchande d'oeufs" 875
1824 Mlle Jenny Legrand : "Une marchande de marrons" 1116
1824 Mlle Jenny Legrand : "Une marchande de légumes" 1117
1824 Mlle L. D'Orival de Criel : "Une fileuse" 1278
1824 Mlle Pénavère : "Une fileuse dans une cuisine" 1319
1825 Mme Haudebourt-Lescot : "Une Maîtresse d'école Italienne"
 37
1827 Mme Dehérain : "Une fileuse" 287
1827 Mme Joubert (née Drolling) : "La marchande de balais alle-
 mande" 601
```

```
K6. 1831 Mlle I. Esménard : "Une bouquetière" 731
1833 Mme Dabos : "La marchande de lilas dans un cabaret" 516
1835 Mme Dabos : "Jeune marchande de cérises au canton de
 Berne" 467
1838 Mme Feytaud : "Une marchande d'oranges bordelaise" 677
1840 Mme Louise Desnos : "La petite marchande de balais" 440
1841 Mlle Elisa Blondel : "Une petite marchande de fruits" 172
1843 Mlle Augusta Le Baron : "La marchande de fruits" 720
1844 Mme Louise Burgot : "Une musicienne ambulante" 249
1844 Mme Juliette de Ribeiro : "La petite marchande de pêches"
 1527
1848 Mme Mathilde Lagache : "La marchande de fleurs (costume
 anversoise)" 2558
1849 Mlle Emma Blanche : "Une marchande de fruits" 189
```

```
L6. 1834 Mlle A. Savary : "Une fileuse ; étude au pastel" 1748
1838 Mlle Antoinette Asselineau : "Une vieille fileuse" 34
1840 Mlle Adèle Ferrand : "La vieille fileuse" 568
1841 Mlle Eugénie Henry : "L'aumône de l'ouvrière" 975
1844 Mlle Amanda Fougère : " Fileuse au fuseau ; étude" 707
1845 Mlle Mélanie Paigné : "La fileuse ; pastel" 1959
1846 Mme Céleste Pensotti : "Pauvre Fileuse" 1403
1846 Mlle Adèle Ferrand : "La vieille fileuse" 646
```

M6. 1853    Mlle Amanda Fougère : "La petite marchande d'oeufs" 479
    1853    Mlle Pauline Malherbe : "Marchande de perdrix" 796
    1859    Mme Marie Barsac : "La marchande de cerises" 154
    1861    Mlle Pauline Malherbe : "Marchandes irlandaises" 2082
    1863    Mme Becq de Fouquières née Louise-Marie de Dreux :
                "Fileuse ; pastel" 1935
    1865    Mlle Emilie Ray : "La cuisinière" 1786
    1866    Mme Lucile Doux : "L'anxiété de la cuisinière" 609
    1866    Mlle Louise Grandmaison : "La bonne" 861
    1866    Mlle Elisa Koch : "Fileuse endormie" 1047
    1866    Mme MacNab née Marie D'Anglars : "La fleuriste de Saint-Leu ;
                dessin" 2384
    1868    Mlle Marie Brosset : "Jeune servante revenant du marché" 361
    1868    Mlle Alexandrine Joannis : "L'écaillère" 1327
    1868    Mme La vicomtesse Reille : "Une soubrette" 2105
    1868    Mlle Cécile Paviot : "Une fileuse ; aquarelle" 3196
    1869    Mlle Marie Brosset : "Une fileuse" 340
    1869    Mlle Jeanne Samson : "Fileuse" 2130
    1870    Mme Adélaide Salles-Wagner : "Musicienne des rues" 2553
    1870    Mlle Amanda Fougère : "Marchande de buis" 1086
    1872    Mme Uranie Colin-Libour : "La servante" 361
    1872    Mlle Cécile Ferrere : "La bouquetière de Trianon" 619
    1872    Mme Louise Eudes de Guimard : "Une marchande de poulets" 192
    1873 SR  Mme Jeanne Nevers : "La Bouquetière" 266
    1875    Mme Alix de Lapérelle : "Fileuse" 1227 (Musée de Châlons-sur-
                Marne)
    1875    Mme Laure Lacombe : "Une fileuse" 2437
    1876    Mlle Pauline Aurens : "Betsy, la bouquetière" 1211
    1876    Mme Jeanne Limousin : "Une chiffonnière, à Antibes" 1330
    1876    Mlle Jeanne Rongier : "Fileuse endormie" 1765
    1877    Mlle Clémentine Tompkins : "Rosa, la fileuse" 2036
    1878    Mme Uranie Colin-Libour : "Une servante" 542
    1878    Mme Louise Dubréau : "Chanteuse des rues" 797
    1879    Mme Jeanne Fichel (née Samson) : "La fleuriste" 1221
    1879    Mlle Eugénie Lebouvier : "La bouquetière ; - statue plâtre"
                5160
    1879    Mme Cécilia Rosabel : "Ma charbonnière" 2589

N6. 1880    Mlle Marie Dubois : "Une laveuse" 1242
    1880    Mme Jeanne Limosin d'Alheim : "Marchande de poissons à
                Arles" 27
    1880    Mme Berthe Edward : "Fileuse" 1337
    1882    Mme J. Fichel : "La cuisinière" 1030
    1882    Mme J. Limosin d'Alheim : "Une laveuse de vaisselle" 1684
    1882    Mme Petiet : "Blanchisseuses" 2107
                (Reviewed and illustrated in "L'Art" 1882 vol. 3
                pp 146, 148-150)
    1882    Mme F. Schneider : "La Grande Lessive" 2424
    1884    Mlle C. de Certain : "Marchande de fleurs" 474
    1884    Mlle J. Scapre-Pierret : "Petite marchande de légumes" 2164
                (ill.)
    1884    Mlle M. Petiet : "Vieille Femme d'Aulus" 1897 (ill.)
    1884 SI  Mme Aline-Marguerite Sisos : "Marchande de fleurs" 201
    1884 UFPS Mme Langlois née Roelly : "La Fileuse" 147
    1884 UFPS Mlle Alice Marais : "Vieille fileuse (la Bourboule)" 161
    1885    Mlle Marie Petiet : "Plumeuses d'oies" 1962 (ill.)
    1885    Mlle Marie-Madeleine Del Sarté : "Ma Bonne" 757
                (reviewed in "L'Art" 1885 vol. 1 p 214)
    1885    Mme Joséphine-Claire Langlois née Roelly : "La fileuse" 1442
    1885    Mlle Marie-Luisa de la Riva : "La marchande de fleurs, à
                Madrid" 2094

```
1885 Mlle Marie-Noémie Flandrin : "Ma femme de chambre" 2781
1885 UFPS Mme Mathilde Worms : "Une Laveuse" 271
1886 Mlle Georges Achille-Fould : "La remouleuse" 8
1886 Mlle Consuelo Fould : "Chiffonnière" 962
1886 Mlle Rosine Cahen : "Trois pour deux sous, madame !" 2625
1886 Mlle Lucie Signoret-Ledieu : "La fileuse ; - statuette
 bronze" 4550
1886 SI Mme Béatrice Berriat-Blanc : "Marchande de lampons - une
 Rousse" *40
1886 UFPS Mme Aimable Beuscher : "Petite bouquetière" 39
1886 UFPS Mlle Marie Magdeleine Del-Sarte : "Ma bonne" 109
1886 UFPS Mme Signoret : "Fileuse, statuette bronze" 22
1887 Mlle G. Achille-Fould : "Marchande de plaisirs" 11
1887 Mlle L. Lamont : "Vieille Normande à son rouet" 1367 (ill.)
1887 UFPS Mlle Herminie Waternau : "Une cuisinière" 309
1888 Mlle G. Achille-Fould : "Marchande de pommes de terre
 frites" 8 (ill.)
1888 Mlle A-E Klumpke : "A la buanderie" 1408 (ill.)
1888 Mme D. de Cool : "Les bouquetières" 630
1888 SI Mlle Henriette Authier : "Bouquetière bourbonnaise" *34
1888 SI Mme Béatrice Berria-Blanc : "Ma Bonne" 79
1889 Mlle B. Atkinson : "Les laveuses" 57
1889 Mme M. Beaumetz-Petiet : "L'écaillère" 161
1889 Mlle A. Weitz : "Au travail" 2724 (ill.)
1889 Mlle Félicie d'Estienne : "Laveuse" 975
1889 Mlle O. Valborg : "Bouquetière" 2602 (ill.)
1889 SI Mme Madeleine Saint-Héran : "Fileuse, paysanne du centre"
 *223
1889 UFPS Mme Frances Fraser : "Fileuse bretonne ; dessin" 261
1889 UFPS Mme Adélaide Salles-Wagner : "Bouquetière de Capri ;
 aquarelle" 581
1890 Mlle B. Callac : "Fileuse bretonne" 428
1890 Mlle M-L Etcheverry : "Marchande de fleurs" 882
1890 Mme Marie Loire : "La bouquetière" 1529
1891 Mlle L. Thornam : "Marchande de poissons ; - Danemarck" 1591
1891 SI Léonie Faynon : "Laveuse" 513
1891 UFPS Mlle Marguerite Arosa : "Laveuses (Bretagne)" 16
1891 UFPS Mme Fournier Del Florido : "Vendeuse de fleurs ; aquarelle"
 314
1891 UFPS Mme Fournier Del Florido : "Vendeuse de fleurs" 315
1891 UFPS Mlle Charlotte Mésange : "La Bonne de chez nous" 556
1891 UFPS Mme Marguerite Pillini : "Laveuses bretonnes (Finistère)" 660
1891 UFPS Mlle Cécile Schlatter : "Bouquetière, éventail - aquarelle"
 708
1892 Mlle C. Fould : "Marchande de fleurs à Londres" 703 (ill.)
1892 SN Harriet Campbell-Foss : "Ouvrière fleuriste" 415
1894 Mlle L.R Wahl : "Fileuse bretonne ; - Douarnenez" 1835
1894 Mme E. Herland : "Marchande de rubans" 927 (ill.)
1894 Mme I-M Ross : "Fileuse vénitienne" 1588
1895 Mme C-M Bénédicks-Bruce : "Blanchisseuses de rivière ;
 aquarelle" 2012
1895 Mme M-G Duhem : " Fleuriste ; pastel" 2248
1895 Mlle M-M Guillot : "Une repasseuse ; pastel" 2367
1895 SFA Frédérique Vallet : "Soubrette ; pastel" 92
1895 SFA Cécile Chennevière : "Blanchisseuses" 120
1895 SN Mlle Elisabeth Nourse : "Fileuses russes" 951
1896 Mlle B. Noriac : "Petite savetière" 1506
1896 SFA Mme Fanny Fleury : "La Fileuse" 42
1897 Mlle J. Comte : "La petite marchande de buis" 412
1897 Mlle M. Tholotte : " Fileuse" 3419
1897 SI Elise-Désirée Firnhaber : "La bouquetière" *380
```

1897 SN    Mlle Marie Villedieu : "Marchande de fleurs" 1228
1897 SN    Katherine McCausland : "Fileusesbretonnes" 1358
1897 SN    Mlle Clémence Molliet : "Fileuse bretonne" 1636
1897 SN    Mlle Marguerite Parguez : "Miniatures"
               1. "Marton la bouquetière" 1676
1898 UFPS Mme Pauline Delacroix-Garnier : "Une laveuse" 158
1898 UFPS Mme Agathe Doutreleau D'Amsinck : "Une Fileuse" 183
1898 UFPS Mme Marcelle Huntington : "La lettre de recommandation ;
               aquarelle" 280
1899       Mlle M. Carpentier : "Marchande de fleurs, au faubourg" 374
               (ill.)
1899       Mlle S-V Goncalves : "Fileuse de Minho (Portugal)" 884
1899       Mlle B. Mackiewicz : "Marchande d'oignons" 1284
1899       Mme E. Rousteaux-Darbour : "Petite marchande d'oranges" 1721
1900       Mlle C. Morgand : "Marchande de légumes" 964
1900       Mme M. de Montille : "Fileuse normande" (illustrated but
               not listed in the catalogue)
1900       Mme A Gonyn de Lurieux : "Les derniers jours" 590 (ill.)

06. 1883     Mme Eva Gonzalès : "Une modiste ; pastel" 2852 (illustrated
               in Claude Roger-Marx op.cit.)
1883       Mlle Marie Petiet : "Ouvroir"
               (This work was not listed in the catalogue. It was
               exhibited according to a reviewer of the Salon of
               the following year ("L'Art" 1884 vol. 1 p 212))
1884       Mlle Marie Petiet : "Lingerie" 1896 (ill.)
               (Reviewed in "L'Art" 1884 vol. 1 p 212)
1884       Mlle J. Rongier : "La mansarde" 2078 (ill.)
1884 UFPS Mlle Marie Petiet : "La lingerie" 185
1886       Mlle Amélie Lacazette : "Seule ressource d'une orpheline"
               1312
1887       Mlle I. Venat : "Les deux orphelines" 2372 (ill.)
1895       Mme L-G de la Bouglise : "Couturières" 257
1895 SFA   Frédérique Vallet : "Modiste parisienne ; pastel" 94
1896 SI    Lucie Conkling : "Brodeuses sur métier" *228
1898       Mlle N. Schmitt : "Brodeuse ; étude" (illustrated but not
               listed in the catalogue)
1900       Mme Juliette Comte : "Modiste au travail" 324

P6. 1884     Mlle I. Venat : "Tisseuse de lin à Morlaas" 2357
1884       Mlle Thérèse Paraf-Javal : "La dentellière ; aquarelle" 3068
1891 UFPS Mme Mary Aub : "Dentellière flamande" 18
1892       Mme Ruth Garnett : "La Petite dentellière" 1891
1894       Mme M. Aub : "Marie l'Anversoise ; - Dentellière" 41
1894 SN    Gabrielle Achenbach : "Une dentellière de Langeac (Haute-
               Loire)" 1
1897 SI    Mme Maria Greuillet : "Tisseuses" *472
1898       Mme L. Krafft Villars : "Dentellière normande" 2023
1900       Mlle F. Plimsoll : "La dentellière de Bruges" 1071

Q6. As Mme L.G. :-
1800       "Un tableau peint à l'huile, représentant des
               ustensiles de ménage" 235
        As Mlle Jenny Le Grand :-
1801       "Tableau représentant des ustensiles de ménage" 220
        As Mlle Jenny Legrand :-
1802       "Une table de cuisine chargée d'ustensiles de
               ménage" 179
1804       "Deux petits tableaux représentant des ustensiles
               de cuisine" 289
1806       "Un intérieur avec des ustensiles de ménage" 346

| | |
|---|---|
| 1808 | "Une jeune fille" |
| | "Elle est occupée à donner à manger à des lapins dans un intérieur orné d'ustensiles de ménage" 374 |
| 1808 | "Une vieille femme" |
| | "Elle prépare des légumes à côté d'un groupe d'ustensiles de cuisine" 376 |
| 1810 | "Une jeune paysanne donne à manger à des petits poussins, sous un hangar rempli de divers ustensiles" 489 |
| 1814 | "Une marchande de poissons, et différens ustensiles" 613 |
| 1814 | "Ustensiles de ménage et légumes" |
| | "On y voit une jeune femme jouant avec son enfant" 614 (Musée de Montpellier) |
| 1822 | "Scènes familières, légumes et ustensiles de ménage" 838 |
| 1824 | "Un dessous de porte rustique, avec figures et ustensiles de ménage" 1115 |
| 1831 | "Intérieur avec figures et ustensiles de ménage" 1316 |

# VOLUME FOUR

## ILLUSTRATIONS

1. An engraving which appears on the title page of Mrs. Ellis'
   "Morning Call.    A Table Book of Literature and Art" 1850 vol.1

2. "The Female School of Art (Queen Square), 1868"
   "Illustrated London News" June 20 1868 vol. 52 p.616

3. Engraving showing the mixed antique class at the Slade School
   in 1881. Illustration in "Illustrated London News" Feb.26 1881 p 205

4. Adrienne Marie Louise Grandpierre-Deverzy : "Intérieur d'un
   atelier de peinture" 1822 (S.no.605). The work depicts the
   studio of her husband, Abel Pujol. Oil on canvas. 96 by
   129 cm. Paris, Musée Marmottan

5. Marie Bashkirtseff : "L'Académie Julian" 1881. Oil on
   canvas. 4' 6" by 6'. State Hermitage Museum, Leningrad

6. "A l"Académie Julian - Un coin de l'atelier, pendant la pose
   du modèle".    Photograph in "Fémina" Feb. 15 1903 vol. 3
   no. 50 p.440

7. "A l'Ecole des Beaux-Arts". Photograph in "Fémina" Feb. 15
   1903 vol. 3 no. 50 p.439

8. Henrietta Mary Ada Ward : "Queen Mary quitted Stirling
   Castle .." 1863 (RA no. 386) Engraving in the Witt Library

9. Henrietta Mary Ada Ward : "Palissy the Potter" 1866 (RA
   no. 385) Oil on canvas. 42½ by 52". Leicester Art Gallery.
   Engraving in Witt Library

10. Henrietta Mary Ada Ward : "The Maid of Orleans" or "Scene
    from the Childhood of Joan of Arc" 1867 (RA no.523).
    Engraving in the Witt Library

11. Emily Mary Osborn : "The Escape of Lord Nithisdale from the
    Tower, 1716" 1861 (RA no.258) Oil on Canvas. 52  by 40½"
    Christie's Sale May 25 1979

12. Anna Lea Merritt : "Love Locked Out" 1890 (RA no.32) Oil
    45½ by 25¼". London, Tate Gallery

13. Henrietta Rae :"Psyche before the throne of Venus" 1894 (RA
    no. 564) Oil on canvas. 76  by 120" Photograph in Witt
    Library

14. Henrietta Rae : "Apollo and Daphne" 1895 (RA no.621) Oil
    Photograph in Witt Library

15. Anna Lea Merritt : "War" 1883 (RA no.560) Oil on canvas.
    40½  by 55". Bury Art Gallery, Lancashire

16. Jessie Macgregor : "In the Reign of Terror" 1891 (RA no.
    1109). Oil on canvas . 92 by 72 cm. Walker Art Gallery,
    Liverpool

17. Jessie Macgregor : "Arrested" 1894 (RA no.311) Oil on
    canvas . 50  by 30" Cutting in Witt Library

18. Sarah Setchel : "Ye shall walk in silk attire" 1848 (NSPW no.54) water-colour 23 by 18¾". Victoria and Albert Museum Vaughan Bequest

19. Sarah Setchel : "The Momentous Question" 1842 (NSPW no.58) water-colour. 23 by 18¾". Victoria and Albert Museum, Vaughan Bequest

20. Fanny McIan : "The Little Sick Scholar" 1841 (RA no.79) Engraving in the Witt Library

21. Elizabeth Siddal : "The Eve of St. Agnes". Gouache. 6½ by 4¾". The National Trust, Wightwick Manor, Staffordshire

22. Elizabeth Siddal : "Illustration to 'Macbeth'". Drawing Ashmolean Museum, Oxford

23. Emily Mary Osborn : "Home thoughts" 1856 (RA no. 519) Oil on canvas.71 by 90 cm. Sotheby's Belgravia Sale July 9 1974

24. Anna Blunden : "The Song of the Shirt" 1854 (SBA no.133) Engraving in "Illustrated London News" July 15 1854 vol. 25 p.37

25. Emily Mary Osborn : "Nameless and Friendless" 1857 (RA no. 299) Oil on canvas. 34 by 44". Collection, Sir David Scott

26. Margaret Gillies : "Trust" 1860 (RA no. 776) Water-colour 24 by 12". Victoria and Albert Museum, London

27. Sophie Anderson : "Elaine" 1870 (RA no. 482) Oil on canvas 62" by 94" Walker Art Gallery Liverpool

28. Lucy Madox Brown : "Romeo and Juliet" 1870 (DG 1871 no.336) Panel 24 by 32". The National Trust, Wightwick Manor, Staffordshire

29. Margaret Sarah Carpenter : "Richard Parkes Bonington" 1833 (SBA 1833/4 no.68) Oil 29 by 24". National Portrait Gallery London

30. Clara Maria Pope : "Composition of flowers in the vase presented to Edmund Kean". Water-colour. Castle Museum Nottingham

31. Anne Frances Byrne : "Grapes and Starwberries" water-colour 7½ by 10¼". Victoria and Albert Museum, London

32. Louise Jopling : "Weary Waiting" 1877 (RA no. 1372) Oil 43 by 33". Sotheby's Belgravia Sale March 25 1975

33. Margaret Murray Cookesley : "The Gambler's Wife" 1897 (Liverpool Autumn Exhibition of Pictures, Walker Art Gallery). Oil on canvas. 59 by 41½". Towneley Hall Art Gallery, Burnley

34. Margaret Sarah Carpenter : "The Lacemaker" (RA 1848 no. 234?) Cutting in Witt Library

35. Mary Ann Sharpe : "Portrait of a young girl" 1830 ("Girl
    Sketching" SBA 1830 no. 721 ?) Water-colour. 20" by 14".
    Abdy London 1932 . Photograph in Witt Library

36. Emma Brownlow : "The Foundling restored to its Mother" 1858
    (RA no. 1013) Oil  30" by 40". Thomas Coram Foundation for
    Children (Foundling Hospital)

37. Alice Mary Havers : "The End of Her Journey" 1877 (RA no.
    1378).Oil on canvas 59⅞ by 85⅞".Rochdale Art Gallery

38. Marie Josephine Angélique Mongez : "Orphée aux Enfers"
    (S. 1808 no. 435) Engraving in Witt Library

39. Pauline Auzou : "Agnès de Méranie" (S. 1808 no. 11)
    Engraving in Witt Library

40. Constance Mayer : "Venus et l'Amour endormis, caressés et
    reveillés par les zéphyrs" 1806 (S. no. 375) Oil on canvas. 97.5
    by 145.7 cm.Wallace Collection, London

41. Marie Josephine Angélique Mongez : "La Mort d'Adonis"
    (S. 1810 no.577). Engraving in Witt Library

42. Marie Josephine Angélique Mongez : "Persée et
    Andromède" (S. 1812 no. 658). Engraving in Witt Library

43. Mlle Béfort : "Thesée et Ariadne" (S. 1812 no. 40). Engraving
    in Witt Library

44. Pauline Auzou : "L'Arrivée de Marie-Louise au château de
    Compiègne" 1810 (S. 1810 no. 21) Oil on canvas. Musée National
    du Château de Versailles

45. Félicie de Fauveau : "Christine, reine de Suède, refusant de
    faire grâce à son grand écuyer Monaldeschi" (S.  1827 no.1785)
    Musée de Louviers

46. Julie Philipault : "Racine lisant 'Athalie' devant Louis XIV
    et Mme de Maintenon" (S. 1819 no.895) Oil  . 114 by 146cm.
    Louvre, Paris

47. Sophie Rude : "La duchesse de Bourgogne arretée aux portes de
    Bruges" (S. 1841 no. 1763) Oil on canvas. 183 by 150cm. Musée
    de Dijon

48. Marcello (Adèle d'Affry) : "Bianca Capello" (S. 1863 no. 2471)
    marble bust. 95 cm high. Musée des Beaux-Arts, Marseille

49. Marcello : "La Gorgone" (S. 1865 no. 3067 ; marble bust). A bronze
    bust of the same is illustrated in "Connoisseur" April 1972 p.233

50. Henriette Browne : "L'Alsace ! 1870" (S. 1872 no. 221)
    Engraving in Witt Library

51. Mme Léon Bertaux : "Psyché sous l'Empire du Mystère" (S. 1897
    no. 2701) bronze 179cm high, 45cm wide. Paris, Luxembourg

52. Elizabeth Harvey : "Malvina pleure la mort d'Oscar ; ses
    compagnes cherchent à la consoler" (S. 1806 no. 247)
    Musée des Arts Décoratifs, Paris

53.    Eugénie Marguerite Servières : "Sujet tiré du roman de
       'Mathilde', par Mad. Cottin" (S 1812 no. 845). Engraving
       in the Witt Library

54.    Marie Guilhelmine Benoist : "Portrait en pied de S.A. la
       duchesse Napoléon Elisa, princesse de Piombino, fille
       de S.A.Mme la grande duchesse de Toscane" (S 1810 no. 34)
       Musée National du Château de Versailles

55.    Mlle Aimée Thibault : "Portrait en pied de S.M. le Roi de
       Rome, peint d'après nature" (S. 1812 no. 891)
       Engraving in the Cabinet des Estampes of the Bibliothèque
       Nationale, Paris

56.    Julie Duvidal de Montferrier : "Mme Campan" Oil 65 by 55 cm
       Musée de Picardie, Amiens

57.    Mme de Mirbel : "Portrait de Louis XVIII" miniature 6  by
       $4\frac{3}{4}$" (probably "Une miniature, portrait du Roi" S 1819
       no. 1675) Wallace Collection, London

58.    Mme C.-N.-J. Favart : "Portrait de feu le C. Favart père
       composant sa comédie de l'Anglais à Bordeaux" (S 1800 no.
       141). Collection, H. Pannier

59.    Gabrielle Capet : "Marie Joseph Chénier" c. 1800
       Stanford University Museum

60.    Mme Adèle de Romance (Romany) : "Portrait de Mad. Raucourt,
       dans le rôle d'Agrippine, au moment où elle dit à Néron :
       asseyez-vous, Néron" (S 1812 no. 292) Photograph in Witt
       Library

61.    Mme Marie-Louise Lefèvre-Deumier : "Le Prince-Président de
       la  République" (S. 1852 no. 1447) marble bust. The
       illustration depicts a bronze bust of the same in the Musée
       de Châlons-sur-Marne

62.    Thérèse Schwartze : "Dr. J.L. Dusseau" Oil on canvas. 81 by
       65.5 cm. Rijksmuseum, Amsterdam

63.    Thérèse Schwartze : "Mlle Thérèse Schwartze faisant son
       portrait" (S. 1888 no. 2271)
       Uffizi Gallery

64.    Anna Bilinska : "Portrait de l'auteur" (S. 1887 no. 234)
       Oil.  117 by 90 cm, Muzeum Narodowego, W Krakowie

65.    Amélie Beaury-Saurel : "Mme Séverine" (S. 1893 no. 101)
       Oil on canvas.  121 by 87 cm. Musée Carnavalet, Paris

66.    Amélie Beaury-Saurel : "Une doctoresse" (S.1892 no. 98)
       Illustrated in "L'Art" 1892 vol. 52 p.239

67.    Amélie Beaury-Saurel : "Portrait de l'auteur" (S. 1887 no.
       2585). Drawing. Illustrated in "L'Art" 1887 vol. 43 p.10

68.    Amélie Beaury-Saurel : "Portrait de l'auteur" (S. 1894 no.
       117). Illustrated on page 156 of the Paris Salon exhibition
       catalogue

no. 2798) marble bust . Musée de Châlons-sur-Marne

70.    Elisa Bloch : "Maria Deraisme" (S.1895 no. 2890). Illustrated on page 271 of the Paris Salon exhibition catalogue

71.    Marguerite Gérard : "Les premiers pas ou la mère nourrice" or "Une mère nourrice présentant le sein à son enfant, que lui amène une gouvernante" (S. 1804 no. 202) Oil. 63 by 65 cm Collection, E. Cognacq

72.    Mme Jeanne-Elizabeth Chaudet (née Gabiot) : "Une jeune fille pleure un pigeon qu'elle chérissait et qui est mort" (S. 1808 no. 122) Oil. 130.5 by 97 cm. Musée des Beaux-Arts, Arras

73.    Pauline Auzou : "Daria ou l'effroi maternel" (S.1810 no.22) Engraving in the Witt Library

74.    Constance Mayer : "L'heureuse mère" (S. 1810 no. 554) Oil on canvas. 194 by 147 cm. Louvre, Paris

75.    Constance Mayer : "La mère infortunée" (S.1810 no. 555) Oil on canvas. 193 by 144 cm. Louvre, Paris

76.    Pauline Auzou : "Le premier sentiment de la coquetterie" (S. 1804 no. 8) Oil on canvas . 55 by 42". Paris, Collection Auzou family

77.    Mme Constance Charpentier (née Blondelu) : "La Mélancolie" (S. 1801 no. 58) Oil on canvas. 130 by 165 cm. Musée de Picardie, Amiens

78.    Mme Marie Cazin : "Désolation". Engraving in the Witt Library

79.    Mlle Z. Durruthy : "Encore seule !" (S. 1897 no. 593) Illustrated on page 79 of the Paris Salon exhibition catalogue

80.    Mme Haudebourt-Lescot : "Portrait de l'artiste" 1825.Oil on canvas. 74 by 60 cm. Paris, Louvre (probably one of the portraits exhibited as no. 547 at the Salon of 1827. See Chapter 4, E5)

81.    Constance Mayer : "Portrait en pied d'un père et de sa fille. (Il lui indique le buste de Raphael, en l'invitant à prendre pour modèle ce peintre célèbre)"(S.1801 no. 238) Collection, J. Seligmann et fils in 1927 (Edmond Pilon op.cit.)

82.    Mme Josephine Houssay : "La leçon" 1894 (S.1894 no. 944) Photograph in Witt Library

83.    Mlle Jenny Legrand : "Intérieur de cuisine". Engraving in Witt Library (possibly the "Intérieur" exhibited at the Salon of 1819 (no. 731) with the description : "On y voit une vieille femme riant du dégoût qu'éprouve un enfant en regardant des huîtres")

84.    Virginie Demont-Breton : "Femme de pêcheur venant de baigner ses enfants" (S. 1881 no. 675). Engraving in the Witt Library

85.    Virginie Demont-Breton : "La Famille" (S. 1882 no. 799) Illustrated on page 147 of the Paris Salon exhibition catalogue

86.    Uranie Colin-Libour : "Emigration" or "L'Emigrante" (S.1885 no.

596). Illustrated on page 123 of the Paris Salon exhibition catalogue (See Chapter 4 note 366)

87.    Mlle I. Venat : "Les deux orphelines" (S.1887 no. 2372) Illustrated on page 229 of the Paris Salon exhibition catalogue

88.    Mlle M-B Mouchel : "Le soir de la paye" (S. 1897 no. 1232) Illustrated on page 86 of the Paris Salon exhibition catalogue

89.    Uranie Colin -Libour : "Le lendemain de la paye" (S. 1896 no. 488). Illustrated on page 117 of the Paris Salon exhibition catalogue

90.    Mlle M. Carpentier : "Marchande de fleurs, au faubourg" (S. 1899 no. 374)  Illustrated on page 39 of the Paris Salon exhibition catalogue

91.    Mlle Consuelo Fould : "Marchande de fleurs, à Londres" (S. 1892 no. 703) Photograph in Witt Library

92.    Mlle Jeanne Rongier : "La Mansarde" (S. 1884 no. 2078) Illustrated on page    of the Paris Salon exhibition catalogue

93.    Madeleine Lemaire : Untitled picture depicting three women in a greenhouse. Photograph in the Witt Library

94.    Louise-Joséphine Sarrazin de Belmont : View of Paris showing the Pont Neuf and Notre-Dame. 49 by 63". Collection M. Newman, London

95.    Margaret Sarah Carpenter : "Self Portrait". Sabin Gallery 1860 Photograph in the Witt Library

96.    Margaret Sarah Carpenter : "Devotion" (BI 1822 no. 199)Oil on canvas 3' 6" by 3'1". Victoria and Albert Museum, London (Sheepshanks Collection)

97.    Margaret Sarah Carpenter : "The Children in the Wood" or "Portraits of the artist's daughters" (BI 1828 no. 183) Oil on canvas  54   by  44½". Private Collection U.S.A. Photograph in the Witt Library

98.    Margaret Sarah Carpenter : "The Spring Nosegay" (BI 1831 no. 101) Oil on canvas. Castle Museum, Nottingham

99.    Margaret Sarah Carpenter : "Hon. Mrs. Henry Marshall" 1841 (RA 1841 no. 385) Oil on canvas. 94 by 75.5 cm. Christie's Sale,New York,Oct. 25 1977

100.    Eliza Sharpe : "Eliza Sharpe and her Sisters. Sketch of the artist seated, and drawing her two sisters, Louisa and Mary Ann" pen and ink 7¾ by 9¼"   . Department of Prints and Drawings, British Museum

101.    Eliza Sharpe : "The Widowed Bride" engraved for the "Keepsake" in 1834. Engraving in the Witt Library

102.    Eliza Sharpe : "Little Dunce" (OWS 1843 no. 110) water-colour 20 by 30½". Sotheby's Belgravia Sale July 8, 1975

103. Eliza Sharpe : "Miss Eliza Sharpe presented with a very long
bill by a remorseless creditor" pencil. 8¼ by 6". Department
of Prints and Drawings, British Museum

104. Louisa Sharpe : "The Wedding" Engraved for the "Keepsake"
of 1832. Engraving in the Witt Library

105. Louisa Sharpe : " The Unlooked-for Return". Engraved for the
"Keepsake" in 1833. Engraving in the Witt Library

106. Margaret Gillies : "Harriet Martineau". Engraved for Richard
Hengist Horne's "New Spirit of the Age" 1844 vol. 2 opposite
page 63

107. Margaret Gillies : "William and Mary Wordsworth" replica by the
artist of the original executed in 1839. Water-colour on
ivory. 11½ by 11". Dove Cottage Trustees

108. Margaret Gillies : "Kate Southey" Dec. 31 1839. Pencil.
In Dora Wordsworth's autograph book. Dove Cottage
Trustees

109. Margaret Gillies : "Portrait of Lady Charlotte Portal and
child" (RA 1859 no. 783). 16½ by 13". Sotheby's Belgravia
Sale, Feb. 27 1979

110. Margaret Gillies : "The End of the Pilgrimage" No. 1. water-
colour. 16¾ by 9⅝ " .
111. Margaret Gillies : "The End of the Pilgrimage" No. 2 water-
colour 16⅞ by 19¼"
112. Margaret Gillies : "The End of the Pilgrimage" No. 3 water-colour
16⅞ by 9⅝"(OWS 1873 no. 157 ; probably all three)
The last three    pictures  are in the Cheltenham Art
Gallery

113. Louisa Corbaux : "Friends" 1864 13½ by 9½". T.R.G. Laurence
and Son. Sale, Crewkerne Somerset, March 17 1977

114. Louisa Corbaux : "Remembrances". Engraving in the Witt Library

115. Louisa Corbaux : "The river of Yarrow". Engraving in the Witt
Library

116. Fanny Corbaux : "The Victim Bride" (BI 1832 no. 163) 2' 8"
by 2' 3". Engraving in the Witt Library

117. Louisa Marchioness of Waterford : "The Third Marquess of
Waterford" Private Collection. Photograph in Witt Library

118. Louisa Marchioness of Waterford : "Mentone Orange Woman" from
Lady Waterford's Note Book. Illustrated in Augustus Hare
op.cit. vol. 2 opposite page 390

119. Louisa Marchioness of Waterford : "Sleeping Disciples" water-
colour. 5 by 15¼". Tate Gallery

120. Louisa Marchioness of Waterford : "Jesus Christ among the
Doctors" water-colour. Illustrated on page 101 of Walter
Shaw Sparrow op.cit.

121. Louisa Marchioness of Waterford : "Relentless Time" water-
colour. H.M. the Queen

122. Eliza Bridell-Fox : "Eliza Flower". Illustrated opposite page
     70 of Richard Garnett's "The Life of W.J. Fox" London 1910

123. Eliza Bridell-Fox : "Elizabeth Barrett Browning" 1859 crayon
     1859. Sold at Sawyer's, Grafton St. in 1954. Cutting in
     Witt Library

124. Eliza Bridell-Fox : "Frederick Lee Bridell".pencil. Southampton
     Art Gallery .

125. Susan Durant : "The Faithful Shepherdess" 1863 (RA 1863 no.
     1025).Marble statue . Mansion House

126. Susan Durant : "George Grote" (RA 1863 no. 1135) marble medallion
     Photograph in the Conway Library

127. Anna E. Blunden : "Vesuvius from Fochia, 'The Dawn of Morning in
     an ancient land'" 1871 15½ by 17½". Sotheby's Belgravia Sale
     Feb. 13 1979

128. Joanna Mary Boyce (Mrs. H.T. Wells) : "Peep-bo" (RA 1861 no.
     463) Oil on canvas. 23¼ by 19¼". Illustrated in a catalogue
     for "An Exhibition of Paintings by Joanna Mary Boyce" at the
     Tate Gallery, June-July 1935

129. Henrietta Mary Ada Ward : "The Princes in the Tower" or "The
     Tower, ay, the Tower" (RA 1864 no. 565) Oil on canvas . 35
     by 32¼" . Rochdale Art Gallery

130. Emily Mary Osborn : "For the Last Time" (RA 1864 no. 555)
     Oil on canvas. 36 by 28". Collection, R.K.F. Brindley Esq.

131. Emily Mary Osborn : "God's Acre" 1866. Engraving in the Witt
     Library

132. Emily Mary Osborn : "A Golden Day-Dream" 1878 (Royal Birmingham
     Society of Artists 1878 no. 431) 21 by 36". Sotheby's Belgravia
     Sale April 18 1978

133. Emily Mary Osborn : "Portrait of Mme Bodichon" (GG 1884 no.
     197). Girton College, Cambridge

134. Lucy Madox Brown : "Après le bal" (DG 1870 no. 12). Water-colour.
     Collection, Mrs. Imogen Dennis

135. Marie-Spartali-Stillman : "Messer Ansaldo's Garden" (NG 1889
     no. 177) . Gouache. 30 by 39½". Parke-Bernet Sale, New York,
     April 9-12 1952

136. Marie Spartali Stillman : "Upon a day came sorrow unto me"
     (GG 1887 no. 303) . Photograph in Witt Library

137. Elizabeth Thompson (Lady Butler) : "Self Portrait" 1866
     Collection, Mr. Rupert Butler

138. Elizabeth Thompson : "Calling the roll after an engagement,
     Crimea" (RA 1874 no. 142) Oil on canvas. 36 by 72". H.M.
     the Queen. On loan to Camberley Staff College

139. Elizabeth Thompson : "The Return from Inkermann" (FAS 1877)
     Oil on canvas. 41¼ by 73½". Ferens Art Gallery, Kingston

upon Hull

140. Mrs. Elizabeth Butler : "Listed for the Connaught Rangers"
     (RA 1879 no. 20) . Oil on canvas. 42 by 67". Bury Art
     Gallery, Lancashire

141. Mrs. Elizabeth Butler : "The Remnants of an army : Jellalabad,
     January 13th, 1842" (RA 1879 no. 582). Oil on canvas. 52 by 92".
     Tate Gallery, London

142. Mrs. Elizabeth Butler : "Scotland for Ever !" (DG 1881) Oil on
     canvas. 40 by 76". Temple Newsam House, Leeds

143. Mrs. Elizabeth Butler : " Floreat Etona!" (RA 1882 no. 499)
     Engraving in the Witt Library

144. Lady Elizabeth Butler : "The Camel Corps" (RA 1893 no. 848)
     Oil on Canvas 55½ by 97½". Christie's Sale May 19 1978

145. Lady Elizabeth Butler : "Dawn of Waterloo" (RA 1895 no. 853)
     Falkland House

146. Ary Scheffer : "Félicie de Fauveau" 1829. Oil. 1033 by 720 cm
     Louvre, Paris

147. Félicie de Fauveau : "Monument en marbre blanc, consacré à la
     mémoire du baron Gros par Mlle Sarazin de Belmont" 1,22 metres
     high and 1,20 metres wide. Musée de Toulouse

148. Rosa Bonheur : "Le Labourage nivernais : le Sombrage" (S. 1849
     no. 204) Musée du Luxembourg

149. Rosa Bonheur : "Un pâturage" Oil on Canvas. 32 by 48 cm. Musée
     des Beaux-Arts de Lille

150. Rosa Bonheur : "Marché aux chevaux de Paris" (S.1853 no. 134)
     Oil on canvas. 96¼ by 199½"  . The Metropolitan Museum of
     Art, New York

151. Rosa Bonheur : "Sheep" 1869. Pastel on board. 13½ by 23"
     Bury Art Gallery, Lancashire

152. Rosa Bonheur : "Le Lion chez lui" 1881 (Lefèvre Gallery, April
     1882) Oil on canvas. 63¾ by 104". Ferens Art Gallery,
     Kingston upon Hull

153. Henriette Browne : "Un frère de l'école chrétienne" (EU 1855
     no. 2640) Engraving in the Witt Library

154. Henriette Browne : "Les Soeurs de Charité" (S.1859 no.433)
     Oil on canvas. 167 by 130 cm. Kunsthalle, Hamburg

155. Henriette Browne : "The Children's Room" 1867. Oil on canvas.
     62.8 by 50.2 cm. Kunsthalle Hamburg

156. Henriette Browne : "Portrait de Mme P." (EU 1878) Illustrated
     in "L'Art" 1878 vol. 14 opposite page 182

157. Henriette Browne : "Pendant la guerre" 1877. Illustrated
     in "L'Art" 1877 vol. 9 p.100

158. Edma Pontillon : "Portrait de Berthe Morisot" ca.1863
     Reproduced by M.-L. Bataille and G. Wildenstein op.cit. p.6

159. Berthe Morisot : "Deux soeurs sur un canapé" 1869. Oil on
canvas. 52.1 by 81.3 cm. National Gallery of Art, Washington
D.C.

160. Berthe Morisot : "Vue de Paris des hauteurs du Trocadéro" 1872
Oil on canvas. 46.3 by 81.3 cm. The Santa Barbara Museum of
Art

161. Berthe Morisot : "La chasse aux papillons" 1874 . Oil on canvas
46 by 56 cm . Louvre, Paris

162 Berthe Morisot : "Les lilas à Maurecourt" 1874. Oil on canvas
50 by 61 cm . Bataille and Wildenstein no. 35

163. Berthe Morisot : "Dans les blés" 1875. Oil on canvas. 46 by
69 cm. Louvre (Jeu de Paume), Paris

164. Berthe Morisot : "Jour d'été" 1879 (Impressionist Ex. 1880
no. 113) Oil on canvas, 46 by 75 cm. National Gallery, London

165. Berthe Morisot : "Le Berceau" 1872 (Impressionist Ex. 1874
no. 104) Oil on canvas. 56 by 46 cm. Louvre, Paris

166. Berthe Morisot : "Jeune femme se poudrant" 1877. Oil on
canvas. 46 by 39 cm. Louvre, Paris

167. Berthe Morisot : "Jeune femme de dos à sa toilette" 1880
Oil on canvas. 60 by 81 cm. Art Institute Chicago

168. Berthe Morisot : "Jeune femme en toilette de bal" 1879
(Impressionist Ex. 1880 no. 120) Oil on canvas. 71 by 54 cm
Louvre, Paris

169. Berthe Morisot : "Portrait de Louise Riesener" 1888
Oil on canvas. 73.5 by 93 cm. Louvre, Paris

170. Berthe Morisot : "Julie Manet et son lévrier Laerte" 1893
Oil on canvas. 73 by 81 cm. Bataille and Wildenstein no.
335

171. Berthe Morisot : "Le Cérisier" 1891 Oil on canvas. 154 by
85 cm. Bataille and Wildenstein no. 275

172. Mary Cassatt : "Miss  Cassatt's mother in a lacy blouse"
1873. Oil on canvas. 62.4 by 57.4 cm. Collection, Estate
of Mrs. Horace Binney Hare (Adelyn Breeskin 1970 no. 27)

173. Mary Cassatt : "Lydia reading the morning paper" 1878. Oil on
canvas. 78.6 by 59 cm.   Joslyn Art  Museum, Omaha,
Nebraska    (Adelyn Breeskin 1970 no.51)

174. Mary Cassatt : "Reading 'Le Figaro'" 1883. Oil on canvas.
104 by 83.7 cm. Katherine Stewart de Spoelberch, Haverford,
Pennsylvania (Adelyn Breeskin 1970 no.128)

175. Mary Cassatt : "The Family" ca. 1886. Oil on canvas. 81.2
by 66 cm. Chrysler Art Museum, Provincetown, Massachusetts
(Adelyn Breeskin 1970 no. 145)

176. Mary Cassatt : "Maternity, with baby observing spectator"
ca. 1890. Pastel on paper. 60.3 by 45.7 cm. Collection, H.
Wendell Cherry, Louisville, Kentucky (Adelyn Breeskin 1970

no. 180)

177. Mary Cassatt : "Portrait of Mrs. Robert S. Cassatt" ca.
1889. Oil on canvas. 96.5 by 68.6 cm. Collection, Mrs.
Gardner Cassatt, Villanova, Pennsylvania (Adelyn Breeskin
1970 no. 162)

178. Mary Cassatt : "The Bath" 1892. Oil on canvas. 100.3 by 66
cm. Art Institute of Chicago(Adelyn Breeskin 1970 no.205)

179. Mary Cassatt : "The Boating Party (near Antibes)" 1893
Oil on canvas. 90 by 117 cm. National Gallery of Art,
Washington D C Chester Dale Collection (Adelyn Breeskin
1970 no. 230)

180. Mary Cassatt : "Baby Charles looking over his mother's
shoulder" ca. 1900. Oil on canvas. 71 by 53 cm.
Brooklyn Museum (Adelyn Breeskin 1970 no. 325)

181. Eva Gonzalès : "Le thé". Illustrated in Claude Roger-Marx
op.cit.

182. Eva Gonzalès : "L'indolence" (S. 1872 no. 723). Photograph
in Witt Library

183. Eva Gonzalès : "Une loge aux Italiens" (Refused at the
Salon of 1874 ; exhibited at that of 1879 no. 1405)
Oil on canvas. 98 by 30 cm. Louvre, Paris

184. Louise Breslau : "Le portrait des amis" (S. 1881 no. 289)
Musée de Genève

185. Louise Breslau : "Le sculpteur Carriès dans son atelier"
(S.1887 no. 342). Musée des Beaux-Arts de la Ville de Paris

186. Louise Breslau : "Portrait de Mlle Julie Feurgard" (S.
1886 no. 336)Musée de Lausanne

187. Virginie Demont-Breton : " La Plage" (S. 1883 no. 740)
Musée du Luxembourg, Paris

188. Virginie Demont-Breton : "Stella Maris" (S. 1895 no. 575)
Engraving in the Witt Library

189. Virginie Demont-Breton : "Les Tourmentés" (S.1905 no.580)
Illustrated on page 181 of the Paris Salon exhibition
catalogue

190. Virginie Demont-Breton : "L'homme est en mer" (S. 1889 no.
796). Cutting in the Witt Library

191. Marie Bashkirtseff : "Jean et Jacques" 1883 (S.1883 no.
125) Illustration in Witt Library

192. Marie Bashkirtseff : "Le Meeting" 1884 (S. 1884 no. 116)
Luxembourg, Paris

193. Marie Bashkirtseff:"Portrait de l'auteur" Engraving in
Witt Library

194. Marie Bashkirtseff : "Portrait de l'artiste" charcoal and

white chalk. 60 by 48 cm. Petit Palais, Paris

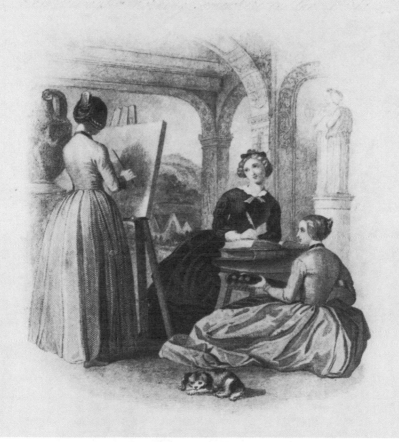

TABLE BOOK

of Literature and Art

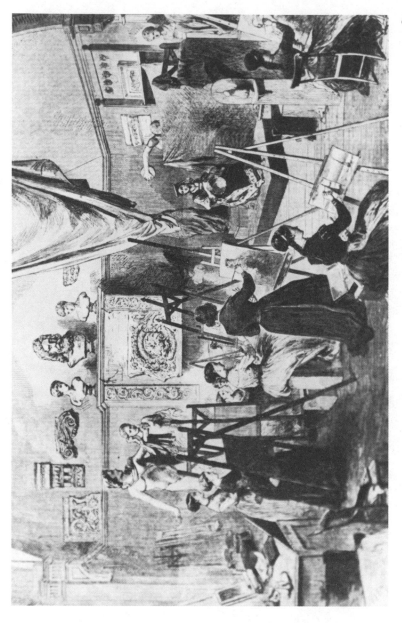

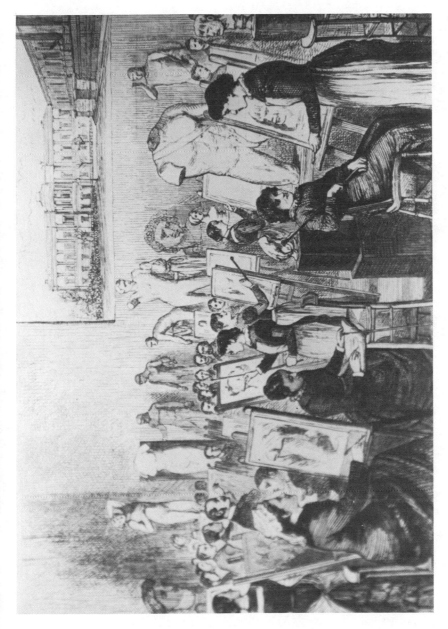

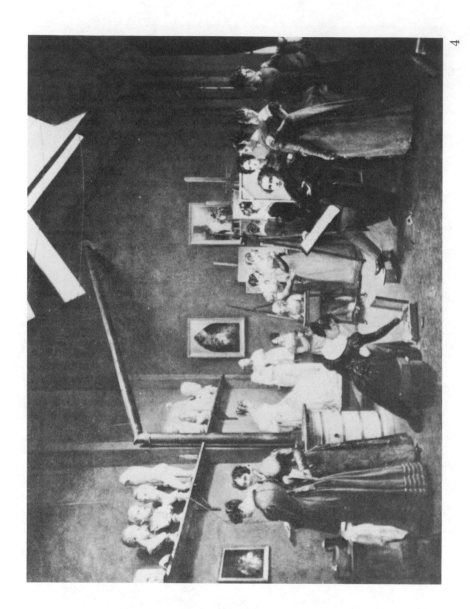

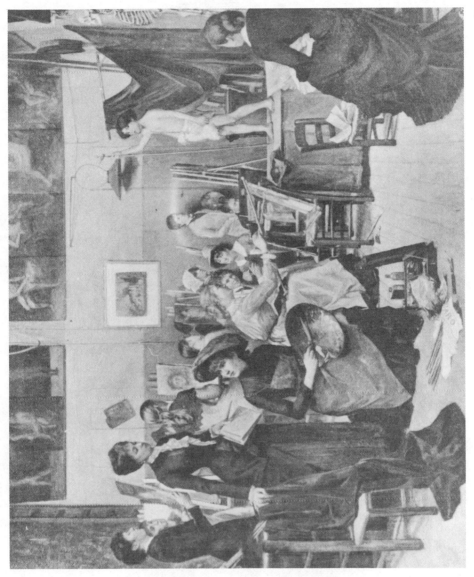

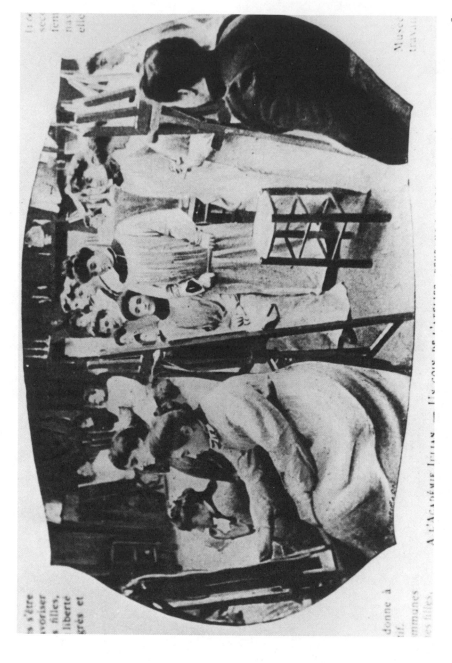

A L'ACADÉMIE IRFAN. — Un coin de l'ateliers pour [...]

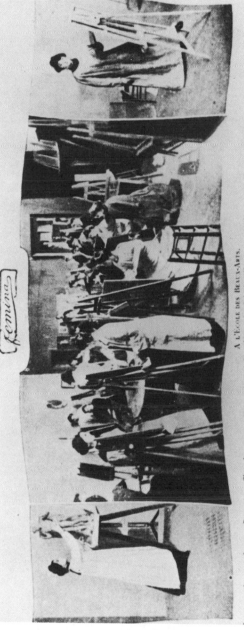

*Femina*

À L'ÉCOLE DES BEAUX-ARTS.

LA « MASSIÈRE » DE L'ATELIER BARRIAS (SCULPTURE). — C'est dans cet atelier aux murs dénudés mais où la lumière est excellente que les jeunes élèves de l'École des Beaux-Arts travaillent d'après le modèle humain. La « massière », élue par ses camarades, est chargée de l'administration de l'atelier, et des rapports avec la direction de l'École.

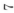

10

11

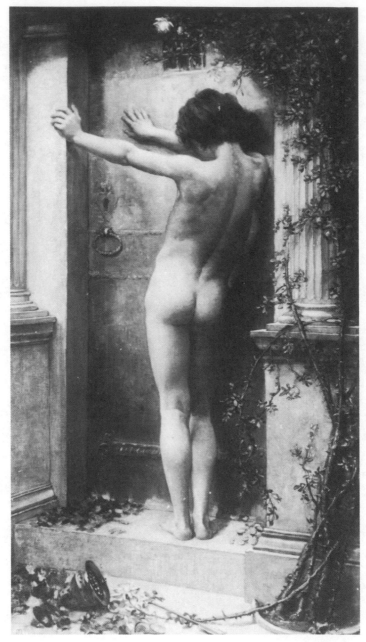

12

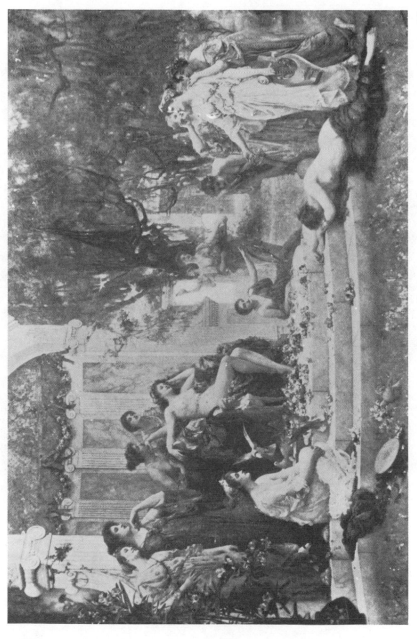

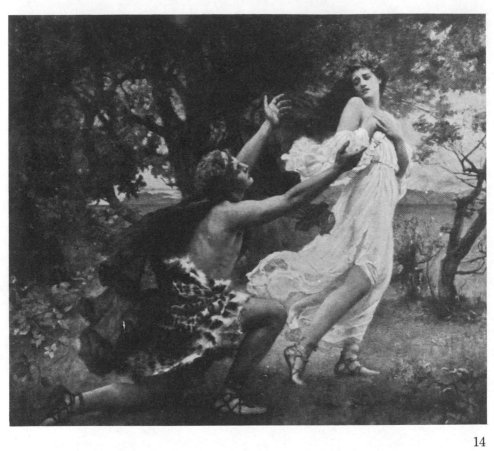

14

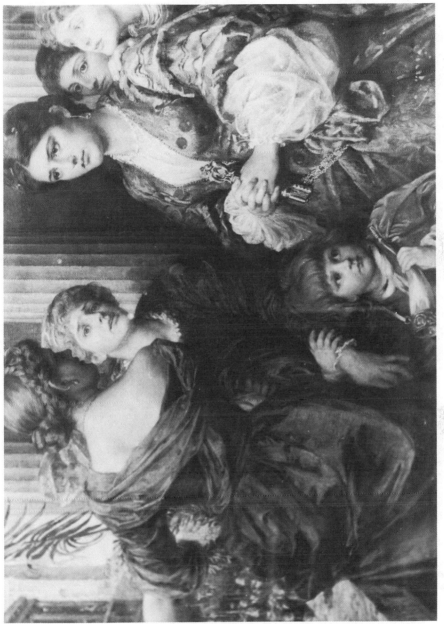

16

18

21

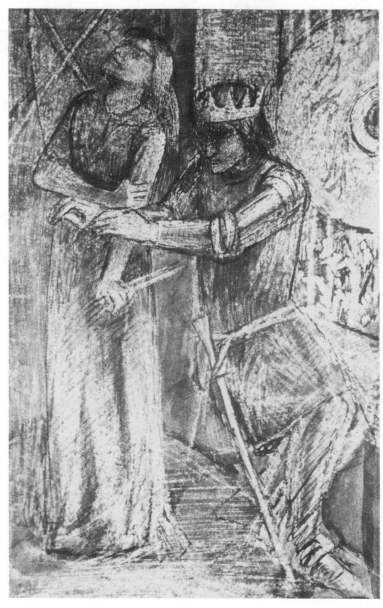

22

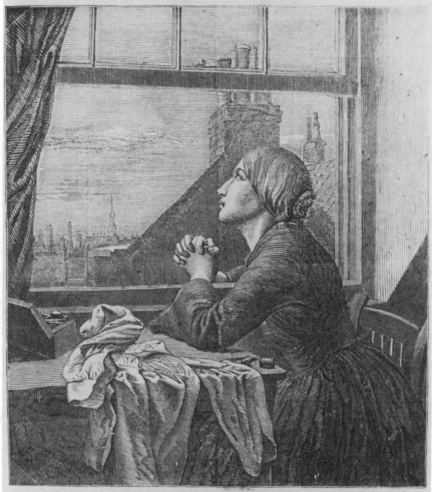

"THE SONG OF THE SHIRT."—PAINTED BY A. E. BLUNDEN.—FROM THE EXHIBITION OF THE SOCIETY OF BRITISH ARTISTS.

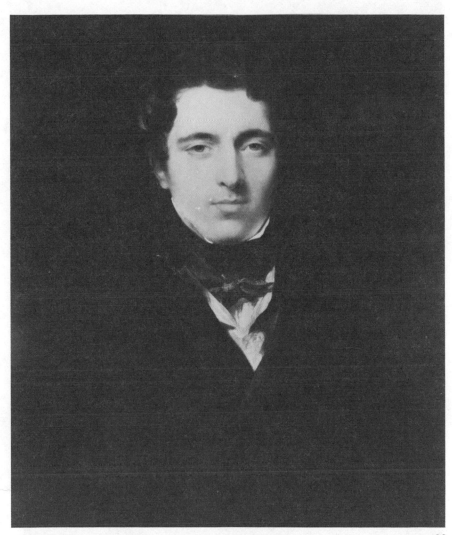

29

30

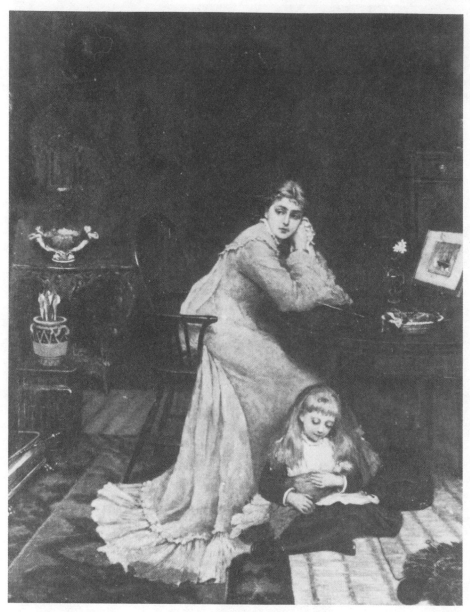

33

34

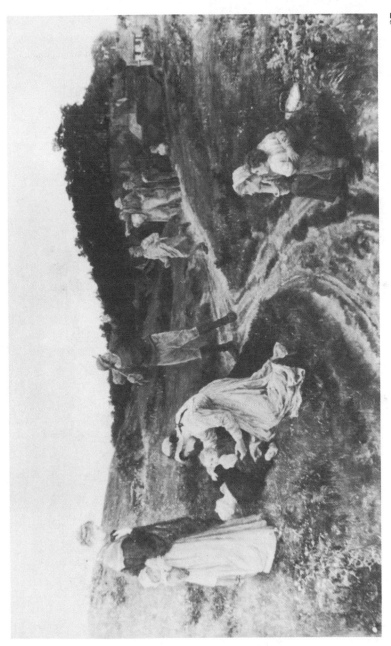

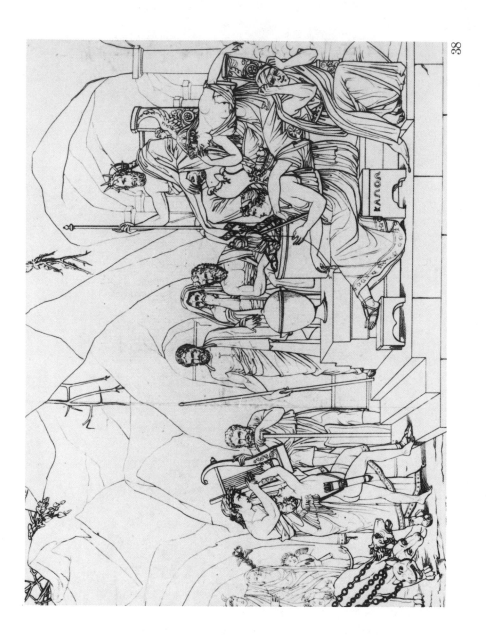

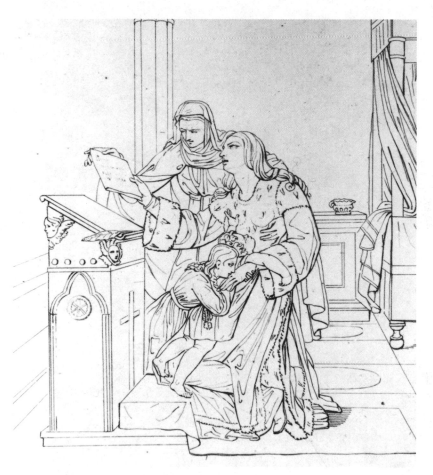

39

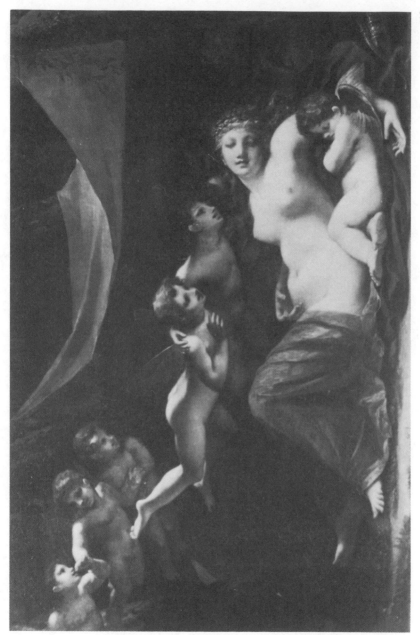

42

43

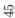

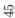

45

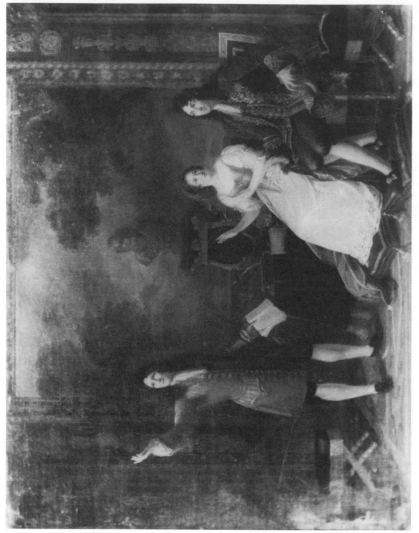

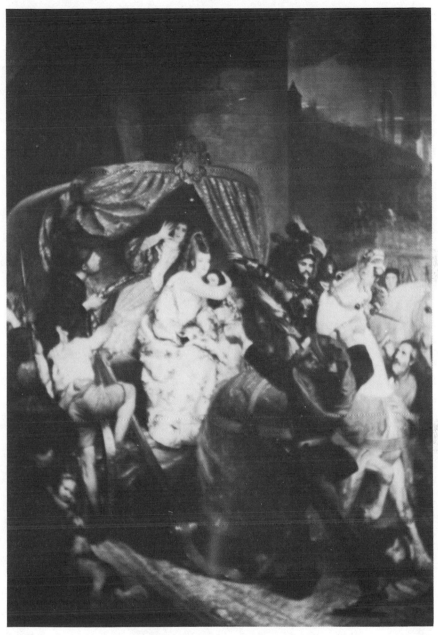

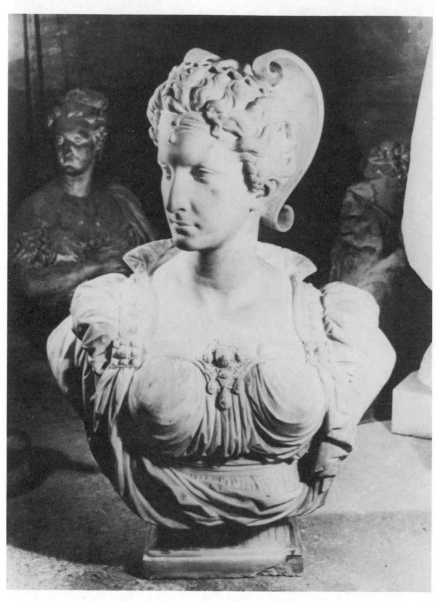

48

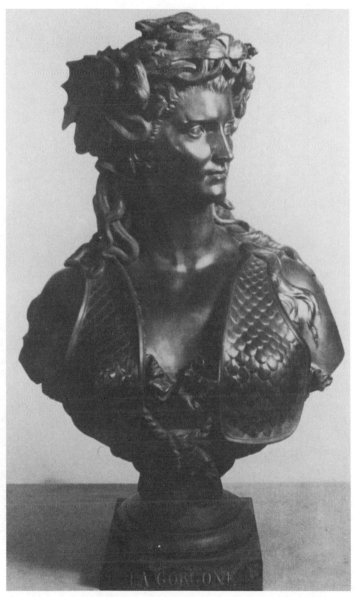

LA GORGONE

49

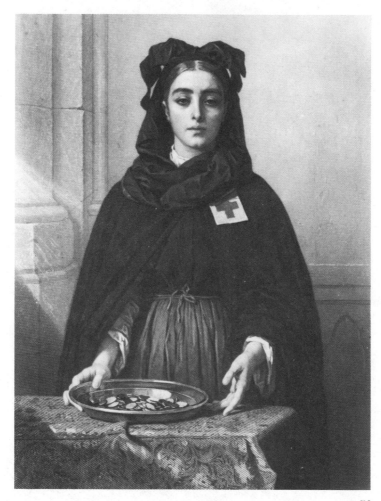

50

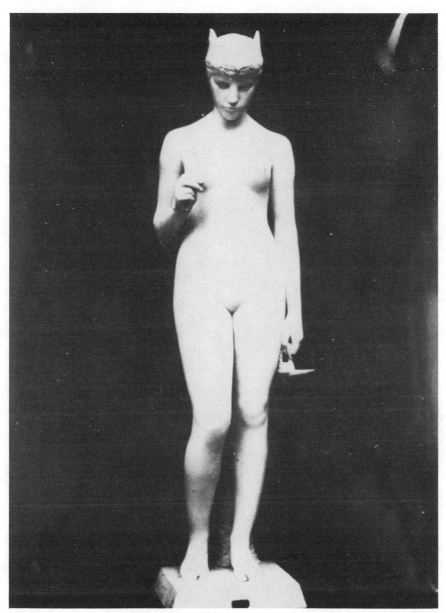

52

53

PORTRAIT DE S.M. LE ROI DE ROME,

*Dédié à Sa Majesté l'Impératrice Marie,*

*Par sa très humble et très Obéissante*
*Servante Aimée Thibault*

56

57

59

60

61

62

63

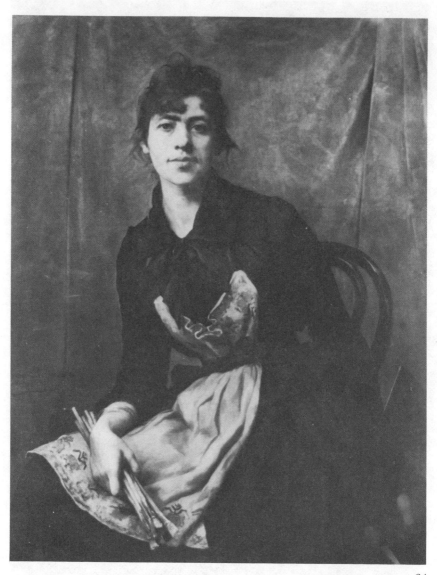

64

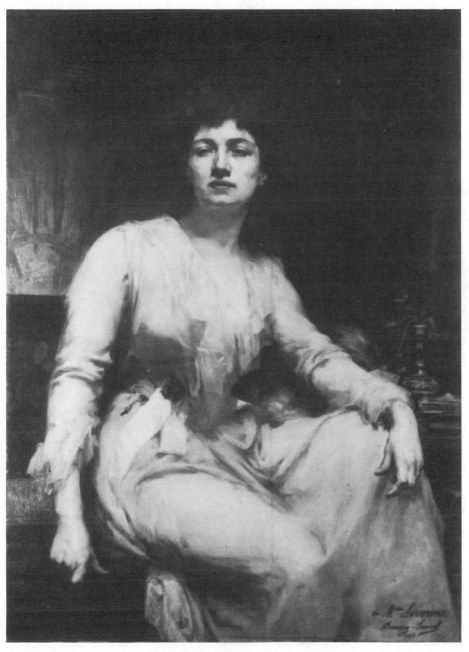

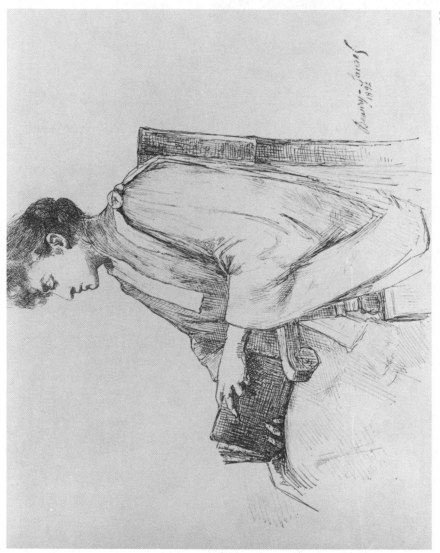

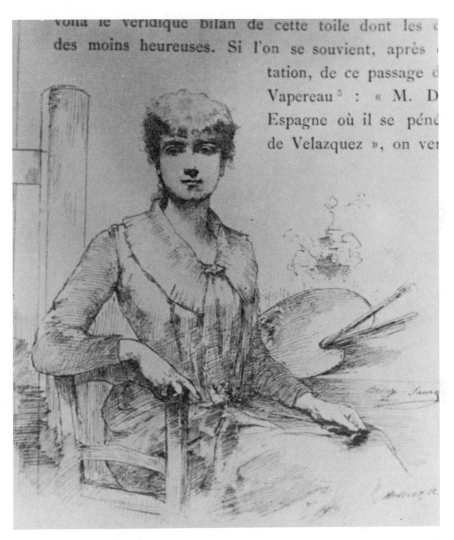

MICHELET, Sc.

Beaury Saurel

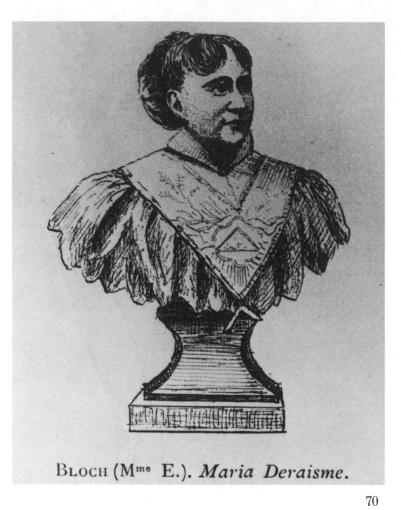

Bloch (M^me E.). *Maria Deraisme.*

72

73

74

75

76

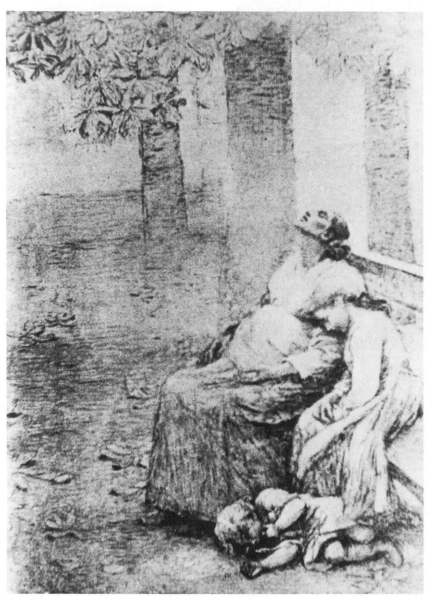

79

80

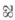

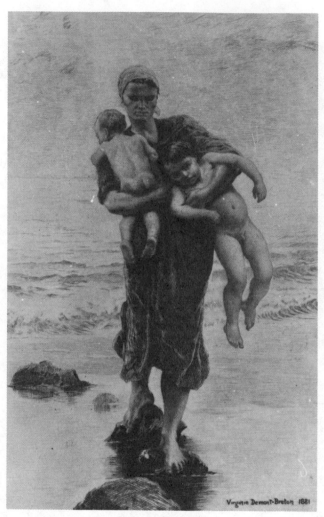

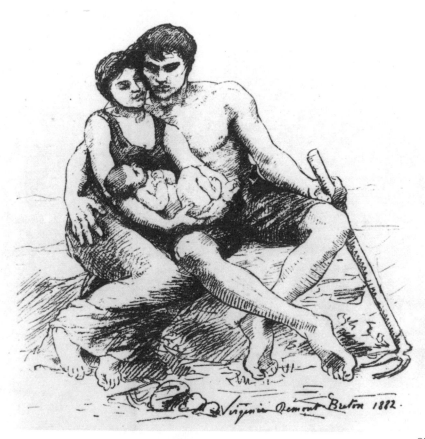

Virginia Demont Breton 1882.

85

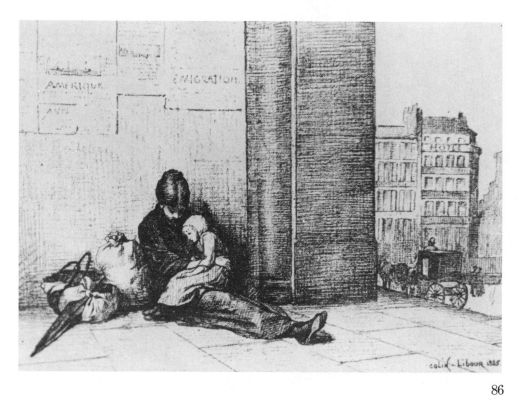

86

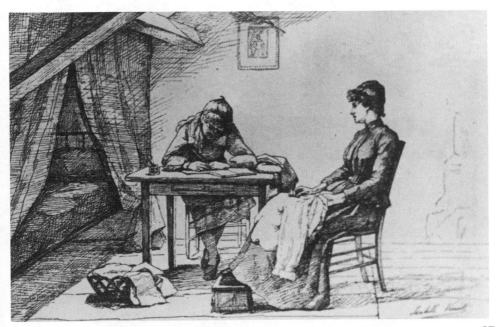

87

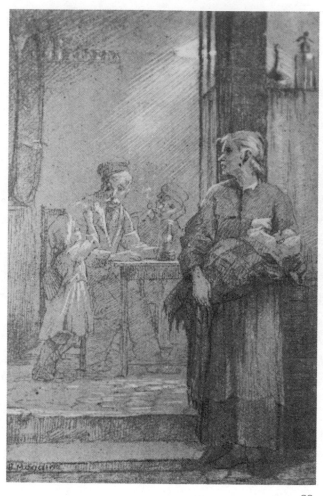

88

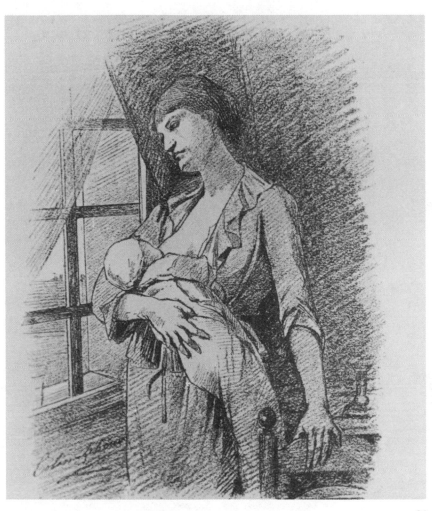

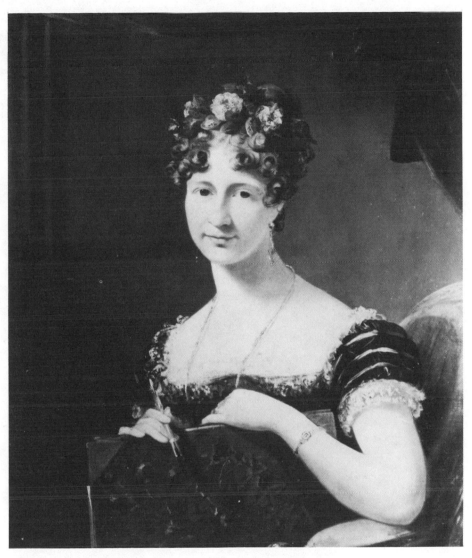

95

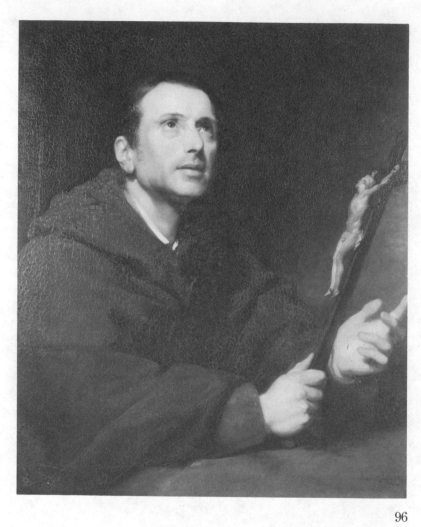

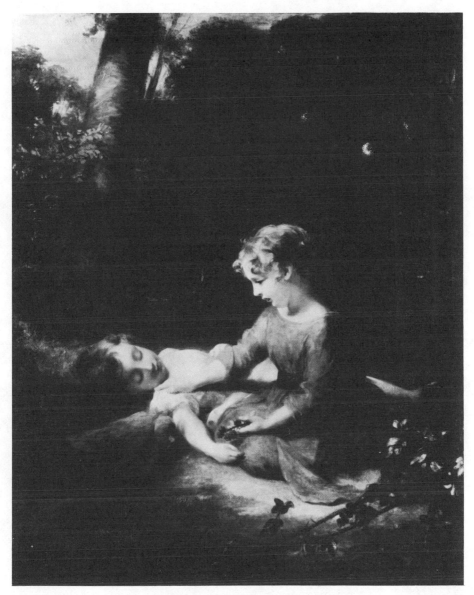

98

99

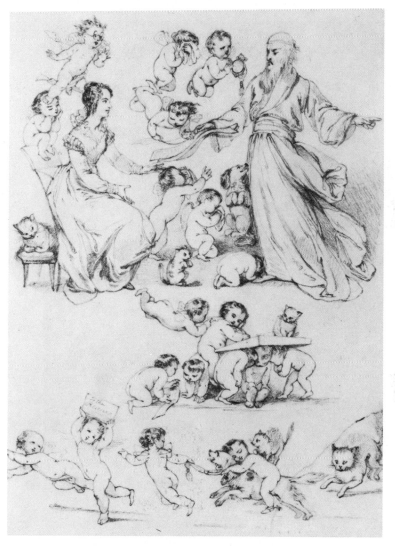

105

very truly yours

106

107

Kate Southey

Margaret Gillies
11 Dec. 183.

108

109

111

114

115

116

118

ELIZA FLOWER
From a drawing by Mrs. E. Bridell Fox

124

126

130

131

133

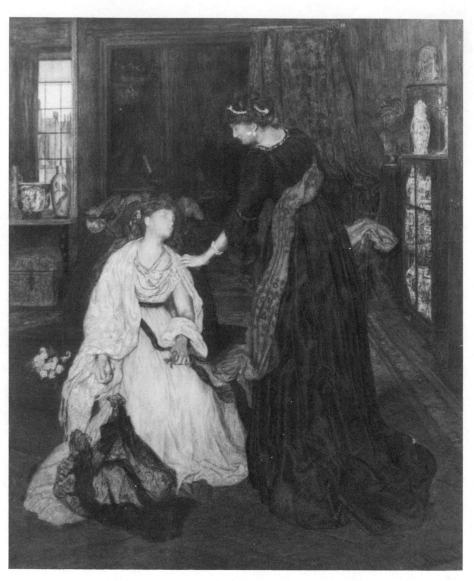

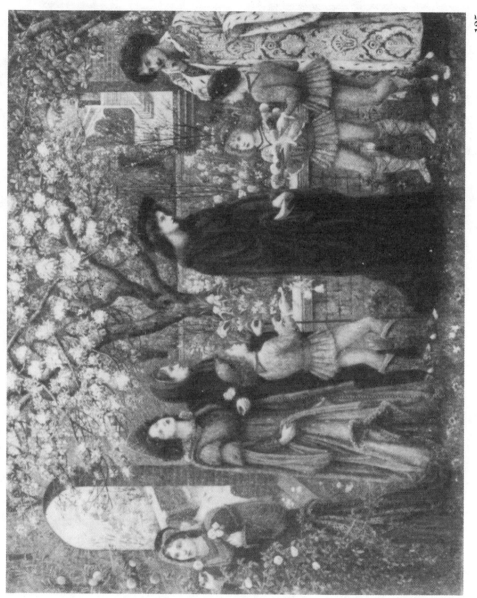

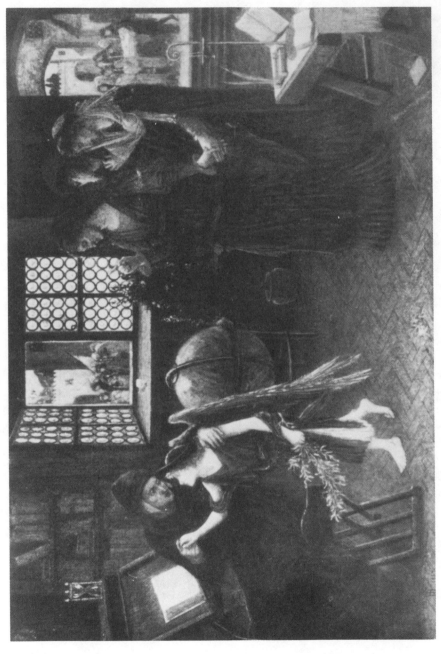

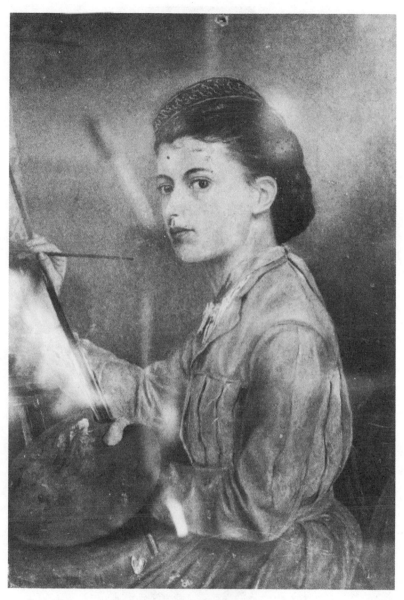

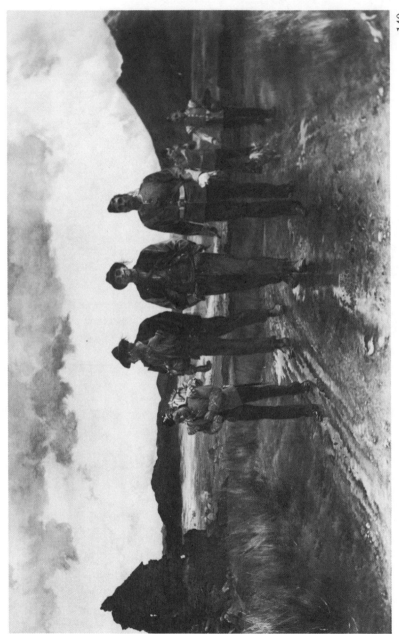

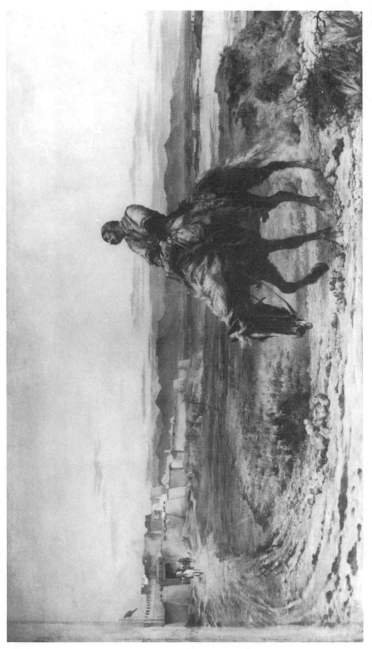

143

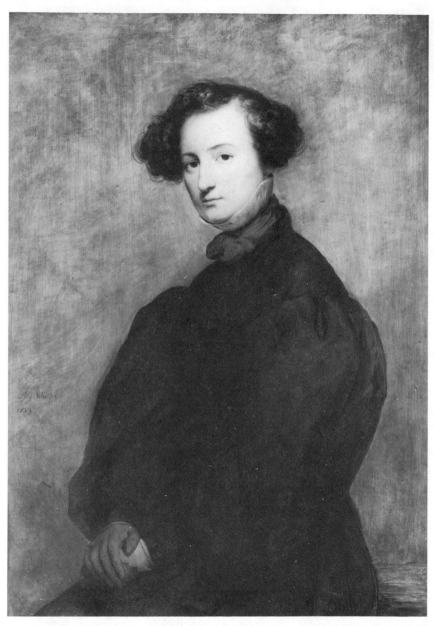

146

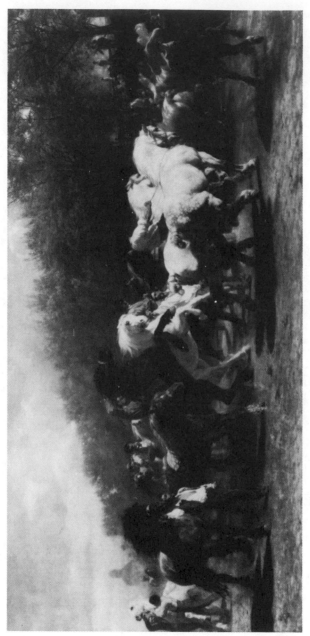

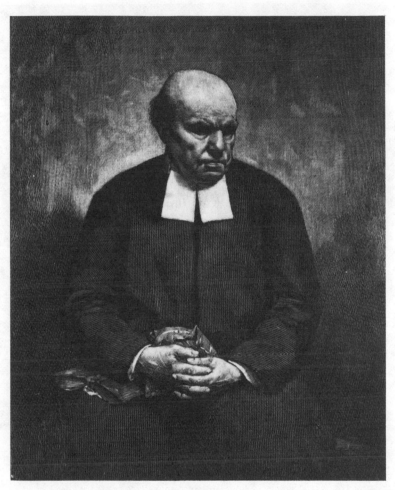

153

154

155

156

157

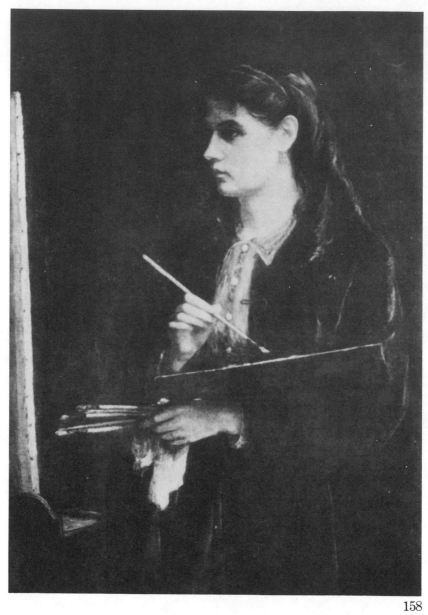

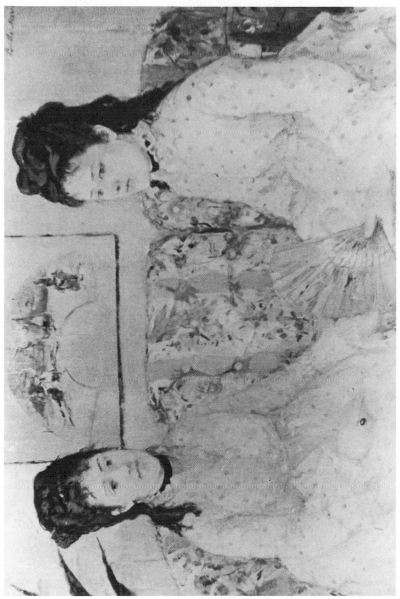

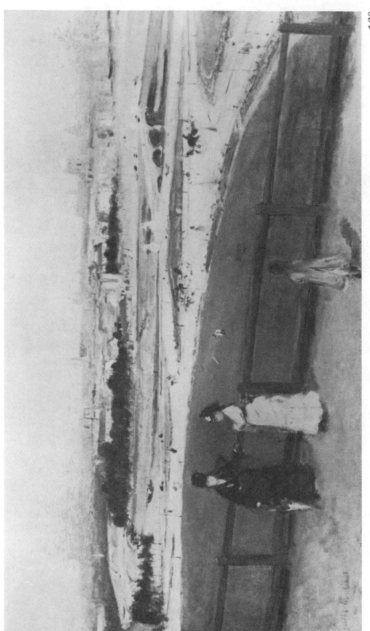

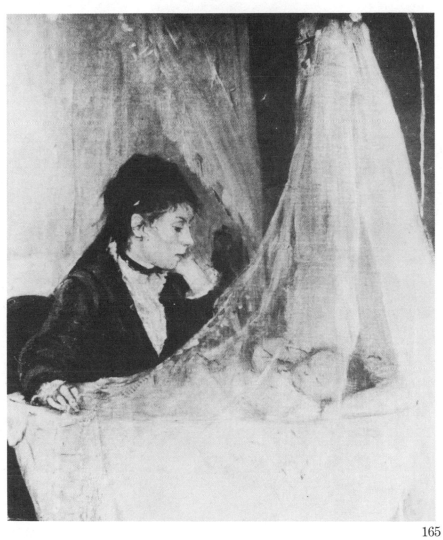

165

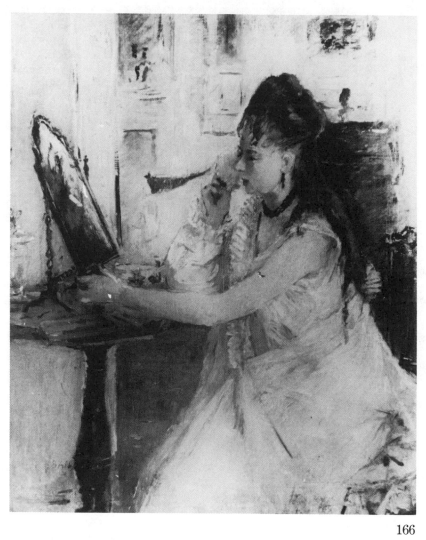

166

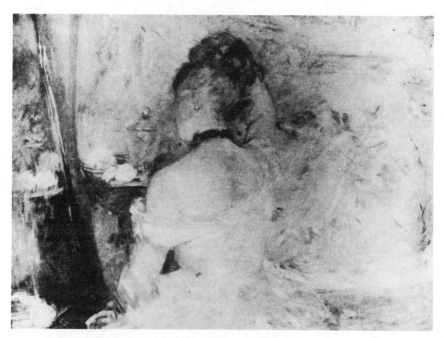

167

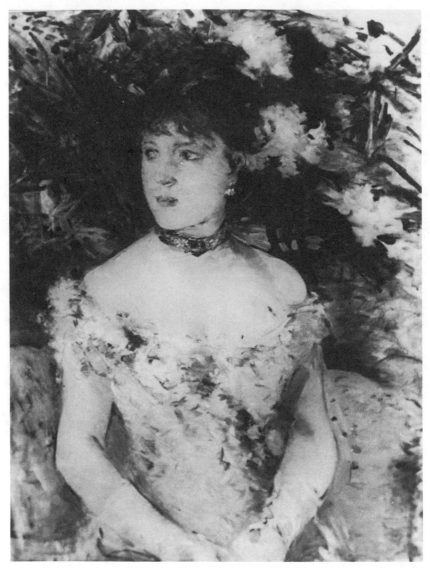

168

170

171

172

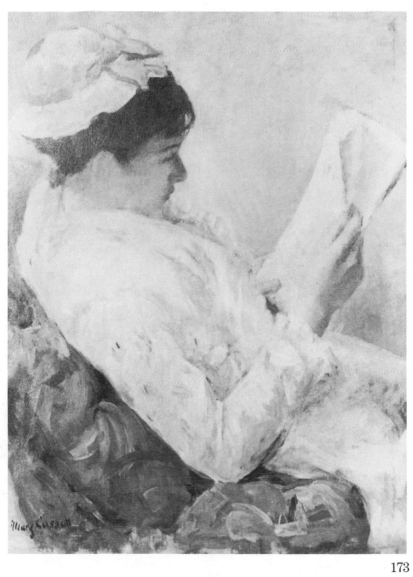

173

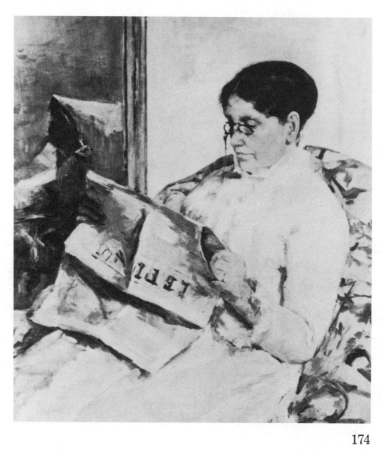

174

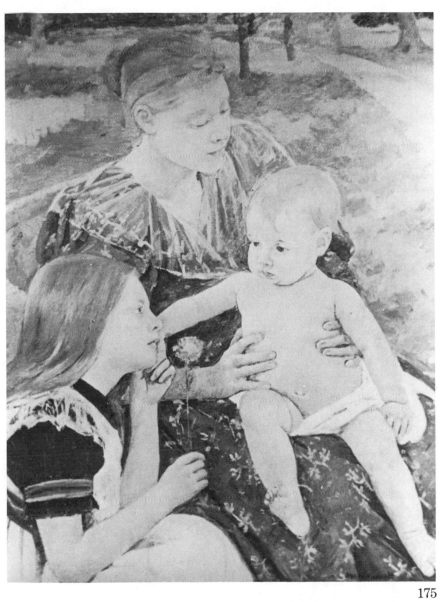

175

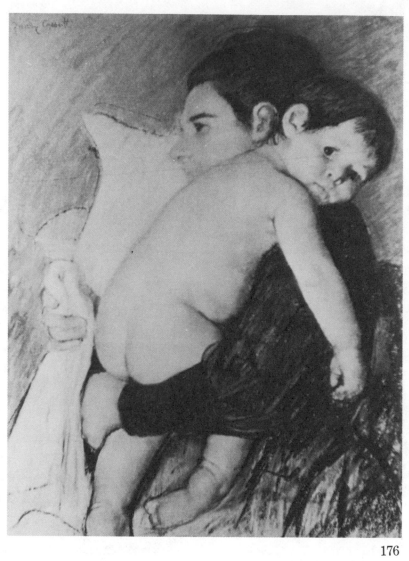

176

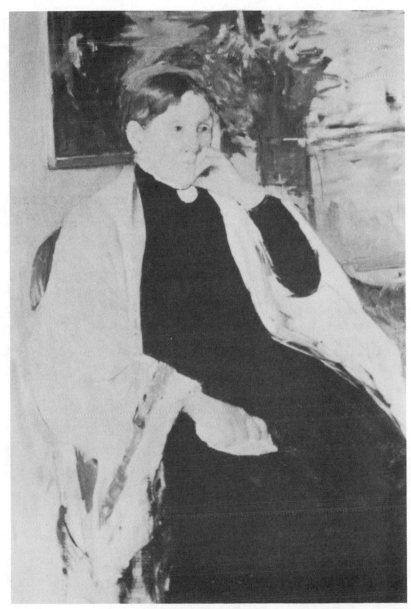

177

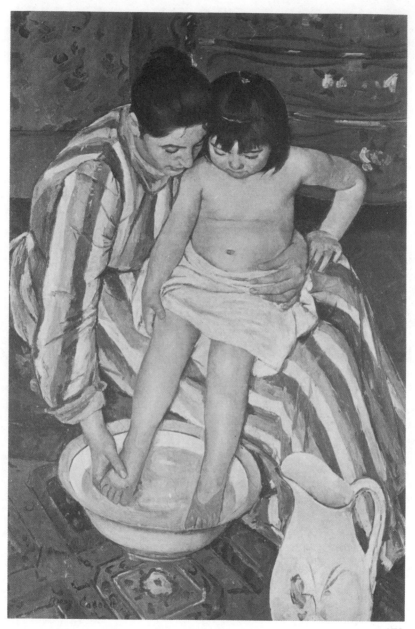

178

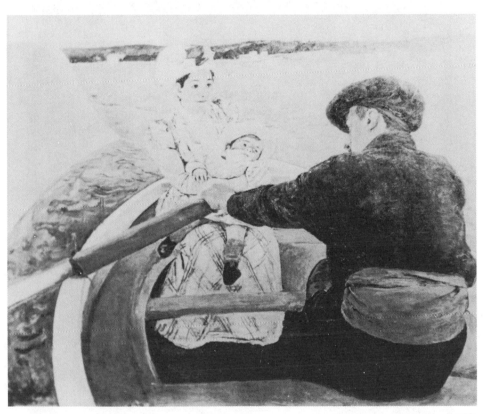

179

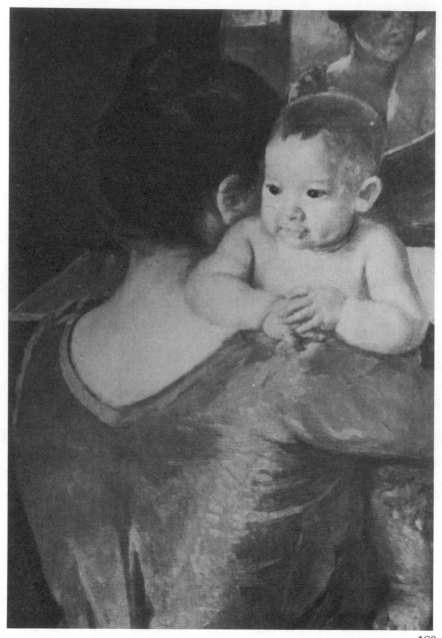

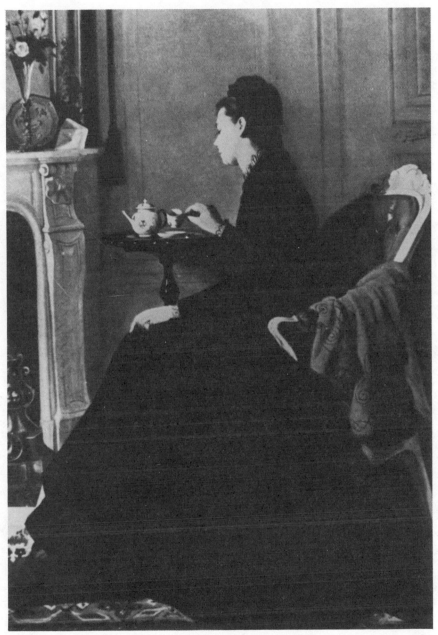

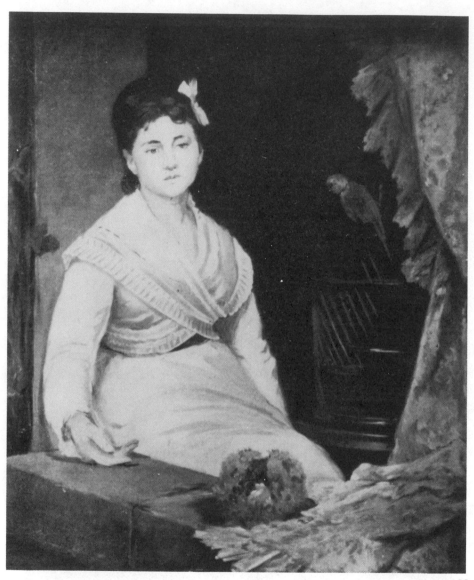

182

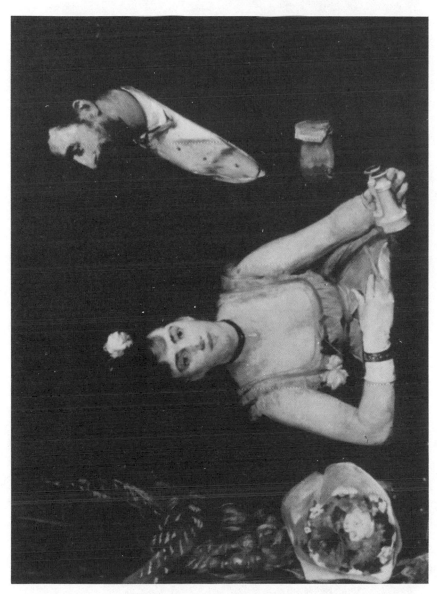

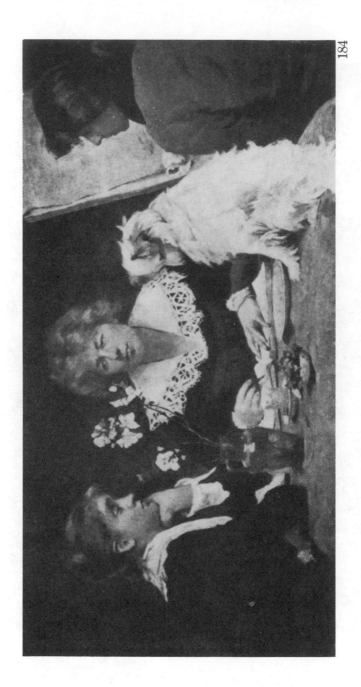

185

186

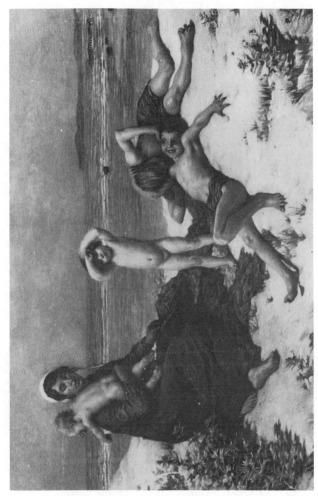

190

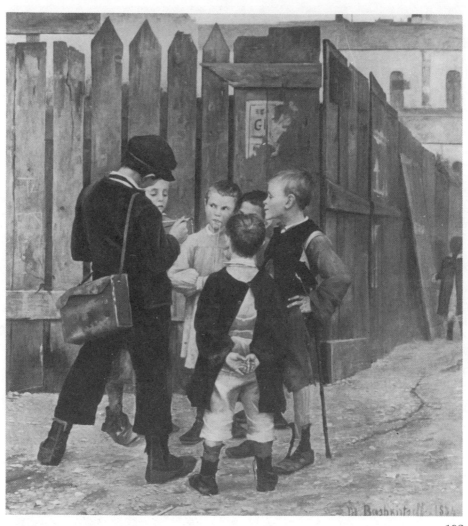

192

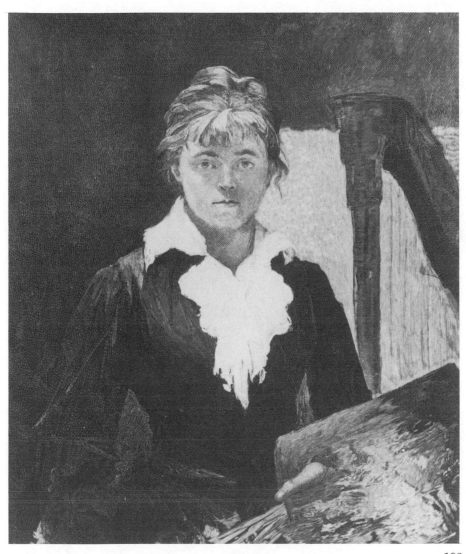

193

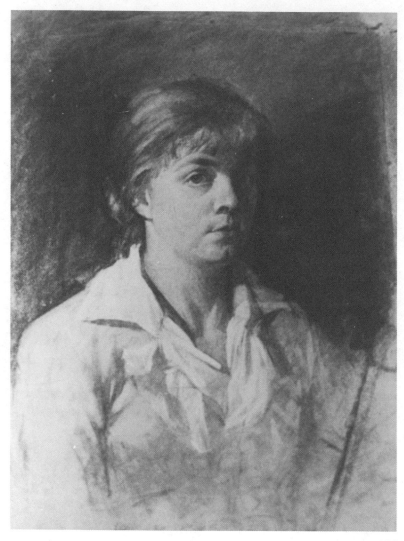

194